Aesthetics Today

Elements of Philosophy

The Elements of Philosophy series aims to produce core introductory texts in the major areas of philosophy, among them metaphysics, epistemology, ethics and moral theory, philosophy of religion, philosophy of mind, aesthetics and the philosophy of art, feminist philosophy, and social and political philosophy. Books in the series are written for an undergraduate audience of second- through fourth-year students and serve as the perfect cornerstone for understanding the various elements of philosophy.

Moral Theory: An Introduction by Mark Timmons

Epistemology: Classic Problems and Contemporary Responses by Laurence BonJour

Aesthetics and the Philosophy of Art: An Introduction by Robert Stecker

An Introduction to Social and Political Philosophy by Richard Schmitt

Epistemology by Laurence BonJour

Aesthetics and the Philosophy of Art, Second Edition by Robert Stecker

Aesthetics Today by Robert Stecker and Ted Gracyk

Aesthetics Today

A Reader

Edited by Robert Stecker and Ted Gracyk

ROWMAN & LITTLEFIELD PUBLISHERS, INC.
Lanham • Boulder • New York • Toronto • Plymouth, UK

Published by Rowman & Littlefield Publishers, Inc.
A wholly owned subsidary of The Rowman & Littlefield Publishing Group, Inc.
4501 Forbes Boulevard, Suite 200, Lanham, Maryland 20706
http://www.rowmanlittlefield.com

Estover Road, Plymouth PL6 7PY, United Kingdom

British Library Cataloguing in Publication Information Available

Library of Congress Cataloging-in-Publication Data

Aesthetics today : a reader / edited by Robert Stecker and Ted Gracyk.
 p. cm.
 Includes bibliographical references.
 ISBN 978-0-7425-6436-7 (cloth : alk. paper)—ISBN 978-0-7425-6437-4 (pbk. : alk. paper)
 1. Aesthetics. 2. Art—Philosophy. I. Stecker, Robert, 1947- II. Gracyk, Ted.
 BH39.A2867 2010
 111'.85—dc22

 2009045173

Printed in the United States of America

To my daughters, Sonia and Nadia

—Robert Stecker

To Frank Ellis and Br. William Beatie, for teaching me how to read a philosophical text

—Theodore Gracyk

Contents

Preface xi

Chapter 1 Environmental Aesthetics: Natural Beauty 1
Introduction 1
Allen Carlson, "Nature, Aesthetic Judgment, and Objectivity" 4
Emily Brady, "Interpreting Environments" 11
Marcia M. Eaton, "Fact and Fiction in the Aesthetic Appreciation of Nature" 19
Mark Sagoff, "Do Non-Native Species Threaten the Natural Environment?" 27
Further Reading 32

Chapter 2 Conceptions of the Aesthetic: Aesthetic Experience 33
Introduction 33
Immanuel Kant, "Analytic of the Beautiful" 37
J. O. Urmson, "What Makes a Situation Aesthetic?" 45
Noël Carroll, "Art and the Domain of the Aesthetic" 53
Gary Iseminger, "Aesthetic Communication" 62
Further Reading 71

Chapter 3 Conceptions of the Aesthetic: Aesthetic Properties 73
Introduction 73
David Hume, "Of the Standard of Taste" 76
Frank Sibley, "Objectivity and Aesthetics" 85

	John W. Bender, "Sensitivity, Sensibility, and Aesthetic Realism"	92
	Jerrold Levinson, "Aesthetic Properties, Evaluative Force, and Differences of Sensibility"	100
	Further Reading	108
Chapter 4	What Is Art?	109
	Introduction	109
	R. G. Collingwood, "Art Proper"	113
	Monroe C. Beardsley, "An Aesthetic Definition of Art"	122
	George Dickie, "The Art Circle"	130
	Stephen Davies, "Non-Western Art and Art's Definition"	137
	Further Reading	146
Chapter 5	What Kind of Object Is a Work of Art?	149
	Introduction	149
	Richard Wollheim, "Art and Its Objects"	154
	Paul Thom, "Interpretation: Process and Structure"	160
	Julian Dodd, "Musical Works as Eternal Types"	169
	Robert Howell, "Types, Indicated and Initiated"	176
	Further Reading	183
Chapter 6	Interpretation and the Problem of the Relevant Intention	185
	Introduction	185
	Gary Iseminger, "An Intentional Demonstration?"	189
	Daniel O. Nathan, "A Paradox in Intentionalism"	198
	William E. Tolhurst, "On What a Text Is and How It Means"	205
	Theodore Gracyk, "Allusion and Intention in Popular Art"	213
	Further Reading	221
Chapter 7	Representation: Fiction	223
	Introduction	223
	John R. Searle, "The Logical Status of Fictional Discourse"	227
	Gregory Currie, "What Is Fiction?"	234
	Peter Lamarque, "How Can We Fear and Pity Fictions?"	242

Kendall L. Walton, "Spelunking, Simulation,
 and Slime: On Being Moved by Fiction" 249
Further Reading 258

Chapter 8 Representation: Depiction 259
Introduction 259
Richard Wollheim, "Seeing-as, Seeing-in, and
 Pictorial Representation" 262
Dominic Lopes, "Pictorial Recognition" 268
John Hyman, "Pictorial Art and
 Visual Experience" 276
Further Reading 284

Chapter 9 Expressiveness in Music 285
Introduction 285
Eduard Hanslick, "The Representation of Feeling
 Is Not the Content of Music" 288
Stephen Davies, "The Expression of Emotion
 in Music" 296
Jenefer Robinson, "A New Romantic Theory
 of Expression" 304
Further Reading 313

Chapter 10 Artistic Value 315
Introduction 315
Malcolm Budd, "Aesthetic Judgment, Principles,
 and Properties" 318
Noël Carroll, "Art and Interaction" 326
James Shelley, "Empiricism and the Heresy of the
 Separable Value" 333
Further Reading 342

Chapter 11 Ethical, Aesthetic, and Artistic Value 343
Introduction 343
Berys Gaut, "The Ethical Criticism of Art" 346
Peter Lamarque, "Tragedy and Moral Value" 354
Matthew Kieran, "Art, Morality and Ethics:
 On the (Im)moral Character of Art Works and
 Interrelations to Artistic Value" 362
Sherri Irvin, "Aesthetics as a Guide to Ethics" 370
Further Reading 378

Chapter 12　The Humanly Made Environment　381

Introduction　381

Gordon Graham, "Art and Architecture"　384

Roger Scruton, "Architectural Principles in an
　Age of Nihilism"　393

Allen Carlson, "Reconsidering the Aesthetics of
　Architecture"　401

Further Reading　406

About the Authors　409

~

Preface

This book aims to provide centrally important texts that explore the current state of the debate on numerous issues within aesthetics and the philosophy of art. Within the constraints created by limitations of space and budget, we have tried to find readings that are both accessible to undergraduates and represent many of the positions on these issues that have garnered the most attention or show the greatest promise toward resolving core issues of contention. With the exception of excerpts from classic texts by David Hume, Immanuel Kant, Eduard Hanslick, and R. G. Collingwood, all of the readings are by contemporary authors working in the Anglophone philosophical tradition.

With the exception of the essays by Sherri Irvin and James Shelley, which are published for the first time in this volume, all the readings have been previously published in books or journals. The editors have abridged most of these essays to enhance their accessibility and maximize our ability to present a variety of positions on a given topic. We aim to provide a wide-ranging introduction to aesthetic theory and philosophy of art for readers, particularly university students, who seek an overview of major controversies, theories, and writers. Each chapter features three or four contrasting views on each topic introduced by an original introductory essay that outlines the chapter's central issues, concepts, and controversies. While some of these pieces are by contemporary philosophers recognized as central figures in their respective fields, we have chosen the selections in each chapter for their capacity to provide a representative set of competing

perspectives within the contemporary debate. Each chapter concludes with a list of further readings on the topic.

One of this collection's assumptions is that aesthetics and the philosophy of art are two distinct, though overlapping, fields. Aesthetics is the study of a certain kind of value that is crucial to living a human life to the full. Many hold that this value derives from a special type of experience and is identified in judgments that an object possesses this value in virtue of its capacity to deliver the experience. However, others believe that the value is better characterized by reference to certain properties of objects. Both views are represented here. Aesthetics in the sense just defined is the subject matter of chapters 1 to 3. The remainder of the volume is devoted to the philosophy of art, which developed from aesthetics but is distinct from it in two important ways. First, the philosophy of art deals with a much wider array of questions pertaining not just to value but to metaphysics, epistemology, the philosophy of mind and cognitive science, and the philosophy of language and symbols in general. Second, the exact role an appeal to the aesthetic should play in answering the central questions within the philosophy of art remains a matter of controversy. There is a tradition that appeals to aesthetic concepts to answer many of these questions: to tell us what art is, what is crucial to understanding and interpreting artworks and to defining artistic value. However, many today believe that art is too complex and diverse to be explicable in terms of a single category such as the aesthetic. On this view, a range of different kinds of value constitutes "artistic value." The modes of appreciating art, the means of understanding art, and the kinds of objects that are artworks are also all plural. Again, both positions are represented here.

The book has been designed to make it easy to use in combination with the second edition of *Aesthetics and the Philosophy of Art: An Introduction* by Robert Stecker. The topics and their order of presentation are the same in both volumes. The underlying pedagogical idea is that students benefit from studying a grounding text that sets out the central controversies within a field in conjunction with an anthology in which students can encounter writings arguing for different views on the controversial issues. However, this collection will also operate just as well as a stand-alone anthology or in combination with any of a number of other introductory texts on these topics that are currently in print. In whichever way it is used, we hope it will provide an accessible, yet challenging, overview of two increasingly vibrant fields of philosophy.

~

Environmental Aesthetics

Natural Beauty

Introduction

The common dandelion is found throughout North America. The mature plant is visually complex, with jagged green leaves framing a long, slender stem that supports a vibrant yellow flower. After a week, as the flower prepares to release its seeds, the plant is visually transformed. The flower becomes a puffy white ball that gradually breaks apart in the wind, scattering white parachuted seeds over the landscape. The dandelion also plays an important role in the life cycle of bees, which seek it out as a vital source of pollen in the early spring, before other plants flower.

However, the dandelion is not native to the Americas. Common throughout Europe, the first dandelions were brought to North America, it is believed, by the Puritans who arrived on the Mayflower in 1620. The early settlers did not bring them for aesthetic purposes but valued the dandelion as an edible vegetable. The immigrants cultivated the plant for both its leaves and roots, which provided nutrition that fought scurvy. They also used it as a digestive medicine. Yet, in America today the dandelion is probably more hated than loved. Dandelion seeds can remain dormant for years, and dandelion roots can survive harsh winter conditions, permitting them to sprout new leaves and flowers in the spring. As a result, dandelions appear suddenly when conditions, which coincide with those for grass, are right. So the dandelion flourishes on lawns, and millions of homeowners regard it as a weed, an aesthetic blight on their efforts to create a uniform green carpet.

Tons of broadleaf herbicides are poured onto American lawns annually to eradicate dandelions.

Aesthetically, the dandelion is delightful, particularly if one considers it as one might an artwork, as an individual object. However, one has a different evaluation if one prefers an unbroken expanse of lawn, in which case it is a stubborn, ugly weed. Here, attention has shifted from the isolated object to the object's contribution to a larger scene. Even so, a scattering of dandelions that will diminish the visual effect of a carefully manicured lawn will not have the same negative effect on a vacant lot or along a highway, where they might be admired for brightening their surroundings. Conversely, the city dweller who thinks of dandelions as weeds may perceive native broadleaf plants as mere weeds when seen in a patch of undisturbed prairie grass. The dandelion thus illustrates the central paradox of the aesthetics of nature. Is there a correct way to view it? Is it a beautiful natural phenomenon? Or, given its non-native, invasive character, is it an ugly noxious intruder into the North American landscape, crowding out other broadleaf flowering plants? Or, to adopt yet another perspective, what about the dandelion-free lawn? Is it the ugly intruder in this story? The presence of a dandelion-free lawn in an area full of dandelions is visual evidence of human behavior that poisons the ground and watershed with the harsh chemicals used to selectively control the weed. These chemicals will have many consequences for other aspects of nature, and people sensitive to these consequences will find it difficult or impossible to admire a scene that adversely impacts the surrounding ecosystem.

Clearly we can evaluate nature and natural objects in multiple ways. Traditional aesthetic theory expects us to ignore the scientific facts that explain why various natural scenes, plants, and animals are present in our environment. We are to evaluate nature's perceptual properties for their own sake, without concern for its native or non-native status, without concern for its effects on other aspects of the environment, and without reference to specialized scientific knowledge. However, context is often relevant to appreciating art—no one supposes we can properly admire William Wordsworth's poem "I Wandered Lonely as a Cloud" if we do not know what the words mean. At the very least, poetic norms should govern our appreciation. For example, when reading poetry, we should attend to both the sound of the words and their meaning. But it is less obvious what norms hold when appreciating nature. Furthermore, once we do take notice of the "unseen" scientific dimension of a patch of flowers in a field, there are no obvious limitations on what we should count as relevant.

Allen Carlson has been enormously influential in arguing that some norms govern aesthetic appreciation of nature, so not every aesthetic judgment is equally justified in response to nature. Superficial, uninformed

perceptual responses are generally misguided. Basic scientific facts about the kind of object that one perceives ought to be taken into account, and these facts give us a reason to treat some aesthetic judgments as true and others as false. The most basic fact is what counts as normal for a natural kind, establishing a perceptual norm for it. For example, a viewer who is ignorant of what is typically true both of horses and of Shetland ponies is in no position to see the cuteness of a Shetland pony. Furthermore, Carlson's point about the correct cognitive stance toward nature extends beyond kinds of objects to kinds of landscapes and natural environments. A beach and an exposed seabed are scientifically distinct categories, and therefore some aesthetic responses that are true of a seabed will not be appropriate to a similar-looking stretch of beach. Furthermore, because we sometimes imitate natural scenes artificially, perceptual features are not sufficient to determine the correct classification of any given natural object or environment. Simply looking at a field cannot reveal whether a dandelion belongs among the many flowers found there. Knowledge derived from natural science is required to arrive at a true estimation of the aesthetic properties of nature.

Emily Brady regards Carlson's thesis as too narrow. Arguing that an aesthetic response is closely connected to our search for meaning, Brady proposes that the integration of imaginative, emotive, and cognitive processes best characterizes aesthetic appreciation. Consequently, there is no single correct way to appreciate a dandelion, a seabed, or cows grazing on green grass in a field. Like art, nature should be approached as an opportunity for a range of aesthetic experiences. Furthermore, Carlson's emphasis on scientific knowledge excludes symbolic significance from nature. Yet, symbolic interpretation is frequently at the heart of aesthetic appreciation.

Responding to Brady, Marcia M. Eaton elaborates on Carlson's cognitive model, emphasizing how it can be used to encourage us to value nature more appropriately. However, a preference for imagination over scientific fact guides many of our aesthetic responses to nature, and Eaton worries that Brady's support for this sort of imaginative freedom encourages us to make foolish decisions about the natural environment. Imaginative responses are dangerous when they wrongly sentimentalize nature or generate attitudes that lead to our indifference to the biological health of various ecosystems.

Mark Sagoff warns against the tendency to admire "natural" ecosystems on the grounds that human-induced changes inevitably harm them. Focusing on the introduction and "naturalization" of non-native plant species, he argues that we have not yet developed clear scientific concepts of native species and environmental harm. This lack of clear scientific concepts is a serious problem for the idea that scientific facts must inform a correct

aesthetic response. If no scientific facts establish that the purple loosestrife, the common dandelion, and the Amur honeysuckle are more harmful to an ecosystem than the plants they replace, how can we find ethical guidance in our aesthetic responses to their presence, whether positive or negative?

∞

Nature, Aesthetic Judgment, and Objectivity*

Allen Carlson

Consider the view that some aesthetic judgments about nature and natural objects (e.g., "The Grand Tetons are majestic") are appropriate, correct, or perhaps simply true; while others (e.g., "The Grand Tetons are dumpy") are inappropriate, incorrect, or perhaps simply false. There are those who accept these views in regard to aesthetic judgments about art, but have serious reservations about accepting them in regard to such judgments about nature. These objectors readily admit and often defend the view that, for example, "*Guernica* is dynamic" is appropriate, correct, or true, but find "The Grand Tetons are majestic" somewhat worrisome—at least in their theoretical moments, if not in their actual practice. One such example is found in Kendall Walton's important paper "Categories of Art."[1] I select Walton's position for consideration for two reasons: First, it presents a persuasive and well-developed account of the truth and falsity of aesthetic judgments about art, which does not directly apply to aesthetic judgments about nature. Second, the position is developed in such a way that it makes possible a clear understanding of why aestheticians might hold an essentially objectivist view concerning aesthetic judgments about art and yet a relativist view concerning those about nature. My general point in considering Walton's position is to demonstrate that a somewhat analogous position does in fact apply to nature. If this is the case, then to the extent that positions of this general type underwrite the objectivity of aesthetic judgments about art, the objectivity of aesthetic judgments about nature is similarly underwritten.

To begin we must have at our disposal a brief and schematic account of Walton's position together with his reservations concerning its applicability to aesthetic judgments about nature. Essentially Walton holds that the truth value of aesthetic judgments about a work of art is a function of two things: first, the (nonaesthetic) perceptual properties which a work actually has, and second, the perceived status of such perceptual properties when a work

*"Nature, Aesthetic Judgment, and Objectivity," *Journal of Aesthetics and Art Criticism* 40:1 (1981): 15–27. Copyright © 1981 The American Society for Aesthetics. Reprinted by permission of Blackwell Publishing Ltd.

is perceived in its correct category or categories of art. He provides evidence for the psychological claim that the aesthetic judgments which seem true or false of a work are a function of the perceived status of its perceptual properties given any category in which the work is perceived; he argues for the philosophical claim that the aesthetic judgments which are true or false of a work are a function of the perceived status of its perceptual properties given that the work is perceived in its correct category or categories.

Consider "Guernica is awkward." If this aesthetic judgment is false, it is false as a function of the perceptual properties of Guernica, i.e., its lines, colors, forms. With this few would disagree. Walton goes further to point out that Guernica can be perceived in different (perceptually distinguishable) categories of art.[2] If Guernica is perceived as a cubist painting, its cube-like shapes will be perceived as standard; this perceived status affects which aesthetic judgments seem true or false to a perceiver on an occasion. "Guernica is awkward" will seem false when the painting is seen in the category of cubist paintings. But is "Guernica is awkward" really true or really false? Walton's philosophical claim is that this depends on the perceived status of the perceptual properties when Guernica is perceived in its correct category. In this particular case Guernica is correctly perceived as a cubist painting; thus the perceived status of its cube-like shapes does not count toward awkwardness.

It follows from Walton's account that in order to determine the truth value of an aesthetic judgment such as "Guernica is awkward," it will not do simply to look at Guernica. Rather, we must perceive Guernica in its correct category. This requires two kinds of knowledge: first, the knowledge that certain factors make cubism its correct category; that is, certain factual knowledge about the history and nature of twentieth-century art. And second, the knowledge how to perceive Guernica as a cubist work; that is, certain practical knowledge or skill which must be acquired by training and experience in regard to the category of cubist paintings and other related categories of art.

We are now in a position to consider the relevance of a Walton-like position to aesthetic judgments about nature. Walton has an essentially objectivist account of aesthetic judgments about art and yet a relativist account of those about nature. In regard to the latter, there seem to be no essentially correct or incorrect categories in which to perceive nature. With nature it appears to be a matter of aesthetically appreciating whatever one can and as much as one can, but not a matter of making true or false aesthetic judgments.

Walton's position embodies not only a philosophical claim but also a psychological claim. The latter is the claim that the aesthetic judgments which seem true or false of a work are a function of the perceptual status of its perceptual properties given any category in which the work is perceived. I think that a similar psychological claim can be demonstrated to hold for

aesthetic judgments about nature. In fact Walton presents one case which suggests that this is so.

> A small elephant, one which is smaller than most elephants with which we are familiar, might impress us as charming, cute, delicate, or puny. This is not simply because of its (absolute) size, but because it is small for *an elephant*. . . . How an elephant's size affects us aesthetically depends, since we see it as an elephant, on whether it falls in the upper, middle or lower part of the range.[3]

This case illustrates the application of the psychological claim to natural objects and provides an example of a relevant category. The category is that of elephants, a perceptually distinguishable category in which we do perceive certain natural objects—under most conditions, elephants. With respect to this category, size is a variable property. Were the elephant small enough—for example, the size of a large mouse—other aesthetic judgments would seem true. In addition to (or as opposed to) appearing delicate, it might appear frail or fragile. And it would certainly strike us as being surprising or disconcerting—aesthetic properties related to certain contra-standard perceptual properties. The point illustrated by this case generally holds true for similar cases. Consider, for example, the aesthetic judgments we take to be true of Shetland ponies (charming, cute) and Clydesdale horses (majestic, lumbering). These judgments are made with respect to the category of horses. Similarly a foal (calf, fawn, etc.) typically strikes us as delicate and nimble when seen in the category of horses (cattle, deer, etc.), but a particularly husky one may strike us as lumbering or perhaps awkward if seen in the category of foals (calves, fawns, etc.).

In the above example, our aesthetic appreciation is directed toward a natural *object*. We also need, however, to consider the application of the psychological claim to a somewhat different kind of example—the aesthetic appreciation of landscapes or of natural environments. In discussing the enriching of aesthetic appreciation, Ronald Hepburn describes the following cases:

> Supposing I am walking over a wide expanse of sand and mud. The quality of the scene is perhaps that of wild, glad emptiness. But suppose that I bring to bear upon the scene my knowledge that this is a tidal basin, the tide being out. I see myself now as virtually walking on what is for half the day sea-bed. The wild, glad emptiness may be tempered by a disturbing weirdness.[4]

Once we recognize beach and sea-bed as categories, perceiving the expanse in the category of sea-beds (as opposed to beaches) results in its appearing to possess a "disturbing weirdness." The weirdness is the result not simply of

the realization that one is walking on a tidal basin, but of the experience of walking where it is, as it were, contra-standard to walk, that is, in perceiving the wide expanse as a sea-bed and perceiving oneself as walking upon that sea-bed.

Similarly, in regard to properties standard, variable, and contra-standard in respect to beaches we might explain the initial aesthetic judgment involving "wild, glad emptiness." As in the case of the size of elephants, the width and expansiveness of, in this case, a beach is a variable property and the limits on the range of width and expansiveness a standard property with respect to this category. Thus if the sand and mud is, as suggested by the quote, quite wide and expansive, that is, in the upper part of the range, the resultant aesthetic impression will be of a "wild, glad emptiness." On the other hand, had the expanse of sand and mud been in the lower part of the range, the beach may have appeared warm and cozy or perhaps cramped and confining. Other examples similar to the above could be provided. Reflection on our judgments about mountains, sunsets, and waving fields of grain appears to bear this out. However, rather than pursue further examples which support this psychological claim, I wish to turn to the more important question of the correctness of such judgments. I wish to ask whether there are persuasive arguments for considering certain categories of nature to be correct and others incorrect, as is the case in regard to categories of art. Given the implausibility of a bifurcated account of aesthetic judgments, I assume that the existence of such arguments constitutes adequate reason for rejecting the category-relative interpretation.

In the remainder I sketch some arguments which give grounds for holding that certain categories of nature are correct and others not. Initially, however, we should note that there is one obvious way in which certain of such categories are correct and others not. It appears, for example, that the category of elephants and not that of mice is the correct category for perceiving an elephant, regardless of its size. The more difficult kind of case is that in which the perceptual properties of a natural object or a part of nature do not by themselves clearly indicate a correct category. Such a case is posed when, given the perceptual properties, it is yet plausible to perceive an object in two or more mutually exclusive categories. Very simple examples are perceiving a sea-anemone as a plant or as an animal, or perceiving a whale as a fish or as a mammal. Whales are not produced by artists who intend them to be perceived in certain categories and are not produced within societies. However, from these truisms, Walton and others apparently move to the view that in regard to nature we are completely without resources for determining a correct category.

What must be recognized is that human production is not the only key to correctness of category. In general we do not produce, but rather discover, natural objects and aspects of nature. Why should we therefore not discover the correct categories for their perception? We discover whales and later discover that, in spite of somewhat misleading perceptual properties, they are in fact mammals and not fish. It is plausible to claim that we have discovered the correct category in which to perceive whales. In the first place, that whales are not of our production does not count *against* this category being correct. In the second, it fits our intuitions in regard to correct categorization or classification of whales if this issue is considered independent of aesthetic issues. And in the third place, this correctness of category can function philosophically in regard to aesthetic judgments about nature as the correctness of categories of art functions in regard to aesthetic judgments about art works. The only significant difference is that in regard to the latter the grounds for correctness are the activities of artists and art critics, while in regard to the former, they are the activities of naturalists and scientists in the broadest sense. But given the differences between art and nature, this is only to be expected.

The above line of thought shifts the burden of proof to those who defend such an interpretation. We must consider some further arguments which do more than shift the burden of proof. To find a realistic case in which perceptual properties are neutral in regard to correctness of category it is useful to envisage a situation where man is involved. We, or landscapers, sometimes construct (or reconstruct) landscapes which are perceptually indistinguishable from natural landscapes. Consider a scenic coastline which appears to be natural, but in fact has been created by man. Imagine that it has been carefully planned and designed to be perceptually indistinguishable from a natural coastline, but its construction involved the removal of buildings and parking lots, the redistribution of great quantities of sand and soil, and the landscaping of the whole area to blend with its surroundings. In such a case perceptual properties alone clearly do not *determine* whether it is correct to perceive the landscape as natural coastline or as artifact, yet the question of which is the correct category can be raised. It is essentially the question of whether it is correct to perceive the object as what it is (an artifact) or as what it appears to be (a natural coastline). It is this form of the question to which I wish to address two additional lines of thought to the effect that certain categories in which we perceive nature are correct and others not.

The first of these two additional arguments can be made clear by imagining another coastline. This is a coastline which is perceptually indistinguishable from the above described coastline, but is natural rather than man-made. We

can assume it is the coastline which served as the model for the man-made one. Since the two coastlines (call them N for natural and M for man-made) are perceptually indistinguishable, there is one level at which our aesthetic appreciation of the two will be identical. This is the level at which we appreciate only perceptual properties such as the curves, lines, colors, shapes, and patterns of N and M. However, there is certainly another level at which aesthetic appreciation occurs. At this level we appreciate not simply, for example, the identical patterns of N and M, but such patterns under certain descriptions. For example, the pattern of M can be described as indicating careful design, as an exact copy of the pattern of N, or as the product of man's ingenuity; while the pattern of N can be described as typical of, say, North American Pacific coastlines, or as the product of the erosion of the sea. It is clear that aesthetic appreciation of perceptual properties under such descriptions constitutes an important part of aesthetic appreciation of nature.

Given the aesthetic relevance of these kinds of descriptions, it must be recognized that the above descriptions of the patterns of N and M are such that those which are true of N's pattern are not true of M's and vice-versa. It is possible to contemplate M in light of the description "being carefully designed by man" and moreover to appreciate it as something in virtue of which this is true, but these possibilities are not likely to be achieved if M is perceived (only) in the category of natural coastlines. The opportunity for such contemplation and appreciation is not provided by perceiving M in this category. Moreover, if we appreciate M as something in virtue of which this description is true, we are simply mistaken; our appreciation involves a false belief. On the other hand, if we perceive M in the category of artifact or perceive N in the category of natural coastlines—the categories of what each in fact is—then aesthetic omissions and aesthetic deceptions of the kind described above need not occur.

There are two things to observe about the preceding argument. As suggested earlier, these features of the example are due to the desire for a realistic case in which perceptual properties themselves cannot be construed as determining the correctness of one or the other category. In this regard it is important to note that this same line of argument applies to, for example, our earlier case involving the categories of beach, sea-bed, and tidal basin. Different aesthetically relevant descriptions are true of the wide expanse of sand and mud depending upon whether it is in fact a beach, a sea-bed, or a tidal basin. And only perceiving the expanse in the category of what it is will avoid various aesthetic omissions and deceptions. Consequently in such cases we similarly have grounds for the determination of the correct category and for rejecting the category-relative interpretation of aesthetic judgments.

The second line of thought for construing the category is in part an ethical argument. It is essentially the contention that this is the best way to keep our aesthetics and our ethics in harmony. It is clear that we do not aesthetically appreciate simply with our five senses, but rather with an important part of our whole emotional and psychological selves. Consequently, it is especially pertinent to the aesthetic appreciation of nature. If our aesthetic appreciation of nature helps to determine our ethical views concerning nature, then our aesthetic appreciation of nature should be of nature as it in fact is rather than as what it may appear to be. By aesthetically appreciating nature for what it is, we will shape our ethical views such that there is the best opportunity for making sound ethical judgments in regard to matters of environmental and ecological concern. Consider again the man-made coastline. What if we discover that it causes environmental and ethical problems? Perhaps it greatly decreases the possibility of successful upstream migration by spawning salmon, or perhaps it causes an undercurrent which is exceedingly dangerous to swimmers. If we perceive the coastline in the category of natural coastlines (and are entrenched in doing so), a sound ethical view might involve noting that fish and men have in such cases long accepted and met the challenges of nature. Consequently perhaps we rightly conclude that we should let nature take its course and swimmers take their chances. On the other hand if we perceive the coastline in the category of artifact or man-made coastline, a sound ethical view might involve regarding our environmental and ethical responsibilities quite differently. Perhaps we, ethically and ecologically, should construct a fish ladder up the coast (as has been done to allow salmon migration around hydroelectric dams), and perhaps we, ethically, should forbid swimmers to use the area.

If this argument together with the others offered above give adequate grounds for claiming truth and falsity for our aesthetic judgments of nature (rather than accepting the category-relative interpretation), then these arguments help to establish a position which has additional merit. This is the merit of bringing the interests and points of view of aesthetics, ethics, and natural science together such that they reinforce one another, rather than stand in opposition as they so often appear to do.

We can, of course, approach nature as we sometimes approach art, that is, we can simply *enjoy* its forms and colors or *enjoy* perceiving it however we may happen to. But if our appreciation is to be at a deeper level, then we must know something about that which we appreciate. This means that for significant aesthetic appreciation of nature, something like the knowledge and experience of the naturalist is essential. It is not surprising that individuals such as Muir, Ruskin, Audubon, and Leopold who demonstrated an acute

aesthetic appreciation of nature in their paintings and writings were not only appreciators of nature but also accomplished naturalists.

Notes

1. Kendall L. Walton, "Categories of Art," *Philosophical Review* 79 (1970): 334–67.

2. "Such categories include media, genre, styles, forms, and so forth—for example, the categories of paintings, cubist paintings, Gothic architecture, classical sonatas—if they are interpreted in such a way that membership is determined solely by features that can be perceived in a work when it is experienced in the normal manner" (Walton "Categories of Art," 338–39).

3. Walton, "Categories of Art," 350–51.

4. Ronald W. Hepburn, "Aesthetic Appreciation of Nature," in *Aesthetics in the Modern World*, ed. Harold Osborne, 49–66 (London: Weybright and Talley, 1968), 55.

Interpreting Environments*

Emily Brady

The aesthetic response to natural and cultural landscapes involves an exploration of aesthetic qualities, and an attempt to make sense of or discover meaning in what we experience. In this paper, I examine the interpretive aspect of environmental appreciation. I argue against a single, cognitive basis for determining a correct interpretation, and put forward an alternative, critical pluralism, which supports a rich interpretive activity that draws upon the multiple meanings we find through our aesthetic experiences.

Many Environments

Aesthetic experience ranges over a diverse set of environments, from more natural to more cultural. On one end of the spectrum we find relatively pristine, unmodified environments, and on the other end, centers of human culture in urban environments. I make a distinction, if not clear-cut, between nature and culture. Cultural landscapes are those that have been intentionally modified by humans but where nature still plays some role. They range from landscapes with traces of human habitation and agriculture, to the heavily modified landscapes of intensive agriculture and sparse settlements of indigenous cultures. Although urban environments would appear to be cultural landscapes, it makes more sense to keep them in a category of their own, since their urban character leaves much less room for nature compared

*Reprinted from *Essays in Philosophy* Vol. 3, No. 1 (January 2002), with permission of the author and the general editor, Michael Goodman. *Essays in Philosophy* can be accessed at www.humboldt.edu/~essays/.

to the rural countryside. It is important to grasp that we encounter a broad range of environments, and that the differences between more natural and more cultural environments will affect our interpretation of them.

Interpreting Environments

Interpretation is the activity of discovering meaning. It is "making sense of" something, and involves exploration and putting together various perceptions into a coherent whole, so that we are able to take in an aesthetic object. In the artworld, one is trying to make sense of a work and the meanings it has. The question directing interpretation would be, "What do you mean?" or "What does it mean?" because one expects there to be something to figure out. With environments that are mostly natural, this question would be odd since there is no meaning internal to landscapes. We bring meaning to them or assign meaning through cultural frameworks. There is still an attempt to make sense of something, but not in terms of searching for meaning that already exists.

Reference to natural causes and processes (alongside human origins, where relevant) could have a kind of relevance for the environment by guiding interpretation. This move is well known as the basis of Allen Carlson's "natural environmental model" of aesthetic appreciation, and it is relevant in his discussion of "order appreciation" in relation to nature. Carlson argues that we can replace the categories of art history with natural history for appropriate appreciation of nature. By identifying such appreciation as correct or appropriate, he assumes a standard of correctness in our interpretation and aesthetic judgment of nature. For example, in his discussion of order appreciation, Carlson says,

> First, the relevant order is that typically called the natural order. Second, since there is no artist, not even one assimilated to processes and materials, the relevant forces are the forces of nature: the geological, biological, and meteorological forces that produce the natural order by shaping not only the plant but everything that inhabits it. Although these forces differ from many that shape works of art, awareness and understanding of them is vital in nature appreciation, as is knowledge of, for example, Pollock's role in appreciating his action painting or the role of chance in appreciating a Dada experiment.[1]

This kind of position entails a cognitive view of interpretation, and sets out clearly what type of knowledge is relevant for interpretation—scientific knowledge and its "common-sense analogues."

The cognitive approach to aesthetic appreciation of nature, and its focus on science as a criterion of correctness, has been challenged by several

environmental aestheticians.[2] I would like to present an approach to interpretation that puts much less emphasis on cognitive sources for discovering meaning through aesthetic appreciation. I want to show how we draw on associations, imagination and emotion, and nonscientific information in interpretation. My view aims at the middle ground between formalist and cognitive approaches. Formalist interpretation of the environment is a perceptual rather than cognitive activity, where our making sense of something involves only those qualities available to perception, such as shapes and colors, perhaps akin to a scenery model of aesthetic appreciation of nature, which rests solely on visual qualities. A cognitive model of interpretation argues for a range of necessary knowledge, from the knowledge of an amateur naturalist to the more sophisticated knowledge of an ecologist or geologist.

In aesthetic interpretation, meanings arise directly out of aesthetic qualities, as perceived by an individual who brings with them a set of values, preferences, and more or less background knowledge, aesthetic experience, perceptual and emotional sensitivity, and imaginative ability. Interpretation begins in exploratory perception, but does not end there. Through perception, we piece together what we apprehend through the senses, grasping shapes and colors, sounds, smells and changing conditions. For example, walking through a pasture, I take in what is around me—cows grazing green grass pockmarked with cowpats, the soft smell of grass mixed with faint sweet fragrances, perhaps from the small white flowers blooming on the tree by the stone wall, and the feeling of uneven ground underfoot, which I have to carefully walk over. My appreciation can be thin, that is, it can rest on a surface rendering of what I perceive, and some of the experience will involve immediate perception rather than interpretation. Or, it may thicken, as I hear the cows munching and am reminded of the first time I walked through this pasture, when my pleasure was tinged with fear of the cows, and I stuck closer to the stone wall. This time the place has a peaceful pastoral quality, compared to the first time, when it was perhaps a little more strange. As I see some of the flower petals floating off the tree in the breeze, I imagine the leaves and fruit that will take their place. Here, the landscape becomes imbued with meaning from personal associations and a basic understanding of seasons changing.

This is a rather ordinary, everyday example, at least in my experience. There are experiences that draw more heavily on various sources for interpretation, such as imagination, emotion, and various narratives. An interesting use of imagination and perception coming together is "seeing as." Seeing as involves seeing objects under an aspect, and it has been described as a kind of interpretive perception. Ronald Hepburn argues that "we need not

confine ourselves to the contemplating of naked uninterpreted particulars"; we should aim to enrich the interpretive element of appreciation:[3]

> In a leaf pattern, I may "see" also blood-vessel patterns, or the patterns of branching, forked lightning: or all of these. In a spiral nebula pattern I may see the pattern of swirling waters or whirling dust. I may be aware of a network of affinities, or analogous forms, that spans the inorganic or the organic world, or both.[4]

Notice that this exploratory activity does not draw on information about the leaf itself, but rather one brings associations or images to bear on perception. This interpretive perception is also the source of many landscapes that are transformed into artworks through paint, sculpture, poems, novels, films and music. For centuries, artists have "remade" the world, transforming their ways of interpreting their surroundings into artistic renderings. Artists are among the most sensitive and creative interpreters of nature, and artworks provide some of the most concrete and enduring interpretations of the environment.

Emotion also has an important role as a source of interpretation of the environment. The aesthetic qualities of some environment, say, the darkness, and tall, heavy trees of a pine forest, may lead to the attribution of expressive qualities of being magical or perhaps even disturbing. It is these expressive qualities that often contribute to the animation of nature, with stories of creatures—mythical or real—lurking deep inside the forest. Expressive qualities give meaning to the environment, and at least in this sense contribute to the interpretive framework. Our own emotions or moods will color how we experience a landscape, but we have to be careful not to assume that this would be how others see it. Disinterestedness requires that we recognize certain meanings as personal, and separate them from more generalizable interpretations.

Last but not least, interpretation is an activity that necessarily involves understanding. By conceiving of aesthetic interpretation of nature as "making sense of," there must be some way in which concepts enter into interpretation, but without [exclusively] embracing a cognitive approach. I believe that models of aesthetic appreciation of nature ought to be open rather than closed. This better accounts for the range of aesthetic experiences we have and the range of abilities that appreciators bring to their experiences of environments.

In debates about interpretation in the arts, philosophers have disagreed about the proper aim of interpretation, that is, what it is that we should be

doing when we interpret works of art. This issue has relevance to the environment too, where we need to ask what exactly is the point of interpreting the environment in the *aesthetic context*. I would argue that the proper aim of interpretation is to enrich aesthetic appreciation in ways that enhance our aesthetic encounters with the environment. Interpretive activity ought to involve a variety of imaginative ways to discover meaning in our environment, ways that increase the value we find there. This is more familiar ground to an aesthetic approach than seeking understanding through a single, correct interpretation. I am suggesting a view of interpretation that would be consistent with aesthetic education, without making such education the *aim* of appreciation.

Interpretation and Knowledge
Given these background aims to my approach to interpretation, I can now say a little more about what role knowledge will play, since this is no doubt a difficult issue to work out. Interpretation does not require more than the basic conceptual framework that we bring to our encounters with nature. Examples of this basic knowledge range from: having basic concepts, or an ability to differentiate one thing from another—this is a tree and this is a rock, to understanding the conditions or states of things—that grass is usually green; that the sun rises in the morning and sets in the evening; that flowers bloom in springtime, and so on. It is not easy to say when commonsense knowledge ends and specialist or scientific knowledge begins. Besides such concepts, whatever background knowledge the individual comes with may be fed into interpretation. Some will come with the experience of a local who walks through a pasture every day, whereas others may be visitors to the place for the first time. The local has acquired an understanding of her surroundings from repeated visits, perhaps looking more closely each time. A visitor may compare this place to their own familiar environments, bringing those associations and concepts into play. In neither case is any particular knowledge necessary to finding meaning in their surroundings. Both can have equally rich aesthetic experiences, although they will have different emphases. For the local, it is the familiar, and perhaps even overlooking what the visitor would notice. For the visitor, it may be new and even strange, perhaps demanding more exploration. Both interpretive frameworks may issue in reasonable interpretations.

Beyond basic knowledge, identifying the range of sources of interpretation turns on the problematic concept of knowledge. In these postmodern times it would hardly do to limit knowledge to factual categories such as the sciences, to ecology, geology, and so on. We ought to include so-called folk knowledge,

through everyday local knowledge of an environment, including knowledge of the landscape from native sources such as mythology and other cultural meanings. We should also not forget that some appreciation draws only on perception, on knowledge acquired purely through perceptual acquaintance with an environment. Widening the scope of knowledge drawn upon does not, however, take away the problem of how we distinguish between acceptable and unacceptable interpretations of the environment. We have to pin down not those interpretations that are true, but those that are reasonable, given particular cultures and types of environments. Before tackling this difficult issue, I shall first consider the range of sources of knowledge we use in making environments meaningful.

Religion and myth are among the most common, less scientific ways people find meaning in landscape. In the Nordic environment of Finland, the word for the Aurora Borealis is "revontulet," which means "fox fires." It is said to derive from old folklore that explains the bright, pulsating, red and blue lights as the painterly effects of the arctic fox's bushy tail, which starts fires and sprays snow into the night sky.[5]

Human history, an extension of these culturally based interpretations, provides a source for making sense of an environment. The Isle of Rum in Scotland is now a designated nature reserve, and it was once considered as a possible location for the reintroduction of wolves. However, much of it is a cultural landscape. Among the desolate moors and sublime mountains, one finds the overgrown ruins of black-houses, evidence of crofters who were cleared from the land to make way for sheep-farming. The ripples in the green fields that come up to the edge of the sea are not natural but rather "lazybeds," an old agricultural practice. On the other side of the island, a more recent reminder of human history is found in a bizarre Victorian folly, an old hunting lodge built by a wealthy merchant. As we take in these parts of the environment, and feed in whatever knowledge we may gather, appreciation shifts from seeing the land as a windswept wilderness to a landscape once inhabited by humans, then sheep, and now left largely to nature, except for conservation workers and visitors.

More generally, we can talk about cultural significance, meaning that is assigned to landscapes in virtue of what they symbolize for particular cultures. Human history, but also cultural meaning, can be found in the disused quarries in Welsh mountain landscapes. Wilderness has significance for many North Americans for being a vast space "untouched" by humans, at once tranquil and threatening, beautiful and sublime. It is a sacred environment, symbolizing freedom and independence as well as the antithesis of modern life.

I have stressed that everyday or commonsense knowledge may also be sufficient for making sense of an environment. But what about scientific knowledge? Different meanings are brought to bear on qualities in our surroundings through the story told by science. In the case of the Aurora Borealis, the colors take on another meaning. We see them not as the fiery art of the arctic fox, but rather as caused by solar winds moving across the upper atmosphere and hitting gas molecules, which creates light. The colors are not the fox's chosen palate, but correspond to the colors of gases in the ionosphere.[6]

Critical Pluralism

Which story makes the most sense for making sense of aesthetic objects? Is one interpretive story better than another, or are all stories equally legitimate? Advocates of the cognitive or science-based models of aesthetic appreciation of nature argue that although these other stories may have some relevance, science provides the ultimate, correct standard for interpretation.

Although Carlson does not specifically address the question of interpretation, if we accept that interpretation is a dimension of aesthetic appreciation, science will provide the correct framework according to his cognitive position. On his view, imaginative and literary descriptions are irrelevant sources of information. In his discussion of cultural knowledge, Carlson does not give a means for determining whether scientific or cultural knowledge takes priority in interpretation, but it is probable, given his views on the correct story within appreciation more generally, that science is the answer.

Philosophers on the other side of the debate accept that multiple stories may lead to multiple acceptable interpretations, but they are sensitive to the problems, aesthetic and moral, of "humanizing nature," or of interpreting nature through only a cultural lens, rather than attempting to experience it also on its own, natural terms. For example, Yuriko Saito is particularly concerned that some cultural associations overly humanize landscapes and prevent us from appreciating their natural value. For example, she comments that tourists appreciate some landscapes "primarily through historical/cultural/literary associations. Plymouth Rock and the Gettysburg battlefield are the prime examples from this country."[7] She recognizes that the cultural and historical values of these places are important, but she worries that such interpretations do not approach nature on its own terms. Also, Saito allows for folk knowledge associations because she thinks that these are not just about "human deeds" with the landscape as a backdrop, but rather they work much more closely with nature's qualities, attempting to interpret it. While I agree with her remarks, I would want to avoid romanticizing folk myths, and also emphasize that, where relevant, in interpretation, we need to recognize

rather than ignore, or attempt to hide, the ways in which culture shapes landscapes.

I have claimed that the aim of interpretation ought to be one that sits easily alongside the spirit of aesthetic appreciation as an enriching encounter with the natural world. Diverse stories can illuminate aesthetic qualities and engage us in a more concrete way than science's abstraction. Stories are determined as relevant on a case-by-case basis according to whether or not they bring out nature's qualities for appreciation in a fruitful way. Given the lack of intended meaning in many natural and cultural environments, it is also the case in prereflective practice that aesthetic interpretation of the natural environment affords greater freedom to the appreciator. As Hepburn has suggested, environments demand "adventurous openness" on the part of the appreciator, and there are countless new perspectives to try out. These points support critical pluralism rather than critical monism. Searching for a single, correct interpretation, being guided by just one story, would be counterproductive not only to what environments themselves demand, but also to what we should expect from ourselves as engaged participants.

Critical pluralism sits between critical monism and "anything goes," the subjective approach of some postmodern positions. It argues for a set of interpretations that are deemed acceptable but which are not determined according to being true or false. A more pragmatic view is taken by some pluralists, where acceptable interpretations are those that work in making sense of something. An interpretation must be defensible—it cannot be outlandish, irrelevant, or the whim of one person. Besides cohering with the aesthetic and nonaesthetic descriptions of the aesthetic object, the validity of interpretations must also be relativized to the background beliefs, values and cultural and historical context of interpreters. This will allow for flexibility, especially in respect of contrasting cultural meanings given to environments.

A happy medium must be found between respecting environments—a normative constraint on interpretation—and allowing for the freedom and diversity of environmental appreciation. In the interpretation of the Aurora Borealis, both folklore and science provide acceptable interpretations; they give alternative ways of seeing the spectacular phenomenon in the sky. If the point were simply to understand what it is we are seeing, with knowledge as the aim, the scientist would give us the best answer. But that is not the point of "making sense" in the aesthetic context. Here, it is about trying out different ways of seeing aesthetic qualities, trying out different perspectives, as part of an exploration of nature and its qualities. The aim is to enrich and deepen appreciation by expanding our ways of relating to different environments, but without trivializing or appropriating them.

Notes

1. Allen Carlson, *Aesthetics and the Environment: The Appreciation of Nature, Art and Architecture* (London: Routledge, 2000), 120.

2. See, for example, objections raised in Yuriko Saito, "Is There a Correct Aesthetic Appreciation of Nature?" *Journal of Aesthetic Education* 18 (1984): 35–46; Robert Stecker, "The Correct and the Appropriate in the Aesthetic Appreciation of Nature," *British Journal of Aesthetics* 37 (1997), 393–402; Cheryl Foster, "The Narrative and the Ambient in Environmental Aesthetics," in "Environmental Aesthetics," ed. Arnold Berleant and Allen Carlson, special issues, *Journal of Aesthetics and Art Criticism* 56 (1998), 127–37; and Emily Brady, "Imagination and the Aesthetic Appreciation of Nature," in "Environmental Aesthetics," ed. Arnold Berleant and Allen Carlson, special issues, *Journal of Aesthetics and Art Criticism* 56 (1998): 139–47.

3. Ronald Hepburn, "Contemporary Aesthetics and the Neglect of Natural Beauty" in *Wonder and Other Essays*, 9–35 (Edinburgh: Edinburgh University Press, 1984), 20.

4. Hepburn, "Contemporary Aesthetics," 20–21.

5. Recounted by Joe Brady in "Aurora Borealis: The Northern Lights," at http://finland.fi/nature_environment/aurora/splendour.html.

6. Brady, "Aurora Borealis."

7. Yuriko Saito, "Appreciating Nature on Its Own Terms," *Environmental Ethics* 20 (1998): 139–40.

Fact and Fiction in the Aesthetic Appreciation of Nature*

Marcia M. Eaton

In 1995, the Baltimore Aquarium opened a coral reef exhibition. The curator was interviewed on CNN and said that she believed that if people see how beautiful such ecosystems are they will tend to act in ways that will better protect these and other environments. If it is true that positive aesthetic response leads to care, it is important for us to learn how to generate aesthetic responses. But it is also important for us to learn how to produce the right sort of care—for there is plenty of evidence that some actions that many people interpret as "caring for the landscape" are not sustainable: mowing with small gasoline engines or fertilizing with chemicals that pollute the ground water. What we must aim for is generating aesthetic response that will lead to sustainable care.

Within philosophical aesthetics, a debate has recently arisen concerning appreciation of nature. This debate centers on questions concerning what it

*"Fact and Fiction in the Aesthetic Appreciation of Nature," *Journal of Aesthetics and Art Criticism* 56:2 (1998): 149–56. Copyright © 1998 The American Society for Aesthetics. Reprinted by permission of Blackwell Publishing Ltd.

is to have an aesthetic experience of nature and when this experience is of the right sort. Does it make sense, for example, to say to someone, "This is the way you *ought* to experience nature"?

These questions have, of course, been answered in a variety of ways. Here I want to talk about two sides of the debate. On the one hand is what I call the cognitive model of nature appreciation, on the other hand the imaginative model.

The cognitive model has best been presented, I believe, in the writings of Allen Carlson. Since appreciation of nature must be directed at nature, Carlson argues that aesthetic appreciation of nature must be directed by knowledge about it. The kind of knowledge necessary is that provided by ecology, namely understanding of different environmental systems and their interactions. Without that one cannot be certain that one's response is to nature and not to something else.

Many people, even those who greatly admire the contributions Carlson has made to environmental aesthetics, believe that the cognitive model is over-intellectualized. Noël Carroll, for example, objects that Carlson fails to give an adequate role to emotion. Cheryl Foster believes that the cognitive model leaves out meditative response that is important in our experiences of nature.

Emily Brady argues that Carlson fails to account for the significance of imagination in our experiences of nature. And it is this last alleged misgiving that I want to discuss. For, I believe, one manifestation of imagination—fiction—plays an enormous role in shaping the way a culture perceives and conceives the environment. Much great art results from flights of the imagination stimulated by nature; we treasure these artworks but will fail to develop strategies for saving and creating sustainable landscapes if we lack understanding of the role that artistic culture plays in shaping human attitudes toward the environment. How might we connect the cognitive model that Carlson champions and the imagination model that Brady insists upon?

Brady believes that Carlson is just one in a long line of Western thinkers to overlook or demean the important contribution that imagination plays. Imagination has undoubtedly received a "bad rap" in the history of Western thought. Eurocentric culture with its interest in developing a science that provides for universal intersubjective agreement based on shared methodology and rules of evidence has not given much direct credit to the role of free flights of fancy. There are signs that this is changing. More attention is being given, for example, to the contribution of creative imagination in scientific discovery. In moral philosophy the role of imagination is increasingly discussed; it is argued that the ability to imagine oneself in another's

shoes is central to moral development, for instance. Brady hopes that she can contribute to an improved status for imagination within the aesthetics of nature.[1]

Aesthetic appreciation of nature, she asserts, is directed at natural objects, and she conceives natural objects as objects that are not products of human creation. In so defining these objects, Brady makes a very common mistake—namely, the mistake of leaving human beings out of nature. Like many writers she seems to think that there is something more "natural" about a beehive than an apartment building. This mistake does not have much impact on Brady's discussion. I mention it because I think it is important for theorists in all fields to remind ourselves that humans are natural.

Brady construes *imagination* broadly—just as I shall construe *fiction* broadly as referring to objects created by and appealing to the imagination. She interprets imagining not just as making believe, but as visualizing or otherwise coming up with ranges of possibilities. She agrees with Immanuel Kant's position that central to human aesthetic pleasure is what he called a "free play of imagination." Aesthetic experiences are marked, he argued, by disinterestedness. We put aside ordinary scientific, ethical, or personal interests and respond to objects as we please. We allow our imaginations full rein. We are free to think of a tree as a person or an animal or a tower or a mountain or whatever. And this freedom gives us, according to Kant, tremendous pleasure. Brady agrees.

Like Carlson, Brady believes that basic distinctions between objects of art and objects of nature generate important distinctions between artistic and natural appreciation. "Various natural objects . . . lack a human maker, an artist, and also an artistic context in respect of the type of artwork."[2] In artworks, intentional acts of an artist give us cues that direct our attention and thus our imagination. These cues are not present in natural objects. Thus, following Kant, the response is additionally free—free from any concern about what it is intended to express or how it functions as an object. Distinguishing natural from artistic objects as she does, Brady is perhaps correct to point out that human responses to nature do not involve considerations about artistic intentions. But this distinction does not, I think, also entail that information about context is either nonexistent or irrelevant. Indeed, knowledge concerning how natural objects function within a particular context is exactly the sort of thing that Carlson and I insist plays a major role in appreciation of nature. It is precisely a failure to understand the proper function of certain kinds of trees or forest soils, for instance, within their specific biosystems (i.e., context) that has led to mismanagement of forests even when providing aesthetic value has been one goal. The concern to protect

forests from fires because burned out areas are usually seen as ugly has meant that plants whose growth is stimulated in burned and blackened soil that warms more quickly in the spring sun have become rarer.

Brady herself discusses the role of context. With respect to nature, imagination is required to appreciate fully changeability and context. I agree. One imagines what a forest looked like before the fire and what it will look like through various stages of succession. Thinking about the consequences of destroying the tiny remainder of old growth forests in the northwestern United States surely requires imagination. But it requires informed imagination. I shall say more about this later when I discuss Brady's concept of what she calls "imagining well."

The contextual aspect of our experiences of nature deserves another kind of consideration. In general, one is more immersed in nature than in art, for one literally moves through it. Brady is primarily interested in the special ways in which immersion stimulates imagination, for imagination "intensifies" experience. It plays exploratory, projective, ampliative, and revelatory roles, according to Brady. Surely she is right about this. There are, admittedly, many positive roles that imagination can play in aesthetic appreciation of nature. Many ecologists describe the aesthetic experiences that drew them to their work in the first place. Many of these undoubtedly involved imaginings. And surely rich imagination is just what is needed if we are to develop new metaphors for designing sustainable landscapes. New visions are required, and this in turn requires creative imagination.

So what do I have against imagination or fiction in the appreciation of forests? Let me begin to explain my concern by quoting Brady.

> A quick glance at a lamb reveals little except an acknowledgment of its sweetness. But the fuller participation of perception and imagination can lead to a truth about innocence. Contemplating the fresh whiteness of a lamb and its small, fragile stature evokes images of purity and naiveté. It is through dwelling aesthetically and imaginatively on such natural things that we achieve new insight.[3]

Brady, we see, believes that aesthetic experience, interpreted in terms of imagination, provides us, as she puts it, with "insight" into the lamb. Appropriate responses involve what she calls "imagining well." Imagining well, she says, "involves spotting aesthetic potential, having a sense of what to *look* for, and knowing when to clip the wings of imagination. This last *skill* involves preventing the irrelevance of shallow, naive, and senti-

mental imaginative responses which might impoverish rather than enrich appreciation."[4]

But is responding to a little white lamb by reflections on innocence appropriate? Are these responses such that they indicate a sense of what to look for? Do they avoid being shallow or naive? I see no way of answering these questions without relying on the kind of cognitive model that Carlson insists upon. Knowledge does not simply deepen the experiences that imagination provides, it directs them, or should direct them if we hope to preserve and design sustainable landscapes. Concepts such as imagining will make no sense unless one knows what the object is that one is talking about, something (in fact, as much as possible) about the object, and something (in fact, as much as possible) about the context in which the object is found.

On the face of it, of course, it seems quite harmless, even charming, to think about trees in terms of human faces or lambs in terms of purity. But, in fact, imaginative fancies—often directed by fictional creations—can and do lead to harmful actions. Fiction, for example, has played an important role in shaping the attitudes, images, and metaphors with which we approach nature. Perhaps the most striking example of the way in which art informs responses to nature is *Bambi*—a book written in 1923 by the Austrian writer Felix Salten. The Walt Disney film version is, of course, a classic. Both the book and movie contain much that is beautiful and in other ways valuable. Many passages and images make it easy to understand why the literary classic has achieved such worldwide popularity that it is hard for anyone to look at a deer and not see Bambi. It has also made it incredibly difficult to look at a deer in terms that are true to it as an object on its own and even more difficult to respond to it in terms appropriate to the role that it increasingly plays in the ecological systems which it has come to dominate. In the United States, most states' departments of natural resources have had as a primary goal preserving and providing deer in sufficient numbers to satisfy hunters. Landscape architects have tended to exacerbate the situation with their preference for defined edges, and have thus also contributed to an increase in forest edge. Such planning has been carried out with a great deal of disregard for organisms other than game animals and birds. The result has been an explosion in the deer population and a decrease in the population of several songbirds and tree species. We are told, in fact, that in some areas deer have become vermin. But how can one look at a deer or a picture of a deer and not imagine it as the innocent, noble creature that Salten depicts? We tend to respond as the fictional account directs us to respond. In the book we are given the following episode, for example. Bambi and his mother see a ferret

kill a mouse. Frightened by the violence, Bambi asks his mother if they will kill a mouse.

> "No," replied his mother.
> "Never?" asked Bambi.
> "Never," came the answer.
> "Why not?" asked Bambi, relieved.
> "Because we never kill anything," said his mother.[5]

This is valuable if one wants to teach children not to be violent, but totally false if one wants to teach children about the actual effect of overpopulation of deer in the forest.

The prose of the story is often beautiful and does, as Brady hopes, heighten insight about the forest. There are beautiful inventories—ones in which vivid images and metaphors certainly help children learn to observe details and connect individual species into an organic whole. But Salten contrasts the gentle deer with the vulgar species that fight for food. Deer, we are told, never fight for food, because there is enough for all. We are seduced into a sentimental image that is hard to shake. Even in the presence of trees ravaged by deer who in their own way do indeed fight for food we continue to think of all deer as Bambis, the consequence being that forest managers find it difficult to convince the public that their numbers should be severely decreased in some areas.

Just as there are lots of deceptively innocent creatures in literature and the other arts, so are there lots of monsters. One reason that it is hard to get people to appreciate wetlands is that they have so often been conceptualized as "swamps" inhabited by various kinds of slime monsters. Death by drowning in quicksand was a common fear even for those of us who grew up in the heart of the U.S. cornbelt.

As I have already said, I do not want to claim that there is no positive role for fiction—for imagination in general—in developing a sound nature aesthetic. I do insist that it must be based upon, tempered by, directed, and enriched by solid ecological knowledge. As I have acknowledged, there are indeed many benefits accruing to creative imagination. Judith H. Heerwage and Gordon H. Orians have described what they believe are three stages in the examination of unfamiliar landscapes:[6]

1. One decides whether to explore or move on.
2. If one decides to stay and explore, one then begins to gather information.
3. Finally one decides whether to stay longer or move on.

It may very well be that flights of imagination—seeing an old man's face in the bark of a tree, for example—is an important factor at the first stage.

Furthermore, developing imagination is probably essential in producing people who are able to envision new and more successful ways of designing and maintaining environments. We have, of course, designed and managed for the human-scale response, often at the disservice of other species. A vivid imagination may be necessary to enable humans to expand the scales to which they respond aesthetically.

Our attitudes toward nature are largely determined by the metaphors with which we conceptualize it; many of these have come to us from literature and the other arts. We have the tree, the spring, the seed, the waters of life. We categorize in terms of light and dark, sun and moon, heaven and earth. We are warned not to lose the forest for the trees. We strive to reach rock bottom or to get at the root of the problem in order for ideas to blossom. Imaginatively developing new metaphors may indeed allow us, as it has sometimes been put, to "think outside of the box." Fiction is of great use here. But this does not mean that there should be no restrictions on the imagination. As we have seen, fiction can sentimentalize and demonize, with serious harm resulting. If sustainable environments are the goal, then fiction must be at the service of fact.

It is often objected that insisting upon a scientific basis for appreciation of nature "takes all the fun out of it." As Emily Dickinson put it, "We murder to dissect."

I confess that I simply do not believe that knowledge kills aesthetic pleasure. Looking closely, for instance, is not detrimental to aesthetic experience, it increases it. Aesthetic interest is not separate from our other interests as human beings. We go back and forth, as it were, between contemplating the object of attention and thinking about other things. I look at a pine bog, think about the way the water is being drained, remember my grandmother's cranberry sauce, delight in the shades of green. Knowledge of the variety of species is likely to draw one's attention to the variety of colors, not detract from them. Sometimes a sense of wonder, even mystery, comes only when we have knowledge, for example, learn that the Minnesota trout lily grows only in two Minnesota counties and nowhere else on earth. Even knowing the names of different flowers may lead one to see the flowers.

In learning what to look for, we achieve the very possibility of seeing— and seeing is surely essential to an aesthetic experience. Seeing something is more likely if we look for it, and we look for it only if we know where and what to look for. John Tester gives the following vivid example.

Lowland hardwood forests occur through Minnesota on sites where the soil is periodically saturated. These forests are dominated by American elm and black ash. Slippery elm, rock elm, basswood, burr oak, hackberry, yellow birch, green ash, aspen, balsam poplar, and paper birch may also be present. Fire is rare in these forests, and wind-through and flooding occur occasionally. They are considered late-successional communities.[7]

If I know that a forest area has been free of disturbances, I may start looking for a yellow birch. And looking, I may find and enjoy the face in the bark.

Even if it were true that knowledge takes some of the fun out, it would be worth the price. For only with knowledge will sustainable practices develop. Without legislating against fiction—indeed in full recognition of the benefits of imagination—one must constantly be aware of its possible harm. I certainly do not advocate that we stop reading or watching *Bambi*. I do advocate that when we do so we remind ourselves and others that it is just a story and that it needs to be balanced with an understanding of the relation between an increasing deer population and a decreasing songbird population.

Finally, we must ask whether the cognitive model deprives the aesthetic of something distinctive. As long as knowledge directs perception of and reflection upon such intrinsic properties, the experience will be recognizably aesthetic. At the same time, I have also urged that we not try to carve out a unique niche for the aesthetic. Human valuings are holistic; we rarely experience something purely aesthetically or purely ethically or purely religiously or purely scientifically, etc. Thus I am far less worried than Brady is that knowledge will get in the way of aesthetic experiences.

The task for all of us is to develop ways of using the delight that human beings take in flights of imagination, connect it to solid cognitive understanding of what makes for sustainable environments, and thus produce the kind of attitudes and preferences that will generate the kind of care we hope for.

Notes

1. Emily Brady, "Imagination and the Aesthetic Appreciation of Nature," *Journal of Aesthetics and Art Criticism* 56:2 (1998): 139–47.

2. Brady, "Imagination," 139.

3. Brady, "Imagination," 144.

4. Brady, "Imagination," 146.

5. Felix Salten, *Bambi*, trans. Whittaker Chambers (New York: Simon and Schuster, 1928), 16.

6. Judith H. Heerwage and Gordon H. Orians, "Humans, Habitats, and Aesthetics," in *The Biophilia Hypothesis*, ed. Edward O. Wilson, 138–72 (Washington, DC: Island Press, 1993), 143.

7. John Tester, *Minnesota's Natural Heritage* (Minneapolis: University of Minnesota Press, 1995), 75.

⌒∞⌒

Do Non-Native Species Threaten the Natural Environment?*

Mark Sagoff

The St. Louis Declaration on Invasive Plant Species (2001) recognizes that "a small proportion of introduced plant species become invasive and cause unwanted impacts to natural systems and biological diversity." The Chicago Botanic Garden Invasive Species Policy (2002), citing purple loosestrife and Japanese honeysuckle as examples, stated, "Invasive plants . . . pose an enormous threat to our native plants, animals and eco-systems." Therefore, "when species are determined to present a risk of becoming invasive, they will be removed from the collection and destroyed."

Since the early days of the Republic until recently, the introduction, cultivation, and domestication of exotic plants appeared to be an unmitigated good. President John Quincy Adams established a national policy that held for more than 150 years. He declared, "The United States should facilitate the entry of plants of whatever nature whether useful as a food for man or the domestic animals, or for purposes connected with . . . any of the useful arts" (Hyland 1977). Historically, the policy goal has been to protect crops and other domesticated plants from threats posed by wild species, not to protect wild species and natural areas from threats posed by cultivated and other introduced plants.

No one questions the urgency of protecting human safety and health from disease-causing organisms and other pests, native or exotic. No one doubts the importance of protecting domesticated environments such as gardens and farms from weeds and other pests that invade from the surrounding natural world. Conservation biologists and other environmentalists, pointing out how costly invasive species can be to human health and agriculture, seek to build support for a different goal, i.e., to exclude and combat introduced species that may "become invasive and cause unwanted impacts to natural systems and biological diversity," again to quote the St. Louis Declaration.

Environmentalists have to overcome obstacles to build public support for policies that target for exclusion or elimination non-native species that harm or threaten to harm the natural environment. First, the concept "harm to the natural environment" must be given a scientific and legal definition;

*"Do Non-Native Species Threaten the Natural Environment?" *Journal of Agricultural and Environmental Ethics* 18:3 (2005): 215–36. Reprinted by permission of Springer Science+Business Media.

otherwise, the values in question will depend on personal preference. Second, given the difficulty both of defining "harm" to natural systems and of predicting how an introduced species will behave in its new habitat, policy makers may have to target all non-native species as potentially harmful, an impossibly huge regulatory task. Finally, the belief that non-native species diminish biodiversity and impair ecosystem health or integrity should not rely on stipulative definitions, for example, on concepts of biodiversity that exclude non-native species or concepts of health that make their presence a per se indicator of environmental decline.

The Problem of Defining Harm to the Environment

A fascinating and growing literature debates many ways to define "invasive" and cognate terms such as "native," "exotic," and "naturalized" species (Rejmanek et al. 2002). This paper does not attempt to comment on the literature that grapples with the difficulty, perhaps the impossibility, of bringing a scientific consensus behind definitions of such elusive concepts as "invasive," "naturalized," "native," and "exotic." This essay instead asks whether, on any plausible understanding of these concepts, ecologists can (1) develop an operational and non-question-begging definition of "harm" to natural environments and (2) by using this definition of "harm," show that non-native species are more likely to cause harm than native species or than species selected at random. Ecosystems constantly change, of course, and non-native species are often responsible for many of those changes. The problem is to explain which of the many effects associated with non-native species are harmful and why.

What is needed is a concept of environmental harm that can be used to determine which of these changes—and therefore which of the species responsible for them—harm natural environments.

If one defines as "harm" any significant change a non-native species causes, the statement that non-native species harm ecosystems represents a tautology. Every significant change a non-native species causes would be defined as harmful, but what justifies that definition? To make a case against introduced species, scientists must rely not on a priori stipulation but on empirical evidence and argument.

It is not obvious that biologists can identify any trait of behavior or morphology that (1) distinguishes established non-native from native species in order (2) to explain why the non-native species could be more "harmful" in general than native ones.

On any non-question-begging conception of "harm," non-native species in a random or otherwise scientific sample of ecosystems may be no more harmful—perhaps less harmful—than native organisms.

Two Sides to Every Story

The Chicago Invasive Species Policy (2002) lists purple loosestrife and Japanese honeysuckle among the worst weeds that infest natural areas. Yet purple loosestrife—although its beautiful flower is often seen—has not been shown to have baneful ecological effects (Anderson 1995). Honeysuckle was introduced by the U.S. Department of Agriculture to improve habitat for birds and small mammals. "The consistently high flower and fruit reproduction of the Amur honeysuckle suited it well for wildlife habitat improvement," Luken and Thieret (1996, 20) report. These authors (1996, 23) add that honeysuckle may still "serve valuable ecological functions (for example, nutrient retention, carbon storage, and animal habitat improvement)" in disturbed areas, where it is commonly found.

One may suspect there are two sides to nearly every invasive species story; if so, general conclusions can be difficult to draw. For example, biologists have praised the work of the zebra mussel in clearing the water column and restoring native grasses in aquatic systems. Were it native, the zebra mussel might be hailed as a savior not reviled as a scourge.

Biologists have no way to predict how an introduced plant will behave in its new habitat, how it may evolve to become competitive, and what impacts it may have on the larger ecosystem. Ecologists often remind us that they do not seek to exclude or target every non-native species but only those that cause or are likely to cause harm. Yet these scientists have no settled understanding or definition of "environmental harm." They concede that even if they had such an understanding or definition, they would not have any way to tell which introduced species are likely to become harmful. Ecologists often remind us that they do not seek to exclude or target every non-native species but only those that cause or are likely to cause harm. Yet these scientists have no settled understanding or definition of "environmental harm." They concede that even if they had such an understanding or definition, they would not have any way to tell which introduced species are likely to become harmful.

Society looks to ecology for advice about how to respond to invasive species. Ecologists could argue that what they do not know may hurt us and that we disregard their ignorance to our peril. In the absence of criteria to define "harm to the environment" and of methods to predict it, no non-native organism can be "proven innocent" (Ruesink et al. 1995).

Ecologists have argued that species richness supports valuable ecosystem properties. Species diversity, according to many accounts, positively affects ecosystem functioning. Thus one could argue that non-native invaders—if they crowd out other species and thus decrease overall species richness—may in that way harm the environment.

To evaluate the effect of introduced species on species richness, however, is to encounter a puzzling phenomenon. Both ecological theory and observation confirm that "invasions may actually increase total species richness" (Parker et al. 1994, 8). Plants introduced by humans have increased the overall diversity of flora in regions, such as central Europe, over the centuries. For example, London has some 2,100 species of flowering plants and ferns growing wild while the rest of Britain has no more than 1,500 species, and Berlin has 839 native species of plants and 593 invasives. "With regard to biological diversity," Huston (1994, 318) has written, "invasions potentially lead to an increase in species richness, as invading species are added to the species gene pool."

Do exotic species increase or decrease the species richness of natural environments? If in any scientific (e.g., random) sample of ecosystems introduced organisms generally, overwhelmingly, and typically increase species richness, and if species richness supports desirable ecosystem properties, then one could argue these organisms benefit those systems.

Tautology

Biologists have also written that exotic species "pollute," "melt down," "harm," "disrupt," "destroy," and "degrade" natural ecosystems. Insofar as these terms refer to aesthetic, moral, or spiritual judgments, they may legitimately enter into political debate and policy discussion. Normative terms such as these figure constantly, however, in the scientific literature of conservation biology and invasion ecology. Is this simply an example of political advocacy parading as empirical science? Is there a scientific or empirical—as well as an aesthetic and spiritual—basis for the assumption that non-native species are, indeed, pernicious in their effects? If non-native species are rarely causes of extinction and generally increase species richness, why should ecologists believe they threaten rather than enhance biodiversity?

The reason that ecologists believe that non-native species threaten biodiversity appears to consist in stipulation, i.e., in word play. Many ecologists define the term "biodiversity" to exclude organisms that colonized a place with human assistance, i.e., to exclude non-native species. If the concept *biodiversity* excludes introduced (including cultivated and engineered) species, non-native organisms logically can detract from but never augment biodiversity. By analogy, antiquarians may define the concept *housing* to exclude in old cities any building constructed after 1950. They could then argue that

any newer building, even if it functions the same way as older buildings in providing shelter and the like, should be excluded or removed, because it threatens or competes with housing.

Similarly, ecosystem integrity and related concepts are generally defined in a way that makes the presence of non-native species a per se indicator of ecosystem decline. No ecologist has proposed a non-question-begging definition of "biodiversity" or ecosystem "integrity." In order to test empirically whether non-native species harm ecosystems or threaten biodiversity, one would have to start with concepts of environmental "harm" (or "degradation," "contamination," "damage," and so on) and "biodiversity" that make no reference to non-native species. In other words, one must define *harm* or *biodiversity* in ways that do not logically entail that alien species cause harm or diminish biodiversity. For every lake that sees a decrease in species richness because of an invader, there may be a thousand ecosystems in which alien species add to biodiversity, ecosystem integrity, stability, resilience, and so on. We do not know. Because there are no established non-question-begging concepts of *invader, biodiversity, ecosystem integrity, stability, resilience,* or *harm to the environment,* there is no conceptual basis for scientific research on invasive species.

References

Anderson, M. G. 1995. Interactions between lythrum salicaria and native organisms: A critical review. *Environmental Management* 19: 225–31

Huston, M. A. 1994. *Biological diversity: The coexistence of species on changing landscapes.* Cambridge: Cambridge University Press.

Hyland, H. I. 1977. History of U.S. plant introduction. *Environmental Review* 4: 26–33.

Luken, J. O., and John W. Thieret. 1996. Amur honeysuckle, its fall from grace. *BioScience* 46: 18–24.

Parker, I. M., D. Simberloff, W. M. Lonsdale, K. Goodell, M. Wonham, P. M. Kareiva, M. H. Williamson et al. 1994. Impact: Toward a framework for understanding the ecological effects of invaders. *Biological Invasions* 1: 3–19.

Rejmanek, M., D. M. Richardson. M. G. Barbour, M. J. Crawley, G. F. Hrusa, P. B. Moyle, J. M. Randall, D. Simberloff, and M. Williamson. 2002. Biological invasions: Politics and the discontinuity of ecological terminology." *FSA Bulletin* 83: 131–33.

Ruesink, J. I., I. M. Parker, M. J. Croon, and P. Kareiva. 1995. Guilty until proven innocent: Reducing the risks of non-indigenous species introductions. *BioScience* 45: 465–77.

∽∞∾

Further Reading

Berleant, Arnold. 1992. *Aesthetics of the environment*. Philadelphia: Temple University Press. Defends immersion in an environment as the aesthetic paradigm.

Brady, Emily. 2003. *Aesthetics of the natural environment*. Edinburgh: Edinburgh University Press. Defends a pluralistic approach to appreciation that integrates objective and subjective perspectives.

Budd, Malcom. 2002. *The aesthetic appreciation of nature*. Oxford: Oxford University Press. Collects all of Budd's writing on the aesthetics of nature.

Carlson, Allen. 2002. *Aesthetics and the environment: Appreciation of nature, art, and architecture*. New York: Routledge. Collection of essays by the most influential figure to defend the environmental model.

Hepburn, Ronald. 1996. Landscape and the metaphysical imagination. *Environmental Values* 5: 191–204. Defends a pluralistic approach to the appreciation of nature.

Matthews, Patricia. 2002. Scientific knowledge and the aesthetic appreciation of nature. *Journal of Aesthetics and Art Criticism* 60: 37–48. Attempts to identify the scientific knowledge needed to fully appreciate nature.

Parsons, Glenn. 2008. *Aesthetics and nature*. Continuum Aesthetics. New York: Continuum. Accessible overview of the field of nature aesthetics.

Parsons, Glenn, and Allen Carlson. 2009. *Functional beauty*. New York: Oxford University Press. Extends Carlson's views on environmental aesthetics to a broader range of different kinds of things.

~

Conceptions of the Aesthetic

Aesthetic Experience

Introduction

In the last chapter, you encountered many examples of beauty in nature. The experience of such beauty is traditionally regarded as a paradigm of aesthetic experience. In fact, some would say that beauty in nature consists in its capacity to provide such experiences. Another paradigmatic source of aesthetic experience is art. A painting, such as Jan Vermeer's *A Woman Weighing Gold*, potentially offers a wide variety of experiences, though many of these could be combined into a single complex experience. For example, one might notice how natural light enters the depicted room, dividing it into two diagonals, above lighter, below darker. One cannot help but perceive that the work represents a woman weighing gold, which glitters on a balance, while on the wall behind her, right above her head, is a painting within the painting. It may require further scrutiny to see that this depicted painting represents the Last Judgment. One might then examine the woman's calm face, dignified posture, and modest dress and wonder just how attached she is to the gold below and to the religion emblematized by the painting above her head. At this point one is almost bound to think that the painting is about more than the scene it immediately depicts. It occurs to me that its imagery represents the necessity of finding a balance in one's life between spiritual and material things. (The painting is also known as *A Woman with a Balance*.) One might then see in the formal and representational structure of the painting both evidence for, and the expression of, this theme. Typically, when one contemplates a work of art in such a way, carefully perceiving aspects of it that seem significant, with perceptions suggesting thoughts and thoughts

33

leading to further perceptions, one's experience becomes more and more intense, and this intensity is experienced as pleasure.

Each art form supplies works that have the potential to provide experiences of equal value. Can you recall such encounters with musical or literary works?

Traditionally, philosophers have focused primarily on art and nature as sources of aesthetic experience. But this was never completely true. Immanuel Kant wrote about finding aesthetic pleasure in wallpaper and plots of pepper plants. Contemporary philosophers have become increasingly interested in the aesthetics of ordinary things. When you shop for clothes, what leads you to choose one item over another? Does the fact that its color, pattern, cut, and material give it a certain look and feel that you find pleasing not play an important role in your choice? Is this kind of noticing and taking pleasure in the look and feel of a fabric just as much an aesthetic experience as that engendered by Vermeer's painting described above?

Yet another kind of experience is sometimes called aesthetic. Have you ever solved a difficult math problem in a surprisingly simple, concise way and found pleasure in discovering such an elegant proof? Mathematicians sometimes talk in this way, identifying some proof as beautiful by virtue of its possessing just such properties. Scientific theories are similarly evaluated on seemingly aesthetic grounds.

If nature, art, the everyday, math, and science are all sources of aesthetic experience, one might wonder whether every aspect of human endeavor is capable of providing such encounters. Or, one might wonder whether the very idea of aesthetic experience is highly ambiguous and its apparently wide application is simply due to the conflation of different conception of said experience.

Both of these hypotheses may possibly true. There is no doubt that several different conceptions of aesthetic experience have arisen since philosophers began to theorize self-consciously about it in the eighteenth century. It is not clear that only one such conception is the correct one. Rather, different people have applied the label "aesthetic experience" to distinct but overlapping sets of experiences. Given this situtation, it is desirable to attempt to construct an overarching conception of aesthetic experience that captures as much as possible of what has traditionally been so designated. The way to do this is to consult the reasons that have traditionally been given for counting something an aesthetic experience.

Here are some issues that arise in deciding on such a conception:

1. A preeminent set of aesthetic experiences—of nature, of most of the arts, and of ordinary artifacts—involves sense perception. Is aesthetic

experience a kind of sensory experience? If so, that would exclude many valuable experiences of the literary arts and of mathematical proofs and scientific theories. Is it better to have a more inclusive conception?

2. Traditionally, some senses are favored over others as potentially delivering aesthetic experience, namely sight and hearing. Should the other senses be excluded? That would mean that one might have an aesthetic experience of the visual appearance of a glass of fine wine, but its taste and fragrance could add nothing to one's aesthetic appreciation.

3. Philosopher's are interested in aesthetic experience because they believe that it is intimately related to an important kind of value: aesthetic value. They differ over both the nature of this value and its relation to aesthetic experience. Are aesthetic experiences essentially aesthetically valuable? That is, is it impossible to have an aesthetic experience that one rates as of no positive or negative aesthetic value whatsoever? If such an experience is valuable, is it definitive of aesthetic experience that it is valuable in a certain way. Traditionally, aesthetically valuable experiences are understood as valued for their own sake rather merely for some further benefit they may yield, such as helping someone to maintain mental health, pass a test, or sharpen powers of discrimination. Is being valued for its own sake a defining feature of aesthetic experience?

4. We noted above that aesthetic experiences tend to be pleasurable, sometimes intensely so. Is this a defining feature of these experiences?

The readings in this section take often competing positions on all these issues. Kant thought that four features are essential to aesthetic judgments of beauty. First, such judgments are subjective; that is, they are based on a felt response of pleasure rather than the application of a rule or a concept. Second, aesthetic judgments claim "universality"; that is, implicit in them is the claim that others ought to judge or respond similarly. Third, such judgments are disinterested, meaning that the response is independent of any advantage that the observer or someone else might gain from the object of the judgment, be it material, cognitive, or moral. The pleasure is even independent of the very existence of the object. What is important is the experience it delivers in the contemplation of it. Finally, the response (or judgment) engages not merely the senses but also the imagination and intellect. Kant characterized this last feature in terms of the free play of the imagination and understanding in responding to an object.

Although Kant's account of aesthetic judgment has been enormously influential, it has a number of puzzling features. Among others, two are preeminent. First, how can one and the same judgment both be subjective and claim universality? Second, how can one experience a painting such as *A Woman Weighing Gold* without applying a variety of concepts in judging it? Regarding the latter issue, in the selection below Kant himself supplied a complicating further thought by distinguishing between "free" beauty and "dependent" beauty and claiming that only the former involves no application of a concept in the judgment of beauty. But this creates still further puzzles. To mention only one, what makes both kinds of judgments, judgments of beauty?

According to J. O. Urmson, aesthetic appraisals are based on the way things appear—look, sound, smell, and so on. Urmson distinguishes two different kinds of relevant appearances. A rose can look red whether or not it is red. Call this a sensory appearance because it is intimately connected to the visual sensation the rose causes in us. But it is also true that a car can look fast even when it is stationary or a building can look sturdy independently of an examination of it structural fitness. Call these expressive appearances because, in such cases, we also say the object expresses the property it appears to have. Aesthetic experience, then, is experience of such appearances, especially in situations in which we are attempting to evaluate an object based on such an appearance. If we like or admire the appearance, we aesthetically evaluate the object positively, and this comes very close to saying that positively valuable aesthetic experiences are invariably pleasurable. Since appearances are made available through the senses, Urmson seems to take aesthetic experience to be a type of sensory experience. He does not favor one sense over another. The smell of a rose can be just as relevant in aesthetically appraising it as its look. Sometimes we are indifferent to a thing's appearance, so not all such experiences have positive or negative value.

Noël Carroll, on most of these issues, takes a very different approach. He aims to critique traditional attempts to define aesthetic experience and to substitute a "deflationary" content-oriented approach. According to Carroll, aesthetic experiences, even those we positively value, need not be pleasurable. We can positively value an aesthetic experience of the shocking, the frightening, or the grotesque, even if we take no pleasure in it. Carroll also denies that aesthetic experience requires a disinterested attention to an object, an influential view that derives from Kant's aesthetic theory. Disinterested attention implies that we seek no personal, intellectual, or even moral advantage from an experience, and Carroll points out that this is just not always so in connection with aesthetic experience. For example, some works of art are ethically charged in a way that makes it impossible to sepa-

rate one's experience of them from the moral stance that they adopt. Finally, aesthetic experience need not be valued for its own sake. One may notice the formal properties of a work just because of the pleasure they give or because one needs to know about them to pass an exam. In either case, one's experience has the same content, and Carroll believes this implies that if the first noticing of formal properties constitutes an aesthetic experience, so does the second. Hence, for Carroll, aesthetic experience is simply the experience of a subset of a work's properties that traditionally, and perhaps arbitrarily, have acquired this association. This includes formal, expressive, and other "aesthetic" properties such as elegance and gracefulness.

Gary Iseminger seeks to defend a more robust account of aesthetic experience. Central to his approach is the concept of appreciation, which involves (1) experiencing that an object has certain properties and (2) valuing this experience for its own sake. So one might encounter Urmson's rose, notice its color, shape, and fragility, smell it sweet odor, and value this experience for itself, that is, independently of whether it brings further advantage. Notice that this does not exclude also valuing the experience because it does bring further advantage, such as the ability to give a correct answer on one's botany exam. Nor does Iseminger's view imply that when we value an experience for its own sake, we always do so because of the pleasure it gives us. On this point Iseminger agrees with Carroll. But Iseminger would say that Carroll, at best, tells half the story about aesthetic experience—he might identify the experiencing part but leaves out the valuing-for-itself part.

Who is right here? Does aesthetic experience necessarily have the valuing aspect that Iseminger finds in it?

Analytic of the Beautiful*

Immanuel Kant
The Judgment of Taste Is Aesthetical
In order to decide whether anything is beautiful or not, we refer to the representation, not by the understanding to the object for cognition but, by the imagination (perhaps in conjunction with the understanding) to the subject, and its feeling of pleasure or pain. The judgment of taste is therefore not logical but aesthetical, by which we understand that whose determining ground can be *no other than subjective*. Every reference of representations, even that

*From *The Critique of Judgement*, 2nd edition, translated by John Henry Bernard (New York: Macmillan and Co., 1914). In the public domain.

of sensations, may be objective (and then it signifies the real in an empirical representation), save only the reference to the feeling of pleasure and pain, by which nothing in the object is signified, but through which there is a feeling in the subject, as it is affected by the representation.

To apprehend a regular, purposive building by means of one's cognitive faculty (whether in a clear or a confused way of representation) is something quite different from being conscious of this representation as connected with the sensation of satisfaction.

The satisfaction which we combine with the representation of the existence of an object is called "interest." Such satisfaction always has reference to the faculty of desire. Now when the question is if a thing is beautiful, we do not want to know whether anything depends or can depend on the existence of the thing either for myself or for anyone else, but how we judge it by mere observation. If anyone asks me if I find that palace beautiful which I see before me, I may answer: I do not like things of that kind which are made merely to be stared at. Or I can answer like that Iroquois *sachem* who was pleased in Paris by nothing more than by the cook-shops. But we are not now talking of this. We must not be in the least prejudiced in favor of the existence of the things, but be quite indifferent in this respect, in order to play the judge in things of taste.

The pleasant and the good have both a reference to the faculty of desire. On the other hand, the judgment of taste is merely *contemplative*; i.e., it is a judgment which, indifferent as regards the being of an object, compares its character with the feeling of pleasure and pain. But this contemplation itself is not directed to concepts; for the judgment of taste is not a cognitive judgment (either theoretical or practical), and thus is not *based* on concepts, nor has it concepts as its *purpose*.

The pleasant, the beautiful, and the good, designate then three different relations of representations to the feeling of pleasure and pain, in reference to which we distinguish from each other objects or methods of representing them. And the expressions corresponding to each, by which we mark our complacency in them, are not the same. That which gratifies a man is called *pleasant*; that which merely pleases him is *beautiful*; that which is esteemed or approved by him is *good*. We may say that of all these three kinds of satisfaction. That of taste in the beautiful is alone a disinterested and *free* satisfaction; for no interest, either of sense or of reason, here forces our assent.

In the case of the pleasant, everyone says that hunger is the best sauce, and everything that is eatable is relished by people with a healthy appetite; and thus a satisfaction of this sort does not indicate choice directed by taste.

It is only when the want is appeased that we can distinguish which of many men has or has not taste.

Explanation: Taste is the faculty of judging of an object or a method of representing it by an entirely disinterested satisfaction or dissatisfaction. The object of such satisfaction is called beautiful.

This explanation of the beautiful can be derived from the preceding explanation of it as the object of an entirely disinterested satisfaction. For since it does not rest on any inclination of the subject (nor upon any other premeditated interest), but since he who judges feels himself quite *free* as regards the satisfaction which he attaches to the object, he cannot ground this satisfaction in any private conditions connected with his own subject, and hence it must be regarded as grounded on what he can presuppose in every other person. Consequently he must believe that he has reason for attributing a similar satisfaction to everyone. He will therefore speak of the beautiful, as if beauty were a characteristic of the object and the judgment logical although it is only aesthetical and involves merely a reference of the representation of the object to the subject. For it has this similarity to a logical judgment that we can presuppose its validity for everyone. But this universality cannot arise from concepts; for from concepts there is no transition to the feeling of pleasure or pain. Consequently the judgment of taste, accompanied with the consciousness of separation from all interest, must claim validity for everyone, without this universality depending on objects. That is, there must be bound up with it a title to subjective universality.

Comparison of the Beautiful with the Pleasant and the Good by Means of the Above Characteristic

As regards the pleasant everyone is content that his judgment, which he bases upon private feeling, and by which he says of an object that it pleases him, should be limited merely to his own person. Thus he is quite contented that if he says, "Canary wine is pleasant," another man may correct his expression and remind him that he ought to say, "It is pleasant *to me*." And this is the case not only as regards the taste of the tongue, the palate, and the throat, but for whatever is pleasant to anyone's eyes and ears. To one violet color is soft and lovely, to another it is faded and dead. One man likes the tone of wind instruments, another that of strings. As regards the pleasant therefore the fundamental proposition is valid: *everyone has his own taste* (the taste of sense).

The case is quite different with the beautiful. It would (on the contrary) be laughable if a man who imagined anything to his own taste thought to justify himself by saying, "This object (the house we see, the coat that person wears, the concert we hear, the poem submitted to our judgment) is beautiful *for me*."

For he must not call it *beautiful* if it merely pleases him. Many things may have for him charm and pleasantness—no one troubles himself at that—but if he gives out anything as beautiful, he supposes in others the same satisfaction. He judges not merely for himself, but for everyone, and speaks of beauty as if it were a property of things. Hence he says "the *thing* is beautiful"; and he does not count on the agreement of others with this his judgment of satisfaction, because he has found this agreement several times before, but he *demands* it of them. He blames them if they judge otherwise. Here then we cannot say that each man has his own particular taste. For this would be as much as to say that there is no taste whatever; i.e., no aesthetical judgment which can make a rightful claim upon everyone's assent.

We say of a man who knows how to entertain his guests with pleasures (of enjoyment for all the senses), so that they are all pleased, "He has taste." But here the universality is only taken comparatively; and there emerge rules which are only *general* (like all empirical ones), and not *universal*, which latter the judgment of taste upon the beautiful lays claim to.

The Judgment of Taste Has Nothing at Its Basis but the Form of the Purposiveness of the Object

Every purpose, if it be regarded as a ground of satisfaction, always carries with it an interest—as the determining ground of the judgment—about the object of pleasure. Therefore no subjective purpose can lie at the basis of the judgment of taste. But neither can the judgment of taste be determined by any concept of the good, because it is an aesthetical and not a cognitive judgment. It therefore has to do with no *concept*. Therefore it can be nothing else than the subjective purposiveness in the representation of an object without any purpose (either objective or subjective); and thus it is the mere form of purposiveness, so far as we are conscious of it, which constitutes the satisfaction that is the determining ground of the judgment of taste.

In order to represent objective purposiveness in a thing, the concept of *what sort of thing it is to be* must come first. The formal [element] in the representation of a thing gives to cognition no objective purposiveness whatever. For example, if in a forest I come across a plot of sward around which trees stand in a circle, and do not represent to myself a purpose, viz. that it is intended to serve for country dances, not the least concept of perfection is furnished by the mere form. But to represent to oneself *objective* purposiveness without purpose, i.e., without the *concept* of that with which it is accordant, is a veritable contradiction.

Now the judgment of taste is an aesthetical judgment, i.e., such as rests on subjective grounds, the determining ground of which cannot be a concept,

and consequently cannot be the concept of a definite purpose. Therefore in beauty, regarded as a formal subjective purposiveness, there is in no way thought a perfection of the object, as would be formal objective purposiveness. And thus to distinguish between the concepts of the beautiful and the good, as if they were only different in logical form, is quite fallacious. For then there would be no *specific* difference between them. I have already, however, said that an aesthetical judgment is unique of its kind and gives absolutely no cognition (not even a confused cognition) of the object. On the contrary, it simply refers to the representation, by which an object is given, to the subject, and brings to our notice no characteristic of the object, but only the purposive form in the determination of the representative powers. The judgment is called aesthetical just because its determining ground is not a concept, but the feeling (of internal sense) of harmony in the play of the mental powers, so far as it can be felt in sensation.

The Judgment of Taste, by Which an Object Is Declared to Be Beautiful under the Condition of a Definite Concept, Is Not Pure

There are two kinds of beauty: free beauty (*pulchritudo vaga*) or merely dependent beauty (*pulchritudo adhaerens*). The first presupposes no concept of what the object ought to be. The second does presuppose such a concept and the perfection of the object in accordance therewith. The first is called the (self-subsistent) beauty of this or that thing; the second, as dependent upon a concept (conditioned beauty), is ascribed to objects which come under the concept of a particular purpose.

Flowers are free natural beauties. Hardly anyone but a botanist knows what sort of a thing a flower ought to be; and even he, though recognizing in the flower the reproductive organ of the plant, pays no regard to this natural purpose if he is passing judgment on the flower by taste. There is then at the basis of this judgment no perfection of any kind, no internal purposiveness, to which the [form] of the manifold is referred. Many birds (such as the parrot, the humming bird, the bird of paradise) and many sea shells are beauties in themselves, which do not belong to any object determined in respect of its purpose by concepts, but please freely and in themselves. So also delineations à la grecque, foliage for borders or wallpapers, mean nothing in themselves; they represent nothing—no object under a definite concept—and are free beauties. We can refer to the same class what are called in music phantasies (i.e., pieces without any theme), and in fact all music without words.

In the judging of a free beauty (according to the mere form), the judgment of taste is pure. There is presupposed no concept of any purpose, for which

the manifold should serve the given object, and which therefore is to be represented therein. By such a concept the freedom of the imagination which disports itself in the contemplation of the figure would be only limited.

But human beauty (i.e., of a man, a woman, or a child), the beauty of a horse, or a building (be it church, palace, arsenal, or summer house), presupposes a concept of the purpose which determines what the thing is to be, and consequently a concept of its perfection; it is therefore adherent beauty. Now as the combination of the pleasant (in sensation) with beauty, which properly is only concerned with form, is a hindrance to the purity of the judgment of taste, so also is its purity injured by the combination with beauty of the good (viz. that [form] which is good for the thing itself in accordance with its purpose).

We could add much to a building which would immediately please the eye, if only it were not to be a church. We could adorn a figure with all kinds of spirals and light but regular lines, as the New Zealanders do with their tattooing, if only it were not the figure of a human being. And again this could have much finer features and a more pleasing and gentle cast of countenance provided it were not intended to represent a man, much less a warrior.

Now the satisfaction in the [form] of a thing in reference to the internal purpose which determines its possibility is a satisfaction grounded on a concept; but the satisfaction in beauty is such as presupposes no concept. If now the judgment of taste in respect of the beauty of a thing is made dependent on the purpose, and thus limited, it is no longer a free and pure judgment of taste.

It is true that taste gains by this combination of aesthetical with intellectual satisfaction, inasmuch as it becomes fixed; and though it is not universal, yet in respect to certain purposively determined objects it becomes possible to prescribe rules for it. These, however, are not rules of taste, but merely rules for the unification of taste with reason, i.e., of the beautiful with the good, by which the former becomes available as an instrument of design in respect of the latter. Properly speaking, however, perfection gains nothing by beauty, or beauty by perfection; but when we compare the representation by which an object is given to us with the object (as regards what it ought to be) by means of a concept, we cannot avoid considering along with it the sensation in the subject. And thus when both states of mind are in harmony our *whole faculty* of representative power gains.

A judgment of taste, then, in respect of an object with a definite internal purpose, can only be pure if either the person judging has no concept of this purpose, or else abstracts from it in his judgment. Such a person, although forming an accurate judgment of taste in judging of the object as free beauty, would yet by another who considers the beauty in it only as a dependent

attribute (who looks to the purpose of the object) be accused of false taste. Both are right in their own way—the one in reference to what he has before his eyes, the other in reference to what he has in his thought. By means of this distinction we can settle many disputes about beauty between judges of taste, by showing that the one is speaking of free, the other of dependent, beauty. The first is making a pure, the second an applied, judgment of taste.

Explanation: Beauty is the form of the purposiveness of an object, so far as this is perceived in it without any representation of a purpose.

General Remark on the First Section of the Analytic

If we seek the result of the preceding analysis, we find that everything runs up into this concept of taste—that it is a faculty for judging an object in reference to the imagination's *free conformity to law*. Now, if in the judgment of taste the imagination must be considered in its freedom, it is in the first place not regarded as subject to the laws of association, but as productive and spontaneous (as the author of arbitrary forms of possible intuition). And although in the apprehension of a given object of sense it is tied to a definite form of this object and so far has no free play (such as that of poetry), yet it may readily be conceived that the object can furnish it with such a form as the imagination itself, if it were left free, would project in accordance with the *conformity to law of the understanding* in general. But that the *imaginative power* should be *free* and yet *of itself conformed to law*, i.e., bringing autonomy with it, is a contradiction. Hence a subjective agreement of the imagination and understanding can subsist along with the free conformity to law of the understanding (which is also called purposiveness without purpose) and with the peculiar feature of a judgment of taste.

Now geometrically regular figures, such as a circle, a square, a cube, etc., are commonly adduced by critics of taste as the simplest and most indisputable examples of beauty, and yet they are called regular, because we can only represent them by regarding them as mere presentations of a definite concept which prescribes the rule for the figure. One of these two must be wrong, either that judgment of the critic which ascribes beauty to the said figures, or ours, which regards purposiveness apart from a concept as requisite for beauty.

Hardly anyone will say that a man must have taste in order that he should find more satisfaction in a circle than in a scrawled outline, in an equilateral and equiangular quadrilateral than in one which is oblique, irregular, and as it were deformed, for this belongs to the ordinary understanding and is not taste at all. Where, e.g., our design is to judge the size of an area, or to make intelligible the relation of the parts of it, when divided, to one another and

to the whole, then regular figures and those of the simplest kind are needed, and the satisfaction does not rest immediately on the aspect of the figure, but on its availability for all kinds of possible designs. A room whose walls form oblique angles, even every violation of symmetry in the figure of animals (e.g., being one-eyed), of buildings, or of flower beds, displeases, because it contradicts the purpose of the thing, not only practically in respect of a definite use of it, but also when we pass judgment on it as regards any possible design. This is not the case in the judgment of taste, which when pure combines satisfaction or dissatisfaction—without any reference to its use or to a purpose—with the mere *consideration* of the object.

In a thing that is only possible by means of design—a building, or even an animal—the regularity consisting in symmetry must express the unity of the intuition that accompanies the concept of purpose, and this regularity belongs to cognition. But where only a free play of the representative powers (under the condition, however, that the understanding is to suffer no shock thereby) is to be kept up, in pleasure gardens, room decorations, all kinds of tasteful furniture, etc., regularity that shows constraint is avoided as much as possible. Thus in the English taste in gardens, or in bizarre taste in furniture, the freedom of the imagination is pushed almost near to the grotesque, and in this separation from every constraint of rule we have the case, where taste can display its greatest perfection in the enterprises of the imagination.

All stiff regularity (such as approximates to mathematical regularity) has something in it repugnant to taste; for our entertainment in the contemplation of it lasts for no length of time, but it rather, insofar as it has not expressly in view cognition or a definite practical purpose, produces weariness. On the other hand, that with which imagination can play in an unstudied and purposive manner is always new to us, and one does not get tired of looking at it. Marsden in his description of Sumatra makes the remark that the free beauties of nature surround the spectator everywhere and thus lose their attraction for him. On the other hand a pepper garden, where the stakes on which this plant twines itself form parallel rows, had much attractiveness for him if he met with it in the middle of a forest. He infers that wild beauty, apparently irregular, only pleases as a variation from the regular beauty of which one has seen enough. But he need only have made the experiment of spending one day in a pepper garden to have been convinced that, once the understanding has put itself in accord with order and regularity, the object will not entertain for long—nay rather it will impose a burdensome constraint upon the imagination. On the other hand, nature, which there is prodigal in its variety even to luxuriance, that is subjected to no constraint of artificial rules, can supply constant food for taste. Even the song of birds, which we can bring under no musical rule, seems to have more freedom, and

therefore more for taste, than a song of a human being which is produced in accordance with all the rules of music; for we very much sooner weary of the latter if it is repeated often and at length. Here, however, we probably confuse our participation in the mirth of a little creature that we love with the beauty of its song, for if this were exactly imitated by man (as sometimes the notes of the nightingale are), it would seem to our ear quite devoid of taste.

⸻

What Makes a Situation Aesthetic?*

J. O. Urmson

We may refer to a person as, in a given situation, getting an aesthetic thrill or aesthetic satisfaction from something, or of his finding something aesthetically tolerable, or aesthetically dissatisfying, or even aesthetically hateful. In a suitable context the adjective "aesthetic" and the adverb "aesthetically" may well be superfluous, but it is sometimes necessary to introduce one of these words in order to make it clear that when we refer, say, to a person's satisfaction we are not thinking of moral satisfaction, economic satisfaction, personal satisfaction, intellectual satisfaction, or any satisfaction other than aesthetic satisfaction. If we merely know that someone gained satisfaction from a play we do not know for sure that we are in the aesthetic field. Thus a play may give me moral satisfaction because I think it likely to have improving effects on the audience; economic satisfaction because it is playing to full houses and I am financing it; personal satisfaction because I wrote it and it is highly praised by the critics; intellectual satisfaction because it solves a number of difficult technical problems of the theatre very cleverly. But the question will still be open whether I found the play aesthetically satisfying. Though these various types of satisfaction are not mutually exclusive, it is clear that when we call a satisfaction aesthetic the purpose must be to mark it off from the other types.

The philosophical task to be tackled in this paper is therefore this: to make explicit what it is that distinguishes aesthetic thrills, satisfactions, toleration, disgust, etc., from thrills, satisfactions, etc., that would properly be called moral, intellectual, economic, etc. I put the question in this form because I think that it is tempting to consider the aesthetic as an isolated matter and within the field of the aesthetic to concentrate unduly upon the most sublime and intense of our experiences; but I am convinced that it is important to ensure that our account of the aesthetic should be as applicable to toleration as to

*"What Makes a Situation Aesthetic?" *Proceedings of the Aristotelian Society*, Supplementary Volume XXXI (1957): 75–92. Reprinted by courtesy of the Editor of the Aristotelian Society: © 1957.

our most significant experiences and should make it clear that in characterizing a reaction or a judgment as aesthetic the point is to distinguish it from other reactions and judgments that are moral, economic, and so on. Only thus can we hope to bring out the full forces of the term "aesthetic."

This is not a problem especially about the appreciation of works of art. No doubt many of our most intense aesthetic satisfactions are derived from plays, poems, musical works, pictures and other works of art. But it seems obvious that we also derive aesthetic satisfaction from artifacts that are not primarily works of art, from scenery, from natural objects and even from formal logic; it is at least reasonable also to allow an aesthetic satisfaction to the connoisseur of wines and to the gourmet. We may take it, then, that we are not exclusively concerned with the philosophy of art, and that whatever the criteria of the aesthetic may be, they cannot be found by trying to delimit a special class of objects.

If the aesthetic cannot be identified by its being directed to a special class of objects, it might be more plausibly suggested that the criteria of the aesthetic are to be sought by looking for some special features of objects which are attended to when our reaction or judgment is aesthetic; beauty and ugliness have often been adduced as the features in question. Alternatively it has often been suggested that aesthetic reactions and judgments contain or refer to some unique constituent of the emotions of the observer, either a special "aesthetic emotion" or an "aesthetic tinge" of some other emotion. I think that most commonly theories elicited by our problem have been variations on one or the other of these two themes, a variation on the first theme being called an objectivist theory and a variation on the second being called subjectivist.

Both of these theories are unsatisfactory as answers to our problem, even if neither is wholly false; in their place, I shall suggest that the correct answer is to be given in terms of the explanation of the reaction or the grounds of the judgment.

Let us suppose that we observe a man in the audience at a play who is obviously beaming with delight. If I now maintain that his delight is purely economic, what have I to do in order to establish this contention? If we find him to be the impresario, and he agrees that the complete explanation of his delight is that there is a full house and the reaction of the audience indicates a long run, what more could possibly be needed to justify us in describing his delight as economic? It seems hard to dispute that in the case of economic delight, the criterion of the reaction's being economic lies in the nature of the explanation of the reaction. Similarly it would be beyond dispute that a man's delight was wholly personal if it were conceded that its explanation was entirely the fact that his daughter was acquitting herself well in her first

part as a leading lady; again his delight will be moral if wholly explained by the belief that the play will have a good effect on the conduct of the audience. It would be very surprising if the way of establishing that delight were aesthetic turned out to be quite different from the way in which we establish [delights] to be moral, personal, economic, intellectual, etc.

We must now note a further point about the logical relation between the concepts of the moral, the aesthetic, the economic, the intellectual, and the personal, as applied to reactions, both because it is of some logical interest and because a misunderstanding of it has led to some silly theories. *Triangular, square,* and *pentagonal,* as applied to surfaces, are clearly species of a single genus and as such are mutually exclusive. On the other hand *triangular, red,* and *large* are three logically unconnected predicates of surfaces. What then are we to say about the predicates *moral, economic,* and *aesthetic* as applied to, say, satisfactions? Clearly they are not mutually exclusive. I may be simultaneously satisfied by a single object aesthetically, morally, and economically, just as well as a man may be simultaneously bald, wealthy, and a widower. But on the other hand to ask whether a satisfaction is moral or aesthetic makes as much sense as to ask whether a surface is square or triangular, whereas only in a very odd context can one ask whether a man is bald or a widower; furthermore, if a satisfaction is wholly moral it is not at all aesthetic, whereas being wholly bald does not prevent a man from being a widower. Thus moral, aesthetic, and economic satisfactions seem neither to be logically disconnected nor to be true species of a genus.

To call a satisfaction aesthetic has the point of distinguishing its status from that of being a moral or economic satisfaction, though a satisfaction may be both aesthetic and moral. It surely follows that the criteria for a reaction's being aesthetic cannot be wholly unrelated to the criteria for its being moral or economic—they must be connected in such a way that we can see how being wholly one excludes being also another and yet how a single reaction can be both moral and aesthetic.

If we find the criterion for distinguishing aesthetic from kindred reactions in the nature of the explanation of the reaction we can readily account for this logical situation. To say that a satisfaction is wholly aesthetic will be to say that the explanation of the satisfaction is wholly of one sort; on the other hand there is clearly nothing to prevent our satisfaction from being multiply grounded and thus simultaneously aesthetic and moral, aesthetic and economic, and so on.

But if we were to accept different kinds of criteria of the aesthetic, the moral and the economic, we should be in difficulties here. Thus if a philosopher were to hold (and some apparently do) that a moral judgment is one

that asserts an object to have a certain character and an aesthetic judgment to be one that announces or expresses the special emotional state of the speaker, he would be maintaining views which, however plausible when consistently adhered to in isolation, are poor bedfellows. For one would expect a wholly moral judgment, interpreted as ascribing a moral character, to deny implicitly the presence of a special aesthetic or special economic character; similarly a wholly aesthetic judgment, interpreted as expressing a special aesthetic emotion, should deny implicitly the presence of a special moral or economic emotion. Consistency is required here.

So much for the logical point of being clear on the relation between the aesthetic, the moral, the economic, etc. Unclarity on the point can lead to other less philosophical confusions. Thus the belief that moral considerations are relevant to a thing's aesthetic rank seems to stem from an awareness that appreciation may be simultaneously based on aesthetic and moral considerations coupled with a blindness to the fact that to call an appreciation aesthetic has as part of its point the effect of ruling out the moral as irrelevant. At the opposite extreme those who rage at any moral comment on a work of art are so conscious that the moral is irrelevant to the aesthetic that they suppose some error in allowing one's general satisfaction to have both a moral and an aesthetic component.

The view that what distinguishes the aesthetic reaction and judgment is the presence of a special emotion is unsatisfactory on two counts. First, we require a similar type of criterion of the aesthetic, the moral, the intellectual and the economic reaction, whereas the emotional criterion is very implausible in some of these cases. Secondly, however plausible with regard to strong emotional reactions, the emotional view is most implausible when we consider such cool aesthetic reactions as that of bare toleration.

The objection to the view that what distinguishes the aesthetic judgment or reaction from others is that it alone involves the recognition or awareness of beauty and ugliness, if offered as a solution to our problem, is rather different. The trouble with this answer to our problem is not that it is false but that it is futile. Of course if I admire a thing aesthetically I must be aware of its beauty, or of its charm, or of its prettiness or some other "aesthetic characteristic"; this is true in the same way as it is platitudinously true that moral admiration must involve awareness of a thing's moral goodness or rectitude or of some other "moral characteristic." But the trouble is that we have no independent way of telling whether we are aware of beauty or ugliness on the one hand or rightness or wrongness on the other; to know this we must know whether our admiration is aesthetic or moral, or, more accurately, to try to discover whether our admiration is aesthetic or moral and to try to discover

whether we are aware of beauty or rightness are not two distinct inquiries but a single inquiry described in two ways neither of which is more luminous than the other. To identify the aesthetic judgment by the aesthetic characters of which it involves awareness is therefore not helpful.

Let me now set out more generally and completely the view that I wish to urge. The terms "good," "bad," and "indifferent" are, I take it, among the widest terms of appraisal that we possess, and we do appraise things on the basis of criteria, criteria to be formulated in terms of the "natural" features of the things appraised. But usually we wish at any time to appraise a thing only from a restricted point of view. We may, for instance, wish to appraise a career from the restricted point of view of its worth as a means to earning a livelihood; to do so we restrict our attention to a special set of the criteria of a good career, all others being for the purpose irrelevant. I wish to suggest that the moral, the aesthetic, the economic, the intellectual, the religious and other special appraisals should all be understood as being appraisals distinguished by their concentration on some special subset of criteria of value. To say that something is good as a means is not to say that it is good in some special sense distinct from that of "good as an end" but to appraise it from a special point of view; similarly to judge a thing aesthetically good is not to call it good in a sense different from that in which we call a thing morally good, but to judge it in the light of a different subset of criteria. We may if we wish choose to invent a special meaning for "beautiful" in which it becomes shorthand for "good from the aesthetic point of view," but that is only a dubious convenience of no theoretical significance. The central task of the philosopher of aesthetics is, I take it, to clarify the principles on which we select the special set of criteria of value that are properly to be counted as relevant to aesthetic judgment or appraisal. We may recognize an aesthetic reaction by its being due to features of the thing contemplated that are relevant criteria of the aesthetic judgment, and the aesthetic judgment is one founded on a special subset of the criteria of value of a certain sort of thing.

In his more philosophical moments A. E. Housman tried to account for the peculiar nature of the aesthetic in terms of emotional, and even physical, reactions; but here is an example of what he has to say at a more literary and less philosophical level: "Again, there existed in the last century a great body of Wordsworthians. They were most attracted by what may be called his philosophy; they accepted his belief in the morality of the universe and the tendency of events to good. To that thrilling utterance which pierces the heart and brings tears to the eyes of thousands who care nothing for his opinions and beliefs they were not noticeably sensitive; and however justly

they admired the depth of his insight into human nature and the nobility of his moral ideas, these things, with which his poetry was in close and harmonious alliance, are distinct from poetry itself."

It does not matter whether we agree with Housman about Wordsworth; but I do hope that all will agree that this is the right sort of way to set about showing that an appreciation is not aesthetic. Clearly Housman does not deny that what the nineteenth century admired in Wordsworth was admirable; but he says that if your admiration of Wordsworth is based on certain grounds (the philosophical truth and moral loftiness of the content of the poetry) it is not aesthetic admiration, whereas if it is based on what Housman calls the "thrilling utterance," by which the surrounding paragraphs abundantly show him to mean the sound, rhythm, and imagery of the words used, then it is aesthetic admiration.

But all this being granted we are still only on the periphery of our subject and the most difficult question remains to be dealt with. It is comparatively easy to see that there must be general principles of selection of evaluative criteria which determine whether our evaluation is to be counted as aesthetic, moral, intellectual, or of some other kind; nor is it at all difficult to give examples of what anyone, who is prepared to accept this way of looking at the matter, can easily recognize as being a criterion falling under one or another principle. It would be a very odd person who denied that the sound of the words of a poem was one of the criteria of the aesthetic merit of a poem, or who maintained that being scientifically accurate and up to date was another; similarly it is clear that the honesty of a policy is a criterion of its moral goodness whereas, even if honesty is the best policy, honesty is not a direct criterion of economic merit. But it is by no means so easy to formulate these general principles.

This difficulty is by no means peculiar to aesthetics. Part of the general view of which the aesthetic doctrine given here is a fragment is that what determines whether a judgment is moral is what reasons are relevant to it; but everyone knows the difficulty of answering the question what makes a judgment a moral judgment. (In my terminology Immanuel Kant's answer would be that the reasons must refer to the rationality or otherwise of consistently acting in a certain way.) Certainly it would be overoptimistic to expect to find very precise principles; probably there will be some overlap of criteria between the various spheres of evaluation in anybody's practice; certainly there are same overt borderline disputes whether this or that criterion is relevant to, say, aesthetic evaluation.

I think, however, that there is one peculiar difficulty in trying to find the principle, however vague, that determines what sort of reasons are rel-

evant to a judgment if it is to be counted as aesthetic. When we think of giving reasons for an aesthetic judgment we tend at once to call to mind what we would give as reasons for our appreciation of some very complex works of art; rightly considering, for example, that the plays of Shakespeare are things intended especially for consideration from the aesthetic point of view. (I believe that a work of art can most usefully be considered as an artifact primarily intended for aesthetic consideration.) We tend to think that we can most usefully tackle our problem by examining what would be relevant to an appreciation of, say, *Hamlet*. But this is most unfortunate, because, dealing with things intended primarily for aesthetic appreciation, we are inclined to treat as relevant to aesthetic appreciation very much more than we would in the case of things not so officially dedicated to aesthetic purposes. I am inclined to think that if *Hamlet* were rewritten to give the essential plot and characterization in the jargon of the professional psychologist there could still be a lot to admire that we at present mention in our aesthetic appreciations, but we would no longer regard it as aesthetic appreciation but rather as intellectual appreciation of psychological penetration and the like.

For these and other reasons, if we are to have any hope of success we must first set our sights less high and commence with the simplest cases of aesthetic appreciation; in this paper, at least, I shall try to look no further.

If we examine, then, some very simple cases of aesthetic evaluation it seems to me that the grounds given are frequently the way the object appraised looks (shape and color), the way it sounds, smells, tastes, or feels. I may value a rose bush because it is hardy, prolific, disease-resistant and the like, but if I value the rose aesthetically the most obviously relevant grounds will be the way it smells; the same grounds may be a basis for aesthetic dislike. Though I might, for example, attempt to describe the shape to make you understand what I see in it, these grounds seem to me to be really basic; if I admire a rose because of its scent and you then ask me why I admire its scent, I should not in a normal context know what you want. Things, then, may have sensible qualities which affect us favorably or unfavorably with no ulterior grounds. Surely there is no need to illustrate further these most simple cases of aesthetic evaluation.

But there are some slightly more sophisticated cases which need closer inspection. I have in mind occasions when we admire a building not only for its color and shape but because it looks strong or spacious, or admire a horse because it looks swift as well as for its gleaming coat. These looks are not sensible qualities in the simple way in which color and shape are.

It is clear that in this sort of context to look strong or spacious or swift is not to seem very likely to be strong or spacious or swift. I might condemn a building for looking top-heavy when I knew very well that it was built on principles and with materials which insured effectively that it would not be top-heavy. It is no doubt a plausible speculation that if a building looks top-heavy in the sense relevant to aesthetics it would probably seem really to be top-heavy in the untutored eye; but if an architect, who knows technically that a building is not top-heavy, judges it to look top-heavy when he considers it aesthetically he is in no way estimating the chances of its being blown over.

We have, then, isolated two types of aesthetic criteria, both of which are cases of looking (sounding, etc.) somehow; in the simpler type it is the sensible qualities, in the narrowest sense, that are relevant; in the slightly more complex type it is looking to possess some quality which is nonaesthetically desirable that matters. We like our motor-cars in attractive cones and we like them to look fast (which does not involve peering under the bonnet); we like, perhaps, the timbre of a bird's note and we like it also for its cheerful or nobly mournful character, but would not be pleased if it sounded irritable or querulous; the smell of a flower may be seductive in itself but it will be still better if it is, say, a clean smell. Both these elementary types of criteria go hand in hand and are constantly employed.

The most obvious criticism of these suggestions is not that they are wrong but that they are incapable of extension to the more complicated situations in which we appraise a work of art. I cannot try now to deal with this sort of objection in any full way. But I should like to make two small points. First, I would repeat my suggestion that we are inclined to allow in nonaesthetic criteria "by courtesy" when we are evaluating a work of art, so that we may even include intellectual merit. Secondly, the fact that such things as intellectual understanding are essential to an aesthetic appreciation of a work of art does not in itself establish the criticism. If for example we enjoy listening to a fugue it is likely that a part of our appreciation will be intellectual; no doubt intellectual understanding of what is going on is also necessary to aesthetic appreciation; but the fact that I cannot enjoy the sound of a theme being continually employed, sometimes inverted or in augmentation or in diminution, unless I have the theoretical training to recognize this, does not prevent my aesthetic appreciation from being of the sound. I am still appreciating the way a thing sounds or looks even when my intellect must be employed if I am to be aware of the fact that the thing does look or sound this way.

⌒∞⌒

Art and the Domain of the Aesthetic*

Noël Carroll

What exactly is the domain of the aesthetic when it comes to art? I would like to suggest a rather modest, even deflationary, answer to this question in what follows.

Perhaps the broadest approach one might take to demarcating the domain of the aesthetic with regard to art would be to say that it encompasses any appropriate response to an artwork—that is, any response to an artwork that is mandated by either its creator and/or by the traditions of artistic production and reception from which the artwork emerges or is situated. Artworks are made and appreciated within contexts governed by norms of response shared reciprocally by artists and audiences, and the appropriate responses to an artwork are just those that conform to the relevant norms. In this light, using a Persian miniature as a kite is not an appropriate response, whereas contemplating it is.

Support for this view of the aesthetic dimension of art might be found in the observable inclination of people to employ the notions of art and the aesthetic interchangeably. One might attempt to explain this disposition by claiming that it indicates that the concepts of art and the aesthetic are intimately connected—so intimately, in fact, that the aesthetic domain, at least with respect to artworks, essentially consists of all and only appropriate responses to artworks. This, of course, leaves to one side the question of the identity of the aesthetic domain with respect to nature. But, in this regard, there are a number of options that a proponent of the present view might explore, such as the notion that the aesthetic response to nature is merely derivative from the aesthetic response to art.

Nevertheless, this solution, though admirable in its simplicity, is inadequate. Tradition does not count any response, or even every appropriate response, to artworks as aesthetic. Literature provides ample evidence of this. In his altogether delightful study *How Proust Can Change Your Life*, Alain de Botton defends the view that Proust intended his great novel to possess what de Botton calls a therapeutic dimension.[1] That is, Proust meant readers to derive insights about life from his writing that they could then use to improve their lives. De Botton's arguments about Proust's actual intentions here seem compelling.

*"Art and the Domain of the Aesthetic," *British Journal of Aesthetics* 40:2 (2000): 198–208. Reprinted by permission of Oxford University Press.

Moreover, such intentions are perfectly intelligible in the tradition of the novel where it is presumed not only that writers typically make observations and recommendations about life, but that readers justifiably expect novelists to do so. With respect to the tradition of the novel, reading a novel for its observations and recommendations about life—which may even involve reflection upon one's own commerce with the world—is, so to speak, covered by the contract between the reader and the author. If anything is an appropriate way of experiencing a novel, reading many of them, as de Botton says, "therapeutically" is.

At the same time, however, what, after de Botton, we have called the therapeutic dimension of novels is exactly what the notion of the aesthetic is characteristically invoked to exclude. An aesthetic experience is supposed to exclude therapeutic experience, at least in its standard usage. But if the therapeutic experience is an appropriate way of experiencing an artwork, and if a therapeutic experience does not count as an aesthetic experience, then it is not the case that an aesthetic experience is simply any appropriate response to an artwork.

The aesthetic is supposed to stand in contrast, as well, to the cognitive. And yet again if we look to the tradition of the novel, we note that novelists often intend their works to provide insight about the world; readers consult them for this reason; and critics assess their success or failure partly in light of the quality of their observations about life. All this is squarely within the tradition of the novel.

Thus, the reader responses to which I have been drawing your attention are warranted as well as mandated. They are appropriate ways of experiencing novels, or at least certain standard types of novels. But then not all appropriate experiences of artworks, in this case novels, are aesthetic experiences.

One very common way to attempt to draw this distinction is to say that the aesthetic experience of an artwork is marked by disinterested and sympathetic attention toward and contemplation of an artwork for its own sake.[2] Aesthetic experience is an attentive response. What sort of attention? Disinterested and sympathetic attention.

In attending to something disinterestedly, we are said to feel a release from the pressing concerns of everyday life—from our own concerns and from the issues [facing] society at large. We appreciate it for its own sake, not for its connection with practical issues. Are its structures unified, is it complex, what are its noteworthy expressive properties, and are they intense or not? This is what disinterested viewers want to know—not "Is the pertinent artwork good or bad for society?" "Will it make money?" or "Will it arouse me sexually?"

Experiencing an artwork aesthetically is also sympathetic. The relevant sort of sympathy involves surrendering to the work—allowing ourselves to be guided by its structures and purposes. Sympathetic attention is directed at the art object and willingly accepts the guidance of the object over the succession of our mental states by the properties and relations that structure the artwork.

[While] this is a very standard account of the aesthetic experience of art, this conception may be fundamentally incoherent. The problem is that the requirement of disinterestedness and the requirement of sympathetic attention may, and indeed often do, stand in conflict.

Many artworks are produced with religious, political, moral, and/or cognitive purposes. They are not designed to be experienced disinterestedly or to afford an experience valued for its own sake. They may be designed to instruct or to arouse sentiments to be discharged in the world of practical affairs. But in such cases, the requirement of sympathetic attention is at odds with the requirement that the experience be engaged for its own sake.

Sympathetic attention to Luis Valdez's play *Zoot Suit* requires at least an initial openness to being morally outraged by the way in which Chicanos are treated in America. There can be no question of whether such indignation is a warranted, art-appropriate response to the play. Similarly, many feminist novels are written in order to elicit sympathetic concern for the plight of women in patriarchal society—not only for the women depicted in the novel but for their real-world counterparts. Such novels are produced to change the world, and a sympathetic response to them at least requires an openness to being moved politically by their point of view.

But if this is right, then the combination of sympathetic attention with disinterested attention in the characterization of aesthetic experience under consideration is an unstable one, inasmuch as sympathetic attention can, and often does, interfere with the possibility of valuing the artwork and the experience thereof for its own sake.

If there is a problem combining the requirement of sympathetic attention with that of valuing the experience of the artwork for its own sake, an obvious solution is to drop the sympathy condition. In that case, an aesthetic experience of an artwork is one in which we necessarily value the experience in question solely for its own sake. This emendation allows that there may be appropriate experiences of artworks that involve indignation, reflection on the situation of society, practical deliberation, and the like, but merely denies that these experiences are aesthetic experiences of art. Clearly this manner of proceeding requires us to look closely at how we are to understand the notion of valuing a work of art and/or the experience thereof for its own sake.

The notion of valuing an experience for its own sake figures in explanations of behavior—that is, it answers questions about why an organism acts a certain way. It says the organism acts that way because it values the experience of such and such an action for its own sake and not for the sake of bringing about something else. But there are at least two different explanatory contexts in which the notion might play a role.

The notion of valuing a certain kind of experience for its own sake may figure in an explanation of why humans have the capacity for aesthetic experience where it plays the role of a relatively ultimate, background causal condition for a certain kind of behavior—that is, it may function to specify a structuring condition of a certain type of behavior; or it may figure as a specification of the proximate cause of a specific behavior.

The hypothesis that aesthetic experiences are just valued for their own sake seems an unlikely one, if it is proposed as a relatively ultimate, structuring cause of the human capacity for having aesthetic experiences. A more plausible account is that, from an evolutionary point of view, the human capacity for having aesthetic experiences was selected and is sustained because of its instrumental value.

Pretheoretically—and, I think, uncontroversially—the major modes of aesthetic experience include experiences of artistic form and experiences of expressive and aesthetic properties. Presumably the capacity for experiences of form are part and parcel of our powers of pattern detection. Pattern detection is certainly an evolutionary advantage for creatures like us. Ultimately it is our keen powers of pattern detection that enabled us to control the environment. Humans with keen powers of pattern detection are the beneficiaries of natural selection. This is probably what accounts for our possession of this aspect of our capacity for aesthetic experience.

The experience of expressive properties in artworks emerges from and contributes to our ability to recognize what is going on with our conspecifics insofar as the detection of such properties is related to our capability to recognize the emotive states and expressive behavior of other humans. This capacity is integral to our need for gathering information about our social habitat. Sensitivity to the emotive states of our conspecifics is certainly adaptive for myriad purposes—both aggressive and affiliative. The aesthetic experience of expressive properties derives from and is connected to this recognitional capacity. Thus, the presence of the capacity in humans can be explained instrumentally. Related to the detection of expressive properties is the detection of what are called aesthetic properties—the perception, for example, of qualities such as the brittleness of a dancer's movement. Quite plausibly, this ability derives from our capacity

to make fine discriminations between stimuli which, like pattern detection, is of great evolutionary advantage, as is the expansion and sophistication of these powers afforded by the history of artistic production and reception.

Of course, the explanations of aesthetic experience that I have just suggested are extremely conjectural. However, I think they have enough initial intellectual appeal to be considered as plausible explanations of the emergence and continued existence of our capacity for aesthetic experience. These conjectures certainly seem to promise more of an explanation of said capacity than the hypothesis that the capacity was just valued for its own sake. As an explanation, the valuation-for-its-own-sake view gives every appearance of being an explanatory placebo, a nonstarter.

But this may not be what the proponent of the intrinsic value of aesthetic experience has in mind. Instead of explaining the origin of our capacity for aesthetic experience, he may have in mind that the notion that aesthetic experience is valued for its own sake is to be understood as pertaining to the proximate cause of certain behaviors in the life of specific organisms, and not as a relatively ultimate cause of the capacity to have those behaviors among members of the species in question.

The capacity for a certain type of behavior evolves in the ancestral lineage of a species because it was advantageous for adaptation, but in the life of a given member of that species the capacity is activated by some internal mechanism. The belief that aesthetic experience is valuable for its own sake, it might be argued, is the internal mechanism which motivates humans to do such things as search artworks for formal patterns, scrutinize them for aesthetic and expressive properties, and so on. Without this belief, so the story goes, humans would not be motivated to engage artworks in the ways that they do.

Perhaps the most compelling consideration in behalf of this view is a thought experiment. Imagine that you are thinking about spending some time with an artwork, perhaps a poem. Further imagine that you tell a friend of an enquiring cast of mind what you are thinking about. He asks you why you should want to spend your time that way. You offer some reasons: you say that it may give you insight into life in a bustling metropolis—that is, you think the poem may help you make sense of the frenzy of urban experience. But he persists: would you still want to spend time experiencing the poem if it provided no such insight? You come up with other reasons, such as that it would accentuate your interpretative powers. But he is relentless: if you knew that this reason and every other reason like it was without substance, would you still persist in wanting to experience the poem?

If this thought experiment is supposed to prove that people engage para-digmatic aesthetic experiences because we, as a matter of fact, believe that such experiences are valuable for their own sake, then I remain unconvinced. Both as individuals and as whole cultures, we appear to agree that aesthetic experience is improving. That is, we seem to think that somehow we make ourselves better people by pursuing aesthetic experiences. Even if our infor-mants continue to affirm the commitment, I do not think that one is entitled necessarily to interpret that as evidence of a belief in the intrinsic value of the aesthetic experience. It may merely be an expression of the vague intima-tion that the experience will be improving even though we cannot articulate precisely the way in which it will be so. Indeed, if we could completely extin-guish our informants' vague conviction that the aesthetic experience would be somehow instrumentally valuable, I am not inclined to accept the conclu-sion that most of our informants would say they would continue to pursue it. But if our informants do not agree that they would engage art if it is shown to lack instrumental value of any sort, then we lack the grounds to infer that they must believe the relevant experience is valuable for its own sake.

At this point, it might be argued that aesthetic experiences are intimately connected to pleasurable sensations. Once we take note of this connection, it is clear that everyone will opt for the experience in question despite its lack of instrumental value because people will value the accompanying sensations of pleasure for their own sake. Consequently, when the intimate connec-tion of aesthetic experience to sensations of pleasure is recognized, there are grounds to suppose that people will remain committed to experiencing the object even if said experience is not instrumentally valuable.

However, this will not provide support for the general thesis that all aesthetic experience is necessarily valued for its own sake, since not all aesthetic experience is pleasurable. It does not compel acceptance of the general proposition that valuation for its own sake is a necessary condition of aesthetic experience.

Furthermore, the invocation of sensations of pleasure here raises the deeper question of whether it is the aesthetic experience that is supposedly valued for its own sake, or whether it is only instrumentally valuable for the pleasurable sensations putatively associated with it; since if it is the pleasur-able sensation that is valued for its own sake in the relevant cases, and if those sensations can be provoked by means other than aesthetic experience, such as the stimulation of the pertinent segments of the brain, then even the idea that valuation for its own sake is a sufficient condition of aesthetic experience would be undermined.

Earlier I argued that it was not evident that people would continue to af-firm an interest in having aesthetic experiences were it conclusively shown

that no instrumental value accrues to aesthetic experiences. The proponent of the thesis that aesthetic experience is necessarily valued for its own sake is apt to respond that he is not making an empirical claim about whether or not people in general will continue to pursue aesthetic experience. Rather his point is a logical one about the necessary conditions for aesthetic experience. An experience only counts as aesthetic experience if it is undertaken in the belief that the experience is valuable for its own sake. That is a consequence of the thesis that aesthetic experience is necessarily a matter of experience valued for its own sake.

However, this proposition seems wildly improbable. Suppose that two people view a painting by Leger. Both observe the formal structure of the composition, locating its unity in the repetition of rounded, tubular-like forms. Both correctly identify the dominant expressive property of the painting as a kind of joyousness and, in addition, both correctly trace the genesis of that expressivity to Leger's use of bright colors. Perhaps both even interpret the painting in the same way—as an affirmation of the pleasures of modern industrial productions.

But then also suppose that one of these viewers—call him Jerome—approaches the painting in this way because he believes the resulting experience is valuable for its own sake, whereas the other viewer—call him Charles—is an evolutionary psychologist who believes that contemplating artworks in terms of their form, their aesthetic and expressive properties, and their interpretations is worthwhile because it enhances his discriminatory powers, his facility for pattern detection, his ability to scope out conspecifics, and so on.

For Charles, it is the belief in the instrumental value of scrutinizing artworks in the relevant ways that operates as the proximate cause of his behavior, whereas for Jerome it is the belief in the intrinsic value of the experience that plays this role. According to the theory that aesthetic experience is necessarily a matter of valuing the experience for its own sake, only Jerome and not Charles is having an aesthetic experience.

But isn't this an unacceptable result? Jerome and Charles are experiencing the same features of the object. Moreover, they are configuring the stimulus in the same ways—in terms of formal structures and expressive properties. Furthermore, these ways of configuring the stimulus are exactly the ones that have been traditionally associated with the aesthetic experiencing of artworks. Given these correlations between the experiences of the artwork on the part of Jerome and Charles respectively, and given the fact that both of them appear engaged in the self-same paradigmatic sorts of aesthetic behaviors, it seems perfectly arbitrary and completely unsatisfactory to maintain that Jerome is undergoing an aesthetic experience, but Charles is not. The

fact that Jerome's experience has been motivated by a different belief—a belief in the intrinsic value of what he is doing—and that Charles' experience has been motivated by another belief—a belief that the experience is, broadly speaking, instrumentally valuable—seems irrelevant to the question of whether or not their experiences are exactly comparable.[3]

If Charles is attending to the painting, deciphering its internal unity, detecting its salient aesthetic and expressive properties, and so on, then he is experiencing the work aesthetically. His experience of the work is on a par with Jerome's in every way that is relevant to the paradigmatic examples of aesthetic experience available in the tradition. An account of aesthetic experience that declares that it is impossible for people with theories like Charles's to have aesthetic experiences does not accord with what we are justified in expecting, given our pretheoretical exemplars of aesthetic experience. Consequently, the view that an aesthetic experience is necessarily, by definition, one valued for its own sake appears false.

If the aesthetic experience of artworks is not a matter of valuing their experience for its own sake, what is it? My, albeit deflationary, suggestion is that we can give content to the notion of aesthetic experience by merely enumerating the kinds of activities and corresponding experiences that we pretheoretically regard to be paradigmatic cases of aesthetic experiences. I have already alluded to them in the course of previous argumentation: they include, at least, tracking the formal structures of artworks, what we might call design appreciation, along with detecting the aesthetic and expressive properties of artworks, and perhaps taking note of the ways in which those properties emerge from what are called the base properties of artworks. This approach can also be called a content-orientated approach because it identifies an aesthetic experience in terms of what it is an experience of, rather than in terms of some supposed, universally recurring quality of the experience, such as intrinsic valuation.

One question that the deflationary, content-orientated, enumerative approach to the aesthetic experience of artworks raises is, of course, how do we know what to put on the list? My rather pedestrian answer is that we look at what has been traditionally regarded as the loci of aesthetic experience. Attention to form or design is one of those things. Think of Clive Bell's notion of significant form, which is descended from Immanuel Kant and has influenced twentieth-century thinking profoundly. The detection of aesthetic and expressive properties is also a frequently cited exemplar, one that gains authority from the historical connection of the invented term "aesthetics" with perceptual discrimination, sensibility, and taste. I have not included the interpretation of meaning on my list because the tradition is somewhat

in conflict on this matter: some regard meaning as an antipode of aesthetic experience, while others include it. But even if interpretation is not counted in and of itself on the list of paradigmatic types of aesthetic experience, this would not utterly disconnect it from aesthetic experience, since interpretation quite frequently is intimately involved with the discernment of the formal, aesthetic and expressive properties of artworks

This list of the contents of aesthetic experience accords nicely with that of Monroe Beardsley, perhaps the leading aesthetic theorist of the second half of the twentieth century. He subsumed aesthetic enjoyment under the labels unity, complexity, and intensity.[4] Unity and complexity, of course, are at least connected to the formal dimension of artworks, while intensity is at least a prominent feature of what he called regional qualities, the aesthetic and expressive properties of artworks. Furthermore, by demarcating aesthetic experience in terms of its content, I am not ignoring the subjective dimension of aesthetic experience, since the properties of the artwork that I have alluded to are all response-dependent properties.

Whether or not more candidates need to be placed on the list is a possibility that I am willing to consider. At this point, all I am asserting is that experiences of the form of the artwork, of its aesthetic and/or expressive properties, and/or of the emergence of said properties are each sufficient conditions for calling an experience aesthetic. This should not be regarded as an impediment to artistic experimentation, however, since, on the one hand, I acknowledge that there are legitimate areas of response to artworks that are not reducible to aesthetic experiences, and, on the other hand, the latitude for experimentation with innovative form, with novel aesthetic and expressive properties, and their implementation is vast. Of course, to render the hypothesis that aesthetic experience amounts to the experience of the formal design of an artwork, and/or of its aesthetic and expressive properties, and/or of some combination of these and, perhaps, their emergence from an articulate medium requires that accounts be developed of the concepts of artistic form, and of aesthetic and expressive properties. But those are tasks for future papers.

Notes

1. Alain de Botton, *How Proust Can Change Your Life* (New York: Vintage, 1997).

2. This particular way of characterizing aesthetic experience is derived from Jerome Stolnitz, *Aesthetics and the Philosophy of Art Criticism* (New York: Houghton Mifflin, 1960), 32–42.

3. This argument is similar to one that George Dickie proposes in his classic "The Myth of the Aesthetic Attitude," *American Philosophical Quarterly* 1, no. 1 (January 1964), 56–65.

4. Monroe C. Beardsley, "The Discrimination of Aesthetic Enjoyment," in *The Aesthetic Point of View: Selected Essays*, 35–45 (Ithaca, NY: Cornell University Press, 1982), 42.

༄

Aesthetic Communication*

Gary Iseminger

A Paradigm of Aesthetic Communication

Consider someone designing and making an artifact with the aim and effect that someone else appreciates it—for example, someone polishing and carving a stone into a smooth spheroid incised with curving lines, then showing it to someone else, who finds it good to look at its graceful shape and decoration. I take this to be a paradigm of aesthetic communication. Such communication thus typically involves three elements: a designer and maker, an artifact made to be appreciated, and an appreciator. The substance of this chapter will consist mainly in explaining these three elements.

In invoking the idea of communication I am conscious of following Leo Tolstoy, who notoriously claims that

> art is a human activity consisting in this: that one man consciously by means of certain external signs, hands on to others feelings he has lived through, and that others are infected by those feelings and also experience them. (Quoted in Lyas 1997, 61)

I have no wish to defend anything like Tolstoy's account in detail. What I want to take from Tolstoy is the idea of a *transaction* involving two people and something "external" that one produces for the other. This transaction, moreover, deserves to be called an instance of communication in that what is produced is designed to be—and, where it is successful, is—not just useful in some way or other but understood by the person to whom it is directed. What makes this communication worthy of being called *aesthetic* is that understanding the thing produced is not necessarily or characteristically a matter of—though it may involve—grasping some semantic content it embodies, but is rather a matter of *appreciating* it, in a sense that I explain in this chapter.

The Centrality of the Concept of Appreciation

Without venturing an essentialist definition, I take it to be a necessary condition of being an aesthetic communication that appreciation somehow be involved. That is to say, for it to be worthwhile even asking to what extent a state of affairs approaches the paradigm of aesthetic communication, that state of affairs must include either someone who at least tries to design and/or make an artifact to be appreciated, or a thing that at least has the capacity to be appreciated, or someone who at least sets out to appreciate something. There's at least *something* aesthetic about a state of affairs that satisfies just one of these disjuncts.

On the other hand, someone designing and making an artifact to be understood by someone else but with no thought of its being appreciated, an artifact whose capacity to afford appreciation is vanishingly small, or an artifact that someone else sees and understands without appreciating, though it shares the structural features of our paradigm of aesthetic communication insofar as both are instances of communication, is not aesthetic in any way. The *aesthetic* character of a state of affairs consists in its connection with appreciation. Accordingly, the account of appreciation to which I now turn is crucial to my project.

Appreciation Defined

Appreciation is finding the experiencing of a state of affairs to be valuable in itself.

A preliminary formal point is that what is appreciated, in the relevant sense, is a state of affairs—something's having a property rather than a thing or property. In the first instance someone appreciates a spheroid's being graceful (the gracefulness of the spheroid, that the spheroid is graceful) rather than the spheroid or gracefulness simpliciter.

The task now is to explain how I understand the concept of experience and the concept of finding something valuable in itself.

Experiencing

Experiencing a state of affairs is a matter of having direct (noninferential but not necessarily infallible) knowledge that that state of affairs obtains. The concept of experience I am invoking, then, is an *epistemic* one—the concept of a certain kind of knowledge—rather than a *phenomenological* one—a concept of something that seems a certain way to its subject. Seeing that the spheroid is graceful is an instance of experiencing the spheroid's being graceful in the relevant sense. Experiencing thus may (but need not) be a sensory matter. (One can, for example, feel the tension between two metaphors in a line of poetry or get a joke.)

Merely knowing that a spheroid is graceful, say, on the basis of testimony, however reliable, is not sufficient for experiencing, and hence for appreciating, that state of affairs.

On the other hand, experiencing a state of affairs, even where it is sensory is not merely sensory. It typically involves conceptual capacities and may depend on prior knowledge. One can see or hear that the water is boiling on the stove and not merely infer that it is boiling. But this requires that one have concepts like *water* and *boil*, and it is facilitated, if not made possible, by prior knowledge that, for example, one recently put some water in the saucepan and turned on the burner.

Accordingly, one could be wrong. One could think that one saw that the water was boiling on the stove (and hence that one had experienced it) when it wasn't. But then one didn't really see (experience) water boiling on the stove. I think of experience (seeing, hearing, etc.) as a way of knowing in the full-blooded sense in which knowing that something is the case requires that it be the case. If experiencing some such state of affairs as a spheroid's being graceful is to be part of appreciating it and hence of aesthetic communication involving it, it must be possible to be right (or wrong) in some sense about whether or not the spheroid is graceful.

Finding Something Valuable in Itself

Finding something valuable, as opposed to merely liking it, requires that one have the thought that it is good, a thought that makes a claim on other people. If I find value in something, I am committed to at least being disposed to recommend it to others and obliged to be in a position to back up any such recommendation I may make. To respond to a challenge to my finding of value with a shrug and the remark, "Well, anyway, I thought it was good," is to give up the claim of value.

Finding something valuable *in itself* is, of course, to be contrasted with finding something *instrumentally* valuable—good as a means to something else.

Finding value, as contrasted with experiencing, as I have explained it, is not an epistemic concept (nor is it a phenomenological one), but only a *doxastic* one—a concept of a certain kind of belief, which may or may not be true. One may, in this sense, find something valuable, in itself or instrumentally (or both), without its being valuable.

Finding Experiencing Valuable in Itself

There is a tradition in the theory of value that holds that ultimately the only thing that one ought to value in itself is experience, in some sense of that

term. Why ought we to value even the things we purchase, it might be asked, if not because they will be instrumental to worthwhile experiences, either our own or others'?

I do not here commit myself to any view about the primacy of experiences in general as valuable in themselves, but I do claim that appreciating something is a matter of valuing in itself the experience it affords. Appreciating a state of affairs thus has the structure of a belief about the value of coming to know that state of affairs in a particular way. One may appreciate a state of affairs that is unworthy of appreciation, but one cannot even do that if one is wrong about what the state of affairs is.

Note that one might well value something without appreciating it. One might, for instance, value a bank note, instrumentally or in itself, without valuing the experience it affords.

Conversely, one might appreciate something without valuing it except as a source of valued experience. Edward Bullough (1912, 758–59) famously imagines finding value in experiencing a fog at sea, apparently without finding anything else good to say about that dangerous and in many ways unpleasant phenomenon.

Experience Valued in Itself and Enjoyment

When we value experiencing a state of affairs in itself, do we necessarily enjoy doing so as well?

No doubt often we do, but not, I think, invariably. There appear to be counterexamples to the thesis that experiences valued in themselves must be enjoyable ones. Consider watching the final scene of *Hamlet* or the conclusion of Alban Berg's opera *Wozzeck*. Someone may value the experience those works afford and not just for what she might learn from them; she may, for example, attend performances of them at every opportunity. She might take pleasure in these scenes or enjoy them, but that would hardly be typical of a discerning and attentive member of an audience at either of them.

When we enjoy experiencing a state of affairs, must we find that experience valuable in itself as well? Not necessarily: people may well enjoy experiences that they do not find valuable. Perhaps this is because they regard them as somehow tawdry or unworthy or at best trivial. One may enjoy savoring the details of an erotic picture, for example, without finding the experiencing of those details to be valuable. And even if someone does value the experience of savoring those details, he would typically value it as instrumental to sexual arousal rather than in itself.

Artifacts Designed and Made to Be Appreciated

Someone who designs and makes an artifact with the aim that it be appreciated will naturally observe certain constraints that arise from this aim and from the nature of appreciation.

Most fundamentally, what is to be appreciated must be capable of being experienced. This is certainly a minimal constraint, but it is not negligible. Many states of affairs are such that we cannot experience them; accordingly, we may design and make states of affairs that are beyond appreciation. A painter might quite consciously produce a painting while working on it only on Sundays and thus be responsible for the coming into existence of the state of affairs of the painting's having been worked on only on Sundays. But we could not see (hear, etc.) that this state of affairs obtained, and, hence, we could not appreciate it.

We could certainly read a sentence, say, on the back of the painting ("This painting was worked on only on Sundays") or as a title (*Sunday Painting #3*), grasp the proposition that the painting was worked on only on Sundays and even come to know that that proposition was true. And it might turn out that knowing that a painting was worked on only on a Sunday would help us to see (experience) and thus to appreciate some other state of affairs involving the painting, say, its deliberate naiveté (as if by a "Sunday painter") or its being a critique of conventional religious observance (as if to say that this is a better thing to be doing than going to church). But none of these things separately nor all of them together amount to seeing that the painting was painted only on Sundays, not even in the conceptually loaded, epistemic sense of "see" in which we can see that a painting is anguished or is a portrait of a screaming pope.

What Can Be Appreciated

More generally, what sort of things can be appreciated? First, though an artifact is a part of my paradigm of aesthetic communication, there is no presumption that only artifacts can be appreciated. It is obvious that natural objects, undesigned and unworked, even unarranged, unframed, and unselected, can afford appreciation in the sense I have described.

Furthermore, although my paradigm of aesthetic communication certainly involves the appreciation of a physical object, there is no necessity that appreciation be thus limited. It is clear, for one thing, that we can see, hear, etc., not only states of affairs, in the sense of things instantiating properties at a time, but *events* or *processes*, states of affairs followed by other states of affairs in time—a person's uttering a sentence, singing a tune, or moving from one place to another, a sound's becoming louder and then dying away,

an avalanche's rumbling down a mountain. So we can experience not only physical states of affairs but physical events or processes.

Moreover, in addition to the experience of middle-sized physical things, events, or processes, I have been assuming that there is what might be called *semantic* experience. Grasping the fact that a proof works, noticing that a remark is funny, feeling the suspense in a well-plotted story, recognizing that the metaphors in a poem cohere and reinforce one another—these seem to exemplify experience in the epistemic sense just as clearly as do seeing that a stone is graceful or that water is boiling.

Meeting the Antiessentialist Objection

I have undoubtedly offered an essentialist account of appreciation. Not to be coy about it, the definition in all of its formal glory would go something like this:

> Def: S appreciates x's being F if and only if S finds experiencing x's being F to be valuable in itself.

We must "look and see" whether this account can withstand antiessentialist scrutiny.

Marshall Cohen objects to the claim that the appropriate way to experience something aesthetically is to contemplate it. On the contrary, he says,

> if one ought to contemplate a Redon or a Rothko, one ought to scrutinize the Westminster psalter, survey a Tiepolo ceiling, regard a Watteau, and peer at a scene of Breughel. (1962, 490–91)

Considerations of this sort are sufficient to undercut the idea that aesthetic experience is essentially contemplative, but the defender of a specifically aesthetic state of mind is unlikely to let the matter rest there. No doubt to identify that state of mind with contemplation is to fall victim to what Ludwig Wittgenstein would call a "one-sided diet of examples," to make "the negligent assumption that the rapt Oriental contemplating a Chinese vase is the paradigm of aesthetic experience," as Cohen says (1962, 491). Someone with essentialist leanings would, however, be bound to remark that contemplation and the various activities Cohen distinguished from it and from one another are all different ways of doing one kind of thing—coming to know properties of these objects by looking at them. Why can we not incorporate this state of mind—experiencing (in the epistemic sense)—into our account of the aesthetic state of mind, appreciation?

One can anticipate a Wittgensteinian rejoinder. Is anything to be gained by assimilating contemplating, scrutinizing, surveying, regarding, and peering to one another as ways of *seeing* that certain states of affairs obtain—not to mention assimilating seeing to hearing, tasting, etc., as ways of sensing and assimilating sensing and understanding (e.g., in the sense of understanding a joke) to one another as ways of experiencing?

There seems to be an initial plausibility to at least the first two assimilations; the concepts of seeing and sensing are familiar and seem readily understandable as concepts of genera whose species are, respectively, contemplating, scrutinizing, etc., and seeing, hearing, etc. Perhaps the same cannot be said for the assimilation of getting a joke to seeing, hearing, and the like, but in all these cases what one hopes to gain is an understanding of unobvious but theoretically enlightening generalizations beneath apparent diversity. Whether something like this is gained by the sorts of essentialist "assimilations" made in this [chapter] is something that the reader will have to decide.

Applying the Concept of Aesthetic Communication

I conclude this chapter with some cases. I first work through a few unobvious and perhaps controversial cases to show how the concept of aesthetic communication as here explicated works out in practice, after which I append some cases on which the reader may sharpen his or her understanding of the idea and of its central concept, appreciation.

Cases

Andre Agassi ending a close tennis match with a delicately struck and perfectly placed drop volley that just clears the net. A spectator can certainly appreciate the shot, admiring it even if he wanted Agassi's opponent to win, but it is unlikely that Agassi has intended it to be appreciated.

Sarah Hughes skating for the gold medal at the Olympics. Skaters are, of course, trying to win. But part of how they win is by skating in a way that affords appreciation (by getting a high score in what the skating world refers to as "artistic impression"). That judges can even pretend to give marks under this heading shows that appreciation is not, as some aestheticians have held, incompatible with critical judgment. Further, a part of the aim of the competitors is to afford appreciation to the audience in a way that distinguishes this case from that of a tennis match.

Carl Andre instructing an assistant to arrange on the floor 120 bricks in a rectangle two bricks high, ten bricks long, and six bricks wide at the Tate Gallery in London and entitling the result *Equivalent VIII*. Most of

the elements of a typical aesthetic communication are undoubtedly present—a designer causing something to be made and displayed with the aim that someone else looks at it. The designer and the maker are probably not the same. The serious question is whether the pile of bricks is displayed with the aim and effect of affording appreciation. As to the effect, it seems unlikely that many people would find it particularly valuable to notice the pattern made by the bricks or the contrast between their rough surface and the smooth floor on which they are laid, so if the aim was to afford visual appreciation, it seems not to have been achieved. Andre, however, has made remarks that suggest that, not surprisingly in a sculpture, the work is supposed to afford appreciation when one interacts spatially with it—"the sensation [of *Equivalent VIII* when displayed in conjunction with the other pieces in the *Equivalents* series] was that they come above your ankles, as if you were wading in bricks. It was like stepping from water of one depth to water of another depth."

Marcel Duchamp mounting a bicycle wheel upside down on a kitchen stool and exhibiting it in a gallery. Duchamp specifically denies that this and other "readymades" were produced with any thought of "délectation esthétique" but were rather based on "indifference visuelle" and a total absence of good or bad taste. So it is clear that he does not propose them as objects affording visual appreciation. An alternative worth exploring is that such works are to be appreciated as certain works of literature are, by understanding what they say and finding value in grasping what they say as presented in the way they say it. Perhaps Duchamp's action can be construed after all as an attempt at aesthetic communication.

A drug company designing, making, and marketing a pill that produces a hangover-free, nonaddictive high. Though it would be surprising if no one valued the experience produced by this pill in itself, it would also be surprising if the experience thus valued was an epistemic one in the present sense. The pill is the instrument producing an experience in the phenomenological sense rather than the object of an experience in the epistemic sense.

The Rolling Stones giving a concert at the Hong Kong Harbour Fest. Certainly many of the listeners at a rock concert appreciate the music, and there may be much to appreciate in it, as the very existence of serious rock criticism shows. But there may be some for whom the music acts like a drug, so that paying attention to it and finding it valuable to track its qualities aurally, or even to move in detailed response to them, is no longer the aim, but rather being swept up in it. Others may be there to relive their lost (or perhaps only imagined) youth. Not everyone in the audience at such a concert is there with the aim of appreciating the music.

Here, then, are some cases for the reader to consider. In what ways are they like and unlike the paradigm of aesthetic communication—someone designing and making something with the aim and effect that someone else will appreciate it?

- Vita Sackville-West designing, planting, and tending the White Garden at Sissinghurst for her family and friends.
- Donna Karan designing and selling a dress.
- Dmitri Shostakovich writing and having performed a symphony to promote (or perhaps to criticize) the Soviet regime.
- Matthias Grünewald painting a crucifixion for use as an altar piece.
- Vincent van Gogh producing and trying to sell a painting to pay the rent.
- The performance artist Ben Vautier sitting in the middle of a street in Nice with a placard on which is written, "Regardez moi cela suffit je suis art." ("Look at me. That's all it takes. I'm art.")
- Thirteen-year-old Cody Albertson drawing an action figure and showing it to his friends.
- Johan Rohde designing the "Acorn" silverware pattern to be made and sold by the Georg Jensen Company.
- The Japanese group Boredom producing and selling a "noise" CD, a collage of electronically distorted and often violent sounds.
- The National Park Service providing a parking pull-out where the view of Mt. Rainier is particularly spectacular.
- Pianist David Tudor, having sat down at a piano before an attentive audience in a concert hall to perform John Cage's 4'33", closing the keyboard, sitting in front of the piano without moving, and then opening it four minutes and thirty-three seconds later.
- Someone in Xi'an about 2,200 years ago making life-sized terra cotta models of warriors to bury with the emperor to protect him in the afterlife.
- Cai Guo-Qiang, described as "possibly the highest-profile Chinese artist working on the global art scene," designing and staging a pyrotechnic display entitled *Transient Rainbow* for the opening of the Museum of Modern Art in Queens in 2002.
- One of the builders of the Neolithic passage tomb at Newgrange in Ireland scratching designs in the large boulders that surround its base.
- A beachcomber picking up a piece of driftwood and displaying it on her mantel.

- Beethoven beginning his Symphony no. 1 with a seventh chord on what turns out to be the tonic, and a knowledgeable listener today recognizing this as a shocking dissonance at the time it was composed.

Notes

1. This account of aesthetic communication is part of an argument that has as a crucial premise the claim that the function of the practice and informal institution of art—the artworld—is the promotion of aesthetic communication as here explained; it concludes that works of art are good as works of art to the extent that they have the capacity to afford appreciation. For details of this argument, see Gary Iseminger, *The Aesthetic Function of Art* (Ithaca, NY: Cornell University Press, 2004).

References

Bullough, Edward. 1912. "Aesthetic distance" as a factor in art and an aesthetic principle. In *Aesthetics: A critical anthology*, edited by George Dickie and Richard J. Sclafani, 758–82. New York: St. Martin's.

Cohen, Marshall. 1962. Aesthetic essence. In *Aesthetics: A critical anthology*, edited by George Dickie and Richard J. Sclafani, 484–99. New York: St. Martin's.

Lyas, Colin. 1997. *Aesthetics*. London: UCL Press.

Further Reading

Allison, Henry. 2001. *Kant's theory of taste*. Cambridge: Cambridge University Press. A learned interpretation and defense of Kant's aesthetic theory.

Beardsley, Monroe. 1982. *The aesthetic point of view*. Ithaca, NY: Cornell University Press. A collection of essays presenting Beardsley's thoughts about art and the aesthetic.

Bell, Clive. 1914. *Art*. London: Chatto and Windus. A formalist theory of art and aesthetic experience.

Carroll, Noël. 2002. Aesthetic experience revisited. *British Journal of Aesthetics* 42: 145–68. Further development of Carroll's deflationary view of aesthetic experience.

Dickie, George. 1974. *Art and the aesthetic: An institutional analysis*. Ithaca, NY: Cornell University Press. Contains a critique of several conceptions of the aesthetic and nonaesthetic definitions of art.

Guyer, Paul. 1997. *Kant and the claims of taste*. 2nd ed. Cambridge: Cambridge University Press. A highly sophisticated and detailed interpretation of Kant's aesthetics.

Kant, Immanuel. 1952. *Critique of judgment*. Trans. J. C. Meredith. Oxford: Oxford University Press. Probably the most influential work on aesthetic theory.

Levinson, Jerrold. 1996. *The pleasures of aesthetics*. Ithaca, NY: Cornell University Press. Contains several essays that explore the nature of aesthetic pleasure and aesthetic experience.

Schopenhauer, Arthur. 1966. *World as will and representation*. 2 vols. Trans. E. F. Payne. New York: Dover. Among the most important nineteenth-century accounts of the aesthetic.

Stecker, Robert. 2006. Aesthetic experience and aesthetic value. *Philosophy Compass* 1: 1–10. Presents an overview of recent accounts of aesthetic experience and argues for an experiential account of aesthetic value.

~

Conceptions of the Aesthetic

Aesthetic Properties

Introduction

A 1973 episode of the television show *Monty Python's Flying Circus* contains a three-minute comedy sketch featuring a conversation between characters named James McNeill Whistler and Oscar Wilde. Whistler makes a clever remark to a small group of friends, followed by this exchange:

> WILDE: I wish I had said that.
> WHISTLER: You will, Oscar, you will.

Whistler's earlier cleverness is enhanced by this reply to Wilde. The skit then proceeds with further exchanges in which Wilde tries to turn attention back from Whistler to himself.

Originally created for British audiences, *Flying Circus* later aired on American public television. Monty Python's humor did not always translate well. One reason was its intellectual content. Many sketches depended on familiarity with philosophical or literary material. Another reason was stylistic. The Pythons favored absurd juxtapositions and violations of comedic norms. Finally, some of the humor was directed at British traditions and customs that did not resonate with Americans. Despite these barriers, *Monty Python's Flying Circus* slowly developed a devoted audience in the United States. The group's fame grew with the success of its subsequent movies.

Viewing episode thirty-nine of the television show, how many Americans understood that Whistler and Wilde were historical figures and not fictional

characters? The comedy sketch was an absurd elaboration of a genuine verbal exchange between the two friends. The two lines quoted above appear, word for word, in many biographies of Oscar Wilde.

Consider, then, two features of the sentence "You will, Oscar, you will" as a response to "I wish I had said that." First, it is witty. Second, it is historically accurate. The latter property depends on the line's relationship to past events; it is historically accurate if and only if Whistler really said it, and this fact is independent of whether viewers believe it to be accurate. Its accuracy is a real, audience-independent property of this aspect of the skit. But what of its property of wittiness? Is that also a real, audience-independent property of this aspect of the same skit, a property that it has even if no member of the audience is aware of it? Or does the line's wittiness depend on its having an audience that appreciates it? In short, is it objective or subjective? Wittiness is normally classified as an aesthetic property, so our answers to these questions may tell us something about aesthetic properties in general.

It seems strange to suppose that a string of words can have the property of wittiness apart from a context that makes them funny to an audience that comprehends their meaning. After all, the sentence is not intrinsically witty. Suppose Whistler had originally said the same words in response to Wilde's asking, "Do you think I will still be discussed in the twenty-first century?" In that case there is nothing clever or humorous about the response, "You will, Oscar, you will." Or suppose that nothing in Wilde's character would support anyone's enjoying the quip. Would it not then be mean-spirited instead of witty? As a feature of the sentence, wit seems to be both context dependent—the line must be said in an appropriate context—and response dependent—it is witty only if audiences routinely respond to it with amusement.

Furthermore, if we find it witty rather than insulting, we seem to assign positive value to this property. The exchange has been preserved because people admire and enjoy it. So wit appears to have two distinct dimensions, both of them response dependent. To call something witty is to say that it regularly causes amusement, and as such we value it.

If it seems odd to focus on wittiness as a species of aesthetic value, rather than on such properties as beauty and expressive power, there is a longstanding tradition according to which humor is one of art's attractions. David Hume's classic essay of 1757, "Of the Standard of Taste," is a case in point. He mentions both comedy and satire as important genres of literature. Although he attempts to explain why comedy does not always travel well between cultures, he thinks that the power to amuse is a genuine reason to value an author's work. (Consider: is it obvious that Shakespeare's The Taming of the Shrew is a

weaker play than the noncomedic *Coriolanus?*) Setting the stage for much of the modern debate about the status of aesthetic properties, Hume argues that response dependency does not imply that everyone's response is equally valid.

For example, Hume offers a strategy for dealing with the fact that many people do not like Monty Python's style of humor. It offends as many people as it amuses. (Dealing extensively with religion, their film *Life of Brian* is a notorious case.) Those who are offended find little or no value in what they dismiss as sophomoric religious sacrilege. We return, therefore, to another version of a problem we encountered in the aesthetics of nature. Is every response equally valid? If so, and the same aspects that amuse some are the aspects that offend others, then wit does not seem a real property of the object in question. Hume's strategy is much like one we discussed in chapter 1. Except for extremely superficial beauties and deformities, aesthetic properties place very particular demands on evaluators. Much like Marcia M. Eaton's example of the yellow birch tree, not everyone is perceptually and cognitively prepared to enjoy Whistler's wit and Monty Python's brand of humor. As Hume argues, not everyone is an equally good judge of the value of the satirical humor in Monty Python's *Life of Brian*. In fact, no one can be expected to be an equally qualified judge of every work of art, and some people are temperamentally or otherwise unfit to judge large swaths of art. Nonetheless, in the same way that experienced, appropriately sensitive wine tasters can detect and evaluate subtle flavors in what they taste, there are "true judges" of the merits and flaws of works of art of every type.

Frank Sibley approaches the objectivity of aesthetic properties by first setting aside their contribution to aesthetic evaluation. The mere fact that something is red is no evidence that it is aesthetically valuable, and likewise a statue's gracefulness does not decide its aesthetic merit. Given that qualification, Sibley argues that there are correct and incorrect attributions of aesthetic properties, in much the same way that people can be right or wrong when identifying something's color. Disagreement and undecidability about an object's color is no reason to deny the reality of colors. Likewise, the fact that children and adults laugh at different things is merely evidence that they are sensitive to different features upon which the humor depends. Pursuing a major theme of Hume's essay, Sibley argues that the convergence of judgment about what we experience in major works of art is strong evidence against a skeptical, antirealist position.

John Bender calls attention to other implications of linking aesthetic properties to sensory ones. Elaborating on Hume's example of disagreements in wine tasting, Bender uses it to opposite purpose, to build a case against the reality of aesthetic properties. Where Hume acknowledges that limited

circumstances prevent unprejudiced, trained judges from agreeing about the presence and value of aesthetic properties, Bender argues that perceptual sensitivity is far more important than Hume and Sibley realize. There are many levels of sensitivity to various sensory properties. Suppose an object is aesthetically balanced and graceful. How are these properties "real"? Many people literally cannot perceive the base properties that account for them. Meanwhile, the heightened sensitivities of others render the object unbalanced and thus less graceful for them, ruining the experience. Given these differences in perceptual sensitivity, any alleged convergence of critical opinion is more likely to be an unjustified dismissal of the responses of those at the two ends of the sensitivity spectrum.

Finally, Jerrold Levinson responds to Bender by approvingly citing Hume and Sibley. Elaborating on Sibley's point that awareness of aesthetic properties depends on one's awareness of an object's other properties, Levinson argues that perceptual limitations must be distinguished from attitudinal sensitivities to what is perceived. Even if there are irresolvable differences in sensitivity to the base properties, each range of sensitivity should allow for convergent agreement about an object's perceptual properties and resulting aesthetic properties. Granted, not everyone can read Jane Austen's *Emma*. But among those who can, the responses that matter are those of readers who fit Hume's description of the unbiased, competent judge; since *they agree* on its wittiness and *value* it, what more is there to argue about? However, given that Levinson ties aesthetic properties so directly to perceptual appearances, is the wit of Austen's writing a genuine *aesthetic* property of her writing? And can there be unbiased judges of humor?

cᘛᗒᕽ

Of the Standard of Taste*

David Hume

The great variety of tastes which prevail in the world, is too obvious not to have fallen under everyone's observation. We are apt to call barbarous whatever departs widely from our own taste and apprehension, but soon find the epithet of reproach retorted on us.

It is very natural for us to seek a *standard of taste*; a rule, by which the various sentiments of men may be reconciled; or at least, a decision afforded, confirming one sentiment, and condemning another.

*"Of the Standard of Taste," in *Four Dissertations*, pp. 203–36 (London: A. Millar, 1757). In the public domain.

There is a species of philosophy, which cuts off all hopes of success in such an attempt, and represents the impossibility of ever attaining any standard of taste. Beauty is no quality in things themselves: It exists merely in the mind which contemplates them; and each mind perceives a different beauty. One person may even perceive deformity, where another is sensible of beauty; and every individual ought to acquiesce in his own sentiment, without pretending to regulate those of others. To seek the real beauty, or real deformity is as fruitless an inquiry, as to pretend to ascertain the real sweet or real bitter. According to the disposition of the organs, the same object may be both sweet and bitter; and the proverb has justly determined it to be fruitless to dispute concerning tastes. It is very natural, and even quite necessary, to extend this axiom to mental, as well as bodily taste.

But though this axiom, by passing into a proverb, seems to have attained the sanction of common sense; there is certainly a species of common sense, which opposes it, at least serves to modify and restrain it. Whoever would assert an equality of genius and elegance between Ogilby and Milton, or Bunyan and Addison, would be thought to defend no less an extravagance, than if he had maintained a pond as extensive as the ocean. Though there may be found persons who give the preference to the former authors, no one pays attention to such a taste; and we pronounce without scruple the sentiment of these pretended critics to be absurd and ridiculous. The principle of the natural equality of tastes is then totally forgotten.

It is evident that none of the rules of composition are fixed by reasonings a priori. Their foundation is the same with that of all the practical sciences, experience; nor are they anything but general observations, concerning what has been universally found to please in all countries and in all ages. Many of the beauties of poetry, and even of eloquence, are founded on falsehood and fiction, on hyperboles, metaphors, and an abuse or perversion of expression from their natural meaning. But though poetry can never submit to exact truth, it must be confined by rules of art. If some negligent or irregular writers have pleased, they have not pleased by their transgressions of rule or order, but in spite of these transgressions: They have possessed other beauties, which were conformable to just criticism; and the force of these beauties has been able to overpower censure, and give the mind a satisfaction superior to the disgust arising from the blemishes. Ariosto pleases; but not by his monstrous and improbable fictions, by his bizarre mixture of the serious and comic styles, by the want of coherence in his stories, or by the continual interruptions of his narration. He charms by the force and clearness of his expression, by the readiness and variety of his inventions, and by his natural pictures of the passions: And however his faults may diminish our satisfaction, they are not able entirely to

destroy it. Did our pleasure really arise from those parts of his poem, which we denominate faults, this would be no objection to criticism in general. It would only be an objection to those particular rules of criticism, which would establish such circumstances to be faults, and would represent them as universally blamable. If they are found to please, they cannot be faults; let the pleasure, which they produce, be ever so unexpected and unaccountable.

But though all the general rules of art are founded only on experience, and on the observation of the common sentiments of human nature, we must not imagine that, on every occasion, the feelings of men will be conformable to these rules. Those finer emotions of the mind are of a very tender and delicate nature, and require the concurrence of many favorable circumstances to make them play with exactness, according to their general and established principles. The least exterior hindrance to such small springs, or the least internal disorder, disturbs their motion, and confounds the operation of the whole machine. A perfect serenity of mind, a recollection of thought, a due attention to the object; if any of these circumstances be wanting, we shall be unable to judge of the universal beauty. We shall be able to ascertain its influence not so much from the operation of each particular beauty, as from the durable admiration, which attends those works, that have survived all the caprices of mode and fashion, all the mistakes of ignorance and envy.

The same Homer, who pleased at Athens and Rome two thousand years ago, is still admired at Paris and at London. All the changes of climate, government, religion, and language, have not been able to obscure his glory. Authority or prejudice may give a temporary vogue to a bad poet or orator; but his reputation will never be durable or general. When his compositions are examined by posterity or by foreigners, the enchantment is dissipated, and his faults appear in their true colors. On the contrary, a real genius, the longer his works endure, and the more wide they are spread, the more sincere is the admiration which he meets with.

It appears then, that amidst all the variety and caprices of taste, there are certain general principles of approbation or blame, whose influence a careful eye may trace in all operations of the mind. Some particular forms or qualities, from the original structure of the internal fabric, are calculated to please, and others to displease; and if they fail of their effect in any particular instance, it is from some apparent defect or imperfection in the organ. A man in a fever would not insist on his palate as able to decide concerning flavors; nor would one, affected with the jaundice, pretend to give a verdict with regard to colors. In each creature, there is a sound and a defective state; and the former alone can be supposed to afford us a true standard of taste and sentiment. If in the sound state of the organ, there be an entire or a consider-

able uniformity of sentiment among men, we may thence derive an idea of the perfect beauty; in like manner as the appearance of objects in daylight to the eye of a man in health is denominated their true and real color, even while color is allowed to be merely a phantasm of the senses.

Many and frequent are the defects in the internal organs, which prevent or weaken the influence of those general principles, on which depends our sentiment of beauty or deformity. Though some objects, by the structure of the mind, be naturally calculated to give pleasure, it is not to be expected, that in every individual the pleasure will be equally felt.

One obvious cause, why many feel not the proper sentiment of beauty, is the want of that delicacy of imagination, which is requisite to convey a sensibility of those finer emotions. But as our intention is to mingle some light of the understanding with the feelings of sentiment, it will be proper to give a more accurate definition of delicacy than has hitherto been attempted. And not to draw our philosophy from too profound a source, we shall have recourse to a noted story in Don Quixote.

It is with good reason, says Sancho to the squire with the great nose, that I pretend to have a judgment in wine: This is a quality hereditary in our family. Two of my kinsmen were once called to give their opinion of a hogshead [of wine], which was supposed to be excellent, being old and of a good vintage. One of them tastes it; considers it; and, after mature reflection, pronounces the wine to be good, were it not for a small taste of leather, which he perceived in it. The other, after using the same precautions, gives also his verdict in favor of the wine; but with the reserve of a taste of iron, which he could easily distinguish. You cannot imagine how much they were both ridiculed for their judgment. But who laughed in the end? On emptying the hogshead, there was found at the bottom an old key with a leather thong tied to it.

The great resemblance between mental and bodily taste will easily teach us to apply this story. Though it be certain, that beauty and deformity, more than sweet and bitter, are not qualities in objects, but belong entirely to the sentiment, internal or external; it must be allowed, that there are certain qualities in objects, which are fitted by nature to produce those particular feelings. Now as these qualities may be found in a small degree or may be mixed and confounded with each other, it often happens that the taste is not affected with such minute qualities, or is not able to distinguish all the particular flavors, amidst the disorder in which they are presented. Where the organs are so fine, as to allow nothing to escape them, and at the same time so exact, as to perceive every ingredient in the composition: This we call delicacy of taste, whether we employ these terms in the literal or metaphorical sense. Here then the general rules of beauty are of use, being drawn from

established models, and from the observation of what pleases or displeases, when presented singly and in a high degree: And if the same qualities, in a continued composition, and in a smaller degree, affect not the organs with a sensible delight or uneasiness, we exclude the person from all pretensions to this delicacy. To produce these general rules or avowed patterns of composition is like finding the key with the leather thong, which justified the verdict of Sancho's kinsmen, and confounded those pretended judges who had condemned them. Though the hogshead had never been emptied, the taste of the one was still equally delicate, and that of the other equally dull and languid. But it would have been more difficult to have proved the superiority of the former, to the conviction of every bystander. In like manner, though the beauties of writing had never been methodized, or reduced to general principles; though no excellent models had ever been acknowledged; the different degrees of taste would still have subsisted, and the judgment of one man been preferable to that of another; but it would not have been so easy to silence the bad critic, who might always insist upon his particular sentiment, and refuse to submit to his antagonist. But when we show him an avowed principle of art; when we illustrate this principle by examples, whose operation, from his own particular taste, he acknowledges to be conformable to the principle; when we prove that the same principle may be applied to the present case, where he did not perceive or feel its influence: He must conclude, upon the whole, that the fault lies in himself, and that he wants the delicacy, which is requisite to make him sensible of every beauty and every blemish, in any composition or discourse.

It is acknowledged to be the perfection of every sense or faculty, to perceive with exactness its most minute objects, and allow nothing to escape its notice and observation. The smaller the objects are, which become sensible to the eye, the finer is that organ. A good palate is not tried by strong flavors, but by a mixture of small ingredients, where we are still sensible of each part, notwithstanding its minuteness and its confusion with the rest. In like manner, a quick and acute perception of beauty and deformity must be the perfection of our mental taste; nor can a man be satisfied with himself while he suspects that any excellence or blemish in a discourse has passed him unobserved. A very delicate palate, on many occasions, may be a great inconvenience both to a man himself and to his friends: But a delicate taste of wit or beauty must always be a desirable quality, because it is the source of all the finest and most innocent enjoyments of which human nature is susceptible. In this decision the sentiments of all mankind are agreed. Wherever you can ascertain a delicacy of taste, it is sure to be approved of; and the best way of ascertaining it is to appeal to those models and principles which have been established by the uniform consent and experience of nations and ages.

But though there be naturally a wide difference in point of delicacy between one person and another, nothing tends further to increase and improve this talent, than practice in a particular art, and the frequent survey or contemplation of a particular species of beauty. When objects of any kind are first presented to the eye or imagination, the sentiment which attends them is obscure and confused. But allow him to acquire experience in those objects, his feeling becomes more exact and nice: He not only perceives the beauties and defects of each part, but marks the distinguishing species of each quality, and assigns it suitable praise or blame. In a word, the same address and dexterity, which practice gives to the execution of any work, is also acquired by the same means in the judging of it.

So advantageous is practice to the discernment of beauty, that, before we can give judgment on any work of importance, it will even be requisite that that very individual performance be more than once perused by us, and be surveyed in different lights with attention and deliberation. There is a flutter or hurry of thought which attends the first perusal of any piece, and which confounds the genuine sentiment of beauty. The relation of the parts is not discerned. The true characters of style are little distinguished. The several perfections and defects seem wrapped up in a species of confusion, and present themselves indistinctly to the imagination. Not to mention, that there is a species of beauty, which, as it is florid and superficial, pleases at first; but being found incompatible with a just expression either of reason or passion, soon palls upon the taste, and is then rejected with disdain, at least rated at a much lower value.

It is impossible to continue in the practice of contemplating any order of beauty, without being frequently obliged to form comparisons between the several species and degrees of excellence, and estimating their proportion to each other. A man, who had had no opportunity of comparing the different kinds of beauty, is indeed totally unqualified to pronounce an opinion with regard to any object presented to him. By comparison alone we fix the epithets of praise or blame, and learn how to assign the due degree of each. The coarsest daubing of a signpost contains a certain luster of colors and exactness of imitation, which are so far beauties, and would affect the mind of a peasant or Indian with the highest admiration. The most vulgar ballads are not entirely destitute of harmony, and none but a person familiarized to superior beauties would pronounce their numbers harsh, or narration uninteresting. A great inferiority of beauty gives pain to a person conversant in the highest excellence of the kind, and is for that reason pronounced a deformity: As the most finished object with which we are acquainted is naturally supposed to have reached the pinnacle of perfection, and to be entitled to the highest applause. A man who has had opportunities of seeing, and examining, and

weighing the several performances admired in different ages and nations, can alone rate the merits of a work exhibited to his view, and assign its proper rank among the productions of genius.

But to enable a critic more fully to execute this undertaking, he must preserve his mind free from all prejudice, and allow nothing to enter into his consideration but the very object which is submitted to his examination. We may observe, that every work of art, in order to produce its due effect on the mind, must be surveyed in a certain point of view, and cannot be fully relished by persons, whose situation, real or imaginary, is not conformable to that which is required by the performance. An orator addresses himself to a particular audience, and must have a regard to their particular genius, interests, opinions, passions, and prejudices; otherwise he hopes in vain to govern their resolutions, and inflame their affections. A critic of a different age or nation, who should peruse this discourse, must have all these circumstances in his eye, and must place himself in the same situation as the audience, in order to form a true judgment of the oration. In like manner, when any work is addressed to the public, though I should have a friendship or enmity with the author, I must depart from this situation; and considering myself as a man in general, forget, if possible, my individual being, and my peculiar circumstances.

It is well known, that in all questions submitted to the understanding, prejudice is most destructive of sound judgment, and perverts all operations of the intellectual faculties. It is no less contrary to good taste: nor has it less influence to corrupt our sentiments of beauty. It belongs to good sense to check its influence in both cases; and in this respect, as well as in many others, reason, if not an essential part of taste, is at least requisite to the operations of this latter faculty. In all the nobler productions of genius, there is a mutual relation and correspondence of parts; nor can either the beauties or blemishes be perceived by him, whose thought is not capacious enough to comprehend all those parts, and compare them with each other, in order to perceive the consistence and uniformity of the whole. Every work of art has also a certain end or purpose for which it is calculated; and is to be deemed more or less perfect, as it is more or less fitted to attain this end. The object of eloquence is to persuade, of history to instruct, of poetry to please, by means of the passions and the imagination. These ends we must carry constantly in our view when we peruse any performance; and we must be able to judge how far the means employed are adapted to their respective purposes.

Thus, though the principles of taste be universal, and nearly, if not entirely the same in all men, yet few are qualified to give judgment on any work

of art, or establish their own sentiment as the standard of beauty. The organs of internal sensation are seldom so perfect as to allow the general principles their full play, and produce a feeling correspondent to those principles. They either labor under some defect, or are vitiated by some disorder; and by that means, excite a sentiment, which may be pronounced erroneous. When the critic has no delicacy, he is only affected by the grosser and more palpable qualities of the object: The finer touches pass unnoticed and disregarded. Where he is not aided by practice, his verdict is attended with confusion and hesitation. Where no comparison has been employed, the most frivolous beauties, such as rather merit the name of defects, are the object of his admiration. Where he lies under the influence of prejudice, all his natural sentiments are perverted. Where good sense is wanting, he is not qualified to discern the beauties of design and reasoning, which are the highest and most excellent. Under some or other of these imperfections, the generality of men labor; and hence a true judge in the finer arts is observed, even during the most polished ages, to be so rare a character: Strong sense, united to delicate sentiment, improved by practice, perfected by comparison, and cleared of all prejudice, can alone entitle critics to this valuable character; and the joint verdict of such, wherever they are to be found, is the true standard of taste and beauty.

But where are such critics to be found? By what marks are they to be known? How distinguish them from pretenders? These questions are embarrassing; and seem to throw us back into the same uncertainty, from which, during the course of this essay, we have endeavored to extricate ourselves.

But in reality, the difficulty of finding, even in particulars, the standard of taste, is not so great as it is represented. Just expressions of passion and nature are sure, after a little time, to gain public [approval], which they maintain forever. Aristotle, and Plato, and Epicurus, and Descartes, may successively yield to each other: But Terence and Virgil maintain a universal, undisputed empire over the minds of men. The abstract philosophy of Cicero has lost its credit: The vehemence of his oratory is still the object of our admiration. Though a civilized nation may easily be mistaken in the choice of their admired philosopher, they never have been found long to err, in their affection for a favorite epic or tragic author.

But notwithstanding all our endeavors to fix a standard of taste, and reconcile the discordant apprehensions of men, there still remain two sources of variation, which will often serve to produce a difference in the degrees of our approbation or blame. The one is the different humors of particular men; the other, the particular manners and opinions of our age and country. In that case a certain degree of diversity in judgment is unavoidable,

and we seek in vain for a standard, by which we can reconcile the contrary sentiments.

We choose our favorite author as we do our friend, from a conformity of humor and disposition. Mirth or passion, sentiment or reflection; whichever of these most predominates in our temper, it gives us a peculiar sympathy with the writer who resembles us.

One person is more pleased with the sublime; another with the tender; a third with raillery. One has a strong sensibility to blemishes, and is extremely studious of correctness: Another has a more lively feeling of beauties, and pardons twenty absurdities and defects for one elevated or pathetic stroke. The ear of this man is entirely turned toward conciseness and energy; that man is delighted with a copious, rich, and harmonious expression. Simplicity is affected by one; ornament by another. Comedy, tragedy, satire, odes, have each its partisans, who prefer that particular species of writing to all others. It is plainly an error in a critic, to confine his approbation to one species or style of writing, and condemn all the rest. But it is almost impossible not to feel a predilection for that which suits our particular turn and disposition. Such preferences are innocent and unavoidable, and can never reasonably be the object of dispute, because there is no standard by which they can be decided.

For a like reason, we are more pleased, in the course of our reading, with pictures and characters that resemble objects which are found in our own age or country, than with those which describe a different set of customs. For this reason, comedy is not easily transferred from one age or nation to another. Learning and reflection can make allowance for these peculiarities of manners; but a common audience can never relish pictures which nowise resemble them.

Where innocent peculiarities of manners are represented, they ought certainly to be admitted; and a man who is shocked with them, gives an evident proof of false delicacy and refinement. Must we throw aside the pictures of our ancestors, because of their ruffs and fardingales? But where the ideas of morality and decency alter from one age to another, and where vicious manners are described, without being marked with the proper characters of blame and disapprobation, this must be allowed to disfigure the poem, and to be a real deformity. I cannot, nor is it proper I should, enter into such sentiments; and however I may excuse the poet, on account of the manners of his age, I never can relish the composition. The want of humanity and of decency, so conspicuous in the characters drawn by several of the ancient poets, even sometimes by Homer and the Greek tragedians, diminishes considerably the merit of their noble performances, and gives modern authors an advantage over them.

⌒⌾⌒

Objectivity and Aesthetics*

Frank Sibley

In this paper I am concerned with aesthetic descriptions. I have in mind assertions and disagreements about whether, for instance, an artwork (or where appropriate, a person or thing) is graceful or dainty, moving or plaintive, balanced or lacking in unity. I deliberately ignore, by a partly artificial distinction, questions about evaluation.

I include, moreover, those remarks, metaphorical in character, which we might describe as *apt* rather than *true*, for these often say, only more strikingly, what could be said in less colorful language. The transition from true to apt description is a gradual one. (These many sorts of remarks can be illustrated from many contexts besides art criticism, e.g., from writers on wines.)

The objectivity under consideration is that of these many sorts of remarks. Is it *true*, a *fact*, that some works *are* graceful, others moving or balanced; that someone denying it could be mistaken, blind to their character, that one man's assertion might contradict another's? Are there correct and incorrect aesthetic descriptions?

What is required first, as I see it, is an understanding of what is involved in a thing *being*, for instance, red, since it is apparently being claimed that, with aesthetic terms, matters are in some vital respect *not like that*. We need to examine, in a general way, the characteristic features of aesthetic terms, comparing them constantly with color words to bring out similarities and differences. This is what, very sketchily, I attempt. For if people deny an objectivity, a possibility of truth and error, to aesthetic descriptions which they allow to color judgments, it is worth trying to see whether the differences warrant drawing such a sharp and crucial line.

One reason for denying objectivity to aesthetic descriptive remarks has been the supposed need of a special quasi-sense or intuition to explain how we come by the knowledge they express. I prefer to put the matter another way, one which has frequently been implied or stated: that, with objective matters, there must be proofs, decision procedures, ways of establishing truth and falsity. Where proof is impossible, there is no objectivity. And since proof is a way of settling who is right and who wrong, there is the related supposition that, where unresolved disputes are endemic and widespread (as wthey are said to

*"Objectivity and Aesthetics," *Proceedings of the Aristotelian Society*, Supplementary Volume 42 (1968): 31–54. Reprinted by courtesy of the Editor of the Aristotelian Society: © 1968.

be in the aesthetic realm), matters are not objective. It is further said that, not only does extensive unresolved dispute indicate that decision procedures (and therefore objectivity) are lacking, but the very possibility of objectivity *requires* (what it is said we lack) a kind of widespread agreement.

We need also be sure that those who say there are no proofs, procedures, or tests have not been looking for the wrong kind, appropriate, say, to concepts of other sorts which aesthetic concepts *could* not closely resemble. Indeed, the skeptic whose first move, when there are disputes, is to demand proofs in aesthetics, is likely to accept other matters as objective enough without making any such demand there.

Suppose we assume, for trial purposes, that aesthetic terms do connote properties; it is obvious at once that these will differ markedly in kind from colors. They will be dependent or emergent in a way colors are not. That is, whereas there is nothing about the way a thing looks that makes it look blue, there are all sorts of visible features that make a thing look, or are responsible for its looking graceful (though their presence does not *entail* what they are responsible for); and any change in them may result in its being no longer graceful. So with the features that make a poem moving or a tune plaintive; and in nonaesthetic matters there is the same sort of situation, for instance, with the features that make a remark funny, are responsible for a facial resemblance or expression, and so on. The inevitable consequence is that unless one is in some degree aware of these responsible features, one will not perceive the resultant quality. Hence, often, the kind of talking, pointing, and otherwise directing attention that may help someone to see them. There is no (or very little) counterpart to this with colors; when we look, we "just see them," or not.

But though this immense dissimilarity separates most aesthetic qualities from colors, there is also a notable similarity. With colors, the ultimate kind of proof or decision procedure, the only kind there could be ultimately, consists in a certain kind of appeal to agreement in reaction or discrimination.

One cannot appeal to other features of an object in virtue of possessing which, by some rule of meaning, it can be said to be red or blue, as one can with such properties as triangular, etc. With colors there is no such intermediate appeal; only directly an appeal to agreement. But if there are aesthetic properties—the supposition under investigation—they will, despite dissimilarities, be like colors in this respect. For though, unlike colors, they will be dependent on other properties of things, they cannot, since they are not entailed by the properties responsible for them, be ascribed by virtue of the presence of other properties and some rule of meaning. Hence a proof will again make no intermediate appeal to other properties of the thing, but directly to agreement. Thus, if the skeptic demands a proof that something is

graceful, requiring us to cite truths about its properties from which this follows, we must concede that proofs are impossible; *but so they are with colors,* and many other objective matters which he does not challenge.

The skeptic who emphasizes that disputes in aesthetics are rife and that widespread agreement is necessary for objectivity doubtless starts from an ideal where there is maximum actual agreement, as with colors. But, if there *were* aesthetic properties, they would *not* be like colors. We should, of necessity, have to expect additional sources of disagreement. We could not expect anything like the ideal of maximum agreement.

One built-in source of disagreement has been mentioned already: aesthetic properties being emergent, the features responsible for them must be noticed in interrelation. If people are unwilling or unable to attend appropriately, disagreement will result, even though, with attention and help, agreement would often occur. These failures may be of many familiar sorts, akin to missing the face in a puzzle picture, missing color harmonies because of focusing on linear composition, seeing a cornice instead of a staircase, etc.

But there are other sources of disagreement. As jokes and humor depend on all sorts of knowledge of human nature and customs, so does the realization that passages in *Lear* or *Othello* are particularly moving. One *could* not expect this recognition from a child or a person lacking certain broadly specifiable experience and development. It is odd therefore that this relevance of one's mental condition should often be cited as a main reason why they cannot be objective matters.

Some people, I am saying, when they develop certain everyday capacities and acquire a diversity of not uncommon experience and knowledge, exhibit a tendency to make similar discriminations. Others with apparently similar knowledge and experience—as well as those lacking it—simply do not. The persisting tendency to agreement (though it may be approximate, more like a concentrated scatter than convergence on a point) is analogous to that which allows us to form the concept *of colors* as properties, and may similarly make it possible to speak of things *being* graceful, moving, etc. *If* there *were* properties discriminable only by people in certain mental conditions, and *if* there were variations in mental endowment, knowledge, and experience, it would be unreasonable *not* to expect a good deal of disagreement in discriminations.

Different objections to the notion of aesthetic properties spring from the view that, since the alleged recognition of them is relative to our physical and mental condition (they are recognized only by beings of a certain sort in certain states), they cannot really be *properties* in objects. There are perhaps three distinguishable arguments here. (1) We cannot speak of properties when awareness of the alleged properties is relative to some type of organism.

This seems irrelevant; colors are in the same position. (2) We cannot speak of properties when awareness of the alleged properties is relative to a certain mental condition, the result of experience, etc. But I see little reason why this, either, should exclude objectivity; it certainly applies to much outside the aesthetic that we regard as objective, recognition of faces as smiling, that sentences have meaning, and so on. (3) Perhaps the real objection is that, since people differ and change, the choice of *which* group of people is held to discern the properties of things must be arbitrary.

This leads me, however, to further characteristics of aesthetic concepts. Since discrimination often depends on experience, knowledge, and practiced attention, the group is inevitably not homogeneous. There will be groups exhibiting partial and merging areas of agreement corresponding to what we ordinarily call areas of limited sensibility and levels of sophistication. There is the sophistication that consists in making finer distinctions and employing a more precise vocabulary. Where the many lump certain things together under a common and generic term ("lovely" or "pretty"), the few may agree in differentiating them more specifically as, say, beautiful, dainty, elegant, graceful, or charming (cf. the division of red into vermilion, crimson, carmine). Then there are hierarchies deriving from wider experience. Sometimes, with growing awareness of subtleties and nuances of style and language, reversals occur; what originally seemed monotonous (say, Bach) becomes subtly varied, moving, and exciting, while what was powerfully moving (say, Tchaikovsky) becomes naive or blatant.

Given experience of our own development, we might (if it did not sound condescending) liken these differences to those between children and adults. Children may laugh heartily at, or be moved strongly by, things we regard as only mildly amusing or moving. But we welcome their reactions; they are on the track that may lead to fuller discrimination, and at least have "agreed" with us in distinguishing the (for us only mildly) funny or moving from things they and we agree are neither. Indeed, this might be all in the circumstances we could (even logically) expect. So with the arts: people of variously developed sensitivity tend to converge on a broad target of agreement, without making the more detailed or sophisticated distinctions.

Even in vision and hearing some people have greater visual or auditory acuity and can distinguish minute differences of color or pitch; we could, if strict, say the colors and notes they distinguish are different, though for some purposes we follow the ordinary man in saying they are the same. It is an illusion to suppose there is always a crisp "Yes" or "No" to questions of color, or to the question which is the reference-group for the "is" of color at-

tribution. A judgment broadly agreed within the penumbra may sometimes be more secure than the more specific judgment of the nucleus or elite, as a judgment that something is red may be more secure than that it is crimson or vermilion. Where there are frequent shifts and divisions of *specific* opinion about a work by critics, but within a widely held but more generic opinion, we may hesitate, or prefer the less discriminating group as the secure reference-group. Whether we accept the detailed agreements of a small nucleus or the broader ones of the penumbra in particular cases (or refuse to prefer either) depends how the minority claim is upheld by related considerations, and sometimes there is not enough to decide. Where we cannot exactly pinpoint a reference-group we correspondingly cannot sharply adjudicate the judgments of nucleus or penumbra as right or wrong, though we can still reject outsiders' judgments (as we can clearly say a face is not scowling, while disputing whether it is smiling, smirking, or leering).

I return now to what earlier I called "ultimate proofs." If aesthetic concepts are as I have pictured them, a proof will consist in a convergence of judgments. But this may require time—a thing would need to exist unchanged over a long period and be regularly scrutinized with care by many people. Thus a work produced last week *could* not yet have met the decision procedure conditions, nor, if two or three generations are required for fashions and counter fashions to neutralize each other, could works produced in, say, the last thirty years. We might insist that a new work is Φ and be right; but we could not, if challenged, give a conclusive proof. Since many things we judge aesthetically are quite ephemeral, many disputes inevitably go unsettled; even where there may be widespread agreement (as over a dancer's performance on a particular evening), the judges (who may be right) are without a logically powerful riposte if a skeptic demands proof. (So, too, in a much modified way, I might be quite sure [and right] in saying a colored flash is green; but I could be wrong, a possibility that diminishes as more people saw it, and one that has long since evaporated with, say, emeralds.)

As agreement on a given case, amongst those who make the widest range of detailed agreeing discriminations, collects over a longer period, it approaches more closely to absurdity to question the case. Enough is enough, though no *sharp* line divides what is questionable from what is not. Put otherwise, possibility of error with a case that has elicited long-lasting convergence decreases as possible *explanations* of error become more obviously absurd; e.g., we could not sensibly reject a centuries-spanning consensus about *Oedipus* as being the result of personal bias, enthusiasm for a novel style, or passing fashions or fads. I do not mean that, in *other* cases, there is always some reason for doubt;

only that the long-attested cases may virtually exclude the *theoretical skeptic's* doubt as absurd. Many other points might be added. For example, there are certain asymmetries: it is harder to justify denying widely acknowledged qualities than to be right in claiming to discover qualities everyone has so far missed. Again, assurance might be strengthened by taking groups rather than single works as paradigms: it may be absurd to deny that the *group A, B, C,* and *D* contains paradigms of grace, even though considerations might just conceivably be brought to make us question one of them.

The forgoing remarks about proof, if correct, indicate that some aesthetic judgments may be characterized as right, wrong, true, false, undeniable, or by similar strong vocabulary. But my remarks about [aesthetic] concepts indicate that this realm may not be rigidly objective; with some judgments (perhaps a sizeable number), we cannot demand or justify a clear "Yes," "No," "True," or "False." This is because, even as time goes by, judgments may be split on certain cases. But the fact that there is insufficient reason to endorse one judgment as right against the other (since ex hypothesi no recourse to anything else could show this) by no means plunges us into subjectivity. The judgment that the poem is cold does not become a permissible candidate because there is dispute whether it is really moving or only mildly touching. If the proportion of cases in which there is no sharp right and wrong about such judgments as these is large in relation to cases which, whether in fact settled or not, might have a clear answer, this is only an enlargement of a kind of in-principle-undecidable area which already characterizes other objective concepts. It does not and could not erase all right–wrong distinctions in the area since these indeterminable cases exist only in relation to the others; only, that is, because the principles that *do* settle cases are not in fact met by these, or are half met and half not. Indeed, I can now mention some more extreme situations. These are the notorious cases (perhaps Liszt or Wagner) where no consensus settles down either way. Here we may offer explanations (e.g., by appeal to types of people, the cool and the emotional, the moral liberal and the moral puritan), understand the differences, and see both sides, or we may find the explanations running dry. In either case we may just leave the differences standing; either judgment is acceptable. Indeed, for some ranges of judgments we prefer terms like "reasonable," "admissible," "understandable" or "eccentric" to "right" and "wrong." Here the rigid objectivist, fearful of giving too much away, might insist that one party *must* be mistaken; but, equally, we might allow that not all disputes are settleable as between certain alternatives. Other objective matters exhibit undecidable areas; this may differ from those only in degree. In any case, at first-order level so

to speak, it will still be the *critic's* duty firmly to give his own honest and careful opinion, for only thus can a genuine consensus emerge or fail to.

There is much in this ocean I have not touched: all the surface disagreements resulting from temporary fashions, the short-lived culture of the eye which makes wide lapels or long skirts look right one month and wrong the next, enthusiasms or satiations with new or old styles, etc. These are phenomena wherein no claims to objectivity might stand, as the skeptic who exploits them well knows. But there seem to me to be ground swells and prevailing currents as well as surface disturbances, and it is to those I have tried to attend.

I am far from thinking I have made a case for aesthetic properties, even in the weak sense that some aesthetic characterizations are true or false, apt or inappropriate, etc. I have simply suggested considerations that need exploring or disposing of before that case, which would refute some forms of skepticism, is abandoned. In giving aesthetic "properties" a trial run, I have examined no aesthetic terms themselves. I tried a more schematic approach. Starting from certain paradigms of properties (if that is what colors are) and retaining certain similarities, I added differences of kind and degree which would result in concepts less rigid than colors (surely, even among properties, very rigid indeed) and closely akin to existing aesthetic concepts. I then asked why concepts like these should *not* be said to concern objective matters. As I warned at the start, I imagine that the abstract account given will not fit all aesthetic terms equally well. Probably a much weaker case must be made for some (like "moving" or "nostalgic") than for others (like "graceful" or "balanced"); but all may have some of these features. Nor do I attach importance to using the philosopher's term "property," which (like "in" and "not in") suggests a sharp distinction, a picture of things with properties stuck on them or not. If we can sketch a continuum of cases, with "properties" merging into "nonproperties," it will matter little whether the jargon of "properties" is enlarged to include aesthetic properties too, in order to indicate important similarities, or whether the line is drawn to include, say, at most, colors. If I am right that in actual practice we do manage to give aesthetic terms a partial but not unsuccessful run as property terms, we will not need to abandon all claims to objectivity. If, on the other hand, a fuller development of the arguments I have offered for assimilating aesthetic terms to property words can be shown to fail, that too would be something. Moreover, the inquiry could have wider implications since, in ethics as well as aesthetics, some illumination about the notions *descriptive* and *property*, which so many things are said *not* to be, would be welcome.

⟨∞⟩

Sensitivity, Sensibility, and Aesthetic Realism*

John W. Bender

Aesthetic realism, surely as attractive a view as moral realism or scientific realism, is unfortunately at least as problematic as its compatriot theories. There are numerous challenges that confront aesthetic realism, but this paper will focus on one that has not received as much attention as some others, but that may be the hardest to rebut. I will argue that plausible variations in individuals' sensitivity to various perceptual properties of art have significant implications for our warranted ascription of aesthetic properties to those artworks. These implications, I think, make realism about aesthetic properties a waning possibility. Variations in sensitivity pose a more trenchant problem for realism than, for instance, variations in aesthetic standards or sensibilities do because it is much more difficult to argue that sensitivities *ought to* converge as more experience or expertise with the art is accumulated.

I doubt that anyone needs to be convinced that individuals manifest differences in sensitivity to numerous perceptual stimuli, but still, the prevalence and magnitude of the differences can be rather startling, and their effects on aesthetic judgments have not been fully appreciated, I would suggest. Consider a few rather random examples.

Among olfactorily normal humans, the ability to smell can differ by four thousand-fold in the threshold for detecting substances such as lemon and orange.[1]

A person's olfactory ability to distinguish an odor is enhanced if the person has a name for that odor.[2]

A given individual may differ markedly in sensory responses to various types of compounds. For example, a person may be ultrasensitive to sourness and relatively insensitive to sweetness, or vice versa. Moreover, we are more sensitive, especially to sweet, bitter, and salty tastes, at twenty to forty years of age than at forty to sixty years of age. Sensitivity to odors and tastes varies during the day, and differently for different individuals. One-third of the American people are insensitive to the bitter taste of phenylthiourea.[3]

A new study by the American Association for the Advancement of Science reports that 25 percent of the population are "supertasters," possessing 25 per-

*"Sensitivity, Sensibility, and Aesthetic Realism," *Journal of Aesthetics and Art Criticism* 59:1 (2001): 73–83. Copyright © 2001 The American Society for Aesthetics. Reprinted by permission of Blackwell Publishing Ltd.

cent more of various taste receptors on their palates than the norm. Supertasters react much more intensely than others to sweetness, bitterness, and the creamy sensation of fat in food. They find caffeine bitter and eschew cruciferous vegetables such as broccoli and cauliflower, which to them taste super-bitter.[4]

Roughly 5 percent of bottled wines are tainted, or "corked," owing to a substance in improperly processed corks, 2,4,6-trichloranisole or TCA. Badly corked wines have a smell and flavor of wet cardboard or a moldy basement. At lesser degrees, the compound can cause the wine simply to taste muted, lifeless, and devoid of fruit. Individual sensitivity to TCA, however, varies dramatically. "People just have different thresholds of perception for different chemical components," explains Christian Butzke of the Department of Enology and Viticulture at the University of California at Davis. "That's why you can get so many descriptions of the same wine by different tasters."[5]

Imagine, now, a few discussions or disputes about wine.

You are trying to convince your friend that the Savenierres you are sharing has a most pleasant refreshing brightness due to its lemony acidity, but your friend's threshold sensitivity to the lemony component is four or four hundred or four thousand times that of your own.

A twenty-year-old supertaster is debating with her sixty-year-old father, for whom not even phenylthiourea seems bitter, whether the bitter finish of an expensive Alsace Gewurztraminer merely gives the wine a sense of nerve and sinew, or whether it leaves it with a harsh, near-metallic final impression that ruins the wine.

At a restaurant, you are trying to return a bottle of Bordeaux with which you are familiar because this bottle seems somewhat dull, with a slight hint of wet cardboard, but the sommelier, who is particularly insensitive to TCA, declares the wine to be sound, being simply "a little closed and reticent at present," and suggests that further aeration will remedy the matter. Half an hour later, you grudgingly admit that the wine is (predictably enough) a little more forthcoming. Yet it is still spoiled for you by the cardboard smell, which the sommelier does not perceive.

These are, it seems to me, instances of unresolvable disagreements, both about the object's aesthetic properties and its ultimate value, which are based upon differences in perceptual sensitivity. These are not really cases of conflicting sensibilities. After all, no one wants a wine to taste of cardboard or to be predominantly bitter or cloyingly sweet. But shared sensibilities (like shared standards) do not guarantee agreement over what satisfies them, agreement on precisely what counts as their positive satisfaction instances. Knowing what to look for is not the same thing as seeing it. That involves sensitivity.

If sensibilities are profitably construed as propensities or abilities for *identifying* that certain features of a work are aesthetically significant, sensitivities are capacities to react to certain properties or magnitudes. Since reactions are frequently not all-or-nothing but rather are a matter of degree, the concept of *intensity* is important to understanding sensitivities. Greater sensitivity is ascribed to the individual who *reacts more intensely* than another to a particular property and also to the individual who *reacts to lower intensities* of a quantity or to finer differences in features or magnitudes than does another. In fact, we might propose that most physical or perceptual sensitivities are conceivable as functions relating intensity of reaction to magnitude of stimulus.

Is it sensible to think that individuals can be more or less sensitive, not only to certain physical quantities, but also to *aesthetic* properties of objects and artworks? Or are aesthetic features the private province of sensibility? We certainly seem to acknowledge that people can exhibit different degrees of sensitivity to a work's sadness or melodramatic character, and also think that one person's rivetingly intense storyline is another's exhaustingly intense, overwrought rendering. But is not talk of sensitivity to aesthetic properties only coherent on a realist view of these properties? And can we really distinguish aesthetic sensitivity from aesthetic sensibility?

Sensitivity to aesthetic properties can be made a cogent notion for the antirealist, I think, provided that it is acknowledged to be grounded in some more basic physical or perceptual sensitivity, and provided that the apparent references to aesthetic properties are construed as judgments that it is plausible or reasonable to describe the object as having a certain position along various more or less general or determinable aesthetic dimensions (e.g., darkly emotional; intense in a positive degree; etc.), but that there is no fact of the matter about which of different *determinate* values the object really possesses. I will offer two examples of what might be construed in this way as cases of variation in aesthetic sensitivity later. But I now wish to take up the challenge of distinguishing sensitivity from sensibility by offering what I hope is a contrastive pair of cases, one involving changing sensitivities, one involving changed sensibilities. The point of the similarities between the cases is that it is not easy to tell from superficialities of a case whether we are dealing with variant sensibilities or sensitivities. But there is a difference that comes out in the details.

Consider two established painters, Juan and Juanita, who presently both pay great attention to *line* in their paintings; i.e., they are extremely careful in executing the painted edge. It was not always this way for Juan. When he looks back at his early paintings, he finds it puzzling how he could have

been so inattentive, so cavalier, about this detail. He now sees these less-carefully painted edges as "ratty," "smeared," "failing to contribute anything positive to the sense of the painting's finish or polish." As he painted more, he became increasingly aware of expanded possibilities for handling line and learned techniques for realizing those different possibilities. As a result of this experience, he is more sensitive to a line's rattiness (or, conversely, to its controlled, painterly character) than he used to be.

Juanita, on the other hand, has always been concerned and attentive to her line, but there has been a change in her sensibilities over time. Early on, she was intent on instilling her line with a sense of freedom and energy, and so was willing to accept more of the casual consequences this had on her edges. Yes, they were a bit reckless, a bit ratty here and there, but this is (she first thinks) a necessary consequence of the technique she uses to create the dynamism, an overriding value. As time passes and her technique matures, however, Juanita becomes more concerned with controlling her edges. She adopts as her standard that her edges must always be painterly: if she can articulate how they could be improved, then they must be repainted to achieve the better result. Of course, these paintings do not exhibit the impulsiveness of her earlier work, but that is now acceptable to Juanita, since she is more interested that her paintings now be expressive of ordered calm than of energy.

I hope these examples highlight the distinction between variations in sensitivity and variations in sensibilities, and also support the idea that there can be variations in sensitivity even in regard to aesthetic properties.

The main point is that when the source of aesthetic disagreements is traceable back to the perception of properties, sensitivity to which we have reason to believe significantly varies from person to person, time to time, or context to context, then realism regarding the disputed work's aesthetic properties will be jeopardized.

The Phenomenology of Sensitivity

Unlike what we found true of sensibilities, differences or changes in sensitivity do seem to license the inference that the way one is experiencing the nonaesthetic properties and relations of the artwork is different or changed. If your sensitivity to sweetness or bitterness has decreased, then familiar things *taste different.* If you have become more sensitive to the frenetic rhythms and short note-values in a certain baroque concerto, you experience it as nerve-racking and assaulting rather than as galloping and fleetfoot: your experience of the piece has changed. The sommelier at my dinner was not tasting what I tasted, we conjecture. The effect of sensitivity differences echoes throughout

one's aesthetic descriptions and evaluations. Both neutral and evaluatively suggestive descriptions are very likely to be affected by sensitivity changes, along with one's summary evaluations of the object.

Is there, across sensitivity differences, a stable phenomenal impression that the work causes in us? It seems to me that, at least in many cases, this would be as unpersuasive as arguing that if the same degree of heat warms one person while causing burning pain in another, there is nevertheless a shared phenomenal impression of heat in the two cases, because both are registrations of heat. In characterizing experiences or phenomenal impressions, it is clearly necessary to allow that differences in intensity are often criteria for individuating one experience from another. When A finds this Chablis searingly acidic while B finds it refreshingly brisk, A and B are having *different experiences* of the acidity of the wine, not different attitudinal reactions to one and the same phenomenal impression. To my lights, the more plausible description of the aesthetic situation here is this: A's greater sensitivity to a physical-structural feature of the wine (its total acidity) causes A to have a gustatory experience of the wine, which A finds warrants describing the wine as "searing," and, if this aesthetic feature ruins the wine for A, it will ultimately be cited as (one of) A's reasons for evaluating the wine lowly. B experiences the acidity in a different, less intense way, which B finds warrants describing the wine as "brisk" and evaluating it more highly than did A.

B finds the wine brisk and A finds it searing. Which aesthetic property does the wine really have? Yes, A and B agree that the wine is highly acidic, but there is no shared "seems-highly-acidic impression"; there are only two distinct experiences that both come under the general rubric, "an experience of acidity," and, at any rate, this is awareness of a nonaesthetic property. Moreover, in case you have qualms identifying "searing" and "brisk" as themselves aesthetic properties, simply consider that A will probably find the wine *unbalanced* as a result of its searing acidity, while it is open for B to be quite happy with the wine's balance. Now we have a paradigm aesthetic disagreement and no underlying shared experience or impression in terms of which we can shelter our realist predilections.

In "Aesthetic Properties, Evaluative Force, and Differences in Sensibility," Jerrold Levinson continues to distinguish phenomenal impressions produced by art and the aesthetic evaluations made of them—evaluations that are often couched in evaluatively suggestive aesthetic predicates, and which involve the attitudes of favor or disfavor, i.e., the taste, of the evaluator.[6] He suggests naming these two elements of his theory *perceptual sensibility* and *attitudinal sensibility*, respectively. A perceptual sensibility is a disposition to receive phenomenal impressions of certain sorts from various constellations

of perceivable nonaesthetic features, while an attitudinal sensibility is a disposition to react to phenomenal impressions of certain sorts with attitudes of favor or disfavor. His passing reference to "sensitivity" suggests that he reserves this term for nonaesthetic features, such as the sugar or acidity of a wine. Levinson's strategy for defending realism still seems to be to construe as much aesthetic disagreement as possible in terms of attitudinal differences, and to find real aesthetic properties within the constancies of perceptual sensibility. He downplays sensitivity differences, saying that if there are baseline differences in people's sensitivities then they might first need to be "calibrated" in some way if their experiences are to be meaningfully compared, but provides no idea of what such calibration might mean or why one should think it is possible. I hope it is clear that my uses of "sensibility" and "sensitivity" offer a quite different picture. I am arguing that differences of sensitivity can affect both one's disposition to see the work in a certain phenomenal way and one's dispositions to judge it positively or negatively. It is also my view that neutral and value-charged aesthetic terms are frequently continuous with one another, the choice of one over the other being a matter of the intensity with which a certain more general property is perceived as being possessed by the work. Sensitivities, not just attitudinal sensibilities, are obviously in operation when we make these discriminations.

The Epistemology of Sensitivity

It is possible for the realist to respond to the antirealist argument that is based on differences in sensibility by claiming that the positions of the parties in aesthetic disputes are always of varying merit, one always being more warranted or justified than the other. Whether this maneuver could ultimately be successful in establishing a kind of "ideal-observer" relational realism about aesthetic properties need not detain us here, I am happy to say, because of an important and very interesting epistemological feature of sensitivity-based disagreements.

We would never think it appropriate to suggest that people with divergent sensitivities *ought to be* coming to the same aesthetic descriptions and evaluations of the same works. Nor would we think that there is one optimal level of sensitivity that gets things *right*, for what would be the grounds for privileging that level? (It surely would not be the *maximal* level of sensitivity, even if there is such a thing, for example.) You likely think of yourself as warranted in finding the wine refreshingly brisk. Now, ask yourself under what conditions you would be warranted in finding the same wine searingly acidic. "Well, of course, if I were four or five times more sensitive to acidity, then I'd be warranted in describing this wine as searing." That is to say, we are prepared to admit that

our disputant with divergent sensitivities is, in fact, warranted in his judgments; aesthetic justification is implicitly relative to given sensitivities.

There is, therefore, no force to the idea that only one disputant is on warranted ground when it comes to aesthetic disagreements sourced in sensitivity differences. Considerations about sensitivity again seem to block the realist's positioning.

Realists are inclined to conceive the conditions under which a person is warranted in her aesthetic ascriptions to be those in which she ascribes something that is true of the work, and her reasons for the ascription involve an awareness of facts about the physical features on which the aesthetic property supervenes. This view ignores the relativity of warrant to variable sensitivities.

The "Wine Is Not Art" Objection

Although not all my examples have been about wine tasting, it might be thought that the heavy reliance here on gustatory and olfactory sensitivity is somehow objectionable. But, despite the shorthand title of this section, any forceful objection cannot be based on qualms over accepting wine as artwork. Surely, many descriptions of wine are undeniably *aesthetic* regardless of wine's status vis-à-vis *art*. Aesthetic descriptions and evaluations are reasonably offered of many objects lying outside of accepted art genres. And I see little that would motivate any attempt to be realistic about the aesthetic properties of art while allowing irrealism about other aesthetic objects.

But the best way to allay fears that we are being philosophically diverted by focusing on taste and smell is simply to offer examples from music and painting. The troubles for realism are not confined to properties of the chemical senses. I offer two such final examples: one from musical performance and one from painting.

The great violinist Jascha Heifetz possessed one of the most remarkable and recognizable tones of any performer on the instrument, and an interesting component of that tone was his outstanding vibrato (the minute rocking of the playing fingers of the left hand that subtly modulates the pitch of the note and makes the sound more animated). Heifetz's vibrato was very fast but also extremely precise and clean. But Heifetz's vibrato pushed the limits: any faster and any less precise and the effect would turn nervous, brittle, manic. In fact, this is my diagnosis of some other virtuosi who played in the same high-romantic, high-energy style of Heifetz, for example, Rugiero Ricci, a prodigious talent whose fatal flaw was precisely his nervous-sounding vibrato. Consider now a person who has greater sensitivity to pitch variations than I have, perhaps someone with perfect pitch for whom any variation in a tone

can be problematic or displeasing. Or, to change the case a bit, imagine someone with a very high sensitivity to the *aesthetic* property of nervous energy. Might it not be predictable that these listeners would offer aesthetic descriptions and evaluations of Heifetz's tone that vary from mine? Might not Heifetz's playing go over into the Ricci camp on their view? What do I say in response when they suggest that I am the one without sufficient sensitivity to make the finest judgments?

To judge from numerous of his paintings, Piet Mondrian possessed an exquisite sense of spatial balance. Many of his works exemplify a global or organic unity that seems achievable only through the most scrupulous awareness of all the identifiable interrelationships between the elements of the works. Now we imagine another painter with similar concerns for such unity through spatial balance who believes that he has achieved this result. To Mondrian's eye, however, the other painter has not been successful. There are interesting regional balances in the work, but Mondrian denies that they coalesce into the wanted overall effect. The other painter, however, rejects this conclusion. He does not see how the relationships Mondrian points to as the offending features have any deleterious effect on the work's overall sense of balance. Is the work sufficiently coherent to be organically balanced or is it not? The painter's eye delivers one answer while Mondrian's eye sees things differently.

Conclusion

Without in any way suggesting that they are the only sources of difficult aesthetic disagreements, I have attempted to distinguish disputes based on differences of sensibility from those based on divergent sensitivities. The fact that differences in sensitivity equally affect our aesthetic descriptions as well as evaluations seems only to make the job of a realist's rebuttal of these issues that much more daunting.

Notes

1. Reported in Alan R. Hirsch, MD, review of *Smell: The Secret Seducer*, by Piet Vroon, Anton van Amerongen, and H. de Vries, *Journal of the American Medical Association* 279 (1998): 1840.

2. Hirsch, review of *Smell*.

3. Maynard A. Amerine and Edward B. Roessler, *Wines: Their Sensory Evaluation*, rev. ed. (New York: W. H. Freeman, 1983), 58.

4. Reported in James Laube, "Stick Out Your Tongue and Say Ah," *Wine Spectator*, May 15, 1997.

5. Reported in Daniel Sogg, "Are You Ready for the New Cork?" *Wine Spectator*, November 15, 1998.

6. Jerrold Levinson, "Aesthetic Properties, Evaluative Force, and Differences in Sensibility," in *Aesthetic Concepts: Essays after Sibley*, ed. Emily Brady and Jerrold Levinson, 61–80 (Oxford: Oxford University Press, 2001).

<div align="center">⌒◇◇◇⌒</div>

Aesthetic Properties, Evaluative Force, and Differences of Sensibility*

Jerrold Levinson

In this essay I revisit a position on aesthetic attributions I have held for some time, a position rooted in some seminal essays of Frank Sibley, and which can be labeled aesthetic realism. First I sketch the position, borrowing with modification from an earlier short essay of mine. I then formulate a number of worries about the position which have lately come into view, and try to see where they lead.

Aesthetic attributions to works of art, and the terms used to effect such attributions, are largely descriptive; that is to say, they are based on, and obliquely testify to the occurrence of, certain looks, impressions, or appearances which emerge out of lower-order perceptual properties. Such looks or impressions or appearances are relativized to a perceiver who views a work correctly, and thus approaches the condition of what has been called, following Hume, a true critic or ideal judge. That means, in particular, someone who properly situates a work with respect to its context of origin, including its place in the artist's oeuvre, its relation to the surrounding culture, and its connections to preceding artistic traditions.

We may grant that many common aesthetic terms, for example, "gaudy," appear to entail evaluations on the part of the speaker. Still, most cannot be held to do so strictly. First, it seems possible to approve a work *for* its gaudiness, say, or *despite* its gaudiness. This suggests that the essence of gaudiness is not a judgment of disapprobation on the speaker's part but instead a kind of appearance: a perceptually manifest effect one can register independently of any evaluative assessment of or attitudinal reaction to that effect.

But suppose for the sake of argument that there is a purely evaluative element in certain common aesthetic terms, ones such as "gaudy" or "maudlin." Suppose, in other words, that it is correct to regard such terms as implying an evaluative stance toward or estimation of an object on the part of a user of

*"Aesthetic Properties, Evaluative Force, and Differences in Sensibility," in Jerrold Levinson and Emily Brady (eds.), *Aesthetic Concepts: Essays After Sibley*, pp. 61–80 (Oxford: Oxford University Press, 2001). Reprinted by permission of Oxford University Press.

the term. There would, I claim, still remain a purely descriptive, distinctively aesthetic content in such an attribution, consisting roughly in an overall impression afforded, an impression that cannot be simply identified with the structural properties that underpin it. For instance, a critic might be brought to admit that he is aware of the look or appearance another critic has remarked on with evident relish, reserving his right to dislike it.

Here is a musical example. The opening of Bach's Concerto for Three Harpsichords and Strings in D minor, BWV 1063 might be described as "starkly grim." Now, some competent listeners like being confronted with it and others do not. It is easy to imagine those latter folk simply labeling the opening "depressingly dour" and having done with it, but it also seems more than likely that they could be brought to acknowledge the aptness of the characterization "starkly grim" as well, only adding under their breaths, "If you like that sort of thing."

Unless one assumes there are core aesthetic impressions of a qualitative sort, distinguishable from reactions of approval or disapproval per se, it becomes difficult to explain what competent critics with evaluative differences of opinion could really be talking about. Surely it's not just that one approves a certain arrangement of lines and colors, or pitches and rhythms, or words and phrases, and the other not. Rather more likely is that each registers the overall effect of the arrangement in question, that there are descriptions, reasonably neutral ones, they could even agree upon to characterize it, but that one favors it and the other does not, or one thinks it makes the work good and the other does not. In addition, failing to acknowledge distinctive aesthetic impressions as the core descriptive content of common aesthetic attributions makes a mystery out of what the aesthetic experiences of perceivers of any sort could possibly consist in.

Whatever evaluative force is carried by such terms as we have just been examining, there are clearly descriptive limits on their application. Not just any visual pattern can be disapproved of by calling it, say, gaudy, chaotic, or flamboyant. Attitudes toward the impressions afforded by artistic structures may evolve over time, even fluctuate back and forth, but surely something unitary of a broadly perceptual sort often remains constant throughout.

More generally, we can say that there is in regard to a given object almost always a descriptive aesthetic content such that ideal judgers who would not apply to the object at all and only the same aesthetic predicates—because they have, by assumption, different reactions or attitudes toward that content—can still agree on what that content is.

So what, then, is there to give pause in this picture of aesthetic attributions and aesthetic properties? What reasons might there be to reconsider

some aspects *of* this picture? Here are some of the worries that have been raised.

One: it is not really possible to separate the descriptive and evaluative components in an attribution or property. Two: there are irresolvable differences in aesthetic judgments among even ideal judges, yet it is unclear that a realist perspective on aesthetic properties can properly accommodate that fact.

In what follows I give each of these worries a hearing.

First worry. Despite what was urged above, many will still be inclined to insist that most aesthetic terms just do have an evaluative component of one sort or another, at least in practice or in context. Very well: simply focus on the evaluatively neutral phenomenal core of such terms and you will arrive at bona fide aesthetic properties. But as Hamlet famously complained, there's the rub. Perhaps it is not really possible to identify the purely evaluative component of an aesthetic term; perhaps what is descriptively conveyed by an aesthetic term cannot be isolated, cannot even legitimately be presumed to exist, apart from what the term conveys in its concrete use. If that is so, then even modest aesthetic realism, affirming the existence of evaluatively neutral aesthetic properties at the root of aesthetic attributions, whether evaluatively charged or not, would be too optimistic.

What to say? Well, one way it might turn out that the phenomenal impressions associated with aesthetic terms might not be exhibitable denuded of all evaluative aspect would be if such impressions were themselves inherently pleasant or unpleasant. The impressions that go with finding something graceful or harmonious, say, are plausibly of that sort. To the extent that phenomenal impressions are inherently pleasant or unpleasant, they would seem of necessity to bring in their trained corresponding reactions of favor or disfavor. Thus, to that extent, isolating neutral phenomenal impressions at the core of aesthetic attributions would be a chimerical pursuit.

But two points bear making in response. First, it is surely not the case that *all* aesthetic impressions are inherently hedonically valenced. It rather seems that most such impressions are, for most perceivers, more or less hedonically neutral—for instance, those of the peacefulness of a landscape, the angularity of a design, or the urbanity of a passage of violin music. Secondly, even *were* all aesthetic impressions hedonically valenced, it would still be possible rationally either to approve or disapprove the affording of such an impression at a particular point in a particular work and to report its occurrence by an appropriate evaluatively charged term. That is to say, the inherent pleasurability of the impression at the core of an aesthetic property would still be distinguishable from the evaluative component of that property, so to speak, when picked out by an evaluatively charged substantive term.

There are other things to say in regard to the problem of the distinctness or isolatability of aesthetic impressions, but they will be evident in my discussion of the third worry noted, that concerning the existence of qualitative phenomena generally.

The real problem about aesthetic attribution, one may insist, still remains. It concerns the fact of continuing and irresolvable differences in aesthetic attributions among even ideal critics, that is, the notable absence of convergence in judgments attributing aesthetic properties to works of art among even optimally prepared and positioned perceivers. For it is that, above all, that threatens aesthetic realism as regards attributions to works of art.[1]

The thought is basically this. Whatever the truth about the descriptive content of substantive aesthetic terms, that is, whether such content is given by qualitative impressions of distinct character or constellations of low-level perceptual features, and especially if such terms have a significant evaluative dimension, whether that is a matter of sense or of conversational implication in relevant contexts, we just cannot reasonably expect to find convergence in the aesthetic judgments of even ideal critics. And that is because of the evident diversity of *sensibilities* among even ideal critics, as even Hume recognized 250 years ago. Ideal critics, like ordinary folk, sort themselves out into sensibility-types or sensibility-groups, and possibly very many of them.

If so, then realism about "real-world," or "thick," aesthetic properties, that is, properties denoted by substantive aesthetic terms of criticism with their evaluative aspects intact, would appear to be a vanishing prospect. That there might always be more stripped-down, "thin," aesthetic properties in the offing that warring critics might be brought to acknowledge would seem to offer only small consolation. For there would be no truth about whether or not a given abstract sculpture was, say, *graceful,* because some ideal critics, of sensibilities A, B, and C, find it so, in virtue of reacting positively to the core impression presented by something that was a candidate for being described as graceful, while other ideal critics, of sensibilities D, E, and F, do not, in virtue of reacting negatively to that same core impression.

Furthermore, supervenience, a pillar of property realism, would also be imperiled, since aesthetic properties would no longer supervene on a work's intrinsic and relational properties—its structural features plus its artistic context—because differing sensibilities among ideal critics would prevent aesthetic properties from emerging on that basis alone. True, one might reply that supervenience of aesthetic properties would still hold, though in a narrow, *sensibility-relativized* form. Instead of gracefulness tout court we would need to speak of, say, gracefulness $_q$, which would amount roughly to being disposed to appear graceful to ideal critics of a given sensibility class,

comprising sensibilities A, B, and C. But this would, admittedly, be a highly qualified sort of supervenience.

At any rate, in order to begin to come to terms with the implications of sensibility diversity for aesthetic realism, we need to look at what sensibilities in this context might consist in. We should at the outset recognize the possibility not only of a diversity of *sensibilities*, but of a diversity of *kinds* of sensibility. There may, I suspect, very well be two basic kinds of sensibility at play here, which we can label *perceptual* sensibility and *attitudinal* sensibility. What I have in mind would parallel the distinction between phenomenal impressions and evaluative reactions in my earlier analysis of evaluatively charged aesthetic properties. A *perceptual* sensibility would be a disposition to receive phenomenal impressions of certain sorts from various constellations of perceivable nonaesthetic features, while an *attitudinal* sensibility would be a disposition to react to phenomenal impressions of certain sorts with attitudes of favor or disfavor. There is no need to assume that an attitudinal sensibility is necessarily a fixed or inborn matter; it might indeed generally have a strong culturally formed component. Furthermore, we would expect that a person's attitudinal sensibility, in regard to given phenomenal impressions, would clearly be modifiable over time, especially insofar as such sensibility was culturally, rather than physiologically, ordained or conditioned.

Suppose then, for simplicity, that there were three sensibilities of each type. That gives nine sensibility-types with both dimensions taken into account: these would be combined, or *perceptual-attitudinal*, sensibilities. So in practice, assuming ideality in all other respects, there could still very well be nine distinct profiles of aesthetic response, corresponding to nine combined sensibility-types, with resulting disagreements in all individual cases. The question naturally arises of telling to what aspect of divergence in sensibility we should attribute any particular disagreement. How could we determine, in a particular case, whether disagreement was rooted in differences in perceptual sensibility, or differences in attitudinal sensibility, or both? What might show, more generally, that judges differed in perceptual sensibility instead of attitudinal sensibility or vice versa?

Though we should certainly be open to the idea of possible diversity in perceptual sensibilities, that is, propensities to receive aesthetic impressions from the same perceptual configurations, it is by no means as clear that there are such among ideal critics as that there is a diversity in attitudinal sensibilities, that is, propensities to like or dislike given aesthetic impressions. So if we can separate descriptive matters from evaluative ones in this arena, as I have been suggesting that we in principle can, there may be more hope for

ultimate convergence in at least descriptive aesthetic attributions among ideal critics than we might think, even if diversity of perceptual sensibilities is, of course, theoretically possible.

But what if that theoretical possibility is realized after all? What if it turns out that there are roughly as many distinct perceptual sensibilities as there are blood types? Well, presumably one would then be well advised to find one's perceptual as well as attitudinal sensibility-group, and stay tuned. But that would not alter the fact that suitably relativized aesthetic properties, at any rate, would still be there for the having and experiencing.

There are two questions it is natural to pose at this point. First, why does it matter whether there are groups of perceivers among whom one is likely to find convergence in aesthetic judgments, given that differences of sensibility clearly do induce divergences, even under ideal conditions and in the last analysis, among aesthetic perceivers? Why should one trouble to identify one's sensibility-group, of any sort? An obvious answer, though perhaps there are others, is that aesthetic recommendations from critics belonging to one's own sensibility-group will be of greater practical worth, having more predictive value as regards one's own aesthetic satisfactions than recommendations from other critics.

Second, is belonging to one such sensibility-group better than belonging to another, and if so, how? A positive answer to this query might emerge as a consequence of addressing the crucial though largely overlooked problem raised by David Hume's celebrated essay on taste, namely, that of explaining why judgments of ideal critics should rationally interest all perceivers, even those far from ideality, and why such perceivers have reason to strive for greater ideality in their own aesthetic dispositions insofar as those dispositions are subject to change.

Before concluding this essay I turn briefly to a critique which John Bender has offered of aesthetic realism, one that gives the concerns highlighted under this last rubric a vigorous expression. I here focus on what seem to be his two main criticisms.

First, evaluatively *neutral* aesthetic attributions, Bender claims, are as disputable, and as relative to critical taste, as evaluatively charged aesthetic attributions:

> But what if the application of purely descriptive aesthetic terms exhibits the same kind of relativity to the tastes or standards of particular judges [as does application of manifestly evaluative aesthetic terms]? Will there not be irresolvable disputes among critics over the most appropriate way to describe or interpret a work's aesthetic content? . . . There can be as much critical indeterminacy

concerning whether a musical passage is sad or resigned as there is in judging it disunified or only uninhibited. . . . I suggest that if aesthetic properties are dispositions to afford phenomenal impressions or looks, as Levinson claims, these impressions will be variable to a not insignificant degree and will reflect the judge's sensibilities just as surely as his or her evaluative reactions do.[2]

My response is as follows. Of course there might be as much divergence among ideal critics regarding neutral aesthetic content as there is among them in regard to their evaluative reactions to such content. That is, diversity of what I above called perceptual sensibilities might have as much to do with nonconvergence in aesthetic judgments among ideal critics as diversity of attitudinal sensibilities. But it seems there is, at least so far as anyone has shown, little *reason* to think this is the case.

To take Bender's illustrative example, it is easy to imagine that ideal critics disagreeing over the application to a stretch of music of charged terms like "disunified" or "uninhibited" will never be brought to agree on one rather than the other, because of their differing hedonic reactions to or evaluative attitudes toward the music in question. But it is less easy to imagine, given our experience with these matters, that more sustained attention to the music, more sensitive appreciation of its style, more heightened awareness of its historical antecedents—and perhaps also further elucidation of the concept of musical expressiveness—would not serve to bring such critics to agree that the music was better described as "resigned" than "sad" or vice versa.

Second, there are insufficient grounds, Bender claims, to believe there is a distinctive phenomenal impression associated with every substantive aesthetic term, isolatable from whatever evaluative force the term possesses, and shared or shareable by ideal critics who yet differ in their evaluative reactions to it:

> Levinson has given too little description of these "impressions" for us to eliminate the alternative: that they vary with taste. After all, is it clear that when I describe a painting as gaudy and you describe it as merely intensely chromatic that the painting is affording both of us the same phenomenal impression? . . . I find a wine searingly acidic while you find it refreshing and zingy. Do we nevertheless share some singular phenomenal impression of the wine's acidity?[3]

Bender is seeking to motivate skepticism as to whether qualitative registrations can be distinguished from hedonic reactions to, or evaluative attitudes toward, such registrations. But I have already indicated how such skepticism can and

should be resisted. I would add only that the fact that we are sometimes unable to make such introspective distinctions with confidence is hardly reason to think that we are in principle, or even usually, unable to make them.

A last remark, as regards taste in the literal sense, the focus of Bender's second example: people just do seem to differ significantly in their baselines in such matters, more so than with other sense modalities. What that means is that people's gustatory responses might first need to be roughly calibrated in some way if their experiences are to be meaningfully compared. For example, some persons may only decisively register sweetness when there are two spoons of sugar in their tea, while others require just a quarter of a spoon. Differences of that sort—that is, differences in sensitivity to nonaesthetic perceptual features, such as sweetness or acidity—may be as likely to account for one taster finding wine searingly acidic while another finds it refreshingly acidic as either differences in the overall phenomenal impression afforded by a wine or differences in the preferences of tasters for degree of perceived acidity.

Clearly, the objectivity for aesthetic properties defended in this essay is not one that accords them a transcendent status, independent of human reactions. What has been defended is rather objectivity as contingent but stable intersubjective convergence in judgments among qualified perceivers.

Recent briefs for antirealism about aesthetic properties give little reason to think there are irresolvable differences of aesthetic characterization—even "real-world" or "thick" aesthetic characterizations—among qualified perceivers for a given artform in *all*, or even *most*, cases. The evidence is rather that this is so only in *some* cases, ones which on that account call attention to themselves, standing out as they do from the boring norm of widespread, unheralded agreement in such matters among those with adequate experience.

Would any competent art lover or critic demur from aesthetic judgments such as that the opening of Beethoven's Ninth Symphony is dark and foreboding? That Austen's *Emma* is witty and clever? That Mondrian's Broadway *Boogie-Woogie* is vibrant and exuberant? That Hitchcock's *Vertigo* is tragic and disturbing? That Duchamp's *In Advance of a Broken Arm* is whimsical and arch? That Varèse's *Ionisation* is raucous and irreverent? That Plath's *Daddy* is bitter and ironic?

Even if irresolvable disagreements among appreciatively ideal observers, stemming from differences of attitudinal or perceptual sensibility, persist in a fair number of cases, precluding realist interpretation of aesthetic attributions, nothing precludes realist interpretation of aesthetic attributions, or interpretation of them as assertably true or false, in the majority of cases. An aesthetic realist, it seems, can rest reasonably content with that.

Notes

1. This is the basic thrust of John Bender, "Realism, Supervenience, and Irresolvable Aesthetic Disputes," *Journal of Aesthetics and Art Criticism* 54 (1996): 371–81.

2. Bender, "Realism," 374.

3. Bender, "Realism," 375.

Further Reading

Cohen, Ted. 1973. Aesthetic/non-aesthetic and the concept of taste: A critique of Sibley's position. *Theoria* 39: 113–52. An impressive critique of Sibley's position.

De Clercq, Rafael. 2005. Aesthetic terms, metaphor, and the nature of aesthetic properties. *Journal of Aesthetics and Art Criticism* 63: 27–32. Defends the view that aesthetic properties have an irreducibly evaluative component.

Goldman, Alan. 1995. *Aesthetic value.* Boulder, CO: Westview Press. An influential treatment of aesthetic properties in a sophisticated subjectivist vein.

Levinson, Jerrold. 2005. What are aesthetic properties? *Proceedings of the Aristotelian Society,* Suppl. no. 78: 211–27. Argues that aesthetic properties are ways of appearing.

Mothersill, Mary. 1984. *Beauty restored.* Oxford: Oxford University Press. Focuses on the property of beauty in arguing that there are no aesthetic principles.

Sibley, Frank. 1959. Aesthetic concepts. *Philosophical Review* 68: 421–50. Classic paper on aesthetic properties.

Zangwill, Nick. 2001. *The metaphysics of beauty.* Ithaca, NY: Cornell University Press. A realist account of aesthetic properties.

~

What Is Art?

Introduction

The place is New York City. The activity takes place over twenty-three days. On each day, a person is chosen at random, followed whereever he or she goes, for however long it takes, until the person enters a private place such as home or office. This ends the activity for the day. The activity is "documented" with photographs, though these may have been cooked up later rather than taken during the twenty-three days of the activity.

This describes a work of conceptual art produced in 1969 by Vito Acconci titled *Following Piece*. If you followed the developments in the world of art during the 1960s, you might feel no surprise that such an activity occurred and was documented and that the process gave rise to something regarded as an artwork. But you might still wonder what exactly constituted the work. Is it simply the activity, or the photographic "documentation," or the combination of these, or yet something else? And, more relevantly to the present chapter, you might wonder about any object or activity, Why is it a work of art? What makes it a work of art. Even, is it really a work of art?

Artists have no doubt been puzzling their audiences for as long as there has been art, and just how long there has been art is itself a hotly debated issue. However, beginning roughly around 1870, artists began to do this on a regular basis, and the term avant-garde was applied to signify a type of art not only hard to understand at the time of production but hard to comprehend *as art*. Some of the works that once puzzled to the extent of creating resistance to the acknowledgement of their artistic status—such as impressionist and

109

postimpressionist painting—are now widely embraced and thoroughly main-stream. But this is not invariably so. Arnold Schoenberg's atonal music and Marcel Duchamp's readymades—such as *Fountain*, a urinal purchased at a hardware store, inverted, and mounted on stand—both produced in the early twentieth century, still generate resistance in many people.

Avant-garde art, or simply modernist and postmodernist art, is often cited as the reason why the question, What is art? has been such a central one in aesthetics for the last hundred years. The very long list of puzzling items created during this period is certainly one reason for pursuing this question. How should we respond to such items, and how is this response connected to those we have to more traditional artworks? More generally, one wants to know what connects *Fountain* or *Following Piece* with whatever one regards as paradigms of art such as Michelangelo's *David* or Tchaikovsky's *Nutcracker*. But puzzling art is hardly the only reason why we ask this question.

Even apart from the avant-garde, we want to understand what links the large variety of objects, forms, and activities that are art. This is somewhat bewildering. Much painting, sculpture, and poetry is representational. How-ever, much music, architecture, and ceramic art is not. Do all these forms have certain properties in common? A related issue concerns the boundar-ies of art. Some crafts can be practiced in pedestrian ways and yet produce very fine work that is beautiful and imaginative. Fine handmade furniture, carpets, and pottery are examples. Can these crafts, when practiced in the latter way, produce artworks as much as painting, which can also be pedes-trian or highly original? (For more on this issue, see the article by Gordon Graham in chapter 12.) Also there is a question about the criteria for let-ting new members into the club because the range of items considered art forms is not static. By now, most people recognize photography and cinema as art forms (which better not mean that every snapshot or every movie is an artwork). But most people would not give the same recognition to video games. Why not?

The question, What is art? was not asked much until the idea of the fine arts solidified sometime in the eighteenth century. The answer widely accepted at that time was that fine art should be defined in terms of repre-sentation. By the 1870s, for a variety of reasons, this answer began to look questionable. For one thing, photography had arrived on the scene but had not yet achieved art status. Photographs were highly realistic representa-tions achieved through mechanical means, thereby co-opting one of the long-standing aims of visual art. On the other hand, "absolute" music, that is, instrumental music without representational aspirations, had by this time achieved high-art status of a preeminent kind. Because of these develop-

ments and others, theorists began to look for other properties, aims, or func-
tions of art that might do a better job of revealing its essence.

One popular answer is that art is expression, in particular the expression
of emotions and attitudes. Philosophers frequently defended this view from
the late nineteenth through the mid-twentieth centuries. Among the most
famous defenses of this answer are found in Leo Tolstoy's *What is Art?* (1898)
and R. G. Collingwood's *The Principles of Art* (1938). A selection from the
latter work is reprinted here. One of the advantages of this view is that it ap-
plies to both representational and nonrepresentational artworks. A challenge
it faces is to explain exactly what expression consists of in such a way that
ordinary expression of feeling, such as my shaking my fists at you in anger,
does not also turn out to be a work of art. Collingwood meets this chal-
lenge by giving a special definition of expression. It is a process of coming to
discover and articulate precisely what one is feeling in all its particularity.
Collingwood thinks that art is this process, which occurs in the imagination
rather than on a canvas or a printed page. An artist who makes painting her
medium uses the work she does on the canvass both to articulate a feeling in
the imagination and to communicate it to others. However, do all artworks
really express emotion in Collingwood's sense? His forthright answer is that
many works usually considered art, including some rated among the very best
such as Shakespeare's plays, are not properly art at all because they fail to be
expressions in his sense. (For further discussion of expression theories, see the
article by Jenefer Robinson in chapter 9.)

An alternative to the expression theory of art is provided by Monroe Beard-
sley in "An Aesthetic Definition of Art." Beardsley's basic idea, refined and
defended in this paper, is that an artwork is an artifact intended to have the
capacity to satisfy aesthetic interest. To many this view has several advantages
over a theory like Collingwood's. First, it takes the work out of the mind of the
artist and puts it back into the world. Second, it picks out an intended func-
tion—delivering aesthetic experience—that is very commonly possessed by
artworks. Finally, since it applies more widely than Collingwood's expression
view, there is less need to exclude works traditionally recognized as art.

However, a definition needs to cover all the items in its extension, and
among other problems for the aesthetic theory, there is the question of whether
all artworks are made with the intention Beardsley requires. For example, does
his definition cover works like *Fountain* and *Following Piece?* Thoughts along
these lines led some philosophers, by the mid-twentieth century, to believe that
any attempt to define art by selecting one preeminent aim, function, or value
was bound to meet with counterexamples. Those skeptical of this approach ad-
opted one of two positions. Some—theantiessentialists—argued that art simply

cannot be defined, while others argued that past attempts had failed because theorists were looking in the wrong places for an answer. The defining feature of art lies in the nonperceptible social or historical relationships artworks bear to each other and to related practices. The next reading pursues this strategy.

George Dickie's groundbreaking suggestion is that being an artwork is a social fact that does not depend on any intrinsic property of the work itself. Rather it is a matter of a work's existing in a network of relationships. Dickie calls this network an artworld system. The potential audience for a work is an artworld public. An artwork is an artifact of a kind created to be presented to such a public. This definition is unlikely to exclude any work produced by the avant-garde. It may, however, exclude candidate objects produced outside any functioning artworld system such as those created by isolated individuals and by early humans from the Paleolithic period. Some object that Dickie's proposal defines *art* in a tightly circular way. Interestingly, Dickie acknowledges that this is so but tries to argue that this is not a defect. However, many have not been convinced. Whatever the success of Dickie's actual proposal, his work on this question, along with that of Arthur Danto, pointed philosophers in a wholly new direction in attempting to find the nature of art.

A related approach, inspired more by Danto's work than Dickie's, is to identify an object as art in virtue of a relation it bears to earlier works. Such historical definitions or identification procedures have taken a variety of forms. Jerrold Levinson proposes that something is an artwork if it is intended for regard in any way that preexisting artworks were correctly regarded. James Carney posits that something is an artwork if it is historically connected to general style features of earlier works. Noël Carroll suggests that we can identify something as an artwork if we can situate it in a narrative that reveals how developments in the artworld explain how the work came to be made.

Stephen Davies's fascinating article "Non-Western Art and Art's Definition" examines aesthetic, institutional, and historical definitions in the light of a variety of questions raised by the apparent fact that art seems to exist across nearly all cultures and no matter how far back one goes in human history. The first question is whether this is a genuine fact or a misconstrual of the data. Some anthropologists and philosophers argue that art is a peculiarly Western concept that arose during a particular period of European history, and we misapply it to non-Western cultures. Davies examines and rejects these arguments. He then attempts to offer positive reasons for thinking that art is found in non-Western cultures. The second question concerns whether current definitions of art adequately account for both non-Western art and recent developments in Western art. Here, Davies argues that none of the definitions we have considered above quite do the trick as they stand.

We end with a challenge to the reader: what is Davies's proposal for a more adequate definition?

⌒∞⌒

Art Proper*

R. G. Collingwood

Art Proper: (1) As Expression

§1. The New Problem

We have finished at last with the technical theory of art, and with the various kinds of art falsely so called. We shall return to it in the future only so far as it forces itself upon our notice and threatens to impede the development of our subject.

That subject is art proper. We must now ask what kinds of things they are to which the name rightly belongs.

An erroneous philosophical theory is based in the first instance not on ignorance but on knowledge. The person who constructs it begins by partially understanding the subject, and goes on to distort what he knows by twisting it into conformity with some preconceived idea. It therefore expresses many truths, but it cannot be dissected into true statements and false statements; every statement it contains has been falsified; if the truth which underlies it is to be separated out from the falsehood, a special method of analysis must be used. This consists in isolating the preconceived idea which has acted as the distorting agent, reconstructing the formula of the distortion, and reapplying it so as to correct the distortion and thus find out what it was that the people who invented or accepted the theory were trying to say.

This method will now be applied to the technical theory of art. The formula for the distortion is known from our analysis of the notion of craft. Because the inventors of the theory were prejudiced in favor of that notion, they forced their own ideas about art into conformity with it. If art is to be conceived as craft, it must likewise be divisible into means and end. We have seen that actually it is not so divisible.

1. This, then, is the first point we have learned from our criticism: that there is in art proper a distinction resembling that between means and end, but not identical with it.

*From *The Principles of Art*, pp. 105–24 and 125–51 (Oxford: Oxford University Press, 1958). Reprinted by permission of Oxford University Press.

2. The element which the technical theory calls the end is defined by it as the arousing of emotion. The idea of arousing belongs to the philosophy of craft, but the same is not true of emotion. This, then, is our second point. Art has something to do with emotion; what it does with it has a certain resemblance to arousing it.

3. What the technical theory calls the means is defined by it as the making of an artifact called a work of art. The making of this artifact is the transformation of a given raw material by imposing on it a form preconceived as a plan in the maker's mind. To get the distortion out of this we must remove all these characteristics of craft. Art has something to do with making things, but these things are not material things, made by imposing form on matter, and they are not made by skill.

In this chapter, accordingly, we shall inquire into the relation between art and emotion; in the next, the relation between art and making.

§2. Expressing Emotion and Arousing Emotion

Since the artist proper has something to do with emotion, and what he does with it is not to arouse it, what is it that he does? Nothing could be more entirely commonplace than to say he expresses [it].

When a man is said to express emotion, what is being said about him comes to this. At first, he is conscious of having an emotion, but not conscious of what this emotion is. All he is conscious of is a perturbation or excitement, which he feels going on within him, but of whose nature he is ignorant. While in this state, all he can say about his emotion is: "I feel . . . I don't know what I feel." From this helpless and oppressed condition he extricates himself by doing something which we call expressing himself. This is an activity which has something to do with the thing we call language: he expresses himself by speaking. It also has something to do with consciousness: the emotion expressed is an emotion of whose nature the person who feels it is no longer unconscious. It has also something to do with the way in which he feels the emotion. As unexpressed, he feels it in what we have called a helpless and oppressed way; as expressed, he feels it in a way from which this sense of oppression has vanished. His mind is somehow lightened and eased.

Suppose the emotion is one of anger. If it is expressed, for example by putting it into hot and bitter words, instead of the sense of oppression which accompanies an emotion of anger not yet recognized as such, we have that sense of alleviation which comes when we are conscious of our own emotion as anger, instead of being conscious of it only as an unidentified perturba-

tion. This is what we refer to when we say that it "does us good" to express our emotions.

The expression of an emotion by speech may be addressed to someone; but if so it is not done with the intention of arousing a like emotion in him. If there is any effect which we wish to produce in the hearer, it is only the effect which we call making him understand how we feel. But, as we have already seen, this is just the effect which expressing our emotions has on ourselves.

§3. Expression and Individualization

Expressing an emotion is not the same thing as describing it. To say "I am angry" is to describe one's emotion, not to express it. The words in which it is expressed need not contain any reference to anger as such at all. Indeed, so far as they simply and solely express it, they cannot contain any such reference.

The reason why description, so far from helping expression, actually damages it, is that description generalizes. To describe a thing is to call it a thing of such and such a kind. Expression, on the contrary, individualizes. The anger which I feel here and now, with a certain person, for a certain cause, is no doubt an instance of anger, and in describing it as anger one is telling truth about it; but it is much more than mere anger: it is a peculiar anger, not quite like any anger that I ever felt before, and probably not quite like any anger I shall ever feel again. To become fully conscious of it means becoming conscious of it not merely as an instance of anger, but as this quite peculiar anger. The poet, therefore, in proportion as he understands his business, takes enormous pains to individualize [emotions] by expressing them in terms which reveal their difference from any other emotion of the same sort.

The artist proper is a person who, grappling with the problem of expressing a certain emotion, says, "I want to get this clear." It is no use to him to get something else clear, however like it this other thing may be. This is why the kind of person who takes his literature as psychology, saying, "How admirably this writer depicts the feelings of women, or bus-drivers, or homosexuals . . . ," necessarily misunderstands every real work of art with which he comes into contact, and takes for good art, with infallible precision, what is not art at all.

§4. Selection and Aesthetic Emotion

If the difference between tragedy and comedy is a difference between the emotions they express, it is not a difference that can be present to the artist's mind when he is beginning his work; if it were, he would know what emotion he was going to express before he had expressed it. No artist, therefore,

so far as he is an artist proper, can set out to write a comedy, a tragedy, an elegy, or the like.

The same considerations provide an answer to the question whether there is such a thing as a specific "aesthetic emotion." If it is said that there is such an emotion independently of its expression in art, and that the business of artists is to express it, we must answer that such a view is nonsense. If artists only find out what their emotions are in the course of finding out how to express them, they cannot begin the work of expression by deciding what emotion to express.

In a different sense, however, it is true that there is a specific aesthetic emotion. As we have seen, an unexpressed emotion is accompanied by a feeling of oppression; when it is expressed and thus comes into consciousness, the same emotion is accompanied by a new feeling of alleviation or easement. We may call it, if we like, the specific feeling of having successfully expressed ourselves; and there is no reason why it should not be called a specific aesthetic emotion. But it is not a specific kind of emotion preexisting to the expression of it. It is an emotional coloring which attends the expression of any emotion whatever.

§5. The Artist and the Ordinary Man

I have been speaking of "the artist," in the present chapter, as if artists were persons of a special kind, differing somehow either in mental endowment or at least in the way they use their endowment, from the ordinary persons who make up their audience. But this segregation of artists from ordinary human beings belongs to the conception of art as craft; it cannot be reconciled with the conception of art as expression. If art were a kind of craft, it would follow as a matter of course. Any craft is a specialized form of skill, and those who possess it are thereby marked out from the rest of mankind. If art is the skill to amuse people, or in general to arouse emotions in them, the amusers and the amused form two different classes.

If art is not a kind of craft, but the expression of emotion, this distinction of kind between artist and audience disappears. For the artist has an audience only insofar as people hear him expressing himself, and understand what they hear him saying. Now, if one person says something by way of expressing what is in his mind, and another hears and understands him, the hearer who understands him has that same thing in his mind.

Thus, if art is the activity of expressing emotions, the reader is an artist as well as the writer. There is no distinction of kind between artist and audience. This does not mean that there is no distinction at all. The poet's difference from his audience lies in the fact that, though both do exactly the same thing, namely express this particular emotion in these particular words, the

poet is a man who can solve for himself the problem of expressing it, whereas the audience can express it only when the poet has shown them how.

§6. The Curse of the Ivory Tower

If artists are really to express "what all have felt," they must share the emotions of all. Their experiences, the general attitude they express toward life, must be of the same kind as that of the persons among whom they hope to find an audience. If they form themselves into a special clique, the emotions they express will be the emotions of that clique; and the consequence will be that their work becomes intelligible only to their fellow artists. This is in fact what happened to a great extent during the nineteenth century, when the segregation of artists from the rest of mankind reached its culmination.

§7. Expressing Emotion and Betraying Emotion

Finally, the expressing of emotion must not be confused with what may be called the betraying of it, that is, exhibiting symptoms of it. When it is said that the artist in the proper sense of that word is a person who expresses his emotions, this does not mean that if he is afraid he turns pale and stammers; if he is angry he turns red and bellows. These things are no doubt called expressions; in the context of a discussion about art this sense of expression is an improper sense. The characteristic mark of expression proper is lucidity or intelligibility; a person who expresses something thereby becomes conscious of what it is that he is expressing, and enables others to become conscious of it in himself and in them. Turning pale and stammering is a natural accompaniment of fear, but a person who in addition to being afraid also turns pale and stammers does not thereby become conscious of the precise quality of his emotion.

Art Proper: (2) As Imagination

§1. The Problem Defined

The next question in the program laid down at the beginning of the preceding chapter was put in this way: What is a work of art, granted that there is something in art proper to which that name is applied, and that, since art is not craft, this thing is not an artifact?

§3. Creation and Imagination

A work of art need not be what we should call a real thing. It may be what we call an imaginary thing. A disturbance, or a nuisance, or a navy, or the like, is not created at all until it is created as a thing having its place in the

real world. But a work of art may be completely created when it has been created as a thing whose only place is in the artist's mind.

The same distinction applies to such things as music. If a man has made up a tune but has not written it down or sung it or played it or done anything which could make it public property, we say that the tune exists only in his mind. If he sings or plays it, thus making a series of audible noises, we call this series of noises a real tune as distinct from an imaginary one.

When we speak of making an artifact we mean making a real artifact. If an engineer said that he had made a bridge, and when questioned turned out to mean that he had only made it in his head, we should say that he had not made a bridge at all, but only a plan for one. A plan is a kind of thing that can only exist in a person's mind. In the case of the bridge there is a further stage. The plan may be "executed" or carried out; that is to say, the bridge may be built.

Next, let us take the case of a work of art. When a man makes up a tune, he may at the same time hum it or sing it or play it on an instrument. He may write it on paper. But all these are accessories of the real work, though some of them are very likely useful accessories. The actual making of the tune is something that goes on in his head, and nowhere else. Hence the making of a tune is an instance of imaginative creation. The same applies to the making of a poem, or a picture, or any other work of art.

What is written or printed on music-paper is not the tune. It is only something which when studied intelligently will enable others (or himself, when he has forgotten it) to construct the tune for themselves in their own heads.

The relation between making the tune in his head and putting it down on paper is thus quite different from the relation, in the case of the engineer, between making a plan for a bridge and executing that plan. The engineer's plan is embodied in the bridge: it is essentially a form that can be imposed on certain matter, and when the bridge is built the form is there, in the bridge, as the way in which the matter composing it is arranged. But the musician's tune is not there on the paper at all. What is on the paper is not music, it is only musical notation. The relation of the tune to the notation is not like the relation of the plan to the bridge; it is like the relation of the plan to the specifications and drawings.

§5. The Work of Art as Imaginary Object

If the making of a tune is an instance of imaginative creation, a tune is an imaginary thing. And the same applies to a poem or a painting or any other work of art. This seems paradoxical; we are apt to think that a tune is not an

imaginary thing but a real thing, a real collection of noises; that a painting is a real piece of canvas covered with real colors; and so on. I hope to show, if the reader will have patience, that there is no paradox here; that both these propositions express what we do as a matter of fact say about works of art; and that they do not contradict one another, because they are concerned with different things.

When, speaking of a work of art (tune, picture, etc.), we mean by art a specific craft, intended as a stimulus for producing specific emotional effects in an audience, we certainly mean to designate by the term "work of art" something that we should call real.

But it does not at all follow that the same is true of an artist proper. His business is not to produce an emotional effect in an audience, but, for example, to make a tune. This tune is already complete and perfect when it exists merely as a tune in his head, that is, an imaginary tune. He may arrange for the tune to be played before an audience. Now there comes into existence a real tune, a collection of noises. But which of these two things is the work of art? The work of art is not the collection of noises; it is the tune in the composer's head. The noises made by the performers, and heard by the audience, are not the music at all; they are only means by which the audience, if they listen intelligently (not otherwise), can reconstruct for themselves the imaginary tune that existed in the composer's head.

This is not a paradox. It is not contrary to what we ordinarily believe and express in our ordinary speech. We all know perfectly well that a person who hears the noises the instruments make is not thereby possessing himself of the music. Perhaps no one can do that unless he does hear the noises; but there is something else which he must do as well. Our ordinary word for this other thing is listening; and the listening which we have to do when we hear the noises made by musicians is in a way rather like the thinking we have to do when we hear the noises made, for example, by a person lecturing on a scientific subject. We hear the sound of his voice; but what he is doing is not simply to make noises, but to develop a scientific thesis. The lecture, therefore, is not a collection of noises; it is a collection of scientific thoughts related to those noises in such a way that a person who not only hears but thinks as well becomes able to think these thoughts for himself.

Music does not consist of heard noises, paintings do not consist of seen colors, and so forth. Of what, then, do these things consist? Not, clearly, of a "form," understood as a pattern or a system of relations between the various noises we hear or the various colors we see. Such "forms" are nothing but

the perceived structures of bodily "works of art," that is to say, "works of art" falsely so called; and these formalistic theories of art, popular though they have been and are, have no relevance to art proper. The work of art proper is something not seen or heard, but something imagined.

§6. The Total Imaginative Experience

The change which came over painting at the close of the nineteenth century was nothing short of revolutionary. Every one in the course of that century had supposed that painting was "a visual art"; that the painter was primarily a person who used his eyes, and used his hands only to record what the use of his eyes had revealed to him. Then came Cézanne, and [he] began to paint like a blind man. His still-life studies, which enshrine the essence of his genius, are like groups of things that have been groped over with the hands; he uses color not to reproduce what he sees in looking at them but to express almost in a kind of algebraic notation what in this groping he has felt. So with his interiors; the spectator finds himself bumping about those rooms, circumnavigating with caution those menacingly angular tables, coming up to the persons that so massively occupy those chairs and fending himself off them with his hands. It is the same when Cézanne takes us into the open air. His landscapes have lost almost every trace of visuality. Trees never looked like that; that is how they feel to a man who encounters them with his eyes shut, blundering against them blindly.

In Mr. Bernard Berenson's hands the revolution became retrospective. He found that the great Italian painters yielded altogether new results when approached in this manner. He taught his pupils (and everyone who takes any interest in Renaissance painting nowadays is Mr. Berenson's pupil) to look in paintings for what he called "tactile values"; to think of their muscles as they stood before a picture, and notice what happened in their fingers and elbows. He showed that Masaccio and Raphael, to take only two outstanding instances, were painting as Cézanne painted, not at all as Monet or Sisley painted; not squirting light on a canvass, but exploring with arms and legs a world of solid things where Masaccio stalks giant-like on the ground and Raphael floats through serene air.

The forgotten truth about painting which was rediscovered by what may be called the Cézanne-Berenson approach to it was that the spectator's experience on looking at a picture is not a specifically visual experience at all. What he experiences does not consist of what he sees. It does not even consist of this as modified, supplemented, and expurgated by the work of the visual imagina-

tion. It does not belong to sight alone, it belongs also to touch. We must be a little more accurate, however. When Mr. Berenson speaks of tactile values, he is thinking, or thinking in the main, of distance and space and mass: not of touch sensations, but of motor sensations such as we experience by using our muscles and moving our limbs. But these are not actual motor sensations, they are imaginary motor sensations. In short: what we get from looking at a picture is not merely the experience of seeing, or even partly seeing and partly imagining, certain visible objects; it is also, and more importantly, the imaginary experience of certain complicated muscular movements.

This suggests that what we get out of a work of art is always divisible into two parts. (1) There is a specialized sensuous experience, an experience of seeing or hearing as the case may be. (2) There is also a nonspecialized imaginative experience, involving not only elements homogeneous, after their imaginary fashion, with those which make up the specialized sensuous experience, but others heterogeneous with them. So remote is this imaginative experience from the specialism of its sensuous basis that we may go so far as to call it an imaginative experience of total activity.

In the light of this discussion let us recapitulate and summarize our attempt to answer the question, What is a work of art? What, for example, is a piece of music?

1. In the pseudo-aesthetic sense for which art is a kind of craft, a piece of music is a series of audible noises. The psychological and "realistic" aestheticians, as we can now see, have not got beyond this pseudo-aesthetic conception.
2. If "work of art" means work of art proper, a piece of music is not something audible, but something which may exist solely in the musician's head (§3).
3. To some extent it must exist solely in the musician's head (including, of course, the audience as well as the composer under that name), for his imagination is always supplementing, correcting, and expurgating what he actually hears (§4).
4. The music which he actually enjoys as a work of art is thus never sensuously or "actually" heard at all. It is something imagined.
5. But it is not imagined sound (in the case of painting, it is not imagined color-patterns, etc.). It is an imagined experience of total activity (§5).
6. Thus a work of art proper is a total activity which the person enjoying it apprehends, or is conscious of, by the use of his imagination.

⁐

An Aesthetic Definition of Art*

Monroe C. Beardsley

Like other questions of the same syntactic form, the question, "What is art?" invites analysis of words and thoughts as well as the phenomena they refer to. But, being a philosophical question, it will not be satisfied by lexicography or psychology. Taken philosophically, the question calls for decisions and proposals: What are the noteworthy features of the phenomena to which the word in question seems, however loosely, to call our attention? What are the significant distinctions that need to be marked for the purposes of theoretical understanding, and that the word "art" or one of its cognates ("artwork," "artistic," "artistry," etc.) is most apt and suitable for marking? How does art, defined in a comparatively clear, if somewhat unorthodox, way, differ from closely related things? Of course it will be a merit in any proposed definition of art if it matches reasonably well at least one fairly widespread use of the term, but it will not necessarily be a merit if the match is close, since philosophical reflection is expected to yield definitions and distinctions rather more valuable to philosophy than casual familiar ones.

I

It should not be necessary to argue that we have need for a definition of art, but since this has been vigorously denied, some argument must be given. The point of a definition is, of course, to fix a meaning. One would think the philosopher of art could use a definition, since he should be curious to know what he is philosophizing about. The critic of an art may be a similar case; it should be useful to him to have criteria for deciding what sorts of thing he is to criticize. The historian of an art—of dance, drama, architecture, or whatever—will surely have use for a definition to tell him what belongs in his history and what does not. Even the practical legislator or administrator may have use for a definition, in deciding, for example, which imported objects to exempt from duties, or which allegedly artistic projects should be funded by the National Endowment for the Arts.

But we must especially note the needs of the anthropologist, and indeed as we move on we should keep in mind this broad cross-cultural perspective. Essential to our understanding of any culture is a grasp of the various forms

*"An Aesthetic Definition of Art," in Hugh Curtler (ed.), *What Is Art?*, pp. 15–29 (New York: Haven Publications, 1983).

of activity that it manifests, and of distinctions that are most significant to the members of the society that has that culture. When we observe someone carving wood or moving about in a circle with others, we must ask whether the activity is religious, political, economic, medical, etc.—or artistic. What function do the participants think of themselves as fulfilling, and how does it relate to other activities in which they engage? Even when the same act of carving or dancing in a ring has more than one character—it is both religious and artistic, say—we do not understand it unless we make this distinction and see that both descriptions apply. In a very few societies, horribly deprived or nearing destruction, we may be able to discern no activities to label "artistic," but there seems to be an ingredient or dimension of culture that runs across most societies, however varied, and whose nature we would like to articulate as well as we can.

There are two definition questions that spring up when we take this anthropological point of view. We may observe activities, and want to know which activities are artistic ones (allowing that they may also be political or pedagogical, etc.). We may notice certain objects that seem to engage the attention of many persons in the society from time to time, and want to know which of them, if any, are artworks (again allowing that they may also be sacred objects or economic objects, etc.). Here are two paired concepts, that of *artistic activity* and that of *artwork*; and already we are faced with one of the definitional decisions we must make. If we have an independent definition of "artwork," it is easy to define "artistic activity" as "activity that involves dealing with artworks." But it may turn out to be impossible, or inconvenient, to give a satisfactory definition of "artwork" without making reference to *some* form of artistic activity, either on the part of those who create artworks or those who receive them or both.

II

Once we know what things are artworks in a particular society, we can identify artistic activities by discovering which activities involve interaction with artworks. Highly central are two artistic activities in particular, for they enable us to define "artwork," which can be used in turn to define the other artistic activities.

The first of these central activities is *art-production*. I use "production" generously: it includes making, altering, assembling, joining, arranging, and other distinguishable actions, including certain kinds of doing (as in dancing). What is produced, I think, is always something physical (an object or event) and perceptual. Often what is produced also has properties that are not perceptual or physical—such as meanings, messages, the capacity to

evoke emotions or images, etc. Since art-production is a species of production in general, if we are going to distinguish it from the rest, we shall need to specify a differentia. One plausible candidate for such a differentia is *mode of production*. But this is barred to us, by the fact that the same process of production, as we said, may result in an object that is both an artwork and a religious object. Another plausible candidate is *intention*: that it is the presence of a certain kind of intention that makes production art-production. This suggestion is immune to the counterrgument just given, for something can be produced with more than one intention—say, both an artistic and a religious intention. Another plausible candidate is *result*: that it is the achievement of a product of a certain kind that makes the production artistic. But this seems to lead to saying that production is artistic when it results in an artwork; and I do not want to adopt this definition since I want to be able to define "artwork" (partly) in terms of its production.

Thus we seem to be beckoned toward adopting a definition of "art-production" that will make use of the concept of intention. But to characterize the specific type of intention needed we must turn to the second central artistic activity, which I have called *reception*. Reception comprises a variety of activities engaged in, in the presence of—or perhaps in response to reproductions or reports or memories of—sculpture, oral performances of literature, films, operas, etc. We view, listen to, contemplate, apprehend, watch, read, think about, peruse, and so forth. Sometimes in this receptive interaction we find that our experience (including all that we are aware of: perceptions, feelings, emotions, impulses, desires, beliefs, thoughts) is lifted in a certain way that is hard to describe and especially to summarize: it takes on a sense of freedom from concern about matters outside the thing received, an intense affect that is nevertheless detached from practical ends, the exhilarating sense of exercising powers of discovery, integration of the self and its experiences. When experience has some or all of these properties, I say it has an *aesthetic character*, or is, for short, aesthetic experience.

When we voluntarily receive those things that are the result of art-production, we often do so with the intention of obtaining aesthetic experience—in other words, we have an *aesthetic interest* in those things. I do not defend this claim here, but I believe myself to be justified in making the assumption that aesthetic experience is desirable, has value, satisfies a genuine human interest.

We have now the makings of the definition I am after, and I propose that:

> an artwork is something produced with the intention of giving it the capacity to satisfy the aesthetic interest.

Admirably terse, but therefore in need of exegesis, which I hope will guard it against misreading. It is an *aesthetic* definition of art, that is, a definition using the concept *of* the aesthetic, and though it is not the only possible aesthetic definition, it is the one I shall henceforth refer to.

To begin at the end, I have to assume that the concept of aesthetic interest is good enough for present purposes, even though it is defined in terms of aesthetic experience, which is the subject of lively and unabated controversy. It is important that the word "capacity" appears where it does: it is enough if he or she intends to fashion something that aesthetic experience *can* be obtained from. The artist may have no idea who, if anyone, will be able to obtain aesthetic experience from it, and maybe no one will. Appropriate interaction with the artwork may be extremely demanding or may depend on rare talents and extensive knowledge. The artist may be content to put his painting away or paint it over, once he is satisfied with what he has done— that is, believes that if someone with the requisite qualifications *were* to take an aesthetic interest in it, that interest would be satisfied to some degree.

The artist who works solely for his or her own enjoyment is an extreme case, no doubt; art-production is normally a social activity in which the producer and receiver are different persons. The impulse to make something capable of satisfying the aesthetic interest and to share it must be a very elementary one in very many societies, and must be present before there is a further desire to establish a continuing group (an institution) with an explicitly acknowledged group aim to foster artistic activity.

When I use the word "intention," I mean a combination of desire and belief: intending to produce a work capable of satisfying the aesthetic interest involves both (a) desiring to produce such a work and (b) believing that one will produce, or is in the process of producing, such a work. If, for example, it is unlikely that a painter could believe that by closing the art gallery and placing a sign on it he would produce something capable of satisfying the aesthetic interest, then it is unlikely that in closing the art gallery and placing a sign on it he was producing an artwork. We must of course allow for far-out beliefs, however unreasonable; there are painters quite capable of believing that closing the art gallery and placing a sign on it might provide aesthetic experience to someone who came to the gallery, found the sign, and meditated on the symbolic significance of this higher order of art that is so self-effacing, so sublimely self-sacrificial that it denies itself its own existence. If this was indeed an intention the painter had in closing the gallery and placing the sign, then I am prepared to classify the closed and labeled gallery an artwork. There is, of course, no implication here about the degree of success; it is enough that something was intended.

The example points up a problem in the application of this definition, though not, in my opinion, a fatal one. To identify the artistic activities and the artworks of a society we must make correct inferences about intentions. And intentions, being private, are difficult to know. But artistic activities are no different in this respect from all other significant activities of a society. We must make use of available verbal testimony, but inferences can legitimately reach beyond that. Once we discover that people in a given society have the *idea* of satisfying an aesthetic interest, and once we know at least some of their ways of satisfying this interest, we can reasonably infer the aesthetic intention from properties of the product. A painting with a religious subject and evident power to move believers to religious devotion may also give evidence of extreme care in the composition, color harmony, subtle variations in light and texture; then we have a good reason to believe that *one* of the intentions with which the painter worked was the aesthetic one. The fact that a product belongs to a genre that already contains indubitable artworks also counts as evidence of aesthetic intention.

According to the definition I propose, and am defending, the aesthetic intention need not be the only one, or even the dominant one; it must have been present and at least to some degree effective—that is, it played a causal or explanatory role with respect to some features of the work. Again, even if we know that a Chinookan story, such as "Seal and Her Younger Brother Lived There," is told mainly to children to teach them a lesson (and so has primarily a pedagogical intention), the presence of aesthetically satisfying formal features and its success in satisfying the aesthetic interest is enough to stamp it as a work of literary art. It is sometimes said that Paleolithic cave-drawings were not produced with any aesthetic intention at all, or aesthetically enjoyed, because they had a magical or religious function. One argument seems to be that no one in the culture could have had an aesthetic interest because the culture left no pure artworks (that is, works produced solely with an aesthetic intention). My view is that we know far too little about what was going on in the minds of Paleolithic people to be at all dogmatic about this, or to use their drawings as a counterexample to the aesthetic definition of art. Moreover—although this is a matter of interesting dispute, too—it seems highly probable to me that early human beings developed a capacity for aesthetic experience and a relish for it *before* they deliberately fashioned objects or actions for the purpose of providing aesthetic experience—just as they must have learned to use fire they found before they learned to make fires, and used found rocks as tools before they shaped rocks into better tools, and caves as housing before they built houses.

It is easy to point out vaguenesses in my definition; borderline cases can be found. Of course, if my definition is deemed hopelessly vague, so that it

marks no useful distinction at all, it must be rejected; but surely, even as it stands, it clearly and decisively admits a large number of things and rules out a large number of other things. I would incline toward generosity and a welcoming attitude toward novelty—but I would look for evidence of some aesthetic intention, and I see no reason to twist my definition to make room for something like, say, Edward T. Cone's one hundred metronomes running down with nobody silly enough to wait around for them—even if this "musical composition" is titled "Poème symphonique."

Common sense should not be abandoned along with philosophical acumen in these matters. The fuss that has been made about Duchamp's *Fountain* has long amazed me. It does not seem that in submitting that object to the art show and getting it more or less hidden from view, Duchamp or anyone else thought of it either as art or as having an aesthetic capacity. He did not establish a new meaning of "artwork," nor did he really inaugurate a tradition that led to the acceptance of plumbing figures (or other "readymades") as artworks today. If there was a point, it was surely to prove to the jury that even their tolerance had limits, and that they would *not* accept anything—at least not gracefully. This small point was made effectively, but the episode doesn't seem to me to provide the slightest reason to regard the aesthetic definition as inadequate. Many objects exhibited today by the avant-garde evidently do make comments of some kind on art itself, but these objects may or may not be artworks. To classify them as artworks just because they are exhibited is intellectually spineless, and results in classifying the exhibits at commercial expositions, science museums, stamp clubs and World's Fairs as artworks. Where is the advantage of that? To classify them as artworks just because they are called art by those who are called artists because they make things they call art is not to classify at all, but to think in circles.

III

It remains to consider some of the reasonable objections that may occur to the reader.

1. If we take artworks as I have characterized them, then it is possible for children, even quite young children, to create artworks. This consequence is unacceptable to philosophers whose definitions assign to artworks an essential dependence on institutions, traditions, or aesthetic theories, for we may suppose that seven-year-olds, say, when they draw pictures, write poems, or make up songs, do not yet participate in what is called the "artworld." But it seems to me invidious to deny children this capability, especially on rather a priori grounds. The basic social activity, as I see it, is one in which a person produces something that

he or she finds aesthetically enjoyable and shares it with others who may be able to appreciate it. Once this concept arises, we can have artworks, however simple and crude they may be. Developmental psychologists who have studied the "artful scribbles" of children (notably Howard Gardner) discern a frequent ability to use pictorial symbol systems for aesthetic purposes.

2. The question arises whether, on the aesthetic definition, forgeries of artworks can themselves be artworks. My answer is that some are and some are not: it all depends on the effective presence of an aesthetic intention. We can imagine a person making an exact copy of a painting by Chirico for the purpose of passing it off as a genuine Chirico; and we can imagine that his method of working is tediously atomistic: he uses instruments to make sure that each small area matches the original perfectly. In that case he might execute the forgery without any aesthetic intention at all. It is far more likely that he will paint with an eye to capturing the peculiar quality of the empty, lonely, ominous space in the Chirico in order to make sure the forgery is good enough as a painting to fool a connoisseur. In that case the forger is producing an artwork. I do not see how the addition of another intention (to deceive someone) makes the product less an artwork—especially since the very success of the deception may depend on the painter's having the intention to make his work as capable as the original one of satisfying the aesthetic interest.

3. It follows from my definition that once an artwork, always an artwork. Anyone who holds that something can become an artwork and cease to be an artwork will object to my definition, and be inclined to adopt an institutional definition. It is sometimes said that, for example, a spinning wheel or snow shovel may begin life as a nonartwork, tied down to its lowly function; that at some point the artworld (prodded by an enterprising museum curator or by a maverick painter like Duchamp) may open its arms to embrace it, placing it on display and thus converting it into an artwork; and that at a still later time this designation or status may be withdrawn, so that the spinning wheel or snow shovel reverts to its original state. If some versions of the institutional theory are right, and there is an implicit or explicit performative act by which nonart can be given art-status, then it seems the process should be reversible by a converse act, as marriages can be annulled, names changed, contracts declared void, cabinet appointments rescinded, votes overturned, priests defrocked, and so forth. But the notion of taking away an object's property of being art is prima facie puzzling, and this puzzlingness is accounted for on the aesthetic definition. Since

what makes art art is an intention with which it was produced, nothing can be art that was not art from the start, and nothing that is art can cease to be art.

4. If it is the intention that counts in art-production, does it follow that one cannot *fail* to produce an artwork, if one intends to? That might seem an unfortunate consequence of the proposed definition. To straighten out the difficulty here requires some careful attention to certain features of actions and intentions. I do not say that the aesthetic intention is the intention to produce an artwork, but the intention to produce something capable of satisfying the aesthetic interest. To intend to produce an artwork is to intend to produce something produced with the intention of producing something capable of satisfying the aesthetic interest. Thus in a certain rather innocuous sense artworks are often produced without the intention to produce an artwork. But of course an artwork cannot be produced without any intention, and in this sense there can be no unintentional artworks.

As far as I can see, the only way one can fail to produce an artwork after setting out to produce something capable of satisfying the aesthetic interest is by failing to make the physical object one tries to make (the clay is defective or the temperature of the kiln not right, so the pot falls apart), or to do the deed one tries to do (the dancer slips and falls instead of completing the pirouette). As long as *something is* produced with the aesthetic intention, an artwork is produced.

5. It is a consequence of my aesthetic definition, then, that tawdry and negligible objects will be classified as artworks. In such a sorting there is no implication of worth or value. Admittedly, this insistence on preserving a value-neutral sense of "artwork," for the purposes sketched at the start of this essay, runs counter to a familiar use of "work of art" for artistic praise. But we need a term for the classification; indeed, without it we will not even be able to make sense of the evaluative expression "a good artwork." Part of my aim in providing a definition of art that has no built-in value-judgments ranking decorative designs, stories, dances, songs, etc., is to encompass the popular arts as well as those for which we lack a convenient label—I suppose because they have been thought of as the real thing: portraits in oil, epic poems, ballet, lieder, etc. To gather popular and "esoteric" artworks in the same broad class is not, of course, to deny differences in value, but it is to invite study of continuities and degrees of accessibility, of complexity, of training in taste, of seriousness in affect, and so forth. I don't see any good reason for not regarding *Guys and Dolls* and *The Pirates of Penzance* as artworks, along with *Tannhäuser* and

The Marriage of Figaro. When it comes to other sorts of products now much studied by scholars—bed-quilts, cigarstore Indians, Dixieland jazz, old Tarzan movies—it may strike some people that we have wandered to the edge of art, if not beyond. There will, of course, always be a question whether something was indeed produced with an aesthetic intention, but even when this intention was probably minimal and the skill to carry it out deficient, the social function served may be the same as that of clearly artistic activities. So a broad definition of art that still retains its essential connection with the aesthetic interest has much to recommend it.

ᢍᢍ

The Art Circle*

George Dickie

The definitions which philosophers have given of "work of art" do not function, nor are they really intended to function, as the dictionary definition of a pedantic word such as "penultimate" functions for most of us. (This is no doubt true of the other definition, which philosophers have given.) Virtually everyone, including even quite small children, has at least a partial understanding of the expression "work of art." Virtually everyone can recognize some things as works of art, knows how some works of art are made, and the like. Thus, virtually no one is in need of a definition of "work of art" in the way that many would be in need of a definition if they came upon an unfamiliar word such as, say, "penultimate." So a philosopher's definition of "work of art" does not and cannot function in the way a definition is supposed to function according to the ideal mentioned earlier—to inform someone of the meaning of an expression one is ignorant of by means of words one already knows. The reason it cannot so function is that anyone who has gotten to the point of reading documents on the philosophy of art will already know what the expression "work of art" means.

What philosophical definitions of "work of art" are really attempting to do is to make clear to us in a self-conscious and explicit way what we already in some sense know. That philosopher's definitions have been so frequently misdirected testifies to the difficulty of saying precisely what we in some sense already know—a difficulty that Socrates tried to get Meno and his slave boy to appreciate. Definitions of terms such as "work of art" cannot inform us of

*From *The Art Circle*, pp. 79–82 and 84–86 (New York: Haven Publications, 1984). Used by permission of the author.

something we are really ignorant of. Furthermore, the fear that some philosophers have of circularity in certain definitions is, I think, groundless. In any event, if a definition of "work of art" is circular, it may just be so because of the very nature of what the definition is about.

In what now follows I shall present an account of art which is clearly circular, or to put it in a better way, an account which reveals the *inflected* nature of art. By "inflected nature" I mean a nature the elements of which bend in on, presuppose, and support one another. In *Art and the Aesthetic* I attempted to define only "work of art," although I discussed the other aspects of the artworld, as I then conceived of them, in some detail. There, in defining, I focused on the "center" of what I am now calling art's essential framework—works of art themselves. I now think that each of the structural intersections of the framework requires definition, for the framework's center is not its only vital part. Consequently, I shall now, in effect, try to supply a small dictionary—a dictionary for the philosophy of art.

I shall begin with a definition of the term "artist," not because it has alphabetical priority over the other terms to be defined, but because the series of definitions seems to flow most easily from this particular source. Any of the structural intersections would, however, serve as a beginning point.

(I) An artist is a person who participates with understanding in the making of a work of art.

There is nothing controversial, or even surprising, about this definition, so matters are off to a smooth start. The definition in itself is not circular, although it does cry out for a definition of "work of art," which will come along shortly. The "understanding" clause in the definition is necessary to distinguish an artist (say, a playwright or a director) from someone such as a stage carpenter who builds various stage elements. What the artist understands is the general idea of art and the particular idea of the medium he is working with. To forestall misunderstanding, let me hasten to add that a stage carpenter or the like may very well understand the art of the stage but that such knowledge is just not required for the carrying out of the function which constitutes his participation in the artistic process. This definition of "artist" also makes it clear that art-making is an intentional activity; although elements of a work of art may have their origin in accidental occurrences which happen during the making of a work, a work as a whole is not accidental. Participating with understanding implies that an artist is aware of what he is doing.

These remarks lead naturally to the definition of "work of art."

(II) A work of art is an artifact of a kind created to be presented to an artworld public.

Being a work of art, thus, involves having a status or position within a structure which in a way is somewhat similar to the earlier view of *Art and the Aesthetic*. According to the present view, however, the status in no way results from a conferral but rather is achieved through working in a medium within the artworld framework. Let me note here that an object need never actually be presented to an artworld public in order to be a work of art. The definition speaks only of the creation of a *kind* of thing which is presented. To forestall one possible misunderstanding, in using the word "kind" here I am not talking about genres or even larger categories such as *painting, play, poem*, or the like. The kind specified by the definition is of a larger sort, namely, an artifact of a kind to be presented. The kind in question is, of course, not to be identified with the kind of work of art, because the kind in question is only an aspect of a work of art.

To forestall another possible objection to the definition, let me acknowledge that there are artifacts which are created for presentation to the artworld publics which are not works of art: for example, playbills. Things such as playbills are, however, parasitic or secondary to works of art. Works of art are artifacts of a primary kind in this domain, and playbills and the like which are *dependent* on works of art are artifacts of a secondary kind within this domain. The word "artifact" in the definition should be understood to be referring to artifacts of the primary kind. The definition could be explicitly reformulated: A work of art is an artifact (primary) of a kind created to be presented to an artworld public.

In the discussion following the definition of "artist," I remarked that art-making is clearly an intentional activity. In a parallel way, the definition of "work of art" implies that such objects are intentional, i.e., are the product of an intentional activity. The definition of "works of art" leads on to the notions of *public* and *artworld*.

(III) A public is a set of persons the members of which are prepared in some degree to understand an object which is presented to them.

This definition is not only not circular in itself, it is stated in a general way and does not necessarily involve the artworld. Put otherwise, it is a formulation which characterizes all publics, not just those of the artworld. The definition of "public" is not formerly tied to the other definitions I am giving. Any actual public, however, will be necessarily tied to some particular

system; for example, the artworld public is necessarily related to artists, works of art, and other things.

(IV) The artworld is the totality of all artworld systems.

At this point it may be worth emphasizing what is perhaps implicitly clear enough, namely, that the roles of artist and public and the structure of artworld systems are herein conceived of as things which persist through time and have a history. In short, the definitions characterize an ongoing cultural enterprise. This definition of "the artworld" certainly gives the appearance of being circular in itself although this impression is at least counteracted by remembering that the expression "all artworld systems" is short for a list which includes literary system, theater system, painting system, and so on. The circularity in itself of the definition of "the artworld" may be real or apparent, but the circularity of the whole set of definitions becomes transparent with the definition of "artworld system."

(V) An artworld system is a framework for the presentation of a work of art by an artist to an artworld public.

The series of definitions has not led down strata after strata until bedrock is reached. The "final" definition, that of "artworld system," simply reaches back and employs all the previous focal terms: "artist," "work of art," "public," and "artworld." What is to be made of this blatant circularity? Conventional philosophical wisdom tells us to recoil in logical horror and to reject it as uninformative and worse. Beginning with the charge of uninformativeness, as noted earlier, in a basic sense we do not need to be informed about art—we already have a fundamental understanding of it. Conventional wisdom notwithstanding, there is a sense in which the definitions are informative; if they accurately reflect the nature of art and the relations which hold among the various elements of the artworld, then they do in a way inform us. These remarks may counter the charge of uninformativeness, but what of the charge of logical fault—the "worse" of the "uninformative and worse"? If, however, the definitions accurately mirror the inflected nature of the art enterprise, then they are not logically faulty.

I have done what I could to show that works of art are embedded in what I have called an *essential* framework. What the definitions I have given do, I believe, is to give the leanest possible description of that essential framework and the embedded works. What the definitions reveal, by eliminating distracting detail, is that art-making involves an intricate, corelative structure which

cannot be described in the straightforward, linear way that such activities as saddlemaking presumably can be described. In short, what the definitions reveal and thereby inform us of is the inflected nature of art. The definitions help us get clear about something with which we are already familiar but about whose nature we have not been sufficiently clear from a theoretical point of view. What the definitions describe and thus reveal is the complex of necessarily related elements which constitute the art-making enterprise.

What shows that the framework has the inflected nature that the definition pictures it as having? Reflection on how we learn about art will, I think, reveal in what sense and why an account of art must be circular. How, then, do we learn what it is that we know about art?

We do not learn about art from the theories or definitions of philosophers; their remarks would be unintelligible if we did not already know about art. We learn about art in different ways, but we invariably do so at a tender age. Children are frequently taught about art by being shown how to make works for display: "Now draw a nice picture to take home to your mother or to put up on the board." One may be introduced to art in a more abstract, lecture-like way: "These are pictures done by some men who lived a long time ago to be put up in churches." Art instruction such as the foregoing are typically preceded by remarks which prepare a child for it; for example, "This is the way we draw a face," which helps a child come to understand representation. I do not mean to suggest by my example that a knowledge of representation is necessary for the subsequent understanding of art, but it is almost always involved in the beginnings of teaching about art—at least with Western art.

These, then, are some of the ways that we learn about art. What is it that such instruction teaches? We learn that a complex of interrelated things is involved in the art-enterprise: artists (oneself, other children, men who lived a long time ago), works (the nice picture, pictures of religious figures), an artworld public (mother, the other children, the teacher, people who go into churches). We also learn that special places can be set aside for the display of works (the refrigerator door at home, the board at school, the walls of a church).

Considered more abstractly, what is it that such instruction teaches us? We are taught about agent, artifact, and public all at the same time, and this is no accident for the various artworld elements do not exist independently of one another. In learning about what a poem, a painting, or a play is, we cannot fail to learn that it is an object with a past—an object which results from a human action—and that it is an object with an intended future—an object which is of a kind which is presented. When we come to know that an object is a work of art, or even just see an object as a work of art (perhaps mistakenly), we fit it into a certain kind of cultural role.

But isn't there more to be said about art? Even many of those who are in general agreement with the institutional approach may feel that there is more to the nature of art than my remarks allow. Certainly those who disagree with what I have said, but still think that art has an essential nature, will feel that there is more to that nature than the institutional theory claims. Monroe Beardsley, for example, clearly thinks that more ought to be said. In the concluding paragraph of "Is Art Essentially Institutional?" he remarks that the institutional approach fails to answer the question which has motivated the main tradition of Western philosophy of art. This tradition has assumed "that there is a function that is essential to human culture, and that appears in some guise in any society that has a culture, and that works of art fulfill, or at least aspire or purport to fulfill."[1] At the end of his concluding paragraph, he remarks that the institutional theory does not tell us ". . . whether there are basic and pervasive human needs that it is the peculiar role of art to serve."[2] Beardsley does not hazard a guess as to what this essential function is or what the basic human needs are, but his remarks certainly suggest that he thinks that works of art fulfill an essential function, i.e., one which must occur in any human culture, which is to satisfy or try to satisfy certain basic human needs. The kind of essentialism which Beardsley has in mind here is different from the essentialism which has characterized many traditional theories. The essential in the imitation theory is that which is necessary for an object to be a work of art, namely, being an imitation. Even if the imitation theory were an adequate theory of art, there would be no compelling reason to conclude that imitations are necessary for human culture, or that they satisfy basic human needs. Parallel remarks go also for the theories of art as symbols of human feeling, art as significant form, and other traditional theories. I suspect that what Beardsley has in mind as occurring in every human culture, i.e., as essential, are created objects which satisfy a (basic) aesthetic need, say, a need for aesthetic experience. To sum up, the essentialism of traditional theories differs from that which I think Beardsley has in mind in the following way. For the traditional theories what is essential is a property which an object must have in order for the object to be a work of art—the property of being an imitation or of being a symbol of human feeling, or whatever. For Beardsley, it is works of art themselves which are essential—essential to society to serve some purpose. The theory Beardsley has in mind is a theory of what works of art do, not of what they are. Beardsley's implied theory is not then a theory of art in the traditional sense and, hence, not in competition with the imitation theory, Susanne Langer's theory, or the institutional theory.

If I understand what Beardsley is suggesting, a number of difficult details would have to be worked out for it to be made plausible. First, there is the

empirical question as to whether every human culture has works of art. This empirical question would have to be answered whether works of art fulfill an aesthetic function, some other kind of function, or a combination of an aesthetic function and some other kind of function. Then there is the difficult conceptual question of saying what "aesthetic" means when an aesthetic need is spoken of. Finally, there is the problem of specifying what it means to say that a need satisfied by art is basic.

In response to the first implied claim, it is not clear to me that a human culture must have art. Beardsley might reply that my formulation is too strong because he has written only of what is essential for ". . . any society that has a culture." If this qualification is made, it must then be discovered what it takes for a society to have a culture in order to even begin to test the empirical question, which now becomes "Does every society with a culture have art?" When put in this qualified way, the question may have lost its empirical nature.

If the need which Beardsley has in mind is an aesthetic need, one is faced with the notoriously difficult task of saying what "aesthetic" means. Actually, Beardsley speaks of needs rather than of a single need, so that he may have in mind that there is an aesthetic need plus one or more other needs which "it is the peculiar role of art to serve." Of course, the larger the number of needs specified, the more difficult it is to envisage its being the peculiar role of art to serve them. In any event, I rather doubt that a satisfactory account can be given of an aesthetic need or of a set of needs which art serves, assuming that either of these is what Beardsley has in mind.

Finally, what does it mean to say that the envisaged needs are *basic*? Are they like the need for air, water, and food, i.e., necessary for life? Or are they like the need for social structure which is necessary for there to be a human culture? If the answer to this last question is in the affirmative, then perhaps we are back to the first thesis, namely, that art is essential for a society with a culture. Beardsley's remarks ought not to be pressed too hard, for he intended them only to raise an issue and to indicate a direction. I have discussed his remarks at the length that I have because they articulate a feeling that many have—that there must be more to art than the institutional theory allows or reveals.

The institutional theory, however, places virtually no restrictions on what art may do; it seeks only to catch its essential nature. The institutional nature of art does not prevent art from serving moral, political, romantic, expressive, aesthetic, or a host of other needs. So there is more to art than the institutional theory talks about, but there is no reason to think that the more is peculiar to art and, hence, an essential aspect of art.

Notes

1. Monroe C. Beardsley, *In Culture and Art* (Atlantic Highlands, NJ: Humanities Press, 1976), 209.

2. Beardsley, *In Culture and Art.*

⌀

Non-Western Art and Art's Definition*

Stephen Davies

The members of all cultures always have engaged in storytelling, drawing, carving and whittling, song, dance, and acting or mime. Frequently these activities are tied to social functions, such as the production of tools, the enactment of ritual, the preservation of a historical record. Their pervasiveness suggests that they are integral, not incidental, to the social ends they serve. Whenever items with handles are made, those handles are decorated; once pots are thrown, they are marked with depictions or patterns; when a couple is married, there is singing and dancing. Moreover, the skills displayed in the exercise of these activities—for instance, in the carver's treatment of his chosen medium—are widely respected and valued.

The practices just described can reasonably be called artistic, and their ubiquity suggests that art is universal. Artistic activity may not be necessary for human social life, but, if not, it appears to be an inevitable spin-off from things that are. Its constant presence indicates that it answers and gives expression to deeply ingrained human needs and patterns of experience.

This first observation should be coupled with another, the significance of which is easily overlooked. We are capable of recognizing that art is made by people in cultures other than our own and of identifying many of their artworks as such. I am impressed by how accessible to Westerners is much sub-Saharan music, Chinese painting, and woven carpets from the Middle East. If art relies on a complex semiotic system, or on an atmosphere of theory, this recognition would be surprising, for such things are culturally arbitrary. If art were as this view supposes, we could have no immediate access to their art. That we do have this access suggests that the properties crucial in inviting an art-regard sometimes are ones that can be perceived with very little culture-specific background knowledge.

*"Non-Western Art and Art's Definition" in Carroll, Noël (ed.), THEORIES OF ART TODAY. © 2000 by the Board of Regents of the University of Wisconsin System. Reprinted by permission of The University of Wisconsin Press.

This is not to deny that there is likely to be much more to the art of other societies than is available to an outsider. Even if art "skillfully encodes culturally significant meanings" that the outsider is in no position to appreciate,[1] something more universal and basic must be involved if we are to explain the outsider's response. The outsider might be incapable of fully understanding the artworks of other cultures where these deal in "culturally significant meanings" but, nevertheless, often can recognize the "artiness" of such pieces and enjoy at least some aspects of this.

In this chapter, I discuss non-Western art and, in particular, what follows from the capacity of Westerners to identify and respond to such pieces as art. This commentary has implications for the philosophical definition of art, as I outline in the last section. But before addressing these issues, I look more closely at challenges often raised to the idea that there is non-Western art as such.

I

It has been held by some anthropologists that there is no non-Western art.[2] The concept is a Western one. Other cultures have different, possibly parallel, concepts of their own. The artifacts of non-Western cultures become art only by being appropriated by Westerners to their own art institutions. Several arguments that have been offered for this conclusion are reviewed and rejected below.

In the West, art often is distinguished from craft. This dichotomy is stressed in the writings of G. W. F. Hegel and R. G. Collingwood, for example. It is widely claimed that art lacks "utility," being made for contemplation distanced from social concerns; that artists should be indifferent to worldly matters in pursuing their muse; that artworks have an intrinsic value and should be preserved and respected. If these views characterize the Western concept of art, many non-Western societies must lack that concept, for their approach and attitude are different. In them, all artifacts or performances are created to meet socially useful functions—masks are worn in religious rituals, carvings propitiate the gods or decorate items for domestic use, songs lighten the burden of repetitive labor. Nothing is created solely for aesthetic contemplation. In many cases, pieces are discarded once they have served the particular purpose for which they were created.

I accept that the notions listed above characterize what has come to be known as fine or high art. The fine arts were described and typed at the close of the eighteenth century, and the associated notion of the artist as a genius unfettered by the rules of a craft, as well as by social conventions, was presented at much the same time. Along with this went the idea that the aesthetic attitude is a psychologically distinctive state of distanced contem-

plation. Prior to that time, Western artists were employed as servants and worked mainly to order. Their art was expected to be functional. Its purposes were to illustrate and instruct, to uplift or delight, to glorify God or art's patrons, to improve the social environment or, at least, to make it more pleasant. Now, if it is silly to suggest that Bach's music or Michelangelo's statues or Shakespeare's plays became art retrospectively, only when they were appropriated by the art establishment and thereby were abstracted from their original settings and functions, it must be accepted that there is a broader notion of art than is covered by the rubric of fine art. Fine or High Art is art. It is art with a capital A. But it is only one kind within a wider genus. So, we can agree with the anthropologist who argues that non-Western cultures do not share the Western notion of fine art without also accepting that this shows them to lack art or its concept. The crucial question is whether non-Western cultures self-consciously create art with a small a, something that is properly called art for what it shares with our basic concept.

A final argument claims that members of traditional societies are unconscious of their culture. Simply, they do what they do, regarding it as natural while remaining oblivious of the history of their practices, of the influences that shaped them, and of the "latent functions"[3] served by the maintenance of their traditions. It is only in confrontation with the "other," with an intrusive alien presence, that the society is forced to define itself, to reflect on its own character. "Construction of culture," creative self-definition through contrast, is the result.

Now, if the creation of art must be self-conscious, it will follow that members of non-Western societies, in being blind to their own cultures, could have no basic concept of art as such. If they acquire one, it will be through exposure to Western views, and their notion will be affected by ours. Moreover, their artlike cultural practices will have no defense against outside influences, whether good or bad. According to Maud Karpeles,[4] folk music develops mainly unconsciously, with cultural insiders lacking awareness of the history and values of their tradition. As a result, untutored singers adapt indiscriminately from traditional and external sources; the natural selection by which the folk tradition evolves then cannot operate freely, because the ordinary process of musical change is continuously subverted.

I regard this argument to be insupportable. The enactment of culture might be largely unconscious in that a society's members do not have to describe to themselves, or to those who share their cultural habits. They call on repertoires and values that have been thoroughly assimilated and which, therefore, do not need to be justified or worked out each time they are pressed into service. Also, the transmission of culture clearly depends

more on imitation and rote learning than on social analysis. It does not follow, however, that a society's members are unconscious of their culture in the further sense of being incapable of articulating, if occasion requires, their practices and mores. Social practices may be "unconscious" in one sense, that of being enacted unthinkingly under normal circumstances, but not in another, that of being beyond the agent's ken. In fact, the evidence suggests not that societies are indifferent to their own histories and values, or that they are insensitive to outside influences, but the reverse.

More particularly, we should challenge Karpeles's assumption that a mindless process of evolution explains the maintenance of, and change in, folk traditions. Her line, like that of the anthropologists who conceive of their studies as dealing with "latent functions" not appreciated by their subjects, reduces the artifacts produced within these cultures to the level of aesthetically pleasing objects shaped by the forces of nature. Denis Dutton has taken this approach to task for ignoring levels of intention manifest in what is achieved.[5] Although art production does not always involve the explicit articulation of goals and intentions, it does not follow that these are absent. The preservation and development of cultural traditions indicate care, attention, commitment, concentration, and deference—for the material and the heritage of works, genres, and styles—on the part of native practitioners and their audiences. Such traditions survive only by being carefully passed down.

II

It remains now to offer a positive characterization of non-Western art, and to do so in a way that explains the ability of cultural outsiders to recognize (if not to thoroughly understand) it as what it is.

I begin by considering a position sketched by Arthur Danto. He is impressed by the fact that some Western artworks are perceptually indistinguishable from nonartworks to those who are unaware of their provenance. The most graphic illustration of the point is provided by Duchamp's readymades, in which a "mere real thing" attains the status of art without alteration in its physical properties. This leads Danto to conclude that what differentiates art from other things is "an atmosphere of theory the eye cannot de[s]cry."[6] By this he seems to mean an art historical context. He applies his idea to non-Western art by means of a "philosopher's example" concerning two nearby but isolated African tribes, the Pot People and the Basket Folk. Both make pots and baskets, and the pots and baskets of the Pot People are not perceptually discriminable from those of the Basket Folk. Nevertheless, the pots of the Pot

People are artworks, whereas their baskets are not, and vice versa for the Basket Folk. Whereas the artworks in both cultures have deep spiritual importance for the tribe, symbolizing their relation to the cosmic order, to life and death, and so on, the nonartworks lack special significance, being no more than practical objects.[7] The tale illustrates Danto's theory, as it is designed to do. What makes something art, whether in an African tribe or in the United States, is an "atmosphere of theory," not properties perceptible to someone ignorant of that conceptual context.

Dutton raises this objection to Danto's tale: If a tribe makes pots that have developed over many generations into their most treasured art, they will be meticulous about the construction and decoration of these.

> Pot making would be a central element in a whole culture, with much thought and worry going into obtaining the perfect clay for making them, firing them for exactly the right kind of finish. Why? Because people just behave in those ways when they create things that mean something to them.[8]

I think that Dutton succeeds in calling into question the plausibility of Danto's scenario. His argument is that artisans take pains over perceptible features of the artifacts that are of central importance to the culture. As it stands, however, that suggestion would apply as readily to culturally significant nonart items as to artworks. How can we distinguish culturally significant practices in which art is absent from those in which it is present? One suggestion, with which I agree, is developed by Dutton[9] and H. Gene Blocker[10] as a result of their communications respectively with carvers in New Guinea and Africa. The crucial claim is that, even if non-Western artists' carvings are utilitarian and not created for "distanced" contemplation, those artists (and other members of their culture) are vitally concerned with the aesthetic nature of what is produced. Their work involves achievements that are aesthetic in character. As Dutton puts it, art involves accomplishment; it displays persistent intelligence and directedness in realizing aesthetic goals.

This account displays an important virtue: it stresses aesthetic properties such as beauty, balance, tension, elegance, serenity, energy, grace, vivacity. Traditionally, philosophical aesthetics has conceived of aesthetic properties not only as central to the character of art, but also as not requiring for their apprehension a detailed knowledge of the social context of production. If (some) non-Western items qualify as art by virtue of displaying humanly produced aesthetic features, this allows us to explain how outsiders, despite their ignorance of the wider sociohistorical context in which such items are created, might recognize them for the artworks they are.

I am inclined to supplement the account offered so far, because I do not think that it is sufficient to distinguish artworks from other items that display humanly created aesthetic properties. I suggest that, in the case of art, the aesthetic effects achieved must be integral to the whole, rather than minor or incidental side features. A tool handle does not become an artwork merely by having a minuscule, but aesthetically pleasing, carving added to it. In addition, I think that the aesthetic character of an artwork must be regarded as essential to its function, so that it cannot be evaluated properly without taking into account the aesthetic achievement it involves. Its function need not be solely that of providing pleasure through the contemplation of its aesthetic properties. Much more often in non-Western cultures, artworks serve socially useful purposes in rituals and the like. In this way, art might always be utilitarian. But it remains distinguishable from *mere* craft in terms of the totality and functional significance of the aesthetic properties it is created to possess.

In summary: In discovering whether a people possess the concept of art, what matters is not that they separate art from other important concerns but that they make items presenting humanly generated aesthetic properties which are essential to the main purposes served by those items. Moreover, such artworks often will be recognizable as such to cultural outsiders, who are not prohibited by their ignorance of life within the culture from noting the aesthetic effects they manifest.

III

It remains to investigate the implications of the preceding for the philosophical enterprise of defining art. I consider two questions.

1. If the presence of humanly created aesthetic properties is crucial to our acknowledging that other cultures have art and to our ability to identify at least some of their artworks, must reference to such properties feature in a successful definition? That is, should "aesthetic" definitions be preferred to other varieties?

I answer "no." Though I have stressed the importance of aesthetic properties in addressing the issue of how we know that other cultures have art, it is not my view that the possession of these is *essential* for something's being art. I accept that conceptual pieces can qualify as art, though these do not possess perceptible aesthetic attributes, and I also accept that ordinary objects might be appropriated to the artworld, as Duchamp's readymades were, so that their being art does not depend on the aesthetic properties they happen to display. Indeed, it could be that, over time, art practices change so that the

emphasis falls on the creation of theory-dependent, historically conditioned artistic properties that have little to do with aesthetic properties as these were traditionally described.

I do not mean to leave the impression that there could be an art-making tradition that at no time focused on the realization of perceptible aesthetic effects. A culture could [not] have a tradition generating artworks *all* of which are nonaesthetic, or are only incidentally aesthetic, in character. A concern with achieving aesthetic effects is *historically* necessary in the development of art practices, though not *logically* necessary to any particular item's being an artwork.

> 2. Do current theories, most of which are prompted by reflection on Western art practice, accommodate non-Western art? In discussing this question, I review the definitions of art proposed by George Dickie and Jerrold Levinson.

Dickie's institutional theory holds that something is art if and only if it is enmeshed within a complex set of institutionally structured social relations.[11] Art status is achieved by an item only if it is appropriately situated within an institutional matrix involving the roles of artist and public, along with artworld practices. What is distinctive to the institution in terms of which art is defined is its structure, not its history or function.

Dickie does not apply his theory to non-Western cultures, but it is easy to see what this would involve. For these cultures to be art-producing ones, they would have to contain art institutions of the kind Dickie outlines.

In some non-Western cultures—those of Japan, China, Indonesia, India, Iran, and Iraq, for instance—art has long been formalized and professionalized in some respects. In many other societies, however, I doubt that art is served by a distinctively structured institution; rather, it is an inseparable aspect of wider social practices concerning kinship, religion, commerce, ritual, and government. I conclude, therefore, that the institutional theory is not adequate to explain the presence of art in these cultures.

Jerrold Levinson offers a recursive account of the extension of "artwork" according to which something is art if it is intended for regard in one of the ways prior artworks have been correctly regarded.[12] On non-Western art, he says this:

> We can only hope to say anything about art in other cultures, or in historically remote circumstances, by trying to understand our own concept as surely as we can, and then gauging the extent to which it can be made to fit with or to

illuminate what we find in those cultures and circumstances. If another culture has art, it must have art in our sense, more or less—whatever the inevitable differences between its art and ours in terms of materials, structure, expressiveness, ritual-embeddedness, object-orientedness, and so on.[13]

Levinson's definition makes no explicit appeal to the intender's cultural location. For that reason, it appears to be indifferent to social boundaries and, thereby, to claim a universality that would have it applying to all artworks, whatever their provenance. But this impression is misleading.

Suppose a Chinese person in the fourteenth century intended a piece to be regarded as were European paintings in the thirteenth century, though she was entirely ignorant of the existence of Europe and its artworks, and further, no extant Chinese artworks called for that kind of regard. Levinson's definition would appear to entail that the Chinese person creates an artwork via cross-cultural reference. This result strikes me as extremely implausible, and I doubt that Levinson would embrace it. Quite rightly, he emphasizes that artists' art-regarding intentions usually are self-conscious in invoking or referring to past art. The recursive character of Levinson's definition aims to stress the extent to which art making is rooted within a historicized, culturally unified practice, not to admit the possibility of cross-cultural art creation that rides roughshod over the artistic traditions of the respective cultures. He means to indicate how art draws on (or sets out to repudiate) its cultural forebears, so that what is possible within the art of a culture depends on what has been previously accepted as art within that same culture. In consequence, Levinson's account must be seen as committed to a kind of cultural relativism in art production, not as espousing universalism.

As it stands, this approach is inadequate. A definition that characterizes art making as artworld relative and that also concedes the existence of autonomous artworlds must explain how artworlds are of a single type. An account is required of what makes the various artworlds *art*worlds. Without this the definition is incomplete at best. While it might identify a factor necessarily common to artworlds, reference solely to the structure of the intentional relationship—that the maker intends the present object to be viewed as similar predecessors have been—is not sufficient to explain how artworlds are of a distinctive kind. Many practices that are not art-making ones are historically reflexive in a similar way and thereby exhibit the same structure of intention.

Levinson does not apply his definition to the autonomous art of other cultures, but he does consider how his intentional-historical conception of art might assimilate Western activities that are like, but marginal to, Western fine art. (As examples, he mentions handmade furniture, sculpted masks,

commercial design, ritual music, and baton twirling.) For that case, he allows that identifying "simply the same structure of connectedness, of intentional invocation, whether immediate or mediate, of predecessor objects or the treatment they were accorded" is too weak to do the job.[14] A stronger suggestion, Levinson thinks, holds that the *content* of the relevant intentions is the same or similar between, say, handmade chairs and art sculptures.[15]

These remarks show how Levinson would attempt to extend his definition to the case of non-Western art. Probably he would maintain that at least some of the regards intended for artworks are common to all artworlds, and that it is this feature that unifies these artworlds as of a single type. When it comes to artworlds, however, the resemblance in intended regards must be substantial. Only then will it be revealed as a feature possessed independently by each artworld that is essential to its being an artworld.

Is there a kind of regard projected for artworks that is common to all artworlds and that is such as to explain how artworlds can be recognized for what they are? In effect, this is what I aimed to establish earlier in this chapter. Initially, if not always, artworks in all cultures are projected for aesthetic regard—that is, for consideration of the aesthetic achievements they are created to display, where these effects concern the whole and are essential to the function the article is designed to serve. This is such a striking feature of art making, viewed across the spread of human cultures, that it explains how we can perceive all cultures as art-making ones and, hence, as having artworlds.

Notes

1. Richard L. Anderson, *Calliope's Sisters: A Comparative Study of Philosophies of Art* (Englewood Cliffs, NJ: Prentice Hall, 1990), 238.

2. For examples, see Jacques Maquet, *Introduction to Aesthetic Anthropology* (Reading, MA: Addison Wesley, 1971), 16; Nelson Graburn, *Ethnic and Tourist Arts: Cultural Expressions from the Fourth World*, ed. Nelson Graburn, 3–4 (Berkeley: University of California Press, 1976); and Sidney Kasfir, "African Art and Authenticity: A Text without a Shadow," *African Arts* 25 (1992): 41–53.

3. See Robert K. Merton, *Social Theory and Social Structure*, enl. ed. (New York: Free Press, 1968), 105, 115–23.

4. Maud Karpeles, "Some Reflections on Authenticity in Folk Music," *Journal of the International Folk Music Council* 3 (1951): 10–14.

5. Denis Dutton, "Art, Behavior, and the Anthropologists," *Current Anthropology* 18 (1977): 387–94.

6. Arthur C. Danto, "The Artworld," *Journal of Philosophy* 61 (1964): 571–84.

7. Arthur C. Danto, "Art and Artifact in Africa," in *Beyond the Brillo Box: The Visual Arts in Post-historical Perspective*, 89–112 (New York: Farrar, Straus & Giroux, 1992).

8. Denis Dutton, "Tribal Art and Artifact," *Journal of Aesthetics and Criticism* 51 (1993): 17.

9. Dutton, "Tribal Art and Artifact," and Denis Dutton, "Authenticity in the Art of Traditional Societies," *Pacific Arts* 9–10 (1994): 1–9.

10. H. Gene Blocker, "Is Primitive Art Art?" *Journal of Aesthetic Education* 25 (1991): 87–97; H. Gene Blocker, *The Aesthetics of Primitive Art* (Lanham, MD: University Press of America, 1993).

11. George Dickie, *The Art Circle: A Theory of Art* (New York: Haven, 1984), 28.

12. Jerrold Levinson, "Defining Art Historically," *British Journal of Aesthetics* 19 (1979): 232–50; Jerrold Levinson, "Refining Art Historically," *Journal of Aesthetics and Art Criticism* 47 (1989): 21–33; Jerrold Levinson, "Extending Art Historically," *Journal of Aesthetics and Art Criticism* 51 (1993): 411–23.

13. Levinson, "Extending Art Historically," 413.

14. Levinson, "Extending Art Historically," 423.

15. Levinson, "Extending Art Historically," 422.

Further Reading

Anderson, James. 2000. Aesthetic concepts of art. In *Theories of art today*, edited by Noël Carroll, 65–92. Madison: University of Wisconsin Press. Argues for an aesthetic definition of art.

Bell, Clive. 1914. *Art*. London: Chatto and Windus. Argues for a formalist definition of art.

Carney, James. 1994. Defining art externally. *British Journal of Aesthetics* 34: 114–23. Defends a historical approach to defining art.

Carroll, Noël. 1993. Essence, expression, and history: Arthur Danto's philosophy of art. In *Danto and his critics*, edited by Mark Rollins, 79–106. Oxford: Basil Blackwell. One of the best expositions of Danto's view on the nature of art.

———. 1994. Identifying art. In *Institutions of art: Reconsiderations of George Dickie's philosophy*, edited by Robert Yanal, 3–38. University Park: Pennsylvania State University Press. Argues that an object can be identified as art if it can be placed in a historical narrative situating it in relation to earlier artworks.

———, ed. 2000. *Theories of art today*. Madison: University of Wisconsin Press. Excellent collection of essays on contemporary attempts to define art.

Danto, Arthur. 1964. The artworld. *Journal of Philosophy* 61: 571–84. An early essay arguing for a historical understanding of the nature of art.

———. 1981. *The transfiguration of the commonplace*. Cambridge, MA: Harvard University Press. Danto's most extensive exploration of the nature of art.

Davies, Stephen. 1991. *Definitions of art*. Ithaca, NY: Cornell University Press. One of the best overviews of the contemporary debate about the definition of art.

Dickie, George. 1974. *Art and the aesthetic: An institutional analysis*. Ithaca, NY: Cornell University Press. Best source of Dickie's early institutional definition of art.

Gaut, Berys. 2000. "Art" as a cluster concept. In *Theories of art today*, edited by Noël Carroll, 25–44. Madison: University of Wisconsin Press. Just what the title says.

Levinson, Jerrold. 1979. Defining art historically. *British Journal of Aesthetics* 19: 232–50. Defends the best-known version of a historical definition of art.

Lopes, Dominic. 2007. Art without "art." *British Journal of Aesthetics* 47: 1–15. Argues that art can be produced in societies that have no concept of art.

Mandelbaum, Maurice. 1965. Family resemblances and generalization concerning the arts. *American Philosophical Quarterly* 2: 219–28. One of the first essays to suggest that art might best be defined in term of nonobservational concepts.

Shiner, Larry. 2001. *The invention of art: A cultural history*. Chicago: University of Chicago Press. Argues that fine art is the product of eighteenth-century thought.

Stecker, Robert. 1986. The end of an institutional definition of art. *British Journal of Aesthetics* 26: 124–32. Argues against Dickie's institutional definition.

——. 1997. *Artworks: Definition, meaning, value*. University Park: Pennsylvania State University Press. Another important overview of the contemporary debate, which proposes a historical-functional definition of art.

Weitz, Morris. 1956. The role of theory in aesthetics. *Journal of Aesthetics and Art Criticism* 15: 27–35. Argues against the possibility of defining art.

Zangwill, Nick. 2007. *Aesthetic creation*. Oxford: Oxford University Press. Defends an aesthetic conception of art.

What Kind of Object Is a Work of Art?

Introduction

For all of his fame, Leonardo da Vinci was a terrible procrastinator who completed very few of the art projects that he started. One of his unfinished paintings, *The Virgin of the Rocks*, has been in London's National Gallery since 1880. For many years, it was located with the remainder of the museum's collection of Renaissance art. Then, in 2006, the film *The Da Vinci Code* directed sudden attention to the painting (along with other artworks and architectural sites featured in the film). Anticipating crowds of visitors who would come to the museum to see the da Vinci painting, the curators of the National Gallery moved it from its usual place, a room deep in the museum, to a room near the front entrance. The move allowed visitors drawn by the painting's status as a da Vinci to see it without disturbing other museum goers.

Now, suppose that the film brings equal attention to all other arts associated with it. As a result, there is suddenly an enormous demand for the music of Richard Harvey, one of several composers who contributed to the score of *The Da Vinci Code*. In particular, suppose Harvey's classical composition *Concerto Antico* becomes hugely popular. Responding to this demand, the London Symphony Orchestra schedules seven concerts a day in London's Barbican Hall in a room that holds twelve hundred people, providing almost the same level of daily access to Harvey's *Concerto Antico* that the National Gallery provides to da Vinci's *The Virgin of the Rocks*.

The first case, moving the da Vinci painting to accommodate the crowds, really happened. The second case, scheduling seven concerts a day of the same music, is an absurd fiction. But why is the latter so absurd? It is not merely that films seldom make stars out of composers—although that does happen from time to time, as when the 1967 film *Elvira Madigan* brought unprecedented attention to the second movement of Mozart's Piano Concerto no. 21. The absurdity stems from our knowing that most people would access the music by listening to a recording of it. And even if they wanted to hear *Concerto Antico* in a live performance, there would be no reason for them to go to Barbican Hall. Any appropriate group of musicians could perform it anywhere in the world where there was an audience for it.

There is an obvious difference in how audiences relate to the two works, *The Virgin of the Rocks* and *Concerto Antico*, and this difference stems from the *kind* of object that each thing is. As a first approximation, we are likely to say that a painting is a physical object, but a musical work is not. So there can only be one *Virgin of the Rocks*, and those who want to view it (rather than, say, a photo of it) can only do so by going to where it is physically located—hence the museum's decision to move the painting. But a musical work can be in many places at once. There have been famous exceptions, as when the Vatican limited performances of Gregorio Allegri's *Miserere* to the Sistine Chapel and did not allow publication of its musical notation. Even then, it was always *possible* for it to have additional performances, inspiring the composer Mozart to visit the Sistine Chapel and, having heard it twice, to write it out from memory and then share it. So where the ontology of painting is singular, with only one authentic instance of each work, the ontology of music is multiple, allowing many instances of the same work. And the latter model easily extends to other performing arts. The same play can be performed in different places at the same time. So can the same ballet. While sophisticated notation is often used to convey an artist's wishes about the basic features of performances, notation is not essential to the process. Folk music enthusiasts have "collected" the same songs in Scotland and America's Appalachia, independently maintained through oral tradition for hundreds of years after immigrants brought these songs to North America. So the ontological issue does not turn on the difference between notated and nonnotated arts.

Although it therefore seems that ontological differences divide the performing arts from the other arts, it is not simply a case of multiple versus single instances. Printmaking allows for multiple authentic instances of the same visual design, and some jazz fans think that true jazz is an improvisational art in which musicians aim to create an unrepeatable musical performance. Or,

for that matter, what about *The Virgin of the Rocks*? The painting in London is one of two nearly identical works created by da Vinci in the course of fulfilling a commission for a church in Milan. The second, later painting is in the Louvre, in Paris. (The only significant difference is the hand gesture of the angel Uriel.) Although the historical record is sketchy, da Vinci may have sold the painting in the National Gallery to a private buyer in order to raise cash, then painted another to collect on his commission.

How do these two paintings relate to one another? When painted by the same artist, are these two instances of one artwork, challenging the thesis that paintings are singular? Or are they necessarily distinct works because they are paintings? Does the process of painting make each painting unique? On the other hand, if the creation process is relevant, then we seem to presuppose very different standards for painting than for performing arts. In the latter, the performance process often results in significant differences in performances, differences that are far more obvious than those that exist in the two da Vinci paintings. Furthermore, it is not altogether clear that the painting in London is quite what da Vinci intended for us to admire. Some details, such as the staff that identifies one baby as John the Baptist, were added to the painting at a later date. Are these additions to be understood as part of the same painting or as an interpretation that does not actually belong to this work of art?

Exploring fundamental differences in the kinds of objects created in the various arts, Richard Wollheim opened the door to a robust debate that has centered on the nature of musical works. Wollheim proposes that questions about the identity of any particular work of art—whether, for example, *The Virgin of the Rocks* remains the same painting after someone alters the design by adding new details—depend on philosophical accounts of the proper criteria for their individuation. Historical facts are not sufficient to settle the matter. Wollheim is willing to grant that paintings and carved sculptures are particulars, that is, unique individuals that come into existence only once, through some specific act of creation, and whose identity requires their continuous existence. However, musical works are his primary case of nonparticular artworks. They can have multiple instances and can exist apart from the existence of any particular thing. Arguing that they are unlike classes or universals, the other generic entities discussed by philosophers, Wollheim argues that nonparticular artworks are types and their many instances are tokens of the type. Conceptually, we are already familiar with this relationship as it applies to human inventions other than artworks. The Boeing 707, for example, is a type of aircraft, and a fixed number of particular airplanes are tokens of this type. Similarly, a

Beethoven symphony is a type, and its performances are its tokens. The significant point is that the type tells us which properties are necessarily present in order for a particular to be a token of a given type. One can perform all the music that Beethoven wrote for his Fifth Symphony without actually performing it. Beethoven specified that the four movements of the Fifth Symphony are to proceed in a specific order. Change their order and one is not performing his symphony.

Although a type tells us which properties are necessary, tokens will have more properties than are specified by the work's creator. Performances of Beethoven's Fifth Symphony always have a determinate length, and these can vary by several minutes. One conductor may take thirty-two minutes. Another may take thirty-four. Yet both will preserve all of its type-necessary properties, including tempo indications. As a result, the work admits of interpretation in producing tokens of it. Philosophers call this the underdetermination of tokens by types.

Paul Thom suggests that, like works for performance, a painting's features are subject to change each time it is interpreted. The particular objects that present paintings to viewers underdetermine its properties. We cannot sustain our ordinary distinction between a painting's own properties and a viewer's interpretation of the work. Just as a performer must choose among competing properties though interpretation, viewers of a painting make sense of it by interpreting it, selecting among its various possible properties. As a result, Thom advocates constructivism, the view that works of art lack a fixed nature. Responding to Van Gogh's painting *The Potato Eaters*, some critics regard the painter's signature as an important element of the painting, while others do not think it counts as a feature. Disagreeing on this, different critics construct different objects of interpretation. The physical object may be the same, but the intentional object is quite different.

Thom goes further: no artwork is a physical object. Paintings are meant to be interpreted, and interpretation is a conceptually guided activity. To put it another way, an uninterpreted painting is just a physical thing consisting of dried paint on a flat surface, and an uninterpreted musical performance is noise. The artwork emerges in the act of interpretation, as an object-under-a-concept. Where the object has features that make no sense, there is no principled objection to correcting, cutting, and otherwise changing it to better reflect the concepts it embodies. The painter who changed *The Virgin of the Rocks* clarified it, in much the way that we rearrange songs and the texts of plays in order to make them accessible to various audiences. So is this a legitimate activity? Many see it as a kind of falsification.

In contrast to Thom, Wollheim endorses contextualism. The creator of a new type does so in a personal and cultural context that, properly understood by later audiences, establishes the necessary properties for the work. When Beethoven indicates that his Ninth Symphony has an allegro first movement and an adagio third, he has specified that the third has a slower tempo than the first. These are facts about the work, fixed forever during the act of composition, and these facts limit performance interpretations and constrain all other critical interpretation. Where these facts are correctly understood, we have no license to alter the work or to otherwise interpret them out of the work.

Contextualism places considerable weight on the time and place of artistic creation. What if, as Julian Dodd contends, musical works cannot be created by human activity? Dodd argues that, as types, they are discovered by composers rather than invented by them. This position shares contextualism's denial that a musical work is an object-under-a-concept, yet it also denies that a great many properties arising from the composer's own historical context are just as dispensable as those put on it by later generations. All generic objects exist eternally, and therefore no human context can add or contribute necessary properties to the type. Beethoven could no more create what we call his Fifth Symphony than he could create triangularity or the number five. Consequently, his expectation that we perform the music with violins and woodwinds rather than electronic synthesizers is ultimately irrelevant to the authenticity of its tokens.

Robert Howell attacks Dodd's view by noting that many types depend on historical contingencies and so are not eternal objects. Beethoven's symphonies form a class, but Beethoven-influenced symphonies are a type, the features of which essentially depend on there having been a person, Ludwig van Beethoven. Johannes Brahms's First Symphony is decidedly Beethoven influenced, but this type can only be stipulated by reference to a historical contingency. So Dodd is wrong to think that all types are eternal. Given that Beethoven's Fifth is the sound structure indicated by Beethoven in the early nineteenth century, its specification requires reference to Beethoven and so, as a type, it cannot be eternal either. It does not matter whether there is an abstract structure, such as a pure sound structure, that preexists Beethoven's life. (Some of Beethoven's works reflect sonata-allegro form, a musical type that he inherited. This admission does not rule out his originality in creating new types within this more general type.) Beethoven's historically contingent choices both define the type that is the Fifth Symphony, as well as many other types, such as being Beethoven influenced. For Howell, artwork types are inherently contextual.

⟨∞⟩

Art and Its Objects*

Richard Wollheim

Let us begin with the hypothesis that works of art are physical objects. I shall call this for the sake of brevity the "physical-object hypothesis." Such a hypothesis is a natural starting point: if only for the reason that it is plausible to assume that things are physical objects unless they obviously aren't. Nevertheless the hypothesis that all works of art are physical objects can be challenged. For our purposes it will be useful, and instructive, to divide this challenge into two parts: the division conveniently corresponding to a division within the arts themselves. For in the case of certain arts the argument is that there is no physical object that can with any plausibility be identified as the work of art: there is no object existing in space and time (as physical objects must) that can be picked out and thought of as a piece of music or a novel. In the case of other arts—most notably painting and sculpture—the argument is that, though there are physical objects of a standard and acceptable kind that could be, indeed generally are, identified as works of art, such identifications are wrong.

That there is a physical object that can be identified as *Ulysses* or *Der Rosenkavalier* is not a view that can long survive the demand that we should pick out or point to that object. For instance, it would follow that if I lost my copy of *Ulysses*, *Ulysses* would become a lost work. Again, it would follow that if the critics disliked tonight's performance of *Rosenkavalier*, then they dislike *Rosenkavalier*. Clearly neither of these inferences is acceptable.

But, it might now be maintained, of course it is absurd to identify *Ulysses* with my copy of it or *Der Rosenkavalier* with tonight's performance, but nothing follows from this of a general character about the wrongness of identifying works of art with physical objects. For what was wrong in these two cases was the actual physical object that was picked out. The validity of the physical-object hypothesis, like that of any other hypothesis, is quite unaffected by the consequences of misapplying it.

For instance, it is obviously wrong to say that *Ulysses* is my copy of it. Nevertheless, there is a physical object, of precisely the same order of being as my copy, though significantly not called a "copy," with which such an identification would be quite correct. This object is the author's manuscript: that, in other words, which Joyce wrote when he wrote *Ulysses*.

*From *Art and its Objects*, 2nd ed., pp. 4–10 and 74–83. © Cambridge University Press, 1980. Reprinted with the permission of Cambridge University Press.

But the connection does not justify us in asserting that one just is the other. Indeed, to do so seems open to objections not all that dissimilar from those we have just been considering. The critic, for instance, who admires *Ulysses* does not necessarily admire the manuscript. And—here we have come to an objection directly parallel to that which seemed fatal to identifying *Ulysses* with my copy of it—it would be possible for the manuscript to be lost and *Ulysses* to survive. None of this can be admitted by the person who thinks that *Ulysses* and the manuscript are one and the same thing.

Moreover, it is significant that in the case of *Rosenkavalier* it is not even possible to construct an argument corresponding to the one about *Ulysses*. To identify an opera or any other piece of music with the composer's holograph, which looks the corresponding thing to do, is implausible because (for instance), whereas an opera can be heard, a holograph cannot be.

A final and desperate expedient to save the physical-object hypothesis is to suggest that all those works of art which cannot plausibly be identified with physical objects are identical with classes of such objects. A novel, of which there are copies, is not my or your copy but is the class of all its copies. (Of course, strictly speaking, this suggestion doesn't save the hypothesis at all: since a class of physical objects isn't necessarily, indeed is most unlikely to be, a physical object itself. But it saves something like the spirit of the hypothesis.)

However, it is not difficult to think of objections to this suggestion. Ordinarily we conceive of a novelist as writing a novel, or a composer as finishing an opera. But both these ideas imply some moment in time at which the work is complete. Now suppose (which is not unlikely) that the copies of a novel or the performances of an opera go on being produced for an indefinite period: then, on the present suggestion, there is no such moment, let alone one in their creator's lifetime. So we cannot say that *Ulysses* was written by Joyce, or that Strauss composed *Der Rosenkavalier*. Or, again, there is the problem of the unperformed symphony.

But perhaps a more serious, certainly a more interesting, objection is that in this suggestion what is totally unexplained is why the various copies of *Ulysses* are all said to be copies of *Ulysses* and nothing else, why all the performances of *Der Rosenkavalier* are reckoned performances of that one opera. The effect, indeed precisely the point, of the present suggestion is to eliminate the possibility of any such reference: if a novel or opera just is its copies or its performances, then we cannot, for purposes of identification, refer from the latter to the former.

The possibility that remains is that the various particular objects, the copies or performances, are grouped as they are, not by reference to some other

thing to which they are related, but in virtue of some relation that holds between them: more specifically, in virtue of resemblance.

But, in the first place, all copies of *Ulysses*, and certainly all performances of *Der Rosenkavalier*, are not perfect matches.

Secondly, it seems strange to refer to the resemblance between the copies of *Ulysses* or the performances of *Rosenkavalier* as though this were a brute fact. It would be more natural to think of this so-called fact as something that itself stood in need of explanation. In other words, to say that certain copies or performances are of *Ulysses* or *Rosenkavalier* because they resemble one another seems precisely to reverse the natural order of thought: the resemblance, we would think, follows from, or is to be understood in terms of, the fact that they are of the same novel or opera.

I want to break off the present discussion and go back and take up an undischarged commitment: which is that of considering the consequences of rejecting the hypothesis that works of art are physical objects, insofar as those arts are concerned where there is no physical object with which the work of art could be plausibly identified.

Once it is conceded that certain works of art are not physical *objects*, the subsequent problem that arises, which can be put by asking, What sort of thing are they? is essentially a logical problem. It is that of determining the criteria of identity and individuation appropriate to, say, a piece of music or a novel. I shall characterize the status of such things by saying that they are (to employ a term introduced by Peirce) *types*. Correlative to the term "type" is the term "token." Those physical objects which (as we have seen) can out of desperation be thought to be works of art in cases where there are no physical objects that can plausibly be thought of in this way, are *tokens*. In other words, *Ulysses* and *Der Rosenkavalier* are types; my copy of *Ulysses* and tonight's performance of *Rosenkavalier* are tokens of those types. The question now arises, What is a type?

The question is very difficult, and, unfortunately, to treat it with the care and attention to detail that it deserves is beyond the scope of this essay.

We might begin by contrasting a type with other sorts of things that it is not. Most obviously we could contrast a type with a *particular*. Then we could contrast it with other various kinds of nonparticulars: with a *class* (of which we say that it has *members*), and a *universal* (of which we say that it has *instances*). An example of a class would be the class of red things: an example of a universal would be redness: and examples of a type would be the word "red" and the Red Flag—where this latter phrase is taken to mean not this or that piece of material, kept in a chest or taken out and flown at a masthead, but the flag of revolution, raised for the first time in 1830 and that which many would willingly follow to their death.

Let us introduce as a blanket expression for types, classes, and universals, the term *generic entity*, and, as a blanket expression for those things which fall under them, the term *element*. Now we can say that the various generic entities can be distinguished according to the different ways or relationships in which they stand to their elements. These relationships can be arranged on a scale of intimacy or intrinsicality. At one end of the scale we find classes, where the relationship is at its most external or extrinsic: for a class is merely made of, or constituted by, its members which are extensionally conjoined to form it. The class of red things is simply a construct out of all those things which are (timelessly) red. In the case of universals the relation is more intimate; in that a universal is present in all its instances. Redness is in all red things. With types we find the relationship between the generic entity and its elements at its most intimate: for not merely is the type present in all its tokens like the universal in all its instances, but for much of the time we think and talk of the type as though it were itself a kind of token, though a peculiarly important or preeminent one (cf. "We'll keep the Red Flag flying high").

These varying relations in which the different generic entities stand to their elements are also reflected (if, that is, this is *another* fact) in the degree to which both the generic entities and their elements can satisfy the same predicates. Here we need to make a distinction between sharing properties and properties being transmitted. I shall say that when A and B are both f, f is shared by A and B. I shall further say that when A is f because B is f, or B is f because A is f, f is transmitted between A and B. (I shall ignore the sense or direction of the transmission, i.e., I shall not trouble, even where it is possible, to discriminate between the two sorts of situation I have mentioned as instances of transmission.)

We now need to say what it is for various particulars to be gathered together as tokens of the same type. For it will be appreciated that there corresponds to every universal and to every type a class: to redness the class of red things, to the Red Flag the class of red flags. But the converse is not true. The question therefore arises, What are the characteristic circumstances in which we postulate a type? The question, we must appreciate, is entirely conceptual: it is a question about the structure of our language.

A very important set of circumstances in which we postulate types—perhaps a central set, in the sense that it may be possible to explain the remaining circumstances by reference to them—is where we can correlate a class of particulars with a piece of human invention: these particulars may then be regarded as tokens of a certain type. This characterization is vague, and deliberately so: for it is intended to comprehend a considerable spectrum of cases. At one end we have the case where a particular is produced, and is

then copied: at the other end, we have the case where a set of instructions is drawn up which, if followed, give rise to an indefinite number of particulars. An example of the former would be the Brigitte Bardot looks: an example of the latter would be the Minuet. Intervening cases are constituted by the production of a particular one which was made in order to be copied, e.g., the Boeing 707, or the construction of a mould or matrix which generates further particulars.

It will be clear that the preceding characterization of a type and its tokens offers us a framework within which we can (at any rate roughly) understand the logical status of things like operas, ballets, poems, etchings, etc.: that is to say, account for their principles of identity and individuation. To show exactly where these various kinds of things lie within this framework would involve a great deal of detailed analysis, more than can be attempted here. I shall touch very briefly upon two general sets of problems, both of which concern the feasibility of the project. [First,] I shall deal with the question of how the type is identified or (what is much the same thing) how the tokens of a given type are generated. [Next,] I shall deal with the question of what properties we are entitled to ascribe to a type. These two sets of questions are not entirely distinct.

First, then, as to how the type is identified. In the case of any work of art that it is plausible to think of as a type, there is what I have called a piece of human invention: and these pieces of invention fall along the whole spectrum of cases as I characterized it. At one end of the scale, there is the case of a poem, which comes into being when certain words are set down on paper or perhaps, earlier still, when they are said over in the poet's head. At the other end of the scale is an opera which comes into being when a certain set of instructions, i.e., the score, is written down, in accordance with which performances can be produced. As an intervening case we might note a film, of which different copies are made: or an etching or engraving, where different sheets are pulled from the same matrix, i.e., the plate.

There is little difficulty in all this, so long as we bear in mind from the beginning the variety of ways in which the different types can be identified, or (to put it another way) in which the tokens can be generated from the initial piece of invention. It is if we begin with too limited a range of examples that distortions can occur. For instance, it might be argued that, if the tokens of a certain poem are the many different inscriptions that occur in books reproducing the word order of the poet's manuscript, then "strictly speaking" the tokens of an opera must be the various pieces of sheet music or printed scores that reproduce the marks on the composer's holograph. Alternatively, if we insist that it is the performances of the opera that are the

tokens, then, it is argued, it must be the many readings or "voicings" of the poem that are its tokens.

Such arguments might seem to be unduly barren or pedantic, if it were not that they revealed something about the divergent media of art.

It is, we have seen, a feature of types and their tokens, not merely that they may share properties, but that when they do, these properties may be transmitted. The question we have now to ask is whether a limit can be set upon the properties that may be transmitted: more specifically, since it is the type that is the work of art and therefore that with which we are expressly concerned, whether there are any properties—always of course excluding those properties which can be predicated only of particulars—that belong to tokens and cannot be said ipso facto to belong to their types.

But there is no way of determining the properties that a token of a given type has necessarily, independently of determining the properties of that type: accordingly, we cannot use the former in order to ascertain the latter. We cannot hope to discover what the properties of the Red Flag are by finding out what properties the various red flags have necessarily: for how can we come to know that, e.g., this red flag is necessarily red, prior to knowing that the Red Flag itself is red?

There are, however, three observations that can be made here on the basis of our most general intuitions. The first is that there are no properties or sets of properties that cannot pass from token to type. With the usual reservations, there is nothing that can be predicated of a performance of a piece of music that could not also be predicated of that piece of music itself. This point is vital. For it is this that ensures the harmlessness of denying the physical-object hypothesis in the domain of those arts where the denial consists in saying that works of art are not physical *objects*. For though they may not be objects but types, this does not prevent them from having physical properties. There is nothing that prevents us from saying that Donne's *Satires* are harsh on the ear, or that Durer's engraving of St. Anthony has a very differentiated texture, or that the conclusion of "Celeste Aida" is pianissimo.

The second observation is that, though any single property may be transmitted from token to type, it does not follow that all will be: or to put it another way, a token will have some of its properties necessarily, but it need not have all of them necessarily.

Thirdly, in the case of *some* arts it is necessary that not all properties should be transmitted from token to type: though it remains true that for any single property it might be transmitted. The reference here is, of course, to the performing arts—to operas, plays, symphonies, ballet. It follows from what was said above that anything that can be predicated of a performance

of a piece of music can also be predicated of the piece of music itself: to this we must now add that not every property that can be predicated of the former ipso facto belongs to the latter. This point is generally covered by saying that in such cases there is essentially an element of *interpretation*, where for these purposes interpretation may be regarded as the production of a token that has properties in excess of those of the type.

"Essentially" is a word that needs to be taken very seriously here. We need to envisage what would be involved if it were to be even possible to eliminate interpretation. For instance, one requirement would be that we should have for each performing art what might be called, in some very strong sense, a universal notation: such that we could designate in it every characteristic that now originates at the point of performance. Can we imagine across the full range of the arts what such a notation would be like? With such a notation there would no longer be any executant arts: the whole of the execution would have been anticipated in the notation. What assurance can we have that the reduction of these arts to mere mechanical skills would not in turn have crucial repercussions upon the way in which we regard or assess the performing arts?

⁓◯⁓

Interpretation: Process and Structure*

Paul Thom

Whenever an object is interpreted, it gets interpreted as something. An interpretation *lends significance* to its object by fitting the object (under a particular representation) to a governing concept.

Interpretation is making sense. But sense can be made of something in two ways. The difference between them corresponds to the difference between something's making sense and our making sense of it. Roughly, this corresponds to the two possible directions of the relation of fit—concept-to-object or object-to-concept. In the first case, interpretations are discovered: by finding out something about the object of interpretation we come to understand it. In the second case interpretations are invented: we make of the object something it previously was not. Interpretations of the first type aim to be authoritative; interpretations of the second type aim rather at playfulness.

Significance characteristically comes about not just case by case but systematically. The elements in significance-systems are rules to the effect that particular items or types of items possess particular significances or types of

*From *Making Sense: A Theory of Interpretation*, pp. 28–48 (Lanham, MD: Rowman & Littlefield, 2000). Reprinted by permission of the publisher.

significance. These rules may state what a given item *signifies*; or they may state what (or what kind of) *significance* the item has.

A language includes such a system of rules. The word "bald" signifies what it signifies in English by virtue of belonging to one significance-system; it signifies what it signifies in German by virtue of belonging to another significance-system. A sequence of actions might be a significance-system: this is why a text can be given enhanced significance by being performed. The word "bald," while not losing its significance as an English word, takes on new types of significance when it is *uttered* by someone in a particular context. It might be a pun, a warning, a distraction, etc. Equally, codes including codes of conduct, styles of performance, and scientific theories are significance-systems. All endow what falls within them with a special type of significance.

Consider Rigoletto's moment of truth as he drags the sack toward the river, believing it to contain the Duke's body:

Ora mi guarda, o mondo . . .
Quest'è un buffone, ed un potente è questo!
(Now, everyone, look at me, . . .
here you see a clown, and there a man of power!)

The significance of the situation for Rigoletto is that it is his moment of *revenge* on the Duke. But Rigoletto's belief is false. When he hears the Duke's voice in the distance, the significance of his situation changes totally. The horrific realization dawns on him that it is his own daughter's body he carries in the sack and that he remains very much under the Duke's heel. As he holds his dying daughter in his arms, he cries out, "Ah, la maledizione!" and in doing so gives voice to another interpretation, an interpretation that makes sense of the otherwise senseless death of his daughter by attributing it to Monterone's curse. We understand this changing significance because we understand the significance-system of operatic melodrama.

We have analyzed interpretation as an operation in which sense is made of an object by representing the object in some way placing that representation in an appropriate context; and conceptualizing that representation within some significance-system.

Is this account adequate? Have we left anything out? Could two saliently different interpretations be indistinguishable in these three respects? It seems so.

Identifying the Object
Interpreters start by identifying the objects of their activity. This they do by selecting a set of identifying features. Such an identification is revisable.

Thomas Kuhn has shown that the ancient Greeks classified as meteoro-
logical a range of phenomena that modern science doesn't see as belong-
ing to any single class. Whereas the ancients lumped rainbows and winds
together with what we call stars and planets as calling for a single explana-
tory interpretation, the moderns have revised, and narrowed, this object.

Selecting the Type of Governing Concept

The process involves the selection of a type of governing concept. The
Greek physicists, to their credit, wanted *natural explanations* of celestial
phenomena, even if they sometimes looked for them in the wrong places.
In so wishing, they were choosing one type of governing concept over oth-
ers as the basis for their interpretations. They might, instead of trying to
explain celestial phenomena by natural causes, have sought supernatural
explanations or aesthetic interpretations. Here we have three types of
governing concepts.

To make sense of the object, the interpreter needs to decide what type of
significance is going to be assigned to it—in other words, to select a type of
governing concept under which the salient aspects of the object are going to
be synthesized. At this stage the interpreter asks questions like, What does
the object represent or express? What is it a part of? What is it really? or
What is its explanation?

When you classify a piece of discourse as an enthymeme, you are assign-
ing a kind of significance to it—the kind of significance possessed by an
argument. In so classifying it, you take it to be an incompletely formulated
argument and you take its incomplete formulation as demanding remedy by
further interpretation. Thus, to classify something as an enthymeme while
being unable to fill in its missing premises is precisely to be at this stage of
the interpretive process and not to have advanced to later stages.

E. D. Hirsch spends some space discussing this stage of the process under
the heading of "genre."[1] He sees genre as something posited at the start of
a process of interpretation but that gets revised in the course of the process:
"A generic conception is apparently not something stable but something
that varies in the process of understanding. At first it is vague and empty;
later, as understanding proceeds, the genre becomes explicit and its range of
expectations becomes much narrower."[2] (As expectations narrow, however,
they may be defeated, and interpreters may find that they have been looking
for the wrong type of significance.)

It is important to remember that the governing concept is not always *given*;
sometimes it is constructed by the interpreter. It is the mark of major interpret-
ers, in the arts as well as the sciences, that they *invent* governing concepts.

Representing the Object to Fit a Concept of the Required Type
It may be that no governing concept of the chosen type fits the object as
things stand; in order to achieve such a fit, the object may need to be rep-
resented. Equally, it may be that, because a given concept of the required
type doesn't fit the current representation of the object, a new governing
concept must be found or forged. It may involve adjusting the concept to
fit the object, or modifying the object to fit the concept, or both. This
stage finds linguistic expression in exclamations like "Ah, I see. It's the
prompter!" or "I can just see it as a musical!" The object has to be *seen*
as the prompter's voice; the object has to be *turned into* a musical. In the
one case, seeing involves insight, in the other, imagination—correspond-
ing respectively to adequational and constructive interpretation. In both
cases the interpreter's "seeing" appears as something that is not under the
control of rules.

Adequational Interpretation
The concept may be fitted to the object. This happens in cases of interpre-
tation that rest on an insight into the object's nature. But even these cases
involve representing the object in such a way that the governing concept
evidently applies to it. Prominent among the types of representation used here
is restructuring.

The object may already be thought of as structured in certain ways: its
specification may include not just a set of features but also some metafeatures
that order or prioritize certain of its first-order features. This structuring
may need to be changed if the object is to fall under the chosen governing
concept. What had been thought of as primary features of the object may
have to recede; other aspects may have to be foregrounded. Michael Krausz
discusses an interesting example. For purposes of interpretation, the features
of Van Gogh's painting *The Potato Eaters* get structured differently by its
different interpreters. To H. P. Bremmer, what is salient in the painting are
certain formal features, including the correspondence between the members
of the family and their coffee cups.[3] Another interpreter, H. R. Graetz, while
recognizing those features as part of the object of interpretation, highlights
other features—the direction and expressive content of the subjects' gazes,
the wall separating the older woman and man, the name "Vincent" on the
chair at the left, the lantern, and the steam rising from the hot potatoes
and coffee.[4] These different structurings of the object are determined by the
different governing concepts adopted by the two interpreters. In Bremmer's
interpretation, the governing concept is "interrelated unity"; this is the sig-
nificance that the interpreter finds in the object's internal formal relations.

In Graetz's interpretation, the gazes and the separating wall—set off against the light-giving lantern and the warming steam—are brought together under the governing concept "expression of isolation." What the example shows is that it would be rational for two interpreters, trying respectively to portray the painting as a formal unity and in terms of its expressive qualities, to highlight different subsets of its features.

Constructive Interpretation

In constructive interpretation the direction of fit is object-to-concept, and interpretive strategies include correction, cuts, and reconstitution.

The process of restructuring is conservative: it leaves the object's content unaltered. By contrast, the strategy of correction changes the object's features. For example, an interpreter who is trying to constitute an authoritative text might alter a passage in the text on the ground that it embodies an error of some kind.

Dennis Bartholomeusz has written on eighteenth-century adaptations of Shakespeare's *The Winter's Tale*, commenting that "an attempt was made to preserve the romance and joy of *The Winter's Tale* without its grief and desolation."[5] This type of interpretive move takes certain features of the object to be undesirable and therefore omits them in the object-as-represented; at the same time other features that may or may not be present in the object are taken as desirable and their presence in the object-as-represented is heightened. Romance and joy are the governing concepts that draw together eighteenth-century versions of *The Winter's Tale* under such an interpretation. These are features of the play, along with the unwanted features of grief and desolation. The object, in these cases, is being fitted to the concept rather than the other way round.

The sorts of reasons that get advanced in favor of such cuts may be illustrated by a few examples. Here are three critics writing on David Garrick's adaptation:

> Besides giving an elegant form to a monstrous composition, you have in your own additions written up the best scenes in this play. [William Warburton][6]
>
> Without considerable alterations, fine music, gay scenes, beautiful decoration and excellent performers, I would not hazard *The Faithful Shepherdess* upon a London stage in these cultivated times. [Thomas Davies][7]
>
> It is possible that extended into Five Acts the Improbabilities and Changes of Place would have tired, whereas at present the whole is more compact, Absurdities are retracted, and our Attention is alive Throughout. [*London Chronicle*][8]

Elegance, fine music, gay scenes, beautiful decoration, and excellent per-
formers—all subsumed under a governing concept of cultivation—are here
taken as the salient features of Garrick's interpretation. They are judged to
be lacking in the object (Shakespeare's play), which, on the contrary, is
characterized by the unwanted features of "monstrousness," "improbability,"
"tiresomeness," and "absurdity."

An even more radical type of representation may occur: reconstitution.
This may take two forms. Conservative reconstitution identifies an aim of
the object of interpretation and reconstitutes the object so as to achieve that
aim better. Radical reconstitution substitutes a (supposedly) better aim and
constitutes an object that aims to achieve this new aim.

As an example of conservative reconstitution consider Chopin's last re-
cital.

> We have it on the authority of Sir Charles Hallé that when Chopin, at his
> final Paris recital (at the Salle Pleyel on Wednesday 16 February 1848), played
> his Barcarolle, he did so by changing the dynamics of bars 84 ff. from forte cre-
> scendo to pianissimo, "but with such wonderful nuances, that one remained in
> doubt if this new reading were not preferable to the accustomed one."[9]

Sometimes interpreters—even, as in this case, authors qua interpreters—go
counter to what the text requires in the name of improving on the text, while
acknowledging the text's aims for what they are. (At least, we may suppose
that this is what Chopin was doing.)

Ates Orga and Nikolai Demidenko, writing about this case, take a further
interpretive step: "In the parlance of computer software, Chopin's music, as
an experience, is 'virtual,' capable of being realized and understood in any
number of ways, each different yet compatible."[10]

Sometimes in the process of matching object and concept, a focus is
maintained on the original object of interpretation. In radical reconstitu-
tion, however, the focus on the original object is lost, forgotten, subverted,
or rejected; and though the process may end up with a product having the
characteristics of an interpretation, it is no longer an interpretation of that
original object.

The Otis Blackwell rhythm-and-blues song "Fever" was recorded by Peggy
Lee in 1958 and again (in a video recording) by Madonna in 1993. The two
performers make something totally different of the song. First of all, consider
the music. Madonna's musical arrangement is cluttered compared to the sug-
gestively spare Lee version. Madonna's rhythm marches mechanically, with

its thudding disco beat, in contrast to the Lee version, which critics describe as "finger-snapping" and "jazzy,"[11] adding that Lee "is a rhythm singer, who moves all around the beat and swings intensely."[12]

Peggy Lee's voice has been described as having "the texture of a sugared almond";[13] the texture of Madonna's voice perhaps is more like an aging cashew. Altogether, Lee's version possesses a musical eroticism lacking in Madonna's.

But does any of this matter? Is Madonna's version primarily a musical performance? David Tetzlaff doesn't think so. He dismisses the musical element in Madonna's performances: "*Irrelevant* is quite a good word to describe the role musical values play in the Madonna phenomenon."[14]

Actually, the music is far from irrelevant in the construction of her total performance, being the base on which it builds: the choreography and camera work presuppose it and are structured by it. (It's also true that the singing and the musical interpretation generally are pretty basic in another sense.) But Tetzlaff has a point. The music, while well integrated with the other elements in Madonna's interpretation, has subsided to a minor place in the whole. Just as in Gounod's *Ave Maria*—where a Bach prelude is reduced to the status of an accompaniment—it is appropriate here to speak of *reconstitution* of the song. Madonna's reconstitution of the song occurs at two levels. There are aesthetic features of her performance, including the stage production; even at the aesthetic level, her "Fever" is not just a song but is framed by simple and effective staging and choreography that hold the viewer's attention through their clear narrative line and stylized simulation of sexual activity. The song has been conceived as, and represented as, a production number—one in which the music has been relegated to a position of minor importance.

Of greater importance is the performance's political dimension, which is complex. One part of it is carried by Madonna's image as an "iconoclastic teenage idol,"[15] challenging boundaries of the sexually permissible. (Though her "Fever" is so highly stylized that it excludes any possibility of giving offense.) Another political element in her reinterpretation of "Fever," and in her performances generally, is carried by that aspect of Madonna's image, which, in Douglas Kellner's words, "highlights the social constructedness of identity, fashion, and sexuality."[16]

In keeping with this message, there is a high degree of irony in Madonna's performances. Her look at the camera shortly after the start of "Fever" continues a recurring feature of her performances. Kellner sees this gesture as signifying that "Madonna would reveal something of herself in the video, but

that she knew that her performance was an act and that she would maintain her control and subjectivity."[17]

Later in the video she winks at the audience, a gesture that is open to a similar reading. Because of this ironic element, it's not always clear what Madonna's political message is. Madonna presents herself (and represents women) as utterly self-possessed, always in control; and some commentators take this to show that her political message is a feminist one. Others take her highlighting of fashion and of her own body as antifeminist. The issue is complex, and raises the question of the very meaning of "feminism," but for present purposes it need not be pursued. Instead, we should query the need for there to be an unambiguous political message. Madonna's performances are art, after all—art that incorporates a play of sometimes conflicting social and political ideas. That play of ideas and images provokes a multiplicity of audience interpretations. While this is bad news for those awaiting a definite political message, it is to Madonna's credit as an artist. Drawing these strands together, we can say—by way of interpretation—that the reconstituted object is subsumed in Madonna's interpretation under a governing concept of *performance*. But this concept of performance is a special one, one that involves self-reference and that is of Madonna's own devising, drawing together elements from gym culture, the world of youth fashion, and Madonna's own performances.

It would be possible to interpret Madonna's "Fever" as an interpretation of the song—an interpretation, perhaps, that passes a sardonic comment on its object. On this view, she illuminates the song but casts it in an unfavorable light. On another view, Madonna's performance is not an interpretation at all but merely the product of a process whose starting point was the song.

Hermeneutic Circles

In speaking of these four stages in the protoprocess of interpretation, I don't mean to suggest that in practice interpretation always proceeds from the identification of an object judged to be deficient in a certain type of significance via its subsumption under a governing concept to its representation under a suitable scheme. The actual sequence of events is rarely so straightforward, as Hirsch observes:

> We *cannot* understand a part as such until we have a sense of the whole. [Wilhelm] Dilthey called this apparent paradox the hermeneutic circle and observed that it was not vicious because a genuine dialectic always occurs between our

idea of the whole and our perception of the parts that constitute it. Once the dialectic has begun, neither side is totally determined by the other.[18]

Hirsch notes that in some later versions (he mentions Heidegger), the hermeneutic circle appears as the idea of an "unalterable and inescapable pre-understanding." By contrast, Hirsch—rightly, I think—prefers to emphasize the temporal aspect of the process and the revisability of its terms, and it seems that Dilthey's reference to a "dialectic" would also sanction this approach.

In the process of interpreting, we sometimes find that the object-as-represented cannot be made to fit the concept without substantially changing one or the other. In this case we can try varying the concept or varying the object, adapting one to fit the other. Thus a genuine dialectic arises among the terms of the interpretation in which any one of them may be adjusted to fit the others.

Notes

1. E. D. Hirsch Jr., "The Concept of Genre," in *Validity in Interpretation*, 68–126 (New Haven, CT: Yale University Press, 1967), ch. 3.

2. Hirsch, *Validity*, 77.

3. Michael Krausz, *Rightness and Reasons: Interpretation in Cultural Practices* (Ithaca, NY: Cornell University Press, 1993), 72.

4. Krausz, *Rightness and Reasons*, 73.

5. Dennis Bartholomeusz, *The Winter's Tale in Performance in England and America, 1611–1976* (Cambridge: Cambridge University Press, 1982), 29.

6. Bartholomeusz, *The Winter's Tale*, 37.

7. Bartholomeusz, *The Winter's Tale*, 38.

8. Bartholomeusz, *The Winter's Tale*, 34.

9. Ates Orga and Nikolai Demidenko, liner notes to Chopin, *The Four Scherzi*, Nikolai Demidenko, Hyperion CDA66514, 1991.

10. Orga and Demidenko, liner notes to Chopin, *The Four Scherzi*.

11. Phil Hardy and Dave Laing, *The Faber Companion to Twentieth-Century Popular Music*, rev. ed. (London: Faber & Faber, 1995), 484.

12. Hardy and Laing, *The Faber Companion*.

13. Liner notes to Peggy Lee, *Peggy Lee: Twenty-Four Great Songs*, Personality PRS 23012.

14. David Tetzlaff, "Metatextual Girl," in *The Madonna Connection*, ed. Cathy Schwichtenberg, 239–63 (Boulder, CO: Westview Press, 1993), 240.

15. Hardy and Laing, *The Faber Companion*, 605.

16. Douglas Kellner, "Madonna, Fashion, and Identity," in *On Fashion*, ed. Shari Benstock and Suzanne Ferriss, 159–82 (New Brunswick, NJ: Rutgers University Press, 1994), 159.

17. Kellner, "Madonna," 171.
18. Hirsch, *Validity*, 259.

⸙

Musical Works as Eternal Types*

Julian Dodd

On 27 May 1992 the Wynton Marsalis Septet premiered Marsalis's *In This House, On This Morning*. Their actions brought about a *sound-sequence-occurrence*: a datable, locatable occurrence of a pattern of sounds. This sound-sequence-occurrence was an occurrence of the work. Yesterday I produced another sound-sequence-occurrence of *In This House, On This Morning* when I placed a compact disc in my compact disc player and pressed "play." But what sort of thing is the musical work which was both performed by the band and played on my compact disc player?

It has become customary to regard works of music as *generic entities*: abstract objects which have sound-sequence-occurrences as instances. And once this move has been made, it is compelling to go on to construe a musical work as a particular sort of generic entity: "to wit, a structural type or kind."[1] That *In This House, On This Morning* should be regarded as a type whose tokens are sound-sequence-occurrences is something which Jerrold Levinson and I agree upon. But what *type* of type is it? A simple view has it that the work is what Levinson has christened "a sound structure": a structured type whose constituents number nothing but sound-types (MAM 64). According to the simple view, then, *In This House, On This Morning* is "'this complex sound[-type] followed by this one, followed by this one,' that is to say, a specified *sequence* of sound[-type]s, with all audible characteristics comprised" (MAM 88). Neither the historico-musical context in which the piece was composed, nor any particular means of sound-production (i.e., instrumentation), are essential to the work. To put the point imprecisely but nonetheless helpfully, what makes *In This House, On This Morning that* work is that it sounds like *that*. Period.

Levinson subjects the simple view to an ingenious battery of arguments which, he contends, illustrate that it needs modification. The argument with which I am concerned is expressed, albeit in a condensed form, in the following statement: "If musical works were sound structures, then musical works could not, properly speaking, be created by their composers" (MAM

*"Musical Works as Eternal Types," *British Journal of Aesthetics* 40:4 (2000): 424–40. Reprinted by permission of Oxford University Press.

65). Levinson takes this argument to be sound, and, as a consequence, argues for a reconstrual of a musical work as a type of a more complex kind, namely "a contextually qualified, person-and-time-tethered abstract object" (MAM 216).[2] According to Levinson, the work is thus an "indicated" structure or type; and this means that it is an "initiated type": a type which was brought into being by Marsalis's act of indication.

I have two rejoinders to make to this. First, Levinson claims that an essential feature of our concept of composition is that composition is a kind of creation. I deny this. In my view, what is essential to composition is *creativity*, not the creation of an entity. My second rejoinder concerns Levinson's suggested emendation of the simple view. Insofar as we can understand what it is for a type to be "tethered" to a time, such indicated structures exist at all times too; so, strictly speaking, there are no types that are *initiated*. Levinson's emendation thus fails to allow for the creatability of musical works anyway.

Let us focus upon the argument's *creatability requirement*. The first thing that we should be careful not to do is to make its denial seem more outlandish than it really is. R. A. Sharpe puts the case against what he terms "musical Platonism" like this:

> A frequently aired criticism of such Platonism in music is that it denies creativity. If a work of music is an abstract entity, a sound pattern that exists independently of the composer, then, instead of creating it, he merely selects it.[3]

But such a criticism confuses creation with creativity. While it is true that a denial of the creatability requirement entails that composition is a kind of selection, it is quite wrong to suppose that this need amount to an account of composition as lacking in creativity: a view of composition as the unimaginative tracing of an abstract pattern. In my view, we must acknowledge its creativity; but we can do this while denying that composers create the works which they compose.

A composer is creative, not through bringing works into existence, but by having to exercise imagination in composing the works she does. A creative thinker is someone who has the imagination to have thoughts beyond the reach of most people. A creative composer is someone who has the imagination to compose works of music that others do not have the capacity to compose. Composition is, indeed, a form of discovery; but discoveries can be creative. Einstein's discovery of the facts which comprise the Special Theory of Relativity was the result of undeniably creative thinking. Well, the same goes, according to a sensible Platonist, for the composition of *In This House*,

On This Morning. This sound structure has always existed, but it took a composer with a huge musical imagination and sensitive feel for the history of jazz to discover it and score it. *Creativity* can coexist with the simple view; it is only the *creation* of musical works which is ruled out.

Having said this, although Levinson grants that discoveries may be creative, he nonetheless insists that it is creat*ability*, not simply creat*ivity*, which is required for a satisfying account of the nature of composition (MAM 228). Why is this? According to Levinson, the way in which we talk about composers and their compositions embodies the thesis that works are brought into being by composers, not discovered by them:

> The whole tradition of art assumes art is creative in the strict sense, that it is a godlike activity in which the artist brings into being what did not exist beforehand—much as a demiurge forms a world out of inchoate matter. The notion that artists truly *add* to the world, in company with cake-bakers, house builders, law makers, and theory constructors, is surely a deep-rooted idea that merits preservation if at all possible. (MAM 66–67)

Two further arguments against the eternal existence of musical works are recoverable from Levinson's work. First, he suggests that the cause of theoretical unity is furthered, if we treat musical composition, like sculpture and painting, as involving the literal creation of a work. And, finally, Levinson claims that the status we attach to musical composition is dependent upon works being created by their composers. "If," he says, "we conceive of Beethoven's Fifth Symphony as existing sempiternally, before Beethoven's compositional act, a small part of the glory that surrounds Beethoven's composition of the piece seems to be removed" (MAM 67).

But what are we to make of these considerations? When it comes to the claim that we hold composers to "truly *add* to the world, in company with cake-bakers, house builders, law makers, and theory constructors" (MAM 67), I feel that Levinson is moving a little too quickly. For the things which cake-bakers and house builders uncontentiously create are not types, but *tokens*: token cakes and token houses respectively. Of course, there may be a person whom we may wish to call "the inventor of the chocolate éclair," but our use of this definite description does not commit us to there having been someone who literally created the *type*. *How* could it? We have no conception of what it would be for a person to do this. As we shall see, the idea that abstract objects can be literally created is of dubious coherence. "The inventor of the chocolate éclair" is used to refer to the person whose act of conceiving of such a confection was responsible for the type's first being

tokened. The type has always existed; the person we call its "inventor" was the (ingenious) individual who first had the idea of such a thing and whose imaginative act started the process which led to the creation of the type's first token.

The fact that our talk of composers "adding something to the world" does not imply that their works are created by them is further evidenced when we attend to what "the world" means in this setting. When we say that a composer has added something to *the world* we are saying that she has added something to our culture; and this latter way of talking does not embody the doctrine that her composition has literally been brought into existence by her. In composing *In This House, On This Morning*, Marsalis certainly added the work to our culture, but adding a work to our culture is a matter of introducing it to our cultural life, of placing it within our culture and opening it up to appreciation. And Marsalis did this, not by bringing the work into existence, but by first scoring it, first tokening it, and hence bringing it to the notice of the jazz world, placing something within our culture that was not there before. The creative act is the discovery of the work.

Levinson's mistake is to suppose that the discredited conception of composition as description is the only alternative to the account of composition as the creation of an entity. For the question that Levinson must answer is this: what would it be for a human action to bring into existence an abstract entity such as a musical work? For it is quite unclear what it could be for someone to *assemble* an abstract, structured type out of similarly abstract constituents. As Stephano Predelli has noted, it is a plausible prima facie maxim that abstract objects cannot be created.[4] And the reason why this principle is so intuitive is this: the creation of an abstract object would have to be a kind of causal interaction between a person and an abstract object or objects; and abstracta cannot enter into such interactions.

But what of Levinson's claim that theoretical unity demands that we regard musical works as being, like paintings and sculptures, created entities? To this, we can make one of two replies, depending on the view we take of the ontological nature of works of art such as paintings and sculptures. First of all, if we assume that the standard view is correct and that the artworks produced by painting and sculpture are concrete, physical particulars, it is by no means obvious that the level of theoretical unity Levinson craves is necessary. For if there really is such a great difference between a symphony and a painting (the former being a type, the latter a particular), it is far from clear that we should expect features we associate with one kind of entity to be instantiated by the other. The second reply is that it may well be the case that any theoretical unity is, so to speak, from the other direction. Levinson,

as we have seen, supposes the artworks of painting and sculpture (artworks which he presumes to be concrete particulars) to be created by an artist; he then seeks to bring pressure to bear to treat works of music as created also. But it is by no means absurd to regard novels and works of music as the paradigmatic artworks, and then to assimilate paintings and sculptures to these. On this kind of view, paintings and sculptures are just as much types as are works of music.

Far from being "central to thought about art" (MAM 66), as Levinson supposes, the idea that works of music are created by their composers appears to be misconceived. It violates our intuition that abstract objects lie outside all causal chains, and, what is more, the value which we attach to musical composition does not depend upon it. But at this point, Levinson is likely to make the following protest: however much my replies may have drawn the sting from his objections to the idea that musical works predate their composition, it is surely desirable to have an account of the nature of musical works which allows for their creation; and does not Levinson's own account of musical works as indicated structures do precisely this? In my view it does not. If Levinson's indicated structures are, as he himself stresses, types (MAM 64), they too will end up being eternal existents.

Levinson, I suggest, misconstrues the nature of types; and this misconstrual can be traced back to his explanation of why sound structures exist eternally. Levinson says that the eternal existence of sound structures is

> apparent from the fact that they—and the individual component sound types that they comprise—can always have had instances. . . . Sound structures predate their first instantiation or conception because they are possible of exemplification *before* that point. (MAM 65)

These are very revealing remarks.

If Levinson's diagnosis of why sound structures exist at all times is correct, then, if we wish to allow for the fact that a musical work was created by its composer, we need to identify the work with a type which could only have had tokens from the time t of its composition. And the most obvious way of generating the sort of type which we need would seem to be by tethering the type to t: that is, by treating the work as the sound structure-as-indicated-by-X (the composer)-at-t (MAM 79).

Having said this, Levinson's claim that sound structures exist at all times *because they* can have instances at all times just strikes me as a non sequitur. A concrete example may help matters. Consider the type: child born in 1999. Clearly, this type could have had no tokens in 1066; but the point, surely, is not that the *type*: child born in 1999 did not exist in 1066, but that the

condition something must meet in order to be a token of that type—namely be a child born in 1999—could not have been met by anything in 1066. The condition something has to meet in order to be a token of the type was the same in 1066 as it is today; it is just that in 1066 nothing could meet it.

Why, then, is it true to say that sound structures exist at all times, if it is not because they can have instances at all times? The reason why this is so is not that they are types *of a certain kind* (that is, types which can have instances at all times), but that they are types *of any kind*. Types, any types, are eternal existents. The identity of a type is determined by the condition a token meets, or would have to meet, in order to instantiate it. Such a condition is, of course, a property; so it follows that a type's identity is determined by the property a token must have in order to be a token of that type. According to the view I am recommending, a property is essentially a property of something: properties are not to be located in Platonic heaven, and instantiation is not a queer relation that crosses ontological realms.

It is this latter result that is important for us. For, given the relation between properties and types, the fact that properties do not come in and out of existence entails that their type-associates do not do so either. Sound structures exist eternally, not because they can have instances at any time, but because they are types, and a type, if it exists at all, exists at all times. At which point, Levinson's notion of an initiated type—a type which is brought into being by an intentional action—begins to look misconceived.

Given that a type exists if and only if its corresponding property exists, the indicated type Ψ-as-indicated-by-Marsalis-in-1992 exists just in case the property *being an instance of Ψ-as-indicated-by-Marsalis-in-1992* exists. Now, by our account of the existence conditions of properties, this property exists if and only if something has it, has had it, or will have it. But it follows from this account that the property in question has always existed and always will exist. That the property has at least one instance at some time means that it exists at all times. And since this is so, and since the existence conditions of a property's type-associate are inherited from those of its corresponding property, it follows that Levinson's indicated type is an eternal existent too. To be sure, the indicated type with which Levinson identifies *In This House, On This Morning* could not have had any instances before Marsalis composed it in 1992. But the point is that whether a type exists at a time is determined, not by whether it can have any instances at that time, but by whether its property-associate exists at that time. And the property-associate in question—*being an instance of Ψ-as-indicated-by-Marsalis-in-1992*—is an eternal existent.

The chief example that Levinson uses to shed light on his conception of an indicated structure or type is the type: the Ford Thunderbird. This type

is, according to Levinson, a metal/glass/plastic structure: Ψ-as-indicated-by-the Ford Motor Company-in-1957 (MAM 81). And Levinson holds that it follows from this conception of the Ford Thunderbird that it is an initiated type: "It beg[an] to exist," Levinson claims, "as a result of an act of human indication or determination" (MAM 81). But when it comes to the question of why we should therefore suppose that this type did not exist in, say, 1900, Levinson only says, once more, that "there could not have been instances of the Thunderbird in 1900" (MAM 81). But whether a type can have any tokens at t is irrelevant to the question of whether the *type* exists at t. The type's identity is determined by the property which a token must have in order to be a token of that type: *being an instance of Ψ-as-indicated-by-the Ford Motor Company-in-1957*. This property is an eternal existent. Hence, the type must be an eternal existent too. This being so, it is better all round simply to say this: in 1900 the type which is the Ford Thunderbird, the abstract entity, existed, but could not have had any tokens at this time. And if this is so for this time-tethered type, then it is the same for any other. Our conclusion stands: if musical works are time-tethered types, they too exist eternally and hence cannot be initiated. The question of why an *indicated* structure should be an *initiated* structure remains mysterious.

Types, so it seems, only have other types as constituents. Sentence-types, for example, are composed of word-types; and works of music, if types, would similarly seem to be things with types, not times, as constituents. The time to which a type is tethered, rather than being a constituent of the type, is a part of the specification of the *condition* which a token must meet in order to be a token of that type. We should not slide from this truth to the misconceived claim that the time of indication is literally a part or constituent of the type.

Of course, there *are* entities which have times as constituents, but such entities are not types. If Jaegwon Kim is right about events, the time at which an event occurs is indeed a constituent of the event.[5] An event, according to Kim, is a complex which has a substance a, a property F and a time t as constituents, and which exists just in case a has F at t. To be sure, if Levinson's indicated structures were Kim's events, Levinson would have no difficulty in explaining why it is that an indicated structure only comes into existence at a certain time. Events only exist from the time at which they happen. But, whether or not Levinson thinks of indicated structures as items akin to Kim's events, such a conflation can be of no help to him. For works of music are not themselves events. *In This House, On This Morning* is not an event: it is something which certain events are instances of. The end result is that we cannot come up with an account of what it is to tether a type to a time

which *both* respects the intuition that works of music are types and has it that such types only come into existence once they are composed. If indicated structures are genuine types, they cannot be created; and if they have times among their constituents, they look like being events rather than types.

Levinson rightly believes (though, as we have seen, for the wrong reason) that musical works, if construed as sound structures, cannot be created by their composers. Largely because the simple view has this consequence, Levinson comes to reject it in favor of his own account of musical works as indicated structures. But his reasoning is defective in two respects. First, as we saw, it is by no means clear that we should regard works of music as being truly brought into existence by their composers. Second, Levinson's own proposed emendation can no more account for the creatability of works of music than can the simple view. If a work of music is a type of any variety, it cannot be created. So my conclusion is this: unless there are other, more convincing, objections to the simple view of musical works as sound structures, we are entitled to stick with it.

Notes

1. Jerrold Levinson, *Music, Art and Metaphysics* (Ithaca, NY: Cornell University Press, 1990), 64. Hereafter MAM.

2. Strictly speaking, Levinson regards the work to be an amalgam of Ψ and a certain performance means structure-as-indicated-by-Marsalis-in-1992 (MAM 78–79). However, this complication need not detain us.

3. R. A. Sharpe, "Music, Platonism and Performance: Some Ontological Strains," *British Journal of Aesthetics* 35 (1995): 39.

4. Stefano Predelli, "Against Musical Platonism," *British Journal of Aesthetics* 35 (1995): 340.

5. Jaegwon Kim, "Events as Property Exemplifications," in *Contemporary Readings in the Foundations of Metaphysics*, ed. C. MacDonald and S. Laurence (Oxford: Blackwell, 1998), 311.

Types, Indicated and Initiated*

Robert Howell

A work such as Beethoven's Fifth Symphony can have many performances and, thus, many instances. Each of those performances, when accurate, presents the same sequence of sounds. This fact suggests identifying the Fifth

*"Types, Indicated and Initiated," *British Journal of Aesthetics* 42:2 (2002):105–27. Reprinted by permission of Oxford University Press.

Symphony with the abstract type that amounts to that sequence and that has the performances (or the concrete sounds that they produce) as its instances. However, this appealingly simple view faces difficulties. For one thing, Beethoven created the Fifth Symphony. For another thing, it seems that another composer, working in a different musico-historical context, might have devised the same abstract sound sequence as did Beethoven while composing a very different work. An identical sound structure composed by Satie would be an uncharacteristic, parodic freak, not the Fifth Symphony once over again.

Such considerations about creation and in particular about historical context have led a number of aestheticians, among them Jerrold Levinson, to reject the identification of a work such as the Fifth Symphony with an abstract sound type. Levinson has argued that a musical work is not a pure abstract type of sound structure but an "indicated type," "Ψ-as-indicated-by-θ-at-t," where Ψ is the sound structure type that the composer θ, through his or her compositional activities, indicates. Such an indicated type is distinct from the abstract structure Ψ itself; it is brought into existence ("initiated") at time t by the composer's activities in the musico-historical context in which the composer is then working, and it is ontologically tethered to that composer, time, and context.[1]

Now comes Julian Dodd to challenge forcefully the underpinnings of all such views.[2] His central charge is that the indicated-type view cannot allow for the creation of musical works, since all types—and, thus, all indicated types—are eternal existents.

Dodd's argument that all types are eternal is unsound. The view of types that Dodd adopts, along with other writers on this topic, is seriously flawed. After pointing out problems with his account, I then develop a more adequate conception of types that unifies artwork types with natural types or kinds. Given this conception, I argue that there is nothing problematic about the idea of an "indicated type."

I turn to Dodd's most fundamental claim, his view that all types—and so all indicated types—are eternal and uncreated. He urges that abstracta cannot enter into causal relations with persons. For Dodd, the most that Beethoven does is to discover, albeit in a creative fashion, the eternal sound type that is the Fifth Symphony. He then "adds" that type to our culture by specifying it through a score or performance in a way that allows us to appreciate what he has uncovered.

However, numerous properties, including those important for indicated types, are not eternal. So Dodd's argument fails. Some types—which turn out to include indicated types—are not eternal.

Concrete examples will help to make these points. The property *being a square* appears to be eternal. It is extremely hard to get any grip on the idea that that property, as opposed to some concrete instance of it like a pat of butter, first came into existence a week ago. Hence, the type Square Thing appears to be eternal. However, things are not so simple if we turn instead to indicated types, as they are described by their proponents. On the indicated-type view, the Fifth Symphony is not the abstract sound structure type S that amounts simply to a given sequence of notes. Rather, it is the entity S-as-indicated-by-Beethoven-in-1804–1808 (the years of its composition)—roughly, S insofar as S is indicated or singled out by Beethoven as specifying a pattern of notes that is to be played in order to manifest the composition. Suppose that we grant that S itself (and the property underlying S that specifies the sequence of notes that constitutes S) is eternal. Then, according to the indicated-type view, we still have to consider the fact that, as it occurs in the Fifth Symphony, S has taken on the property of *being indicated by Beethoven in 1804–1808*. Or, to invoke the idea of a property-associate, we have to consider the property that all token instances (that is, all performances) of the Fifth Symphony have insofar as they are such instances. According to indicated-type proponents, that property is the property of *having the basic S structure and also being produced in a way that is properly connected to Beethoven's 1804–1808 acts of indication*. (For indicated-type proponents, an instantiation in a performance of the S structure does not count as a performance of the Fifth Symphony unless that performance is properly related, through the scores used, the training of the conductor and musicians, and so on, to those acts.) According to Dodd, who accepts both claim (a) (type existence implies property existence) and claim (b) (property existence implies type existence), the Fifth Symphony, as an indicated type, exists if and only if the property just mentioned exists. Yet, given its relation to contingent, temporally initiated entities and events (Beethoven and his acts), can that property possibly be uninitiated and everlasting? Indeed, is it possible that all properties that involve such relations exist at every point in time?

Perhaps it is plausible to hold that, if a property (or, more generally, if any sort of metaphysical abstractum) is a wholly general thing that has no essential connections to the contingent entities that occur in the world alongside it, then that property is eternal. (Or perhaps even that claim is not clear, but we need not settle these issues of general metaphysics here.) However, the property just mentioned is not such a wholly general thing. Rather, that property is essentially tied to Beethoven and his 1804–1808 acts. Yet it surely then cannot be eternal. How can it already have existed in, say, 1600—or at the moment of the Big Bang—when the specific concrete entities to which it essentially

relates had themselves not yet come into existence? To suppose that it can would be like supposing that your signature—not just ink marks geometrically congruent to it, but actual marks that attest to you, to your own personal identity—could exist a million years before you do or that the set consisting of last night's thunderstorm and today's gusting of the wind could preexist both these events. If, however, the property in question is not eternal, then, given claim (a), neither is the indicated type that is the Fifth Symphony. Indeed, we can bypass these points about properties and property-associates altogether and note directly that no indicated type can exist until all the entities with which it is essentially involved exist. Hence the Fifth Symphony cannot pre-exist Beethoven and his acts of indication. A central thesis of the indicated-type theory—that such works are temporally initiated types—therefore escapes Dodd's reasoning unscathed.

The problem does not arise only from properties peculiar to the indicated-type theory. There is a host of other perfectly ordinary properties, involving essential relations to contingent, temporally initiated entities, that yield the same problem—for instance, the properties of being a son of Abraham Lincoln, of being Beethoven's nephew, of having seen Emily Dickinson, of surviving the Battle of Britain, or of being an Elizabethan playwright. Nor can the problem be escaped by proposing that each of these properties is really just a compound of wholly general, eternal properties.

Constructing an adequate theory of property existence involves complex metaphysical issues lying far from the green fields of aesthetics. Roughly, however, and in contrast to Dodd's implausible view, a property can be taken to exist just in case it is a logico-metaphysical compound of existent base properties or else is itself such a base property. (Thus *being green and being round*, *being round and being not round*, and *being green if square* all exist if their constituent properties exist.) Such properties exist when any entities they essentially involve exist themselves.[3] On this account, *being square* presumably is eternal, but *being a son of Lincoln* does not exist until Lincoln himself does.

I think that further progress in understanding the positive nature of indicated types—and, indeed, of types in general—requires rethinking the subject. In particular, we need to distinguish properties from what I will call patterns, and both properties and patterns should be distinguished from types themselves.

Properties are predicative features of objects. Patterns in turn are specified by properties. They include such things as the shape shared by square things. *Having alternating light and dark squares* roughly specifies the checkerboard pattern, and that pattern exists given that that property does. I suppose also that a pattern is distinct from the property that specifies it. (Although the

checkerboard pattern and the property just mentioned have the same instances, it is true of the pattern but not of the property that it is made up of squares. *Having alternating light and dark squares* is not itself literally made up of any shapes.) The arrangement exists, as an abstract thing, if the property exists but is uninstantiated. However, the arrangement is not then possessed by anything, not even by some wraithlike thing.

Both patterns and the properties that underlie them are to be distinguished from types. In making this distinction, I am interposing a third thing, the pattern, between the property and what writers like Dodd take to be the type. In my view, the automatically existing abstract thing is really only the pattern, the arrangement of parts or features that the property specifies. The type involves the pattern, but for the type to exist more is required than merely for the property (and so for the pattern) to exist. This point is not a matter of mere terminology. It is crucial to understanding types as they occur both in nature and in human practice. Actual examples of types—as opposed to made-up cases such as Square Thing or Son of Lincoln—will serve to drive it home. As these examples show, types are serious entities that play important roles in nature or human life, while patterns are mere arrangements that may or may not be of any significance.

Types arise out of human practices. Words do not exist in a natural language merely because properties exist that specify sound-and-meaning patterns that are admissible in that language. "Glank" does not exist as an actual word (type) in English, meaning "joyful jeep," simply because there exists, uninstantiated, the property *being a /glank/ phonemic sequence used in English to mean joyful jeep.* Similar points can be made about types such as the Fifth Symphony and such technological types as the jet engine and the Ford Thunderbird.

Word and sign types do not come to exist because we somehow operate on the patterns and properties as they occur, uninstantiated, in some Platonic heaven. Instead, such types come into existence when some community establishes a practice of producing (and recognizing) concrete sound and visual items (noises, marks on rocks, and so on) that instantiate the relevant pattern and so have the property that underlies it. Such a practice may of course be part of a larger practice (of speaking a given language or of using a set of traffic signs), and establishing the practice may serve a variety of semantic, formal, and expressive ends. Through the practice the community may set up a rule that makes instances of the pattern carry (insofar as they are produced according to the rule) certain information or meanings (for example, no parking!). Or the pattern may have been singled out because it is singularly attractive or interesting to hear or see. The structure of the pattern

may also allow the means used to produce its instances (the human voice, ink brushes, and so on) to be employed in ways that show off the capacities of those means and that perhaps also serve to express the emotions and attitudes of those who use them.

When through the coming into existence of a community practice, a pattern takes on the property of functioning to carry such semantic, formal, and expressive qualities—or when the pattern simply takes on the property of being singled out, through the existence of the practice, for production and recognition by the community—the pattern becomes a *type*. The property here is not the property that underlies the pure pattern itself (say, the geometric property that specifics the pure, geometric design that the sign incorporates). Rather, it is a property of the pattern, roughly the pattern's property of actually being used in the community in order to carry those qualities. Moreover, the type itself then functions, given the community practice, as a new entity distinct from the pure pattern. The clockwise hooked cross used in pre-Columbian Amerindian cultures to signify such things as, apparently, fire, the changing seasons, good fortune, and energy shares its geometric pattern with the Nazis' swastika. But the two count as distinct symbols. Neither is identical to that pattern itself. Each carries a different meaning, the one benign, the other evil.

Insofar as types arise out of human practices in this way, those types exist only through those practices. They are thus temporally initiated entities that have instances of their own. The type does not exist until the pattern actually takes on the property of being used in the community in the relevant way.[4] They are not all indicated, in the sense of being ontologically tied to the particular individuals who originate the practices that generate them or to the particular actions by which they do so. However, for the reasons just explained, they are all temporally initiated and distinct from the abstract patterns that they involve. These points also apply to musical works such as the Fifth Symphony, although such works involve a multitude of subtler, deeper features than do mere word types, idiomatic phrases, or tribal symbols.

In composing the Fifth Symphony, Beethoven performs a total act a of indication in a cultural context in which people want to have, and have established a practice of having, stimulating sound patterns fixed and repeatedly brought to their attention. By performing a in that context, Beethoven sets up a specific practice of producing and recognizing certain concrete instances of the S pattern. Because they are produced in accordance with that practice, those instances will carry the various formal, semantic, and expressive qualities that belong to the Fifth Symphony (as against, say, the imagined Satie symphony). For example, they will show Beethoven's characteristic

symphonic style. The type in question is thus distinct from the pure S pattern itself, which does not have that property essentially. To the extent that the Fifth Symphony shows features characteristic of Beethoven's compositional style and of his particular act a—or to the extent that it expresses, say, hope for his audience's freedom—it cannot exist until Beethoven and act a exist.

Philosophers are thus wrong to regard all types as eternal entities, the existence of which is implied by the existence of the eternal properties that underlie them. Types that are the products of human practices are all initiated. They exist only once the practices in question do. Some such types are indicated and exist only through their actual creators or their creators' particular acts. "Creation" is exactly the right word for the kind of type production that I have described.

Finally, if we consider the Fifth Symphony in terms of Dodd's simple framework of properties and types, then the property-associate for that symphony is the property *having the basic S structure and being produced in a way that is properly connected to Beethoven's 1804–1808 acts of indication*. If the preceding discussion is correct, then the type (in my sense) that constitutes that symphony is the S pattern, that pattern then having, essentially, the property of being used in the way specified by the practice. The S pattern, having that property, in turn corresponds to a property that belongs to all the instances of the symphony. That property, which all those instances have insofar as they are such instances, is the property that specifies the S pattern and the use of the S pattern in the way noted. If we now introduce property-associates of types when types are treated as I have above, that property will presumably be the property-associate of the (type) Fifth Symphony.

If the above account of types is on the right track, the Fifth Symphony is the indicated type that arises through and only through Beethoven's act a, the act that sets up the practice that specifies that type. Hence for a concrete S sound sequence to be an instance of that symphony (and not, say, of the Satie symphony), that sound sequence must be counted by the practice as being used in accordance with it. However, given the way that the practice is established through a, the sound sequence can be counted by the practice as being used in that way only if the sound sequence is produced in a way that is properly connected (through scores, musical training, and so on) to a. And any S sound sequence so connected to a will be counted by the practice as used in that way.

Hence we may regard the [earlier] property-associate as equivalent to the property-associate, just noted, that specifies the S pattern and the use of the pattern in the way that I have suggested above.

If the above remarks are right, there are no special problems about taking musical works of the sort Levinson considers to be indicated types, and there are reasons to accept such a position. Dodd's arguments to the contrary turn on mistaken views of both properties and types and should thus be rejected.

Notes

1. Jerrold Levinson, *Music, Art, and Metaphysics* (Ithaca, NY: Cornell University Press, 1990), chs. 4 and 10.

2. Julian Dodd, "Musical Works as Eternal Types," *British Journal of Aesthetics* 40 (2000): 424–40.

3. This is not a complete analysis. I only sketch a criterion that agrees with common views and avoids Dodd's implausible implications.

4. The type exists when the community is put in the position to produce and recognize the instances. Whether the community then does so depends on further factors.

Further Reading

Davies, David. 2004. *Art as performance*. New York: Blackwell. Defends a single conceptual framework in which all works of art are the same sort of thing.

Davies, Stephen. 2001. *Musical works and performances: A philosophical exploration*. Oxford: Oxford University Press. Defends contextualism and argues that musical works are a number of different kinds of things.

Goodman, Nelson, and Catherine Elgin. 1988. *Reconceptions in philosophy*. Indianapolis: Hackett, 49–65. Defense of literary works as an abstract sequence of symbols.

Levinson, Jerrold. 1990. *Music, art, and metaphysics*. Ithaca, NY: Cornell University Press. Highly influential collection of essays from a contextualist point of view.

Margolis, Joseph. 1980. *Art and philosophy*. Atlantic Highlands, NJ: Humanities Press. Margolis's clearest statement of his version of constructivism.

Ridley, Aaron. 2003. Against musical ontology. *Journal of Philosophy* 100: 203–20. Argues that investigating the ontology of music addresses no interesting issues.

Stecker, Robert. 2003. *Interpretation and construction*. Oxford: Blackwell Publishers. A critique of constructivism and a defense of contextualism.

Thomasson, Amie L. 2006. Debates about the ontology of art: What are we doing here? *Philosophy Compass* 1: 245–55. An overview of recent theorizing that rejects overly revisionist approaches (e.g., that of David Davies).

~

Interpretation and the
Problem of the Relevant Intention

Introduction

Among the innumerable controversies within literary criticism, one of the most famous concerns the correct interpretation of Henry James's novella *Turn of the Screw*. The work begins with a group of people telling ghost stories to each other. When it is the narrator's turn, he relates the story of a governess, but this is cast in her own words so that she becomes a narrator of the events of her story framed within the larger story-telling context. Her story is about a period when she cares for two children, a boy and a girl, at an English country house. The children claim to see the ghosts of their former governess and a groom. The story is shot through with uncertainties that the governess feels within herself and ambiguities she encounters within the household. There is much evidence of ghosts, but for every piece of evidence, a question can be raised about it. So, predictably, there are two main interpretations of the story. According to one, it is a straightforward ghost story; the uncertainties placed within are there to create suspense but not to raise doubts about the fundamental nature of the story. According to the other, it is not a ghost story at all, at least in the sense in which it is true in the story that there are ghosts. Rather, it is a psychological tale primarily about the mind of the governess. A third interpretation is also possible, indeed inevitable, given the first two, namely, that the story is ambiguous in supporting both readings so that neither the first nor the second is exclusively right.

How are such disputes to be resolved? The way the debate takes place strongly suggests that the participants think that one of the sides is right

and the other wrong. This would be just as true for proponents of the third interpretation who are committed to the view that it is incorrect to advocate exclusively either of the first two readings. Are the participants right in taking this attitude? What role should the original intention of the author play in deciding the issue? Is his intention the decisive thing in determining the correct interpretation? Should it be completely ignored? Are there intermediate views between these extremes?

As it happens, James wrote a preface to the story when he published his collected shorter works. Some claim that this preface settles the issue because he does characterize *Turn of the Screw* as a ghost story. However, others find that the preface is just as ambiguous as the story itself, and this perhaps favors the third reading rather than the first. But even if it favors one or another reading, someone could resist the claim that it does so decisively. This is so for two reasons. First, even if one is an intentionalist about interpretation, an author's later pronouncements do not necessarily reflect his original intention for any number of reasons. The author may have forgotten or may be disingenuous. Second, if one is not an intentionalist, what does it matter what James says in his preface, since at most it will reveal his intention?

Intentionalists and anti-intentionalists have opposed each other for a long time, and one may wonder if it is possible to make progress on this issue of how to interpret artworks any more than it is possible to resolve a particular interpretive dispute like the one over *Turn of the Screw*. However, one strategy for resolving a deadlocked issue is to break it up into somewhat simpler ones, and debates about interpretation are ripe for this treatment. There are in fact several different issues hiding within the questions raised so far. One is whether there are objectively correct (true) interpretations of works or interpretation is just a matter of subjective opinion. Resolving this question depends on giving an account of what interpretations are actually asserting and seeing whether these are matters of fact or not. Other questions include what we are aiming to accomplish when we give interpretations and whether all interpreters share one common legitimate aim or there is a plurality of aims. The latter option raises the possibility that there may not be a single answer to the first question. The right answer may vary depending on aim. A third question concerns whether artworks have meanings and, if so, how to characterize these meanings. Finally, there is the issue of whether there is a single correct interpretation of a work or whether a multiplicity of acceptable interpretations. Again this may depend on our notion of work meaning and of the aims of interpretation.

The relevance of an artist's intention to interpretation can enter in answering several questions. First, is it at least one aim of interpretation to discover what an artist intends in her work, whatever the relation of inten-

tion to the work's meaning? Second, do intentions determine meaning or play some role in doing so. Third, is it an objective fact that an artist has one intention or another?

The readings collected in this chapter offer a variety of answers to these questions. According to Gary Iseminger's "An Intentional Demonstration?" the texts that constitute literary works are often compatible with two or more incompatible interpretations. When this is so, Iseminger argues, only one of these interpretations can be correct and that is the one intended by the author of the work. Only that one gives a genuine explanation of the text under interpretation. A fundamental point of contention between Iseminger and some other writers is whether incompatible interpretations can be equally correct or acceptable.

One should be careful to distinguish Iseminger's view and one that is sometimes called the identity thesis. The latter asserts that the meaning of a work is identical to the intention of its creator. One problem with the identity thesis is that not every intention is successfully carried out, and there is no reason why this cannot happen with the intentions of artists in creating their works. But it is no more plausible to suppose that the meaning of a text or work is identical to an intention that never took off than it would be correct to say that I made a pitch if the ball never left my glove (though I intended it to). Iseminger's thesis is more moderate. An interpretation has to be compatible with a text before it is appropriate to invoke the author's intention.

Daniel Nathan opposes even this moderate kind of intentionalism in "A Paradox in Intentionalism." Nathan offers a novel argument against the relevance of intention to the interpretation of artworks that is actually based on one intention that he believes all artists share. All artists intend their works for public consumption. This carries with it, according to Nathan, the idea that the work should stand on its own without reference to other intentions of the artist. In essence, the intention to create a work for public consumption implies that the artist intended that her meaning should not be consulted. Hence, an interpretation should make no reference to it. Supposing that artist's do intend their works for public consumption, the central question raised by this argument is whether this really prohibits inquiry about an artist's further intentions.

William Tolhurst in "On What a Text Is and How It Means" offers an argument that answers this question in the negative. Tolhurst distinguishes between three kinds of meaning. Word-sequence or sentence meaning is the literal meaning of sentences that constitute the text of a literary work. "I love you" and "you love me" have words that are equivalent in meaning, but the sentences are different in meaning in virtue of the arrangements of the words, that is, the syntax. Notice the meaning of the word sequence leaves

the meaning of any particular use of that sequence underdetermined because, for one thing, it does not give the reference of the pronouns, which will vary from use to use; it also does not tell us whether the words are being used literally or ironically, and so on. Call the use of a word sequence an utterance. The two other kinds of meaning Tolhurst distinguishes are utterer's meaning and utterance meaning. The former is the intended meaning of the user of the word sequence. According to Tolhurst, the meaning of a work is identical not to either word-sequence meaning or utterer's meaning but to the meaning of the utterance itself. Utterance meaning is still characterized in terms of intentions. It is "the intention that a member of the intended audience would be most justified in attributing to the author." So while Tolhurst does not accept even the moderate intentionalism proposed by Iseminger, he also rejects the complete anti-intentionalism of Nathan. Utterance meaning is conceived here as a hypothesis formulated by an audience. Intentions enter into the fixing of utterance meaning twice for Tolhurst: as the object of the hypothesis and in the identity of the audience that formulates it.

If we apply this to *Turn of the Screw*, Tolhurst's proposal works something like this. First we identify the intended audience. For many authors, this would be their contemporary readership. For Henry James, however, aware of his greatness as a writer, it is plausible that he wrote as much for posterity as for his contemporaries. Hence, his intended audience probably should be characterized in more idealized terms as readers with certain skills and knowledge who are not necessarily bound by the prevailing views that existed at the end of the nineteenth century in Europe and America. The second step is to identify a hypothesis about James's intention in *Turn of the Screw* that readers would be most justified in attributing to James. On Tolhurst's theory, that is the meaning of the work.

The question this leaves us with is whether such a hypothetical intentionalism is preferable to a moderate actual intentionalism such as that proposed by Iseminger. It is clearly preferable to the identity thesis, but Iseminger's moderate view is no more committed to the identity thesis than Tolhurst's. On Iseminger's view, work meaning is a function of word-sequence meaning disambiguated by the artist's actual intention. Should we completely abandon the search for intentions, as Nathan seems to recommend? If we do, how do we resolve the ambiguities that remain after we grasp the conventional meaning of the sentences of a work?

Theodore Gracyk's "Allusion and Intention in Popular Art" provides a variety of examples from movies and popular music whereby you can test the intuitions forged through encountering the readings mentioned thus far. Gracyk himself argues that the popular arts often raise complex issues of interpretation despite the fact that they are much more accessible to their

audience than contemporary "high" art. He does this by examining the presence of allusions in popular art, that is, the occurrence of references to other artworks or nonartworks in a given piece. He argues that reference to an artist's intention is essential to determining whether an allusion is present and also its significance in the work.

Gracyk's position here is close to Iseminger's. How would Nathan and Tolhurst account for allusions in art? Who has the best way of handling them? Can we extrapolate from the best theory about allusion to the best view of other interpretive issues such as those raised about *Turn of the Screw*?

⌒✕⌒

An Intentional Demonstration?*

Gary Iseminger

I

What is the connection, if any, between the author's intentions in writing a work of literature and the truth (acceptability, validity) of interpretive statements about it? E. D. Hirsch has argued for a close connection in his vigorous defense of what he calls "the sensible belief that a text means what its author meant."[1] Here is his argument:

> A determinate verbal meaning requires a determining will. Meaning is not made determinate simply by virtue of its being represented by a determinate sequence of words. Obviously, any brief word sequence could represent quite different sequences of verbal meaning, and the same is true of long word sequences, though it is less obvious. . . . But if a determinate word sequence does not necessarily represent one, particular, self-identical, unchanging complex of meaning, then the determinateness of its verbal meaning must be accounted for by some other discriminating force which causes the meaning to be this instead of that or that or that, all of which it could be. This discriminating force must be an act of will, since unless one particular complex of meaning is willed . . . there would be no distinction between what an author does mean by a word sequence and what he could mean by it.[2]

What I propose to do in this essay is to present and evaluate not so much an interpretation of this passage as an argument inspired by it. It will help, I think, to confine the argument initially to a single case and worry later about the extent of its applicability. For this purpose, let me take the beginning of Gerard

*Material excerpted from "An Intentional Demonstration," from *Intention and Interpretation*, edited by Gary Iseminger, pp. 76–96. Used by permission of Temple University Press. © 1999. All rights reserved.

Manley Hopkins's poem "Henry Purcell," which I shall label Text 1, and two imagined interpretive statements about it, which I shall identify as 1A and 1B.

Text 1

> Have fair fallen, O fair, fair have fallen,
> so dear
> To me, so arch-especial a spirit as heaves
> in Henry Purcell,
> An age is now since passed, since parted;
> with the reversal
> Of the outward sentence low lays him,
> listed to a heresy, here.[3]

1A. The poem "Henry Purcell" expresses the wish that Henry Purcell shall have had good fortune.
1B. The poem "Henry Purcell" does not express the wish that Henry Purcell shall have had good fortune.

With this example in hand, I shall simply present the argument as it applies to it in a "regimented" form; the remainder of my essay, then, will be devoted to trying to figure out what, if anything, the argument shows.

1. Text 1 is compatible with interpretive statement 1A about the poem "Henry Purcell," and Text 1 is compatible with interpretive statement 1B about the poem "Henry Purcell."
2. Exactly one of the two interpretive statements 1A and 1B is a true interpretive statement about the poem "Henry Purcell."
3. If exactly one of two interpretive statements about a poem, each of which is compatible with its text, is true, then the true one is the one that applies to the meaning intended by the author.

Therefore,

4. Of the two interpretive statements 1A and 1B about the poem "Henry Purcell," the true one is the one that applies to the meaning intended by the author.

Now this argument is certainly a valid one; the interesting issues, therefore, are what can be said on behalf of the premises and what it would matter if the conclusion should indeed turn out to be true.

II

The plausibility of the first premise hinges on relatively simple facts about ambiguity in English words and constructions, though these facts are not always easy to discern in this somewhat cryptic and convoluted poem.

The issue is whether the wish being expressed is that good things shall have happened to (fair fortune shall have befallen) Purcell or rather that he shall have become a good person or done good things (shall have fallen, turned out, fair). These are clearly distinct wishes, and what premise 1 of my Hirschian argument claims is that these words in this order can be used to express either one (which is not to exclude the possibility that they might be used to express both at once.)

The notion of a text is here being taken as a relatively rich notion—not just an inscription but a type in some language, capable of being used to say some things and not others; and the notion of an interpretation is being taken as a relatively impoverished one—involving merely the choice among alternative dictionary definitions. And the point of premise 1 is that, even with the gap between text and interpretation thus narrowed as much as it can be, that gap still remains. The text supports more than one interpretation.

It is appropriate here to consider the possible generalization of premise 1 to other texts and to other kinds of interpretive statements. On the latter point first, is it so clear that statements 1A and 1B deserve to be called interpretive statements at all? The sort of interpretive dispute Hirsch considers in some detail, for instance, that between Cleanth Brooks and F. W. Bateson about Wordsworth's "A Slumber Did My Spirit Steal," has to do rather with the general tone of the poem: is it affirmative or rather pessimistic?

I don't think that anything in the argument in fact hinges on the claim that statements 1A and 1B are themselves interpretive statements. For surely the acceptability of these more exciting kinds of interpretive statements will be limited and controlled by the correctness of statements like 1A and 1B in much the same way that the acceptability of statements like 1A and 1B is limited and controlled by facts about the language in which the text is written. (It is perhaps not too fanciful to suggest, for example, that a specifically Roman Catholic interpretation of the poem would be made much more plausible by 1A's being correct; this wish of good fortune is a wish that only a Roman Catholic would make.) If, as our conclusion has it, the truth of statements like 1A and 1B is internally connected with facts about the author's intentions, then so will be the acceptability of our more glamorous interpretations.

What about *length?* Hirsch also says that "the same is true of long word sequences, though it is less obvious."[4] To this, Monroe Beardsley has replied: "It is not hard to find or invent a short sentence that is simply ambiguous. But the more complex the text, the more difficult it is (in general) to devise two incompatible readings that are equally faithful to it."[5] The point about length, presumably, is that, as the sentences succeed one another, even if each individual sentence is ambiguous, one is typically led by the context to resolve ambiguities one way rather than another. It may be, for example, that someone who was unsure how to read the first two lines of "Henry Purcell" would be moved by reading the next two to some such reflection as this: "Purcell's problem, according to the poem, is that he was a Protestant, is damned for it, and having died in that state, couldn't have done anything himself to repair the situation; if that's so, it makes more sense to wish that something good shall have happened to him than that he shall have done something good." Having so reflected, then, he would be inclined to accept statement 1A and might perhaps even deny the second conjunct of premise 1.

But the point is not that either reading of the first two lines will ground an equally satisfying reading of the poem; it is only that, *considered as a text,* Text 1 rules out neither statement 1A nor statement 1B, and this would be so no matter how much the surrounding text might talk about the impossibility of Purcell having done anything for himself after his death and about the necessity of grace having been freely bestowed on him if he is not to be damned. The thoughts and wishes thus taken to be expressed by the poem might indeed be in some sense incoherent and unsatisfying, but they would seem to be expressible thoughts and wishes, and there seems to be no way to tell *from the text considered as a text* that they are not there being expressed. This is all that premise 1 claims, and the fact that, as interpreters, we routinely and usually correctly pick our way through minefields of ambiguities all day everyday on the basis of cues from the larger contexts, both linguistic and "existential," in which ambiguous sentences occur, is not to the point.

My final comment on premise 1 is that it makes explicit the claim that *the text is not the poem.* Premise 1 *distinguishes* Text 1 from (the first part of) the poem "Henry Purcell." I will not dwell on this point now, but I think it is crucial for the argument. This distinction between text and poem no doubt raises difficulties that will have to be faced, as well as not being particularly harmonious with a place where Hirsch says it is a matter of choice, not ontology, that we take the author's will as "normative" in interpretation.[6] For just this very reason, it seems to me that the argument I have given, based on but distinct from Hirsch's, *will* require a defense of an "ontology" of the literary work, at least to the extent that it is claimed to be not identical to a text.

I conclude that premise 1 seems very plausible indeed, and it seems, further, that a similar claim would be true of most written texts in natural languages.

III

The second premise is simply the application of the laws of excluded middle and noncontradiction to statements 1A and 1B. They are contradictories, so, by the first law, at least one of them is true and, by the second, at most one of them is [true].

It is crucial to recognize that they *are* contradictory, not just different. If, instead of 1A and 1B, we had either the pair

> 1A. The poem "Henry Purcell" expresses the wish that Henry Purcell shall have had good fortune.
> and
> 1B'. The poem "Henry Purcell" expresses the wish that Henry Purcell shall have done good things.

or the pair

> 1A'. The poem "Henry Purcell" does not express the wish that Henry Purcell shall have done good things.
> and
> 1B. The poem "Henry Purcell" does not express the wish that Henry Purcell shall have had good fortune.

then the situation would be different; nothing makes it logically impossible for both 1A and 1B to be true or for both 1A' and 1B to be false, for example. For purposes of the present argument, premise 2, I think, is what Hirsch's talk about the "determinateness of verbal meaning" comes to. The poem has at least one, and at most one, of two complementary properties.

Could we plausibly *deny* that poems are determinate even in this minimal sense? Can we make plausible a restriction on the scope of the law of excluded middle (or, less likely, the law of noncontradiction)? I think that more needs to be said about this, but all I want to argue here is that some such relatively high price will have to be paid if one wants to deny premise 2 and that asserting 2 does *not* fly in the face of claims about ambiguity and richness as characteristic of literature. To defend premise 2 is not necessarily to advocate interpretive intolerance and reveal a prosaic mind unfit to respond to the subtleties of art. (Notice, by the way, that no claim is here being made that a work of literature cannot *contain* or *express* contradictory

propositions, in whatever way literary works contain or express propositions.)

A slightly more promising strategy is to suggest that 1A and 1B are not, as they appear to be, straightforward, one-place predications about the poem but should rather be parsed as relational statements about Text 1 and varying interpretations. Thus, it might be urged, statement 1A should really be expanded into

1A". The text "Henry Purcell," under interpretation A, expresses the wish that Henry Purcell shall have had good fortune.

Statement 1B should be read as

1B". The text "Henry Purcell," under interpretation B, does not express the wish that Henry Purcell shall have had good fortune.

Now, of course, there is nothing to prevent them from both being true.

Once again, what becomes crucial is the ontological claim that there are poems and that they are not identical with their texts. All I want to say about that here is that there does seem to me to be a presumption in favor of the view that there are poems, and reflection suggests reasons of the sort that are summarized in the first two premises for refusing to identify them with their texts. At the least, the kind of relational reparsing of statements 1A and 1B just suggested would, I should think, have to be motivated by something more than the bare desire to deny premise 2 and thus avoid the intentionalist conclusion.

If statements 1A and 1B are, as they appear to be, attributions of complementary predicates to the same thing, and if that thing is appropriately "determinate" in the sense that it satisfies the laws of noncontradiction and excluded middle, then premise 2 is plainly true.

IV

Premises 1 and 2 tell us that exactly one of two statements about a poem is true and that the text by itself is insufficient to determine which one it is. Premise 3 aims to provide us with the necessary further principle. Once again, what principle appears plausible will depend on our conception of the nature of the object in question, in this case, our notion of the "ontology" of the literary work.

Under the natural supposition that the poem, though not identical to the text, is created by the writer of the text (and, typically, *in* writing it), it is not much of a jump to argue that it is the author's will rather than anyone else's

that resolves the indeterminacy. This is perhaps a short way with those who think of the critic or reader as a kind of partner in a joint venture with the poet. Once again, however, except as colorful *façons de parler*, such thoughts do not seem very impressive as *premises* when stacked up against the intuition that poets make poems (which is not to say, of course, that one could not be argued out of that intuition).

It is important to recognize that premise 3 is an ontological principle rather than an epistemological one. It is not, except indirectly, advice on how one is likely to *find out* which of the two contradictory statements about the poem is true; instead, it claims to tell us what *makes* the true one true. In the example I have chosen we have the author's retrospective statement that he intended to wish good fortune to Purcell rather than to wish that he shall have done well. The crucial point, though, is not what Hopkins said later about the poem, but what he intended when he wrote it. What he said later is important only because in this case he happens to have said later just what it was that he did intend when he wrote it. It must not be supposed that I am suggesting that we are powerless to interpret without the author's having told us what he or she meant or that the author is privileged as a critic of his or her own work. What *determines* which of the two contradictory statements is true of the poem is a combination of what the powers of the text are and which of those powers the author intended to activate.

It is perhaps necessary to say something about the free bandying about of words like "will" and "intend." Sentence types can be used to say certain things rather than others, and where a given type can be used to say more than one thing, which one (or more) among the possibilities it is being used to say on a given occasion is a function of some fact about the user, a fact that, for want of a better word, we can describe as the *intention* of the user. Such a view does imply that context does not *determine* meaning, though it may be what we most often have to go on in trying to discover it. Imagine someone standing by a disabled automobile, holding a red can, flagging down a passing car, and saying to the person who has stopped to give assistance, "My car just ran out of gas." Might such a person be using that sentence on that occasion to say that his Pullman just dashed from a cloud of argon? It seems to me obvious that he might be, and that what would make it the case that he was, would be some fact about what that person's thoughts were at the time he uttered the sentence (together with the fact that the sentence can be so used, of course.) Any attempt to deny this, I suspect, springs either from dogmatic adherence to a contextualist theory of meaning, from confusion of impossibility with (extreme) improbability, or from confusion between epistemological and ontological questions.

If, in general, what is said on a given occasion is a function of what the sentences used *can* be used to say and what the user means to say from among those possibilities, and if the interpretation of literature is, in this respect, like the interpretation of utterances generally, then premise 3 seems very plausible.

V

Perhaps I can now sum up the ontological theses with which I have been trying to prop up my Hirschian argument by proposing a revision of the "sensible belief" with which Hirsch begins, the belief that "a text means what its author meant." Beardsley calls this the Identity Thesis, that "what a literary work means is identical to what its author meant in composing it." Let me formulate the Identity Thesis as follows, in order to highlight the assumption, embodied in Beardsley's discussion of it, that the work is a text:

> *Identity Thesis.* A literary work is a text whose meaning is identical to what its author intended (meant) in composing it.

Let me now propose for discussion instead the following, less memorable, but also, I think, less objectionable principle, which I shall call the Revised Identity Thesis.

> *Revised Identity Thesis.* A (typical) literary work is a textually embodied conceptual structure, whose conceptual component is (identical to) the structure—compatible with its text—which its author intended (meant) in composing it.

Several remarks are in order concerning this proposal. Note, first, that I do not propose it as embodying a set of conditions that are necessary and jointly sufficient for something to deserve to be called a literary work of art. For one thing, it is clear that sufficient conditions are not in question; virtually any textually transmitted message, whether literary or not, meets these conditions. I *do* claim that typical or central cases exemplify these conditions; roughly speaking, they specify a genus of which literature is a species.

The Revised Identity Thesis makes it quite clear that what is primarily at issue is a view about the "identity" of the literary work *itself*, an "ontology" of the literary work, rather than a view about the "identity" of two "meanings," the work's and the author's.

The claim is that a typical literary work is a member of a set of ordered pairs, the pairs in question being those whose first member is a text and whose second member is a conceptual structure (a "meaning"). The text is

a structure of linguistic types in some language, typically produced by the author of the work; the conceptual structure is one that meets two conditions, that of being compatible with the text and that of being intended by the author.

VI

A literary work is determinate with respect to properties with respect to which a text is indeterminate, and authors typically create literary works by writing texts and meaning something by them. These two intuitively plausible claims seem to me finally to be the foundation of the Hirschian argument. The first does not rule out "rich variousness," but it does support premises 1 and 2, and hence the distinction between poem and text; the second does not make it impossible for a literary work to have properties its author did not intend it to have, but it does make plausible the principle embodied in premise 3. If these views are acceptable, then so is the conclusion that the truth conditions of interpretive statements about a typical literary work, however narrowly or generously "interpretive" is taken, include facts about the author's intentions.

There may still be intentional fallacies; nothing I have said lends support to the view that a literary work really has all and only properties its author intended it to have, nor the view that a literary work is good to the extent that it fulfills its author's intentions, nor the view that what the author says in interpreting his own work must necessarily be taken as authoritative. But to the extent that objections to these excesses, if such they be, have been based on an appeal to the general principle that interpretive statements about a typical literary work are logically independent of statements about the intentions of its author, those objections have not been well taken.

Notes

1. E. D. Hirsch Jr., *Validity in Interpretation* (New Haven, CT: Yale University Press, 1967), 1. See ch. 1, p. 2.

2. Hirsch, *Validity*, 46–47. See ch. 1, p. 16.

3. John Pick, ed., *A Hopkins Reader* (New York: Oxford University Press, 1953), 16. This example, along with many others relevant to the question of the connection between interpretation and intention, is mentioned in Frank Cioffi, "Intention and Interpretation in Criticism," *Proceedings of the Aristotelian Society* 64 (1963–1964), 85–106.

4. Hirsch, *Validity*, 47. See ch. 1, p. 16.

5. Monroe Beardsley, *The Possibility of Criticism* (Detroit, MI: Wayne State University Press, 1970), 26. See ch. 2, p. 29.

6. Hirsch, *Validity*, 24–25.

⸙

A Paradox in Intentionalism*

Daniel O. Nathan

I argue that intentionalism in aesthetics is vulnerable to a different sort of criticism than is found in the voluminous literature on the topic. Specifically, a kind of paradox arises for the intentionalist out of recognition of a second-order intention embedded in the social practices that characterize art. The paper shows how this second-order intention manifests itself, and argues that its presence entails the overriding centrality of the public text, and hence a rejection of the interpretive stance distinctive of intentionalism itself.

Intentionalism, the view that the actual author's intentions determine the meaning of a work, has long been a familiar position in aesthetics. The purported link between proper interpretation of a text and the intention of the author has maintained its theoretical grip despite the fact that over the past half-century art-critical intentionalism has met with powerful rebuttals from a variety of different quarters. The central project here is to mount a new sort of objection to intentionalism. By examining some of the inherent properties of art as a normatively driven cultural enterprise, this essay attempts to reveal a fundamental inconsistency at the heart of the intentionalist project.

Art-critical intentionalism comes in many varieties, but its most essential claim is that the meaning of a work of art is the meaning that the artist intended it to have. A rather extreme version holds that a work of art, say a literary text, can only mean what its historical author meant by it, even when what the author meant bears no particular relation to the conventional meanings of the words constituting the text. Thus, that view would hold that in any cases of conflict between apparent word meanings and author's intent, author's intent always trumps. More moderate intentionalists hold that textual meaning is constrained by conventional word meaning, and that the historical author's intent plays its central role in disambiguating otherwise equivocal linguistic expressions. Such a role would of course be very important not only with ordinary cases of equivocation, but also when it comes to the very heart of the literary, namely the use of tropes. For, on this view, it is what the author had in mind that will tell us that "The clouds were silver threads" should not be understood as a false literal statement, but as a metaphorical assertion. In a related fashion, the determination of whether a text is to be interpreted as ironic or straightforward will also rest upon the actual author's intention, ac-

*"A Paradox in Intentionalism," *British Journal of Aesthetics* 45:1 (2005): 32–48. Reprinted by permission of Oxford University Press.

cording to this view. Since both metaphor and irony, arguably, rest on a type of equivocation between literal and figurative, the moderate position as described has a surprisingly wide range of application, an application so wide in fact that there may be no text that could be properly interpreted without an assessment of actual authorial intention. What both versions of intentionalism share is the claim that the meaning of a work is directly determined by the actual author's intentions with respect to its meaning.

Art-critical intentionalism takes specific and idiosyncratic facts about the historical writer's/artist's life to fundamentally determine the proper interpretation and description of the work in question. It must be kept in mind that such intentionalism takes those facts to be relevant *not* as general indices of the linguistic or other public conventions in place at the time of the work's creation, but rather *just because* they are facts about the author's life, beliefs, and behavior, the latter being taken to be in some manner constitutive of the work's meaning. This reflects the claim that the author's life (and, most importantly, certain mental acts of the author) and the work's meaning are logically inseparable.

Intentionalist Inclinations

There is a certain common sense as well as philosophical attractiveness to moderate intentionalist positions in aesthetics, an inherent plausibility to the equating of meaning with intention. That attraction requires some explanation. Despite apparently devastating objections, first by Monroe Beardsley and then many others in aesthetics and literary theory, the intentionalist view remains stubbornly resilient; it has even, arguably, begun to retake the field in contemporary scholarship. The position's popular staying power seems a consequence of a variety of commonsense and philosophical factors, each of which plays in its direction.

The commonsense inclination toward intentionalism has many sources. Here are a few of the most important ones:

1. *The causal link between intention and speech, and the conceptual link between intentionality and language generally.* Common sense tells us that because speech is an intentional action, what a person says comes through the mechanism of that person's intentions. As a consequence, it seems reasonable enough to seek after the speaker's intent as evidence of what was said. It is indeed unquestionably good indirect evidence. However, intentionalism goes from that to assert a stronger link, a strict conceptual connection, for if understanding an item as language requires that we understand it as purposeful (intentional),

then grasping that purpose requires attending to the individual whose specific purpose it was. Or so the intentionalist infers.

2. *Authorial responsibility for the text.* It is the author's/artist's work, so interpretations of that work should be guided by his or her judgment. In making interpretive decisions for performing a Beethoven symphony, we seek to reflect the qualities inherent in the symphony, but the qualities of the symphony are those that *Beethoven* placed there, so it is his understanding that should be the source for decisions on how to manifest those qualities.

There are also several different and more daunting philosophical concerns that tilt in favor of actual intentionalism. First, consider the nature of *conversational interests*: Ordinary conversation, the most familiar use of language, has been taken to imply the truth of intentionalism. When we converse, the typical objective is to discover what is on the mind of the other person. Often our search even seems unconfined by the lexical meanings of the words being used, as when we say that we properly understand that what one Texas State Speaker of the House was getting at was "eminent domain" despite the fact that the words he uttered were "intimate domain."

If one views the conversational context as paradigmatic of communication, and the process of communication as central to interpretive tasks, one is likely to expect many types of interpretation to function in a fundamentally analogous way. The argument here will be that on the contrary, *for good reasons*, it would be a mistake to follow this expectation when it comes to artistic interpretation. Specifically, while in conversation it often does not primarily matter how the communication is effected, the "how" turns out to be especially fundamental to the historically defined social practices that constitute the artistic enterprise. In the artistic realm, it is crucial that the effect produced on the auditor be a function of her recognition that the object/gesture/action was so intended to have that effect.

The second deep philosophical concern that any critic of intentionalism faces is the question of *drawing lines* regarding what is to count as relevant extratextual information. Any defensible version of anti-intentionalism must allow certain sorts of extratextual information (linguistic connotations, historical and cultural information) to be relevant to proper interpretation. There is some difficulty drawing a nonarbitrary distinction between clearly pertinent historical information from specific historical information about the author's life, mental state, and circumstances. To grasp a work one must surely understand the language in which it is written. Hence, if the meaning of a word in Elizabethan English differs from its meaning today, then one must know the Elizabethan meaning to properly interpret Shakespeare's *Hamlet*.

Access to certain historical facts thus seems undeniably relevant. On what grounds are we justified at stopping short of historical information about how Shakespeare himself thought about the words he used? Isn't that after all the point of finding out what the words meant at the time to begin with?

Arguing that the justification and location of a "veil of ignorance" masking off details about the actual author's intentions lacks any principled grounding, Anthony Savile has it that "the veil is fully lifted as soon as it starts to be unpinned."[1] He says that to halt the lifting of the veil just where the anti-intentionalist would simply begs the question in favor of the centrality of a certain conception of the text. But my argument in the coming sections will be that the placement of the veil is not arbitrary, and instead reflects characteristic artistic interests that dictate that it not be fully lifted.

Finally, behind much of the resistance to anti-intentionalism is a sense that the weight of Paul Grice's theory of meaning, probably the most influential modern theory of meaning, stands behind intentionalism. For present purposes, it would be useful to identify the criterion Grice sets out for non-natural meaning:

S (a speaker) means something p by U (an utterance) if and only if he intends (i) that H (the hearer) shall think p, (ii) that H shall recognize that first intention, and (iii) that H shall treat such recognition as a reason for conforming to the first intention.

This is obviously an intentionalistic theory of meaning. One might note how closely it corresponds in spirit to the way intentionalistic theory was spelled out above, especially in the notion that the latter takes a work to have the meaning it does *just because* it was so intended. That point appears to directly correspond to (iii) in Grice's definition, namely that recognition of the first intention is to be treated as a reason for taking the utterance to mean p. But it remains to be seen whether the heft of Grice's theory will finally support intentionalism with respect to art-critical interpretation.

The Paradox

The central difficulty with the intentionalist approach lies in an internal paradox. "Paradox" may not be the appropriate label, for this may not be, strictly speaking, a paradox. Perhaps it is better called a practical paradox, or merely a difficulty that has the flavor of paradoxicality about it. The basic idea is this: the production of an object for public consumption (for example, a text that is put forth to be read by a public audience) carries with it the intention to create something that will stand otherwise independent of one's intentions. In Gricean terms, in meaning p by U, I intend that U convey p in a way that does

not require my audience to reach beyond U to grasp p. Specifically, I intend U to convey all that is needed, so that access to any intentions not already expressed in U is not necessary. That is where the element of paradox arises: if my assumption about the production of a public object is true, it would appear that there is an underlying and essential authorial *intention that one's intentions not be consulted.* That is its most paradoxical statement; but the idea is that one intends that *extratextual* access to what might be called one's first-order intentions not be sought or needed. For such access to be needed is an indication of the failure of the author; for it to be sought is an indication that the text is being slighted. Respect for this overarching second-order intention is then inconsistent with investigation of the other intentions an author may have had in producing the public object in question.

A basic purpose in writing what I will call a "public text" is that it be readable to people who cannot know the details of my personal life. It should be noted that this is both liberating and confining: the author is neither expected nor required to accompany the product to explain it—in fact, to *have* to do so would signify that something was lacking in the object—but on the other hand the author is bound by some set of external, interpretive rules. Hence, the claim here is not merely that, as a matter of empirical fact, most or even all artists *have* this second-order intention. In art there is a necessary presupposition that the object be treated in a certain way, bound both by relevant interpretive rules and by the rules and conventions that themselves define and are defined by the practice.[2] In this case, as I will argue, those conventions entail the independence of the text from the intentions of the author.

How the Second-Order Intention Arises in Art
There are at least two ways that this second-order intention manifests itself within literature and the arts generally. They are labeled here "autonomy" and "framing."

1. Autonomy
Even in the midst of the creative process, any author can become a reader of her own work. Sometimes the author may see that an element of her work falls short of her expectation or that a character or dramatic feature has developed in a direction that she had not anticipated. This, in turn, might call for some sort of revision of the text. Whether or not the revision is carried out, the unrevised work is apparently separable from the aspirations of the author. If this separation can happen in the midst of the creative process, it surely can also occur once the work is complete. And if the author can so detach in this way from some particular element of the work, there is no

reason to suppose that authors cannot do the same with respect to the work as a whole. The work can be experienced as an autonomous creation.

This potential of authorial detachment and its obvious importance within the creative process suggest a need to think of the work as so detached. Thus, one might see the second-order intention implicit here in the intention to create a work capable of outstripping one's immediate intentions, a work that could be different in various respects from the way it was conceived in the act of writing. This move to the autonomy of the literary text constitutes a dramatic contrast with conversational intentions. Indeed, this second-order intention is a necessary presupposition of the artistic endeavor, a precondition to a work being understood as a work of literature. The created work will necessarily have features that its author may not have foreseen or intended. But once created, all its features become fair game for interpretation and criticism. And the best interpretation turns out to be the one that can make the best sense of the greatest number of features available in the work. The art-critical process appears to require that much.

2. Framing

Framing, as it will be used here, amounts to another sort of separation of the work of art from the life of the artist, and framing itself is prerequisite to the attribution of certain formal and representational properties to works of art. To make this clear assume that, for present purposes, the point of interpretation is to explain the human artifact that we have before us, be it a novel, a poem, a painting, or a sonata. One can explain an artifact from any of a wide range of plausible perspectives, from the sociocultural and psychological, to the economic or aesthetic/artistic. However, what the artist qua artist seeks is aesthetic/artistic interpretations.[3] That fact seems embedded in the very project of writing a novel or composing a sonata. How is this artistic presupposition to be understood, and how does it relate to the paradox of intention?

The answer of interest here lies in the fact (a fact that sounds more controversial than it turns out to be) that what makes something art, and calls forth specifically artistic interpretation, is at least in part its separation from the life of the artist.

Notice, first, how certain uniquely artistic qualities depend upon the artist's act of framing the work in a fashion that cuts it off from her own life and, moreover, from the mundane world in general. Consider initially a commonplace about the literal sort of framing that takes place in the visual arts and its relation to formal visual properties: the framed scene will have inherently different spatial and geometric relationships than its natural correlate has precisely by virtue of the existence of its frame. The frame itself establishes

an artificial space. Thus, the balance and geometry of a Renaissance work (for example, the triangularity of Raphael's *La Belle Jardinaire*, a portrait of Mary with Christ and John the Baptist as children) cannot finally correspond to the natural scene of which it might be imagined to be a version. This is so because those aesthetic qualities arise only as a consequence of the grouping of figures being lifted out of a setting and placed just so within the boundaries of the canvas (the "frame"). After all, in the absence of any sort of a frame one would have a difficult time speaking of visual balance at all. Or consider how the crowded feel of any of a number of Dorothea Lange Depression-era photographs arises out of the interplay of the postures of the figures with the artificially confining limitations set by the cropping of the picture. It is a feeling that again could not inhere in the natural scene without some act of framing, such formal qualities always being relative to a frame.

Changing to a different range of artistic qualities and their first instance in literature, consider the difference between observing some event in real life, and reading that same event transposed into a scene within a novel. In interpreting the scene from the novel, one considers the language in which the event is described or the point the event might play in the structure of the novel; one looks perhaps for aspects of character development within the fictional world, seeks thematic links to the rest of the novel or to other works of literature. Such characteristics and relationships are productive of and inherent to artistic/aesthetic interpretation. Back within a life, however, the sorts of explanations sought are of a radically different nature: entirely different issues and different kinds of features become relevant.

The return of the poem to the poet's life arguably puts the possibility of universality at risk; what is expressed becomes just one other feature of a particular individual's life, at a particular time, in a determinate cultural milieu. Sylvia Plath's work is then only the manifestation of a specific set of childhood traumas, each experienced uniquely by one young woman, and her consequent adult clinical depression. But, in that examination, it is psychological properties within a demonstrably unique set of experiences that are foregrounded. This threatens to rob the work of its universality by obscuring the aesthetic qualities of the poetry itself. At once, an entire string of potentially rich external references to other works of art are also lost.

Return now to visual art with the expanded sense of framing and consider the work of the surrealist painter de Chirico. De Chirico's paintings are characterized by numerous interesting features, but one particularly strange and evocative image occurs repeatedly in his works: the image of a distant train. Sometimes it fringes the horizon on a series of trestles, sometimes it is only marked by a distant plume of billowing white smoke, but it is there in

many of his canvases. Suppose further that we discover that de Chirico had an especially unhappy childhood in part because of the extended absences of his father, a train engineer. This opens an entirely different explanation of the repeated and evocative presence of a distant railroad train in many of de Chirico's paintings. But, attending to such a personal history seems to interfere with our attention to the potential symbolic richness of the train image internal to the works themselves. Explained in this way the image loses its extravagance, its surprise, its subversive effect.

My claim is that there is a paradox in adverting to authorial intentions in the interpretation of works of art. The paradox arises out of consideration of a second-order intention. Thus, the argument has been that a respect for intention seems to require the overriding centrality of the public work or text for purposes of interpretation, and hence itself entails a rejection of the very interpretive stance that is distinctive of intentionalism itself.

Notes

1. Anthony Savile, "Instrumentalism and the Interpretation of Narrative," *Mind* 105, no. 420 (1996): 556–61.

2. Peter Lamarque and Stein Haugom Olsen introduced a relevantly similar notion in *Truth, Fiction, and Literature* (Oxford: Clarendon Press, 1994).

3. Again, compare Lamarque and Olsen's description of the literary stance as being "defined *by* the expectation of . . . a certain type of value, i.e., literary aesthetic value, in the text in question" (*Truth, Fiction, and Literature*, 256).

On What a Text Is and How It Means*

William E. Tolhurst

In this article I shall refute and replace a widely accepted view of the relation of an author's intentions to the interpretation of his work. This is the view that considerations of what an author intended, although perhaps heuristically useful, are irrelevant as evidence for an interpretation. However, in rejecting this position I shall not take what has seemed to some to be the only alternative, i.e., the position that what a text means is necessarily what its author meant. Thus I shall show that an author's intentions, although relevant to a determination of textual meaning, do not constitute that meaning as a matter of necessity.

*"On What a Text Is and How It Means," *British Journal of Aesthetics* 19:1 (1979): 3–14. Reprinted by permission of Oxford University Press.

One important locus of this dispute has been the debate between Monroe Beardsley[1] and E. D. Hirsch.[2] Beardsley maintains that the text itself is the sole determinant of textual meaning and that authorial intention is not a legitimate source of evidence for interpretation. His basic position is that a text is a piece of language whose meaning is determined by linguistic rules independently of what an author might have intended. Certainly this position seems plausible; words and sentences do have fixed and determinate meanings which are independent of the intentions of individual language users. For his part Hirsch denies that what Beardsley has called the intentional fallacy is a fallacy at all. He contends not only that the author's intentions are relevant to an interpretation of a text but that they constitute the meaning of the text. His position is based on a theory of meaning which holds that the meaning of a text is an intentional object existent in the mind of a language user. Such an object cannot exist apart from a mind so we have two choices for the standard of textual meaning, the contents of the mind of the writer or those of the mind of the reader. But the meaning of the text is the standard for judging the correctness of the latter, so the idea the author had in mind seems to win out by default.

In order to resolve this dispute I shall argue that Beardsley's view of what a text is and his concomitant view of textual meaning are mistaken and should be replaced by what might be called a causal theory of textual meaning and identity. I begin by showing that a text cannot be viewed as a mere sequence of words whose meaning and identity are solely a function of a set of linguistic rules; that a text must be viewed as an utterance whose meaning and identity are defined in part by the context in which it has been produced.

Finally I shall outline a theory of textual meaning which will clarify the relation between an author's intention and the meaning of his work.

1. Utterances and Word Sequences

I begin with a general distinction between three basic types of meaning, utterer's meaning, utterance meaning, and word-sequence meaning. It will then be shown that textual meaning is properly a kind of utterance meaning and that utterance meaning is in part determined by the meaning of the word sequence uttered and in part by the context of discourse in which it is uttered, a context which may well include the author's intention.

If we consider language use in general, there is a clear distinction between the meaning of an utterance and the meaning of the word sequence used to make that utterance. In this discussion, an utterance is defined as a particular occasion of use of a string of words. The terms "word sequence" or "sentence" will be used to refer to the strings of words used to make utterances. Thus the

distinction between a word sequence and an utterance of that word sequence is a type/token distinction. I will show that the meaning of a particular token of a word sequence cannot always be determined solely by reference to word-sequence (or type) meaning, by showing that two different tokens or uses of the same sentence can have different meanings even though the sentence is not ambiguous.

The following example should suffice. Consider the sentence "Nixon is the best president since Lincoln." We could imagine Ron Ziegler uttering it seriously and thereby asserting that Nixon is the best president since Lincoln. We could also imagine someone who does not share Ziegler's views to have uttered it ironically and thereby to have said something quite different; at the very least to have denied the assertion we have imagined Ziegler to have made. Similarly, we could imagine someone uttering it quizzically and thereby managing to ask whether Nixon was the best president since Lincoln. Clearly each of these utterances has a different meaning notwithstanding the fact that each of them uses the same sentence. Furthermore, it would seem that in each case the sentence has the same meaning—at the very least this sentence is not ambiguous in the way that a sentence such as "I saw her duck" is. Thus since each of these instantiations of the same sentence has a different meaning qua utterance even though the sentence is not ambiguous, it would seem that utterance meaning is distinct from and underdetermined by sentence meaning.

Utterer's meaning and utterance meaning are also distinct. Utterer's meaning is just whatever an utterer means by his use of a linguistic token. It might be thought that utterer's meaning is the same as utterance meaning, but the two must not be conflated. Although people on the whole do manage to write and say what they mean, the identity between what a person means by his utterance and what that utterance means is only contingent and not necessary. People sometimes fail to say what they mean: malapropisms and slips of the tongue are a part of everyone's linguistic experience. Thus utterer's meaning is not always utterance meaning.

2. Textual Individuation

We must now consider just what kind of meaning textual meaning is. The two most plausible categories are utterance meaning and word-sequence meaning. Utterer's meaning is not a real possibility since we can sometimes tell that a text means one thing and that the author meant something else. This is not to say that utterer's meaning is irrelevant to a determination of textual meaning; it is just to say that it is not identical with it.

We shall defend the view that textual meaning is utterance meaning, but this view is not without its difficulties. An utterance, as we have defined

it, is a particular object or event which has a definite location in space and time. A text, however, is a type of object which may be instantiated in many physical objects. Thus it is necessary to show a text qua type is different from a word sequence qua type and why textual meaning should be analyzed in terms of utterance (or token) meaning. In order to overcome this difficulty we shall suggest a theory of textual individuation which will enable us to see how a text can be a type even though textual meaning is essentially utterance or token meaning.

There is little trouble in viewing a text as an utterance when that text is the direct production of a language user. A person's letters to his friends are utterances to them which are not in principle different from spoken utterances. The problem is that works of literature do not seem to be like this; they undeniably have many instances. Consider Samuel Johnson's letter to Lord Chesterfield. [It] must be understood within a particular context of discourse. It is, then, to be understood as an utterance. What makes the copy of Johnson's letter contained in my copy of Boswell's biography an instance of the same text which Johnson wrote is the fact that my copy has been produced as a replica of the original token of that text and thus stands in a particular causal relation to it. The meaning of my copy is determined by the original context of discourse in which Johnson wrote.

Since on our view both textual identity and meaning are determined by the original instance of the text and its meaning, it is clear that a text can be a type even though textual meaning is utterance meaning. We will now argue for the plausibility of this view by showing that different written instantiations of the same word sequence can have different meanings qua texts and how some of what we know about the meaning of at least one literary text depends upon viewing it as an utterance.

3. Support for the Theory That Textual Meaning Is Utterance Meaning

We will now examine a work of literature, Jonathan Swift's "Modest Proposal," and show how a proper understanding of it is based on our knowledge of the context in which it was produced and against which it must be understood. This work is ironic. In as much as irony is often the result of a discrepancy or tension between the meaning of the word sequence and the meaning of the utterance, it provides a useful means for distinguishing the two.

In this work Swift has created a persona who is uttering the word sequence seriously and thus stands in a nonironic relation to it. The irony is the result in part of the obvious disparity between what the author has said *through* the work and what the persona has said in it. Since the persona's relation to his utterance is not ironic, there is nothing in the meaning of the word sequence

which would preclude its being used nonironically. Since we can imagine the word sequence which this work instantiates to have been used non-ironically and still know that it is ironic, its being ironic cannot be explained solely by reference to word-sequence meaning.

Swift's "A Modest Proposal for Preventing the Children of the Poor People in Ireland from Being a Burden to Their Parents or Country, and for Making Them Beneficial to the Public" is ostensibly an essay advocating that Irish babes should be raised as delicacies for the tables of the wealthy, thus providing an income for their parents and relieving them and the state of the burden of caring for superfluous children. There is no doubt that this work is ironic; it is clearly a satire delineating intolerable social conditions and commenting on certain attitudes toward them. There is no temptation to identify the opinions of the persona or dramatic speaker Swift has created with those of Swift himself. Furthermore, it is also clear that any reasonably intelligent member of the audience Swift is addressing would also take the work as ironic. Given that we know that the work is ironic, how do we know this? What is there about the work which justifies us in interpreting it this way? There seems to be nothing in the meaning of the work as a word sequence which requires us to understand it in this way. And if we leave the author's views out as irrelevant, we seem to be left only with the persona whose relation to the proposal is not ironic.

One reason we can tell that the work is ironic is that to the average reader or writer of the period the practices of infanticide and cannibalism would seem morally outrageous. Given the prevalence of this view, it is highly unlikely that anyone would seriously advocate such practices. Since we know this about the context of discourse, it is highly likely that any text which appears to advocate these practices is ironic. Thus our taking of the work to be ironic seems to be in part a function of our knowledge of the general social context in which it was originally produced and understood.

That this is in fact so can be demonstrated by the following consideration. Imagine a world very much like the one in which Swift wrote except that in our imaginary world people hold somewhat different moral views; in particular they see nothing wrong with the practice of infanticide so long as the infant is less than two years old. We will suppose further that in this world an author, J*n*th*n Sw*ft, has come to write an essay which is word for word identical to the one the real Jonathan Swift wrote. In our imaginary case there is no distinction to be made between the author and persona of the essay. Sw*ft meant it to be a straightforward recommendation to ameliorate the unpleasant living conditions in Ir*l*nd. Furthermore, that is the way his readers take the

proposal and it is speedily adopted. Thus the production of J*n*th*n Sw*ft is not ironic even though its meaning as a word sequence is the same as that of Swift's essay taken as a word sequence. If we take the text to be a word sequence and not an utterance, it is impossible to distinguish between the productions of Swift and Sw*ft even though they are clearly different in meaning; the former is ironic whereas the latter is not. If, however, we take the text to be an utterance whose identity is, in part, defined by the context in which it was produced, then we have a clear solution to our problem. We are simply dealing with two different texts notwithstanding their superficial similarity.

The difference between the meaning of an utterance and the meaning of a word sequence is not that the former is not governed by linguistic rules or is less public. The difference lies in the character of the linguistic rules governing utterance meaning which requires us to take note of the public context in which the word sequence is used as well as the meaning of the word sequence itself in determining the meaning of the utterance. This may be illustrated by the rules governing our understanding of the use of demonstrative terms such as "I," "now," "then," etc. In order to determine what person is referred to by a particular use of the term "I" or what time is referred to by a particular use of the word "now," the rules governing the use of these terms require us to know something of the situation in which they are used. It is not necessary to posit a difference in linguistic rules between the world Swift wrote in and the one we have imagined Sw*ft to have written in to explain the difference between the meaning of their texts.

By now it should be clear that there are a number of advantages to viewing texts as utterances and textual meaning as a kind of utterance meaning. First among these is that this enables us to avoid the extremes of Hirsch and Beardsley on the problem of authorial intention. We are not forced to hold that word sequences are indeterminate in meaning apart from an author's intention, nor are we forced into holding that word-sequence meaning completely determines the meaning of the text no matter what intentions the author had. However, this view only prepares the way for a solution to the problem of the relation of the author's intention to textual meaning. The solution itself must be the result of a more detailed analysis of the nature of utterance meaning.

4. Utterer's Meaning and Utterance Meaning

Once it is seen that textual meaning transcends word-sequence meaning and is a function of the context of discourse as well, one is naturally tempted to account for this on the hypothesis that textual meaning is just the intention which the author intended to fulfill in producing the text. This is Hirsch's

theory. Although this theory would explain the dependence of textual meaning upon the context of discourse, it cannot be correct.

It is an inescapable fact that an author or speaker can fail to write or say what he means, and this is impossible on Hirsch's theory. We are all familiar with occasions on which a speaker or writer has failed to say or write what he meant either through a slip of the tongue (or pen) or through having false beliefs about the meanings of the words he used. Merely intending to mean something by an utterance is not sufficient to guarantee that the utterance will mean what we mean. Therefore it is a mistake to make the necessary identification of textual meaning with what the author meant. What an utterer means and what his utterance means can differ.

If we examine the reason utterer's meaning sometimes diverges from utterance meaning, it becomes apparent that the divergence is due to a mistake on the part of the utterer (speaker or writer). The two most obvious such cases are (1) where a person fails to utter the word sequence he intended to utter, through a slip of the tongue or pen, and (2) where a person holds false beliefs about the meaning of the word sequence he utters. In these cases utterance meaning diverges from utterer's meaning because it is not in general reasonable to expect a member of the intended audience to be able to grasp the utterer's intention.

5. Utterance Meaning

Just as utterer's meaning specifies how an utterance was meant by the utterer, utterance meaning specifies how it should be understood by the audience. Thus utterer's meaning tells what a speaker is trying to accomplish whereas utterance meaning tells us what intention or purpose that utterance is most plausibly viewed as fulfilling. Of course, what a person is trying to do and what he is doing generally turn out to be the same even when he is not doing it very well.

Utterance meaning is the intention which a member of the intended audience would be most justified in attributing to the author. Thus utterance meaning is to be construed as that hypothesis of utterer's meaning which is most justified on the basis of those beliefs and attitudes which one possesses qua intended hearer or intended reader. The reason utterer's meaning and utterance meaning diverge in the cases examined in the previous section is that a member of the intended audience could be justified in understanding the utterance as an attempt to fulfill an intention different from the one the utterer in fact had. Of course, often in these cases a member of the intended audience may be able to discern the true intentions of the utterer. But this ability will require knowledge which the person could have lacked without ceasing to be a member of the intended audience. Thus he will not possess

this knowledge of the utterer's meaning in virtue of being a member of the intended audience.

There is generally little trouble in identifying the group of people who are the intended audience for any particular utterance; they are those with whom the utterer is trying to communicate. There may be cases where those the utterer seems to be addressing are not really his intended audience. These cases seem to be exceptional. There do not seem to be any hard and fast rules in this area for determining who the intended audience is, but this is not, by and large, a practical problem for understanding most texts.

There is one sort of case where it is not safe to assume that the intended audience is necessarily the average hearer or reader of the utterance. Some-times, especially in the case of literary texts, an author may not have written for any specific extant group of readers, but for what might be called the ideal or qualified reader, i.e., one possessed of a particular level of intelligence, experience, sensitivity, knowledge, etc. It should not be thought that in presupposing this knowledge the author has ensured that his work will mean what he means. Were the author sufficiently inept, it might turn out that a reader with a thorough knowledge of the referent of an allusion would still be unable to discover the author's intention.

6. Utterance Meaning and the Author's Intention

With this analysis of utterance meaning we should now be able to clear up some of the confusion surrounding the relation between an author's inten-tion and the meaning of his work. In understanding an utterance one con-structs a hypothesis as to the intention which that utterance is best viewed as fulfilling. Since utterance meaning is that hypothesis which is best supported by the knowledge which the intended audience possesses qua intended audience, wherever such information is necessary for a determination of ut-terance meaning, it will be public in the sense that it is shared by both the utterer and his audience. So far as literature is concerned, since the author is usually addressing a group of people who cannot be supposed to have a detailed knowledge of his psyche, such knowledge would not in general seem to be required for literary interpretation. But it may well be necessary to have a good deal of knowledge of the historical context in which the work was written. The author might well take such knowledge for granted in his reader. Thus in order to understand fully John Dryden's *Mac Flecknoe* and *Absalom and Achitophel* one would have to know something about the minor playwrights and theater of the latter half of the seventeenth century as well as something about seventeenth-century political intrigue. Although in un-derstanding a text one forms a hypothesis as to the author's intentions, it is

one based upon knowledge already possessed in virtue of being a member of the intended audience. Thus in interpreting a work it is illegitimate to cite as evidence information lacked by that audience.

We are now in a position to resolve the following puzzle. On the one hand in interpreting a statement ironically or in some other nonliteral way we seem to be concerned with the intention with which that statement was uttered. Yet it also seems that no matter what an author in fact intended, this cannot alter the meaning of what he has written. The work is a public object and the reader is as qualified to interpret it as is the author. This theory of utterance meaning can explain how this apparent conflict can be resolved. It is true that by and large we are figuring out what an author meant when we interpret his work, but it is also true that he is not in a privileged position with respect to the interpretation of his work and that it is not in general necessary to delve into the author's biography.

Notes

1. Monroe C. Beardsley, *The Possibility of Criticism* (Detroit, MI: Wayne State University Press, 1970).

2. E. D. Hirsch, *Validity in Interpretation* (New Haven, CT: Yale University Press, 1967).

Allusion and Intention in Popular Art*

Theodore Gracyk

I

Popular art is aimed at a mass audience, and this unquestionably means that it is intentionally designed to be easily accessible to large numbers of people. It stands in contrast to much "high" modern and postmodern art which often requires considerable contextualization and explanation before any sort of an appreciative encounter is possible.

However, the accessibility of mass art does not preclude the presence of complex messages that require sophisticated interpretation. Some plausible interpretations will not be obvious to the majority of the mass audience. Many popular movies, for example, invite interpretation, some as obscure in meaning as the works of John Cage or Jasper John.

*"Allusion and Intention in Popular Art," in William Irwin and Jorge J. E. Gracia (eds.), *Philosophy and the Interpretation of Pop Culture*, pp. 65–87 (Lanham, MD: Rowman & Littlefield, 2007). Reprinted by permission of the publisher.

My primary aim in this paper is to argue for this claim by showing that mass and popular art regularly employ allusion. In this respect, popular art introduces some of the esoteric elements that are sometimes treated as the province of antipopulist, museum-based high art. Although some allusions are simple and accessible to almost everyone, many allusions in popular works require the critical insight. If I can show this much, it will reconcile the presence of interpretive challenges for understanding with the position that mass art is designed to be easily accessible mass audiences.

My second central thesis is that tracking allusions requires appeal to artists' intentions. In arguing for this claim, I am not presupposing that all acceptable interpretations of artworks must make reference to such intentions. I am arguing, however, that such reference plays an ineliminable role in art interpretation, whether we are concerned with high art or mass art.

II

Consider *The Matrix* (1999), the first film in the trilogy. Recall the scene in which Morpheus offers Neo the choice to learn what the matrix is. "I imagine," says Morpheus, "that right now you're feeling a bit like Alice, tumbling down the rabbit hole." Here we have an allusion to the opening chapter of Lewis Carroll's *Alice's Adventures in Wonderland*. The allusion is obvious, and signals that strange things are likely to happen. But Morpheus extends his allusion. He offers Neo two pills. "After this, there is no turning back. You take the blue pill, the story ends. You wake up in your bed and you believe whatever you want to believe. You take the red pill, you stay in Wonderland, and I show you how deep the rabbit hole goes." This additional allusion to Wonderland and the rabbit hole adds no new information to the scene. But suppose we pause and ask why the pills are blue and red, and why blue means "stop" and red means "continue." After all, Morpheus and Neo are operating in a simulation of "the end of the 20th century," where red means "stop" and green means "go."

The color choice is not arbitrary, and it deviates from twentieth-century practice because it is an allusion to a nineteenth-century text. It alludes to Chapter Six of Lewis Carroll's *Sylvie and Bruno*. Sylvie is invited to choose one of two lockets, one with a blue gem and the other with a red gem. The blue locket is engraved with the phrase "All—will—love—Sylvie," while the red is engraved with "Sylvie—will—love—all." Seeing the difference, Sylvie selects the red locket. "It's very nice to be loved," she said, "but it's nicer to love other people!"

So Neo's choice parallels Sylvie's in crucial respects. Each is offered something red and something blue, and each chooses the red one. Since it is obvious that this scene in *The Matrix* alludes to one Lewis Carroll novel, *Alice's Adventures*, it seems apparent that the same scene contains an

equally important, although less obvious, allusion to a second Lewis Carroll novel. However, unlike the first reference, there is no reason to think that Morpheus is making an allusion to *Sylvie and Bruno*. That novel is obscure, and there is no reason to suppose, in this fictional world, that Morpheus would know it and would expect Neo to know it, too. So in this case, the film makes the allusion without having a character fictionally allude. This subtle allusion to *Sylvie and Bruno* is ingenious, and those who discovered it received a foreshadowing of what was to come at the end of the Matrix trilogy. In choosing the red pill, Neo would not escape fate. Fate, remember, is what Neo wants to escape by taking the red pill. Despite his rejection of self-sacrifice in *The Matrix Reloaded* (2003), Neo will ultimately be the one to love all. In short, this allusion suggests at the outset that Neo is a Christ figure who must die for humankind.

So I think that the same scene contains two allusions, one obvious and one subtle. What analysis of allusion is broad enough to count the references to Alice and to the lockets as allusions despite their many differences?

III

I will employ a variant of the analysis of allusion defended by William Irwin. Following Irwin, an allusion is an intended reference that calls for associations that go beyond mere substitution of a referent.[1] There are three necessary conditions for the presence of allusion that are jointly sufficient. They are the presence of indirect reference, authorial intention to allude, and the possibility of detection in principle.

On this model, *The Matrix* alludes to *Sylvie and Bruno* in advance of audience recognition of the connection. It satisfies the condition that an allusion must offer the audience the possibility of its recognition. Its reference to a source text is established by textual similarity that makes the allusion capable of detection.

Our tendency to emphasize literary allusion limits recognition of allusion throughout popular culture, where it is frequently visual or aural. My daughter and I recently watched the movie *Alien*. One of the film's first images is an establishing shot of the exterior of the spacecraft. My daughter's immediate response was that the image was remarkably like the opening frames of *Star Wars* (episode IV). Since I assume that Ridley Scott knew that his opening sequence mimics the opening sequence of *Star Wars*, it seems to be a case of nonliterary artistic allusion to an identifiable text.

We should also look for cross-modal allusion, that is, allusion between two arts that appeal to two sensory modalities. *The Matrix* offers a cross-modal allusion to *Sylvie and Bruno*, taking us from the visual prompt of two colors to the literary text and its verbal description of two lockets. One of

my favorite cross-modal allusions is the photograph on the front the Rolling Stones album *Get Yer Ya-Ya's Out!* (1970). It illustrates Bob Dylan's lyric "jewels and binoculars hang from the head of the mule" from "Visions of Johanna" (1966).

For my purposes, the important distinction is between artistic allusion and nonartistic allusion. With artistic allusion, both the source text and the alluding text are a work of art. With nonartistic allusion, either the source text or the alluding text is not a work of art, or there is no identifiable source text. If we examine popular culture with this distinction in mind, artistic allusion is widespread in mass art.

So my first major point is that artistic allusion intentionally refers the audience to another text, an identifiable source text. I will argue that this relationship places normative conditions on audience interpretations of such allusions, in principle limiting the associations that carry from source text to alluding text. If a property cannot be independently assigned to the source text, then associating that property with the alluding text cannot be an association justified by the presence of the allusion. If we do not treat the allusion as intentional, then there is no normative force to our recognition that two texts are similar. For example, if we do not treat the allusion as intentional, there is no interpretative error in anachronistically supposing that the 1994 film *Forrest Gump*'s "Run, Forrest, run" alludes to the 1999 film *Fight Club* when it is really the other way around.

IV

Some analyses of allusion reject the necessity of citing authorial intention. Let us look at two anti-intentionalist arguments in greater detail.

Influenced by literary poststructuralism, some anti-intentionalists argue that authors do not intend any "specific interpretation" of the allusion when they introduce one. Authors cannot control the reader's associations, so "no specific interpretation of the allusion can be demonstrated in any convincing way to be intended by the author." An author or artist can create an allusion and can intend that we find it, but the author can neither "direct" nor "control" its meaning or "what sorts of interpretations arise from it."[2] Therefore, an allusion "gains a meaning only through the reader's actualization of it."[3]

However, the fact that a speaker cannot control the associations in the audience's mind is no evidence against the relevance of authorial intentions. If I advise you that the brakes on the car are faulty and warn you against driving it, my words might cause you to think about a near accident that you had yesterday. I didn't intend for you to think about this incident, for I tried to get you to think about the future, not the past. My inability to control your

thoughts is no evidence that you have complete interpretive power over the meaning of my words. The fact that some associations are subjective, arbitrary, or unexpected does not show that artists cannot intend to suggest one set of associations rather than others.

Monroe Beardsley offers a very different argument against authorial intentions. He dismisses references to intentions as unnecessary appeals to private mental events. Tokens of a text are public objects, and the text does what it does apart from its author's intentions. Beardsley notes that one line in T. S. Eliot's "The Waste Land" alludes to a line written by Edmund Spenser.[4] Beardsley proposes that Eliot's text alludes to Spenser's, and that it does so even if "Eliot never read or heard a line of Spenser." *Texts* allude, not authors, and texts allude by virtue of their place in an artistic tradition.

Among the many rejoinders made to Beardsley, I think that the best response is to call attention to conversational implicature.[5] Conversations are full of sentences that convey more information than is actually said. Suppose Sue asks Miranda if she wants to go to lunch, and Miranda answers, "I'm not hungry." Miranda might be telling Sue that she does not plan to go to lunch, or perhaps she is suggesting that she does not want to have lunch with *Sue*. The declarative sentence states neither of these things, but Miranda's answer certainly *intends* more than it says. When Sue wonders whether Miranda is rejecting lunch with Sue or merely rejecting lunch, Sue is pondering Miranda's intentions. Actual conclusions about what is meant beyond what is said are constrained by Paul Grice's Cooperative Principle, which is the general assumption that each utterance in a conversation will advance "the accepted purpose or direction of the talk exchange in which you are engaged."[6] Among its subprinciples are requirements to be relevant and to be sufficiently informative.

Similarly, artworks pose interpretive challenges that require audiences to regard them as designed to convey ideas that they do not overtly present. With ordinary conversational implicature, remarks that do not seem directly relevant will, on the assumption of relevance, be taken to *imply* something relevant. Likewise, many cases of artistic meaning are enriched by the seeming irrelevance of some of their features. Randy Newman's song "I Love L.A." (1983) names several major thoroughfares in Los Angeles, concluding the list with "Sixth Street." But why Sixth Street? It's not famous. It is an unremarkable street in downtown Los Angeles. Its inclusion invites those of us who've driven on it to reconsider the rest of the list, and suggests that Randy Newman included it in order to make the whole list ironic. Pride about Santa Monica Boulevard is made to look foolish, as foolish as pride in Sixth Street. The song says one thing, but Randy Newman intends us to understand something more.

Artworks, including mass artworks, invite us to reflect on the intentions of their designers. Consequently, if I had reason to think that "Eliot never read or heard a line of Spenser," then I would conclude that there is no allusion at this point in the poem. Likewise, if the codirecting Wachowski brothers were not aware of *Sylvie and Bruno*, then *The Matrix* does not allude to the two lockets. In that case, my claims about the relevance of the lockets constitute a misunderstanding of the film.

Artistic allusion also involves an intention to bring about an effect beyond mere recognition of the intention to allude. The additional effect is twofold: the audience is directed to a *specific* source text, and there is a new interpretation of the alluding text. The fact that the audience supplies this interpretation does not negate the possibility that specific meanings are part of this authorial intention. When you do a crossword puzzle and the clue for 5 across is "feline," the intention is that the reader will fill in the appropriate horizontal spaces with some appropriate word. If there are three spaces and the first two are already filled in with a "c" and an "a," most people will fill in the third space with a "t." And this is the intended effect of the clue.

In artistic allusion, the textual similarity that refers the audience to the source text is like a clue in a crossword puzzle. It alludes, but it also authorizes some associations and proscribes others. I have proposed that this normative aspect of allusion would be absent if allusion did not require authorial intention. Recognition of allusion requires recognition of an intention to allude, and this recognition is recognition that the author, in alluding, asks us to make it relevant to the current situation.

In mass art, an artistic allusion authorizes and proscribes various meanings in the alluding text, meanings that are accessible even if one is not aware of the presence of allusion. One can understand Neo's decision in taking the red pill without noticing the allusion. But for those who catch the allusion, it authorizes and proscribes additional meanings that arise from associations with the source text. This doubling of intentions explains how mass art can satisfy the accessibility condition, while at the same time it can incorporate subtle and even obscure references that are not accessible to much of the mass audience.

V

When the allusion is recognized and the audience makes connections under the auspices of Grice's Cooperative Principle, different aspects of the allusion will limit the range of associations appropriate to it. An artistic allusion reflects two artistic decisions: the choice of a source text, and the choice of

an "echo," quotation, or paraphrase from among the many that might be employed. The two decisions are closely related.

In mass art, a good allusion will serve as a functional element of the alluding text independent of its alluding function. Apart from their indirect reference, the red and blue pills allow us to see Neo's choice without his having to announce it. Two different mass artworks may allude to the same source text but will choose different allusive elements, ones appropriate to their own direction. When Jefferson Airplane's Grace Slick wrote a song alluding to both of Carroll's Alice books, she chose to mention the rabbit (but not the rabbit hole), Alice, changes in size, the caterpillar with the hookah, the Red Queen, and the pieces on the chessboard coming to life. *The Matrix* mentions Alice and the rabbit hole but not the rabbit, and I can't recall any references to caterpillars, chess, and hookahs. Grace Slick and her band, Jefferson Airplane, were interested in elements that could serve as drug references in the absence of detailed knowledge of the Alice books. *The Matrix* explores altered realities, but not the sort that comes about by ingesting psychoactive drugs.

Let me apply this insight to some other examples. A viewer of *Alien* who hasn't seen *Star Wars* will understand the narrative purpose of the alluding shot. Viewers of *Kill Bill: Vol. 1* (2003) who don't know that Uma Thurman's yellow jumpsuit is an allusion to Bruce Lee's final film (*Enter the Dragon*, 1973) don't expect her to be naked, so the outfit has a purpose apart from the allusion. It also makes her stand out from the multitude of attacking villains in a big fight scene. In mass art, virtually all allusion satisfies this two-fold function. But when allusions occur, there is the possibility of recognition (in principle) that two distinct decisions must have been made. A source text was chosen, and an element from that source text was chosen, subject to conventions that allow its integration into the alluding text without diminishing access for those who miss the allusion.

The same integration strategy is employed in the traditional fine arts. It would be silly to suppose that fine art allusions are present solely for the sake of their allusive effects, creating incomprehensible elements for those who do not grasp their reference to a source text. Eliot's "The Love Song of J. Alfred Prufrock" contains a subtle allusion to John Donne's "The Relic." (Eliot's "arms that are braceleted and bright" echoes Donne's "a bracelet of white hair.") Yet Eliot's line has its own descriptive function, independent of the fact that it alludes. While creators of both high and low art enhance their work with allusion, recognizing that they do so is not essential to the enjoyment of either the poem or the rock song.

VI

I will conclude by suggesting two additional points about mass art allusion. If we admire the wit and skill behind a good allusion, we may think a good deal about the associations that are intended. Most of the audience for mass art returns to the same text, watching their favorite films many times and listening to the same music again and again. Allusions that were overlooked may suddenly appear, in part because the audience member will have learned new things in the meantime. Watching *The Matrix* after learning of the *Sylvie and Bruno* allusion, I became more aware of how the theme of choice and fate was introduced at other points in the plot, and I looked to see how the theme of love might be related to each of them. The allusion's pleasurable prompt of recognition (my awareness that the author intends to allude) is not at odds with its puzzle pleasure. The pleasure of recognition is sometimes an invitation to a puzzle, a puzzle that may be solved over time and after multiple experiences of the same text.

Finally, I'd like to note that the analysis of mass art that I've endorsed is neutral about the saturation of the alluding text by the source text. Are allusions necessarily local, small-scale aesthetic effects? Is this more likely to be the case with popular art? Some authors insist that allusion is a local event within a text. This view is reinforced by the assumption that allusions please through their immediacy. I think we have thousands of real cases where a long stretch of a work or even a whole work alludes. The most obvious cases involve music sampling and remakes of films and songs. Films often allude to scenes from plays and other films when constructing new narratives. Gus Van Sant's film *My Own Private Idaho* (1991) is an obvious example. The stilted quality of many scenes derives from its extended borrowings from Shakespeare's *Henry IV*, Parts One and Two. Many fans of actor Keanu Reeves have seen the film and they can follow the story despite their ignorance of Shakespeare. But much of its aesthetic richness comes from the extended allusion.

Remakes, in which an entirely new version is created, can satisfy the conditions of allusion. Consider the phenomenon of tribute albums, in which an assortment of pop musicians contributes "covers" of songs by the same artist. One of my favorites is the British package *The Last Temptation of Elvis: Songs from His Movies* (1990), in no small part because of the allusion of the title. When Bruce Springsteen covers "Viva Las Vegas" and the Jesus and Mary Chain cover "Guitar Man," each renders the song in their own styles. But the musicians intend that we compare what they have done with the "originals," the Elvis Presley versions, and we are invited to interpret each new performance in light of the Elvis source text. I will leave you to think about

film remakes and how later versions are purposely enriched by our memories of the source films.

To sum up, the pleasure that comes from recognition of an allusion is not always resolved in the immediate recognition of its significance. As in high art, many mass art allusions are obscure for much of the audience. Some are puzzles even for those who notice their presence. But a successful work of mass art must satisfy an accessibility condition. For those who "get" a small-scale allusion, part of its aesthetic richness is how it dovetails into the alluding work without disrupting accessibility for those who don't grasp it.

Notes

1. William Irwin, "What Is an Allusion?" *Journal of Aesthetics and Art Criticism* 59 (2001): 294.

2. Joseph Pucci, *The Full Knowing Reader: Allusion and the Power of the Reader in the Western Literary Tradition* (New Haven, CT: Yale University Press, 1998), 41.

3. Pucci, *The Full Knowing Reader*, 40.

4. Monroe C. Beardsley, "Intentions and Interpretations," in *The Aesthetic Point of View: Selected Essays*, ed. Michael J. Wreen and Donald M. Callen, 188–207 (Ithaca, NY: Cornell University Press, 1983), 200.

5. There are various versions of this argument, and mine derives from Robert Stecker, *Artworks: Definition Meaning Value* (University Park: Pennsylvania State University Press, 1997), 172–73, and Robert Stecker, *Interpretation and Construction: Art, Speech, and the Law* (Malden, MA: Blackwell, 2003), 29–50. See also Peter Lamarque, *Fictional Points of View* (Ithaca, NY: Cornell University Press, 1996), 178–80.

6. Paul Grice, *Studies in the Way of Words* (Cambridge, MA: Harvard University Press, 1989), 26–31.

Further Reading

Barnes, Annette. 1988. *On interpretation*. Oxford: Blackwell. Defends moderate actual intentionalism but also pluralism about acceptable interpretations.

Beardsley, Monroe C. 1970. *The possibility of criticism*. Detroit, MI: Wayne State University Press. An argument against the relevance of intention in interpretation.

Carroll, Noël. 2001. *Beyond aesthetics: Philosophical essays*. Cambridge: Cambridge University Press. Contains a number of essays that argue for moderate actual intentionalism.

Davies, David. 2007. Reading fiction (2): Interpreting literary works. In *Aesthetics and literature*, 70–97. London: Continuum. Argues against both actual and hypothetical intentionalism.

Davies, Stephen. 2006. Author's intentions, literary interpretations, and literary value. *British Journal of Aesthetics* 46: 223–47. Argues that the aim of interpretation is to optimize the work's aesthetic value.

Goldman, Alan. 1990. Interpreting art and literature. *Journal of Aesthetics and Art Criticism* 48: 205–14. Another argument for a value-optimizing view of the aim of interpretation.

Hirsch, E. D. 1967. *Validity in interpretation.* New Haven, CT: Yale University Press. A classic argument for actual intentionalism.

Iseminger, Gary, ed. 1992. *Intention and interpretation.* Philadelphia: Temple University Press. A valuable collection airing a variety of views on this issue.

Knapp, S., and W. B. Michaels. 1985. Against theory. In *Against theory,* edited by W. J. T. Mitchell, 222–32. Chicago: University of Chicago Press. An argument for the identity thesis.

Lamarque, Peter. 2002. Appreciation and literary interpretation. In *Is there a single right interpretation,* edited by Michael Krausz, 285–306. University Park: Pennsylvania State University Press. Posits that the aim of interpretation is to enhance appreciation and argues against the idea that artworks have meanings.

Levinson, Jerrold. 1996. *The pleasures of aesthetics.* Ithaca, NY: Cornell University Press, 175–273. Contains an important argument for hypothetical intentionalism.

Livingston, Paisley. 1998. Intentionalism in aesthetics. *New Literary History* 50: 615–33. Argues for moderate actual intentionalism.

———. 2005. *Art and intention.* Oxford: Oxford University Press. An extremely thorough exploration of the multifaceted roles of intention in art.

Nathan, Daniel. 1992. Irony, metaphor and the problem of intention. In *Intention and interpretation,* edited by Gary Iseminger, 183–202. Philadelphia: Temple University Press. An anti-intentionalist argument.

Nehamas, Alexander. 1981. The postulated author: Critical monism as a regulative ideal. *Critical Inquiry* 8: 133–49. An argument for hypothetical intentionalism.

Stecker, Robert. 1997. *Artworks: Definition, meaning, value.* University Park: Pennsylvania State University Press. Contains an overview of several facets of the debate about interpretation.

———. 2003. *Interpretation and construction: Art, speech, and the law.* Oxford: Blackwell. Argues for moderate intentionalism and for pluralism about the aims of interpretation.

CHAPTER SEVEN

~

Representation

Fiction

Introduction

Compare the following two occasions. On the first, you are watching a documentary about the Japanese surprise attack on Pearl Harbor. It is quite well done and fully engrosses your attention. Actors re-create some conversations, reports, and speeches from the period before, during, and after the battle. Despite their presence, however, most would regard the documentary as a work of nonfiction. On the second occasion, you watch the movie *Pearl Harbor*. It also engrosses your attention and strives for a degree of historical accuracy. Although it is about an actual historical event and may include as characters individuals who really lived during the period, this movie is a work of fiction. Do you agree that the documentary is nonfiction while the movie is fiction? Whether you do or not in this particular case, there is a distinction to be made between works of nonfiction and works of fiction. What crucial factors distinguish these two categories?

Now think about something else that occurs on the two occasions. As you watch the documentary and the movie, you will have a variety of responses. Some of these responses will be cognitive. Based on the documentary, you will form a variety of beliefs. The movie also might give rise to beliefs about some things that happened at Pearl Harbor, but it will also give rise to another set of beliefs about what is true in the fictional story you are watching with regard to events and people whom you may have no reason to think are actual. Some of the responses will be imaginative. Both documentary and movie may provoke you to imagine what it was like to be

under attack at Pearl Harbor or to be an attacker for that matter. But the movie, most likely, will involve you more closely with the lives of some particular characters, who may be purely fictional. What you imagine with respect to them may have no parallel in the documentary. Finally, some of your responses will be emotional. In some cases, the documentary and the movie may evoke the very same emotions in you since they are about the same actual event. So in both cases you may feel indignation about the attack or despair at the death and destruction it wrought, or possibly some degree of admiration for the cleverness and skill of the Japanese in launching a surprise attack on the headquarters of the American Pacific fleet. However, other cases are more problematic. Suppose in the documentary you witness the death of some sailors during the attack. Knowing these were real young men, you are saddened by their fate. Suppose in the movie you witness the death of some fictional sailors, whom you have gotten to "know" over the course of the movie. Your feelings might actually be more intense in this case, but you also know that no one is actually suffering the fate you seem to be witnessing. Do you feel the same pity in the case of the real sailors you see in the documentary and the fictional ones in the movie? Does the fictional nature of the latter case create some important difference in the nature of our emotional responses?

This example raises two kinds of questions about fictional representation. First, what is fiction, and what distinguishes it from nonfiction? Second, what is the nature of our responses to fiction, and do they differ importantly in certain ways from our responses to nonfiction? The readings in this chapter address both issues.

John Searle and Gregory Currie offer answers to the question, What is fiction? To appreciate their answers, it is important to realize that some alternative views that might at first seem appealing are in fact nonstarters. One might claim that "fiction" is synonymous with "falsehood" or deals with people who never existed and events that never occurred as opposed to history, which is about real people and events. As our initial example shows, neither of these thoughts characterizes all fiction, which can be about events that really happened and include as characters people who really lived through them.

Searle proposes that fiction is a kind of pretense, particularly in the use of language. For example, if I begin a story with "There were once three bears who had porridge for breakfast every morning," I use words that would normally be taken as making an assertion about a matter of fact. So I might assert about my neighbors, "The Popoff family has three members, and they have porridge for breakfast every morning."

However, in the case of the story about the bears, I am not asserting anything. Instead, according to Searle, I am pretending to make an assertion and inviting my reader to join me in the pretense. So, even if my fictional story describes actual events such as the attack on Pearl Harbor, my story is fictional because I only pretend to assert that such events occurred during the attack. More generally, instead of actually performing speech acts known as illocutionary acts—such as making assertions, asking questions, and issuing commands—an author of fiction pretends to perform these acts.

Gregory Currie offers an alternative view. For Currie, an illocutionary act is characterized by a distinctive intention that a speaker or writer has in performing the act. So when I assert that something is true, I intend for my audience to believe that something to be true, to recognize that I intend for them to do so, and to make their recognition of my intention a reason for doing so. Currie thinks that when we create a fiction, we have a different but equally distinctive intention, namely that my audience make believe that something is true, recognize my intention for them to do so, and make this recognition a reason for doing so. Notice the two intentions have exactly the same structure and only differ in the attitude the audience is intended to adopt to the sentences uttered. So, if assertion is an illocutionary act, fiction making should be considered not the pretense of making illocutionary acts but a distinctive illocutionary act in its own right.

One problem for both Searle and Currie is that their respective theories of fiction are exclusively focused on the use of language in creating works of fiction. But there are also nonlinguistic fictions such as movies and pictures. Can you think of a way of extending either theory to these types of fiction?

The essays by Peter Lamarque and Kendall Walton focus on our responses to fiction, in particular our emotional responses. To appreciate their views on this subject, we must situate them within an ongoing debate on this topic. A purported paradox, sometimes known as the paradox of fiction, sets the terms of the debate. Here is an instance:

1. Sally pities Anna (where Anna is the character Anna Karenina in the novel by Leo Tolstoy bearing that name).
2. To pity someone, one must believe that they exist and are suffering (have suffered).
3. Sally does not believe that Anna exists.

All of these propositions have an initial plausibility: they assert (1) an occurrence of familiar phenomena, (2) a widely held belief about emotions, and (3) that Sally has a belief about fictional characters that is also widely

shared. Yet the three propositions taken together form an inconsistent triad and imply the contradiction that Sally does and does not pity Anna. To resolve the paradox, at least one of these propositions has to be rejected. Some question the third, wondering whether, while immersed in the novel, Sally forgets or suspends her disbelief that Anna is merely a fictional character. The problem with this approach is that, even when one is perfectly aware of the fictionality of Anna and the events surrounding her, it still seems possible to be moved by the novel. So most philosophers have focused their attention on propositions 1 and 2. Roughly speaking, Lamarque argues that we should reject 2, while Walton argues that we should reject 1.

Lamarque claims that we may feel real pity for Anna because feeling pity and other emotions does not always involve believing that the object of emotion exists; therefore, 2 is false. Belief is one kind of thought that can give rise to an emotion, but not the only kind. Vividly imagining a certain state of affairs, for example, an alien invasion of Earth, might also cause an emotion, in this case fear. According to Lamarque, something along these lines is precisely what happens when we respond emotionally to fiction. We are responding to thoughts in our own heads that we have imagined vividly, which can give rise to real emotions of pity, fear, and so on.

Walton does not buy this account. He does not deny that encounters with fiction can generate vividly imagined thoughts. Further, he endorses the idea that these thoughts can provoke an intense response in us: our heart starts beating faster, adrenaline flows, our palms become sweaty, or a lump forms in our throat and tears stream from our eyes. That is, these thoughts may engender the sensations and physiological effects associated with a given emotion. But they do not give rise to other things, for instance, the belief that the object of emotion exists and has the property that would make the emotion appropriate. In the case of pity, the property would be that the object suffers. Also absent is the behavior or tendency to behave that usually accompanies an emotion. If I really fear something, I might have a tendency to flee or take some other defensive action. All this leads Walton to conclude that, while I may be in an intense emotion-like state, I do not literally feel pity or fear the characters of fiction or thoughts about those characters in my head. Rather, it is part of Sally's make-believe that she pities Anna, though this can have the real effects described above. Hence it is proposition 1 that is false.

Lamarque emphasizes the similarities between "standard cases" when we feel an emotion and our responses to fiction. Walton emphasizes differences. Which emphasis, if either, is more important in understanding our responses to fiction?

⚬✖⚬

The Logical Status of Fictional Discourse*

John R. Searle

I

I believe that speaking or writing in a language consists in performing speech acts of a quite specific kind called "illocutionary acts." These include making statements, asking questions, giving orders, making promises, apologizing, thanking, and so on. I also believe that there is a systematic set of relationships between the meanings of the words and sentences we utter and the illocutionary acts we perform in the utterance of those words and sentences.[1]

Now for anybody who holds such a view the existence of fictional discourse poses a difficult problem. We might put the problem in the form of a paradox: how can it be both the case that words and other elements in a fictional story have their ordinary meanings and yet the rules that attach to those words and determine their meanings are not complied with: how can it be the case in "Little Red Riding Hood" both that "red" means red and yet that the rules correlating "red" with red are not in force? This is only a preliminary formulation of our question and we shall have to attack the question more vigorously before we can even get a careful formulation of it.

II

Let us begin by comparing two passages chosen at random to illustrate the distinction between fiction and nonfiction. The first, nonfiction, is from the *New York Times* (December 15, 1972), written by Eileen Shanahan:

> Washington, Dec. 14—A group of federal, state, and local government officials rejected today President Nixon's idea that the federal government provide the financial aid that would permit local governments to reduce property taxes.

The second is from a novel by Iris Murdoch entitled *The Red and the Green*, which begins,

> Ten more glorious days without horses! So thought Second Lieutenant Andrew Chase-White recently commissioned in the distinguished regiment of King Edwards Horse, as he pottered contentedly in a garden on the outskirts of Dublin on a sunny Sunday afternoon in April nineteen-sixteen.[2]

*"The Logical Status of Fictional Discourse," *New Literary History* 6:2 (1975): 319–32. Reprinted by permission of the author.

The first thing to notice about both passages is that, with the possible exception of the word *pottered* in Miss Murdoch's novel, all of the occurrences of the words are quite literal. Both authors are speaking (writing) literally. What then are the differences? Let us begin by considering the passage from the *New York Times*. Miss Shanahan is making an assertion. An assertion is a type of illocutionary act that conforms to certain quite specific semantic and pragmatic rules. These are:

1. The essential rule: the maker of an assertion commits himself to the truth of the expressed proposition.
2. The preparatory rules: the speaker must be in a position to provide evidence or reasons for the truth of the expressed proposition.
3. The expressed proposition must not be obviously true to both the speaker and the hearer in the context of utterance.
4. The sincerity rule: the speaker commits himself to a belief in the truth of the expressed proposition.[3]

Notice that Miss Shanahan is held responsible for complying with all these rules. If she fails to comply with any of them, we shall say that her assertion is defective. If she fails to meet the conditions specified by the rules, we will say that what she said is false or mistaken or wrong, or that she didn't have enough evidence for what she said, or that it was pointless because we all knew it anyhow, or that she was lying because she didn't really believe it. Such are the ways that assertions can characteristically go wrong. The rules establish the internal canons of criticism of the utterance.

But now notice that none of these rules apply to the passage from Miss Murdoch. Her utterance is not a commitment to the truth of the proposition that on a sunny Sunday afternoon in April of 1916 a recently commissioned lieutenant of an outfit called the King Edwards Horse named Andrew Chase-White pottered in his garden and thought that he was going to have ten more glorious days without horses. Such a proposition may or may not be true, but Miss Murdoch has no commitment whatever as regards its truth. Furthermore, as she is not committed to its truth, she is not committed to being able to provide evidence for its truth. Again, since there is no commitment to the truth of the proposition there is no question as to whether we are or are not already apprised of its truth, and she is not held to be insincere if in fact she does not believe for one moment that there actually was such a character thinking about horses that day in Dublin.

Now we come to the crux of our problem: Miss Shanahan is making an assertion, and assertions are defined by the constitutive rules of the activity

of asserting; but what kind of illocutionary act can Miss Murdoch be performing? In particular, how can it be an assertion since it complies with none of the rules peculiar to assertions?

Let us begin by considering one wrong answer to our question, an answer which some authors have in fact proposed. According to this answer, Miss Murdoch or any other writer of novels is not performing the illocutionary act of making an assertion but the illocutionary act of telling a story or writing a novel. On this theory, newspaper accounts contain one class of illocutionary acts (statements, assertions, descriptions, explanations) and fictional literature contains another class of illocutionary acts (writing stories, novels, poems, plays, etc.). The writer or speaker of fiction has his own repertoire of illocutionary acts which are on all fours with, but in addition to, the standard illocutionary acts of asking questions, making requests, making promises, giving descriptions, and so on. I believe that this analysis is incorrect. By way of illustrating its incorrectness I want to mention a serious difficulty which anyone who wished to present such an account would face. In general the illocutionary act (or acts) performed in the utterance of the sentence is a function of the meaning of the sentence. We know, for example, that an utterance of the sentence "John can run the mile" is a performance of one kind of illocutionary act, and that an utterance of the sentence "Can John run the mile?" is a performance of another kind of illocutionary act, because we know that the indicative sentence form means something different from the interrogative sentence form. But now if the sentences in a work of fiction were used to perform some completely different speech acts from those determined by their literal meaning, they would have to have some other meaning. Anyone therefore who wishes to claim that fiction contains different illocutionary acts from nonfiction is committed to the view that words do not have their normal meanings in works of fiction. That view is at least prima facie implausible since if it were true it would be impossible for anyone to understand a work of fiction without learning a new set of meanings for all the words and other elements contained in the work of fiction, and since any sentence whatever can occur in a work of fiction, in order to have the ability to read any work of fiction, a speaker of the language would have to learn the language all over again.

Back to Miss Murdoch. If she is not performing the illocutionary act of writing a novel, what exactly is she doing in the quoted passage? The answer seems to me obvious. She is pretending to make an assertion, or imitating the making of an assertion. I place no great store by [either] of these verb phrases, but let us go to work on "pretend," as it is as good as any. When I say that Miss Murdoch is pretending to make an assertion, it is crucial to distinguish two quite different senses of "pretend." In one sense of "pretend,"

to pretend to be or to do something that one is not doing is to engage in a form of deception, but in the second sense of "pretend," to pretend to do or be something is to engage in a performance which is *as if* one were doing or being the thing and is without any intent to deceive. If I pretend to be Nixon in order to fool the Secret Service into letting me into the White House, I am pretending in the first sense; if I pretend to be Nixon as part of a game of charades, it is pretending in the second sense. Now in the fictional use of words, it is pretending in the second sense which is in question. Miss Murdoch is engaging in a nondeceptive pseudoperformance which constitutes pretending to recount to us a series of events. So my first conclusion is this: the author of a work of fiction pretends to perform a series of illocutionary acts, normally of the representative type.

One cannot truly be said to have pretended to do something unless one intended to pretend to do it. So our first conclusion leads immediately to our second conclusion: the identifying criterion for whether or not a text is a work of fiction must of necessity lie in the illocutionary intentions of the author. What makes it a work of fiction is the illocutionary stance that the author takes toward it, and that stance is a matter of the complex illocutionary intentions that the author has when he writes or otherwise composes it.

So far I have pointed out that an author of fiction pretends to perform illocutionary acts which he is not in fact performing. But now the question forces itself upon us as to what makes this peculiar form of pretense possible. It is after all an odd, peculiar, and amazing fact about human language that it allows the possibility of fiction at all. Yet we all have no difficulty in recognizing and understanding works of fiction. How is such a thing possible?

In our discussion of Miss Shanahan's passage in the *New York Times*, we specified a set of rules, compliance with which makes her utterance an assertion. I find it useful to think of these rules as rules correlating words (or sentences) to the world. Think of them as vertical rules that establish connections between language and reality. Now what makes fiction possible, I suggest, is a set of extralinguistic, nonsemantic conventions that break the connection between words and the world established by the rules mentioned earlier. Think of the conventions of fictional discourse as a set of horizontal conventions that break the connections established by the vertical rules. They suspend the normal requirements established by these rules. Such horizontal conventions are not meaning rules; they are not part of the speaker's semantic competence. Accordingly, they do not alter or change the meanings of any of the words or other elements of the language. What they do rather is enable the speaker to use words with their literal meanings without undertaking the commitments that are normally required by those meanings. My third conclusion then is this:

the pretended illocutions which constitute a work of fiction are made possible by the existence of a set of conventions which suspend the normal operation of the rules relating illocutionary acts and the world. In this sense, to use Ludwig Wittgenstein's jargon, telling stories really is a separate language game; to be played it requires a separate set of conventions, though these conventions are not meaning rules; and the language game is not on all fours with illocutionary language games, but is parasitic on them.

This point will perhaps be clearer if we contrast fiction with lies. Lying consists in violating one of the regulative rules on the performance of speech acts. Since the rule defines what constitutes a violation, it is not first necessary to learn to follow the rule and then learn a separate practice of breaking the rule. But in contrast, fiction is much more sophisticated than lying. To someone who did not understand the separate conventions of fiction, it would seem that fiction is merely lying. What distinguishes fiction from lies is the existence of a separate set of conventions which enables the author to go through the motions of making statements which he knows to be not true even though he has no intention to deceive.

If, as I have said, the author does not actually perform illocutionary acts but only pretends to, how is the pretense performed? It is a general feature of the concept of pretending that one can pretend to perform a higher-order or complex action by *actually* performing lower-order or less complex actions which are constitutive parts of the higher-order or complex action. Thus, for example, one can pretend to hit someone by actually making the arm and fist movements that are characteristic of hitting someone. The hitting is pretended, but the movement of the arm and fist is real. The same principle applies to the writing of fiction. The author pretends to perform illocutionary acts by way of actually uttering (writing) sentences. The utterance acts in fiction are indistinguishable from the utterance acts of serious discourse, and it is for that reason that there is no textual property that will identify a stretch of discourse as a work of fiction. It is the performance of the utterance act with the intention of invoking the horizontal conventions that constitutes the pretended performance of the illocutionary act.

The fourth conclusion of this section, then, is a development of the third: the pretended performances of illocutionary acts which constitute the writing of a work of fiction consist in actually performing utterance acts with the intention of invoking the horizontal conventions that suspend the normal illocutionary commitments of the utterances.

Dramatic texts provide us with an interesting special case of the thesis I have been arguing in this paper. The author of the play is not in general pretending to make assertions; he is giving directions as to how to enact a

pretense which the actors then follow. Consider the following passage from Galsworthy's *The Silver Box*:

> Act I, Scene I. The curtain rises on the Barthwick's dining room, large, modern, and well furnished; the window curtains drawn. Electric light is burning. On the large round dining table is set out a tray with whiskey, a syphon, and a silver cigarette box. It is past midnight. A fumbling is heard outside the door. It is opened suddenly; Jack Barthwick seems to fall into the room . . .
>
> Jack: Hello! I've got home all ri - - - (*Defiantly*)[4]

It is instructive to compare this passage with Miss Murdoch's. Murdoch, I have claimed, tells us a story; in order to do that, she pretends to make a series of assertions about people in Dublin in 1916. What we visualize when we read the passage is a man pottering about his garden thinking about horses. But when Galsworthy writes his play, he gives us a series of directions as to how things are actually to happen on stage when the play is performed. When we read the passage from Galsworthy we visualize a stage, the curtain rises, the stage is furnished like a dining room, and so on. That is, it seems to me the illocutionary force of the text of a play is like the illocutionary force of a recipe for baking a cake. It is a set of instructions for how to do something, namely, how to perform the play. The element of pretense enters at the level of the performance: the actors pretend to be the members of the Barthwick family doing such-and-such things and having such-and-such feelings.

III

The analysis of the preceding section, if it is correct, should help us to solve some of the traditional puzzles about the ontology of a work of fiction. How is it possible for an author to "create" fictional characters out of thin air, as it were? To answer this let us go back to the passage from Iris Murdoch. The second sentence begins, "So thought Second Lieutenant Andrew Chase-White." Now in this passage Murdoch uses a proper name, a paradigm-referring expression. Just as in the whole sentence she pretends to make an assertion, in this passage she pretends to refer (another speech act). One of the conditions on the successful performance of the speech act of reference is that there must exist an object that the speaker is referring to. Thus by pretending to refer she pretends that there is an object to be referred to. To the extent that we share in the pretense, we will also pretend that there is a lieutenant named Andrew Chase-White living in Dublin in 1916. It is the pretended reference which creates the fictional character and the shared pretense which enables us to talk about the character. The logical structure of all this is complicated,

but it is not opaque. By pretending to refer to a person, Miss Murdoch creates a fictional character. Notice that she does not really refer to a fictional character because there was no such antecedently existing character; rather, by pretending to refer to a person she creates a fictional person. Now once that fictional character has been created, we who are standing outside the fictional story can really refer to a fictional person.

Another interesting feature of fictional reference is that normally not all of the references in a work of fiction will be pretended acts of referring; some will be real references as in the passage from Miss Murdoch where she refers to Dublin. What is the test for what is fictional and what isn't? The answer is provided by our discussion of the differences between Miss Murdoch's novel and Miss Shanahan's article in the *New York Times*. The test for what the author is committed to is what counts as a mistake. If there never did exist a Nixon, Miss Shanahan (and the rest of us) are mistaken. But if there never did exist an Andrew Chase-White, Miss Murdoch is not mistaken. If Sherlock Holmes and Watson go from Baker Street to Paddington Station by a route which is geographically impossible, we will know that Conan Doyle blundered even though he has not blundered if there never was a veteran of the Afghan campaign answering to the description of John Watson, M.D. In part, certain fictional genres are defined by the nonfictional commitments involved in the work of fiction. The difference, say, between naturalistic novels, fairy stories, works of science fiction, and surrealistic stories is in part defined by the extent of the author's commitment to represent actual facts, either specific facts about places like Dublin or general facts about what it is possible for people to do and what the world is like. For example, if Billy Pilgrim makes a trip to the invisible planet Tralfamadore in a microsecond, we can accept that because it is consistent with the science fiction element of *Slaughterhouse Five*, but if we find a text where Sherlock Holmes does the same thing, we will know at the very least that that text is inconsistent with the corpus of the original nine volumes of the Sherlock Holmes stories.

IV

The preceding analysis leaves one crucial question unanswered: why bother? That is, why do we attach such importance and effort to texts which contain largely pretended speech acts? The reader who has followed my argument this far will not be surprised to hear that I do not think there is any simple or even single answer to that question. Part of the answer would have to do with the crucial role, usually underestimated, that imagination plays in human life, and the equally crucial role that shared products of the imagination play in human social life. And one aspect of the role that such products play derives from the fact that serious (i.e., nonfictional) speech acts can be conveyed

by fictional texts, even though the conveyed speech act is not represented in the text. Almost any important work of fiction conveys a "message" or "messages" which are conveyed by the text but are not in the text. Only in such children's stories as contain the concluding "and the moral of the story is . . . " do we get an explicit representation of the serious speech acts which it is the point of the fictional text to convey. Literary critics have explained on a particularistic basis how the author conveys a serious speech act through the performance of the pretended speech acts which constitute the work of fiction, but there is as yet no general theory of the mechanisms by which such serious illocutionary intentions are conveyed by pretended illocutions.

Notes

1. See J. R. Searle, *Speech Acts* (Cambridge: Cambridge University Press, 1969), esp. chs. 3–5.

2. Iris Murdoch, *The Red and the Green* (New York: Viking, 1965), 3.

3. For a more thorough exposition of these and similar rules, see Searle, *Speech Acts*, ch. 3.

4. John Galsworthy, *Representative Plays* (New York; Charles Scribner's Sons, 1924), 3.

c≫ɔ

What Is Fiction?*

Gregory Currie

I

What distinguishes fiction from nonfiction? In order to understand what distinguishes fiction from other kinds of discourse it may be helpful to inquire into the conditions which must prevail in order for a successful act of fictional communication to take place. Such an approach suggests a "speech act" analysis of fiction, and it is a version of this theory that I will offer here. Such analyses of fiction are relatively common in the current literature, but the prevailing tendency is to regard fictional utterance (in a generalized sense of utterance which includes writing) as a "pseudo-performance" which is not constitutive of a fully fledged illocutionary act.[1] I want to resist this tendency. My strategy is to treat the utterance of fiction as the performance

* "What is Fiction?" *Journal of Aesthetics and Art Criticism* 43:4 (1985): 385–92. Copyright © 1985 The American Society for Aesthetics. Reprinted by permission of Blackwell Publishing Ltd.

of an illocutionary act on a par with assertion. I shall then attempt a defini-
tion of fiction in terms of this illocutionary act (together with a causal condi-
tion). Before I come to the details of the proposal let us take a critical look at
the reasoning which has led speech act theorists to reject this approach.

II

The idea that fiction is associated with a distinctive illocutionary act is con-
sidered and rejected by John Searle in his influential study of our topic.[2] A
principle which Searle adheres to is this:

> In general the illocutionary act performed in the utterance of a sentence is a
> function of the meaning of the sentence. We know, for example, that an ut-
> terance of the sentence "John can run the mile" is a performance of one kind
> of illocutionary act, and that an utterance of the sentence "Can John run the
> mile?" is a performance of another kind of illocutionary act, because we know
> that the indicative sentence form means something different from the inter-
> rogative sentence form (64).

Searle's point is: the meaning of a sentence determines the kind of illocu-
tionary act it is used to perform. I shall call this the *determination principle*.

Searle applies this principle to the idea that the difference between fiction
and nonfiction is a difference between kinds of illocutionary acts performed.
On this view the writer of nonfiction is performing the illocutionary act of
asserting, while the writer of fiction is performing the illocutionary act of
"telling a story" (63).

Searle rejects this theory because the writer of fiction may use the same
indicative sentences as the writer of nonfiction. And this is inconsistent with
the determination principle.

I want to make two observations about this argument. First, the argument
depends entirely upon the determination principle. But the principle seems
obviously false. The same sentence may, given the right context, be used to
make an assertion, ask a question, or give a command (e.g., "You are going
to the concert").

Secondly, it turns out that Searle's own theory of fiction offends
against the determination principle. On Searle's view the author of fic-
tion engages "in a nondeceptive pseudo-performance which constitutes
pretending to recount to us a series of events" (65). In doing so "an author
of fiction pretends to perform illocutionary acts which he is not in fact
performing" (66). What Searle is saying is that the same sentence with the
same meaning can occur in nonfiction as the result of the illocutionary

act of assertion, and again in fiction as the result of an act which is not an illocutionary act at all. So sentence meaning does not determine the illocutionary act performed.

It is not true that to utter a sentence generally used to perform one illocution without fulfilling the conditions appropriate for that act is always merely to perform a pretence of that act. Suppose that a speaker who utters an indicative sentence, "It's hot in here," is actually giving the command "Open the window." We would not describe such an action as a pretence. The speaker intends his utterance to be understood as a command, and believes that the context will enable his hearer to divine his intention. So too with the author of fiction. He relies upon the audience being aware that they are confronting a work of fiction, and assumes that they will not take utterances which have the indicative form to be assertions. He is thus not pretending anything. He is inviting us to pretend, or rather, to make-believe something.

If, as I have suggested, we think of fiction in communicative terms, then I think we see that the hypothesis of authorial pretence plays no role in the explanation of how such communication takes place. What is required is that the reader understands which attitude toward the statements of the text the author intends him to adopt. In the case of fiction the intended attitude is one of make-believe. So the author of fiction intends not merely that the reader will make-believe the text, but that he will do so partly as a result of his recognition of that very intention. Recognition of that intention secures "illocutionary uptake." So while it is essential that the author have a certain complex intention it is not required that he engage in any kind of pretence.

III

These last remarks serve to introduce the strategy I shall adopt here. I shall take up the suggestion of P. F. Strawson and others that the illocutionary act is a function of the speaker's intention.[3] There are arguments for thinking that speech acts of a purely conventional kind are not amenable to analysis in terms of any mechanism based on a speaker's intentions. But for many cases the intentional approach seems right, and I believe it is right for the case of fiction. It enables us to distinguish the action of the author of fiction from that of the one who merely recites or acts out a fictional work.

We now have the elements for an account of the illocutionary act performed by an author of fiction. The author of fiction intends that the reader make-believe P, where P is the sentence or string of sentences he utters. And he intends that the reader shall come to make-believe P partly as a result of his recognition that the author intends him to do this. The author intends that the reader will read the work *as* fiction because he perceives the work to

be fiction; that is, because he realizes it to be the product of a certain intention. The reader may recognize this intention in a number of ways; through his perception in the work of certain familiar elements of fictional style, or simply by noting that the work is presented and advertised as fiction.

With this in mind we may present the following definition of fictional utterance, where U is the utterer, \emptyset a variable ranging over characteristics of persons, and P a proposition.

(F)
U performs the illocutionary act of uttering fiction in uttering P if and only if
There exists \emptyset such that U utters P intending that anyone who were to have \emptyset
(1) would make-believe P;
(2) would recognize U's intention of (1);
(3) would have (2) as a reason for doing (1).

\emptyset may be any characteristic or group of characteristics the author would acknowledge as sufficient to ensure that anyone possessing them would, under normal circumstances, grasp his illocutionary intentions. It may be as general as "member of the author's speech community." On this definition it is of course possible for someone to write fiction without intending that anyone shall actually read it. This definition may require refinement of some kind. But my aim here is to present the outlines of a program, not to pursue any one aspect of it in great depth.

IV

In characterizing fictional communication in this way, do we arrive at a satisfactory definition of fiction itself? Not immediately. If we say that a discourse is fictional if and only if it is the product of the illocutionary intention defined by the schema F, then we are faced with some problem cases. For example, an author may concoct a story which he intends the audience to believe rather than to make-believe. It has been suggested to me that this was Defoe's intention in writing *Robinson Crusoe*. I do not know whether this is the case, but it certainly might have been. If we were to discover that it was, we would surely not cease to regard *Robinson Crusoe* as fiction. Conversely, there may be cases where the author had a fictional intention but where we do not want to grant the fictional status to the resulting text. Someone may write a strictly autobiographical account of his or her life (perhaps a life full of highly unlikely events), adopting as he or she does certain stylistic devices usually indicative of fictional discourse. The author might intend that the audience make-believe the story, and reasonably expect that the audience will understand that this is the intention. But it

is doubtful whether such a work is genuinely fiction. These are difficulties for my theory. They are also difficulties for a position like Searle's.

What examples like the first suggest is the existence of some capacity on the part of the literary public to confer the status of fiction on works which are not fiction merely in virtue of the intentions of their authors. If Defoe really did intend the reading public to be taken in by *Robinson Crusoe*, then what he produced was not fiction but deceptive assertion. (This is as much a consequence of the Searle theory as of mine, and I think it is intuitively correct.) But it is also true that *Robinson Crusoe* is today too firmly in the fiction category to be shifted by discoveries about the author's intentions. I think we should say that a "core" category of fiction is defined by the author's illocutionary intentions, and then allow for a category of "secondary" fiction defined in terms of a prevailing tendency in the community to adopt the make-believe attitude toward the texts in question. (The case of the Bible tends to confirm this hypothesis. Some people certainly read biblical stories "as fiction," but there are sufficiently many who don't to prevent the fictional attitude from prevailing. And I think we would not comfortably say, whatever our theological standpoint, that the Bible *is* fiction.)

The case of the apparently fictional autobiography presents another kind of difficulty. It is not that the community may intervene to revoke the work's fictional status; intuitively the work never was fiction at all. Is it because the story is true? No. Someone may write a historical novel, staying with the known facts and inventing incidents only where historical knowledge is lacking. Suppose it then turns out that these events described in the novel exactly correspond to what actually happened. I want to say that the work is fiction, even though it is entirely true.

It may be thought that the trouble arises because the author is engaging in a kind of deception. There are counterexamples to the proposal which do not depend upon such a deceptive intent as this.

Here are the counter examples:

1. Jones finds a manuscript *m* which he takes to be fictional and which he determines to plagiarize. He produces his own text, exactly recounting the events in *m*, but written in a somewhat different way. But *m* was, unknown to Jones, nonfiction. Surely Jones's text is nonfiction; but on my theory it is fiction.
2. Jones experiences certain events which he represses. He then writes a story, recounting those events, but which he takes to be a fiction invented by himself. Again, Jones's text is surely nonfiction; on my theory it is fiction.

In these counterexamples the trouble seems to be caused by what we may call an "information-preserving chain" from certain obtaining events to the text in question. That is, in these cases Jones's production of his text depends (causally) upon him processing information which correctly describes certain events.

Let us say, then, that a work is fiction (in the "core" sense) if and only if it is the product of an intention of the kind specified in the schema (F), *and* the resulting text is not related by an information-preserving chain to a sequence of actually occurring events. This allows us to avoid counterexamples 1 and 2 and the deceptive intent counterexample, for in that example there clearly is an information-preserving chain from author to text. It also explains, incidentally, why the accidentally true historical novel is fiction—there is no information-preserving chain between event and text.

V

I turn now to a distinct advantage of this theory over Searle's. It enables us to distinguish the activity of the author of fiction from that of the speaker of fiction, the actor, or the reciter of poetry. Searle tends to assimilate the one to the other. He tells us that "the actor pretends . . . to perform the speech acts and other acts of [the] character [he portrays]."[4] Thus both author and actor are engaging in the same kind of pretence. They are both pretending to perform illocutionary acts which they do not in fact perform.

On the theory presented here we can clearly see the difference between the actions of the author and the actor. The author is performing a genuine illocutionary act determined by his intentions. But the actor on the stage is not performing any illocutionary acts. This is evident from the fact that what he is doing when he utters his lines is quite independent of any illocutionary intentions he may have. What determines that he is acting is the fact that his utterances and other actions are intended by him to conform to the script and to the directions of the play, together with the fact that he is doing these things in the right institutional setting. To be acting the actor must have various intentions. But he does not need to have any of those intentions which would make his utterance an illocutionary act.

This explains our intuition that the actor's linguistic performance is a pseudo-performance in the sense that it is not the performance of an illocutionary act. But this is not true of the author of fiction, who performs a genuine illocutionary act.

VI

There are some complications in the notion of make-believe that we need to take note of. I have spoken as if we always make-believe those propositions contained in the text of a fictional work. This is not so.

The author of fiction frequently uses words and sentences nonliterally. What happens in such a case? Suppose that an author of fiction uses words ironically or metaphorically or in some other nonliteral way. Then he is uttering the proposition P but not with the intention of getting us to make-believe P. He intends that we should make-believe Q, where Q is a proposition distinct from P. He does this by invoking the same mechanism of conversational implicature, described by Paul Grice, which we invoke when we speak nonliterally in ordinary conversation.[5] Thus if the author says P at some point in his text, and if the previous course of his text makes it seem inappropriate that we should make-believe P at that point, then we cast about for some other proposition that it would be appropriate for us to make-believe.

Make-believe is complicated in another direction. There are things that we are called upon to make-believe in a work of fiction that are neither stated nor conversationally implicated by the text itself. If Sherlock Holmes leaves London and arrives in Edinburgh without his mode of transport being described, we are clearly called upon to make-believe that he travelled there by some conventional means of transport. We are not to make-believe that he travelled by a teleportation device of his own invention, for it is surely false "in the fiction" that he used such a device.

The question is, How do we mesh the idea of a proposition being true in a fiction with our account of make-believe? Must the reader make-believe all and only those propositions true in the fiction? It will certainly not generally be the case that the author intends the reader to make-believe all and only all the propositions true in the fiction. It is probably true in the Sherlock Holmes stories that Holmes, for all his amazing powers, is a human being in the biological sense. But it would have been a philosophically very self-conscious Conan Doyle who intended his audience to make-believe that proposition. Perhaps we can use the vagueness of the concept of make-belief here to our own advantage, simply articulating it further in the way that suits us best. Thus it is perhaps convenient to say that the wholly successful act of fictional communication involves make-believing exactly those propositions true in the fiction.

If we pursue this line, or any line similar to it, we start to complicate matters by separating the intended act of fictional communication from the reader's act of make-believe. There will be cases of successful fictional communication where the reader is required (ideally) to make-believe propositions which the author does not intend him to make-believe. But this is not an unacceptable

consequence. We merely have to understand that fiction involves a two-leveled structure of make-believe. To be fiction the text must be such that what it contains is intended by its author to be make-believed. But in picking up the invitation, the reader also picks up an obligation (ideally) to make-believe certain things not explicitly stated in (or conversationally implicated by) the text.

Let us note also that works of fiction may contain sentences which are nonfiction. The author of fiction may make statements which he does not intend the reader to make-believe, but rather to believe. Thus Walter Scott breaks off the narrative of *Guy Mannering* in order to tell us something about the condition of Scottish gypsies. And it is pretty clear that what he is saying he is asserting. This is an obvious point. But there is a related and less obvious point. The distinction, within a text, between fictional and nonfictional statements is not the same as the distinction between what authors (and readers) acknowledge as factual and what they do not so acknowledge. Thus consider a statement within a fictional text, the truth of which is common knowledge between the author and the intended readership—for instance a fact about London geography. Such a statement may be offered as an integral part of the narrative, as vital to our understanding of how certain events in the novel take place. The offering of such information is, it seems to me, very different in status from the clearly nonfictional utterances which constitute Scott's remarks on gypsy life. We are not intended to bracket out the geographical information from the rest of the story; we are intended, I think, to adopt the make-believe attitude toward it as much as toward the description of fictive characters and their doings. Thus it may be that we are asked to make-believe not only what is true, but also what is common knowledge between author and reader. A statement may be both fictional *and* common knowledge.

Notes

1. See John Searle, "The Logical Status of Fictional Discourse," *New Literary History* 6 (1975): 319–22. Most writers on the "logic" of fiction believe that the author is engaging in some kind of pretence. See also Richard Ohmann, "Speech Acts and the Definition of Literature," *Philosophy and Rhetoric* 4, no. 1 (1971): 1–19; Barbara Herrnstein Smith, "Poetry as Fiction," *New Literary History* 2, no. 2 (1971): 259–81; D. M. Armstrong, "Meaning and Communication," *Philosophical Review* 80, no. 4 (1971): 427–47; R. L. Brown and M. Steinmann, "Native Readers of Fiction: A Speech-Act and Genre-Rule Approach to Defining Literature," in *What Is Literature?* ed. P. Hernadi, 141–60 (Bloomington: Indiana University Press, 1978); M. C. Beardsley, "Aesthetic Intentions and Fictive Illocutions," in Hernadi, *What Is Literature?*, 161–77; D. K. Lewis, "Truth in Fiction," *American Philosophical Quarterly* 15, no. 1 (1978): esp. 40.

2. See Searle, "The Logical Status." Page references are to the reprint of this article in Searle's *Expression and Meaning* (Cambridge: Cambridge University Press, 1979).

3. See H. P. Grice, "Meaning," *Philosophical Review* 66, no. 3 (1957): 377–88; H. P. Grice, "Utterer's Meaning, Sentence Meaning and Word Meaning," *Foundations of Language* 4, no. 3 (1968): 225–42; H. P. Grice, "Utterer's Meaning and Intentions," *Philosophical Review* 78, no. 2 (1969): 147–77; P. F. Strawson, "Intention and Convention in Speech Acts," *Philosophical Review* 73, no. 4 (1964): 439–60; D. M. Armstrong, "Meaning and Communication," in *Meaning*, ed. S. R. Schiffer (Oxford: Clarendon Press, 1972).

4. Searle, *Expression and Meaning*, 69.

5. See H. P. Grice, "Logic and Conversation," in *Syntax and Semantics*, vol. 3, *Speech Acts*, ed. P. Cole and J. L. Morgan, 41–58 (New York: Academic Press, 1975). For an application of these ideas to literature, see Mary Louise Pratt, *Towards a Speech Act Theory of Literature* (Bloomington: Indiana University Press, 1975), ch. 5.

How Can We Fear and Pity Fictions?*

Peter Lamarque

I

Desdemona lies innocent and helpless on the bed. Over her towers Othello, who pronounces with solemn finality, "Thou art to die." The enormity and horror of what is about to happen fills us with anger and dismay. Desdemona pleads for her life. But "'Tis too late." Othello has resolved to act, and deaf to his wife's most pitiful pleas, he suffocates and kills her.

As we watch this tragedy unfold, can we truly be described as feeling fear and pity? Are we really *in awe* of Othello's violent jealousy and *moved* by Desdemona's innocent suffering? But how could we be when we know full well that what we are watching is just a play? Such questions have a long history, but more recent discussion has thrown up a number of puzzling suggestions. It has been argued, for example, that our fear at horror movies is only a "quasi fear" occurring as part of a "game of make-believe" that we play with the images on the screen.[1] It has been argued, too, that while our fear and pity might be genuine and quite natural they nevertheless involve "inconsistency" and "incoherence."[2] And, in contradiction to Aristotle, it has also been suggested that what emotional responses we do have to fiction are not only quite dissimilar from "real-life emotions" but are in no way integral to a proper literary response.[3]

* "How Can We Fear and Pity Fictions?" *British Journal of Aesthetics* 21:4 (1981): 291–304. Reprinted by permission of Oxford University Press.

At the heart of the issue seems to lie a paradox about beliefs. On the one hand, it is assumed that as reasonably sophisticated adults we do not believe that the depicted sufferings or dangers involve any real suffering or danger. On the other hand, we respond often enough with a range of emotions, including fear and pity, that seem to be explicable only on the assumption that we do believe there to be real suffering or real danger. For how can we feel fear when we do not believe there to be any danger? How can we feel pity when we do not believe there to be any suffering?

This apparent tension between the beliefs we hold about the nature of fiction and the beliefs needed to explain our responses to fiction seems to threaten at least some commonsense intuitions. I suggest that the best way to reconcile our intuitions and get a clearer perspective on the matter is to shift discussion away from beliefs to the fictions themselves and correspondingly from the emotions to the objects of the emotions. I hope that the paradox of beliefs will disappear when more basic issues on these lines have been sorted out. The central question I shall address is, What are we responding to when we fear Othello and pity Desdemona?

Kendall Walton has reminded us of the logical oddities of our relations with fictional characters. For example, we can talk of them affecting us but not of us affecting them. A logical gap exists between us and them, and those who think that fiction and reality are inextricably mixed should reflect on just how wide this gap is. Exploring the nature of the gap will be at the heart of this investigation.

Walton points out what looks like an asymmetry between physical and psychological interaction between the real world and fictional worlds. No *physical* interaction across worlds, in either direction, seems to be possible. Within their world, Othello can kill Desdemona and within ours I can kill you, but a logical barrier prevents them from killing us and us from killing them. It looks as if the barrier against *psychological* interaction across worlds is more selective. Can we not be frightened, amused, and angered by beings in a fictional world? Walton advises against accepting any cross-world interaction even in the one-way psychological cases where it seems to occur. He ingeniously suggests that the apparent psychological effect on us by fictional characters takes place not across worlds but *in a fictional world*. We are not really afraid but only *fictionally* so. The physical symptoms of our emotions, the clammy palms and prickly eyes, indicate merely a "quasi" emotion in this world. For Walton, to interact in any way with a fictional character, we must "enter" a fictional world.

While I am sympathetic to much of what Walton proposes and heedful of his advice not to accept cross-world interaction if we can help it, I think there is a simpler and less paradoxical way out. Rather than having us enter fictional

worlds, which involves problems about just which fictional worlds we can enter and whether we can ever enter the *right* worlds,[4] it seems more satisfactory to have the fictional characters enter our world. Against Walton, then, I will argue that it is *in the real world* that we psychologically interact with fictional characters. If so, then we can be really afraid and really moved.

II

What is it in our world that we respond to when we fear Othello and pity Desdemona? My suggestion is that fictional characters enter our world in the mundane guise of descriptions (or, strictly, the senses of descriptions) and become the objects of our emotional responses as thought contents characterized by those descriptions. Simply put, the fear and pity we feel for fictions are in fact directed at thoughts in our minds.

First a word about thoughts. I will distinguish between thoughts as states of consciousness and thoughts as representations. As states of consciousness, thoughts are individual and unique; they are properties of a person at a time. As representations, thoughts are types, they can be shared and repeated. Two thoughts as representations are identical if and only if they have the same content. Two thoughts have the same content if and only if they are identified under the same description. Identifying descriptions of thought contents can be of two kinds, which I shall call "propositional" and "predicative." The thought "the moon is made of green cheese" has a content identified under a propositional description, the thought "a piece of cheese" is identified under a predicative description.

It is important to notice the relations between a thought content and belief. Belief is a psychological attitude held in relation to a propositional content. It is one among many attitudes—including disliking, rejecting, remembering, and contemplating—that we might take to the contents of some of our thoughts. This distinction between thought and belief is important in what follows, for the thought contents derived from fictions do not have to be believed to be feared.

Thoughts as representations can be the proper objects of emotional responses such as fear and pity. What is it to be an object of fear? Not everything that we fear exists or is real; we might fear ghosts, leprechauns, or Martians. It is helpful to distinguish between being frightened *of* something and being frightened *by* something. "A is frightened by X" normally implies the existence of X; "A is frightened of Φ" does not imply the existence of Φ, though "Φ" would be one of the descriptions under which A identities what he or she is frightened of. What we are frightened *by* I will call the "real" object of our fear; what we are frightened *of* I will call the "intentional" object.[5] It is my contention that the real objects of our fear in fictional cases are thoughts. We

are frightened *by* thoughts, though we are not frightened *of* thoughts, except in special circumstances. There are parallels with the objects of pity. Our feelings of pity can have real and intentional objects. The real object of our pity, what we are moved *by*, is what arouses our emotion. As with fear, this too can be a thought. The intentional object of our pity will be the direct object of the verb "pity" and will be identified under some intentional description. We do not pity thoughts, but thoughts can be pitiful and can fill us with pity.

The introduction of thoughts as the real objects of our responses to fiction arises out of our earlier paradox of belief. Suppose we claim to be frightened of Martians and Martians do not exist. If we believe that they exist, it is no help to introduce *thoughts* of Martians as an attempt to eliminate intentional objects. For the belief itself has already landed us with such objects. But if we do not believe that Martians exist but still claim to find them frightening, then the introduction of thoughts as an intermediary has genuine explanatory value. We can be frightened by the thought of something without believing that anything real corresponds to the content of the thought. We find the thought frightening and might believe it to be frightening, but that belief raises no paradox in relation to our other beliefs about fiction.

I want to make four points about being frightened by thoughts. First, the propensity of a thought to be frightening is likely to increase in relation to the level of imaginative involvement that is directed to it. Thoughts can differ among themselves with respect to *vividness*. Part of what I mean by involvement with a thought is the level of attention we give to it, which can be increased, for example, by bringing to mind accompanying mental images or by "following through" its consequences. For this reason it is often not so much single thoughts that are frightening as thought clusters. One has to be in the right "frame of mind" to find a thought frightening, which is partly indicated by a tendency to develop thought clusters.

Second, I can be frightened by a thought or a thought cluster at a time when I am in no actual danger and do not believe myself to be in danger. At this moment I am in no danger of being mauled by a lion. But it is not absurd or irrational but natural and likely that I might be frightened here and now by the thought of being mauled should I bring to mind snarling teeth, the thrashing of claws, searing pain, and so on.

Third, it need not be even remotely probable or likely that I will ever face the danger envisaged in a frightening thought, and I need not believe it to be probable. I might find the thought of being stranded on a distant planet frightening without supposing that this will, or even could, happen to me.

Finally, the fear associated with a frightening thought is a genuine, not a "quasi" or fictional, fear. This brings us back to Walton, for whom the fears associated with fictions are not real fears. Does anything argued by Walton

count against thought contents evoking real fears? He imagines Charles watching a horror movie about a terrible green slime. Charles shrieks and clutches his chair as the slime oozes relentlessly toward him. First, Walton argues that because *Charles is fully aware that the slime is fictional,* we cannot say that he is genuinely afraid. The argument here, though, does not affect the fear associated with a frightening thought; this fear is the real thing. We have seen in the second and third points that we can be frightened by a thought regardless of whether we believe ourselves to be in any danger and regardless of whether we believe the content of the thought to be either true or probable. Walton's argument might establish that Charles is not afraid *that the slime is threatening him,* but it does not show that he is not frightened. We need to distinguish between Charles's being frightened *by the slime* and his being frightened by *the thought of the slime.* The former presupposes the reality of the slime, so it cannot be true; but neither the reality of the slime nor Charles's belief in its reality is presupposed by the latter.

The second part of Walton's argument to show that Charles is not genuinely afraid is that he does not manifest the behavioral evidence we would expect from someone who is genuinely afraid of the slime; he does not call the police or warn his friends. Indeed not, for he knows well enough that no real slime exists for the police to investigate. Nevertheless, there might be behavioral evidence that he is frightened by the thought of the slime. He might close his eyes and try to bring other things to mind.

My conclusion at this stage of the argument is that mental representations or thought contents can be the cause of emotions such as fear and pity quite independently of beliefs we might hold about being in personal danger or about the existence of real suffering or pain. This is the first step toward resolving our original paradox of belief.

III

What I must now argue is that when we fear the slime or we pity Desdemona, our fears and tears are directed at thought contents. My claim will be that the explicit or implicit propositional content of a fictional presentation determines and identifies the thought contents to which we react.

All that we know about the fictional worlds *of* novels and stories is ultimately derived from the descriptive contents of the fictional works themselves. An author does not assert the content as true and in turn an informed reader does not believe it to be true but rather imagines it to be so.

When we ask for the reference of the names "Othello" and "Desdemona," we are asking what the names refer to in the world of the fiction, from the internal perspective, or what they refer to in the real world, from the external

perspective. In the play, the names stand for those very persons whose tragic fate imaginatively engages us. On the external perspective, assuming the fictionality of Othello and Desdemona, the references are to fictional characters. Characters, from that perspective, are abstracted sets of qualities corresponding to the descriptive content of the narratives that introduce them. Thus the sense of the name "Desdemona" is given by such descriptions as the person who is named "Desdemona" in Shakespeare's play *Othello*, who loses her handkerchief; who talks innocently to Cassio, who is killed by her jealous husband, and so on. When Desdemona enters our world, she enters not as a person, not even as an imaginary being, but as a complex set of descriptions.

Here, then, we have an explanation of the logical gap between our world and fictional worlds. In the fictional world they exist as people; in the real world they exist only as the senses of descriptions. "Referring to a character" just means either pretending, through the conventions of storytelling, to refer to a person or actually referring to meanings found in or derivable from a work of fiction.

IV

Now we have all the logical apparatus needed to show that when we fear and pity fictional characters, our emotions are directed at real, albeit psychological, objects. We have, on the one hand, the notion of a thought content, which can be the proper object of emotion. On the other hand, we have the propositional contents of fictional sentences. The final hurdle is to show what relations obtain between the thought contents in our minds and the propositional contents of the fictions.

To what thought contents must we respond for us to be said to be truly fearing Othello or pitying Desdemona? Not any tears are tears for Desdemona, and not any thoughts are thoughts about Othello.

In general there must be both a causal and a content-based connection between the thoughts in our minds and the sentences and descriptions in the fiction. It seems to be a necessary condition that there be a causal route back from the thought to Shakespeare's play. That is, Shakespeare's play must have some explanatory role in accounting for the genesis of the thought.

A causal connection, though, is not sufficient. There must also be a closer link connecting the senses of Shakespeare's sentences and the thoughts to which we respond. More often than not we acquire the relevant thoughts from a combination of our own descriptions and a suitable subset of an author's descriptions.

Much that we believe to be fictionally true about Desdemona will not be derived directly from either the sense of Shakespeare's sentences or the

sense of sentences logically implied by those sentences. For we read fictional prose, or poetry, against an intellectual and imaginative background, and much that we call understanding a work of fiction involves supplementing the explicit content with information drawn from this background. So the imaginative reconstruction that readers or producers put on the events and personalities leading up to Desdemona's death might issue in mental representations far different from those directly or logically related to the propositional contents expressed in the original text. Yet these divergences might be licensed through looser forms of implication arising from conventions governing appropriate response to fiction.

In general, we can say that we are responding to a fictional character if we are responding to thoughts, with the required causal history, that are identified through the descriptive or propositional content either of sentences in the fiction or of sentences logically derived from the fiction or of sentences supplementing those of the fiction in appropriate ways.

V

My conclusion is simple: when we respond emotionally to fictional characters, we are responding to mental representations or thought contents identifiable through descriptions derived in suitable ways from the propositional content of an original fictional presentation. I think this conclusion, given the arguments leading up to it, affords explanations of a number of puzzling features of fictions. It shows, for example, how we can know something is fictional but still take it seriously without having to believe it. We can reflect on and be moved by a thought independently of accepting it as true. This in turn accounts for the intuition that belief and disbelief stay in the background when we are engaged with fiction. Vivid imagining replaces belief. It explains any apparent dissimilarity between our emotional responses to fiction and "real-life emotions." Although we do not react to the killing of Desdemona as we would to a real killing before our eyes, we do react much as we would to the thought of a real killing. The thought and the emotion are real. Fictions are made up of sets of ideas, many having correlates in reality, and these ideas invite an imaginative supplementation and exploration. In connection with fictional characters, this "filling in" process is not unlike that of *coming to know another human being*: hence the sense of the "roundedness," "completeness," "objectness" of characters. Further, it explains the logical asymmetry in our psychological interactions with fictional characters, why we can fear but not rebuke them, admire but not advise them: their transformation into mental representations determines these constraints.

We can push the conclusion a bit further and use it to explain why our responses to fictional characters are so closely bound up with our responses to the whole work in which they appear. It is not just that *someone* is killed by a jealous husband that gives the emotive power to *Othello* but that the description of the killing is connected in a quite particular way with a great number of other descriptions in the play, including those of Desdemona. The cluster of descriptions that give sense to "Desdemona" will tend to issue in just those clusters of thoughts which I earlier suggested can increase our involvement with a thought and thus the intensity of our response to it. We see the structural ordering of language in a literary work as determining the ordering of thoughts in a reader. Much of the value of literature, both aesthetic and cognitive, lies in its power to create complex structures of thought in our minds.

Notes

1. Kendall L. Walton, "Fearing Fictions," *Journal of Philosophy* 75 (1978): 5–27; see also Kendall L. Walton, *Mimesis as Make-believe: On the Foundations of the Representational Arts* (Cambridge, MA: Harvard University Press, 1990).

2. Colin Radford, "How Can We Be Moved by the Fate of Anna Karenina?" *Proceedings of the Aristotelian Society* 69, suppl. (1975), 67–80.

3. Stein Haugom Olsen, *The Structure of Literary Understanding* (Cambridge: Cambridge University Press, 1978), ch. 2, 24–45

4. See Robert Howell, "Fictional Objects: How They Are and How They Aren't," *Poetics* 8 (1979), 129–77, who raises difficulties for Walton's account along these lines.

5. The account of "intentional object" here is similar to that in G. E. M. Anscombe, "The Intentionality of Sensation: A Grammatical Feature," in *Analytical Philosophy*, ed. R. J. Butler, 158–80 (London: Blackwel, 1965), second series.

Spelunking, Simulation, and Slime: On Being Moved by Fiction*

Kendall L. Walton

Works of fiction induce in appreciators thoughts about people, situations and events; let's say that they induce appreciators to imagine them. The imagined people, situations, and events are frequently ones that do not really exist or occur, but we can speak of them as constituting a "fictional world," the world of the novel or story or film.

* "Spelunking, Simulation, and Slime: On Being Moved By Fiction," in Mettje Hjort and Sue Lavers (eds.), *Emotion and the Arts*, pp. 37–49 (Oxford: Oxford University Press, 1997). Reprinted by permission of Oxford University Press.

This much is not controversial. But it is important to realize how little it comes to, how much remains to be explained. Why should we be interested in these nonexistents? Why should we bother thinking about or imagining them? We haven't yet distinguished novels and other fictions from a mere list of sentences. When we read and understand these sentences, they induce us to entertain the thoughts that they express. But that is all. Fictional worlds seem so far to be worlds apart, worlds having nothing to do with us, ones that we merely peer into from afar.

Consider children's games of make-believe. Children do not peer into worlds apart, nor do they merely engage in a clinical intellectual exercise, entertaining thoughts about cops and robbers. The children are in the thick of things; they *participate* in the worlds of their games. We appreciators also participate in games of make-believe, using works as props. Participation involves imagining about ourselves as well as about the characters and situations of the fiction—but not just imagining *that* such and such is true of ourselves. We imagine *doing* things, *experiencing* things. We bring much of our actual selves, our real-life beliefs and attitudes and personalities, to our imaginative experiences, and we stand to learn about ourselves in the process.[1]

There have been lively discussions recently, in the philosophy of mind and cognitive science, about what is called "mental simulation." Fiction and the representational arts are rarely mentioned in them, but the notion of mental simulation dovetails almost uncannily with my make-believe theory. Insights concerning simulation reinforce and augment my theory of fiction. Indeed, the participation in make-believe that I described is itself a form of mental simulation.

Many discussions of *Mimesis as Make-believe* have concentrated on my negative claim that it is not literally true, in ordinary circumstances, that appreciators fear, pity, grieve for, or admire purely fictitious characters. Charles, who fidgets and tenses and screams as he watches a horror movie, does not, I argue, really fear the Slime portrayed on the screen. The reasons that have been advanced against this claim are, in my opinion, very weak. Of even more concern, however, is the undue emphasis that commentators have put on this issue, at the expense of the positive aspects of my make-believe theory. This presents me with the ticklish job of defending the negative claim while directing attention to other more important matters. Simulation theory will be helpful in both parts of this task. In particular, it will help to counter a surprisingly prevalent assumption that imagining (and make-believe, which I understand in terms of imagining) can be only a clinical, antiseptic, intellectual exercise, and so cannot have a central role in explaining the genuinely emotional responses to fiction that appreciators experience.

It goes without saying that we *are* genuinely moved by novels and films and plays, that we respond to works of fiction with real emotion. Some have misconstrued my make-believe theory as denying this. "The key objection to Walton's theory," says Noël Carroll, "is that it relegates our emotional responses to fiction to the realm of make-believe."[2] That would indeed be a mistake. In fact, our responses to works of fiction are, not uncommonly, more highly charged emotionally than our reactions to actual situations and people of the kinds the work portrays. My make-believe theory was designed to help explain our emotional responses to fiction, not to call their very existence into question. My negative claim is only that our genuine emotional responses to works of fiction do not involve, literally, fearing, grieving of admiring fictional characters.

Let's begin with an experiment. Imagine going on a spelunking expedition. You lower yourself into a hole in the ground and enter a dank, winding passageway. After a couple of bends there is absolute pitch darkness; you light the carbide lamp on your helmet and continue. The passage narrows. You squeeze between the walls. After a while you have to stoop, and then crawl on your hands and knees. On and on, for hours, twisting and turning and descending. Your companion, following behind you, began the trip with enthusiasm and confidence; in fact she talked you into it. But you notice an increasingly nervous edge in her voice. Eventually, the ceiling gets too low even for crawling; you wriggle on your belly. Even so, there isn't room for the pack on your back. You slip it off, reach back, and tie it to your foot; then continue, dragging the pack behind you. The passage bends sharply to the left, as it descends further. You contort your body, adjusting the angles of your shoulders and pelvis, and squeeze around and down. Now your companion is really panicked. Your lamp flickers a few times, then goes out. Absolute pitch darkness. Yon fumble with the mechanism . . .

This experiment demonstrates the power of the imagination. I did not for a moment while I was composing the preceding paragraph or reading it over, think I actually was wriggling on my belly in a cave. I merely imagined it. Yet my imaginative experience was genuinely distressing, upsetting—loaded with "affect," as psychologists say. Rereading the paragraph for the umpteenth time gives me the shivers.

You may not find it distressing to imagine crawling in a cave—maybe you aren't claustrophobic. In that case, a different experiment would probably demonstrate to you the power of the imagination. Try imagining climbing a nearly vertical rock face, looking down on a valley several thousand feet below, as the wind screams around you. Or imagine being in an automobile accident, or discovering an intruder in your home.

It is because of my (dispositional) claustrophobia that I find it distressing to imagine slithering on my belly through the cramped passages of the cave. The slithering is only imagined, but imagining it activates psychological mechanisms I really possess, and brings on genuine distress. What I called the power of the imagination is really the power of dynamic forces of one's actual personality released by the imagination.

In performing experiments like this one, people are likely to find themselves imagining more than what they are specifically asked to. When, in response to instructions, I imagine having to squeeze through a long, narrow passageway, it will probably occur to me, in my imagination, that the passageway is too small to allow me to pass my companion should I want to retrace my steps. I might then imagine undertaking one or another course of action: pausing to collect my wits, or rushing ahead hoping to find a wider place quickly before I completely lose my nerve, or suggesting to my friend that we try slithering backward, or simply gritting my teeth and going on. What I go on to imagine beyond what is called for, like the distress that accompanies my imaginings, depends heavily on my character and personality, on how much self-confidence I have, on my propensities to blame myself rather than others, or vice versa, on whether I am fundamentally of an optimistic or a pessimistic disposition.

None of this is news. But it needs to be emphasized to counter the peculiar tendency, in some discussions of fiction and the imagination, to think of imagining as a sterile intellectual exercise.

My imagining experiment is an instance of mental simulation. In imagining as I did, I simulated an experience of a caving expedition. Mental simulation has most often been invoked, in the recent literature, to explain how we acquire knowledge of the mental lives of other people. The intuitive idea is that we put ourselves imaginatively in the other person's shoes and judge, on the basis of our own imaginative experience, what she is thinking and feeling, or what she decides to do. Simulation can also serve to predict what one's own experience would be like should one really go spelunking in the future, for instance. I am interested now mainly in simulation itself, apart from its use in ascertaining or predicting the actual experiences of another person or oneself.

In a study often discussed by simulation theorists, subjects were asked to suppose that a Mr. Crane and a Mr. Tees are scheduled to take different flights, departing at the same time from the same airport. Their limousine is caught in traffic on the way to the airport, and arrives 30 minutes after the departure time. Mr. Crane is told that his flight left on time. Mr. Tees is told that his was delayed and just left five minutes ago. The subjects were then asked which of the two is more upset? Most said that Mr. Tees is. How did

they arrive at this conclusion? According to Alvin Goldman, they simulated the experiences of Tees and Crane.

> The initial step, of course, is to imagine being "in the shoes" of the agent, e.g., in the situation of Tees or Crane. This means pretending to have the same initial desires, beliefs, or other mental states that the attributor's background information suggests the agent has. The next step is to feed these pretend states into some inferential mechanism, or other cognitive mechanism, and allow that mechanism to generate further mental states as outputs by its normal operating procedure. In the case of simulating Tees and Crane, the states are fed into a mechanism that generates an affective state, a state of annoyance or "upsetness." More precisely, the output state should be viewed as a pretend or surrogate state, since presumably a simulator doesn't feel the *very same* affect or emotion as a real agent would. Finally, upon noting this output, one ascribes to the agent an occurrence of this output state.[3]

What exactly are the outputs of mental simulations? Goldman says that what is experienced by the simulator of Mr. Crane and Mr. Tees is a "pretend or surrogate state" of annoyance. Outputs usually include more than imaginings, however. I have already said that when I imagine the spelunking expedition, I experience intense "affect," as well as being induced to engage in further imaginings. My shuddering, my clammy palms, my cold sweat, and the sensations that accompany them, are not merely imagined.

What about feeling real emotions? A person simulating Mr. Tees may really be distressed or upset (in one sense of these terms, anyway). I do not think it is true, literally, that the simulator is *annoyed at having missed her flight*. She *didn't* miss a flight, and she knows it. Imagine being passed over in favor of your best friend for a coveted position. Let's suppose that you conclude from your imaginative experience that, were your friend to be offered the job in real life, you would feel jealous. I do not think it is literally the case that you *are* jealous of him for receiving the offer, when you only imagine that he did.

Looking ahead to the case of Charles and the Slime, we can ask whether, when I negotiate the twists and turns of the cavern in my imagination, I am literally afraid. Do I fear that my (utterly fictitious) carbide lamp will malfunction, or that my (equally fictitious) companion will become hysterical? I think not—although I may experience these specific object-directed fears in imagination, and my genuine (standing) claustrophobia has a lot to do with the imaginings.

In simulating, one's psychological mechanisms are being run "offline." This means at least that they are disconnected from some of their usual behavioral manifestations. Sitting in my armchair, I do not carry out the

decisions I imagine making; nor do I behave, in other ways, as I would if I were actually in a cave. Whether one's fear or jealousy or annoyance is actual or merely imagined, when one engages in simulation, depends on whether fear or jealousy or annoyance of the relevant kinds requires either the usual links to behavior or the belief that the situation is actual.

Back to emotional responses to works of fiction. The movie induces Charles to simulate an experience of being attacked by a Slime. It induces him to imagine a Slime, and to imagine its going after him. As a result, he undergoes a complex combination of experiences, including both affective responses and additional imaginings, beginning with imagining himself to be in grave danger. His initial imaginings engage certain of his psychological mechanisms, and the results reflect aspects of his actual personality and character (perhaps a standing propensity to be repelled by things that are amorphous or slimy, not to mention concern for his own well-being).

I stand by my contention that it is only in imagination that Charles fears the Slime, and that appreciators do not literally pity Willy Loman, notwithstanding the consternation these opinions have caused among commentators. Indeed, I believe that these negative claims depart little from common sense, and should not seem either very surprising or very momentous. We are now in a position to dispatch some of the main objections that have been leveled against them.

Concerning Amos Barton, a character in George Eliot's *Scenes of Clerical Life*, Noël Carroll remarks that "given the intensity of our feelings" it "seems counterintuitive" to "give up the idea that we are saddened by the plight of Barton."[4] This does not seem counterintuitive to me. Would a similar but less intense reaction not qualify as feeling sad (mildly sad) for Barton? The intensity of one's feelings is no reason to insist that the correct description of one's experience has to be that of (literally) being saddened by Amos Barton, or fearing the Slime, or grieving for Anna Karenina.

Richard Moran faults my make-believe theory for suggesting a lack of "real-world accountability" in our responses to fiction.[5] He observes that "responses of laughter, lust, indignation, relief, delight in retribution, etc., are normally treated as expressions of genuine attitudes that we actually have, and are esteemed or repudiated accordingly," as when one chortles at a racist joke. He evidently thinks that responses consisting in imaginative experiences of the kinds I attribute to appreciators would be "as remote from real temperament as the events onscreen are remote from his real beliefs about the world." It is obvious from our discussion of simulation how far off the mark this objection is. There simply can be no doubt that imaginings often reflect actual attitudes, desires, values, prejudices, and so forth, and are thus

subject to esteem and repudiation. Fantasizing about torturing kittens may, depending on the circumstances, indicate a cruel nature as surely as actually doing so would.

Feelings actually experienced are part of the output of simulations and are revealing of character. They are also, on my account, an important component of appreciators' imaginative responses to fiction. Nothing follows about whether an imaginer is best understood [to be] literally experiencing a given intentional psychological state or merely experiencing it in imagination. If I read a story about kittens being tortured, the mere fact that I imagine this probably does not, in this case, reflect badly on my moral character. If I should find myself imagining it with a sense of glee, however, I may have reason to worry. The glee is real. But my experience certainly does not have to be described as actually taking pleasure in the suffering of kittens, in order to signal a cruel streak in my character.

Some objectors seem to think that it is just intuitively obvious that Charles fears the Slime, that readers feel sorry for Anna Karenina, and so forth. The simulation theorists I mentioned express contrary intuitions about similar cases. It is true that we readily describe appreciators as fearing, feeling sorry for, and admiring characters in fiction. Is there a presumption that what is commonly and naturally said is true? At most there is a presumption that in thus speaking, people *express something true*. Our question is whether what is said, taken literally, is true. Saying that Charles is afraid of the Slime is a way of expressing the truth that it is fictional ("true" in the world of make-believe) that he fears the Slime. We also express truths about what is fictional when we say, "There is a horrible green Slime on the loose."

Moran points out that many common everyday emotional experiences concern "what is known to be in some sense nonactual," or things which are not "in the actual here and now"—that our responses to fiction are not special in this regard. There are feelings directed at "things that might have happened to us but didn't"; there are "spontaneous empathetic reactions such as wincing and jerking your hand back when someone else nearby slices into his hand"; there is "the person who says that it still makes her shudder just to think about her driving accident"; and there are backward-looking responses such as relief, regret, remorse, nostalgia.[6] Moran thinks these are all "paradigms" or "central instances" of emotional experience. His idea seems to be that responses to fiction of the kinds under discussion are not essentially different from them, and hence have to be regarded as themselves instances of emotional response. There is certainly no quarrel so far. All of the examples mentioned, including the reactions to fiction, are indeed clear and obvious instances of emotional response. Are they clear

instances of emotions whose objects are things not present? Regret, remorse, and nostalgia are, but these are plainly irrelevant to the issue at hand. The fact that regret and nostalgia are feelings about events long past has no tendency to suggest that appreciators literally pity or admire people they know do not exist and never did.

Some of Moran's other examples are more interesting, and more like the fiction cases, although it is mysterious how they are supposed to contribute to his argument. Is the person who shudders on recalling her automobile accident terrified of the truck that she remembers careening into her car years previously? It certainly does not follow that she is, literally, afraid of the truck. Vivid memories like the ones Moran discusses involve imagining; one relives the remembered experience. The shudders result from vividly imagining the truck careening into one's car, despite one's being fully aware that that is not now happening. One is terrified of the truck in imagination; there is no need to insist that one is (also) actually terrified of it. This is another instance of mental simulation; one simulates one's own past experience.

After all the ink that has been splattered on the question of whether appreciators' experiences include emotions of various kinds vis-à-vis fictional characters and situations, it may be disappointing to learn that it doesn't much matter. It doesn't; not for our purposes. The positive side of my account of appreciators' responses to fiction is much more important.

This imaginative participation, we now see, consists (in part) in mental simulation. We simulate experiences, including the fear and grief and admiration, whether these emotions are construed in such a way that appreciators, literally, experience them, or in such a way that they merely imagine doing so. In either case, appreciators bring much of themselves to the make-believe; their actual psychological makeup, attitudes, interests, values, prejudices, hang-ups, and so forth, come powerfully into play. And this sometimes makes their experience of the fiction a deeply moving one. The connection with simulation is especially helpful in cashing out the suggestion that appreciating works of fiction and engaging in other make-believe activities are important in helping us to understand ourselves.

Even if we were to hold that appreciators do, literally, experience [emotions], we would need to recognize that they experience them in imagination as well. Charles imagines a Slime oozing toward him, and, in his imagination, it threatens him. It would be strange to deny that he fears it in his imagination also, even were we to decide that his experience counts as one of actually fearing it.

Some who insist that appreciators experience fear or pity or grief toward fictional characters and situations admit that the emotions they experience are of a different kind from the fear or pity or grief that one feels toward

real people and situations. We might think of *fear-of-fictions*, for instance, as a variety of fear different from *fear-of-perceived-dangers*. Some hold that the intentional object of fear or pity (what "the Slime" in "Charles fears the Slime" refers to) is something of an entirely different kind in the fiction cases: a collection of properties (Noël Carroll), or a "kind of imagining" (Peter Lamarque). Some say appreciators of fiction are frightened by thought contents (Lamarque), or that their pity involves beliefs and desires about what is fictional rather than what is actual (Alex Neill).[7]

The stated rationale for describing appreciators as experiencing fear, pity, and so forth, of different kinds, rather than as imagining fearing and pitying, is to underscore the similarity to the real-life cases. But in one way this exaggerates the differences. Appreciators imagine having pity or fear of ordinary, everyday kinds, with ordinary kinds of objects. I imagine pitying a person who really suffers a tragedy, not thought contents or collections of properties. The words that may come to me as I imagine are not, "Oh, that poor thought content!" but simply, "Oh, that poor waif!" The view that we really do fear, pity, and admire fictitious entities, but with fear, pity, or admiration of a special kind, fails to account for the phenomenology of our experiences, in particular for the close analogies they manifestly bear to possible "real-life" experiences. To account for this, we need to recognize that we imagine feeling fear, pity, and admiration of the kinds we might actually feel in "real life." Once we recognize this, there is little reason to insist that we also, really, fear, pity, and admire fictional characters.

Notes

1. The preceding points are explained much more fully in Kendall L. Walton, *Mimesis as Make-believe: On the Foundations of the Representational Arts* (Cambridge, MA: Harvard University Press, 1990).

2. Noël Carroll, *The Philosophy of Horror: Or, Paradoxes of the Heart* (London: Routledge, 1990), 73–74.

3. Alvin Goldman, "Empathy, Minds and Morals," in *Mental Simulation: Evaluations and Applications*, ed. Martin Davies and Tony Stone, 185–208 (Oxford: Blackwell, 1995), 189.

4. Noël Carroll, "Critical Study: Kendall L. Walton, *Mimesis as Make-believe*," *Philosophical Quarterly* 45 (1995): 95

5. Richard Moran, "The Expression of Feeling in Imagination," *Philosophical Review* 103 (1994): 75–106.

6. Moran, "The Expression of Feeling in Imagination," 78.

7. Carroll, "Critical Study," 84–86; Peter Lamarque, "Essay Review of *Mimesis as Make-believe*," *Journal of Aesthetics and Art Criticism* 49 (1991): 164; Alex Neil, "Fiction and the Emotions," *American Philosophical Quarterly* 30 (1993): 1–13.

cଠ୭

Further Reading

Charlton, William. 1984. Feeling for the fictitious. *British Journal of Aesthetics* 24: 206–16. Argues that when we seem to feel an emotion for a fictional character, it is really directed at actual people.

Currie, Gregory. 1990. *The nature of fiction*. Cambridge: Cambridge University Press. An important inquiry on a variety of philosophical issue related to fiction.

Dilworth, John. 2004. Internal versus external representation. *Journal of Aesthetics and Art Criticism* 62: 23–36. Explores the nature of representation in fiction.

Gendler, Tamar Szabo, and Karson Kovakovich. 2006. Genuine rational fictional emotions. In *Contemporary debates in aesthetics and the philosophy of art*, edited by Matthew Kieran, 241–53. Oxford: Blackwell. An argument based on brain research that we feel real emotion toward fictions.

Hjort, M., and S. Laver, eds. 1997. *Emotion and the arts*. Oxford: Oxford University Press. A valuable collection of essays on a variety of issues concerning art and emotion.

Moran, Richard. 1994. The expression of feeling in imagination. *Philosophical Review* 103: 75–106. Argues that our emotional reactions to fiction are continuous with other aspects of our emotional life.

Neill, Alex. 1993. Fiction and the emotions. *American Philosophical Quarterly* 30: 1–13. Argues against a single uniform treatment of emotional reactions to fiction.

Walton, Kendall. 1990. *Mimesis as make-believe*. Cambridge, MA: Harvard University Press. An important investigation into many aspects of our imaginative engagement with fictional representation.

CHAPTER EIGHT

~

Representation

Depiction

Introduction

In his "Life of Leonardo da Vinci" in *Lives of the Most Eminent Painters, Sculptors, and Architects*, Giorgio Vasari preserves several anecdotes concerning da Vinci's process in painting *The Last Supper*. Although the image is well known through its numerous reproductions, the actual work is painted on the wall of the dining hall of the monastery of Santa Maria delle Grazie. Vasari tells us that the monastery's prior or second in charge became impatient with da Vinci's ongoing procrastination—the painting took three years to complete. He was particularly upset to see da Vinci staring at the wall for hours at a time without painting. Called on to explain his behavior, the painter defended himself by saying that "men of genius" do their primary work when it appears that they are doing nothing, for they are exploring the ideas that inform their creations.

Da Vinci left us his own thoughts about what may have been going on when he seemed inactive. In order to generate more creativity, da Vinci advises visual artists to look at cloud formations and to study walls that show signs of soiling and age: "I have in the past seen clouds and wall stains which have inspired me to beautiful inventions of many other things." He adds that this technique is particularly useful for creating imaginary landscapes—this might be the origin of the background of the *Mona Lisa*—and "figures darting about."

Da Vinci makes a connection that lies at the heart of Richard Wollheim's influential discussion of the common phenomenon of "seeing-in." Da Vinci

connects seeing-in to the process of creating visual art. We look at one thing, knowing perfectly well what it really is, but we see something more. Wollheim argues that this psychological process allows audiences to understand pictorial representation. (Wollheim originally called the process "seeing-as," but in the selection included here, he explains why that moniker is inappropriate.) He claims that the only important difference between seeing something in a cloud formation and seeing it in a painting is that in the latter case someone intends for the thing to be seen there, where as this is not true in the former case. You can be wrong about what a painting depicts, but you cannot be wrong about what there is to see "in" a cloud formation, for there are no independent standards of correctness. Yet, whether we have a case of tourists looking at da Vinci's *The Last Supper* or da Vinci himself staring at blank parts of the same wall, searching for inspiration, Wollheim thinks that we have two cases of the same thing: twofold *seeing*. We do not see the paint on the wall and then *infer* what da Vinci intended to depict. Art lovers see that one of the apostles remains serene while others are angry, as if seeing people. At the same time, the experience of pictorial representation is twofold, for it requires simultaneous attention to the artistic medium (the painted surface) and the represented state of affairs.

Dominic Lopes is skeptical about the explanatory power of citing twofoldness. Given the wide variety of things that count as pictures, and given that pictures understood in one culture are frequently opaque to another, Lopes doubts that Wollheim has correctly identified the basic perceptual process for recognizing visual representations. Like Wollheim, Lopes proposes that the unifying feature lies in our visual response to them. However, Lopes doubts that we actually *see* as much as Wollheim claims, so he turns to a distinct psychological ability, visual recognition, another response mechanism that is independent of representing.

Humans are able to recognize familiar objects, even those that have been noticeably changed. We are particularly skilled at reidentifying familiar faces, and we can do so when seeing them from a variety of angles. Most importantly, we can recognize particular faces and other visual objects even if we cannot recall any specifics about our previous encounters. Recognition depends on encountering the right sort of visual information, without requiring an exact match with particular things we have previously experienced. Lopes proposes that the information retrieval and manipulation that explains these abilities also accounts for our ability to engage in pictorial representation.

Lopes distinguishes two slightly different modes of recognition. Because the capacity for recognition is independent of conscious recall, it can be exploited to provide us with spontaneous recognition of pictured objects we have never

actually seen. This is content recognition. In other cases, we will also recognize a two-dimensional design as a particular familiar object. This is subject recognition. A pattern that could elicit this second form of recognition "portrays" something. When that something is a person, it is a portrait. But portraits need not elicit recognition from life. After all, portraits of persons long since dead will never actually elicit recognition. Given the right information, one representation can teach us to recognize the same content in another, as when Americans recognize the same face on the penny and the five-dollar bill.

John Hyman worries that both Wollheim and Lopes are looking in the wrong place to explain pictorial representation. They are overly concerned with the underlying psychological processes, which leads to subjectivism, an explanatory dead end. This focus does not tell us enough about the objective similarities between pictures and what they picture.

Hyman is particularly negative about seeing-in. Wollheim's account of the twofoldness of seeing-in is so general in its explanatory principles that it does nothing to explain why we "see" what we do see, rather than something else. Furthermore, Wollheim makes too much of the distinction between "seeing" two different things: the object actually seen (e.g., the painted canvas or the pixels on a computer screen) and the object "seen in" that object (i.e., the object depicted). However, in some cases media are manipulated in order to frustrate the twofoldness of seeing-in. Most notably, there is the tradition of trompe l'oeil (literally, "deceives the eye") painting, in which painters work to hide any trace of their own brushwork and paint objects in full size. When the technique is executed successfully, the effect is a realism in which viewers see the content without seeing the medium. Do such objects not refute Wollheim's claim that we must simultaneously attend to the medium and the pictorial content? And, extending the problem, do we not often forget that we are looking at a lighted screen when watching television or a movie?

Why, then, do the shapes and colors on a two-dimensional surface depict one thing and not another? How, in seeing blotches of color, do we see thirteen figures seated at a table? Is there something about those colors and shapes that objectively invites seeing *The Last Supper* one way and not another? Hyman proposes that we must address *this* issue if we want a theory of visual depiction. He posits that we visually identify ordinary objects by noting their outline shapes, their sizes, and their colors. These are the very same elements that painters and other visual artists manipulate in their works, supplying corresponding visual cues in, for example, colored patches of paint or in shapes presented in an etching. Thus, a visual depiction succeeds when the visual surface includes distinctive shapes (which have particular sizes and colors) that match the shapes (and sizes and colors) that we would actually

see if we were instead looking at whatever the image depicts from an appropriate distance from our point of observation.

We leave it to the reader to examine a range of pictures and to decide whether successful picturing is restricted to distinct objects that have distinctive outlines. If not, Hyman does not provide a full account of the objective mechanisms of pictorial representation.

<div align="center">c◇ɔ</div>

Seeing-as, Seeing-in, and Pictorial Representation*

Richard Wollheim

What is unique to the seeing appropriate to representations is this: that a standard of correctness applies to it and this standard derives from the intention of the maker of the representation, or "the artist" as he is usually called—a practice harmless enough, so long as it is recognized that most representations are made by people who neither are nor claim to be artists. Naturally the standard of correctness cannot require that someone should see a particular representation in a particular way if even a fully informed and competent spectator could not see it that way. What the standard does is to select the correct perception of a representation out of possible perceptions of it.

In Holbein's famous portrait in three-quarters view I normally see Henry VIII. However, I may have been going to too many old movies recently, and I look at the portrait and, instead of seeing Henry VIII, I now find myself seeing Charles Laughton. There is a standard which says that one of the perceptions is correct and the other incorrect; this standard goes back to the intentions of Holbein, and, insofar as I set myself to look at the representation as a representation, I must try to get my perception to conform to this standard. However, if Holbein had failed to portray Henry VIII (and the picture commissioned was a test of his powers), and, accordingly, Henry VIII was not visible in the painting, then the standard would not require me to see Henry VIII.

It is important to appreciate that, while a standard of correctness applies to the seeing appropriate to representations, it is not necessary that a given spectator should, in order to see a certain representation appropriately, actually draw upon, rather than merely conform to, that standard of correctness. He does not, in other words, in seeing what the picture represents, have to do

* "Seeing-as, Seeing-in, and Pictorial Representation," in *Art and Its Objects*, 2nd ed., pp. 205–26. © Cambridge University Press 1980. Reprinted with the permission of Cambridge University Press.

so through first recognizing that this is or was the artist's intention. On the contrary he may—and art historians frequently do—infer the correct way of seeing the representation from the way he actually sees it or he may reconstruct the artist's intention from what is visible to him in the picture.

Where previously I would have said that representational seeing is a matter of seeing x (= the medium or representation) as y (= the object, or what is represented), I would now say that it is, for the same values of the variables, a matter of seeing y in x. There are three considerations that favor this change, and they at the same time go a considerable way toward making clear the distinction between the two phenomena.

The first consideration favoring the change from seeing-as to seeing-in concerns the range of things that we may see in something as opposed to those which we may see something as. Given that the something seen is a particular—and this is the relevant case for representational seeing—all we may see it as is a particular: but, as for seeing-in, we may see not only particulars in it, but also states of affairs. It cannot need to be argued that, if seeing-in and seeing-as do differ in this way, or in the objects that they can take, then the perceptual genus to which the seeing appropriate to representations belongs must involve seeing-in rather than seeing-as. For certainly scenes may be represented as well as persons and things.

The second consideration is this: If I see x as y, then there is always some part (up to the whole) of x that I see as y. Further, I must be able to specify just which part of x, or whether it isn't the whole of x, that I allegedly see as y, whereas no such requirement is placed upon seeing-in. I may see y in x without there being any answer to the question whereabouts in x I can see y, and consequently without my being obliged to produce any such answer in support of the claim I might make to see y in x.

If in this way seeing-as requires, and seeing-in does not require, localization, then seeing-in goes with representational seeing. For the seeing appropriate to representation does not require localization. At first this might be obscured by considering too narrow a range of cases. For sometimes the seeing of representations is localized. Looking at Piero's portrait of Federigo da Montefeltro, and seeing the notch scooped out of the nose, I can go on to say exactly where on the panel I see this. However, I could neither have nor be expected to have a corresponding answer when what I see is, say, a crowd of people of which all but the leading members are obscured from view by a fold in the ground (cf. Michelangelo's Sistine *Deluge*) or cut off by the frame (cf. Cosimo Rosselli's *Way to Calvary*); or the gathering of the storm; or that the stag is about to die; or the degradation of the young rake. Nor in any of these cases would it be to the point to say that I see what I see "in the picture as a whole."

A third consideration is this: Seeing-in permits unlimited simultaneous attention to what is seen and to the features of the medium. Seeing-as does not. That the seeing appropriate to representations permits simultaneous attention to what is represented and to the representation, to the object and to the medium, and therefore instantiates seeing-in rather than seeing-as, follows from a stronger thesis which is true of representations. The stronger thesis is that, if I look at a representation as a representation, then it is not just permitted to, but required of, me that I attend simultaneously to object and medium. So, if I look at Holbein's portrait, the standard of correctness requires me to see Henry VIII there; but additionally I must—not only may but must—be visually aware of an unrestricted range of features of Holbein's panel if my perception of the representation is to be appropriate.

This requirement upon the seeing appropriate to representations I shall call "the twofold thesis." The thesis says that my visual attention must be distributed between two things though of course it need not be equally distributed between them.

There are several arguments that favor the twofold thesis.

The weakest argument is that the twofold thesis at least tells us what is experientially different about seeing someone in a representation. However, this is a weak argument for the twofold thesis, since there are other ways of trying to define the distinctive phenomenology of seeing representation. So, for instance, Sartre, who is keen to distinguish the phenomenology of seeing y in a representation from that of seeing y face to face, at the same time insists that seeing the object of a representation is incompatible with attending to the material features of the representation. The details of Sartre's account need not detain us, but its existence is relevant.

There are, though, two stronger arguments in favor of the twofold thesis, one of which contends that this is how we must see representations, the other that this is how we ought to. The first argument takes its premises from the psychology of perception. Under changes of viewing point the image remains remarkably free from deformation and to a degree that would not be true if the spectator were looking at the actual object face to face or if the representation was photographed from these same viewing points. The explanation offered of this constancy is that the spectator is, and remains, visually aware not only of what is represented but also of the surface qualities of the representation. He engages, in other words, in twofold attention, and has to if he wants to see representations in the way that we have come to regard as standard. The second argument considers a characteristic virtue that we find and admire in great representational painting: in Titian, in Vermeer, in Manet we are led to marvel endlessly at the way in which line

or brushstroke or expanse of color is exploited to render effects or establish analogies that can only be identified representationally, and the argument is that this virtue could not have received recognition if, in looking at pictures, we had to alternate visual attention between the material features and the object of the representation.

Seeing-as shows itself to be, fundamentally, a form of visual interest in or curiosity about an object present to the senses. This curiosity can take the form of an interest in how the object is or of an interest in how it might be or might have been. If this is so, it follows that we cannot see something as something it (or its counterpart) could never have been. So, looking at a particular, we can see it only as having properties that might be possessed by, or as falling under concepts that could apply to, a particular. This is, of course, the first characteristic assigned to seeing-as, and the second is intimately connected with it. For, if seeing x as f is to exercise our visual curiosity about x, then not merely must it be imaginable that x is f, but, more specifically, we must be able to imagine how x would have, or would have had, to change or adapt itself in order to take on the property of being f. We would have to be able to imagine just how much of x would have to go, and just how much could stay, under this transformation. And this turns out to be, on reflection, the localization requirement. The third requirement takes us a step further on, and further cements the union of seeing-as with visual curiosity. We have already noted that, in those cases where x is indeed believed to be f, seeing x as f goes beyond merely seeing x and simultaneously judging x to be f: seeing x as f is a particular visual experience of x. So in the same way, in the case where x is not believed to be f, or is even believed not to be f, seeing x as f goes beyond seeing x and simultaneously imagining it to be f: it also is a particular, though a very different, experience of x. Now, just because it is, there is no room when seeing x as counterfactual f also to be visually aware of those properties of x which would have to change if x were actually to be or become f. In other words, the properties that sustain my perception of x as f would have themselves to be perceptually masked if I am—as I have put it—to try out the appearance of f upon x. So twofoldness in the case of seeing-as is ruled out.

Seeing-in, by contrast, is not the exercise of visual curiosity about a present object. It is the cultivation of a special kind of visual experience, which fastens upon certain objects in the environment for its furtherance. And it is from this that the various characteristics of seeing-in, in particular those which distinguish it from seeing-as, follow. The cultivated experience can be, as experiences in general can be, of either of two kinds: it can be an experience of a particular, or it can be an experience of a state of affairs.

And this remains true even when the experience is cultivated, or induced, through looking at a particular: in other words, a state of affairs can be seen in a particular. This is the first characteristic I have assigned to seeing-in, and what it attests to is the relative dissociation of the cultivated experience from visual awareness of what supports it, and from this in turn derive the two other characteristics assigned to seeing-in: namely, the contingency of localization, and the possibility of twofold attention. To require localization would be tantamount to a denial of any dissociation and so it must be absent, and twofold attention is a way of exploiting the dissociation.

I have, however, spoken of "relative dissociation," and advisedly. For the artist who (as we have seen) exploits twofoldness to build up analogies and correspondences between the medium and the object of representation cannot be thought content to leave the two visual experiences in such a way that one merely floats above the other. He must be concerned to return one experience to the other. Indeed he constantly seeks an ever more intimate rapport between the two experiences, but how this is to be described is a challenge to phenomenological acuity which I cannot think how to meet.

This essay leaves a number of loose ends, which I shall indicate.

A major problem, for the philosophy of art on the one hand, and the philosophy of perception on the other, concerns the range or scope of seeing-in. How, in perception generally and in the perception of the visual arts in particular, do seeing-as and seeing-in divide the field? The answer certainly does not seem to be that they divide the field according to the sorts of object perceived. On the contrary, there are many sorts of objects which at times excite seeing-as and at other times excite seeing-in. An example which comes to mind is one which is often taken unreflectingly as a central case of seeing-as: the seeing of clouds. For sometimes it seems correct to say that we see a cloud as a whale; but at other times, if the distinction is taken seriously, the situation seems to be that we see a ravine, or a vast sandy beach, or a cavalry charge, in a cloud.

More difficult is the question whether there are perceptions which share both in seeing-in and in seeing-as. An example which suggests itself is the way we see certain of Jasper Johns' flag paintings. The tendency to think of our perception of these paintings as cases of seeing-in derives from the fact that we are aware of them as representations, with all that this involves. They are intended to be of flags: flags are visible in them: and awareness of the pigmented features of the canvas is possible, and encouraged. However, reflection shows that, if they are representations, they have abandoned several crucial characteristics available to representations. In the first place,

each picture represents a single particular: we are never shown a state of affairs of which the represented particular is a constituent. But though this is rare amongst representations, it is not irregular. Secondly, the representation is (in the cases I have in mind) cropped to the contours of the object's—that is, the flag's—representation. Again, this, as we have seen, is compatible with seeing-in: for it is just the kind of case in which we are justified in saying that we see the flag "in the picture as a whole." Thirdly, the object shares its essential properties (or most of them) with the picture itself—both are two dimensional, both are made of textile, both are colored and to the same design instructions. Now these three ways in which the norm of representation is departed from work to establish a rival tendency. The spectator starts imagining the painting taking on the property of being a flag: and in doing so he gradually becomes (as he has to) visually unaware of those properties of the picture which would have to change if this transformation were to come about. And thus he is drawn toward seeing the picture as a flag. Of course, what is crucial to the Johns case is that not merely is it problematic, but it was intended to be so, and the ambiguity is one that we are maneuvered into. If there is a way out of this ambiguity, this is through no fault of Johns. These paintings may illustrate a philosophical problem, but they do so in order to present an aesthetic problem, which we are required not to resolve but to experience.

Most difficult of all, and a matter on which I have said nothing, though I may have provided some materials out of which something can be said, is how we appropriately perceive sculpture. The perception of theater may be not unrelated.

In conclusion, one observation is worth making which might partially explain the persistence of the view that the seeing appropriate to pictorial representations involves, and therefore may be elucidated through, seeing-as. If it is true that the appropriate perception requires that, confronted with the representation of y, a spectator should see y in the representation, he is able to do this only because he first sees the representation as a representation. "Seeing the representation as a representation" here describes a mental set which a spectator might or might not have at his disposal, and which has been claimed by some, though by no means conclusively, to be a matter of cultural diversity. But it is crucial to recognize that, if this is supposed to show that seeing-in rests upon seeing-as, what the representation is seen as is never the same as what is seen in the representation. Seeing y in x may rest upon seeing x as y but not for the same values of the variable y.

⹊⊗⹊

Pictorial Recognition*

Dominic Lopes

Recognition plays a fundamental role in identifying what pictures represent. A picture represents by conveying aspectual information from its subject, on the basis of which viewers can recognize its source. Recognition is, I contend, a mode of identification which explains pictures' diversity and aspectual structure, as well as the system-relativity of pictorial competence.[1]

Perceptual Recognition

Almost everyone has had the experience of meeting an acquaintance not seen for many years, perhaps not since childhood. At first, we experience something familiar in the sight of his face, but only after a moment do we recognize him, seeing more or less clearly how his current features echo his earlier appearance. The ability to visually recognize objects involves and makes available a rich store of visual information acquired in earlier encounters with them. And while it is true that when an object is recognized, we often recall certain facts about it—its name, salient features, and past doings. This is not to say that recognition requires rich information from past episodes. It may, at a minimum, consist in nothing more than a disposition to identify an object currently perceived as one encountered in the past, together with a feeling of familiarity with it.

Recognition takes three forms: we recognize features, individual objects, and kinds of objects. Although I shall concentrate on recognition of individuals, what I say goes for all forms of recognition. The ability to recognize individuals no doubt accompanies the formation of social structures that depend on being able to re-identify those objects with which we have had dealings. Face-recognition is probably the most sensitive recognition ability that humans possess. Most people can recognize hundreds, perhaps thousands of faces, often associating them with copious information from past encounters.

Psychologists describe recognition abilities of a certain sophistication as "dynamic." Rudimentary, nondynamic recognition abilities are those which require overwhelming similarity between incoming information and information stored from the past. But objects change in countless ways, and dynamic recognition abilities are those that link currently perceived ob-

* From *Understanding Pictures*, pp. 43–51, 117–31, and 144–50 (Oxford: Oxford University Press, 1996). Reprinted by permission of Oxford University Press.

jects with objects perceived in the past despite what may amount to radical changes in appearance.

Face-recognition is exceptionally dynamic. We can recognize faces though their features are contorted by laughter, grimaces, and other expressions, and we can recognize them changed over time—often, as we are wont to exclaim, to the point of being beyond recognition. Indeed, some psychologists *define* face-recognition as an ability to recognize faces changed in these ways.

To say that recognition is dynamic is to say that features, objects, and kinds of objects can be recognized under different aspects. That is, recognition is dynamic when an object once seen as having one set of visual properties can be recognized at a later time under another set of properties. If recognition is dynamic over differences in viewpoint, then an object seen in profile, for example, can be recognized on the basis of stored information about its visual appearance when seen frontally.

An ability to recognize objects seen from different spatial locations is dynamic over one kind of aspect; an ability to recognize aged faces is dynamic over another. I call the kinds of aspects with respect to which objects can vary but remain recognizable "dimensions of variation." Recognition may thus be reckoned more or less dynamic in proportion to the number of dimensions over which it is preserved, and it may be said to have reached a limit when one is unable to recognize objects across a new dimension of variation.

The fact that recognitional dynamism is relative to dimensions of variation is what explains its generativity. Generativity is a crucial feature of any useful recognition ability: being able to recognize an object under a new kind of aspect must suffice for being able to recognize other objects under the same kind of aspect. Thus recognition is generative over changes in viewpoint when being able to recognize one object seen from a novel viewpoint suffices for being able to recognize other objects transformed in similar ways. Being able to recognize one face after ageing is generative if it suffices for being able to recognize other faces after ageing. Of course, generativity is not boundlessly elastic within a dimension of variation.

Recognition and Thought
Recognition is one perceptual skill that enables us to think of objects, and so potentially to refer to them.

Dynamic and generative recognition abilities endow their possessors with concepts of objects, kinds, and properties. It does not follow, though, that concepts of the *aspects* under which they are recognized must (though they may) figure in thinkers' conceptual repertoires. To recognize an object under a range of aspects is to have a concept of the object, but not necessarily to have

a concept of those aspects of it. In other words, the aspectual information on which recognition is based is nonconceptual. Features of objects' appearances to which recognition is sensitive need not be features of which perceivers possess concepts. For instance, there is evidence that face-recognition depends on a perceptual sensitivity to such properties as the proportional distances between facial features, but these are not properties of which perceivers need have or, indeed, usually have concepts.

Perceivers obviously need not have concepts of stable shape descriptions in order to recognize objects. The contents of mental representations underlying recognition, whether they are templates, feature-detectors, or stable shape descriptions, are nonconceptual. Their workings are explained at the subpersonal level—the level of neural organization and psychological architecture—rather than the personal level of sensations, beliefs, thoughts, and intentions.

The Autonomy of Recognition

This picture of recognition, its place in thought, and the type of information on which it is based is at odds with the view of recognition that dominates the philosophical literature. This view is that recognition is reducible to descriptive identification. However, this assimilation of recognition to description is mistaken.

In the first place, descriptive identification requires recall of an object's identifying features. But whereas recognition involves an awareness of an earlier encounter with the object recognized, recall always produces a belief that the item remembered had some property. In minimal cases of recognition one may feel familiar with an object and identify it as something encountered before, yet be unable to recall anything about its past appearance.

Not only is it possible to recognize an object without being able to recall its features, but it is also possible to recognize something when recall is actually erroneous. I might recognize somebody as someone I met in Paris; but when I discover that we really met in Vienna, I need not conclude that I failed to recognize my acquaintance. Nor, indeed, does recall suffice for recognition. It is disconcerting, but not uncommon, to know the identity of someone met on a particular occasion, to know where and when you met him and what he was doing at the time, yet to fail recognize him.

Identifying things by recognizing them is not a matter of recalling features they possessed in the past and descriptively matching them with features they are currently perceived to have. This conclusion is important for two reasons. It secures an autonomous place for recognition within human cognition. More important for present purposes, though, it sustains the hope that recognition might be the underlying perceptual mechanism that explains depiction.

Pictorial Recognition

I propose that identifying what a picture represents exploits perceptual recognition skills. In particular, viewers interpret pictures by recognizing their subjects in the aspects they present. The thrust of this is not simply that pictorial representation makes use of recognition abilities for objects, kinds, and properties. Rather, the ability to recognize pictures' subjects is an extension of the dynamism of recognition. Pictures are visual prostheses; they extend the informational system by gathering, storing, and transmitting visual information about their subjects in ways that depend upon and also augment our ability to identify things by their appearance.

It would be a mistake to suppose, however, that pictorial recognition is identical with ordinary visual recognition. Unlike ordinary recognition, pictorial recognition operates at two levels. A picture is first of all a flat surface covered with marks, colors, and textures, and the primary purpose of a theory of depiction is to explain how this design comes to represent scenes and objects as having properties.

At the second level, viewers recognize pictures' contents as of their subjects. The victory-signing-man-with-hooked-nose-and-drooping-jowls-picture is recognized as an aspect of Nixon—this is "subject-recognition." Subject-recognition may fail when a viewer sees a picture as representing a figure as having such-and-such properties but is unable to identify the picture's subject because she cannot recognize what such-and-such is an aspect of. Somebody who has never seen Nixon (even in a picture) may not be able to recognize a picture as of him, though she can recognize what kind of man it represents.

Content-recognition and subject-recognition are not entirely insulated from each other. Content-recognition can be informed by simultaneous subject-recognition.

Having acknowledged this complexity, it nevertheless remains the case that recognizing a picture's subject in its content and its content in its design are different skills. Each is exercised within different dimensions of variation, and competence in one does not entail competence in the other. One may possess a robust ability to recognize objects and features changed across many dimensions of variation, yet lack the ability to recognize objects and features when they are shown in pictures (though doubtless this ability is easily acquired). And being able to recognize what kinds of objects pictures represent does not imply being able to recognize the objects themselves.

This makes sense of the fact that there are two ways to fail to grasp a picture. You can fail to grasp a picture's content—it just looks like a jumble of shapes and colors—even though you know it represents a familiar object.

Or you can tell what kind of object is represented, yet fail to grasp that the object is *that* familiar object.

The dimensions of variation across which pictorial recognition is dynamic go far beyond those across which ordinary recognition is dynamic. Pictures can be recognized when they represent their subjects as having combinations of properties quite unlike those their subjects could be seen to have. Pictures' subjects can be recognized when skewed and bent out of shape, when shown in reversed or curvilinear perspective, and when shown inside out or rearranged, as in X-ray pictures. Finally, the ability to recognize faces distorted by the satirist's pen seems hardly surprising when considered an extension of our ability to recognize faces changed by growth and age.

The main advantage of explaining depiction as an ability to recognize pictures' subjects over pictorial aspects is that the dynamism of recognition accounts for the diversity of depiction. The particular dimensions of variation, including essentially pictorial ones, over which recognition is dynamic determine the variety of ways that pictures can depict. They alone set the limits on the pictorial imagination.

Competence

Pictorial competence is system-relative because recognition is generative within pictorial dimensions of variation.

The ability to recognize things in pictures is generative only within, not between, systems, because recognition is generative only within dimensions of variation. Being able to recognize something presented under a pictorial aspect typical of one system does not suffice for being able to recognize anything presented under an aspect typical of another system. Competence in depiction is gained a system at a time, rather than a picture at a time.

Pictorial competence is manifest not only through generativity, but also through transference. Whereas generativity is the ability to interpret novel pictures of familiar objects, transference is the ability to identify an unfamiliar object through a picture of it. But if recognition is an ability to identify familiar objects, how can it explain transference? One answer to this question is that pictures of unfamiliar objects are usually recognized as objects having familiar properties. Thus transference depends on the generativity of content-recognition, not subject recognition. A second answer is that a picture may convey information about the properties of an unfamiliar object so as to endow a viewer with a recognition ability for that object. Pictures, as well as visual experiences, can convey information sufficient to initiate recognition abilities. We can recognize the movie star walking down Hollywood Boulevard as someone seen in *People* magazine.

The claim that interpreting pictures depends on the exercise of aspect-relative recognition abilities explains not only why pictorial systems are individuated by the aspects they present, but also why pictorial competence is tied to systems. Pictorial competence is system-relative because recognition is relative to dimensions of variation; systems can be individuated by the kinds of aspects they present because we are able to recognize objects with dimensions of variation defined by those aspects.

My suggestion is, in sum, that pictures embody information enabling viewers to recognize their contents and their subjects. The recognition skills we bring to pictures depend on and extend the dynamic recognition skills exercised in ordinary perception. I have argued that recognition is not reducible to description, that it is dynamic, aspectual, and systematic, and that this explains the diversity and generativity of depiction. The task for philosophy ends at identifying these structural and logical properties of recognition and their implications for thought and reference.

Recognition and Resemblance

Pictures resemble their subjects. This is hardly surprising, since just about everything resembles everything else in some respect. Pictures' resemblances to their subjects are highly variable from one system to the next, and noticing these resemblances, while integral to our experience of pictures, depends in part on the processes by which we interpret pictures. In other words, pictorial resemblances are representation-dependent.

Picture-subject similarities are aspect and system-relative. Pictures in different systems present different aspects of objects recognizable in different dimensions of variation. For example, depending on the kind of aspect presented, similarities among sizes on the picture plane may correspond to similarities among real sizes, among distances, or, in icon painting, among positions of persons represented in the celestial hierarchy.

What resemblances we notice are at least in part a matter of the processes of recognition in virtue of which we recognize the picture's content and subject. Moreover, these recognition-dependent resemblances vary with systems of depiction. Any design can depict any object provided it is recognizable as of that object, and the kinds of designs in which we can recognize things may vary with the dimensions of variation across which recognition is dynamic.

Basic Picturing

A picture is a representation that embodies information on the basis of which its source can be identified by a suitably equipped perceiver. In this section I set out the two forms of basic picturing—basic portrayal and basic depiction.

A picture "basically portrays" an object or scene if and only if it embodies aspectual information from it on the basis of which a suitable perceiver is able to recognize it. ("Portrayal," as I use it, is the depiction of any single object, whether human or not.)

While not all pictures are portraits, we have seen that all represent their subjects as having some properties, and this goes also for portraits of individuals who cannot be recognized. A picture "basically depicts" a property or kind of object F if and only if it embodies aspectual information derived from Fs on the basis of which a suitable perceiver is able to recognize it as an F.

Of course, basic portrayal and depiction are by no means infallible. Ambiguous pictures may be recognizable as of multiple objects or kinds of objects, and some pictures may not be recognizable as of their subjects by any suitable perceivers.

For the remainder of this chapter I want to qualify and defend my claim that basic pictures need be recognizable only by "suitable perceivers." Who are "suitable perceivers," and why are they the benchmark for depiction? In particular, what sort of skills must one possess to qualify as a suitable perceiver?

I suggest that a suitable perceiver for a given picture is one who possesses a *suitably dynamic* recognition ability. We have seen that there are two levels of recognition. A suitable perceiver must have certain competencies at each level.

To begin with, suitable perceivers must be adept at interpreting pictures—they must be able to recognize pictures' contents. This is the general requirement. A more specific one is that suitable perceivers of *a given picture* must additionally have recognition abilities for pictures in the same system.

There are two possible objections to this proposal. On the one hand, it seems to set too exacting a standard, because many pictures represent objects and people with whom we have lost contact and whom nobody can recognize. On the other hand, it seems to set too permissive a standard, since any scribble that somebody somewhere can recognize as of its subject counts as a basic picture. Let me answer these objections in turn.

The Mona Lisa is perhaps the most famous portrait of a figure with whom we have long lost acquaintance, though art museums are full of pictures whose sitters we do not know. Suitable viewers possessing recognition capacities for the subjects of these pictures no longer exist.

That this is so is a not wholly unexpected or undesirable implication for my theory of depiction. Pictures like the Mona Lisa have suitable viewers, albeit they do not have suitable viewers *now*. And it would be absurd to claim that a picture's subject must be recognizable by viewers in every time and place. Furthermore, the requirement that suitable perceivers be able to recognize a picture's subject explains the difference between the under-

standing enjoyed by Leonardo's contemporaries, who were acquainted with whoever sat for the *Mona Lisa*, and that enjoyed by modern viewers, who are not acquainted with her.

In any case, the argument that many pictures have no suitable perceivers is overstated. It wrongly assumes that a recognition ability for an object depends on an acquaintance with it. In fact, recognition abilities need not derive from personal acquaintance with things. Information endowing perceivers with recognition abilities may be, and often is, put into circulation by those who are directly acquainted with an object, for the benefit of those not acquainted with it. Often this information is distributed in the form of verbal testimony, but the role that pictures play in circulating information that can prompt recognition is not insignificant.

We must remember that pictures are not infrequently our initial perceptual contact with objects, and enable us to reidentify them in the future. Pictures, in other words, can endow us with recognition abilities. And although somebody who gains a recognition capacity for Wellington from a £5 note will assuredly never exercise it to identify Wellington himself, she might exercise it to identify Wellington as the source of other pictures. Thus recognition might come into play when seeing an aspect of an unfamiliar object in a picture provides a basis for recognizing the same object if ever confronted with it under other aspects. Basic depiction can depend on an extant recognition ability or the provision of a new one.

Finally, pictures of unrecognizable objects may be treated in somewhat the same way as we treat fictions. Although viewers may know that a picture had a source and was intended to depict it, identifying that source may have become impossible. But when appreciation of a picture, particularly a portrait, calls upon us to entertain thoughts about the character and doings of its subject, we may pretend to have recognized it, as a way of having the sort of thoughts required for aesthetic appreciation. This is comparable to the way in which readers of chronicles of distant times and places can appreciate the stories they contain by treating them as fictions.

The second line of protest to requiring that basic pictures be recognizable to suitable perceivers is that it is too permissive, conferring the status of a basic picture on anything that might trigger the cultivated recognition capacities of any small class of viewers. If certain Parisians belonging to an ante bellum avant-garde can recognize art dealers under cubist aspects, then cubist picturing is basic. However, we should not lose sight of the crucial fact, which is the sine qua non of depiction, that our repertoire of recognition skills can be enlarged. Recognition is generative in new dimensions of variation, new systems. Once we understand how the Kwakiutl depict ravens, we are usually able to interpret their pictures of whales, bears, and beavers as well.

I grant, however, that there is a limit to what counts as a suitably dynamic recognition capacity. It is necessary to rule out pictures which trigger highly idiosyncratic recognition abilities. The artist Henri Michaux produced abstract frottages and watercolors of objects as they appeared to him under the influence of mescaline. If Michaux's pictures accurately represent, as well they may, what their subjects look like to somebody in a drug-induced state, then we may suppose that anybody in such a state would be able to recognize them. Yet it seems wrong to say that Michaux's pictures are basic pictures just because they trigger *some* perceiver's recognition skills. For a less outré example, consider Josef Karsh's photograph of Pablo Casals, shown from the back, playing the cello. It seems wrong to say that the photograph basically represents Casals just because a few close acquaintances can recognize him from the back. It seems equally strained to insist that a child's "drawing" represents its mother because the child (and its mother, no doubt) can idiosyncratically recognize its subject.

The notion of a "suitable perceiver" is in some measure a normative one. A suitable perceiver of a picture is one who possesses recognition abilities that a normal person would possess. It is in part because depiction has built into it a normative conception of what skills should be required for interpreting pictures that our ideals of pictorial representation have a history, changing from time to time and place to place. It strikes me as not at all implausible that, since the invention of photography, the history of recent art is a history of experimentation with the limits of pictorial recognition. Perhaps, then, our normative concept of the pictorial has become an essentially contested one, so that what counts as a suitable way of engaging viewers' perceptual talents is not only variable and sensitive to context, but also a matter of dispute.

Note

1. My account of recognition is inspired by Gareth Evans's in chapter 8 of *The Varieties of Reference*, ed. John Henry McDowell (Oxford: Oxford University Press, 1982), 267–304.

⌒⟨∞⟩⌒

Pictorial Art and Visual Experience*

John Hyman

There is no consensus about how exactly the experience of looking at a picture should be defined, but it is generally agreed that defining this experience is the key to the theory of depiction.

* "Pictorial Art and Visual Experience," *British Journal of Aesthetics* 40:1 (2000): 21–45. Reprinted by permission of Oxford University Press.

Perhaps one reason is a prevailing tendency among philosophers to think of perception as a purely passive operation in which perceptible objects produce sensory perceptions in the minds of sentient animals by causing changes to occur in their sense-organs. For if we think of perception in this way, then we are bound to conceive of an artifact which is designed to have a certain sort of appearance or to make a certain kind of sound as designed to have a certain *psychological effect*; that is, we shall think of it as designed to produce a certain kind of sensory perception. And it will therefore seem that the differences between different kinds of artifact of this general sort consist in the differences between the particular kinds of sensory perception they are designed to produce. Pictures will be distinguished in this way from dyed fabrics, musical instruments, perfumes, and cheeses; and pictures of forests will be distinguished from pictures of battles in the same way. E. H. Gombrich has expressed this idea nicely: "What may make a painting like a distant view through a window," he writes, "is not the fact that the two can be as indistinguishable as is a facsimile from the original: it is the similarity between the mental activities both can arouse." "The goal which the artist seeks . . . [is] a psychological effect."[1]

I doubt whether this right; but even if I am mistaken, and it is right to conceive of a picture as an artifact designed to produce a certain sort of psychological effect, it does not follow that the nature of pictorial art can be explained by defining this effect, since the effect itself may not be definable except as a sensory perception of a picture. The quandary is a familiar one.

The sort of problem we are concerned with is one which often arises in philosophy, a puzzle about theoretical priority. Puzzles of this sort have the form: should we explain A in terms of B; or should we explain B in terms of A? Is a beautiful thing beautiful because we enjoy contemplating it, or do we enjoy contemplating a beautiful thing because it is beautiful? "Subjectivism" and "objectivism" are the unsatisfactory labels often attached to the two positions offered by the question. But neither position is correct; and the principal point of aesthetic theory is to find a via media between them.

A plausible theory of depiction must also find a via media. I shall show how the theory of depiction can avoid both the false subjectivism which attempts to define the content of a picture purely in terms of the perception it is apt to produce in us, and the false objectivism which defines the content of a picture in terms which make no reference to our perception of it.

First, I shall argue that there is a strict and invariable relationship between the lines, shapes, and colors on a picture's surface and its *internal* subject, which can be precisely defined without referring to the psychological effect a picture will tend to produce. I shall argue that it can be defined by means

of three principles. The significance of the word "internal" is this. Consider Frans Hals's portrait of Johannes Hoornbeek. The phrase "the man in Hals's picture" can be used in two different ways: to describe what we can see when we look at the picture; or to refer to the man whom the picture portrays. Thus, "The man in Hals's picture is dead" is false if the phrase is being used in the first way, to describe Hals's picture; but it is true if it is being used in the second way, to refer to Johannes Hoornbeek. For convenience, we can say that the *external* subject of Hals's portrait is dead, but its *internal* subject is not. The three principles I shall defend are concerned only with the *internal* subject of a picture.

The concept that we need to make use of, in order to formulate the first of these principles, is the concept of occlusion shape. To occlude something is to hide it from view. For example, a circular plate viewed obliquely will occlude or be occluded by an elliptical patch on a plane perpendicular to the line of sight: if the plane is the surface of a wall behind the plate, then the shape of the patch on the surface of the wall which is occluded by the plate will be an ellipse; and if the plane is the surface of a pane of glass lying in front of the plate, then the plate will be precisely occluded by an elliptical opaque patch on the surface of the glass. Hence the plate's occlusion shape is elliptical. An object's occlusion shape is a function of its shape and its orientation relative to the line of sight of a spectator. The occlusion shape of an object, relative to a line of sight, is a perfectly objective matter.

The concept of occlusion shape plays the following role in the theory of depiction. Consider an engraving of a man's head. If an engraving depicts a man's head, the shape of the smallest part of the picture which depicts the man's nose or chin must be identical to the occlusion shape of the nose or the chin in the picture. The general principle, which I shall call the Occlusion Shape Principle, is easily proved by means of a thought experiment. In fact, the thought experiment is an unusual one, because it can actually be performed. The experiment is to try to trace the shape of the part of a picture which depicts something—say, a house or a tree or a man or a part of his body—by running a finger across its surface, without simultaneously tracing the occlusion shape of the corresponding part of the picture's internal subject—the house or the tree or man in the picture. Alternatively, one might try to trace the occlusion shape of part of a picture's internal subject without tracing the actual shape of the part of the picture that depicts it. It only takes a moment's reflection to see that neither thing is possible. Hence the occlusion shape of a part of a picture's internal subject and the actual shape of the smallest part of the picture that depicts that part of its subject must be identical. I shall use the letter "S" to signify a part of a picture's internal subject,

and the letter "P" to signify the smallest part of the picture that depicts S. The Occlusion Shape Principle can therefore be stated as follows: the occlusion shape of S and the actual shape of P must be identical. This should not be regarded as a discovery about depiction. It is simply a precise statement of the indispensable thought that an object is depicted by defining its outline.

The concept that we need to make use of in order to define the second principle is the concept of relative occlusion size. The relative occlusion size of two objects, like an object's occlusion shape, is a matter of geometry, not psychology. Suppose I hold out my hands in front of me and extend one arm further than the other. My hands will not appear to differ in size, but the greater occlusion size of the nearer hand will be evident. The nearer hand occludes a larger patch of the wall beyond. The relative occlusion size of my hands is a function of their relative size and their relative distance from my eyes.

Just as the occlusion shapes of the objects represented in a picture are the occlusion shapes they are represented as having, so are their relative occlusion sizes. And just as the occlusion shape of S and the actual shape of P must be identical, the relative occlusion size of S_1 and S_2 and the relative size of P_1 and P_2 must be identical. I shall call this the Relative Occlusion Size Principle. Whereas an object's occlusion shape is a function of its shape and its orientation relative to the line of sight of a spectator, the relative occlusion size of two objects is a function of their relative size and their relative distance from a spectator.

When we turn from shape and size to color, the situation may at first appear more complicated. To begin with, S and P need not resemble each other in color, for the internal subject of an engraving (whatever the color of the ink) need not and generally will not have a determinate color. But suppose S does have a determinate color. Must it be the same as P's color? Objects that match in color for a given observer under a given illumination are said to match *metamerically* for that observer under that illumination; and if they match under all illuminations, they are said to match *isomerically*. But since comparisons of either sort depend on comparing the two objects under the same illumination, it simply is not possible to determine whether S and P match metamerically or isomerically if the picture is one in which objects are shown under a particular illumination. For, of course, we cannot take a sample of the pigment and, as it were, reach into the picture with it, or lift something out of a picture and place it on the surface. So we need to decide, before considering whether S's color must be the same as P's, what method of comparison to employ.

Normally when we look at a uniformly colored wall with a cast shadow lying across it, say the shadow of a tree or of a piece of furniture, it will look

just as I have described it: uniformly colored, with a part of it shaded, but not darker in color. This uniformity in color is called a uniformity in *surface color*. But if we look at a part of it where there is a sharp transition from light to shadow, through a reduction screen [e.g., a sheet of dark grey card with a hole cut out of it], the patch we can see will look as if it has two parts with different colors, one darker than the other. Here, our attention is directed towards *aperture color*.

The distinction between surface color and aperture color suggests a straightforward solution to our problem. The solution is that S and P may differ in surface color, and P may vary in surface color without producing a corresponding variation in S's surface color; but if we divide a picture into color-patches that are small enough to prevent us from perceiving the characteristics of the ambient light within the picture, then each such patch must be identical in aperture color to the part of the picture's subject that it represents, under optimum illumination. I shall call this the Aperture Color Principle.

It is important to notice how modest these three principles are. First, they tell us nothing about what *kind* of thing a picture represents, as opposed to the occlusion shapes, relative to the spectator's line of sight, of its various parts, their relative occlusion size, and their aperture colors. For example, if part of a picture represents a duck's bill or a rabbit's ears, the Occlusion Shape Principle does not tell us which; although it does tell us that if the picture can be seen either as a picture of a duck or as a picture of a rabbit, the duck and the rabbit must have the same occlusion shape, relative to the spectator's line of sight. Secondly, they say nothing about the relationship between the surface of a portrait and the actual man portrayed: they only concern the relationship between the surface of a picture and its *internal* subject. Finally, the Occlusion Principles do not imply that the parts of the internal subject of a picture must have fully determinate occlusion shapes and relative occlusion sizes; and the Aperture Color Principle does not imply that the parts of the subject of a picture have determinate aperture colors. But the Occlusion Principles do imply that any indeterminacy in the occlusion shapes and relative occlusion sizes of parts of a picture's internal subject will be precisely matched by a corresponding indeterminacy in the shapes and relative sizes of the corresponding parts of the picture's surface.

The three principles are modest; but they prove there is a strict and invariable relationship between the lines and shapes and colors on a picture's surface and its internal subject which can be defined without referring to the picture's psychological effect on a spectator.

If the nature of pictorial art is to be explained by defining the psychological effect which a picture is designed to produce, what form should the definition of the experience take? We can approach this question by considering Richard Wollheim's theory of depiction. Wollheim has argued that a picture is a marked surface which was designed (successfully) to produce in a spectator "an experience with a certain phenomenology," which he calls "seeing-in."[2] This thesis places Wollheim squarely in the mainstream of recent philosophy, because he explains the nature of depiction in terms of the psychological episode a picture is designed to produce. But Wollheim's theory of depiction is unsatisfactory.

First, it simply is not true that whenever I see what a picture depicts, "I discern something standing out in front of, or . . . receding behind, something else." This would be true only if every picture depicted something standing out in front of or receding behind something else, or if an object in a picture always appeared to be standing out in front of or receding behind the picture's surface. But in fact there are many pictures which satisfy neither of these conditions. The lithograph of a bull by Picasso is a picture of this kind. There is no need to suppose that the complex experience Wollheim describes needs to occur when one looks at this drawing and sees what it depicts, any more than when one looks at the words on a printed page.

Secondly, the theory tells us something about the generic nature of the experience of seeing a certain kind of object in something, but nothing about its specific nature. What is missing is an explanation of how the experience of seeing a bull in something is related to the experience of actually seeing a bull.

Thirdly, as Wollheim acknowledges, the nature of seeing-in is such that he cannot count a trompe l'oeil painting as a picture: "They incite our awareness of depth, but do so in a way designed to baffle our attention to the marks upon the surface."[3] But a trompe l'oeil will produce the effect it is designed to produce only when a spectator cannot see it *as* a marked surface, or see that what he is attending to is a marked surface. Since a picture is, loosely speaking, a particular kind of marked surface, these are circumstances in which a spectator cannot see that what he is attending to is a picture. But it is one thing to say that a trompe l'oeil is designed to prevent a spectator, at least for a moment, from seeing that it is a picture; and quite another to deny that it is a picture.

Wollheim's theory cannot be regarded as a success. But the failure is an instructive one; and its principal lesson, for present purposes, arises from the second criticism made above, namely that the theory fails to explain the difference between a picture of one sort of thing and a picture of another

sort of thing. The lesson is that depiction cannot be defined in terms of the psychological episode a picture is designed to produce except by specifying the kind of sensory perception produced by a picture which depicts *an object of such and such a kind*. Specifying the kind of sensory perception produced by every picture, regardless of what it depicts, is not an option.

If we conceive of a picture as an artifact designed to produce a distinctive kind of psychological effect, we shall find ourselves unable to define this effect, except by making use of the concept of depiction. A noncircular definition of the psychological effect that a picture produces in a spectator's mind is as elusive as a noncircular definition of the sentiment produced by contemplating something beautiful. It is a platitude that the shape of a certain sort of object in a picture must be a shape that an object of that sort in a picture can have; but this platitude represents the most that a psychological theory of depiction can achieve. If we are aiming to explain what we understand when we understand the concept of a picture, or in other words, to lay out in a lucid and systematic fashion the content of our thoughts about pictorial art, the psychological theory of depiction is a dead end.

When we look at a picture, we can generally tell that it depicts, say, a field of poppies or a chestnut in blossom, simply by looking at it—that is, without making any sort of inference—as long as we know, or can imagine, what a field of poppies or a chestnut in blossom looks like, or would recognize such a thing if we saw it. The Occlusion Principles and the Aperture Color Principle disclose how, and to what extent, the surface of a picture controls our experience when we perceive its content, and hence how the shapes and colors on the surface of a picture and the spectator's knowledge of appearances—that is, his ability to tell things by their sizes, shapes, and colors—jointly explain his perception of its content.

Consider the brushstrokes that depict the gold braid on Jan Six's cloak in Rembrandt's portrait of him. That they convey the appearance of gold braid is undeniable. They do it with sublime ease. The resemblance theory promises to explain this fact in terms of an objective correspondence between the brushstrokes and gold braid—a correspondence which our visual experience of the painting can register but which obtains quite independently of any facts about this experience. But this promise cannot be fulfilled, because objectively speaking Rembrandt's brushstrokes do not resemble gold braid more closely than they resemble a flight of stairs or a pile of books.

It does not follow that the content of a picture depends on the nature of the sensory perception it is apt to produce in our minds. And in fact this is the reverse of the truth, for the nature of the perception depends on the content of the picture—for example, brushstrokes which depict gold braid.

A picture is not an optically administered hallucinogen. The psychological effect that a picture is designed to produce is the visual experience of perceiving its visible properties—its representational ones and its nonrepresentational ones. And we perceive the former by perceiving the latter: that is, we can tell what a picture depicts because we can see the shapes and colors on its surface. There is no harm in saying that the brushstrokes *produce exactly the effect* of gold braid, if this means simply that they can, to our wonder and delight, successfully depict it. But this fact must, in the final analysis, be explained by the shapes and colors of these brushstrokes and the shapes and colors of gold braid.

There are three precise principles connecting the nonrepresentational and representational properties of a picture—their surface and their content—that can be stated without referring to the perception which the picture is apt to produce in us. The experience of looking at a picture is the only decisive test of what it depicts. Seeing that part of a picture represents gold braid does not depend on perceiving a resemblance between this part of the surface of the picture and gold braid—any more than seeing that a particular piece of gold braid is a piece of gold braid depends on perceiving a resemblance between it and other, previously seen, pieces of gold braid.

We can say, first, that something—namely a picture or part of one—depicts an object of a certain kind if, and only if, it is a marked surface which was designed (successfully) to let us see that it depicts an object of that kind immediately; secondly, that we can see that a picture or part of one depicts an object of a certain kind immediately—that is, without making any sort of inference—because we can see the occlusion shapes and the relative occlusion sizes and aperture colors of the various objects it represents and their various parts; and thirdly, that we can see these because they are the actual shapes and relative sizes and aperture colors of the corresponding parts of the picture's surface.

If this is correct, the Occlusion Principles and the Aperture Color Principle lie at the heart of the theory of depiction; and their full significance lies in the fact that they imply that we can tell what kinds of objects a picture represents because we can see their sizes and shapes and colors—that is, in just the same way as we can tell what the visible objects in our environment are. This is not to say that we make inferences from propositions describing the sizes and shapes and colors of objects, in order to determine what a picture depicts, any more than we make such inferences in order to identify the visible objects in our environment. On the contrary. How can we tell that sparrows are sparrows and magpies magpies? By recognizing their distinctive sizes and shapes and colors, and the sizes and shapes and colors of their parts.

No inference is brought into play by this answer, and in fact none normally occurs when we see a sparrow or a magpie and can tell that that is what it is, or when we see what a picture represents. A picture is designed to let us to see what it represents immediately, without making any sort of inference, and the three principles explain precisely how it can do so.

Notes

1. E. H. Gombrich, "Illusion in Art," in *Illusion in Nature and Art*, ed. E. H. Gombrich and R. L. Gregory, 193–243 (London: Duckworth, 1973), 240; E. H. Gombrich, "Experiment and Experience in the Arts," in *The Image and the Eye*, 215–43 (Oxford: Phaidon, 1982), 228.

2. Richard Wollheim, *Painting as an Art* (Cambridge, MA: Harvard University Press, 1987), 46.

3. Wollheim, *Painting*, 62.

⟨∞⟩

Further Reading

Feagin, Susan. 1998. Presentation and representation. *Journal of Aesthetics and Art Criticism* 56: 234–40. A defense of seeing-in against the objection based on trompe l'oeil.

Goldman, Alan. 2003. Representation in art. In *The Oxford handbook of aesthetics*, edited by Jerrold Levinson, 192–210. Oxford: Oxford University Press. A defense of the resemblance account of depiction.

Goodman, Nelson. 1976. *Languages of art*. Indianapolis: Hackett. Highly influential critique of the resemblance view and development of the idea that depictions belong to a special type of symbol system.

Hopkins, Robert. 1998. *Picture, image, and experience*. Cambridge: Cambridge University Press. A highly sophisticated presentation of the resemblance account of depiction.

Levinson, Jerrold. 1998. Wollheim on pictorial representation. *Journal of Aesthetics and Art Criticism* 56: 227–33. A defense and modification of the seeing-in view of depiction.

Wollheim, Richard. 1987. *Painting as an art*. Cambridge, MA: Harvard University Press. Princeton, NJ: Bollingen Foundation Press. Reprint, Wollheim supplements the seeing-in account with the importance of recovering artists' intentions.

CHAPTER NINE

~

Expressiveness in Music

Introduction

As high school graduation day approaches, greeting cards arrive in the mail from relatives who live too far away to attend the graduation ceremony. A favorite aunt cannot afford the airfare, so she mails a card and a generous check. Inside she writes, "I'm so proud of you!" She underlines the sentence twice for emphasis, then adds words of regret that she cannot deliver the card personally. Another card arrives from a mother's cousin. It also contains a gift of money, but there is no personal sentiment beyond "Good luck!" and, under that, "Cousin Pat."

On graduation day, the students form two lines outside the gymnasium. They wait for their cue to enter; then the line crawls forward to the sounds of the trio section of Sir Edward Elgar's Pomp and Circumstance March no. 1. Originally written for the coronation of King Edward VII, Elgar's march has been used for countless American graduation ceremonies since Yale University adopted it more than a century ago. As instructed, the students move in time to the slow beat of the music—step, pause, step, pause. Befitting its royal origins, the music sets a deliberate, stately pace. The normally undisciplined, slouching teenagers take on the appearance of upright, confident, proud adults. As the graduates pass the assembled family and friends, some people in the audience begin to weep tears of joy.

As with so many rites of passage, graduation can be an intensely emotional event. With this in mind, review the details sketched above and notice the different ways that emotions manifested. Some gestures, such as the aunt's

personal note, come across as sincere expressions of heartfelt emotion. Some, most notably the tears, are spontaneous. Others, such as the acts of sending a card and marching in procession, are governed by cultural traditions.

Because it involves a bodily response, crying seems to express emotion directly. It is difficult to fake crying. Greeting cards seem very different. They involve planning and are often used to express sentiments in the sender's absence. There seems a lot more room for faked emotion, where the outward signs of the emotion do not necessarily correspond with the person's psychological state. So what are we to make of the two cards? Are they equally sincere? Many people will regard the aunt's card—like the crying in the gymnasium—as more genuine and sincere than the perfunctory card from the mother's cousin. Nonetheless, the person who *appears* to be going through the motions and whose congratulations seem less heartfelt might be just as emotionally moved as the others while lacking the words to convey that emotion. So it appears that some level of skill can be involved in expressing emotion, in making us aware of its presence. Artists often work to acquire such skill.

What about the music in the gymnasium? Although at first it may seem odd to think of Elgar's music as sharing something in common with tears, music is often thought to express emotions. In fact, many people regard music as the most expressive of the arts.

Notice the terminology here: the tears, the greeting card, and the music "express" emotions. Generally, we say that something expresses an emotion if it reveals or makes known a genuine emotion of a particular person. But Elgar is long dead. Does the music still express his emotions? And why would we express *his* emotions at our ceremony? Because we want something that fits a mood? Or that helps to create one? Music seems more like a greeting card than tears, for it has a life apart from its composer and so can be used by others to express their emotions.

If Elgar's music does what we want it to do, do we care if it expresses a faked emotion? (Perhaps he did not feel proud that Edward was being crowned.) When a thing presents emotion without expressing its creator's own emotions, or when its sincerity does not seem to matter, many philosophers say that we have "expressiveness."

Sincere or not, works of art seem expressive. Once artists acquire skills for presenting an emotion in an artistic medium, there seems no good reason why their public delineation of an emotion must originate in their own feelings. And by using their art, we can "borrow" expressiveness for our own purposes. In selecting music to play at a public event such as a graduation ceremony, we want music that does more than keep the marchers in step with one another. We want it to be appropriately expressive. For example, the use of Elgar's march is not just a matter of tradition. Elgar actually wrote

and published a series of six marches called "Pomp and Circumstance," several of which would puzzle or alarm the audience during the processional and recessional stages of a graduation. No. 3, for example, opens with ominous music that soon gives way to an aggressive, more militaristic march—not the emotive message we want accompanying the typical graduation ceremony.

Although common sense tells us that we select music for a ceremony or event because we are aware of its emotive qualities, Eduard Hanslick famously argues that this view is both false and harmful to music appreciation. A nineteenth-century Viennese music critic and music professor, Hanslick provocatively argues that music is incapable of expressing emotional characteristics. It would be wrong to describe Pomp and Circumstance March no. 1 as joyful, not because it expresses something else, such as pride, but because it lacks a feature necessary for expressiveness. In order for an emotion to be present, it must be directed at some situation or object by someone who has definite beliefs about the situation. The person's beliefs are part of what defines the particular emotion. For example, a feeling of melancholy requires the person to believe that her present situation is worse than her previous one. She must believe that she has experienced loss. However, a piece of *instrumental* music cannot convey the information that distinguishes melancholy from, say, weariness. At best, the music can convey a sense of movement potentially present in any of several emotions. If we think that Elgar's march expresses pride instead of anger, we do so because we can rule out anger: anger "moves" differently than pride. But that is still not enough to delineate pride. Other features, such as the circumstances in which we play the music or associated lyrics, supply the beliefs that guide the interpretation.

Stephen Davies deals with Hanslick's objection by noticing that we frequently perceive expressiveness in nonmusical cases. In these cases, we distinguish an expressive appearance from our understanding of what might actually be happening emotionally. As an example, Davies notes that the face of a basset hound looks sad even when we know that the dog is happy. Thus, we can identify expressiveness in the case of an animal, distinctly from anything actually expressed. So there is no real problem in moving on to nonliving, nonsentient things. Here, we experience an appearance of expressiveness despite our knowledge that no emotions can be expressed. A sequence of sounds is an obvious case, and here the expressiveness is all the more apparent for the very reason that Hanslick allows—an appearance of movement is essential to the experience of music. Frequently, the way someone moves indicates his or her emotional state. Therefore, it is both natural and appropriate to attribute expressive vocabulary to music.

Jenefer Robinson argues that Davies's "doggy theory" is inadequate for the job. Like Hanslick, she thinks that the music itself provides too little

information to give us the appearance of a definite emotion. She also agrees that the information must be supplied from elsewhere. Unlike Hanslick, Robinson thinks that we can turn to a long tradition of artistic practice that provides us with the missing information. In particular, we can turn to the tradition of reading a sequence of appearances as an intentionally constructed persona. (A basset hound's face always looks more or less the same. A good piece of music is constantly changing. So we must focus on making sense of sequencing.)

Robinson argues that there is an established tradition in which artists seek to express emotions—sometimes, as in romanticism, their own. This tradition extends to instrumental music. To convey emotions successfully, composers must do the same thing as poets. They must judge how an audience will interpret their artistic choices with full knowledge that they are artistic, expressive choices. So, in a tradition in which the audience understands that the goal includes the display of emotions, the audience will ask what emotion or sequence of emotions best accounts for the choices encountered in the work's design. (Robinson's position can be usefully compared to William Tolhurst's hypothetical intentionalism in chapter 6.) Finally, Robinson warns us to remember that emotions are more than what we feel. Emotions are complex processes, with multiple dimensions. If we do not cooperate with a composer's invitation to look for the controlling persona, highly expressive musical compositions will appear largely arbitrary.

⌦

The Representation of Feeling Is Not the Content of Music*

Eduard Hanslick

Until now, the course pursued in musical aesthetics has nearly always been hampered by the false assumption that the object was not so much to inquire into what is beautiful in music as to describe the feelings which music awakens.

Music, we are told, cannot entertain the mind with concepts of the understanding, as poetry does; nor yet the eye, like sculpture and painting, with visible forms. Hence, it is argued, its object must be to work on our feelings. "Music has to do with feelings." This expression, "has to do," is highly characteristic of all previous works on musical aesthetics. But what the nature of the link is that connects music with the emotions, or certain pieces of music

* From *The Beautiful in Music: A Contribution to the Revisal of Musical Aesthetics*, translated by Gustav Cohen, 7th ed., pp. 15–38 and 43–59 (London: Novello, Ewer and Co., 1891). In the public domain; edited and translation amended by Theodore Gracyk, used by permission.

with certain emotions; by what laws of nature it is governed; what the canons of art are that determine its form—all these questions are left in complete darkness by the very people who have "to do" with them. Only when our eyes have become somewhat accustomed to this obscurity do we detect that the emotions play two roles in music, as currently understood.

On the one hand it is said that the aim and object of music is to excite emotions or "finer emotions." On the other hand, the emotions are said to be the subject matter which musical works are intended to represent.[1]

These propositions are alike in that one is as false as the other.

The first of these propositions is found in the introduction to most music textbooks; its refutation will not take us long. The beautiful, strictly speaking, aims at nothing, since it is nothing but a form which has, as such, no aim beyond itself. If the contemplation of something beautiful arouses pleasurable feelings, this effect is distinct from the beautiful as such. I may, indeed, place a beautiful object before an observer with the intention of giving him pleasure, but this purpose does not create the beauty of the object. The beautiful is and remains beautiful even when it arouses no emotions, and even when it is neither seen nor thought. In other words, although beauty pleases an observer, it is independent of him.

In this sense music likewise has no aim, and the mere fact that this particular art is so closely connected with our feelings does not justify the assumption that its aesthetic significance depends on this connection.

In order to examine this relation critically we must first scrupulously distinguish between the terms "feeling" and "sensation," although in ordinary speech no objection need be raised to their indiscriminate use.

Sensation is the perception of a certain sensible quality, such as a sound or a color. Feeling is the consciousness of our mental state, together with satisfaction or discomfort, and so with its encouragement or inhibition.

If I sense (perceive) the smell or taste of some object, perceiving its form, color, or sound, I call this state of consciousness "my sensation" of these qualities; but if sadness, hope, cheerfulness, or hatred noticeably elevate me or depress me beyond my habitual level of mental activity, I am said to "feel."

The beautiful, first of all, affects our senses. This, however, is not peculiar to beauty, but is common to all phenomena whatsoever. Sensation is the beginning and condition of all aesthetic pleasure and it is the initial basis of all feeling, and this fact presupposes some relation, and often a complicated one, between the two. No art is required to produce sensation; a single sound or a single color can do it. As previously stated, the two terms are generally employed indiscriminately, but in older books, writers call "sensation" what we would label "feeling." What those writers intend to convey, therefore, is

that music should arouse our feelings, and fill our hearts with piety, love, joy, or sadness.

In the pure act of listening we enjoy the music alone and do not think of importing into it any extraneous matter. But the tendency to allow our feelings to be aroused implies something of this sort. An exclusive activity of the intellect, directed at beauty, involves a *logical* rather than an aesthetic relation, while a predominant effect of feeling brings us onto still more slippery ground, implying, as it does, a *pathological* relation.

These inferences, derived long ago from general principles of aesthetics, apply with equal force to the beautiful in every art. So if music is to be treated as an art, it is not our feelings but our imagination which must supply aesthetic tests. This modest premise seems advisable, seeing that the soothing effect of music on the human passions is always affirmed with such emphasis that we are often in doubt whether music is a police regulation, an educational rule, or a medical prescription.

Yet musicians are less prone to believe that all arts must be uniformly gauged by our feelings than that this principle is true of music alone. It is this very power and tendency of music to arouse in the listener any given emotion which, they think, distinguishes this art from all the others.

Unable to accept the doctrine that the purpose of all art is to arouse such feelings, we are equally unable to regard it as the specific aim of music to do so. Grant that imagination is the true organ for apprehending beauty, and it follows that all arts are likely to affect the feelings indirectly. Do not Raphael's Madonnas fill us with piety, and do not Poussin's landscapes awaken in us an irresistible desire to roam about in the world? These questions admit of one answer. It is equally true of poetry and of many extra-aesthetic activities, such as religious fervor, eloquence, etc. We thus see that all the other arts also affect our feelings with considerable force. The inherent peculiarities assumed to distinguish music from the other arts would depend, therefore, upon the degree of intensity of this force. However, this attempt to solve the problem is highly unscientific and is, moreover, of no use, because the decision whether one is more deeply affected by a Mozart symphony, a tragedy by Shakespeare, a poem by Uhland, or a rondo by Hummel must depend, after all, on the individual himself. Arousal of feeling by the beautiful in music is merely one of its indirect effects. Only imagination is directly affected. Many scholarly studies of music make an analogy between music and architecture. It is undeniable. But did it ever occur to any architect in his right mind that the *aim* of architecture is the arousal of feelings, or that feelings are its subject matter?

Every real work of art appeals to our emotions in some way, but none in any exclusive way. No aesthetic principles of music can be deduced from the fact

that there is a connection between music and the emotions. We might as well study the essential properties of wine by getting drunk. The question is the *specific* mode in which music affects our feelings. Therefore, instead of sticking to the vague and secondary effects of musical phenomena, we ought to go deep into the works themselves and to bring out the laws of their specific nature.

Our feelings can never be the basis of aesthetic laws, so it is essential to notice that words, titles, and other conventional associations (especially in sacred, military, and operatic music) often send our feelings and thoughts in a direction which we are wrongly biased to assign to the character of the music itself. Rather, the connection between a piece of music and resulting feelings is not explained by strictly causal laws, because the mood varies with our musical experience and impressibility. In the present day we wonder how our grandparents could take a particular sequence of sounds to correspond precisely to a particular expression of feeling. For example, compare the effects which works by Mozart, Beethoven, and Weber produced on the hearts of listeners when they were new as compared with today. How many compositions by Mozart were said by his contemporaries to be the most perfect expressions of passion, warmth, and vigor of which music is capable! The peaceful well-being and moral sunshine of Haydn's symphonies were placed in contrast with the violent bursts of passion, the bitter conflicts, and the stabbing pains embodied in Mozart's music. Twenty or thirty years later, precisely the same comparison was made between Beethoven and Mozart. Mozart, the emblem of supreme and transcendent passion, was replaced by Beethoven, and Mozart was promoted to Haydn's Olympic classicism. Every observant musician will, in the course of a long life, observe similar changes of taste. Despite this varying effect on feelings, many impressive works still have their musical merit, and the aesthetic enjoyment of their originality and beauty is not altered for us. Thus, there is no invariable and inevitable connection between musical works and certain states of mind; the connection is much more subject to change than in any other art.

Thus, the effect of music on the emotions does not possess the inevitableness, exclusiveness, and uniformity that a phenomenon must display in order to establish aesthetic principles.

Far be it from us to underrate the deep emotions which music awakens from their slumber, or the joyful or sad moods which our minds dreamily experience. We only protest the unscientific procedure of deducing aesthetic principles from such facts. Music undoubtedly awakens feelings of joy and sorrow in the highest degree. But might not the same or a still greater effect be produced by the news that we have won the first prize in the lottery, or by the life-threatening illness of a friend? So long as we refuse to include lottery

tickets among the symphonies, or medical bulletins among the overtures, we must not treat the emotions it produces as an aesthetic specialty of music or of a certain piece of music in particular. The manner in which music arouses feelings always depends on the specifics of the particular case.

Almost complete unanimity proclaims the full range of human feelings to be the subject of music, because feelings are believed to be in direct contrast to the determinacy of intellectual conceptions. Thus they are the feature by which music is distinguished from the ideal of the other fine arts and poetry. According to this theory, therefore, sound and its artful combinations are but the material and the medium of expression by which the composer represents love, courage, piety, and delight. The innumerable varieties of emotion constitute the idea which, on being translated into the physical body of sound, lets it walk the earth in the form of a musical composition. The beautiful melody and the skillful harmony as such do not charm us, but only what they signify: the whispering of tender love, or the stormy violence of conflict.

In order to reach solid ground we must first ruthlessly eliminate these old clichés. The *whispering*? Yes, but not the whispering of love. The *storminess*? It may be reproduced, admittedly, but not of conflict. Music may reproduce phenomena such as whispering, storming, roaring, but feelings of love or anger exist only in our hearts.

The representation of definite feelings and emotions is not among music's own powers.

Our emotions have no isolated existence in the mind and cannot, therefore, be singled out by an art which is closed to the representation of the remaining mental states. They are, on the contrary, dependent on physiological and pathological conditions, on concepts and judgments—in fact, on the whole domain of intelligible and rational thought which so many people oppose to the emotions.

What, then, makes a feeling into a definite one—into the feeling of longing, hope, or love? Is it the mere degree of strength or weakness, the fluctuations of inner motion? Certainly not. These can be the same in the case of dissimilar feelings or may, in the case of the same feeling, vary with the person and the time. Only by virtue of ideas and judgments—perhaps unconsciously in moments of strong feelings—can an indefinite state of mind pass into a definite feeling. The feeling of hope is inseparable from the conception of a happier state which is to come, and which we compare with the present state. Melancholy compares a past state of happiness with the present. These are perfectly definite ideas or conceptions. Without them—without the apparatus of thought—we cannot call a feeling "hope" or "sadness," for this makes them what they are. Separating them, nothing

remains but a vague sense of motion which at best could not rise above a general feeling of satisfaction or discomfort. Love cannot be conceived apart from the image of the beloved individual, or apart from the desire and the striving for the happiness, glorification, and possession of the object of our affections. It is not mere mental activity, but rather the conceptual core, the actual historical content, which makes it to be love. Dynamically speaking, love may be gentle or stormy, happy or painful, and yet it remains love. This reflection alone ought to make it clear that music can express only those qualifying adjectives, and not the substantive, love, itself. A determinate feeling (a passion, an emotion) as such never exists without an actual historical content which can, of course, only be communicated through the medium of definite ideas. Music cannot present concepts in "an indefinite form of speech"—is it not a psychologically unavoidable conclusion that it is likewise incapable of expressing determinate emotions? The determinate character of an emotion rests precisely on its conceptual core.

Likewise, poetry and the visual arts first produce something concrete. Only then, indirectly, can the picture of a flower girl call up the general impression of girlish contentment and modesty. In like manner, but with a more reckless and arbitrary interpretation, the listener discovers in a piece of music the idea of youthful contentedness or in another the idea of transitoriness. These abstract notions, however, are no more the subject matter of the musical compositions than of these pictures. It is absurd to talk of the musical representation of "feelings of transitoriness" or of "youthful contentedness."

What part of the feelings, then, can music represent, if not the subject involved in them?

Only their *dynamic* properties. It may reproduce the motion accompanying a mental process, according to its momentum: speed, slowness, strength, weakness, increasing and decreasing intensity. But motion is only one aspect of feeling, not the feeling itself. Many people suppose that the descriptive power of music is sufficiently explained by saying that, although incapable of representing the subject of a feeling, it may represent the feeling itself—not the person who is loved, but the feeling "love." In reality, however, music can do neither. It cannot depict love but only an element of motion which may occur with love, or in any other feeling, but which is merely incidental to its character. Instrumental compositions cannot depict the ideas of love, anger, or fear, because there is no necessary connection between these ideas and beautiful combinations of sound. Which of the elements inherent in these ideas, then, does music know how to capture so effectively? Only the element of motion (in the wider sense, of course, according to which the

increasing and decreasing force of a single note or chord is also "motion"). This is the element which music has in common with our emotions and which it creativity investigates in a thousand variations and contrasts.

Many music lovers think it characteristic of only the older "classical" music to disregard emotion, and it is at once admitted that no feeling can be shown to form the subject of the forty-eight preludes and fugues of J. S. Bach's "well-tempered clavichord." It aims at nothing beyond itself, and interpretations of the kind mentioned would, in this case, present more obstacles than attractions—evidence that music need not *necessarily* awaken feelings or represent them. The whole domain of florid counterpoint would then have to be ignored. But if large departments of historic, aesthetically defensible art have to be passed over for the sake of a theory, then that theory is false. A single leak will sink a ship, but those who cannot wait can knock out the whole bottom.

Play the theme of a symphony by Mozart or Haydn, an adagio by Beethoven, a scherzo by Mendelssohn, one of Schumann's or Chopin's compositions for the piano, anything, in short, from the stock of our most sustaining music. Who would be bold enough to point out a definite feeling as the subject of any of these themes? One will say "love." Possibly. Another thinks it is "longing." Perhaps. A third feels "spirituality." No one can contradict him. And so on. Can we talk of a definite feeling being *represented*, when nobody really knows *what* is represented? To *represent* something is to clearly exhibit it; to distinctly show it. But how can we call *that* the subject *represented* by an art, which is really its vaguest and most indefinite element, eternally subject to debate?

Having absolutely denied the possibility of representing emotions by musical means, we must be still more emphatic in rejecting the opinion that renders it the *aesthetic principle* of music.

The beautiful in music would not depend on the accurate representation of feelings even if it were possible. Let us pretend, for a moment, that it is possible, and examine its practical implications.

Suppose there was a perfect alignment of the real and alleged power of music, that it was possible to represent feelings in music, and that these feelings were the subject of musical compositions. To be consistent, we would have to call those compositions the best which perform the task in the most perfect manner. Yet do we not all know compositions of exquisite beauty without any such subject? (For example, Bach's preludes and fugues.) On the other hand, there are vocal compositions which aim at the most accurate expression of certain emotions within the limits referred to, and for which this accuracy is the supreme principle. On close examination, the result is

that the rigorous fit of music to feelings in musical depiction is generally in an inverse ratio to the independent beauty of the music. So rhetorico-dramatical precision and musical perfection go together only halfway, and then proceed in different directions.

The recitative clearly shows this, because it is the kind of music that best accommodates itself to rhetorical requirements down to the very accent of each individual word, attempting to be nothing more than a faithful copy of rapidly changing states of mind. Therefore, it is the true embodiment of the theory before us, and it should be the most perfect music. But in the recitative, music degenerates into a mere servant and relinquishes its individual significance. Here is proof that the representing of definite states of mind is contrary to the nature of music, and that in the end they are antagonistic to one another. Play a long recitative, leaving out the words, and ask about its musical merit and meaning. Any music to which we solely ascribe this effect should be able to pass this test.

Dance is a similar case in point, as can be observed with any ballet. The more the graceful rhythm of its forms is sacrificed in the attempt to convey definite thoughts and emotions by means of gesture and mimicry, the closer it approximates the triviality of mere pantomime. The prominence given to the dramatic principle in the dance proportionately lessens its rhythmical, plastic beauty. Opera can never be quite on a level with recited drama or with purely instrumental music. A good opera composer will, therefore, constantly combine and reconcile the two factors, rather than a principled dominance of on one or the other at any moment. When in doubt, however, he will always allow the claim of music to prevail, because the primary element in the opera is music, not drama. This is evident from our different attitudes of mind when we attend a play or an opera in which the same subject is treated. The neglect of the musical part will always be far more keenly felt.

Notes

1. To show how deeply these doctrines have taken root, we will select some examples from their vast number. The following emanate from the pens both of old and modern writers on music:

Johann Mattheson: "When composing a melody, our chief aim should be to illustrate a certain emotion (if not more than one)." (*Vollkommener Capellmeister*, 143.)

J. G. Neidhardt: "The ultimate aim of music is to rouse all the passions by means of sound and rhythm, rivaling the most eloquent oration." (Preface to *Temperatur*.)

J. Mosel defines music as "the art of expressing certain emotions through the medium of systematically combined sounds" in *Versuch einer Aesthetik des dramatischen Tonsatzes*, 1813.

C. F. Michaelis: "Music . . . is the language of emotion," and so forth. (*Über den Geist der Tonkunst*, 2nd essay, 1800, 29.)

W. Heinse: "To picture, or rather to rouse the passions, is the chief and final aim of music." (*Musikal. Dialoge*, 1805, 30.)

J. J. Engel: "A symphony, a sonata, etc., must be the representation of some passion developed in a variety of forms." (*Über musik. Malerei*, 1780, 29.)

J. Ph. Kirnberger: "A melodious phrase (theme) is a phrase taken from the language of emotion. It induces in a sensitive listener the same state of mind which gave birth to it." (*Kunst des reinen Satzes*, Part II, 152.)

J. G. Sulzer: "While language expresses our feelings in words, music expresses them by sounds." (*Theorie der schönen Künste*.)

J. W. Boehm: "Not to the intellect do the sweet strains of music appeal, but to our emotional faculty only." (*Analyse des Schönen der Musik*, Vienna, 1830, 62.)

Gottfried Weber: "Music is the art of expressing emotions through the medium of sound." (*Theorie der Tonsetzkunst*, I [2nd ed.], 15.)

❧

The Expression of Emotion in Music*

Stephen Davies

The appearances that display emotion characteristics are not always human appearances. Basset hounds and Saint Bernards are sad-looking dogs. Presumably they do not feel sad more often than any other breed of dog. The sadness lies in their appearance and not in their feelings.

Dogs have their own, doggy ways of showing their feelings. Happy dogs wag their tails, try to lick their owners' faces, and so on; sad dogs tuck their tails between their legs, hang their heads, howl, and so forth. Though some people claim that dogs are capable of pretense with respect to their feelings, we generally seem to think that doggy behaviors almost always *express* the doggy feelings they display; we are inclined to take *appearances* of doggy feelings as always tied closely to expressions of doggy feelings.

The emotion characteristics we attribute to the appearances of dogs are not those of doggy, but of human, emotions. The relevant resemblance is between the facial features or comportment of the dog and the looks of sad

* Material reprinted from *Musical Meaning and Expression*, pp. 227–40 (Ithaca, NY: Cornell University Press, 1994). Copyright © 1994 by Cornell University Press. Used by permission of the publisher and the author.

people; in these cases we find a similarity with human, rather than with doggy, behaviors or physiognomy.

The appearances of inanimate or nonsentient things are also sometimes seen as presenting emotion characteristics. Weeping willows may be sad-looking, but not happy-looking, because their shapes are seen as resembling those of people who are downcast and burdened with sadness. Cars, viewed from the front, might be seen to bear some resemblance to the human face, with the headlights as the eyes, and so on. Depending on the disposition and shape of the grill, for instance, some cars are sad-looking while others are happy-looking (and many have expressionless faces). Where sadness is attributed to willows, cars, and the like, there can be no doubt that it is emotion characteristics that are involved, for there is no question of these trees and machines feeling the emotions presented in their appearances.

This is not to say that we set out deliberately to look for resemblances to humans, though we may do so. Rather, we find such resemblances sometimes forced to our attention. The disposition to find human appearances wherever possible seems inherent to our mode of experiencing the world rather than a point of view we might adopt solely at will.

I claim that the expressiveness of music consists in its presenting emotion characteristics in its appearance. Talk of musical sadness, say, involves a secondary, derivative use of the word "sad." It is a use established in ordinary, nonmusical contexts in which we attribute emotion characteristics to the appearances of people, or nonhuman animals, or inanimate objects. To that extent, the expressiveness attributed to music is not mysteriously confined to the musical case. Emotion characteristics in appearance are attributed without regard to the feelings or thoughts of that to which they are predicated. These properties are public in character and are grounded in public features. The sadness of music is a property of the sounds of the musical work. The expressive character of the music resides within its own nature.

The expressiveness of music depends mainly on a resemblance we perceive between the dynamic character of music and human movement, gait, bearing, or carriage.

Motion is heard in music, and that motion presents emotion characteristics much as do the movements giving a person her bearing or gait. That music is experienced as spatial and as involving motion is widely acknowledged. Many who think that music expresses emotion tend to locate the basis of its expressive power in its dynamic character.

In the paradigm (nonmusical) case, movement involves the passage of an individual through space and time. It presupposes (1) the existence of

an individual with an identity that persists through time and is independent of its location; (2) a set of coordinates relative to which the location of the individual can be measured—that is, motion is relational; and (3) changes in the location of the individual (or its parts) at different times. For example, the earth moves in its orbit about the sun.

The recognition of motion requires the ability to identify an individual that alters its location (in relation to the relevant coordinates) through time. Sounds and musical themes can be individuals of the appropriate sort and, accordingly, can be heard to be in motion. The brass band plays the overture from Bizet's *Carmen* as it marches by; the theme moves along with the musicians. However, we still have not captured the phenomenon discussions of musical movement attempt to describe.

Usually it is claimed that music unfolds within and through aural space. Aural space is not to be confused with real space; it has no location relative to the equator, for instance. Crucial to the experience of aural space is the recognition that notes at different, determinative pitches are high or low with respect to each other. I suppose that, if we did not experience octaves as recurring instances of the same individual, which instances are to be distinguished in terms of the individual's location in aural space, we would not be inclined to hear relations between notes at other intervals in spatial terms. Coordinates are established within aural space by the way we hear and individuate pitches.

That music is heard in spatial terms would appear to be more or less universal. What of movement within this space? Notes are heard not as isolated individuals but as elements in themes, chords, and the like. These higher units of organization involve motion that unfolds through time. There is movement (stepwise, not gliding) between the notes that constitute the theme. Rhythm, meter, and tempo generate the pace of this movement. The experience is not merely one of succession, but of connection.

If melody, rhythm, meter, and tempo generate the experience of motion across the surface of sound, simultaneity of sounds (harmony, polyphony, counterpoint) provides the dimension of depth or volume. Also important here is texture, which is as likely to be a matter of instrumentation as of voice-spacing and the number of notes per unit time. An orchestral unison has a depth and power a solo violin could not achieve. Register also seems relevant to musical depth. A trombone has more weight (inertia) of tone than a flute when the two play the same note at the same volume. Loudness or softness also can contribute a spatial effect, as can the character of the attack and decay of the note.

Our experience of movement in music no doubt depends to some extent on our associating the movements of the performer with the sound of the music. As Olga Meidner says, "Every performer uses his muscles and to some extent can be seen to do so. Thus even for listeners music is consciously associated with actual movement as well as evoking preconscious empathic and kinaesthetic perceptual impressions of movement" (1985, 351). Often the association seems far from arbitrary, in that qualities of the performer's gestures transfer directly to the sound of the tones she plays. Where notes are produced by blowing, striking, or scraping, the manner in which the instrument is approached directly affects audible properties of the tone played, such as its entry and decay.

But just as musical movement is heard as depending sometimes on the actions involved in performance, so too our descriptions of human actions depend sometimes on the movement we hear in music. We say of the pianist's hand that it moves *up* the keyboard to reach the higher notes, but no part of the keyboard is higher than another. Similarly, in moving *up* the fingerboard to reach the higher notes, the cellist's fingers move nearer to the ground; we locate the performer's body in such cases in aural space rather than in real space. Movement in music is not merely a matter of crude imitation or association; rather, we hear in music patterns of tension and release, and these resemble in their structure kinaesthetic aspects of movement as well as the teleological character that marks human action.[1]

It should come as no surprise, then, that we call the sections of symphonies, suites, and the like "movements." And that the general terms for loudness and softness are "volume" or "dynamics." And that music is described constantly in terms primarily used to denote space, movement, and action: abandoned, waltzing, singing, rushing, hesitant, vivacious, distant, multilayered, turgid, transparent, shallow, fast, slow, dragging.

Musical movement in aural space differs from the paradigm of movement introduced earlier in two respects (only the first of which usually attracts attention): (1) Nothing goes from place to place. The theme contains movement but does not itself move; the notes of the theme do not move, although movement is heard between them.[2] Following from this, (2) there is no independently identifiable individual that moves. As a way of acknowledging this departure from the paradigm case, musical space and movement are described as "ideal" or "virtual," or "metaphorical."

One might deal with the apparent discrepancy between musical movement and the paradigm in two ways. One might reject the differences as more apparent than real, arguing that musical space is heard as wedded to actual space and that the same physiological mechanisms operate in either case.

This is the line favored by Carroll Pratt (1931, 48–54), who suggests that notes of different pitches are heard as coming from different (real) spatial locations. These claims are criticized by Malcolm Budd (1983), and rightly so in my view. Alternatively, one might question the dominance and exclusive authenticity of the paradigm. This second course is the one I prefer. If many familiar kinds of movement do not involve change in location, the musical examples cease to be distinctive or puzzling and talk of motion, to the extent that it is ordinary, will involve moribund, rather than lively, metaphor in such cases; that is, musical motion will be neither unusual nor mysterious.

Time itself is frequently described in spatial terms: there is the flow of time; there is the passage of time; time unfolds. Sometimes alterations other than straightforwardly spatial ones are described as involving movement. For example, a river is in constant motion, though it does not move from place to place unless it shifts its banks. By contrast, the erosion of a mountain through time is not likely to be described as involving the motion of the mountain. What distinguishes the mountain from the river? The answer, I think, is that rivers, as opposed to mountains, are conceived of as processes. The river does not move but is constituted by the motion of the water it contains. In the case of a river, of course, something—droplets of water—does move from place to place. Not all processes are constituted by elements that have a location in space, however. There may be political moves toward war in the Middle East; the Dow Jones Index responds by dropping; as a result, the government lurches to the right; this causes my spirits to plunge; the peace movement attains new standing. In these cases, no identifiable individual changes its location in space and nothing moves from place to place. These all are cases of temporal process. They differ from the river in that neither they nor their constitutive elements exist in space.

I suggest that music is an art of temporal process. A theme is constituted by movement in the way that the progress of the Dow Jones Index is. The progress of the Dow Jones Index can be graphed, but the coordinates against which that movement is recorded are not in real space (even if the graphic representation is; compare this graphic representation with musical notation). The Dow Jones Index can be set against the New Zealand's Barclay's Index over the same period; many temporal processes are multistranded (compare this with harmony and polyphony). The use of terms of position and movement concerning music is perhaps secondary, but the same secondary use is common outside the musical context. Musical movement differs from the paradigm (spatial displacement) introduced above because the movement is that of a process in time, not because musical movement is aberrant or distinctive. In musical cases, one can deny the appropriateness

of such characterizations, or deny the objectivity of the phenomenon experienced, only by calling into question very widespread, mundane descriptions and experiences of nonmusical phenomena. Moreover, the description of music in such terms does not seem eliminable; I doubt that one can discuss tonality, or the closure at the end of a Beethoven symphony, say, without invoking notions of space or movement.

One feature of much musical movement has yet to be mentioned: Typically, the movement is not heard as random. Usually musical movement is heard as teleological, as organized around a target that exercises a "gravitational pull" on other notes. In tonal music, the target is the tonic. The tonic is heard as a point of repose. Notes other than the tonic are heard as drawn toward it, with the strength of the attraction depending on the place of the note in the scale, on its "distance" from the tonic. For example, in the major scale, melodically the leading note is the most strongly drawn to the tonic. Chords are comparatively tense or relaxed (discordant or concordant) in relation to the tonic chord; discords strain for resolution. As a result, the course of music, its motion, corresponds to an experience of increasing or diminishing tension, push and pull, pulse and decay, with closure achieved at the arrival of the final tonic. Music not only is experienced as involving motion relative to a framework of musical space, it is experienced as involving motion relative to a particular, pitched note (and its octaves, and a triadic chord with the tonic as its fundamental), and the progress of that motion is experienced as possessing a pattern of tension and relaxation. Tonality cannot be described without invoking spatial terminology.

Within any culture, the immediate experience of the tonality/modality of a piece, and consequently of the patterns of tension and release in connection with musical movement, depends on the listener's familiarity with the musical style in question. The expressive character of the piece is unlikely to be identified or experienced correctly by someone not conversant with the practice of the musical culture (or the style of the musical subculture) within which the piece finds it home. The point can be taken further: many musical factors other than tonality affect musical movement, as was noted earlier. One could not reasonably expect a person from a culture in which music is monodic or antiphonal to appreciate and understand polyphonic music. And one could not reasonably expect a person who belongs to a culture in which tonality and harmony perform important structural roles to recognize the cadential function served by gongs or drums in Javanese gamelan or Japanese Kabuki, for example.

If there is a natural element in scalar organization across the globe, it is one hedged about and transformed by arbitrarily cultural conventions. This

is consistent with the view that all musical cultures recognize (in their own music) the possibility of teleological movement. It is also consistent with the view that judgments about the teleology of musical movement are intersubjective, and not purely personal (private).

The discussion of the teleology of musical movement as a function of tonality/modality has led to questions about the character of atonal music. One might expect music that avoids tonality (as twelve-tone composition is often conceived as doing) to be experienced as generating random movement. If music takes its meaning from its structural integrity and expressive nature, and if these depend on the teleological character of musical movement, then atonal music might be thought to lack sense.

There is a basis, I think, for concerns of the kind mentioned here—some contemporary works seem to go nowhere and, once started, have no reason for ending when they do—but it is not obvious why whole schools, as opposed to particular works, should be condemned on this score (that is, this could be due to factors other than departure from tonality). The question is this: are there ways of organizing musical materials, other than traditionally tonal ones, that might be used to create musical structures that can be perceived to be coherent? The works of contemporary Western composers (as well as much non-Western music) suggests that there are. Twelve-tone technique is consistent, in fact, with near-tonal writing and has been used in this manner by Schönberg, Berg, and Stravinsky. Even if one abandons the major scale, it is possible to create tonal centers (no less transient than those in Wagner's music, for example) with motivically structured tone rows, as Anton Webern does. There are many ways other than restricting the number of available chromatic pitches to draw more attention to some notes than others, to establish nodal points of relative repose. Means other than scalar ones can create patterns of tension and release. Rhythm, instrumentation, dynamics, and register all have their part to play in shaping the progress of a musical work. Several writers suggest that the directionality of musical movement is not automatically abandoned when traditional (Western) tonal approaches are rejected.

My overall theory, then, is this: In the first and basic case, music is expressive by presenting not instances of emotions but emotion characteristics in appearances. Our experience of musical works and, in particular, of motion in music is like our experience of the kinds of behavior which, in human beings, gives rise to emotion characteristics in appearances. The analogy resides in the manner in which these things are experienced rather than being based on some inference attempting to establish a symbolic relation between particular parts of the music and particular bits of human behavior. Emotions are heard in music as belonging to it, just as appearances of emo-

tions are present in the bearing, gait, or deportment of our fellow humans and other creatures. The range of emotions music is heard as presenting in this manner is restricted, as is also true for human appearances, to those emotions or moods having characteristic behavioral expressions: music presents the outward features of sadness or happiness in general.

This theory has several advantages. It allows that expressiveness is a property of music that is always publicly evidenced and directly manifested. It involves an attribution of expressiveness that has a familiar use in nonmusical contexts. More than this, the theory accords quite neatly with our experience of musical expressiveness, since I take that experience to be one finding the expressiveness in the work and regarding that expressiveness usually as rather general in character.

Of course, many have argued that music is expressive because it is experienced as similar to human behavior and comportment. Typically though, such views hold that this resemblance grounds an inference to someone's felt emotion or felt mood. The position for which I have argued is distinguished by its explanation of how expressiveness resides in the appearance presented in the music, without any connection to [felt] emotions. In this view, emotion is immediately, not mediately, presented in music, just as it is in the sad-lookingness of the basset hound.

Notes

1. Minimalist composers such as Steve Reich and Philip Glass sometimes set up mesmerizingly static patterns in their music. Such pieces rely for their effects on the listener's awareness of the dynamic potential of music; they are written *against the background* of musical teleology.

2. Roger Scruton says, "We may find ourselves at a loss for an answer [to the question, What is this line that moves?]: for, literally speaking, nothing *does* move. There is one note, and then another; movement, however, demands *one* thing, which passes from place to place" (*The Aesthetics of Architecture* [London: Taylor & Francis, 1979], 81).

Works Cited

Budd, Malcolm. 1983. Motion and emotion in music: How music sounds. *British Journal of Aesthetics* 23: 209–21.

Callen, Donald. 1985. Moving to music—for better appreciation. *Journal of Aesthetic Education* 19: 37–50.

Meidner, Olga. 1985. Motion and e-motion in music. *British Journal of Aesthetics* 25: 349–56.

Pratt, Carroll C. 1931. *The meaning of music: A study in psychological aesthetics.* New York: McGraw-Hill.

Scruton, Roger. 1979. *The aesthetics of architecture.* London: Taylor & Francis.

⸏∞⸐

A New Romantic Theory of Expression*

Jenefer Robinson

If an artist expresses an emotion in a work of art, then

1. the work is evidence that a persona (which could but need not be the artist) is experiencing/has experienced this emotion;
2. the artist intentionally puts the evidence in the work and intends it to be perceived as evidence of the emotion in the persona;
3. the persona's emotion is perceptible in the character of the work;
4. the work articulates and individuates the persona's emotion; and
5. through the articulation and elucidation of the emotion in the work, both artist and audience can become clear about it and bring it to consciousness.

It is an activity of an artist that consists, roughly speaking, in the manifestation and elucidation of an emotional state of a persona. The person's or persona's emotional state is expressed in the character of the artwork, just as the expressive character of a person's face or gestures or tone of voice may express the emotional state of that person. The expression by an artist of an emotion in a work is an intentional act whereby the artist articulates and individuates the emotion expressed. But this analysis still leaves unanswered the question of how artistic expression is achieved, and in particular how emotions are "elucidated" and "individuated" in works of art.

"An emotion" is not a state or a disposition but a *process*, an interactive process or transaction between a person and an environment (which is often another person). As the process unfolds, the initial affective or emotional appraisal—*This is weird*, or *I like this*, or *This is threatening*—gives way to cognitive appraisals and reappraisals of the situation. In fear or anger I may assess my ability to control or to cope with the situation. At the same time, the initial affective or emotional appraisal produces in me certain physiological and motor responses, including facial and gestural expressions, which communicate to others and perhaps to myself how I have appraised the environment. The angry person frowns, tenses, and prepares in bodily ways for attack; the fearful person trembles, freezes, and then

* From *Deeper than Reason: Emotion and Its Role in Literature, Music, and. Art*, pp. 270–72, 274–79, 307–10, 325, and 332–37 (Oxford: Oxford University Press, 2005). Reprinted by permission of the publisher.

perhaps prepares for flight; the joyful person smiles, relaxes, and possibly skips or jumps for joy.

When the process is over, I may label it with one of the folk-psychological terms for emotions in my language: I say I was "angry," "sad," "delighted," or whatever. It is by using ordinary emotion words like these that we try to make sense of our emotional experiences in folk-psychological terms.

Another way in which we might try to make sense of our emotional experiences, however, is by "expressing" them in works of art.

In general, there are two interrelated ways in which a person's or persona's emotions can be expressed (individuated or articulated) in art. Broadly speaking, emotions in art can be expressed by focusing either on what happens to the person in the interaction or on what happens to the environment.

Focusing first on the environment, works of art that describe or represent the world, such as poems, paintings, and works of photography, are able to express an emotion by articulating the way the world appears to a person in that emotional state. As a result of an emotional interaction with the environment, the environment takes on a particular aspect: to the angry person the world seems to thwart and offend him; to the fearful person the world is threatening. To the sorrowful person the world is a drab and pointless place; to the person in the throes of happy love, the world looks good: a place of welcome, beauty, and manifold satisfactions. Secondly, if we focus on the person doing the expressing, such works of art can express an emotion by *articulating the thoughts, beliefs, points of view, desires, etc., of the person who seems to be expressing the emotion*. To the angry person the world is full of offences; to the fearful person the world is a threatening place. Since the emotional experience is the result of an interaction between person and environment, there is only a difference of emphasis between describing or representing the world from the point of view of an angry or fearful person and simply describing or representing the point of view itself, and/or the thoughts, wants, goals, and interests that shape the point of view.

In some artworks there are layers of personae, so that in novels, for example, (implied) authors can express their emotions and attitudes partly through the way they portray their narrator or narrators, partly through the way the narrators describe or depict the characters, and partly through self-expression on the part of the characters. In plays the expression of emotion by characters is usually the most salient kind of expression. Thus Shakespeare portrays King Lear on the heath powerfully expressing his rage and grief in a way that (1) provides evidence that he is "genuinely" expressing his own emotions; (2) is perceptible in the words he utters; (3) articulates and elucidates his emotion; and (4) enables the audience to

some extent to feel the emotion he is feeling and to reflect upon and get clear about this emotion.

Similarly, many paintings represent the expression of emotion in the sense that they depict people in the act of expressing their emotions. In painting, of course, characters do not express their emotions verbally but via their facial expressions, behavior, and actions or action tendencies. In the most expressive of such works, the way the artist depicts these things itself helps to articulate the emotions expressed by the "characters" in the painting, as when violent brushwork and lurid colors help to convey the characters' violent emotions. And at the same time, the way the painter depicts the characters also expresses something of his own attitude toward them (or that of his artistic persona).

Action painting takes this a step further. Even when no characters are depicted, as in the abstract drip paintings of Jackson Pollock, it is the very actions by which the paintings are made that express the artist's (or his persona's) emotions.

In this respect action painting is similar to dance. Dance can express the emotions of a persona by *enacting the gestures, behavior, facial expressions, action tendencies, and actions of a person who is in and manifesting a particular emotional state*. And a song can express emotions in two ways: as poetry it can articulate the thoughts and point of view of a persona—usually the "protagonist" of the song—who is in a particular emotional state, and as music it can enact the action tendencies, movements, and tone of voice of this persona.

The articulation and elucidation of an emotion in art is not an all-or-nothing affair. Some works of art articulate an emotion to some degree but not particularly vividly. An emotion can be more-or-less successfully "individuated." The examples I will focus on, however, are mostly paradigms of artistic expression. Notice that I am not trying to explain what makes these works *works of art* but what makes them *expressions*, a very different thing.

The Doggy Theory of Musical Expressiveness

The most widely accepted theory of musical expressiveness today is probably Peter Kivy's. Kivy argues that to hear music as expressive is in the first instance to anthropomorphize or "animate" the music: "we must hear an aural pattern as a vehicle of expression—an utterance or a gesture—before we can hear its expressiveness in it." Kivy takes as his chief exemplar of expressiveness the face of the St. Bernard dog in which, because of our tendency to animate our surroundings, we naturally see sadness, just as we naturally hear sadness in certain expressive "contours" in music. Kivy maintains that music can be expressive of an emotion without being an *expression* of anyone's

emotion, just as the St. Bernard's face is expressive of sadness without being an expression of its own sadness: he just happens to look that way. Music is expressive "in virtue of its resemblance to expressive human utterance and behavior."[1]

Sometimes music mimics expressive human *utterance*. Sometimes music mimics expressive human *gestures* and *bodily movements*. Kivy contrasts the "Pleni sunt Coeli" from Bach's Mass in B minor which is said to express "exuberant" or "leaping" joy with Handel's "I Know That My Redeemer Liveth" from *Messiah* to which he attributes a "confident but more subdued joy."[2] He ascribes the difference to the fact that the Bach passage "maps" bodily motion and gesture "of tremendous expansiveness, vigor, violent motion," whereas the Handel passage "suggests, rather, a dignified public declaration of faith: a speaker firm, confident, stepping forward, gesturing expressively, but with a certain circumspection."[3] In both cases what is "mapped" by the motion of the music are bodily gestures that in a human being would be expressive of the states indicated.

Not all expressiveness in music can be explained in terms of the resemblance between musical "contours" and expressive human speech and behavior. Kivy augments his account of musical expressiveness by allowing that some musical phrases, melodies, rhythms, and so on, are "a function, simply, of the customary associations of certain musical features with certain emotive ones, quite apart from any structural analogy between them."[4] Thus there is no resemblance between the minor key and a sad human voice or posture.

Kivy implicitly denies that there is any such thing as musical expression in the Romantic sense. In his view we call music "expressive" not because composers are expressing anything in it, but because listeners hear it as expressive: they "animate" or "anthropomorphize" what they hear. The composer's job is to provide musical gestures that can be readily animated in this way. But that is not normally what expressing an emotion means. Expressiveness is not primarily something perceived by perceivers. The only reason people perceive weeping as expressive of melancholy is that it is normally an expression (or, more correctly, a betrayal) of melancholy. Similarly, when a composer expresses some emotion in his music, it is primarily something that he does or that he makes it appear that he does. In this respect the doggy theory is profoundly misleading: the St. Bernard's expression simply doesn't play any comparable role in its psychology.

For Kivy expressiveness is a surface phenomenon, a matter of how something looks or sounds. But expression is not just a matter of appearances: a melancholy human face is perceived as such because it is usually the result of melancholy.

Stephen Davies develops a theory of musical expressiveness that is similar to Kivy's. Davies goes beyond Kivy in some important respects. In particular,

1. Davies stresses that musical movement, "like human action and behavior (and unlike random process) . . . displays order and purposiveness" and "provides a sense of unity and purpose."[5]

2. Perhaps for this reason, Davies is optimistic about the possibility of music's expressing cognitively complex emotions, such as "hope, embarrassment, puzzlement, annoyance, and envy." Davies thinks it might be possible for a piece of music to express hope, for example, if the emotion characteristics in a longish piece or passage of music were judiciously ordered. A natural progression of feelings might be conveyed by an appropriate sequence of emotional characteristics in appearances. "Thus the range of emotions that can be expressed in music . . . goes beyond the range of emotion-characteristics that can be worn by appearances."[6]

3. Davies attacks Kivy for insisting that music is never about anything and is therefore not about emotions. After all, the faces of basset hounds and St. Bernards do not mean anything. They are just God's gift to basset hounds and St. Bernards. However, composers intentionally choose "sounds with one expressive potential rather than another" and this suggests that "it is not inappropriate that we find significance in the appropriations that occur."[7] Composers have "much more to 'say' about emotions than those emotions have to 'say' about themselves under standard conditions."[8]

Much of what Davies wants to say about musical expression seems to me to be exactly right: (1) yes, music can convey "a pattern of feelings," and "a sense of order and purposiveness,"[9] not just particular feelings such as sadness and joy; (2) yes, music can express some cognitively complex emotions; (3) yes, music is sometimes about the emotions it expresses. Unfortunately, these conclusions are inconsistent with the doggy theory.

1. If musical expressiveness is solely a matter of emotion characteristics in appearances, then the only way in which it can convey "a pattern of feelings" is by presenting one emotion appearance after another, for example, gloom followed by joy followed by more gloom, and ending in tranquility. But a sequence of this sort hardly substantiates the claim that music conveys a sense of order and purposiveness, since there is no organic con-

nection between one state and the next, and so no *development* from one state to the next: the states are simply concatenated. This is insufficient to warrant talk of a teleological quality in musical expressiveness.

2. A similar problem besets the idea that emotion characteristics in appearances can convey cognitively complex emotions. Davies is claiming more than his view allows. Even if we grant that hope "naturally" occurs in a particular sequence of states (perhaps, sadness, anxiety, transient joy?), there will be no way to tell the difference between cheerfulness and hope if all we have to go by is a sequence of emotion characteristics in appearances. Hope requires the expression of desires and thoughts. Merely coming after sadness and before tranquility, for example, isn't enough to distinguish hope from transient joy.

3. I think Davies is right to say that music can be about emotions and that composers can "comment" on and "say" things about emotions in their works, but, again, Davies's theory does not allow him to say this. There is no way that emotion characteristics in appearances can say anything and even though a composer can arrange emotion characteristics in appearances in interesting sequences, that's all they are: interesting sequences. Without connections between one emotional state and another, nothing much can be "said."

In summary, there are several fundamental problems with the doggy theory.

Emotion as Process, Music as Process

If emotions are processes and if our emotional life occurs in streams, then it is reasonable to think that music, which is itself a process or a series of processes occurring in streams, would be peculiarly well suited to mimic or mirror emotions. How exactly does it do this? Clearly there are some aspects of emotion—facial expressions, hormonal secretions—that music would be hard put to reflect, but most of the important aspects of an emotion process can be mirrored by music.

The doggy theory suggests one way in which this might happen: music can mirror the vocal expressions and the motor activity—including expressive bodily gestures and action tendencies that characterize particular emotions. More significantly, music can mirror the cognitive or evaluative aspects of emotion. Most obviously, there are many ways in which music can mirror *desire*, aspiration, or striving. A theme may struggle to achieve resolution, fail, try again, fail again, try a third time, and finally achieve closure. Or one theme may gradually and with apparent difficulty transform into another

with a different character. Music can also mirror the effects of *memory*, as when a musical idea harks back to or seems to remember an earlier moment in the work.

In these ways the music is actually able to *articulate* a specific cognitively complex emotion by articulating desires, points of view, action tendencies, and so on in the musical persona.

I do not want to be committed to Edward Cone's view that all music should be experienced as an utterance by a persona in a work and hence potentially an expression of that persona in the full Romantic sense.[10] I would say that this is but one metaphor in terms of which we can construe music. Some music is best heard as dance music, other music as pictorial, other music again as primarily mathematical structure. Even among pieces that are reasonably construed as rhetorical utterances, there are many different kinds of utterance, such as orations, conversations, narratives, and dramas. Thus some Haydn string quartets can plausibly be heard as conversations among the players, while Beethoven's later symphonies are perhaps best construed as psychological dramas. Some music can be reasonably heard as belonging to more than one appropriate context. Hearing a piece of music in different contexts may reveal different aspects of the "expressive potential" of the piece. Thus the witty, conversational quality in Haydn's Opus 33 quartets can be best appreciated if the instruments are heard as characters in conversation. At the same time, the metaphor reaches only so far. Not every aspect of the work is rewardingly heard in terms of the conversation metaphor.

If we postulate a persona in music, we are in a position to say, as Davies is not, that pure instrumental music can be *about* the emotions it expresses. The composer, in creating the persona or personae or characters in the music is able to comment on their emotions and convey his attitudes toward them. So Brahms characterizes the dying woman in "Immer leiser" as suffering, yet as ultimately resigned to her fate. Moreover, to me at least, he seems to be commenting on more than just the situation of his character. He also seems to be expressing his own attitude to love and death. The transformation at the end is not just a shift in the *character's* perspective, but also a shift in Brahms's conception of life, love, and death: like much of Brahms's late music it has a certain serenity indicating perhaps that Brahms has accepted his fate and the loneliness at the heart of his life.

Finally, if there is a persona or set of characters in a piece of instrumental music, then a piece of "music alone" can be a genuine Romantic expression of emotion in a protagonist, just like a song, and not just a sequence of expressive contours. "Immer leiser" is a passionate utterance that expresses

the unfolding, ambiguous, shifting emotions of the dramatic protagonist, mirroring aspects of her emotion processes, evolving evaluations, thoughts, desires, and action tendencies, as well as the vocal and gestural expressions emphasized by the doggy theory. If there is a persona or character in a piece of Romantic instrumental music, then perhaps it too can express the emotions of that persona or character in just the same way.

The Persona under Attack

Several objections are commonly made to the idea that music—or some music—should be interpreted as the expression of emotion in a persona or characters. My own view is that some Romantic pieces of music should indeed be experienced as containing a persona whose unfolding emotional life is portrayed in the music. Important aspects of the work are likely to be inaccessible to listeners who do not listen in this fashion.

But are you actually hearing what is in the music? Davies objects that personae are not in the music in the way that melodies and harmonies are. They are imported from the outside. Critics who interpret music in terms of the expression of emotion by characters or personae in it are not emphasizing some interesting features that are really there in the music, although hitherto unnoticed; they are not talking about aspects *of the music* at all, but simply letting their imaginations run wild.

In some cases this charge is easily rebutted. Shostakovich plants his signature DSCH [the German transliteration of the initials "D. Sch."] all over the Tenth Symphony, so it is hardly far-fetched to imply an autobiographical intention. But what of other music in which there is no explicit evidence that the composer meant his music to contain characters or a persona? Davies says: "It seems straightforwardly false" that there are "practices or conventions calling on the listener to hypothesize a persona in the music."[11] It follows that there is no reason to think that composers should be understood as having intended to invoke such practices and conventions. I question this conclusion.

There is as a matter of fact a long tradition in Western music of populating music with characters. Much Baroque music was based on dance forms, and it is natural to hear such music as the movements performed by some person or character who is dancing to the music. Even in Kivy's favorite example of "music alone," the fugue, the different strands of the fugue are often described as voices or as characters. C. P. E. Bach wrote a set of descriptive pieces for keyboard called "Character Pieces," illustrating the indecisive person, the complacent person, and so on. In the Romantic period, where the idea of art as expression gained widespread currency, and which also saw the invention of the tone poem and of elaborate forms of programme music, it

was natural for composers to think of their music as utterances by characters or personae in the music. Today, Elliott Carter is but one notable example of a composer who thinks of his main musical ideas as characters and thinks of their development as the development of characters.

The Romantics, however, gave a special twist to the tradition of characters in music: they put *themselves* into their music as characters or personae. In programmatic works such as the *Symphonie Fantastique*, this is quite explicit, and it is almost as explicit in Shostakovich with his signature DSCH. Not all Romantic composers wear their hearts on their sleeves to this extent, however. Brahms is a far more reticent, introspective composer, at least in his later works. Nevertheless, it is perfectly consistent with the Romantic aesthetic that he should conceive of an Intermezzo as dramatizing a psychological or emotional conflict that could well have been a conflict in his own psyche, and as expressing conflicting emotions that could well have been his own.

In view of this long tradition of hearing characters in music and in view of the Romantic aesthetic of self-expression in music, it is eminently reasonable to interpret at least some Romantic instrumental music as expressions of emotions in characters or personae in the music.

Davies's second main objection is that interpretations in terms of narratives or dramas containing characters or personae are too idiosyncratic to count as interpretations *of the music* rather than fanciful free associations to it. Now, it is true that music is not constrained to the same degree that poetry is, but music has an "expressive potential" realized in different ways in different contexts that nevertheless sets broad limits on the kinds of emotional narrative or drama that the music can exemplify and the kinds of emotional process that the music can express.

I conclude that although music permits a wider variety of appropriate interpretations than literature does, since the expressive potential of a piece allows for diverse interpretations, nevertheless there are constraints on these kinds of interpretations. In addition to the general ones—they should be consistent with what is known about the author's compositional practices, and they should account for as much of the work as possible in a consistent way—there are constraints imposed by the expressive potential of the music. Not every reading is equally appropriate. Some are more idiosyncratic and indefensible than others.

Notes

1. Peter Kivy, *The Corded Shell: Reflections on Musical Expression* (Princeton, NJ: Princeton University Press, 1980), 59.

2. Kivy, *The Corded Shell*, 53.

3. Kivy, *The Corded Shell*, 54.

4. Kivy, *The Corded Shell*, 77.

5. Stephen Davies, *Musical Meaning and Expression* (Ithaca, NY: Cornell University Press, 1994), 229.

6. Davies, *Musical Meaning*, 262.

7. Davies, *Musical Meaning*, 265.

8. Davies, *Musical Meaning*, 273.

9. Davies, *Musical Meaning*, 229.

10. Edward T. Cone, *The Composer's Voice* (Berkeley: University of California Press, 1974).

11. Stephen Davies, "Contra the Hypothetical Persona in Music," in *Emotion and the Arts*, ed. Mette Hjort and Sue Laver, 95–109 (Oxford: Oxford University Press, 1997), 101.

Further Reading

Budd, Malcolm. 1992. *Music and the emotions: The philosophical theories.* New York: Routledge. Overview of seven major accounts of emotions in music.

Davies, Stephen. 1997. Contra the hypothetical persona in music. In *Emotion and the arts*, edited by Mette Hjort and Sue Laver, 95–109. Oxford: Oxford University Press. A critique of the persona view.

Kivy, Peter. 1980. *The corded shell.* Princeton, NJ: Princeton University Press. A well-known defense of expressiveness as phenomenal appearance.

———. 2009. *Antithetical arts: On the ancient quarrel between literature and music.* Oxford: Oxford University Press. Contains a discussion of Hanslick and an extended critique of the persona view.

Levinson, Jerrold. 1996. *The pleasures of aesthetics.* Ithaca, NY: Cornell University Press, 90–125. Overview of the debate about musical expression and a defense of the persona view.

Robinson, Jenefer, and Gregory Karl. 1995. Shostakovitch's Tenth Symphony and the musical expression of cognitively complex emotions. *Journal of Aesthetics and Art Criticism* 53: 401–15. An attempt to show that music can express complex emotion when conceived as the expression of a musical persona.

Zangwill, Nick. 2004. Against emotion: Hanslick was right about music. *British Journal of Aesthetics* 44: 29–43. Identifies Hanslick's central arguments and argues that his position is essentially correct.

~

Artistic Value

Introduction

Ingmar Bergman, one of the great directors of the twentieth century, made movies over four decades from 1941 to 1981. Most were produced on the same island off the Swedish coast where Bergman set up a studio. Visually, the movies are sometimes starkly beautiful, sometimes grotesque, and sometimes surreal. Though he made comedies (*Smiles of a Summer's Night* and a film version of Mozart's *Magic Flute* being the greatest), he was drawn to serious themes: faith and doubt, death, insanity, loneliness, memory, and the nature of personal relationships, especially the destructiveness within them. Among his earliest great successes is *The Seventh Seal*, about a knight who returns from the crusades to find a plague-ravaged homeland. The movie is about a journey. The knight wants to return to his castle and rejoin his wife. The world through which he makes his way is bleak, violent, and full of death. In fact he meets the personification of death during this journey and, to save himself, challenges Death to a game of chess. The match between the knight and Death is one of the movie's great motifs. But so is a subplot about the knight's squire. While the knight struggles with a crisis of faith, the squire has lost all religious belief. Yet, it is the squire who answers what viewers might consider a knight's calling, saving a mute girl from rape, for example. Eventually the knight and the squire acquire an entourage—the mute girl, a troop of actors—as they journey toward the castle, staving off Death with the game of chess. When the knight finally reaches his castle, he loses the game: he fails to save himself and his household, but by distracting

Death, he manages to save the troop of actors. Death, too, then acts out of character, giving the knight one night with his wife. The movie ends with one of its great scenes: the actors witness Death leading the knight and his household in a dance, the dance of death, which is not nearly as grim as the preceding journey. It is almost joyous.

Arguably, *The Seventh Seal* is among the great works of cinematic art. What makes this so? Why is it valuable as art? It is certainly aesthetically impressive, with some stunningly beautiful scenes. Its plot involves fascinating inversions: in the roles of knight and squire; in the outcome of the chess game that the knight initiates to save himself but ultimately uses to save the actors; in unrelenting Death's relenting, at least temporarily; in the perception of death, the life ending event dreaded for most of the movie but not so dreadful by the end.

The movie explores important issues. For example, the journey constantly raises questions about what makes life valuable and explores many answers: religious faith, simple pleasures (at a wonderful picnic the entourage eats a meal of milk and strawberries), marital bliss, compassion for others. The film may suggest that some of these answers hold up better than others.

It is also sometimes puzzling and invites multiple interpretations. What is its attitude to religious faith, to death, and to the meaning of life? Is the film an allegory, a picaresque tale, a tragedy or comedy, an amalgam of genres?

It also marks an important moment, perhaps an important era, in the history of cinema. Bergman's work exemplifies a period when much of the creative energy in filmmaking is shifting from corporate studios to more independent filmmakers who write and direct their movies.

So, the film is aesthetically and cognitively valuable, intellectually challenging, and art historically important. Most would not deny any of these claims, but they would disagree about which of them is relevant to the film's value as art and about the nature of this value.

This chapter's readings explore this very issue. According to Malcolm Budd, we can evaluate a work such as *The Seventh Seal* from many points of view indicative of the many kinds of value it can possess: "a cognitive value, a social value, an educational value, a historical value, a sentimental value, a religious value, an economic value, a therapeutic value." Budd wants to distinguish all of the values just mentioned from its value as a work of art. The artistic value of a work is the value of the experience it offers to those who understand it. Thus Budd characterizes artistic value in terms of an experience a work is capable of providing and distinguishes this value from such others as a work's cognitive value, historical value, and therapeutic value. Although Budd does not use the word "aesthetic" in characterizing

the relevant experience, it is natural to think of Budd's view as identifying artistic and aesthetic value, a supposition reinforced by Budd's explication of what understanding an artwork entails. To understand an artwork, ones experience "must be imbued with an awareness of . . . the aesthetically relevant properties of the work." At the same time, Budd recognizes that other philosophers who have held a view similar to his have rendered their position implausible by offering a very narrow characterization of aesthetic experience. For example, some restrict aesthetic experience to experience of a work's formal properties. To counteract this tendency, Budd wants to define the experience of a work of art as broadly as possible. This, however, creates a different kind of problem—that of seeming to let in through the back door some of those values he so sharply distinguishes from artistic value. "The experience a work of art offers can involve the invigoration of one's consciousness, or a refined awareness of human psychology or political or social structures, or moral insight." Why should we value a work for invigorating our consciousness if not for the therapeutic value this provides? Why should we value a work's moral insight if not for the cognitive value this provides? So, the fine line that views like Budd's must thread is not to be overly narrow on the one hand but, on the other, to remain purely experiential.

Noël Carroll is critical of identifying the artistic with the aesthetic. He does not wish to exclude aesthetic experience of course, but he argues that many nonaesthetic responses are equally characteristic of, and central to, our response to art. In the essay reprinted here, he emphasizes three types of response. One type treats a work as an interpretive puzzle and focuses on discovering hidden meanings and resolving ambiguities. Another related kind of interpretive response identifies structural and formal features and asks what purpose they serve in the work. Recall that we found a whole series of inversions in *The Seventh Seal*, which raises the question of what purpose they serve in the movie. Noticing the inversions may be part of the aesthetic response, but figuring out why they are there takes us beyond that response. Finally, Carroll points out that we take an interest in situating a work within a tradition or history, that is, in discovering how it relates to other artworks that are its contemporaries and predecessors.

Although Carroll does not discuss the issue of artistic value per se, he certainly believes that the various nonaesthetic responses to art that he discusses typify the way we appreciate and value artworks. This strongly suggests that Carroll would claim that some of the nonaesthetic ways that we value a work like *The Seventh Seal* are a proper part of its artistic value, and these include its art historical and intellectual value in providing interpretive puzzles. This runs counter to Budd's exclusion of such values. On the other

hand, in exploring our nonaesthetic responses to art, Carroll can be read as broadening our notion of what is involved in the experience of a work of art. Such a broadening might actually help to support Budd's proposal. We leave it to the reader to decide whether Carroll's argument does more to undermine or support Budd's view.

Unlike Carroll, James Shelley has no problem identifying artistic value with aesthetic value. What he objects to is the idea that aesthetic value is the value of the experience something provides, a view he calls aesthetic empiricism. Shelley argues that an empiricist about artistic value either has no coherent account of the value of aesthetic experience or, to provide such an account, must abandon other claims they make that are crucial to their understanding of the value of art. Hence, Shelley offers a critique of the view Budd proposes from a direction completely different from that derived from Carroll's essay.

Aesthetic Judgment, Principles, and Properties*

Malcolm Budd

Artistic and Nonartistic Values

The central question in the philosophy of art is, What is the value of art? Philosophical reflection on art would be idle unless art were valuable to us, and the significance of any question that arises in philosophical reflection on art derives directly or ultimately from the light that its answer throws upon the value of art. If we construe art as the totality of works of art, the value of art is the sum of the individual values of these various works of art. What, then, is the value of a work of art?

However, it would be premature to attempt to answer this question as it stands, because its meaning is indeterminate. Whatever can be evaluated, can be evaluated from different points of view, and corresponding to the point of view from which it is assessed, the value attributed to it will be of a different kind. A work of art can have many different kinds of value—a cognitive value, a social value, an educational value, a historical value, a sentimental value, a religious value, an economic value, a therapeutic value; it can possess as many kinds of value as there are points of view from which it can be evaluated. What an artist tries to do is to create a product with a distinctive kind of value. She attempts to make something that is valuable *as art*, or, more specifically, *as art of such-and-such a kind*. I shall call this value

* From *Values of Art*, pp. 1–43 (London: Penguin Press, 1995). Reprinted by permission of the publisher.

"artistic value" or "the value of a work of art *as a work of art*." The prime task of a theory of value in art is to elucidate the distinctive value of art.

It will be as well to deal at once with an objection that is likely to be brought against this idea of the value of a work of art as a work of art. The objection is aimed at the implication that the value is unitary, and it exists in two related forms. The first maintains that it is necessary to give an irreducibly disjunctive account of value *across* the arts, because for each art form—music, painting, sculpture, architecture, literature, dance—there is a distinct kind of value. There is no overarching value that unifies this set of values. The second version presses the point further by claiming that it is necessary to give an irreducibly disjunctive account of value *within* each art, since each art form admits works of art of different natures and aims and these various kinds of work have values specific to them. So within the art of music, there is the value of a song as a song, the value of a symphony as a symphony, and so on.

Neither form of the objection is persuasive, and each is open to the same response. It is true that the features of a work of art that make it good as music are different from those that make a work good as literature, that what makes a painting a fine landscape is not what is responsible for the value of a painting of the Annunciation. There are different varieties of artistic value. But this shows only that artistic value can be realized in many different ways, not that it lacks an essence.

Given what has happened to the concept of art, especially in this century, an account of artistic value cannot be extracted from the present concept of art. Instead, I specify a distinctive value—a value that works of art can possess, and which is possessed to a high degree by all great works of art; I then count an evaluation of a work of art as an evaluation of it *as art* insofar as the work is being evaluated with respect to the distinctive value I have specified. My answer to the question will demonstrate the unity of the concept of artistic value, or, more accurately, will give unity to it.

Intrinsic and Instrumental Values

A perspicuous elucidation of the concept of artistic value is possible in terms of what I shall call "the experience a work of art offers." Although what is involved in understanding a work of art varies, it is definitive of a work of art that it can be understood. I mean by "the experience a work of art offers" an experience of the work in which it is understood. So the experience a work offers is an experience of interacting with it in whatever way it demands if it is to be understood. For you to experience a work with (full) understanding, your experience must be imbued with an awareness of (all) the aesthetically

relevant properties of the work—the properties that ground the attribution of artistic value. The experience a work of art offers is an experience *of* the work itself. It does not have a nature specifiable independently of the nature of the work. It is also not any person's actual experience, but a type.

My claim is that the value of a work of art as art is intrinsic to the work in the sense that it is (determined by) the intrinsic value of the experience the work offers. It should be remembered that the experience a work of art offers is an experience *of the work itself,* and the valuable qualities of a work are qualities *of the work,* not of the experience it offers. It is the nature of the work that endows the work with whatever artistic value it possesses; this nature is what is experienced. The work's artistic value is the intrinsic value of this experience.

By the intrinsic value of an item I do not mean a value that depends solely on the intrinsic nature of the item—a value that depends solely on its internal properties as contrasted with an extrinsic value—a value that depends, wholly or in part, on its relations to other things. My conception of intrinsic value opposes it, not to extrinsic value, but to instrumental value. By the instrumental value of a work of art I mean the value of the actual effects of the experience of the work on people or the effects that would be produced if people were to experience the work. My claim therefore implies that the instrumental value of a work of art, its beneficial or harmful effects, is not the value of the work of art as a work of art.

If a work possesses artistic value, this does not consist in the work's actually accomplishing some valuable end or in the fact that it would, if experienced with understanding, accomplish such an end. This is easy to see, for what is achieved by experiencing a work of art depends not only on the experience that its appreciation yields but also on the character, attitude and will of any person who experiences it. There is only a personal answer to the question whether the appreciation of a work of art kindles or dampens a desire to enhance the lives of other people, whether it is a stimulus to, or a safety-valve which prevents, immoral action, or whether it infects with, or inoculates against, a mood of despair. The influence of a work of art is not like the operation of certain drugs which, independently of the subject's attitude, character and will, produce their distinctive effects regardless.

It counts in favor of the identification I propose that there is a conspicuous mismatch between our opinions about the artistic value of a work and our opinions about the instrumental value of the experience it offers. The fact is that most of us, perhaps all of us, know very little about the beneficial or harmful effects of the experience of a particular work of art on particular people or people in general.

There are two further considerations that should facilitate acceptance of my claim about artistic value. The first is that many of what are thought of as benefits of the experience of art are intrinsic to the experience, not merely products of it. The experience a work of art offers can involve the invigoration of one's consciousness, or a refined awareness of human psychology or political or social structures, or moral insight, or an imaginative identification with a sympathetic form of life or point of view that is not one's own. But since such benefits are aspects, not consequences, of the experience the work offers, the irrelevance of the actual effects of the experience to the work's artistic value does not imply the irrelevance of these kinds of benefits. On the contrary, such benefits contribute to making the experience intrinsically valuable and partly constitute the ways in which it is so.

The second consideration is that an experience can be *such as* to be conducive to a beneficial effect on people—people who are concerned to profit from the work that affords the experience. This is what Yvor Winters had in mind when thinking of poetry as a moral discipline:

> Poetry . . . should offer a means of enriching one's awareness of human experience and so of rendering greater the possibility of intelligence in the course of future action; and it should offer likewise a means of inducing certain more or less constant habits of feeling, which should render greater the possibility of one's acting, in a future situation, in accordance with the findings of one's improved intelligence. It should, in other words, increase the intelligence and strengthen the moral temper; these effects should naturally be carried over into action, if, through constant discipline, they are made permanent acquisitions.[1]

Although the appreciation of poetry does not automatically result in improvements of the kind Winters indicates, the nature of fine poetry is such as to help to induce them in those who apply themselves in the manner he advocates.

Aestheticism

It would be a misunderstanding of my account of artistic value to object to the implied downgrading of the instrumental value of the experience of a work of art. For my identification of the artistic value of a work of art with the intrinsic value of the experience it offers carries no such implication. I have made no claim about the comparative ranking of different kinds of value. Measured by a certain yardstick (a moral yardstick, for example), the value of a work of art as a work of art will not be the most important kind of value that a work of art can possess. But the issue of the identification

of artistic value is, What is artistic value? [and] not, What is the worth of
artistic value?

There is a further misunderstanding to which my account of artistic value
is liable as an unacceptable form of aestheticism. The charge of aestheticism
is likely to arise if it is thought that the identification of a work's artistic
value with the intrinsic value of the experience the work offers is tantamount
to the doctrine of "Art for Art's Sake." But this doctrine is strikingly equivo-
cal: many different views have sought shelter under its banner, and the force
of the charge varies accordingly. Here it will be sufficient to dissociate my
account from four dogmas.

The first dogma is the existence of a specifically aesthetic emotion, which
it is the artistic function of art to arouse. But it is clear that this does not
follow from my claim about artistic value; and the emotion it posits is only a
myth. The second is the irrelevance of a work's subject-matter to its artistic
value. According to this doctrine, it does not matter what a work represents,
only how it represents it. This doctrine [is] not implied by the conception of
a work's artistic value as the intrinsic value of the experience it offers. The
third dogma is the requirement that the spectator's response to a work of art
should be disconnected from her attitude to the moral or other evaluative
point of view that the work expresses. But it is not necessary to accept the
theory of a work of art as a world, to be experienced and valued indepen-
dently of one's own beliefs and values, and only in terms of whether it creates
a coherent and satisfying world of its own. The final dogma is the complete
lack of determination of a work's artistic value by any values that are not
specifically artistic or aesthetic values. But the claim that a work's artistic
value is determined by the intrinsic value of the experience it offers does not
imply that its artistic value is independent of any values it may possess that
are not art-specific or specifically aesthetic. The truth is that artistic value
does not exist in a watertight compartment impermeable by other values;
on the contrary, other values can be determinants of artistic value, as when
a novel's value is a function of its intelligence, wit, imagination, knowledge
and understanding of human life.

Art and Communication

I now need to refine the idea of assessing the intrinsic value of the experi-
ence offered by a work of art. In undergoing such an experience either you
find it in some way rewarding or you do not. Only if you find it in some way
rewarding do you have reason to consider the experience intrinsically valu-
able. But the reward given by the experience can be related to the experience
in two different ways. On the one hand, it can be such that in principle it
is possible to obtain that reward without undergoing the experience of the

work. On the other hand, undergoing the experience of the work is partly constitutive of the reward. In a case of the first kind, it is not essential to the reward given by the experience that you should undergo the experience. If the experience is valuable to you only for this detachable reward, you are not finding the work valuable *as a work of art.* You are valuing the work as you value a drug, for the effect it produces. For you to find a work valuable as a work of art, your experience must not consist of two separable components, the intrinsically rewarding component being a mere effect of an intrinsically unrewarding component—the experience of the work itself.

This conclusion receives clarification and support from a consideration of the doctrine that art is essentially a form of communication. To obtain a coherent form of the doctrine it is necessary to understand the concept of communication in its usual sense, as in the conveyance of information from one person to another. Suppose I have received a letter from a friend in which she communicates her thoughts. Here we shall distinguish the vehicle of communication from the "message" communicated. If the message had been communicated by means of speech, semaphore or Morse code, for example, a different vehicle would have been used to communicate the same message. This distinction between vehicle and message can be drawn in all cases of communication, no matter whether the message—what is communicated—is a thought, an emotion, an attitude, or an experience.

The relevance of this distinction to the doctrine that art is essentially a form of communication emerges at once if this doctrine is understood as a thesis about the value of art, to the effect that when we value a work as a work of art, (1) it communicates something to us, (2) we value it only because it communicates this to us, and (3) we value it to the degree that we value what it communicates. But it is clear that this conception of the value of art misrepresents our attachment to works of art. The distinction between vehicle and message means that for any message there are in principle many vehicles capable of communicating that message. So this conception of artistic value implies, first, that we must assign the same artistic value to anything else that communicates exactly the same message as the one communicated by a work we value, and, second, that from the point of view of our interest in art, for any work of art we must be indifferent between experiencing it or something else that communicates the same message. Yet neither implication is correct. If our sole reason for valuing a work of art is that it communicates a particular message, so that the manner in which the message is communicated does not matter to us, our attachment to the work is wrongly described as our valuing it *as* a work of art. The moral is clear: the communication conception of artistic value misrepresents the importance of the experience of the work, crediting it only with an instrumental role in the

production of what is valuable in the experience of art, rather than locating the reward in the experience itself.

It is, of course, true that what a work of art communicates can be *integral* to its value as a work of art, for it may be integral to the experience the work offers. But it is the message *as communicated by the work*, the message *as realized in the experience of the work*, that determines the work's artistic value, not the message itself.

Intersubjectivity, Criticism, Understanding, and Incommensurability

What kind of property is artistic value? In the first place, although it is not a genuinely absolute value, it is not relative in any disturbing way. For instance, it does not have the kind or degree of relativity that attaches to sentimental value, which is relative both to persons and times. Objects do not in themselves possess sentimental values, but are valued by some, but not other, people on account of what they remind them of. In contrast with this, a sentence ascribing artistic value to a work does not indicate a relation between a certain person and the work. But artistic value resembles sentimental value in being a sentiment-dependent property. A sentiment-dependent property has to be explicated in terms of an affective response to the object in which the value is found. Given that the notion of a sentiment covers all the ways in which something can be found intrinsically rewarding, artistic value is a sentiment-dependent property.

But the fact that artistic value is a sentiment-dependent property does not imply that it is a "merely" subjective property; for the instantiation of the property is independent of any individual's reaction to the work. It is integral to our concept of artistic value that nobody is immune to error about a work's artistic value. On the contrary, the concept of justifiability intrinsic to the concept of artistic value introduces the ideas of appropriateness and inappropriateness into our understanding of a person's response to a work of art, and renders the value intersubjective by admitting the possibility of well-founded approval or criticism of a person's assessment of the artistic value of a work.

I have claimed that you attribute artistic value to a work insofar as and to the degree that you regard the experience it offers as being intrinsically valuable. An experience merits such a response if there is good reason to find it intrinsically rewarding. My account of artistic value therefore has built into it a normative dimension. Unless your response to a work is defensible by reference to features of the work that must be appreciated if the work is to be understood—features of the work that are open to others, that endow it with value, and that constitute good reasons for responding as you do—your response lacks any right to be thought of as indicative of the work's artistic value.

This is reflected in the distinctive practice, thoughts, and feelings of those who evaluate works of art as art. For reflection on a work's artistic value has a twofold aim: to grasp the meaning of the work and so to appreciate it for what it is worth. This involves an attempt to characterize the work in such a manner as to warrant or mandate a certain kind of response. The primary concern of criticism is the attempt to describe works of art in ways which justify our responses to them. Criticism seeks to establish the correct understanding of a work, to articulate its distinctive merits and defects, and so to assess its artistic value. This involves encouraging a certain way of experiencing the work: criticism's claim is that the work should be experienced in accordance with the offered interpretation, which discloses the work's true aesthetic qualities. Now a work's artistic value is dependent on its aesthetic qualities, which in turn are dependent on its nonaesthetic features.[2]

Any work of art can be experienced in many ways, but only an experience in which the work is understood is relevant to the work's artistic value. But it does not follow that there is only one possible evaluation of a work that is compatible with understanding it correctly and completely. In the first place, I have not claimed that there is only one understanding of a work that is both correct and complete.[3] If there is more than one such interpretation then there will be room for more than one evaluation that is not rendered null by lack of understanding. Secondly, even if there is only one correct and complete understanding of a work, it does not follow from the fact that lack of understanding undermines the authority of an evaluation that understanding guarantees its unique validity. Three additional premises are needed to reach this conclusion. The first is that the evaluation of works of art admits the concept of correctness. The second is that there is only one evaluation of a work that is correct. The third is that correctness of understanding ensures correctness of evaluation. While the first of these is certainly consonant with our practice of evaluating works of art, the second is contentious and the third implausible.

It should not be expected that criticism, perfectly carried out, will always result in a single, definitive evaluation of a work. This would only be so if, for each pair of incompatible qualities, one being an aesthetic merit and the other a demerit, the following were true: if a particular work can be experienced as possessing one member of the pair and can also be experienced as possessing the other member of the pair, then for at least one of these qualities it must be incorrect to experience the work as possessing that quality. But this is not always the case.[4] When it is not true, the work's nature and artistic value are indefinite. In such a case we must confine the demand for unanimous assent by relativizing the judgment to the work as *experienced* as *possessing one of the qualities*.

Indefiniteness also enters judgments of artistic value in another way. For an important feature of artistic value is its incommensurability. Artistic value is not a measurable quantity. This implies that when one work is better than another, there is no precise amount by which it is better. It also implies that issues of comparative artistic value are sometimes indeterminate: in some cases, it is neither true that one of the works is better than the other, nor that they are precisely equal in value. One reason why artistic value is incommensurable is that there are different kinds of qualities that can endow a work with value and there is no common unit in terms of which their contributions to a work's artistic value can be measured.

In sum: artistic value is intrinsic, sentiment-dependent, intersubjective, anthropocentric and incommensurable.

Notes

1. Yvor Winters, In Defense of Reason (London: Routledge & Kegan Paul, 1960), 28–9.

2. For a penetrating account of the relation between aesthetic qualities and nonaesthetic features, see Frank Sibley, "Aesthetic Concepts," Philosophical Review 68 (1959),421–50, and Frank Sibley, "Aesthetic and Non-Aesthetic," Philosophical Review 74 (1965), 135–59.

3. For an excellent defense of the uniqueness claim and an analysis of the idea of a work's canonical interpretation, see Anthony Savile, The Test of Time (Oxford: Clarendon Press, 1982), ch. 4., 60–85.

4. This has been emphasized by R. K. Elliott, especially in "The Critic and the Lover of Art," in Linguistic Analysis and Phenomenology, ed. Wolfe Mays and S. C. Brown, 117–27 (London: Macmillan, 1972).

ᑫᗄᑐᕀ

Art and Interaction*

Noël Carroll

Ideas of the aesthetic figure largely in two crucial areas of debate in the philosophy of art. On the one hand, the aesthetic often plays a definitive role in characterizations of our responses to or interactions with artworks. That is, what is thought to be distinctive about our commerce with artworks is that these encounters are marked by aesthetic experiences, aesthetic judgments, aesthetic perceptions. Furthermore, the use of aesthetic terminology in such accounts of our interactions with artworks is, most essentially, "experiential"

* "Art and Interaction," Journal of Aesthetics and Art Criticism 45:1 (1986): 57–68. Copyright © 1986 The American Society for Aesthetics. Reprinted by permission of Blackwell Publishing Ltd.

or "perceptual" where those terms are generally understood by contrast to responses mediated by the application of concepts or reasoning.

Secondly, notions of the aesthetic are also mobilized in theories of the nature of art objects; the artwork, it is claimed, is an artifact designed to bring about aesthetic experiences. Thus, these two claims—that aesthetic responses distinguish our responses to art, and that art objects can be defined in terms of the aesthetic—though ostensibly independent, can, nevertheless, be connected by means of a neat, commonsensical approach that holds that what an object is can be captured through an account of its function. The art object is something designed to provoke a certain form of response, a certain type of interaction. The canonical interaction with art involves the aesthetic. So the artwork is an object designed with the function of engendering aesthetic experiences, perceptions, attitudes, and so forth.

The purpose of this paper is to dispute both the thesis that aesthetic responses are definitive of our responses to artworks and the thesis that art is to be characterized exclusively in terms of the promotion of aesthetic responses. It will be argued against the first thesis that many of our entrenched forms of interaction with artworks—what may be neutrally designated as our art responses—are not aesthetic in nature, nor are they reducible to aesthetic responses. The argument here proceeds by enumerating and describing several of our nonaesthetic though eminently characteristic responses to art objects. Along with doing things like attending to the *brittleness* of a piece of choreography—a paradigmatic aesthetic response—we also contemplate artworks with an eye to discerning latent meanings and structures, and to determining the significance of an artwork in its art historical context. These art responses, often interpretive in nature, are as central as, and certainly no less privileged than, aesthetic responses in regard to our interactions with artworks. Moreover, if an expanded view of the art response is defensible, then our concept of art, especially when construed functionally, must be broadened to countenance as art objects that are designed to promote characteristically appropriate art responses distinct from aesthetic responses.

The delimitation of the relevant art experience to the aesthetic experience—the maneuver that gives the aesthetic theory of art much of its exclusionary thrust—appears to me to be a liability. The aesthetic definition of art privileges aesthetic experience to the exclusion of other nonaesthetic forms of interaction that the art object can be designed to promote. I shall argue that there is no reason for the aesthetic experience to be privileged in this way insofar as it seems to me that we cannot rule out other, nonaesthetic forms of response to art as illegitimate on the grounds that they are not aesthetic responses.

A great many of our typical, nonaesthetic responses to art can be grouped under the label of interpretation. Artists often include, imply, or suggest meanings in their creations, meanings and themes that are oblique and that the audience works at discovering.

There are artists in every art form who strive to incorporate oblique or hidden meanings or themes, and nonobvious adumbrations of the oblique themes in their work. In Peter Hutchinson's interpretation of *Tonio Kröger*, we find an example of an oblique theme, that of the split personality, and of an adumbration thereof, the use of the character's name to convey, in a camouflaged way, extra inflection concerning the nature of the split person-ality. Hutchinson writes,

> In *Tonio Kröger*, [Thomas] Mann's most famous early story, the eponymous hero bears features of two distinct qualities in his name: those of his artistic mother, and the more somber ones of his self-controlled father. It is his mother from whom Tonio has inherited his creative powers—she comes from "the South," a land lacking in self-discipline but rich in self-expression, and its qualities are symbolized in his Christian name (with its clear Italian ring). His father, on the other hand, the upright Northerner, the practical man of com-mon sense and sound business acumen, bears a name suggestive of dullness and solidity (it derives from the Middle Low German "Kröger," a publican).[1]

The presence of such obliquely presented themes and adumbrations occurs fre-quently enough, especially in certain genres, that audiences customarily search for hidden meanings that are likely to have been implanted in the artwork.

With certain forms of interpretation, the spectator's relation to the artwork is gamelike. The spectator has a goal, to find a hidden or oblique theme, which goal the spectator pursues by using a range of hermeneutical strategies. This interpretive play is something we have been trained in since grammar school, and it is a practice that is amplified and publicly endorsed by the criticism we read. The obliqueness of the artist's presentation of his theme confronts the audience with an obstacle that the audience voluntarily elects to overcome. How the artist plants his theme and how the audience goes about discovering it—in terms of distinctive forms of reasoning and observation—are primarily determined by precedent and tradition, though, of course, the tradition allows for innovation both in the area of artmaking and of interpretation. Within this gamelike practice, when we discover a hidden theme we have achieved a success, and we are prone, all things being equal, to regard our activity as rewarding insofar as the artwork has enabled us to apply our skills to a worthy, i.e., challenging, object. But this type of interpretive play, though characteristic of our interaction with artworks, and rewarding, [does not exemplify] the aesthetic response.

Our interpretive, nonaesthetic responses also include the discernment of la-tent structures. When we contemplate art, we often have as a goal, upon which we may expend great effort, figuring out the way in which a given painting or musical composition works. In the presence of an artwork, we characteristi-cally set ourselves to finding out what its structure is as well as often asking the reason for its being structured that way. Or, if we sense that an artwork has a certain effect, e.g., the impression of the recession of the central figure in Malevich's *Black Quadrilateral*, we examine the formal arrangement and principles that bring this effect about. Again, this is something we have been trained to do and something that pervades the discussion of art in both infor-mal and professional conversation. Identifying the structure or structures of a work is, like the identification of a hidden meaning, one criterion of a success-ful interaction with art. Moreover, this form of interaction is not "aesthetic," as that is normally construed, but it should not, for that reason, be disregarded as a characteristic and appropriate mode of participating with artworks.

One may wonder whether it is correct to claim, as I have, that the philoso-phers of art tend to ignore the importance of interpretation. For much of the literature in the field concerns issues of interpretation. This, admittedly, is true in one sense. However, it must be added that the attention lavished on inter-pretation in the literature is not focused on interpretive play as a characteristic form of the experience of interacting with artworks but rather revolves around epistemological problems, e.g., are artist's intentions admissible evidence; can interpretations be true or are they merely plausible; and so forth. This epistemological focus, moreover, tends to take critical argument as its subject matter. Thus, the fact that philosophers have such epistemological interests in interpretation does not vitiate the point that interpretive play is an ingredient in our characteristic experience of artworks which philosophers, by privileging the aesthetic, have effectively bracketed from the art experience proper.

Philosophers are tempted to exclude interpretive play from the art experi-ence proper. The essential experience of art, for them, is a matter of feeling pleasure. Interpretive activity, on the other hand, it might be said, has no obvious connection with pleasure. But I'm not so sure of this.

Within the practice of art spectatorship, among the goals of the enter-prise, we find the making of interpretations of various sorts. Pursuit of these goals in our encounters with artworks occupies large parts of our experience of artworks. Our interpretations can succeed or fail. They can be mundane or excellent. When our interpretations succeed, we derive the satisfaction that comes from the achievement of a goal against an established standard of excellence. I see no reason to deny that this type of satisfaction is a type of pleasure even though it differs from the type of pleasurable sensation, or thrill, or beauteous rapture that theorists often appear to have in mind when

speaking of aesthetic experience. The exercise of the skills of art spectator-ship is its own reward within our practice.

I suspect that since art evolved over a long period of time and through the interactions of many different cultures, it may support a plurality of interests such that the art experience is comprised of a plurality of activities of which having aesthetic experiences of some sort is one, while engaging in interpretive play is another. There are undoubtedly more activities than only these two. Furthermore, it may be the case that none of the multiple types of interactions that comprise the art experience is unique to encounters with art. Of course, this might be granted at the same time that the proponent of the aesthetic theory urges that nevertheless aesthetic experience is a necessary component of any experience of art whereas other responses, like interpretive play, are not. At that point, the aesthetic theorist will have to show that aesthetic experience is such a necessary component. That will not be easy to do without begging the question. Suppose my counterexample to the notion that aesthetic experience is a necessary component of every art experience is Duchamp's *Fountain*. I note that it is an object placed in a situation such that it has an oblique significance which supports a great deal of interpretive play. But it does not appear to promote the kinds of response that theorists call aesthetic. So it affords an art experience that is not an aesthetic one. The aesthetic theorist can attempt to block this counterexample by saying that *Fountain* is not an artwork and that an interpretive response to it, therefore, is not even an experience of art. But he can only do this by asserting that aesthetic experience is definitive of art and of what can be experienced as art. Yet that begs the question insofar as it presupposes that a work designed to provoke and promote interpretive play cannot be art because interpretive play is not a criterion of the kind of experience appropriate to art.

One might argue that interpretive play is not fundamental to the art experience in the sense that it is not the original purpose for which the works we call art were created. But this faces problems from two directions. First, hermeneutics has been around for a long time and may even predate our notion of taste. Second, if one makes this argument with aesthetic experience in mind, can we be so certain that promoting aesthetic experience was the original purpose for which many of the more historically remote objects we call art were made? Moreover, if it is claimed that many of the ancient or medieval artifacts we call art at least had a potentially aesthetic dimension, it must be acknowledged that most of the self-same objects also possessed a symbolizing dimension that invited interpretive play.

An aesthetic theorist might try to solve this problem by saying that interpretive play, sans any particular affect or perceptual focus, is a sufficient

condition for calling a response "aesthetic." However, this move involves abandoning not only the letter but also the spirit of the aesthetic approach, for the tradition has always used the idea of the "aesthetic" to single out a dimension of interaction with objects which is bound up with perceptual experience, affective experience, or a combination thereof. In short, to assimilate interpretive play as a mode of aesthetic experience misses the point of what people were trying to get at by use of the notion of the "aesthetic."

One key feature of the notion of the aesthetic, mentioned by Beardsley and others,[2] is object directedness. In this light, having aesthetic experiences or aesthetic perceptions is, in large measure, a matter of focusing our attention on the artwork that stands before us. The implicit picture of spectatorship that this approach suggests is of an audience consuming artworks atomistically, one at a time, going from one monadic art response to the next. But this hardly squares with the way in which those who attend to art with any regularity or dedication either respond to or have been trained to respond to art. Art—both in the aspect of its creation and its appreciation—is a combination of internally linked practices, which, to simplify, we may refer to as a single practice. Like any practice, art involves not only a relationship between present practitioners but a relationship with the past. Artmaking and artgoing are connected with traditions. Entering the practice of art, even as an artgoer, is to enter a tradition, to become apprised of it, to be concerned about it, and to become interested in its history and its ongoing development. Thus, a characteristic response to art is, given an artwork or a series of artworks, to strive to figure out and to situate their place within the tradition of a specific art form or genre. This implies that important aspects of our interaction with artworks are not, strictly speaking, object directed, but are devoted to concerns with issues outside the object. Nor is this attending to the historical context of the object undertaken to enhance what would be traditionally construed as our aesthetic experience. Rather, our wider ambit of attention is motivated by the art appreciator's interest in the tradition at large. Yet this deflection of attention from the object is not an aesthetic aberration. It is part of what is involved with entering a practice with a living tradition.

To be interested in the tradition at large is to be interested in its development and in the various moves and countermoves which comprise that development. For example, encountering one of Morris Louis's *Unfurleds*, we may remark upon the way in which it works out a problematic of the practice of painting initiated by the concern of Fauvists and Cubists with flatness. The painting interests us not only for whatever aesthetic perceptions it might promote, but also for the way in which it intervenes in an ongoing painterly

dialectic about flatness. To be concerned with the significance of the painting within the tradition of modern art is not inappropriate, but rather is a characteristic response of an appreciator who has entered the practice of art.

Confronted with a new artwork, we may scrutinize it with an eye to isolating the ways in which it expands upon an existing artworld dialectic, solves a problem that vexed previous artists, seizes upon a hitherto unexpected possibility of the tradition, or amplifies the formal means of an art form in terms of the art form's already established pursuits. But a new artwork may also stand to the tradition by way of making a revolutionary break with the past. A new artwork may emphasize possibilities not only present in, but actually repressed by, preceding styles; it may introduce a new problematic; it may repudiate the forms or values of previous art. When Tristan Tzara composed poems by randomly drawing snippets of words from a hat, he was repudiating the Romantic poet's valorization of expression, just as the Romantic poet had repudiated earlier poets' valorization of the representation of the external world in favor of a new emphasis on the internal, subjective world. Tzara's act wasn't random; it made perfect sense in the ongoing dialogue of art history.

The "other-directed," as opposed to the "object-directed," interpretive play we characteristically mobilize when interacting with art takes other appropriate forms than those of detecting stylistic amplifications and repudiations. For example, we may wish to contemplate lines of influence or to consider changes of direction in the careers of major artists. These concerns as well are grounded in our interests, as participants, in an evolving tradition. However, rather than dwell on these, I would rather turn to a proposal of the way in which the detection of a repudiation—insofar as it is an important and characteristic interpretive response to art—can enable us to short-circuit the dismissal, by aesthetic theorists of art, of such works as Duchamp's *Fountain*.

Let us grant that Duchamp's *Fountain* does not afford an occasion for aesthetic experiences or aesthetic perceptions as those are typically and narrowly construed. Nevertheless, it does propose a rich forum for interpretive play. Its placement in a certain artworld context was designed to be infuriating, on the one hand, and enigmatic and puzzling on the other. Confronted by *Fountain*, or by reports about its placement in a gallery, one asks what it means to put such an object on display at an art exhibition. What is the significance of the object in its particular social setting? And, of course, if we contemplate *Fountain* against the backdrop of art history, we come to realize that it is being used to symbolize a wealth of concerns. We see it to be a contemptuous repudiation of that aspect of fine art that emphasizes craftsmanship in favor of a reemphasis of the importance of ideas to fine art.

Now my point against aesthetic theorists of art is that even if *Fountain* does not promote an aesthetic interaction, it does promote an interpretive interaction. Moreover, an interpretive interaction, including one of identifying the dialectical significance of a work in the evolution of art history, is as appropriate and as characteristic a response to art as an aesthetic response. Thus, since *Fountain* encourages an appropriate and characteristic art response, we have an important reason to consider it to be a work of art even if it promotes no aesthetic experience.

The aesthetic theorist may, of course, admit that interpretive responses to the hidden meanings, dramatic significance and latent structures are appropriate within the practice of spectatorship. But he might add that they are not basic because the practice of art spectatorship would never have gotten off the ground, nor would it continue to keep going, if artworks did not give rise to aesthetic experiences. Our desire for aesthetic pleasure is the motor that drives the art institution. These are, of course, empirical claims. Possibly aesthetic pleasure is what started it all, although it is equally plausible to think that the pleasure of interpretation could have motivated and does motivate spectatorship. But, in any case, this debate is probably beside the point. For it is likely that both the possibility of aesthetic pleasure and the pleasure of interpretation motivate artgoing, and that interacting with artworks by way of having aesthetic perceptions and making interpretations are both appropriate and equally basic responses to art.

Notes

1. Peter Hutchinson, *Games Authors Play* (London: Methuen Young Books, 1983), 80.

2. Monroe Beardsley, "Aesthetic Experience," in *The Aesthetic Point of View*, ed. Michael Wreen and Donald Callen, 285–97 (Ithaca, NY: Cornell University Press, 1982); Jerome Stolnitz, "The Aesthetic Attitude," in *Introductory Readings in Aesthetics*, ed. John Hospers, 17–27 (New York: Free Press, 1969), 17–27.

Empiricism and the Heresy of the Separable Value*

James Shelley

It has become customary to distinguish two kinds of value empiricism in aesthetics: empiricism about *aesthetic* value is the view that an object has whatever aesthetic value it has because of the value of the experience that it

* Used by permission of the author.

affords; empiricism about *artistic value* is the view that an object has whatever artistic value (i.e., value as an artwork) it has because of the value of the experience that it affords. (Adherents of one version of empiricism or the other include Monroe Beardsley [1982], Malcolm Budd [1985, 1995], George Dickie [1988], Alan Goldman [1995, 2006], Kendall Walton [1993], Jerrold Levinson [1996], Robert Stecker [1997a, 1997b], Richard Miller [1998], Peter Railton [1998], James Anderson [2000], and Gary Iseminger [2004]). During the latter part of the twentieth century, these two varieties of empiricism were often asserted, occasionally developed, but rarely defended. Little defense was needed as no serious challenge ever materialized; our inability to imagine alternatives must have seemed defense enough. Only in the past few years has any real critical pressure been brought to bear against either view. (See Zangwill [1999], Sharpe [2000], D. Davies [2004], and Kieran [2005]). Ratcheting up that pressure is my aim here.

Because what I have to say against value empiricism of both kinds is insensitive to the difference between them, I will speak as if there were no difference. Sometimes I will use the generic term *empiricism* to mean either theory. Sometimes I will use the generic expression "the value of the artwork," or the still more generic expression "the value of the object," to mean either value. And sometimes I will simply slide between talk of one theory and talk of the other and between talk of one value and talk of the other.

I begin with an objection to empiricism that some empiricists have anticipated, principally Malcolm Budd, Stephen Davies, and Jerrold Levinson, but that seems never to have been raised by any true detractor. Suppose empiricism to be true of some artwork. Then anything other than the artwork that affords the same experience has the same value. But nothing other than the artwork can have the same value—the value of an artwork is not separable from the artwork in the way, for example, that the value of a drug is separable from the drug. So empiricism is not true.

The standard reply to this objection is to deny what Budd calls "the heresy of the separable experience," which I take to be the view that for any artwork something other than it could afford the experience it affords (Budd 1985, 125). Here for example is Budd:

> The fundamental error . . . is [the] separation of what gives music its value . . . from the music itself. [The objection] represents a musical work as being related in a certain way to an experience which can be fully characterized without reference to the work itself. It therefore regards music purely as a tool. . . . But the obligation to provide an independent description of the experience can never properly be discharged. For the [objection] misrepresents the

nature of the value music has for those who appreciate it as music. It implies that there is an experience which a musical work produces in the listener but which in principle he could undergo even if he were unfamiliar with the work . . . But there is no such experience. (1985, 123–24)

And here is Stephen Davies:

The pleasure of appreciating music is not some frisson to which the musical work stands *merely* as the cause or occasion, for, whereas such pleasure is indif-ferent to its cause, the pleasure of appreciating a musical work for itself qua music is not indifferent to the individuality of its object. . . . Most types of plea-sure are logically bound up with the appreciation of the individuality of their objects, so that there is no description of the pleasure which is independent of an account of the object. (1994, 315–16)

And here is Levinson:

If we examine more closely these goods . . . we see that their most adequate description invariably reveals them to involve ineliminably the artworks that provide them. . . . The pleasure we take in the Allegro of Mozart's Symphony no. 29 is, as it were, the pleasure of discovering the individual nature and potential of its thematic material, and the precise way its aesthetic character emerges from its musical underpinnings. . . . There is a sense in which the pleasure of the Twenty-ninth can be had only from that work. (1996, 22–23)

In each of these passages we find the heresy of the separable experience de-nied on the grounds that it is impossible adequately to describe, or fully to characterize, the experience that an artwork affords without reference to the artwork. But if it is impossible adequately to describe the experience that an artwork affords without reference to the artwork, this is presumably because the experience is the experience that it is because it is of the artwork. Indeed, if the experience of the allegro of Mozart's Twenty-ninth Symphony is not the experience that it is because it is of the allegro of Mozart's Twenty-ninth Symphony, then there is no reason why it cannot be had from something else.

So, I will assume that when the empiricist claims that it is impossible fully to describe the experience afforded by an artwork without reference to the artwork, she means to commit herself to the stronger claim that the experi-ence of the artwork is the experience that it is because it is of the artwork. But if the experience of the artwork is the experience that it is because it is of the artwork, then what gives that experience the value that it has? This is a question that the empiricist cannot afford to ignore: if she cannot explain the

value of the experience to which she appeals, she cannot explain the value of the object it is her purpose to explain. It is also a question that empiricists largely have ignored: the few suggestions empiricists have thrown out are consistent with more than one interpretation; still other explanations are inconsistent with empiricism itself.

One explanation is suggested by the fact that the empiricist often regards the experience to which she appeals as a pleasure. So Levinson regards the experience afforded by the allegro of Mozart's Twenty-ninth Symphony as a pleasure, and Davies apparently regards the experience afforded by any good musical work as a pleasure. In such cases the question, What gives the experience of an artwork its value? becomes the question, What gives the pleasure taken in an artwork its value? And the answer to this question may seem too obvious to require stating. Surely a pleasure has its characteristic value—its value as a pleasure—because of its phenomenal character; surely pleasures are characteristically worth having because of what it is like to have them. Of course you might value a pleasure for something other than its phenomenal character; you might value a pleasure for the consequences of having it, for example, or you might even value a pleasure because of what it is a pleasure in. But if someone holds that some pleasure is valuable (as Levinson and Davies do) but does not go on to explain what makes that pleasure valuable (as Levinson and Davies do not seem to do), then surely there is an implication that the pleasure is valuable because of its phenomenal character. Of course the empiricist does not always regard the experience to which she appeals as a pleasure. But even when she does not, she still seems to understand the value of the experience on the model of the value of a pleasure, that is, she still seems to understand the experience as having an intrinsic (i.e., noninstrumental) value that is available only to those who undergo the experience; she still seems to understand the experience as worth having because of what it is like to have it.

So I think that the empiricist is plausibly interpreted as holding generally that the experience to which she appeals has its value because of its phenomenal character. But if this is what the empiricist in fact holds, then her theory succumbs to an objection similar to the one with which we began. If the experience of an artwork is the experience that it is because it is of the artwork—as Budd, Levinson, and Davies all apparently hold—it may then be granted that nothing other than *that* artwork can afford *that* experience. But from this it does not follow that nothing other than *that* artwork can afford an experience having *that* value. If the experience of the artwork has the value that it has because of its phenomenal character, but is not the experience it is because of its phenomenal character, then there is no reason why some other experience, one afforded by something other than the artwork—a drug,

perhaps—cannot have the same phenomenal character and so have the same value. But then the artwork and the drug have the same value, and the value is evidently separable from the artwork, which, all sides agree, is not the case. (With the sole exception of Robert Stecker, an empiricist who accepts the separability of the value from the object. See Stecker 1997a, 256.)

A second possible explanation promises to avoid this result. It is suggested by the fact that the empiricist's point in denying the heresy of the separable experience is to avoid commitment to the corresponding heresy of the separable value, i.e., the view that for any artwork something other than it could have just its value. This is clear in Budd's opening claim that "the fundamental error . . . is [the] separation of what gives music its value . . . from the music itself." But if in denying that the *experience* is separable from the artwork the empiricist means also to be denying that the *value* of the experience is separable from the artwork, then in affirming that the *experience* cannot be adequately described without reference to the artwork, the empiricist must also mean to be affirming that the *value* of the experience cannot be adequately described without reference to the artwork. But if the value of the experience of an artwork cannot be adequately described without reference to the artwork, this is presumably because the experience has the value it has because it is of the artwork. Indeed, if the experience of the allegro of Mozart's Twenty-ninth Symphony does not have the value that it has because it is of the allegro of Mozart's Twenty-ninth Symphony, then there is no reason why that value cannot be had from something else.

So, the empiricist is plausibly interpreted as committed to the view that the experience has the value that is has because it is of the artwork. But just how does being of the artwork—how does having the artwork as its content—give the experience its value? The natural explanation, I think, is that the experience has its value because it is of something valuable, i.e., that it has its value because of the valuable content that it conveys. But if this is what the empiricist has in mind, her theory is evidently circular, since the value of the artwork would then derive from the value of the experience and the value of the experience would derive from the value of the artwork. It may seem as if there is another avenue open to the empiricist here: she may claim that while the experience has its value because it is of the artwork, this is not because the artwork is antecedently valuable, but because the artwork is such as to afford an experience having just the value-conferring phenomenal character that it has. But unless there is some reason to think that only *that* artwork can afford an experience having *that* phenomenal character, it is difficult to see how this explanation differs from the first. And the empiricist has offered no such reason.

A third possible explanation promises to supply this deficiency. It follows after the first explanation in appealing to the phenomenal character of the experience to explain the value of the experience but departs from the first explanation in appealing to the artwork to individuate not the *experience* that the artwork affords but the *phenomenal character* of the experience that the artwork affords. Granted, no actual empiricist identifies phenomenal character as that aspect of experience that she wishes to individuate according to the artwork. But heading off commitment to the heresy of the separable value clearly is the empiricist's aim in appealing to the artwork to individuate something experiential. If there is reason to think that this end cannot be achieved by individuating the experience *simpliciter* but can be achieved by individuating its phenomenal character, there is reason to prefer the third explanation to the first. Moreover, if there is reason to think that circularity can be headed off only by explaining the value of the experience by appeal to something other than the content of the experience, there is also reason to prefer the third explanation to the second.

So suppose the empiricist advances this third explanation. There is room to worry whether the proposal to individuate phenomenal character externally is coherent. But I propose to worry instead whether this explanation, granting its coherence, really manages to steer empiricism clear of the heresy of the separable value. If the phenomenal character of an experience is the phenomenal character that it is because of the object of the experience, it may then be granted that nothing other than *that* object could afford an experience having *that* phenomenal character. But from this it does not follow that nothing other than *that* object could afford an experience having *that* value in virtue of its phenomenal character. To allow that phenomenal character can be individuated externally is to allow that internally indistinguishable experiences can have different phenomenal characters. Hence if the experience has the value that it has in virtue of its phenomenal character in the typical way that experiences have their value in virtue of their phenomenal characters—i.e., if the experience has its value in virtue of what it is like to have the experience—then there is no reason why some other experience, having some other phenomenal character, afforded by some other object—a drug, perhaps—cannot have the same value. But then the object and the drug have the same value and the value is evidently separable from the object, which, all sides agree, is not the case.

A fourth putative explanation promises to remedy this third. It appeals to the object of the experience, not merely to explain what makes the phenomenal character of the experience the phenomenal character that it is, but to explain what makes the phenomenal character of the experience

such that it gives the experience the value that it has. Only then would it follow that nothing other than *that* object could afford an experience having a phenomenal character that gives the experience *that* value. But the trouble with this explanation is that it is not one. Have we any purchase on how two experiences, each internally indistinguishable from the other, each having its value in virtue of its phenomenal character, might nevertheless differ in value? Have we any purchase on how an object of an experience—an antecedently valueless object no less—might determine the value that the experience has in virtue of its phenomenal character? The empiricist may claim that the object *somehow* makes the phenomenal character such that it *somehow* gives the experience the value it has. But to make such a claim is not to give an explanation of the value of the experience. It is conceded that one has no such explanation: the *somehows* are just what need explaining; they are what must be explained before the empiricist can rightly claim to have explained anything.

A fifth attempt might arise from the thought that the previous explanations all accede too readily to the terms of a false dilemma. Must the value of the experience be explained by appeal either to its phenomenal character or to the antecedent value of its object? What prevents the empiricist from appealing to some other feature of the experience in explanation of its value? What prevents her, I think, is the difficulty of finding any other feature plausibly suited to the task. Consider one recent attempt, made by Alan Goldman:

> Aesthetic experience . . . is aimed first at understanding and appreciation, at taking in the aesthetic properties of the object. The object itself is valuable for providing experience that could only be an experience of that object. . . . Part of the value of aesthetic experience lies in experiencing the object in the right way, in a way true to its nonaesthetic properties, so that the aim of understanding and appreciation is fulfilled. Aesthetic experience should be grounded in an acceptable interpretation of its object, and an acceptable interpretation is one that maximizes the value of the experience while being constrained by the objective or base properties of the object. (2006, 339–41)

When Goldman says that aesthetic experience "aims *first* at understanding and appreciation" (my emphasis), I take him to be claiming that the aim of understanding and appreciating its object is basic to aesthetic experience—presumably as basic as what Goldman elsewhere refers to as the aim of being "subjectively satisfying" (2006, 341). From this claim it follows that the value of aesthetic experience consists partly in fulfilling its aim of understanding and appreciating its object. But while it may be that aesthetic experience is

valuable, in part, because it fulfills its aim of understanding and appreciating its object, it cannot be that its object is valuable, even in part, because of its capacity to afford an experience in which it is understood and appreciated. The value of a good poem cannot consist in its capacity to afford an experience in which it is *understood*, since, all things being equal, a bad poem has this capacity in equal measure. It is of course true that only a good poem rewards an understanding of it. But then a good poem's capacity for rewarding understanding is evidently to be explained by the poem's being good; it is evidently in virtue of its being good that a poem rewards us on condition that we understand it. By contrast, it may well be that a good poem and a bad poem are not, all things being equal, equally capable of affording experiences in which they are *appreciated*. According to certain uses of "appreciate," at least, you can appreciate only what is good. But then the good poem's capacity for being appreciated is to be explained by its being good—it is in virtue of its goodness that we appreciate the poem; the poem's goodness is what we appreciate about it.

Thus, appealing to the feature of understanding and appreciating its object is no better than appealing to the feature of having value-conferring phenomenal character or to the feature of having an antecedently valuable object as its content. If it plausibly explains some value that aesthetic experience might have, it does not explain any value that aesthetic experience might have in virtue of which its object has the value that it has. It therefore seems that the empiricist will have to appeal to some other feature of the experience: some feature that is not understanding and appreciating its object, or having value-conferring phenomenal character, or conveying valuable content; some feature appeal to which implicates the object, thereby avoiding commitment to the heresy of the separable value, but does so without implicating the antecedent value of the object, thereby avoiding circularity, while yet remaining genuinely explanatory of the value of the experience *and* in a way that the value of the experience can be genuinely explanatory of the value of the object.

Has the experience to which the empiricist appeals any such feature? I see no reason to think that it has. Has any empiricist any idea what that feature might be? I believe there is good reason to think none does. Perhaps I am wrong about this. But if I am, some empiricist ought to tell us what that feature is. Until one does, we are right to conclude that empiricism, if not empty, is precisely what empiricists have urged that it is not: a theory that understands the value of an artwork to be indifferent to the character of its bearer, just as if that value consisted simply in the capacity of its bearer to af-

ford some frisson to which it stands merely as the cause or occasion; a theory that places no logical restrictions on what might have the value that the allegro of Mozart's Twenty-ninth Symphony has, so that that value might be had not merely by something other than the allegro of Mozart's Twenty-ninth but by something wholly other from it; a theory, in short, that regards the artwork as a pure tool.

Works Cited

Anderson, J. 2000. Aesthetic concepts of art. In *Theories of art today*, edited by N. Carroll. Madison: University of Wisconsin Press, 65–92.

Beardsley, M. 1982. The aesthetic point of view. In *The aesthetic point of view*, 15–34. Ithaca, NY: Cornell University Press.

Budd, M. 1985. *Music and the emotions: The philosophical theories*. London: Routledge.

———. 1995. *Values of art: Painting, poetry, and music*. London: Penguin.

Davies, D. 2004. *Art as performance*. Oxford: Blackwell.

Davies, S. 1994. The evaluation of music. In *What is music?* edited by P. Alperson, 307–25. University Park: Pennsylvania State University Press.

Dickie, G. 1988. *Evaluating art*. Philadelphia: Temple University Press.

Goldman, A. 1995. *Aesthetic value*. Boulder, CO: Westview Press.

———. 2006. The experiential account of aesthetic value. *Journal of Aesthetics and Art Criticism* 64: 333–42.

Iseminger, G. 2004. *The aesthetic function of art*. Ithaca, NY: Cornell University Press.

Kieran, M. 2005. *Revealing art*. London: Routledge.

Levinson, J. 1996. *The pleasures of aesthetics*. Ithaca, NY: Cornell University Press.

Miller, R. 1998. Three versions of objectivity: Aesthetic, moral, and scientific. In *Aesthetics and ethics*, edited by J. Levinson, 26–58. Cambridge: Cambridge University Press.

Railton, P. 1998. Aesthetic value, moral value, and the ambitions of naturalism. In *Aesthetics and ethics*, edited by J. Levinson, 59–105. Cambridge: Cambridge University Press.

Sharpe, R. A. 2000. The empiricist theory of artistic value. *Journal of Aesthetics and Art Criticism* 58: 312–32.

Stecker, R. 1997a. *Artworks: Definition, meaning, value*. University Park: Pennsylvania State University Press.

———. 1997b. Two conceptions of artistic value. *Iyyun* 46: 51–62.

Walton, K. 1993. How marvelous! Towards a theory of aesthetic value. *Journal of Aesthetics and Art Criticism* 51: 499–510.

Zangwill, N. 1999. Art and audience. *Journal of Aesthetics and Art Criticism* 57: 315–32.

⟪⟫

Further Reading

Beardsley, Monroe. 1958. *Aesthetics: Problems in the philosophy of criticism.* New York Harcourt, Brace. Argues that the value of art lies in the aesthetic experience it provides and that such aesthetic experience is a means to many other valuable ends.

Carroll, Noël. 2001. *Beyond aesthetics.* Cambridge: Cambridge University Press. Contains several essays that critique an aesthetic conception of artistic value.

Dickie, George. 1988. *Evaluating art.* Philadelphia: Temple University Press. Argues for a pluralistic conception of artistic value.

Goldman, Alan. 1995. *Aesthetic value.* Boulder, CO: Westview Press. An important treatment of the nature of aesthetic value and the value of art.

Lamarque, Peter, and S. H. Olsen. 1994. *Truth, fiction and literature: A philosophical perspective.* Oxford: Oxford University Press. An argument that literature is primarily to be valued for its aesthetic qualities.

Stecker, Robert. 1997. *Artworks: Definition, meaning, value.* University Park: Pennsylvania State University Press. Contains an argument for a pluralistic and instrumentalist understanding of artistic value.

Young, James. 2001. *Art and knowledge.* London: Routledge. An exploration of the cognitive value of art.

Zangwill, Nick. 1995. The beautiful, the dainty and the dumpy. *British Journal of Aesthetics* 35: 317–29. Explores the nature of art's aesthetic value.

~

Ethical, Aesthetic, and Artistic Value

Introduction

Joseph Conrad's *Heart of Darkness* (1899) is one of the great literary works about the colonization of Africa. It tells the story of an English sailor named Marlow who becomes captain of a river steamboat in the Belgian Congo and journeys upriver to a remote ivory-collecting station in a part of the Congo that is a blank on the maps of the day. The events of the story are not the stuff of great adventure. Marlow first travels to Belgium to garner his appointment acquired with the help of an aunt. He sails down the coast of Africa where he sees vigorous Africans in canoes and a European warship firing canons into the interior for no discernible purpose. Marlow arrives at the port city, a place of rusting supplies, disarray, and misery for the local people. He travels on to the central station where he receives his assignment and meets his fellow travelers and crew. His mission is to find Kurz, the European (his ancestors were from every corner of that continent) in charge of the ivory-collecting station, whom no one has heard from in some time. His fellow travelers are the manager and "the pilgrims," as Marlow calls them, whose pilgrimage is the search for ivory. The crew members are cannibals. When they near the inner station, they are attacked by locals—about the only bit of overt excitement in the story. It turns out that Kurz, who has become a rogue operator and holds the natives in thrall, engineered the attack. Also sick and close to death, Kurz eventually dies on the steamer, uttering the most famous words of the story, "The horror, the horror," possibly expressing the realization of what he has become, or of what European colonization is, or

343

of whatever the "darkness" of the title symbolizes. Kurz entrusts to Marlow a packet of papers that the manager wants. For Marlow, Kurz and the manager are "two nightmares" between which he must choose. In the end, Marlow decides to protect Kurz, who is at least larger than life both in terms of the ideals with which he arrived in Africa and depth to which he descended once there. Marlow brings the papers back to Europe, but they prove to be of little consequence.

The life of this story lies in the dense, symbolic language in which it is told, which weaves a complex system of images and many layers of meaning. From the very beginning of Marlow's tale, the language reflects a constantly repeated, endlessly varied play of light and darkness. Just unpacking and reconnecting these symbols, images, and meanings yields many aesthetic rewards. But there is also an unavoidable ethical edge to the story having to do with its colonial theme. The Europeans in Africa, other than Marlow himself, are invariably cast in a discrediting light. They are greedy, base, foolish, and indifferent to the suffering they cause. The main ethical controversy surrounding *Heart of Darkness* concerns its portrayal of Africans. On the one hand, they always come off better than the Europeans. When the steamboat is attacked, the "pilgrims" behave like fools, while the cannibals behave bravely and sensibly. They are shown to be more vital and nobler than the Europeans. Marlow feels far more grief over the death of his African helmsman during the attack than over that of Kurz. But the same Africans are also called savages, and their trappings are described as barbaric. A good example is the description of Kurz's African lover: "Along the lighted shore moved a wild and gorgeous apparition of a woman. She walked with measured steps, draped in striped and fringed clothes, with a slight jingle and flash of barbarous ornaments. She carried her head high." All and all, this woman is put in a very noble light, but then there are the words "barbarous" and perhaps "wild." The significance of "apparition" is characteristically left open to interpretation. To ethically evaluate this work's stance toward the native Africans, one must decide first how one takes such words uttered by Marlow, second how much weight one gives them, and finally how thoroughly one identifies Conrad's stance with that of his narrator. (Marlow is a thoroughly English seaman. Conrad came to England as an émigré from a Polish-speaking part of the Russian Empire whose population was itself dispossessed of its national identity and often felt oppressed.) Evaluations range from that of the African writer Chinua Achebe, who claims, "Conrad is a bloody racist," to others who say that he lays bare the evils of colonialism. If anything is clear, it is that Conrad is not the type of writer to produce black-and-white portrayals even when dealing with the interaction of white Europeans and black Africans in the most oppressive and exploitative of all the African colonies.

Clearly, *Heart of Darkness*, like many other works of art, is open to both ethical and aesthetic evaluation. This much is uncontroversial but suggests further questions that are hotly debated. First, does both the ethical and aesthetic assessment of the work bear on its overall *artistic* value? If you agree with Achebe's view that *Heart of Darkness* expresses racism, does that lower your estimate of it as a work of art? Would a more positive ethical assessment tend to raise your assessment of its artistic merit? Second, do a work's ethical and aesthetic values have a bearing on each other? If you thought that *Heart of Darkness* was racist, should that judgment interfere with your aesthetic appreciation of the story? Would it tend to lower your assessment of its aesthetic value? Alternatively, is the artistic and aesthetic value of an artwork independent of its ethical value, as Immanuel Kant argues? (See his selection in chapter 2.)

The readings in this chapter adopt a variety of views about these and related issues. Berys Gaut argues that the ethical evaluation of a work does indeed have a bearing on its aesthetic and artistic evaluation. Gaut points out that one must take great care to discern the ethical attitudes a work ultimately manifests as opposed to ones expressed by characters or a narrator or even one the work itself invites its audience to adopt temporarily but later reevaluate. Such care would be very appropriate to a complex and many layered work like *Heart of Darkness*. However, once the relevant attitudes are identified, Gaut believes that they operate uniformly on a work's aesthetic and artistic value. A work is always aesthetically and artistically worse insofar as it manifests ethically problematic attitudes and better insofar as it manifests ethically admirable ones.

Peter Lamarque argues that narrative artworks typically have a variety of dimensions, each requiring different kinds of evaluation. Such works have fictive, literary, and moral facets. When we evaluate a literary work as a work of art, we are primarily concerned with its literary dimension. The moral aspect of a work may supply it with a theme, and this is very relevant to evaluating a work as art. But here we are concerned with issues internal to the work: the way the themes organize plot, characterization, literary structure, imagery, and other devices into a unified and satisfying whole. This is independent of the evaluation of a work's ethical stance, which is found in its moral dimension and is not, according to Lamarque, directly relevant to the work's artistic value. For example, in *Heart of Darkness*, there is the theme concerning "the dark places of the earth." Marlow's very first words are "and this also has been one of the dark places of the earth," referring to England. Ostensibly these are unmapped and uncivilized places, as one might think England was before the Roman conquest, but as the story unfolds and "darkness" acquires moral overtones, it becomes less clear

which places are dark and which are light. This theme controls much of the imagery and content of the work in a beautifully complex way, but, for Lamarque, this evaluation is independent of an assessment of the moral stance the work ultimately adopts.

Matthew Kieran agrees with Gaut that the ethical evaluation of a work has a bearing on its aesthetic and artistic evaluation. However, he disagrees that works' ethically defective aspects always tend to make them artistically worse. While this sometimes happens, in the case of some works, ethically problematic aspects can actually make them better. This is because we can learn from such features of artworks. So Kieran claims that a work's cognitive value contributes to its artistic value, and a moral defect can have cognitive value. Suppose that Conrad really has inserted morally problematic perspectives into *Heart of Darkness*; do we want to allow, with Kieran, that it could be a better work for expecting readers to confront these features?

Sherri Irvin takes the themes of this chapter in a new direction in two different ways. First, she is concerned with the interaction of the ethical and the aesthetic in life rather than art. Second, she is concerned with the way our aesthetic attitudes can modify and enhance our ethical aspirations. If Gaut and Kieran argue that ethical value bears on aesthetic value, Irvin tries to show us how aesthetic value bears on ethical value. In doing so, she draws further implications from some of the ideas explored by Allen Carlson and Marcia M. Eaton in chapter 1.

<center>⸙</center>

The Ethical Criticism of Art*

Berys Gaut

Ethicism

This essay argues that the ethical criticism of art is a proper and legitimate aesthetic activity. More precisely, it defends a view I term ethicism. Ethicism is the thesis that the ethical assessment of attitudes manifested by works of art is a legitimate aspect of the aesthetic evaluation of those works, such that, if a work manifests ethically reprehensible attitudes, it is to that extent aesthetically defective, and if a work manifests ethically commendable attitudes, it is to that extent aesthetically meritorious.

This thesis needs elucidation. The ethicist principle is a *pro tanto* one: it holds that a work is aesthetically meritorious (or defective) insofar as it man-

* "The Ethical Criticism of Art," in Jerrold Levinson (ed.), *Aesthetics and Ethics*, pp. 182–203. © Jerrold Levinson 1998. Reprinted with the permission of Cambridge University Press.

ifests ethically admirable (or reprehensible) attitudes. (The claim could also be put like this: manifesting ethically admirable attitudes *counts toward* the aesthetic merit of a work, and manifesting ethically reprehensible attitudes *counts against* its aesthetic merit.) The ethicist does not hold that manifesting ethically commendable attitudes is a necessary condition for a work to be aesthetically good: there can be good, even great, works of art that are ethically flawed. Examples include Wagner's Ring Cycle, which is marred by the anti-Semitism displayed in the portrayal of the Nibelungen; some of T. S. Eliot's poems, such as *Sweeney among the Nightingales*, which are similarly tainted by anti-Semitism; and Leni Riefenstahl's striking propaganda film *The Triumph of the Will*, which is deeply flawed by its craven adulation of Hitler. Nor does the ethicist thesis hold that manifesting ethically good attitudes is a sufficient condition for a work to be aesthetically good: there are works such as Harriet Beecher Stowe's *Uncle Tom's Cabin*, which, although the ethical attitudes they display are admirable, are in many ways uninspired and disappointing. The ethicist can deny these necessity and sufficiency claims, because she holds that there are a plurality of aesthetic values, of which the ethical values of artworks are but a single kind. So, for instance, a work of art may be judged to be aesthetically good insofar as it is beautiful, is formally unified and strongly expressive, but aesthetically bad insofar as it trivializes the issues with which it deals and manifests ethically reprehensible attitudes. We then need to make an *all-things-considered* judgment, balancing these aesthetic merits and demerits to determine whether the work is, all things considered, good.

The notion of the aesthetic adopted here should be construed broadly. In the narrow sense of the term, aesthetic value properties are those that ground a certain kind of sensory or contemplative pleasure or displeasure. In this sense, beauty, elegance, gracefulness, and their contraries are aesthetic value properties. However, the sense adopted here is broader: I mean by "aesthetic value" the value of an object qua work of art, that is, its artistic value. This broader sense is required, since not all of the values of an object qua work of art are narrowly aesthetic. Besides a work's beauty, we may, for instance, aesthetically admire it for its cognitive insight, its articulated expression of joy, the fact that it is deeply moving, and so on.

The notion of manifesting an attitude should be construed in terms of a work's displaying pro or con attitudes toward some state of affairs or things. What is relevant for ethicism are the attitudes really possessed by a work; so the attitudes manifested may be correctly attributable only by subtle and informed critical judgment. A novel may state that it condemns the sexual activities it describes, but from the subtly lubricious and prying manner in which it dwells on them, it may be correct to attribute to it an attitude of

titillation, not of moralistic disgust. Just as we can distinguish between the attitudes people really have and those they merely claim to have by looking at their behavior, so we can distinguish between real and claimed attitudes of works by looking at the detailed manner in which events are presented.

Objections to Ethicism

1. Ethicism fails to distinguish sharply enough between ethical and aesthetic evaluation. There is an aesthetic attitude in terms of which we aesthetically evaluate works; this aesthetic attitude is distinct from the ethical attitude we may adopt toward works; and ethical assessment is never a concern of the aesthetic attitude. So the ethical criticism of works is irrelevant to their aesthetic value.

The existence of the aesthetic attitude has, of course, been much disputed.[1] But, even if we accept its existence, its adoption is compatible with ethicism. The aesthetic attitude may be individuated by some feature intrinsic to it or by its formal objects.

Consider the case in which the attitude is individuated by its formal objects: these may be understood in narrow aesthetic fashion, as beauty and its subspecies, such as grace and elegance. Since the presence of these properties arguably does not require, or suffice for, the presence of ethical properties, it may be held that ethical assessment is irrelevant to aesthetic evaluation. Yet this objection is unconvincing, for the list of properties deployed is too narrow to embrace all those of aesthetic relevance. In the assessment of art, appeal is made to such properties as raw expressive power and deep cognitive insight as well as to beauty, elegance, and grace; and the relevance of these expressive and cognitive values explains how there can be great works, such as Les Desmoiselles d'Avignon, that are militantly ugly. There is reason, then, to spurn the restricted diet of aesthetically relevant properties offered by the narrow aesthetic views, and as yet no reason to exclude ethical properties from a heartier menu.

The alternative is to individuate the aesthetic attitude by some feature intrinsic to it, and for the opponent of ethicism the most promising feature is the detachment or disengagement we purportedly display toward fictional events. Since it is logically impossible to intervene in such events, the will is detached, practical concerns are quiescent, an attitude of contemplation is adopted. But the step from the claim that the will is disengaged and therefore that ethical assessment has no role to play does not follow: there is similarly no possibility of altering historical events, and we are in this sense forced to

have a detached attitude toward them, but we still ethically assess historical characters and actions.

The point about ethics and the will deserves elaboration, for it will be relevant to the position defended later. Much of our ethical assessment is directed at what people feel, even though these feelings do not motivate their actions. Suppose that Joe is praised for some deserved achievement by his friends, but he later discovers that they are secretly deeply jealous and resentful of him. Their feelings have not motivated their actions, yet we would properly regard these people as less ethically good were we to discover this about them. They are flawed because of what they feel, not because of what they did or their motives for doing it. So for the ethical assessment of character an affective-practical conception of assessment is correct, a conception which holds that not just actions and motives, but also feelings that do not motivate, are ethically significant.

2. Ethical assessment is relevant to a work's aesthetic merit, but ethicism gives the connection the wrong valence: works can be good precisely *because* they violate our sense of moral rectitude. Often the most fascinating characters in works are the evil ones, such as Satan in *Paradise Lost*.

It is important to distinguish between the evil or insensitive characters represented by a work and the attitude the work displays toward those characters. Only the latter is relevant to the ethicist thesis. Satan is indeed fascinating because evil, but the work represents him as such, showing the seductive power of evil, and does not approve of his actions. Milton was not a Satanist. It is true that some works, such as de Sade's *Juliette*, not merely represent evil but also manifest approval toward that evil. If this work has indeed any serious aesthetic merit, it can in part be traced to the literary skill with which it represents the attitude of finding sexual torture erotically attractive; yet the ethicist can consistently and plausibly maintain that the novel's own espousal of this attitude is an aesthetic defect in it.

It may be objected that the novel's approbatory attitude toward evil is a reason why it is aesthetically good: evil arouses our curiosity, and the novel's ability to satisfy this curiosity, to show us what it is like to engage in such actions, is a prime source of its aesthetic merit. This still does not undermine ethicism. For our interest here is in being able to imagine what it is like to have evil attitudes, and so in coming to understand them, and this is satisfied by the vivid *representation* of an evil attitude. But, again, representation of an attitude by a work does not require the work itself to share that attitude:

works may manifest disapproval toward characters or narrators who are represented as evil.

The Merited-Response Argument

The question remains as to why ethicism should be endorsed.

Ethicism is a thesis about a work's manifestation of certain attitudes, but in what does this manifestation of attitudes consist? It is obvious that works prescribe the imagining of certain events: a horror film may prescribe imagining teenagers being assaulted by a monster; *Juliette* prescribes imagining that acts of sexual torture occur. Perhaps less obviously, works also prescribe certain responses to these fictional events: the loud, atonal music of the horror film prescribes us to react to the represented events with fear; *Juliette* invites the reader to find sexual torture erotically attractive.[2] The approbatory attitude that *Juliette* exhibits toward sexual torture, then, is manifested in the responses it prescribes its readers to have toward such torture. The attitudes of works are manifested in the responses they prescribe to their audiences.

It is important to construe this claim correctly to avoid an objection. Consider a novel that prescribes its readers to be amused at a character's undeserved suffering but that does so in order to show up the ease with which the reader can be seduced into callous responses. One response (amusement) is prescribed, but a very different attitude is manifested by the work (disapproval of the ease with which we can be morally seduced); hence, the manifestation of attitudes is distinct from the prescription of responses. What this objection reveals is that prescriptions, like attitudes, come in a hierarchy, with higher-order prescriptions taking lower-order ones as their objects. Thus, my amusement at the character's suffering is prescribed, but there is a higher-order prescription that this amusement itself be regarded as callous and therefore as unmerited. So the complete set of prescriptions that a work makes must be examined in order to discover what attitudes it manifests. Here, as elsewhere, the application of the ethicist principle requires a grasp of interpretive subtleties and contextual factors.

The claim that works prescribe certain responses to the events described is widely applicable. *Jane Eyre*, for instance, prescribes the imagining of the course of a love affair between Jane and Rochester, and also prescribes us to admire Jane's fortitude, to want things to turn out well for her, to be moved by her plight, to be attracted to this relationship as an ideal of love, and so forth. Similar remarks apply to paintings, films, and other representational arts. Music without a text is also subject to ethical criticism if we can prop-

erly ascribe to the music a presented situation and a prescribed response to it. If Shostakovich's symphonies are a musical protest against the Stalinist regime, we can ethically assess them.

The notion of a response is to be understood broadly, covering a wide range of states directed at represented events and characters, including being pleased at something, feeling an emotion toward it, being amused about it, and desiring something with respect to it. Such states are characteristically affective, some essentially so, such as pleasure and the emotions, while in the case of others, such as desires, there is no necessity that they be felt.

Though a work may prescribe a response, it does not follow that it succeeds in making this response merited: horror fictions may be unfrightening, comedies unamusing, thrillers unthrilling. This is not just to say that fear, amusement, and thrills are not produced in the audience. Rather, the question is whether the prescribed response is appropriate or inappropriate. If I am afraid of a harmless victim in a horror movie because of her passing resemblance to an old tormentor of mine, my fear is inappropriate. So prescribed responses are subject to evaluative criteria.

Some of these criteria are ethical ones. As noted earlier, responses outside the context of art are subject to ethical evaluation. I can criticize someone for taking pleasure in others' pain. The same is true when responses are directed at fictional events, for these responses are actual, not just imagined ones. If we actually enjoy some exhibition of sadistic cruelty in a novel, we can properly be criticized for responding in this fashion.

If a work prescribes a response that is unmerited, it has failed in an aim internal to it, and that is a defect. Is the failure of a prescribed response to be merited an *aesthetic* defect? That this is so is evidently true of many artistic genres: tragedies that do not merit fear and pity for their protagonists, comedies that are not amusing, are aesthetic failures in these respects. In general it is a bad work of art that leaves us bored and offers no enjoyment at all. We are also concerned not just with whether a response occurs, but with the quality of that response: humor may be crude, unimaginative, or flat, or may be revelatory, profound, or inspiring.

The aesthetic relevance of prescribed responses wins further support from noting that much of the value of art derives from its deployment of an affective mode of cognition—derives from the way works teach us, not by giving us merely intellectual knowledge, but by bringing that knowledge home to us. This teaching can reveal new conceptions of the world in the light of which we can experience our situation, can teach us new ideals, can impart new concepts and discriminatory skills—having read Dickens, we can recognize the Micawbers of the world. And the way knowledge is brought home

to us is by making it vividly present, so disposing us to reorder our thoughts, feelings, and motivations in the light of it. We may think of the universe as devoid of transcendent meaning, but it may take *Waiting for Godot* to make that thought concrete and real. We may believe in the value of love, but it may take *Jane Eyre* to render that ideal unforgettably alluring. On the cognitive-affective view of the value of art, whether prescribed responses are merited will be of aesthetic significance, since such responses constitute a cognitive-affective perspective on the events recounted. Such responses not merely are affective but include a cognitive component, being directed toward some state of affairs or thing, and bringing it under evaluative concepts.[3] By prescribing us to be amused by scenes of sexual torture, *Juliette* aims to get us to approve of the imagined events, and so to endorse an evaluation about events of that kind.

These observations can be assembled into an argument for ethicism. A work's manifestation of an attitude is a matter of the work's prescribing certain responses toward the events described. If these responses are unmerited, because unethical, we have reason not to respond in the way prescribed. Our having reason not to respond in the way prescribed is a failure of the work. What responses the work prescribes is of aesthetic relevance. So the fact that we have reason not to respond in the way prescribed is an *aesthetic* failure of the work, that is to say, is an aesthetic defect. So a work's manifestation of ethically bad attitudes is an aesthetic defect in it. A parallel argument shows that a work's manifestation of ethically commendable attitudes is an aesthetic merit in it. So ethicism is true.

To illustrate: If a work prescribes our enjoyment (as almost all art does to some extent), but if we are supposed to enjoy, say, gratuitous suffering, then we can properly refuse to enjoy it, and hence the work fails aesthetically. Conversely, if the comedy's humor is revelatory, emancipating us from the narrow bonds of prejudice, getting us to see a situation in a different and better moral light and respond accordingly, we have reason to adopt the response, and the work succeeds aesthetically in this respect.

Objections to the Argument

1. The argument does not support ethicism. To say that a prescribed response is unmerited is to say that the work is emotionally unengaging; but then the work's failure is a result of the failure to engage, and not of its ethical corruption. Indeed, if, despite its ethical corruption, the work does emotionally engage, then its ethical badness is not an aesthetic defect.

The objection misconstrues the argument, even in respect of responses that are emotions. A work may engage an emotion even when it does not merit it (it may, for instance, manipulate us into feeling a sort of pity we know is merely sentimental), and only merited emotions are relevant to the argument. It is whether the emotion is merited that is important, and ethical merits are partly constitutive of whether the emotion is merited; hence, ethical values play a direct role in determining whether the work is aesthetically defective.

2. Works may prescribe responses that are not aesthetically relevant: a royal portrait may be designed to impart a sense of awe and respect toward the king depicted, and a religious work may aim at enhancing the viewer's sense of religious reverence, but such responses are aesthetically irrelevant. So ethicism rests on a false premise.

This is not so. A painting is not just a beautiful object: it aims to convey complex thoughts and feelings about its subject, providing an individual perspective on the object represented. Thus it is that a painting not only can be a representation, but can also embody a way of thinking in an affectively charged way about its subject, and this perspective on its subject is an important object of our aesthetic interest in the work. So if a painting does not succeed in meriting the responses prescribed, it fails on a dimension of aesthetic excellence.

So the merited-response argument stands. And the truth of ethicism shows that the aesthetic and the ethical are intertwined. While those who have supposed them to form a unity have overstated their closeness, the two evaluative domains have proved to be more tightly and surprisingly interconnected than many had thought possible.

Notes

1. See George Dickie, "The Myth of the Aesthetic Attitude," in *Philosophy Looks at the Arts*, ed. Joseph Margolis, 100–16, 3rd ed. (Philadelphia: Temple University Press, 1987).

2. The notion of prescribing imagined feelings is to be found in Kendall Walton, "Psychological Participation," in *Mimesis as Make-believe: On the Foundations of the Representational Arts* (Cambridge, MA: Harvard University Press, 1990), section 2, 249–54. Richard Moran defends the claim that actual feelings can be prescribed in "The Expression of Feeling in Imagination," *Philosophical Review* 103 (1994): 75–106.

3. For cognitive-evaluative views of responses, see Patricia Greenspan, *Emotions and Reasons: An Inquiry into Emotional Justification* (London: Routledge, 1993); Robert C. Roberts, "What an Emotion Is: A Sketch," *Philosophical Review* 97 (1988): 183–209; and Elijah Millgram, "Pleasure in Practical Reasoning," *Monist* 76 (1993): 394–415.

c∞๑

Tragedy and Moral Value*

Peter Lamarque

Philosophers have long been intrigued by tragedy: Aristotle sought to define and defend it, Hume wanted to account for the peculiar pleasures it affords, Schopenhauer and Nietzsche were attracted by the view of life it implies. Those who study tragedy do so perforce from some perspective or other. The thought that tragic drama gives moral insight, or teaches a moral lesson, is one such familiar perspective. But it is one that needs careful handling. The danger of the search for moral wisdom in the great works of tragedy is that it can become just another form of appropriation, losing sight of what is truly distinctive about tragedy conceived as literature. No doubt there is something intrinsically uplifting or disturbing about the stories of Antigone or Agamemnon or King Lear such that reflection on these characters' more or less disastrous responses to a personal crisis can stir us to think again about our own moral precepts. But that seems to ignore the mode in which the stories are presented, the role of representation, of art itself, in what the stories have to tell. What needs exploring is the distinctive literary response to the works and how that might engage with moral content.

The particular focus for my discussion will be the question of why and how the representation of human suffering and disaster can have value, in particular moral value. Clearly not any representation of human suffering is morally valuable, indeed some representations are quite the opposite, being actually immoral, morally depraved, or morally exploitative. So how can we distinguish between those representations which merit our sympathetic involvement and those that do not, being wantonly cruel or self-indulgent or voyeuristic or pornographic?

First of all, there is a constraint on subject matter: the suffering associated with tragic drama is of a distinctive kind. For one thing it must be circumstances largely outside the agents' control, for which they are not wholly culpable, which brings about their downfall. More than that, as Aristotle insists, the person who suffers in this way must have morally admirable qualities, such as to elicit pity and sympathy at their demise.

Nevertheless, the description of the tragic hero as morally admirable only compounds the problem of why the representation of such characters

* "Tragedy and Moral Value," *Australasian Journal of Philosophy* 73:2 (1995): 239–49. Reprinted by permission of the publisher (Taylor and Francis Ltd, http://www.informaworld.com).

suffering reversals of fortune should have any moral or aesthetic value. Perhaps the most common line of thought which seeks to explain the moral seriousness of tragedy is the notion that the dramatic portrayal of tragic events expresses metaphysical or religious views of the world which are of independent moral significance. It is part of Christian theology, for example, that suffering is the path to redemption. Many tragic dramas—though it has to be said not all—represent suffering and death as a kind of purging, a way of ushering in a new order, laying a foundation for renewal and hope, even of resurrection. When Fortinbras enters at the end of *Hamlet* he holds out the promise of a new order in the face of death and destruction.

Even in the non-Christian tradition, the value of tragedy is commonly seen to reside in a metaphysical picture of the world, albeit a bleaker, less consoling kind. Characteristically it is a metaphysics of a world governed by fate or natural law that is depicted as blindly indifferent to human suffering and to human conceptions of fairness and benevolence. Portraying humans in the grip of such metaphysically terrifying forces is seen as a salutary moral reminder of human frailty within an indifferent world. The romantic metaphysicians of the nineteenth century, notably Hegel, Schopenhauer, and Nietzsche, all see the value of tragedy in the image it presents of human life overwhelmed by these uncontrollable, barely understood forces.

Such religious and metaphysical conceptions of tragedy only tell part of the story. Because they apply only to particular tragedies, within clearly defined traditions, they do not seem to answer in principle the question we have posed, which is far more general in nature, namely, what moral value can reside in depictions of human suffering. It is not sufficient to locate this value in an independently statable metaphysical view of the place of man in nature even if there are characteristic themes in tragic drama that reinforce some such general vision. For what gets left out of account is the specific means by which this vision [is] represented in literary works and the special achievement of this mode of presentation. The interesting question is not just what visions of human life underlie tragic drama but what special contribution is made by the imaginative realization of such visions in works of literature.

My own approach can be called humanistic in that I am inclined to suppose, like Aristotle, that the great tragic dramas retain an enduring human interest because they develop themes of a more or less universal nature; they have a "moral content" that engages imaginatively with some of the deepest concerns of human beings in their attempts and repeated failures at living a moral life. The interest of this conception lies in the way it is *worked out*, in particular the way it is located among other conceptions: that of literature,

of moral content, of fiction, of the imagination. I will try to take a few steps toward that further working out.

Traditionally we can identify two strands of thought about moral content in literature, or in tragedy in particular. One is the idea of a *moral lesson* or moral principle derivable from a work; the other is the idea of a *moral vision* expressed in a work.

The first idea, that of a moral lesson, can probably be traced back to the tradition of folk-tales or parables whose purpose was to illuminate or teach a *moral* that gives meaning and interest to a narrative. The interesting question is not whether moral lessons or principles can be drawn from great works of literature—for it is always easy enough to do so—but what status should be given to them or where they should be located within an adequate theory of literary appreciation.

Consider an example from George Orwell in his essay "Lear, Tolstoy and the Fool," written in 1947. Orwell argues that *King Lear* has two morals, one explicitly stated, one merely implied:

> First of all, . . . there is the vulgar, common-sense moral drawn by the Fool: "Don't relinquish power, don't give away your lands." But there is also another moral. Shakespeare never utters it in so many words, and it doesn't very much matter whether he was fully aware of it. It is contained in the story, which, after all, he made up, or altered to suit his purposes. It is: "Give away your lands if you want to, but don't expect to gain happiness by doing so. Probably you won't gain happiness. If you live for others, you must live *for others*, and not as a roundabout way of getting an advantage for yourself."[1]

Orwell is no doubt right that at one level such homespun lessons about what to expect if you give away your lands *can* be derived from *King Lear*. But the patent inadequacy of this account to explain either the literary interest of the play or indeed its moral seriousness points up a general weakness of the moral lesson view of moral content. Either the moral lesson is too close to the work, tied too specifically to the characters and incidents in the work, in which case it cannot function as an independent generalizable moral principle, or the moral lesson is too detached, too loosely connected to the specifics of the work to be perceived as part of the literary content or meaning that the work expresses. The tension here is precisely between the *derivability* of the moral principle and its *independence* as a general moral truth.

It is important to see that the problem is not just that of how to formulate a moral lesson in some derived statement. For literary works all too of-

ten provide such statements themselves. The closing speech by the Chorus in the *Antigone* would be an obvious example:

> Wisdom is the supreme part of happiness; and reverence toward the gods must be inviolate. Great words of prideful men are ever punished with great blows, and, in old age, teach the chastened to be wise.[2]

But to extract this moral homily from the play, independent of its specific literary function, would be utterly misleading. For the literary interest of the Chorus' words is much more subtle; although supposedly alluding to Creon as growing wise through suffering, there is more than a hint that they are referring to themselves as well. The Chorus' own stance with regard to Creon and Antigone shifts during the play. Many of the conflicts in the play are mirrored in the attitudes of the Chorus, a detailed account of which would need to explore the shifting dynamics of power and justice, fear and arrogance, in the relations of the Chorus to the main protagonists. The moral lesson drawn by the Chorus reflects inward more than outward; it prompts us to think again about the kind of wisdom both they and Creon have acquired and the different forms that "chastening" has taken throughout the drama.

When derived moral lessons are relativized in this way to interpretative frameworks, they come to acquire a quite different status from that of independent moral truths; that is, they acquire the status of thematic statements or descriptions. Here is Wilson Knight, in *The Wheel of Fire*, arguing that *King Lear* can be interpreted as what he calls "comedy of the grotesque":

> though love and music—twin sisters of salvation—temporarily may heal the racked consciousness of Lear, yet, so deeply planted in the facts of our life is this unknowing ridicule of destiny, that the uttermost tragedy of the incongruous ensues, and there is no hope save in the broken heart and limp body of death.[3]

Wilson Knight uses the concepts "ridicule of destiny" and "tragedy of the incongruous" not as components of a moral lesson that can be learned from the play and applied independently of it but as thematic concepts for an enhanced understanding of the play. Although he might appear to be making a generalizable comment about the role of ridicule and the comic in tragic situations, the interest of his analysis is grounded in what light it can shed on specific scenes in *King Lear*. It is of course a commonplace that moral concepts and moral propositions can appear in thematic descriptions but it is not always recognized that moral content *as it figures in thematic statements* and moral content *as it figures in independent moral principles* are

performing two radically different functions and are thus assessable in radically different ways.

Let me turn next to moral content conceived as moral vision. Here the idea is that the moral value of tragedy lies in what it shows, not in what it *states* or *implies* propositionally. The metaphor of a picture or view or vision of the world is widely used in this context. Thus Iris Murdoch writes: "The study of literature . . . is an education in how to picture and understand human situations."[4] On her view, great art helps us acquire a more detached, objective, selfless perspective on the world.

In a related strand of argument the idea of moral vision has been thought to embody an insight into ethics itself, as well as the connection between literature and ethics. This is notable in the Wittgensteinian school as represented, for example, by D. Z. Phillips and R. W. Beardsmore who have both argued that it is not the central task of ethics to formulate and apply general principles but rather to stress the particularity of moral situations and the idea that profound moral disagreements reside not in a difference of *beliefs* but in different ways of *looking* at the world.[5] The argument is then brought to bear on literature with a parallel more or less explicitly drawn between a moral agent on the one hand and a competent reader on the other. The idea is that the moral agent and the reader both in effect confront complex moral situations with both called upon to adopt an imaginative perspective on those situations that should yield in the one case a moral judgment or appropriate action and in the other a moral insight or revised way of seeing. A competent reader might hope to learn from the literary work not by formulating a derived moral principle but by acquiring a new vision or perspective on the world.

A not dissimilar position is taken by Hilary Putnam.

What . . . the novel does is aid us in the imaginative re-creation of moral perplexities, in the widest sense . . . [I]f moral reasoning, at the reflective level, is the conscious criticism of ways of life, then the sensitive appreciation in the imagination of predicaments and perplexities must be essential to sensitive moral reasoning. Novels and plays do not set moral knowledge before us, that is true. But they do (frequently) do something for us that must be done for us if we are to gain any moral knowledge.[6]

Again it seems beyond doubt that literary works—including works of tragedy—have the capacity to foster "sensitive appreciation in the imagination of predicaments and perplexities." And no doubt it is also right that there is a moral aspect to this. But there is a danger with this whole line of thinking. The imaginative and moral and literary dimensions blur into one another in

a way that threatens to weaken such insights as we might hope to gain about the moral value of tragedy or the literary representation of suffering. But I do think we can build on the simple intuitions that govern both the "moral lesson" and "moral vision" views of moral content.

First of all we need to acknowledge at least a *prima facie* distinction between a *fictive* dimension, a *literary* dimension, and a *moral* dimension in works of tragedy. Explaining both how these are distinct and also how they interrelate will be the basis of the account that follows. My suggestion is that these dimensions are not reducible one to the other but that if we want to find a general explanation of the moral values of tragedy we need reference to all three.

The fictive dimension involves a mode of utterance, one that invites and elicits an imaginative response, rather than a response grounded in belief and verification. Fictive story-telling disengages standard conditions of assertion, it creates worlds and characters, it encourages participation, not a concern for correspondence with the facts. The fictive dimension is value neutral. There is no inherent value in the fictive mode, only instrumental values.

The literary dimension is different in several respects. For one thing it is not value neutral. To identify a literary dimension in a work is to identify something of value in the work, some special interest that it promises, some expectation that it will reward a certain kind of attention. To appreciate a work for its literary values is to attend to its aesthetic qualities but in particular to the way that it sustains and develops a humanly interesting content or theme. We have already seen how such a theme might have a moral content, i.e., might be expressed in a proposition apparently of the same form as a moral principle or injunction. Of course themes can take other forms as well. But a description of a theme with moral content is not functioning as a description of an independent moral principle. Rather the description offers a way of identifying some central focus or unity in the work. There is no implication that a work must sustain some one determinate theme.

Both the fictive and the literary dimensions can be explained in terms of a certain kind of attention given to a work: a certain perspective on the work, conventionally determined. The fictive dimension invites what might be called a fictive stance—that of imaginative involvement and cognitive distance—while the literary dimension invites a related, but distinct, literary response, the attempt to define a unifying aesthetic purpose in the work, through thematic interpretation.

There can be a moral dimension to a work, not reducible to the other two, that facilitates some further moral appropriation of the work's content, either as a contribution to moral philosophy or as illustrative support for some broader metaphysical picture or just for clarifying one's own moral

precepts. The moral vision theorists like Murdoch or Phillips (or even Schopenhauer and Nietzsche) appropriate the vision (i.e., moral content) of tragic drama into their own independent moral theories. Their mistake is to suppose that the moral dimension is simply subsumed under the literary dimension; that there is a seamless transition from being literary critics to being moral philosophers; that in finding a true thematic description they have thereby found a generalizable moral principle.

In order to bring out more precisely how the fictive, literary, and moral dimensions interrelate—and thus how it is that representations of suffering in tragedy can merit our moral interest and involvement—let me briefly offer one further, and final, distinction: that between internal and external perspectives on imaginary worlds. This distinction is absolutely fundamental to understanding the values we attribute to fictional representations.

The internal perspective on an imaginary world is paradigmatically that of the fictive stance, namely, direct imaginative involvement with the subject of a work. Readers or viewers can project themselves into a fictional world and become participants or observers in that world. In contrast, the external perspective involves no imaginative projection; it focuses on the fictionality of the worlds depicted, on modes of representation, on literary devices and narrative structure, on theme and genre, on possible interpretations. Under the internal perspective, fictional characters are imagined to be fellow humans in real predicaments, objects of sympathy and concern, similar to ourselves in many respects; under the external perspective they are viewed as fictional characters, linguistic or ideological constructs, whose nature and qualities are grounded in the descriptive modes by which they are presented. The two perspectives nicely interact. Take our reaction to the death of Cordelia in *King Lear*; internally and imaginatively viewers are dismayed by so futile and tragic a loss. Yet from the external perspective, Cordelia's death is essential to the tragic structure of the play. From the internal perspective we might wish her spared, from the external perspective we want the play just as it is.

There are deeper connections still. The external perspective, an awareness of modes of representation, dictates the kind of involvement appropriate from the internal perspective. If that is right it follows that the responses of pity and fear that are so central to Aristotle's account of tragedy are not just vague and contingent reactions to characters conceived as real people. They are an integral part of an imaginative engagement with the tragedy's representational content; a failure to respond in that way is at least partly a failure of understanding.

What is valuable about artistic representation is the careful mediation of the two perspectives, the guidance of imaginative response by the very structures of representation itself. An appropriate response to the speech by the Chorus at the end of the *Antigone* is dictated by the function it is seen as serving in the structure of the play, i.e., as more than just a moral homily offered for our edification. Again the matter is normative, for one who fails to respond has not only failed imaginatively but also in understanding.

Returning then to the moral content of tragedy we can see that there are different interlocking elements. Taken as a literary work a tragic drama will invite an interpretation of its central themes, characterizable often in moral terms; this interpretation will be specific to the work, it is a way of redescribing and unifying elements of the work's subject matter and must be sensitive to the modes in which that subject matter is presented. But tragedies are also dramatic productions that engage viewers imaginatively. The dramatic presentation both elicits and controls a sympathetic and imaginative response that serves to make the moral themes more immediate. Only at this point is the further appropriation of the moral content of tragedy possible or valuable. Generalizations about the theme of people of good character suffering terrible reversals of fortune can yield an important moral perspective on human life only in the light of a full assimilation of the sympathetic, imaginative response to tragic drama, mediated by some overall conception of how the elements of the drama cohere within a thematic interpretation.

The moral value of tragic drama is *constituted* by the fact that certain modes of representing tragic events afford controlled imaginative access to themes of human failure and disaster. This access is uniquely available to art in the way that it exploits and balances the tension between internal and external points of view. There is no simple answer to why we should want such access to human suffering. But in general surely no explanation is needed for why matters of such central human concern should be of enduring human interest.

Notes

1. George Orwell, *The Collected Essays, Journalism and Letters of George Orwell, Vol. IV* (eds.) Sonia Orwell and Ian Angus (London: Secker and Warburg, 1968), 298.

2. Sir Richard C. Jebb, *The Tragedies of Sophocles* (Cambridge: Cambridge University Press, [1904] 1957), 172.

3. G. Wilson Knight, *The Wheel of Fire* (London: Methuen, 1972), 175.

4. Iris Murdoch, *The Sovereignty of Good* (London: Routledge, 1970), 34.

5. See, for example, D. Z. Phillips, *Through a Darkening Glass* (Basingstoke, UK: Macmillan, 1986); and R.W. Beardsmore, *Art and Morality* (Basingstoke, UK: Macmillan, 1971).

6. Hilary Putnam, "Literature, Science and Reflection" in *Meaning and the Moral Sciences*, 83–94 (London: Routledge, 1978), 86–87.

⌒∞⌒

Art, Morality, and Ethics: On the (Im)moral Character of Art Works and Interrelations to Artistic Value*

Matthew Kieran

1. Introduction

Imagine that you have just seen or read a work you find deeply troubling. It is artistically inspired and yet deeply morally problematic. The imagery may be audacious, the use of the medium inspired, the characters gripping. So what's the problem? It solicits responses or turns on attitudes that are immoral. Consider a paradigmatically immoral attitude: Nazism, racism, misanthropy, misogyny. What should we say about such a case? Is it just a matter of moral qualms getting in the way of appreciation? Or is a work's moral character integral to how we should evaluate it as art? Consider the huge variety of works these questions might apply to. Homer's *Iliad*, Icelandic sagas, *Beowolf*, medieval Christian morality plays, Swift's *Gulliver's Travels*, the novels of the Marquis de Sade, Wagner's operas, some of Ezra Pound's and T. S. Eliot's poetry, hard-boiled fiction, gangster movies, rap music, to name but a few, radically differ with respect to a wide range of what we take to be fundamental aspects of our moral conceptions. The very same racist attitudes D. W. Griffith's seminal film *Birth of a Nation* glorifies, culminating in the Ku Klux Klan coming to the rescue of the American nation, are the ones that *American History X* condemns. When considered as art, should we thereby condemn the former and praise the latter for this reason?

2. Autonomism/Aestheticism

A standard line is that we should not. Artistic value is held to be constituted by aesthetic features such as a work's harmony, complexity, and intensity as constituted by its lower-level features (Beardsley 1958). Thus what matters

are such things as whether a work's imagery is coherent, its development of themes complex and its style vivid. It is the promotion of these features that are the goal of artistic endeavor and the object of artistic appraisal. Different aspects of the work such as its fictional status, cognitive content or instructional values are conceptually distinct. Hence the moral character of a work as such is strictly irrelevant to its value as art (Lamarque 1995). This is not to deny that interactions amongst these aspects can intrude upon one another. The moral didacticism of D. H. Lawrence or Spike Lee, say, may undermine the complexity or coherence of a work's themes or imagery. But the moral character of a work affects its artistic value only as an indirect side effect. There are no internal relations amongst these aspects so it is never the moral character of a work as such that affects a work's artistic value (Anderson and Dean 1998). Furthermore, this is held to be so, even assuming that we often learn from art and works can enhance our moral understanding. For what insight we gain is distinct from whether a work is any good as art.

There are [two] further points that could be made in support of this line. Firstly, that the practice of criticism itself sets aside the direct evaluation of moral attitudes that are integral to works. It is not uncommon after all to see critics praising works despite or independently of the moral attitudes implicit in [them]. Secondly, different works that have mutually inconsistent moral characters are often rated as highly as one another. The moral universe of James Ellroy's L.A. quartet, *The Black Dahlia*, *The Big Nowhere*, *L.A. Confidential*, and *White Jazz*, is a Hobbesian one shot through with a heavy dose of Freud. Everyone is driven by self-interest. In many respects it is at odds with the moral world of Jane Austen. Here characters have a much larger self-determining role, altruism is possible and being morally good is straightforward (though becoming so is not). Yet we might rate the works of such authors just as highly as one another. How can that be unless we are prepared to set aside worries about differences in moral character between these vastly contrasting works?

3. The Relevance of Moral Character to Artistic Value

In the last decade or so this line has come under increasing attack, notably influenced by Aristotle and David Hume. From Aristotle (367–322 BCE) we get the idea that tragedy, and indeed art generally, can have cognitive value. We sometimes appreciate and value works in terms of their insight and understanding. One of the most important ways this is so is in terms of moral understanding. It might be thought that aestheticism can only be maintained by disregarding a core and recurrent goal of artistic practice (Gaut 2007). However, this would be too quick. It assumes that the instructional aspiration is central to art rather than an aim many people who are artists put art to.

(The latter is a weaker inference which, the aestheticist would say, doesn't beg the question.)

The cognitivist could start by pointing to the ways in which narrative art is saturated with moral concepts, discourse and evaluation. We can't meaningfully engage with and respond to many works without drawing on moral assumptions (Carroll 1998). It is, for example, difficult to see how one could understand Jane Austen's novels unless one had some sort of a grip on concepts like blame, praise, pride, shame, guilt, responsibility, duty and snobbery. However, though the point is a challenging one, it is insufficient to establish an internal connection between the artistic value and moral character of works. The mere fact that we depend on moral understanding to engage with many works doesn't show that the moral appropriateness of a work is relevant to artistic value. We can see this if we note that appreciating Roman Catholic icons requires some kind of grasp of Christianity. It doesn't thereby automatically follow that evaluating icons as visual art depends on the truth of Christianity. This would be, the aestheticist will claim, to beg the question.

What the cognitivist needs is an account of how the instructional aspiration connects directly up with what works do as art. As soon as we realize this, aestheticism looks like it's in a weak position. What is art particularly good at? It uses artistic means to engage the imagination and thereby see things in a new light, make connections, convey insights and get us to respond emotionally (Carroll 1998, 2002; Gaut 2006, 2007; Kieran 1996, 2005). Art uses certain aspects of the relevant media, genre constraints, style, devices, and techniques to do these things particularly well. Thus respect for cognitive value is internal to artistic practice(s). The relevance of the moral character of a work may just fall out of the cognitive conception of artistic value. Where a work tries via artistic means to convey insight, then the cognitive content of the work is relevant to its value as art. This will often include, though is clearly not exhausted by, its moral character.

A distinct way of connecting artistic value to a work's moral character can be derived from both Aristotle and Hume (1757). Its commitments are more minimal since it does not rely on assumptions about the cognitive value of art being internal to artistic value. All it adverts to is the fact that works of art solicit responses from us. Indeed in order for a work of art to succeed it must elicit from us those emotions and feelings essential to the realization of its artistic goals. For a tragedy to work as a tragedy we must feel sympathy for the central character, for a horror movie to succeed as a horror movie we must feel suspense, fear, and horror. In some cases the

responses solicited by a work will advert to or depend on moral features, assumptions and attitudes (Carroll 1996; Gaut 1998, 2007). Sympathy for a character, admiration or horror at their actions and approval of the attitude to life a work expresses, for example, can all be internally connected to moral assumptions. Where this is so, the moral character of a work is relevant to its artistic value.

What of the considerations said to favor aestheticism above? Firstly, that critics sometimes set aside the moral character of a work in evaluating it may show no more than that critics sometimes do this in order to highlight other artistic virtues or vices a work possesses. Furthermore, criticism commonly does advert to the moral character of works as directly relevant (Gaut 2007). Rating different works with mutually inconsistent moral characters just as highly as each other need not be a function of setting moral character aside. It may just show that such works have different artistic virtues.

4. Moralists and Immoralists

Ethicism holds that wherever there is a moral flaw the work is of lesser value as art, and wherever it is morally virtuous the work's value as art is enhanced (Gaut 1998, 2007). There are at least two arguments for the view deriving from the considerations suggested above. (1) Given that cognitive value is internal to artistic value, where this is directly linked to the artistic means deployed, ethicism follows. Why? The misrepresentation of moral features, the solicitation of morally inappropriate responses, or the commendation of that which should be condemned involves misunderstanding. (2) Whether or not we should respond as solicited by a work depends upon whether that response is merited or not. If a horror movie solicits fear, whether such a response is merited or not depends on whether we judge the monster to be scary. Where the response concerns moral features, whether a response is merited or not will in part depend on moral considerations. If a work solicits admiration for a character in virtue of killing someone, then whether such a response is merited will in part depend upon whether we judge they are morally justified in doing so.

Ethicism is controversial. Once we have granted the relevance of a work's moral character, why assume that the relation to artistic character must go a particular way? Lots of art is challenging, gets us to respond to things in ways that, in real life, we would not. Why assume how we ought to respond in real life should govern our responses to art works? Consider a work like James M. Cain's *The Postman Always Rings Twice*. It's a noirish study of romantic passion written in a hard-boiled style. A drifter turns up at a roadside diner, ends up getting a job there, and seduces the wife of the owner. They end

up killing the owner, a well-meaning older Greek man, and in the ensuing police enquiry the couple implode amidst acrimony, jealousy, and distrust. The complex of responses required, for the narrative's suspense to work, centrally includes our sympathizing with the murderous couple. It is a mark of the novel's success that it manages to get us to do so. This isn't an isolated phenomenon. Consider common responses to *The Sopranos*, *The Godfather*, gangsta rap music, or Homer's *Iliad*. Perhaps what matters is not so much whether responses are merited or not but rather whether they are intelligible (Kieran 2001, 2005).

In real life we wouldn't sympathize with the couple in *The Postman Always Rings Twice* for putting their own passion above the life of the Greek husband. But then this isn't real life. So we can allow the force of our internalized moral prohibitions to slacken and go with the responses sought from us. Perhaps all that is required is that the artistic mediation renders intelligible the responses sought for—as opposed to being merited morally speaking. There are many works that have this sort of dynamic from admiring the warrior glory sought by Achilles in *The Iliad* to the cluster of attitudes upon which *Sin City* depends. Think about the incongruities, cruelties, or downright unfairness that comedies and satires often depend on. We would not find many such attitudes and responses to be morally merited in real life. Nonetheless, they connect up with enough of our own attitudes and desires for us to find them intelligible. This opens up the possibility that a particular work may be better as art in virtue of its immoral character.

The point made here relies on emphasizing how the fictional or make-believe context of a work allows us to enjoy putatively immoral imaginative activity. Let us start from the recognition that something's being fictional can set up an aesthetic distance between us and that which the work portrays. We are free to contemplate events portrayed as we could or would not were the events themselves real, and this helps to explain both how we get pleasure from engaging with works we take to be morally problematic and how they may deepen our understanding. Knowing whether or not something is fictional seems to make a crucial difference to the way we respond to representations. However it's not straightforwardly a play's fictional status that is crucial to a work's soliciting morally problematic responses, though what is required are two things closely associated with fictionality: (1) artistic devices mediating the representation of events portrayed (for example, in literature these range from style, poetic form, imagery, and metaphor to interior monologues); and (2) the states of affairs represented are at a distance from us (i.e., we cannot intervene). This is as true of past events or modal facts as it is of fictional ones.

Now a challenge to this line of thought can be presented thus. Artistic mediation may facilitate the separating off of immoral imaginative activity from our normal responses. Nonetheless we are often unable or unwilling to imaginatively enter into the dramatic point of view from which certain responses and attitudes to a work follow. We sometimes are alienated from works in virtue of the fact that they involve attitudes we deem to be immoral.

There is something important here but the line of argument isn't quite right. It fails to account for how and why our responses and attitudes to works sometimes differ though the relevant moral character is the same. For example the moral character of works by James M. Cain and Jim Thompson are in many relevant respects the same. The central characters are anti-heroes we identify with despite their fecklessness and the ease with which they dispatch the lives of others for their own good. Yet I find myself much more easily prepared to enter into the responses sought for by the former rather than the latter. Why? At least in part because doing so with Cain's novels brings some kind of payoff in a way that isn't usually true with Thompson's novels. At least part of the explanation concerns an evaluation of the costs and benefits of doing so. In some cases allowing my moral scruples to be overridden looks likely to bring some kind of payoff and in other cases it doesn't. The important point here is that when engaging with fictions we are all often prepared to entertain and enter into moral responses and attitudes we take to be, in real life, deeply morally problematic.

The above considerations have been taken to motivate a kind of anti-theoretical position. Namely, a work's moral character can be relevant but how so just depends on the particularities of the work in question. In one case a work's immoral character may mar it and yet in another it may enhance it. There is no essential relation between artistic and moral value (Jacobson 2006). The worry with the antitheory approach is that it just seems to be a restatement of the problem rather than a solution to it. We are owed some kind of account as to how and why the relationship can go differently in distinct cases. If we have a general account of artistic value then there's good reason to think that there will be a general account of how it links to the assessment of a work's moral character.

An alternative position, cognitive immoralism, starts by agreeing with the relevance condition underlying one argument for ethicism. Where the moral character of a work is tied to its cognitive value, then its moral character is relevant to its value as art. The relationship is often as characterized by ethicism but not always—and this is so for a principled reason. Where there is a cognitive pay off in virtue of the immoral character of a work, and this is sufficient to outweigh our reluctance to indulge in the responses sought from

us, then the immoral character of the work turns out to be an artistic virtue rather than a vice (Kieran 2003, 2005). A morally problematic work can thus, artistically speaking, redeem itself.

Consider the Belgian film *Man Bites Dog*. The dramatic conceit is that the audience is watching a pseudodocumentary where a crew records the everyday life of a serial killer called Benoit. The opening sequence establishes him as funny and charming, talking about having to do a postman on the first day of every month and the difficulties involved in getting rid of dead bodies (especially midgets). He loves his girlfriend, respects his family, is worn down by mundane aspects of his "job," and is given to articulating considered discourses on the nature of life and death. The surreal humor is maintained, though gradually things get somewhat darker, until a pivotal scene involving the camera crew being drawn into a vicious rape. When I saw the film at the cinema everyone laughed up until the central scene and from then on the atmosphere was deadly quiet. The switch in framing suddenly foregrounds how being fascinated by, laughing at and delighting in screen violence both manifests and perpetuates the brutalization of society. It highlights how both the media and by extension we ourselves may be complicit in the very things we pruriently condemn. For the audience experiences how easily they can be seduced into laughing at actions that delight in extreme violence. The film gets us to both learn something about ourselves and treat more seriously than we might otherwise have done the possible links between our responses to fictions and to real life. Note that for the film to work, for us to get that cognitive gain, it must be the case that for much of the film we respond as solicited in ways we would judge to be unmerited in real life.

There are two main objections to the account. The first starts from the form of a dilemma. Either we are being asked to imagine having an immoral attitude, in which case there's no moral problem, or a work is immoral in virtue of getting us to have immoral attitudes, but then we don't learn anything since we can't learn what is false (Gaut 2007). I have suggested that in the *Man Bites Dog* case we learn something, namely that we can be seduced into responding to violence in ways we should not. Thus, the objection goes, we are forced on to the first horn of the dilemma. Surely, if anything is, this is a film with a moral character. How should the objection be responded to? The ethicist [says] that the work isn't immoral in character since my merely being asked to imagine having an immoral attitude isn't immoral. Well, it depends. The work actually invites an immoral attitude. We laugh at and are amused by the slaughter of innocents as mediated by the film. Just because the overall aim of the film is to make a moral point, it doesn't automatically follow that

the lower-level strategies used or our responses to them are thereby merited or rendered moral. If a film shows me my capacity to be seduced into delighting at cruelty by actually getting me to do so, then the means are still morally problematic even if the end is morally good.

The second objection goes as follows. A work with an immoral character may cultivate understanding. However, we could just as easily have learnt the same thing from a work that doesn't have an immoral character: whatever the insight, it is not essentially tied to the immoral aspect of any work (Stecker 2005). Thus the morally problematic character of a work remains an artistic flaw. But this is too quick. It is far from obvious that learning certain things isn't closely tied to responding in morally problematic ways. At least, given the kind of creatures we are, it certainly seems psychologically true that we sometimes only learn after having made mistakes—especially moral ones. One of the things that art enables us to do is to explore attitudes and responses we would try not to in real life given our moral prohibitions. Quite apart from that, why grant that what we learn must be peculiar to the morally problematic responses in order for [them] to enhance a work's value? It may be true that I could have learnt the same thing about the appeal of violence from a work that condemns it rather than one that glorifies it. However, that is neither here nor there. The crucial claim is whether or not the (im)moral character of a work cultivates my understanding. Immoral or morally problematic aspects of a work, where they cultivate understanding, can contribute to a work's artistic value rather than detract from it.

Works Cited

Anderson, James C., and Jeffrey T. Dean. 1998. Moderate autonomism. *British Journal of Aesthetics* 38, no. 2: 150–66.

Aristotle. 1996. *Poetics*. Trans. M. Heath. London: Penguin (1996).

Beardsley, Monroe. 1958. *Aesthetics: Problems in the Philosophy of Criticism*. New York: Harcourt, Brace and World.

Carroll, Noël. 1996. Moderate moralism. *British Journal of Aesthetics* 36, no. 3: 223–37.

———. 1998. Art, narrative and moral understanding. In *Aesthetics and ethics: Essays at the intersection*, edited by Jerrold Levinson, 126–60. Cambridge: Cambridge University Press.

———. 2002. The wheel of virtue: Art, literature, and moral knowledge. *Journal of Aesthetics and Art Criticism* 60, no. 1: 3–26.

Gaut, Berys. 1998. The ethical criticism of art. In *Aesthetics and ethics: Essays at the intersection*, edited by Jerrold Levinson, 182–203. Cambridge: Cambridge University Press.

————. 2006. Art and cognition. In *Contemporary debates in aesthetics and the philosophy of art*, edited by Matthew Kieran, 115–26. Oxford: Blackwell.

————. 2007. *Art, emotion and ethics*. Oxford: Oxford University Press.

Hume, David. [1757]1993. Of the standard of taste. In *Selected essays* edited by Stephen Copley and Andred Edgar, 133–53. Oxford: Oxford University Press.

Jacobson, Daniel. 2006. Ethical criticism and the vices of moderation. In *Contemporary debates in aesthetics and the philosophy of art*, edited by Matthew Kieran, 342–55. Oxford: Blackwell, 2006.

Kieran, Matthew. 1996. Art, imagination and the cultivation of morals. *Journal of Aesthetics and Art Criticism* 54, no. 4: 337–51.

————. 2001. In defence of the ethical evaluation of narrative art. *British Journal of Aesthetics* 41, no. 1: 26–38.

————. 2003. Forbidden knowledge: The challenge of cognitive immoralism. In *Art and morality*, edited by Sebastian Gardner and Jose Luis Bermudez, 56–73. London: Routledge, 2003.

————. 2005. *Revealing art*. London: Routledge, 2005.

Lamarque, Peter. 1995. Tragedy and moral value. *Australasian Journal of Philosophy* 73, no. 2: 239–49.

Stecker, Robert. 2005. Review of revealing art. *British Journal of Aesthetics* 45, no. 4: 441–43.

ᴄ◯◯ᴐ

Aesthetics as a Guide to Ethics*

Sherri Irvin

Most discussions of aesthetics in relation to ethics have focused on art. A central question has been whether the moral value of an artwork affects its aesthetic value: should we think that a film is worse, aesthetically, because its content is morally objectionable? There has also been considerable discussion of the contribution artworks make to moral education by moving us to recognize the plights of others or to envision new possibilities for action. Some suggest that an artwork's success in this domain may be central to its aesthetic value.

Discussions of a relationship flowing in the other direction, from aesthetic value to moral value, have been much less common. Clive Bell, who held (rather notoriously) that the only thing relevant to an artwork's value as art is its abstract form, suggested that a work with aesthetic value automatically has positive moral value: the sort of bliss it generates is of such great value that, apparently, it nullifies any negative effect of the work's representational content.[1] In general, though, the dominant view about the contribution of aesthetic value to moral value is much weaker and taken to be so obvious

* Used by permission of the author.

that no one bothers to argue for it. Roughly, the view is that people like things with aesthetic value, and any moral value such things have is simply derived from the fact that people like them.

Some recent developments in aesthetics, though, have paved the way for a broader exploration of the relationship between aesthetic and ethical value. Chief among these is an expansion of the concept of the aesthetic. Until recent decades, the vast bulk of discussions took art (or, in a few cases, nature) as their primary subject matter. Recently, though, aestheticians have been exploring the application of aesthetic concepts to other areas of life, such as sex, sports and so on. In the process, they have suggested that traditional aesthetic concepts are too narrow: aesthetic experiences can lie at any point on the spectrum running from positive through banal to negative, and aesthetic properties can be any properties that contribute to the qualitative feel that is central to an aesthetic experience. A consequence of this broadening is that aesthetic concepts can now be applied quite pervasively. I have argued, for instance, that the following experiences and activities are aesthetic in nature:

> I run my tongue back and forth on the insides of my closed teeth, feeling the smoothness of their central surfaces and the roughness of the separations between them. . . . When I am petting my cat, I crouch over his body so that I can smell his fur, which at different places smells like trapped sunshine or roasted nuts, a bit like almonds but not quite. . . . I move my wedding ring back and forth over the knuckle that offers it slight resistance, and I jiggle it around in my right palm to enjoy its weight before sliding it back on.[2]

If the aesthetic is pervasive in human experience, then we should expect that the interactions between aesthetic and ethical value are complex and widespread, with the aesthetic informing the ethical in many ways. Here I offer a preliminary exploration of some of the possibilities. I make no suggestion that some systematic relationship of the aesthetic to the ethical holds in all of the cases I discuss. My exploration is motivated, in considerable part, by a vague unease I have long felt about contemporary ethical theory. My concern is well captured in an observation of Lawrence Blum's: "By and large, contemporary moral philosophy has not felt pressed to explore what it is like to be a person who lives according to its various normative theories, nor how one gets to be such a person."[3] Aesthetics, as I see it, is in large part about matters of "what it is like": it is a consideration of the qualitative feel of human experience. An ethics that is sensitive to these matters will, I think, do a better job of capturing what it is to be a morally good person and how one is, from one's position within a particular human life, to go about becoming one.

372 ⌢ Chapter Eleven

Aesthetic Value and Moral Motivation

Imagine a person for whom a certain kind of sensual indulgence features prominently among her aesthetic values. She enjoys fine wines and cigars, luscious desserts, and fine cuts of meat. The elimination of cruelty also figures among her values, though the relevance of this to her epicurean practices has not been apparent to her. She is, perhaps, vaguely aware that the production of meat sometimes involves suffering for animals. But then something increases or intensifies this awareness. She learns that veal calves and factory-farmed chickens suffer greatly throughout their lives and that beef cattle often undergo botched slaughtering procedures that amount to torture. Her new, vivid awareness provokes a confrontation between her two values: the value of sensual pleasures, which she explicitly celebrates, and the value of avoiding cruelty, which has been a background feature in her life.

If we considered only her new awareness of the suffering of animals and the value she places on avoiding cruelty, we would be able to offer a simple prescription for what she should do: namely, stop eating meat. But given the value she places on the sensual, this simple prescription is likely to backfire. I have heard many people say that, although they recognize the moral value of vegetarianism, they simply cannot bring themselves to give up meat. The problem is not that they are bad people; in fact, some of them strike me as quite admirable people. The problem is that they see vegetarianism as a simple case of sacrifice, of adopting an asceticism that, from the point of view of our subject, may appear both to conflict with other things she values highly and to smack of self-righteousness.

When we are considering what she should do, we need to think about more than what she must give up. We need to think about this in the context of the life she is living and the values she strives to realize through that life. Sensual pleasure is one of these values, and nothing in her new realization about animals suggests that holding such a value is wrong in itself. What is needed is a way of integrating the value that opposes cruelty with the value placed on the sensual: our moral agent needs to find a sensual way to stop eating meat. This might involve starting out by abandoning veal, which is among the morally worst cases, while scanning the menus of her favorite restaurants for overlooked options. It might eventuate in a new enthusiasm for the cheese course, an exploration of Indian food, or the organization of a dinner with friends for which they hire an upscale vegetarian chef for the price of a meal in their favorite French restaurant.

Why should we allow that the moral value of eliminating cruelty may, or even should, be realized gradually and sensually, rather than immediately and in an attitude of sacrifice? First of all, if the moral project is undertaken in

such a way as to satisfy the agent's aesthetic value, there will be little reason for her to backslide, since the void left by what she has given up is filled by other suitably satisfying things. Is this simply virtue for losers—moral development for people too weak to adhere to principles whose force they recognize? I would say, instead, that this sort of view is realistically responsive to facts about us as human beings. Certain structural aspects of our lives and, probably, our minds lead to an erosion, over time, in the salience of morally relevant information (e.g., about the harms associated with factory farming), but not in the salience of our aesthetic values and desires. A moral view that aspires to practical success must take into account what human beings are really like and how they are really motivated.

Here is a second reason to see moral duties as inflected by aesthetic values. People avoid pursuing certain kinds of moral projects, or even acknowledging certain kinds of morally relevant information, because they fear that to do so would require a rather vast restructuring of their lives, or at least a very significant sacrifice of time and energy. Consider the snarl of moral problems evident in Western societies: we are, individually and collectively, using many more resources than we need, contributing to the degradation of the natural environment, causing unnecessary suffering to animals, purchasing goods produced in sweatshops, and allowing human beings in other parts of the world to starve to death and to die of preventable and treatable illnesses. The scale of these problems is vast. Since we are not prepared to modify our lives in the rather extreme ways that would signal that we have fully grasped the seriousness of a particular moral issue, and since doing relatively little does not seem nearly enough, consistency almost seems to demand that we simply refrain from acknowledging the issue in the first place.

But if we accept a gentler approach to moral improvement, one that endorses the attempt to integrate our moral values with our aesthetic values rather than viewing the moral values as trumps, perhaps we can allow ourselves to travel a step or two down the path of moral improvement rather than simply turning away because we are not willing to travel all the way to the destination. If we take these first steps, we may learn that we are capable of doing things we did not expect, or that giving up certain things is not as difficult or unpleasant as we thought. New possibilities may become visible to us, and we may be able, or even want, to take further steps. Perhaps our epicurean subject will find that she can satisfy the value she places in sensual pleasures with fewer visits to restaurants and fewer cashmere suits; and by freeing up the resources formerly devoted to these things, she can more fully realize her moral values. She might learn, over time, that realizing her

moral values is more satisfying than she expected, and she might even come to value sensuality less highly, so that the ongoing restructuring is not felt as a sacrifice at all. She might never have recognized the viability of these choices from her starting position, but they may seem perfectly reasonable, even natural, once she has begun moving in a particular direction.

Moral and Aesthetic Values in the Structure of a Life

Thus far, I have focused on how moral motivation can be enhanced when aesthetic value is harnessed in the service of moral value. There is a larger aesthetic issue at stake in many such cases though. My particular aesthetic preferences are not the only, or the most important, way aesthetic value enters into the composition of my life. My life has an overall structure, including values, commitments, relationships, activities, and behaviors. In my view, it is legitimate for each of us to attempt to structure our lives in ways that makes them good lives for us.[4] When I say it is legitimate, I mean it carries moral weight: the importance to me of living a life that is good for me can outweigh or annul certain other kinds of moral demands.

What counts as a good life in this sense? I cannot give a complete answer here. But some of the structural elements that contribute to a life's being a good one, I suggest, are irreducibly aesthetic in nature. In particular, it appears that a good life will be characterized by

1. Fit between one's personality or character and the projects, activities, and behaviors through which one's values are realized, so that one is not perpetually uncomfortable doing the things that will realize one's values.
2. Narrative coherence over time, which involves the following aspects:
 a. The life structure includes projects, commitments, relationships, and activities to which one adheres in the medium to long term.
 b. The evolution of the structure over time makes sense in light of values that the individual held at various earlier moments.

The fit and coherence exhibited by a structure are essentially aesthetic notions, whether the structure is a building, a work of narrative fiction, or the structure of one's life. I do not mean to suggest that these are the only important qualities that should be realized within the structure of one's life or even that a higher degree of fit or coherence is always an improvement: it is possible, whether in art or elsewhere, to have a structure that suffers from being a bit too balanced, too refined, or too seamless. Diversity, too, is a critical aesthetic feature of a life.

I emphasize fit and coherence because they are crucial in allowing us to feel at ease in our lives and others to feel at ease in theirs (in which we are participants). A life that lacks enduring features that allow us to know what to expect is a life in which we are constantly on our guard. While unpredictability may be an experience that we prize at some moments, a life completely fragmented or unpredictable is one that cannot genuinely be *lived*; it is rather a case of one's being buffeted by forces in a way that makes nonsense of the notion of deliberation about what to do. A life involving ongoing commitments, projects, relationships, and activities, then, is much more likely to be experienced as a good life from within. It also seems more likely to realize one's values successfully; for the realization of values tends to occur through commitments that are sustained over a period.

I have also suggested that a good life is one in which changes in the structure over time make sense in light of the individual's values at earlier moments. This requirement need not lead to undue conservatism. Over a period of years, the evolution of the life structure may lead to an outcome that would not have been predictable given the values the individual held much earlier. Narrative coherence leaves plenty of room for the individual to develop, grow, and change over time.

What is the moral relevance of these ideas about what makes a life good for the person living it? If people have a legitimate expectation of being able to structure their lives to be good in the ways I have described, then morality must be thought of as something that can be integrated and interwoven into a structure whose basic integrity must be preserved over time. And one aspect of moral agency is such integration and interweaving, an essentially creative process that involves the application of aesthetic criteria among others.

This view has implications both for how we should implement moral projects and for what it is reasonable for others to require of us. Moral ideals which demand that we abandon our current life structure typically have very little motivational force, and I suggest that this is due not to moral lassitude on our parts but to the fact that such ideals ignore the moral weight of a life that is worth living for the agent. A classic example is the moral ideal promulgated by Peter Singer in his famous paper "Famine, Affluence and Morality."[5] Singer proposes that an individual give away his goods until he is at the point of being nearly as badly off as the people his actions are helping, perhaps taking only the bare minimum for meals and sleep that would allow him to continue functioning in his helping capacity.

When people first encounter this view, they tend to be incredulous, even when they identify with the obvious and deep compassion for others that it

manifests. The demand that we abandon or demolish the structure of our lives is one that we, as agents already situated within that structure, simply cannot be expected or obligated to accept. A good life for the individual is one that satisfies certain criteria, including aesthetic ones, and these constrain what the individual may be required to sacrifice in pursuit of the good for others.

The moral relevance of aesthetic criteria provides ammunition against incredibly demanding views like Singer's; it also offers hints about how moral improvements are best pursued. When the agent is working from within the structure of her existing life, she should seek projects and activities that fit with other elements of that structure and with her personality and character traits. This means that she may take certain elements of the structure as fixed points, at least provisionally, and aim to work around them or implement them as she develops her moral projects. Moreover, it means that she may, and indeed should, select moral projects based not just on their efficacy in securing the good for others but also on the degree to which they cohere with her personality and existing commitments. She might choose to volunteer with programs aimed at adults rather than children, for instance, to ensure a better fit with her personality and inclinations.

Similarly, this view implies that, in many cases, the blame for an individual's failure to pursue certain morally desirable projects should be mitigated. A person may recognize the great value of public political activism, especially in an age in which many people feel disempowered or apathetic, and may greatly admire those who engage in it. But he may also recognize that such activism involves aspects that would make him profoundly uncomfortable, including a willingness to interact regularly with strangers and engage them in ways that may lead to confrontation. It is legitimate for him to express his moral values, instead, through activities that do not clash with central elements of his personality.

This view might seem to let the agent off the hook too easily. After all, if one recognizes that a particular sort of moral project is especially admirable, should one not strive to be the kind of person who can pursue such projects and ideals? My answer is a qualified yes. The proper response to such situations will sometimes be to set oneself upon a path by way of which, over time, significant changes to both one's personality and the structure of one's life will result. But there are a number of things to keep in mind. First, there are limits on the degree to which personality can be altered, and certain aspects of the life structure may be so central to that life's integrity and to the identity of the person whose life it is that their abandonment cannot be contemplated. Second, both the path and its endpoint may look quite dif-

ferent depending on whose life structure is in question. This means that, for many types of moral claim, it will be wrong to think that they apply universally. Third, the fact that what is advocated is a path or process rather than simply an endpoint, as well as that aesthetic criteria of fit and coherence constrain the nature of the path, is already a significant departure from the prescriptions contained within most moral views. Fourth, this sort of view makes it much more likely that moral motivation will be generated and sustained. Moral and aesthetic values, rather than being in competition, will be mutually reinforcing, which makes it more likely that the moral values will continue to be successfully realized over time.

The Moral Value of Aesthetic Satisfaction

At this point I will introduce another relationship between the moral and the aesthetic, namely, that the pursuit of aesthetic satisfaction is, itself, morally good. I have argued elsewhere that it is possible to cultivate a thoroughgoing aesthetic sensibility that may enhance everyday moments of life, such as time spent in meetings at work or standing in line at the grocery store. Indeed, I think this is a significant part of what certain spiritual traditions, such as meditative varieties of Buddhism, should be seen as advocating.

If we can increase our levels of satisfaction by developing our aesthetic sensibility in this way, then we have self-interested reasons for doing so. But is this morally relevant? I suggest that it is.[6] First, current strategies of pursuing aesthetic satisfaction in industrialized countries tend to involve pernicious patterns of consumption. Purchasing a consumer product leads to short-term satisfaction that erodes quickly and raises the bar for future satisfactions. For this reason, consumers frequently abandon products that are still perfectly usable and devote vast resources to acquiring objects that satisfy their needs either inefficiently or not at all. In addition to the obvious harms to the natural environment, this continually escalating pattern leads people to feel that they have no time, energy, or money to give away: any excess resources may be needed in the future to secure the ever-higher standard of living one will need to feel even partial satisfaction. If we can learn to achieve true aesthetic satisfaction by attending to the rich and diverse stimuli available to us in everyday life, this may free up great quantities of resources for moral projects that benefit others.

The effects of enhanced aesthetic satisfaction in everyday life seem likely to extend beyond the material as well. People whose lives are relatively barren in satisfactions are, it seems, rarely moral exemplars. Those who are in the best position to express compassion, generosity, and other morally admirable traits are those who see the beauty in life, even while they perceive

the suffering of others. Attention to the aesthetic satisfactions available in everyday moments may free people from excessive concern with their own satisfactions so that they can devote more attention to the needs of others.

Conclusion

My aim here has been to argue for a loose-knit collection of claims about the moral relevance of the aesthetic. I have argued that attention to aesthetic values may promote moral motivation, that aesthetic values should be regarded as constraining moral demands, and that the pursuit of aesthetic satisfactions may itself have positive moral value. These arguments suggest that moral thinking should be aesthetically informed to a much greater degree than has been typical. The aesthetic is a central dimension of a good life, and a life's being good for the person living it has considerable moral weight, both in itself and because of the positive consequences for others that stem from it. Moral thinking that neglects aesthetic considerations, then, is likely to result in theories that are deficient not only from an aesthetic but from a moral point of view.

Notes

1. Clive Bell, *Art* (New York: Frederick A. Stokes Company, 1913).

2. Sherri Irvin, "The Pervasiveness of the Aesthetic in Everyday Experience," *British Journal of Aesthetics* 48 (2008): 30–31.

3. Lawrence Blum, *Moral Perception and Particularity* (New York: Cambridge University Press, 1994), 183.

4. There are some limits to this. Perhaps there are pedophiles for whom nothing but a life including child sexual abuse could be experienced from the inside as a "good" life, and in such a case it would not be legitimate for them to pursue this form of life.

5. Peter Singer, "Famine, Affluence, and Morality," *Philosophy and Public Affairs* 1 (1972): 231.

6. Irvin, "Pervasiveness of the Aesthetic," esp. 41–42.

⟨∞⟩

Further Reading

Anderson, John, and Jeffrey Dean. 1998. Moderate autonomism. *British Journal of Aesthetics* 38: 150–66. Defends the idea that ethical and aesthetic value in art are mutually independent of each other.

Carroll, Noël. 1996. Moderate moralism. *British Journal of Aesthetics* 36: 223–37. Argues that the ethical dimension of a work sometimes has a bearing on its aesthetic value.

———. 2000. Art and ethical criticism: An overview of recent research. *Ethics* 110: 350–87. Just what the title says.

Eaton, Marcia. 2001. *Merit, aesthetic and ethical*. Oxford: Oxford University Press. A wide-ranging exploration of the interaction between ethical and aesthetic value.

Gaut, Berys. 2007. *Art, emotion and ethics*. Oxford: Oxford University Press. A book-length defense of the idea that works are aesthetically better insofar as they are ethically meritorious and aesthetically worse insofar as they are ethically defective.

Hyman, L. 1984. Morality and literature: The necessary conflict. *British Journal of Aesthetics* 24: 149–55. An argument for the autonomy of aesthetic value.

Jacobson, Daniel. 1997. In praise of immoral art. *Philosophical Topics* 25: 155–99. An argument that moral defects sometimes make works artistically better.

John, Eileen. 2006. Artistic value and opportunistic moralism. In *Contemporary debates in aesthetics and the philosophy of art*, edited by Matthew Kieran, 332–41. Oxford: Blackwell. Another argument for the immoralist thesis.

Kieran, Matthew. 2001. In defense of the ethical evaluation of narrative art. *British Journal of Aesthetics* 41: 26–38. Argues that the ethical dimension of a work is relevant to its evaluation as art.

———. 2003. Forbidden knowledge: The challenge of immoralism. In *Art and morality*, edited by J. Bermudez and S. Gardiner, 56–73. London: Routledge. Another argument for immoralism.

Levinson, Jerrold, ed. 1998. *Aesthetics and ethics*. Cambridge: Cambridge University Press. An important collection of essays on the topic.

Lopes, Dominic. 2005. *Sight and sensibility*. Oxford: Oxford University Press. An exploration of the value of visual art, including the interaction of its ethical and aesthetic dimensions.

Nussbaum, Martha. 1990. *Love's knowledge*. Oxford: Oxford University Press. Essays on the ethical value of literature.

Stecker, Robert. 2005. The interaction of aesthetic and ethical value. *British Journal of Aesthetics* 45: 138–50. An argument for interaction.

———. 2008. Immoralism and the anti-theoretical view. *British Journal of Aesthetics* 45: 145–61. Argues against the immoralist position.

CHAPTER TWELVE

~

The Humanly Made Environment

Introduction

Planning your first visit to the East Coast of the United States, you are especially excited to visit New York City. Making a list of the major sites that you plan to visit, you begin with the Empire State Building, the Statue of Liberty, and Ground Zero. As an art lover, you naturally plan to see a play on Broadway and will visit the Metropolitan Museum of Art. Your first morning in the city, you catch a cab from your hotel to the museum. Upon arriving, you find yourself overwhelmed by the sheer size of the building, by the eight massive columns flanking its doors, and by the imposing staircase leading up to them. However, you find you have arrived a few minutes before the museum opens. Realizing that it is located on the edge of Central Park, you decide to take a short stroll along one of the paths that lead into the park. Although you enjoy the beauty of the mature trees, they are not impressive in quite the same way as the columns along the museum's facade. Yet the tranquility of the meadows, ponds, and woods provides a peaceful contrast with the bustle of the heavy traffic along Fifth Avenue. You soon retrace your steps to the museum, eager to see the originals of so many paintings that you have discussed in your art history class.

Only later, reading your guidebook, do you learn that Central Park is a completely artificial, human-designed environment—largely the work of landscape architect Frederick Law Olmsted. You now realize that you experienced the park while operating under the mistaken assumption that, apart from the paths, benches, and other human products, it was a slice of nature

preserved in the city. Yet it was no less designed for effect than the museum building itself.

Continuing your visit to cities in the Northeast, you visit Boston and then the adjacent city of Cambridge, where you plan to see Harvard University. On the way to the Harvard campus, you pass the Massachusetts Institute of Technology (MIT). Much of MIT seems drab. It does not match the stereotypical major university, which Harvard's stately red-brick buildings and well-groomed lawns better exemplify. You find particularly surprising the jumbled, thrown-together look of one cluster of buildings at MIT, which turns out be the Ray and Maria Stata Center. Designed by architect Frank Gehry, the center opened in 2004 as home to engineering and computer science. The single building misleads viewers by looking like a cluster of distinct buildings, an effect enhanced by the eclectic and somewhat whimsical mix of colors used for its different parts. A further lack of unity arises from the different materials covering different segments of the building. Furthermore, where most buildings have exterior walls that rise straight into the air at a ninety-degree angle from the ground, some random segments of the Stata Center are rounded. Many more are sharply angled. Some even rise from the ground slanting inward, then suddenly change direction and slope outward, as though a giant had punched the building, collapsing it toward the middle.

Many people think that the Stata Center looks like a random mess. Others insist that its tossed-together appearance is symbolically liberating for its occupants, conveying a no-rules invitation to creativity in their teaching, learning, and research.

However, the center's unusual appearance is not its only claim to fame. Cambridge is subject to some harsh winter weather, including snow and ice. Three years after the center opened, MIT sued both the construction firm and the building's architect for significant damages. MIT alleged that the center's faulty design and construction led to cracks, drainage problems, leaks, and falling snow and ice, which blocked exits. Gehry, the architect, was sensitive to the issue of snow and ice in relation to the steep angles on the exterior. He has publicly said that the snow and ice problems are due to the school's decision to save money by eliminating some design elements.

According to principles articulated by Gordon Graham, the Stata Center is an architectural failure, as is any building that fails to satisfy its users. Although it may succeed as spatial design and thus as a work of art, that is not enough. Buildings are essentially functional objects. Design and construction problems cannot be excused in the way that they can for paintings and music. Suppose that someone commissions a portrait and then thinks that the finished painting is a poor likeness. Is the painting necessarily a failure? Suppose that a composer writes ballet music, but the choreographer rejects

the music because it does not last long enough to showcase the central character, to be danced by a famous ballerina. Has the composer failed? Graham suggests that the painting and the music might still succeed aesthetically, as works that merit attention for themselves. Thus, architecture is fundamentally different from the other fine arts. At the same time, the fact that buildings are not sculptures must be balanced against the recognition that the designed appearance of a building invites scrutiny for what it communicates about that building's intended function, as well as about the people who will use it. And the best buildings will do something further: when functionally successful, they will also expand our understanding of how such a building can function.

Extending these insights to other planned, functional spaces, we might revisit New York's Central Park with an eye to what it says about New Yorkers. Is there, for example, a determinate function for public spaces to guide our evaluation? Or, more narrowly, is there a determinate function for public parks? More narrowly again, is it a distinctively *American* public park?

Graham and Roger Scruton are alike in being highly critical of much modern architecture and the thinking behind it. However, Scruton differs from Graham in two important ways. First, Scruton is suspicious of the idea that individual architects should be awarded the same status as great painters and composers. Rembrandt and Beethoven displayed creative genius, for both brought an element of genuine revolution to their respective art forms, overturning inherited traditions and liberating future practice. Agreeing with Graham that architecture is necessarily functional, Scruton proposes that architecture has at least eleven fundamental principles that cannot be violated or overturned. So there is little room for creative genius in architecture—at least not genius on the scale permitted in the other arts. Architects are most like other artists in their symbolic activity, which, with buildings, is primarily a matter of designing the facade, or "face," that a building presents to the passerby. Scruton sees a building as a public gesture and asks us to evaluate it as such. Given that most people find the look of the Stata Center shocking, does it contribute to a positive civic experience, or does it encourage civic division?

Second, Scruton notes that most buildings will serve many functions, and to think of the special cases (e.g., the Metropolitan Museum of Art) is to ignore the need to design most buildings with a facade that does not symbolize any particular use. What will the exterior of the Stata Center signify if the building is later used for some very different purpose? Would it, for example, present a suitable facade for a law school?

Allen Carlson suggests that Graham and Scruton are far too generous in regarding architecture as a fine art, even if as a very special case. They make too much of the tensions between functionality and symbolism that come

from viewing the human-made environment through the lens of fine art. Carlson draws on his work with the aesthetics of nature and recommends dissolving the supposed tension by adopting an ecological perspective. Not surprisingly, Carlson also warns that traditional thinking puts too much emphasis on appreciating individual buildings.

Carlson's analysis is initially much like Scruton's. Both insist on viewing buildings as culturally embedded human environments. But then, Carlson asks, why stop with buildings? In this respect they are no different from all the other designed objects in the human-built "landscape." Buildings, utility poles, and roadways all work together in an integrated, designed human environment. Each object functions by fitting into a larger system. Should they not *all* be evaluated accordingly? There is no more reason to identify and appreciate projects by "name" figures—Frank Gehry and Frederick Law Olmsted—than to single out an individual utility pole for aesthetic contemplation. All questions of aesthetic merit and human expression should be subordinated to the issue of functional fit within a framing environment. The mere appearance of functional success—a street with a pleasing series of facades, for example—must give way to a concern for genuine functional fit.

In concluding with Carlson, we come full circle back to our opening consideration of natural beauty. In the same way that Carlson thinks we are in no position to appreciate a dandelion if we view it in ignorance of its environmental consequences, he challenges us to bring an equally informed perspective to our encounter with every object in our lived environments.

So, is there any object or environment, natural or human designed, that does not merit aesthetic scrutiny?

Art and Architecture*

Gordon Graham

I

"Is architecture an art?" This question may seem an odd one. Surely, it may be said, there cannot be any doubt. Our ordinary ways of thinking and speaking place architecture among the arts no less than music or drama, a practice that even the briefest visit to the extraordinary buildings of the Italian Baroque, for

* "Art and Architecture," *British Journal of Aesthetics* 29:3 (1989): 248–57. Reprinted by permission of Oxford University Press.

instance, will confirm. But the question of the precise status of architecture is not so easily settled, just because its classification as an art appears to conflict with another feature which is commonly taken to be its distinguishing mark, and which sets it off from the other arts, namely its practicality. Writers on architecture as far back as Vitruvius have observed that good building must have a practical as well as an aesthetic aspect, and be alive to changing needs and technologies as much as elegance and geometrical form.

Architecture is useful in a way that all the other arts are not. That is to say, the architect's products are essentially functional, whereas those of the painter and musician are not. It is important to be clear about this difference, however. Music and painting can serve practical purposes; the sound of an orchestra can be used to drown out a baby crying, and a painting can be used to cover a crack in the wall. Such uses are not intrinsically related to the character of music or painting as art, it is true, but more aesthetic purposes may also be served. Incidental music can perform an important function in the theater and cinema, and the designer and painter of stage sets may contribute a great deal to the overall artistic effect of a drama or an opera. Since this kind of use for painting and music constitutes an aesthetic function it cannot be viewed as contingent in the same way that the earlier examples can.

Nevertheless, in neither case can the purpose served be regarded as essential, because even an aesthetic function is something in the absence of which the music and the painting can survive. We can listen to incidental music for its own merits and not merely for the contribution it makes to the play (Mendelssohn's music for A Midsummer Night's Dream is a good example), and stage sets and backdrops, though not often exhibited as works of art in their own right, clearly could be. More importantly for present purposes, we might prefer to listen to or look at such things in isolation from their original context, because they had greater artistic merit on their own (as is the case with Schubert's Entr'act from Rosamunde, for instance).

This possibility is important, because it shows that where music or painting are given a function, even an aesthetic one, both can fail to satisfy that function and yet continue to have artistic merit. Music that does little or nothing to intensify the drama for which it is written may nevertheless succeed as music. What this shows is that even aesthetic functions in music and painting can be abandoned without loss to their essential character as worthwhile objects of aesthetic attention. And the same can be said for sculpture, drama, literature, and so on.

But the same cannot be said for architecture. Whatever else the architect does, he builds, and this means that he necessarily operates under certain functional constraints. A building which fails in the purpose for which it is built

is an architectural failure, whatever other merits it might have. The simplest mark of such failure is that the building falls down, but there are many more of greater interest. The architect who designs a house in which comfortable and convenient living is virtually impossible has failed, however attractive his building may appear in other respects, and the same is true of those who build office blocks, hospitals, universities, factories, and so on. In every case, the building must satisfy a user, whose purpose is something other than merely admiring the building. This means that what the architect, unlike other artists, aims to produce must have a use other than an aesthetic use and one which, importantly, it cannot fail to satisfy without losing its merit as architecture.

II

This last remark might be disputed. Why must a building have purpose? Surely there are buildings—the temples which decorate eighteenth-century gardens for instance—with no purpose at all? Someone might expand this sort of example by saying that the purpose of some architecture is mere ornamentation, constructed solely to be admired and enjoyed, and not for any other more utilitarian reason. This rather suggests that architecture can be engaged in for its own sake, just as the other arts are, and though it may be relatively rare for buildings to be erected for this reason, this is just a matter of empirical fact. It might as easily be the case that almost all the music we have was composed with a view to performing a certain function.

But the case for functionless architecture cannot be made out so easily. The ornaments of the eighteenth century are clearly parasitic; they are delightful copies of buildings whose original purpose was not merely to delight. Moreover, even in these cases we are admiring *buildings*. When we admire a building, we cannot merely be admiring how it looks, for if we were, however large, it would be indistinguishable from a piece of sculpture. Sculpture, I take it, is essentially three dimensional—to appreciate it we need to walk round it, to see it from different angles in order to appreciate its proportions and so on. Architecture aims at something more than this, and consequently it is not enough for a building to be elegant. This point is confirmed by the fact that, though many ruins are impressive pieces of architecture from a distance, it would not have done for the architect to have built them that way.

Let us agree, then, that architecture is a useful art, and further, that it *must* be useful while other arts only have the possibility of usefulness. This conclusion is important because it raises another side of the question. If architecture is useful, wherein lies its art? To conclude that architecture is essentially useful is surely to concede that it is craft and not art at all. If a building has to perform a given function, and performs it well, what can it matter whether

it also possesses the sort of attributes that would normally be associated with a work of art?

We can put the issue most plainly by employing the familiar distinction between form and function. Music and painting, though they may have functions, are also interesting for their form, and often for their form alone. Buildings, on the other hand, must have a function. If, however, that function is satisfied by a variety of forms, how can it matter from the architectural point of view which of these forms the building takes? To put the question this way, of course, presupposes that there is such a thing as "the architectural point of view." Perhaps rather it is the case that *both* form and function matter, independently, and that the architectural point of view is best thought of as a fusion of different interests and considerations. This is the view expressed by a seventeenth-century Provost of Eton, Sir Henry Wooton, for instance, who wrote that "well-building has three conditions: firmness, commodity and delight," and no doubt there is something right about this. The question, however, is just how the first two and the third might be related.

There appear to be two possibilities. Either form and function in architecture are quite independent and are simply held together contingently by the fact that some of those who build functional buildings also care about their form artistically considered, or form and function in architecture are more intimately related in some way.

III

Consider the first possibility. Can we build in such a way that form and function are divorced, but given equally close consideration? Sometimes it seems that we can. For instance, Orchestra Hall in the city of Minneapolis is a building which aspires to this sort of separation. The inside was designed independently of the outside and in designing it the dominant consideration was the functional one of acoustic. Consequently, behind the stage there are large blocks projecting at odd angles from the wall, and though these may well be regarded by many concertgoers there as an unusual, if somewhat extravagant, decorative feature, their purpose is not aesthetic at all but the absorption and reflection of sound. Around this acoustically designed hall an outer shell has been erected, and in its case the sole consideration has been aesthetic form, which is to say, how it looks to the nonconcertgoing observer who cares nothing for its function and hence for its interior.

One can imagine objections to building in this way. A building ought to have a unity, it might be said. But if those who want to go to concerts and those who want their city embellished by impressive buildings are both satisfied, the architect can claim to have done all that can be done.

A more modest claim would be that buildings in which form and function are unified are better than those in which they are divorced, because the kind of building we have been considering constitutes a sort of fraud or deception. This is the thought, one imagines, which lies behind objections to facades and similar forms of ornamentation. In the days when bankers sought greater respectability than was usually associated with the borrowing and lending of money, banks were erected for this purpose only to be clad with an imposing facade lifted from buildings erected for some quite other purpose. The same sort of phenomenon is to be found in a great deal of postrevolutionary architecture in the USA, where classical styles were used to lend the new republic the appearance of a political solidity it did not really enjoy. In this the architectural styles of the temples of the ancient world were "robbed" of their outward appearance by those who had neither use nor sympathy for the religious purposes which had generated them.

I do not think it excessively high-minded to think that the copying of styles and the extensive use of facades is in a sense deceptive and intended to be so. The point of building in this way, after all, has generally been to make things seem other than they are. Nor, consequently, is it fanciful to think that, other things being equal, such deception is better avoided, if it can be.

It might be agreed that facades are better avoided, and yet at the same time denied that architecture should not pursue its different concerns separately. Not all ornamentation is facade. But the argument against facades is in fact easily extended. If a building can show its structure in an aesthetically satisfying way, other things being equal, this is better than if its structure has to be hidden or elaborately adorned to attain the same effect. Some such principle has commended itself to generations of architects, most notably perhaps those responsible for the Gothic revival of the nineteenth century.

We may conclude on the strength of the argument so far, then, that an architecture in which form and function are treated separately may be said to be deficient just in the sense that there is reason to regard a more unified architecture as preferable. This brings us then to a direct consideration of the alternative—that form and function in architecture may be more intimately related.

Initially, at any rate, there appear to be two possibilities here also. Either form follows function, or form determines function. The first of these, of course, is recognizable as an architectural slogan, one coined by the American architect Louis Sullivan in fact, though it expresses a sentiment that had informed architecture on both sides of the Atlantic since the Gothic revival. What this reveals is that we are dealing here with normative views, views of how architecture ought to proceed, and this explains the campaigning

zeal with which functionalism and its alternatives were promoted amongst architects themselves, a zeal most clearly displayed in Adolf Loos's remark that "ornamentation is crime."

In short, the attempt to conceive of architecture as an art form with its own integrity is an attempt to arrive at a normative conception, and the criticism of any such attempt should consider its merits as an ideal. Let us, then, consider both proposals in this light.

IV

Form follows function—the function should determine the form. This is another way of saying that how a building is constructed must depend on what it is used for. There is some obvious truth in this. A school which was so organized that it made teaching virtually impossible—voices did not carry, the blackboard could not be seen, and so on—would be an architectural failure. But though close attention to function will determine many features of the building it cannot determine them all. For instance a school serves its function just as well, other things being equal, whether yellow or red brick is used for its walls. And even more ambitious features of a building may remain indeterminate even when the demands of function have been, apparently, satisfied.

The inability of function fully to determine form is in fact illustrated by many of the buildings which the aspiration informed. Take, for instance, the Houses of Parliament in London. The competition to replace the buildings destroyed by fire in 1834 was won by Charles Barry. But the government decided that the Parliament building should express the sort of Englishness associated with Elizabethan and Jacobean styles, about which Barry was somewhat ignorant. As a result he called upon Augustus Pugin to design a very great deal of the detail, and it is this detail that gives the building its distinctive and memorable character. But none of this detail is in any sense required by the fact that this was to be a legislative assembly. No doubt the number of seats, and offices, and supplementary service rooms was determined by the original brief, and perhaps the natural demands which the voice makes upon a debating chamber were also important. There is a great deal of latitude in the satisfaction of these demands, however, and the point is that Pugin's contribution, far from being functional, is an embellishment of a structure which might have been embellished in other ways and yet served its function, including its expressive function, equally well.

Form, then, cannot simply follow function, for too often a grasp of function leaves too many issues undecided. Sometimes people have been inclined to deny this, if only we are prepared to accept simple buildings—the sort of

stark and unadorned building associated with Modernism. In fact, however, there are two errors here. The failure of function to determine form is a logical failure, not the practical one of ignoring simplicity, and the sort of simplicity to be found in Modernist buildings arises not from functionalism, but its opposite, the belief that function should follow form.

V

The principal influence on Modernist architecture was, of course, Charles-Edouard Jeanneret, better known by his pseudonym Le Corbusier. Le Corbusier was himself a painter and his conception of architecture, which he contrasted with mere "building," is of a pure art which explores space and shape through the medium of construction. Its relation to function is essentially creative and revisionary. In his designs the architect does not take the function of a building as preconceived and given, but as something which is itself molded by the form of the building. In this light, the architect becomes not merely the observer and server of socially ordained functions, but the creator of new ones.

The influence of this line of thought was most marked in the design of housing. The point at the heart of this school of thought was not to accept but to create a conception of living. The relative simplicity of the style and lack of ornamentation arose not from a desire to let function determine form, but from a realization, and confinement, of function within geometrically simple forms.

The influence of this conception of architecture was immense. It even reversed the roles of architect and client in accordance with its theories, for whereas formally clients had decided what sort of building they wanted and found someone to build it, increasingly they turned to architects to tell them what sort of building they ought to want. But the result, as almost everyone now concedes, was widespread failure to satisfy need. Houses and apartment blocks were built which no one wanted to, or could, live in, and gigantic offices created in which working conditions were often intolerable. This sort of failure was illustrated most dramatically in 1972 when the Pruitt-Igoe flats in St. Louis, which had won an award from the American Institute of Architects only seventeen years before, were blown up at the request of the residents because they had proved impossible to live in.

This failure arises at least in part from a conceptual flaw in the central idea behind Modernism. Whatever form we give a building must in part be determined by its function, whether consciously or not. No artistic conception, however brilliant, can make a multistorey car park into a dwelling

place because people being the creatures they are want and need shelter. But, and this is the other side of the flaw—a multistorey car park could have a design which explores volume and space in a manner so striking that it thoroughly alters our idea of what a car park could be. In short, form can no more determine function exhaustively than function can determine form.

VI

We have now considered three possibilities, first that form and function in architecture may be treated quite separately, secondly that form must follow function, and thirdly that architectural form can itself establish functions. Interpreted as normative principles of architecture, none of these has proved wholly satisfactory. The most we can say is that a style of architecture which satisfies both functional and aesthetic considerations and has a greater unity is intelligible as an ideal, and one to which many generations of architects have aspired.

In considering this ideal more closely, however, it is not easy to see just how form and function might be unified. Form must in part be determined by preconceived function, but can never be wholly so, and while architectural forms can enlarge our ideas of how given functions may be satisfied, they cannot create them from scratch. What we want, then, is architecture in which form and function are not wholly independent concerns, but in which neither can be subsumed under the other. Ideally form and function in architecture must complement each other, and one way in which this might be accomplished is through a style of building which not only serves but also expresses the function.

How might the form of a building, i.e., its design and appearance, express the function it is intended to serve? How can architectural features convey ideas?

At least part of this problem arises from the fact that in many cases the ideas of function involved just seem the wrong sort of thing to be expressed in building style. How could St. Pancras railway station, though undoubtedly impressive, sensibly be thought to express the idea of traveling by train? And besides this there is a further question about what exactly the idea to be conveyed is. Should St. Pancras say "traveling by train" to the spectator, or just "traveling," or even more abstractly "movement"? It is not so much that we find it difficult to answer these questions but that they seem inappropriate questions to raise.

The ease with which these difficulties are raised and absurdities imagined, however, may blind us to real possibilities. It is not absurd to think that a

building might express some ideas—grandeur or elegance, for instance—and not too difficult to connect these with the function a building might have. For instance the Marble Hall in Holkham Hall, Norfolk, is rightly described as both elegant and grand, a rather fine blend of classical and Baroque styles in fact, and its purpose just was to allow both guests and hosts to display their elegance and grandeur.

But yet more plausible as examples of buildings which express ideas closely associated with the function they are intended to serve are the mediaeval churches of Western Europe. It has been pointed out many times that everything about a Gothic cathedral, but especially the spire, draws our attention upwards, just as the minds and souls of those who worship in it should also be drawn upwards. The nave must fill those who stand in it with a sense of how small and fragile they themselves are, an attitude singularly appropriate for those entering the presence of God. And similar remarks can be made about church architecture of other periods, and this is enough to show that, at its finest, architecture can unify form and function in this way—the form can express as well as serve function.

VII

We may conclude, then, that in the terms of the discussion set down here architecture can indeed be an art. That is to say, we can conceive of, and have reason to aspire to, an architecture in which neither form nor function is subservient, but in which the two are not divorced either, and moreover we can find examples of existing buildings which realize something of this ideal. To say that the ideal is possible, however, is not to say that it is common, or even that it is everywhere desirable. There will always be building that serves its function quite adequately but which is not specially imaginative or attractive, and no doubt there will always be architects, like the Neo-Classicists in America, who give stylistic considerations precedence over those of convenience. More importantly, though, there will always be building in which equal but independent attention is given to form and function, and which results in buildings that are pleasant to use and which enhance the built environment. Perhaps the most we should hope for, in fact, is that most architecture is of this sort, for it is precisely aspirations, such as Le Corbusier's, to an architecture which is more than mere building, which has led very often to inconvenient and unattractive buildings.

Nevertheless, what the argument has shown is that architecture can be something more than good design, though the chief interest in understanding just what more is possible may lie not so much in directing future aspirations as a better appreciation of existing glories.

c∞ɔ

Architectural Principles in an Age of Nihilism*

Roger Scruton

The search for objective canons of taste has often proved to be the enemy of aesthetic judgment. By pretending to an authority which cannot reasonably be claimed, this search provokes an original rebellion against the Father. Repudiating the dictatorship of one law, the rebellious offspring refuses to accept the advice of any other and opts for an aesthetic anarchy, rather than submit once again to a discipline which had become intolerable to him. At the same time he stands more in need of this discipline than ever: and the greater the rebellion, the more implacable the need.

The tale is familiar, and its lesson is one that man is destined not to learn, or to learn only when the price of disobedience has been paid. But let us, for all that, draw the lesson, since debates about modern architecture are futile otherwise. Just as we should not look for more objectivity in any study than can be obtained from it, so should we not be content with less. The substance of aesthetic judgment lies in feeling, imagination, and taste. But this subjective matter is objectively formed: it is brought to the forum of discussion, and given the status and the structure of a rational preference. Hence there is both the possibility, and the necessity, of aesthetic education. The disaster of modern architecture stems from a misunderstanding of this education, and a disposition to discard the true disciplines of the eye and the heart in favor of a false discipline of the intellect.

Of course, the aesthetic preference, like any human faculty, may remain infantile and unexamined. In architecture, however, there is special reason to resist the pleasure principle. The person who builds imposes himself on others, and the sight of what he does is as legitimate an object of criticism as are his morals and his manners. It is not enough for an architect to say, I like it, or even, I and my educated colleagues like it. He has to *justify its existence,* and the question is whether he and his colleagues are right.

The search for some kind of coordination of tastes is forced on us by our nature as social beings. It may seem strange to describe aesthetic values as solutions to a "coordination problem." In architecture, however, they are that, and more besides. Through aesthetic reflection we endeavor to create a world in which we are at home with others and with ourselves. That

* From *The Classical Vernacular: Architectural Principles in an Age of Nihilism* (Manchester, UK: Carcarnet Press, 1994). Copyright © 1994 by Roger Scruton. Used by permission of the author.

is why we care about aesthetic values, and live wretchedly in places where they have been brushed aside or trampled on. Man's "estrangement" in the modern city is due to many causes besides modern architecture. But who can deny that modern architecture has played its own special part in producing it, by willfully imposing forms, masses, and proportions which bear no relation to our aesthetic expectations and which arrogantly defy the wisdom and achievement of the past?

What was primarily wrong with modernism was not its rigidity, its moralizing, its puritanical zeal—although these were repulsive enough. Modernism's respect for discipline was its sole redeeming feature: but it was a discipline about the wrong *things*. It told us to be true to function, to social utility, to materials, to political principles. It told us to be "of our time," while enlisting architecture in those insolent experiments for the refashioning of man which have threatened our civilization with such disaster. At the same time, modernism threw away, as a worthless by-product of the past and a symbol of its oppressive rituals, the *aesthetic* discipline embodied in the classical tradition.

Postmodernism is a reaction to modernist censoriousness. It "plays" with the classical and gothic details which were forbidden it by its stern parent, and so empties them of their last vestiges of meaning. This is not the rediscovery of history, but its dissolution. The details with which it plays are not the ornaments it takes them for: their significance is that of an order which lies crystallized within them, and to use them in defiance of that order is to undo the work of centuries. Instead of the unbending rectitude of modernism, we are given the self-service life-styles of the moral playground. We are now even further from the discipline-in-freedom that we need.

Where, then, should we look? In what laws or principles should the aesthetic choice be grounded, and how can those laws and principles be justified to the person who does not share them? The practice of good architecture depends upon the presence of a motive, and that motive is not given by the philosophy which recommends it. It comes to us through culture—in other words, through a habit of discourse, submission, and agreement which is more easily lost than won, and which is not detachable, in the last analysis, from piety. If Ruskin is to be esteemed above all other critics of architecture it is not for his judgments (many of which were wrong, and all of which were eccentric), but for his elaboration of that truth. It is partly the failure to read Ruskin which explains the widespread conviction that the materials, the forms and the work of the builder can be understood by anyone, whatever the condition of his soul.

Nevertheless, all is not lost. It is possible for a civilization to "mark time" in the absence of the spirit which engendered it. It is by learning to "mark time" that Western civilization has endured so successfully since the Enlightenment. Our civilization continues to produce forms which are acceptable to

us, because it succeeded in enshrining its truth in education. An astonishing effort took place in nineteenth-century Europe and America to transcribe the values of our culture into a secular body of knowledge, and to hand on that knowledge from generation to generation without the benefit of the pulpit or the pilgrimage. Nowhere was this process more successful than in the field of architecture. All the busy treatises of the Beaux-Arts, of the Gothic, Greek, and Classical revivalists, of the critics and disciplinarians of the syncretic styles, had one overriding and urgent concern: to ensure that a precious body of knowledge is not lost, that meaning is handed down and perpetuated by generations who have been severed from the inner impulse of a justifying faith. And, looking at the nineteenth-century architecture of Europe and America, who can doubt the success of their endeavor?

The most important change initiated by the modern movement was to wage unconditional war on this educational tradition. Certain things were *no longer to be studied*. Architects now emerge from schools of "architecture" unable to draw (either the human figure, on the perception of which all sense of visual order depends, or even the forms of building); they are, as a rule, ignorant of the Orders of classical architecture, with no conception of light and shade, or of the function of moldings in articulating them, and without any idea of a building as something other than an engineering solution to a problem stated in a plan. That result is a natural consequence of the program of "reeducation" instituted by Le Corbusier and the Bauhaus. We should not be surprised, therefore, if the efforts of the reeducated architect are so seldom attended with success.

I wish to record and endorse some of the principles which informed the education of the nineteenth-century architect, in the course of which they have acquired more nuances than I need here repeat. My procedure will be to lay down eleven *fundamental* principles, and then to throw down a challenge to those who would reject them. Finally, I shall add eleven more specific principles, whose authority is less obvious.

1. Architecture is a human gesture in a human world, and, like every human gesture, it is judged in terms of its meaning.
2. The human world is governed by the principle of "the priority of appearance." What is hidden from us has no meaning. (Thus a blush has a meaning, but not the flux of blood which causes it.) To know how to build, therefore, you must first understand appearances.
3. Architecture is useful only if it is not absorbed in being useful. Human purposes change from epoch to epoch, from decade to decade, from year to year. Buildings must therefore obey the law of the "mutability of function." If they cannot change their use—from warehouse to garage, to church, to apartment block—then they make room for other buildings

which can. The capacity of a building to survive such changes is one proof of its merit: one proof that it answers to something deeper in us than the transient function which required it.

4. Architecture plays a major part in creating the "public realm": the place in which we associate with strangers. Its meaning and posture embody and contribute to a "civic experience," and it is against the expectations created by that experience that a building must be judged. Of all architectural ensembles, therefore, it is the street that is the most important.

5. Architecture must respect the constraints which are imposed on it by human nature. Those constraints are of two kinds—the animal and the personal. As animals, we orient ourselves visually, move and live in an upright position, and are vulnerable to injury. As persons we live and fulfill ourselves through morality, law, religion, learning, commerce and politics. The reality and validity of those personal concerns can be either affirmed or denied by the architecture that surrounds us, just as our animal needs may be either fulfilled or thwarted. Buildings must respect both the animal and the personal sides of our nature. If not, they define no place for our habitation.

6. The primary need of the person is for values, and for a world in which his values are publicly recognized. The public realm must permit and endorse either a recognized public morality, or at least the common pursuit of one.

7. The aesthetic experience is not an optional addition to our mental equipment. On the contrary, it is the inevitable consequence of our interest in appearances. I see things, but I also see the meaning of things, and the meaning may saturate the experience. Hence appearance becomes the resting place of contemplation and self-discovery.

8. The aesthetics of everyday life consists in a constant process of adjustment, between the appearances of objects, and the values of the people who create and observe them. Since the common pursuit of a public morality is essential to our happiness, we have an overriding reason to engage in the common pursuit of a public taste. We must never cease, therefore, to seek for the forms that display, as a visible meaning, the moral coordination of the community.

9. A beautiful object is not beautiful in relation to this or that desire. It pleases us because it reminds us of the fullness of human life, aiming beyond desire, to a state of satisfaction. It accompanies us, so to speak, on our spiritual journey, and we are united with it by the same sense of community that is implied in the moral life.

10. Taste, judgment and criticism are therefore immovable components of the aesthetic understanding.
11. All serious architecture must therefore give purchase to the claims of taste. It must offer a public language of form, through which people can criticize and justify their buildings, come to an agreement over the right and the wrong appearance, and so construct a public realm in the image of their social nature.

Here I shall pause to take stock. What I have said can be defended only by defending a whole culture, and the way of life that has grown within it. To those who despise that culture, or who have lost all sense of its validity, I can make no appeal. Yet, if they have lost the culture of their forefathers, the onus is on them to replace it, and not on me to persuade them that they are wrong. The great discourses of architecture—Alberti, Serlio, Palladio, Ruskin—were written from a standpoint within the culture to which we are heirs.

With that I shall move from my eleven abstract principles to the eleven derivative principles which would form the basis of a pattern book in the Kingdom of Ends.

12. The problem of architecture is a question of manners, not art. In no way does it resemble the problem which confronted Wagner in composing *Tristan*, or that which confronted Manet and Courbet when they endeavored to paint the modern world as it really seems. Such artistic problems faced by people of genius demand upheavals, overthrowings, a repudiation or reworking of traditional forms. For this very reason the resulting stylistic ventures should not be taken as prescriptions by those lesser mortals whose role is simply to decorate and humanize the world.

 The problem of architecture is addressed to those lesser mortals—among whom we must count the majority of architects. For such people to model their actions on an idea of "creativity" taken from the great triumphs of modern art is not only a supreme arrogance: it constitutes a public danger against which we should be prepared to legislate. Our problem is this: by what discipline can an architect of modest ability learn the aesthetic decencies? The answer is to be found in aesthetic "constants," whose value can be understood by whomsoever should choose to build.

13. The first constant is that of scale. To stand in a personal relation to a building, I must comprehend it visually, without strain, and without

feeling dwarfed or terrorized by its presence. Only in special circumstances do we take pleasure in buildings of vast undifferentiated mass (like the pyramids of Egypt), or of surpassing height. The spires of a Gothic cathedral, the competing towers of Manhattan: these clusters of stone and glass in flight, which start away from us like enormous birds, are rare achievements, in one case designed, in the other arising by an invisible hand from the pursuit of commerce. They delight us by defying our normal expectations. If the cathedral does not frighten us, it is because it is an act of worship: an offering to God, and an attempt to reach up to him with incorruptible fingers of stone. But that which thrills us in Manhattan also disturbs us: the sense of man over-reaching himself, of recklessly extending his resources and his aims. And the massive weight of the pyramids strikes us with awe: time stands still in these blocks of stone, trapped in an airless coffin beneath a terrifying monolith.

Such constructions cannot serve as models for the ordinary builder, in the circumstances of daily life. A building must face the passerby, who should not be forced to look up in awe, or to cringe in humility, beset by a sense of his own littleness.

14. Buildings must therefore have facades, able to stand before us as we stand before them. It is in the facade that the aesthetic effect is concentrated. In addition to destroying old-fashioned decencies of scale, modernism also abolished the very concept of the "face" in building. The modernist building has no orientation, no privileged approach, no induction into its ambit. It faces nothing, welcomes nothing, smiles and nods to no one. Is it surprising that we are alienated?

15. It follows that the first principles of composition concern the ordering of facades. But to establish such principles we must break with the tyranny of the plan.

The "diseducated" architect is not, as a rule, sent out into the world to study its appearance. He is put before a drawing board and told to plan. The result is the "horizontal style"; the style, or lack of it, which emerges from composing in two-dimensional layers. This style has generated the major building types of modernism.

Its bad manners can be attributed to four causes, all of them resulting from the tyranny exerted by the ground-plan. First, an unnatural regularity of outline. Secondly, and consequently, the need for a site that will fit the plan, and therefore for a barbarous work of clearance. Thirdly, the absence of an intelligible facade. Fourthly, the denial (implicit in those foregoing qualities) of the street. Such buildings

either stand behind a little clearing, refusing to align themselves; or else they shuffle forward and stare blankly and meaninglessly into space. They appear in our ancient towns like expressionless psychopaths, hungry for power, and careless of all the decencies that would merit it.

16. Composition requires detail, and the principles of composition depend upon the sense of detail. Here too matters have not been unaffected by modernist diseducation. The hostility to "ornament" led to a corresponding neglect of detail, and to an emphasis on line and form as the main variables of composition. It came to seem as if architecture could be understood simply through the study of *geometry*; buildings were conceived as though cast in moulds out of some pliable fluid. (And, in due course, this is exactly how modernist buildings were made.)

 The fact is, however, that words like "form," "proportion," "order," and "harmony" can be applied to buildings only if they have significant parts. Harmony is a harmony among parts; proportion is a relation between perceivable divisions, and so on. The form of a building is perceivable only where there are details which divide and articulate its walls.

17. The true discipline of style consists, therefore, in the disposition of details. Hence the basis of everyday construction must lie in the pattern book: the catalogue of details which can be readily conjured, so as to form intelligible unities. All serious systems of architecture have produced such books (even if they have existed in the heads and hands of builders, rather than on the printed page). They offer us detachable parts, rules of composition, and a vocabulary of form. By means of them, an architect can negotiate corners, build in confined spaces, match wall to window, and window to door, and in general ensure an effect of harmony, in all the varying circumstances imposed on him by the site and the street which borders it.

18. The art of combination relies for its effect on regularity and repetition. The useful details are the ones that can be repeated, the ones which satisfy our demand for rhythm, sameness, and symmetry. To invent such details, and at the same time to endow them with character and life, is not given to every architect at every period.

19. As the Orders make clear, the true discipline of form emphasizes the vertical, rather than the horizontal line. The art of design is the art of vertical accumulation, of placing one thing above another, so as to create an order which can be spread rhythmically from side to side. It

is by virtue of such an order that buildings come to stand before us as we before them, and to wear the human face that pleases us.

20. To endow a facade with vertical order, it is necessary to exploit light, shade and climate, to divide the wall space, and to emphasize apertures. In other words, it is necessary to use moldings.

 The abolition of moldings was a visual calamity, the effects of which can be clearly witnessed in the modern American city. The real ugliness came not with the skyscraper, but when the skyscraper was stripped of all those lines, shadows, and curlicues which were the source of its life and gaiety. Without moldings, no space is articulate. Edges become blades; buildings lose their crowns; and walls their direction (since movement sideways has the same visual emphasis as movement up and down). Windows and doors become mere holes in the wall. Everything is sheer, stark, uncompromising, cold. In a nutshell, moldings are the sine qua non of decency, and the source of our mastery over light and shade.

21. The building of a human face in architecture depends not only on details but also on materials. These should be pleasant to the touch, welcoming to the eye and accommodating to our movements. They should also take a patina, so that their permanence has the appearance of softening and age. The duration of a building must, like the building itself, be marked by *life*. It must show itself as mortality, finitude, sadness, experience, and decay. Hence concrete, even if it lends itself to massive aesthetic effects like the dome of the Pantheon, is not a suitable material for the ordinary builder.

22. The discipline of such a builder consists in the ability to perceive, to draw, to compare and to criticize details; and thereafter to combine those details in regular and harmonious forms, whatever the shape of the site in which he works, and without doing violence to the surrounding order.

Those twenty-two points do not dictate a style, but only the form of a style. But of course, they are in keeping with the tradition of Western architecture as it existed until the First World War, and they are enacted in the Classical and Gothic pattern books of the nineteenth century. But it is not enough to study a pattern book. Education is needed before you can apply it, and the question remains what form that education should take. I am inclined to say that the aspiring architect should go into the world and use his eyes. He should study the great treatises of architecture and learn to see with the eyes of others. He should learn to draw the shadows that fall on

a Corinthian order, cast by the lines, moldings, and ornaments of a whole vertical cross section. Then, perhaps, he will be ready for his first project: to design a facade between two existing buildings, in such a way that *nobody will be forced against his will to notice it.*

But such an education requires mental effort, and spiritual humility. And whatever things are taught in schools of architecture, those two qualities are not among them.

<div style="text-align:center">⌁◇⌁</div>

Reconsidering the Aesthetics of Architecture*

Allen Carlson

The purpose of this discussion is twofold: first, to propose a somewhat different approach to a traditional topic of aesthetic inquiry, the aesthetics of architecture; second, to suggest, by means of the consideration of this topic, some of the ways in which recent work in environmental aesthetics may bring illumination to traditional areas of aesthetic interest and concern. As background, it is initially useful to consider the typical manner of approaching this topic.

Traditionally the aesthetics of architecture has been thought of as a part of the aesthetics of art. Architecture itself has often been considered a lesser art, but yet one which must find its proper place in a unified artistic aesthetic. The aesthetic concepts and theories that serve in the analysis of the fine or pure arts have been pressed into service for architecture as well. Thus the aesthetics of architecture has concentrated on particular structures that can be viewed as "works of architecture" comparable to works of art and with features comparable to those we find aesthetically interesting and pleasing in works of art. The concentration has been on solitary, unique structures which have been carefully designed and created by the architect as artist. If they are in certain ways work-of-art-like or in particular sculpture-like, so much the better. In short, the focus has been on individual, magnificent buildings—the *works* of one kind of "artist."

This traditional approach has certain difficulties. Even more so than the concept "work of art," the concept "work of architecture" is a curious abstraction, and the class of works of architecture is a highly gerrymandered class. Even the paradigmatic works of architecture are unlike typical works of art in a number of ways. For example, as buildings they have functions and thus

* "Reconsidering the Aesthetics of Architecture," *Journal of Aesthetic Education* 20:4 (1986): 21–27. Copyright 1986 by the Board of Trustees of the University of Illinois. Used with permission of the University of Illinois Press.

are intrinsically connected to the peoples and cultures that use them. And as buildings they are also related to other buildings, not only functionally related to those with similar uses, but structurally related to those similarly designed and constructed and even physically related to those adjacent to them. Moreover, as buildings they are built in places and thus intimately tied not only to physically adjacent buildings, but to the cityscapes or landscapes within which they exist. Given this web of interrelationships, it is difficult to ground the abstraction "work of architecture" securely, and picking out the particular works of architecture begins to look like a rather arbitrary process. In short, once we start looking at and thinking about buildings, we realize that they do not easily fit a concept analogous to the favored concept of a work of art, that of a unique, functionless, and often portable object of aesthetic appreciation.

It is in part this web of interrelationships that moves me toward what may be called an ecological approach to the aesthetics of architecture. I am also interested in the aesthetics of natural environments and think there are resources in this area applicable to architecture.[1] Here, however, I stress ecological factors only to the extent of considering works of architecture not as analogous to works of art, but rather as integral parts of something like a human ecosystem comparable to the ecosystems that make up the natural environment.

To develop this comparison, we need to note initially that the natural environment is composed of interlocking ecosystems characterized by a feature I call *functional fit*. Each ecosystem itself must fit with various other systems, and the constituents of any system must likewise fit within it. At the level of the individual organism this is termed having an ecological niche. The importance of such niches, and of functional fit in general, has to do with survival. In this lies an ecological interpretation of the biological principle of the survival of the fittest: without a fit neither individual organisms nor ecosystems long survive. It is in this sense that the fit is functional. Ecosystems and their components do not fit together as the pieces of a puzzle, but rather as the parts of a machine. Each has a function, the performing of which helps to maintain not only the part itself, but also the other components of the system, the system itself, and ultimately the whole natural environment.

Once the importance of functional fit is realized, the concept easily finds a place in our aesthetic appreciation of natural environments. When aesthetically appreciated under this concept, nature can no longer be perceived simply as a collection of individual, disjointed natural objects, organisms, or landscapes. No such component of an ecosystem can be fully appreciated in isolation, but must be perceived in terms of its fit with larger wholes, Moreover, since the fit is functional, functional descriptions take on new

significance. Landscapes become habitats, ranges, and territories, the dwelling, feeding, and surviving spaces and places of organisms. And organisms themselves become players in a unified drama of life. Indeed, the ecological concept of functional fit may be seen as analogous to the aesthetic notion of organic unity, a notion imported from the appreciation of nature and traditionally utilized as a fundamental concept in the aesthetic appreciation of works of art.

Returning to architecture, an ecological approach involves perceiving architecture in its broadest sense as our natural human environment, that is, perceiving our created landscapes, cityscapes, and the buildings and structures which comprise them as analogous to interlocking ecosystems, with the notion of functional fit as the key to appreciating their creation, development, and continued survival. When so perceived, natural human environments display the kind of organic unity we aesthetically appreciate in nature. In many cases a landscape or a cityscape or even a particular building has developed naturally over time—has as it were organically grown—in response to human needs, interests, and concerns. It thus has a fit which need not be the result of intentional design, but of those forces that have shaped it such that a fit of the components occurs naturally. Such fits are explicitly functional in that they accommodate the fulfilling of various interrelated functions, indeed, the fact that these functions are fulfilled is the essence of the fit. We are perhaps most familiar with such functional fits in rural landscapes, where certain kinds of buildings, farms, and rural communities fit functionally together and into the landscape they occupy and help form.[2] However, functional fits can also be appreciated in the city, especially in older neighborhoods, ethnic districts, and city market areas. When a functional fit has been achieved in such places, there is an ambiance of everything being and looking as it should, of being and looking right or appropriate—as if the whole were the result of processes akin to the ecological and evolutionary forces that shape the natural environment.

An ecological approach to the aesthetics of architecture which dictates the appreciation of architecture under the concept of functional fit has a number of immediate consequences. The first of these is an emphasis on all buildings rather than simply on the magnificent or the especially designed. The functional fit of the ecosystem gives importance to each of its components. Thus in light of an ecological approach, structures such as the gas station, the shopping center, and the factory are each as integral a part of the natural human environment and as viable a candidate for aesthetic appreciation as are the paradigmatic works of architecture. Related to this consequent is an equal emphasis on nonbuildings—both other

kinds of structures and artifacts of the natural human environment as well as that environment itself. Bridges, highways, and power lines become objects of appreciation, as do the landscapes through which they pass. On an ecological approach, then, architectural aesthetics becomes a subdivision within landscape aesthetics. This consequent seems quite appropriate, for even the paradigmatic objects of traditional architectural aesthetics, the especially designed and magnificent buildings, are each, after all, built in a place. They are not portable as are typical works of art, and thus severing their appreciation from that of the cityscapes or the landscapes in which they exist seems at best highly artificial and at worst quite absurd. In this, I suspect, lies part of the aesthetic absurdity of such cases as the moving of London Bridge to Lake Havasu City, Arizona.

The above remarks emphasize the significance which an ecological approach gives to each of the various components of our natural human environment. However, as the London Bridge example suggests, such an approach also stresses the interrelationships among these components. Given the importance of functional fit, the complexes in our human environments, like the ecosystems of natural environments, become focuses of aesthetic appreciation. Rather than emphasizing this or that building, appreciation shifts to, for example, the downtown, the banking district, the neighborhood, and even the suburb. The fit within and between such places and spaces, together with their ambiance and atmosphere, their feel, take on greater aesthetic significance. Closely related to this, and ultimately more important, is another set of relationships—those between any human environment and the people whose environment it is. Buildings are no more people and culture free than they are cityscape and landscape free. There is a tradition of appreciating pure works of art as isolated, people- and culture-free entities. This tradition is probably wrongheaded even with respect to artworks, but it is clearly so with respect to buildings and their environments. Thus on an ecological approach questions of how buildings reflect, represent, and express peoples and their cultures acquire new importance. They become a part of the essence of aesthetic appreciation rather than a curious sideline of such appreciation. The aesthetic absurdity of moving London Bridge lies not simply in moving it from one landscape to another, but also in taking it, through space and time, from one culture to another.

A further consequent of an ecological approach is that functionalism acquires renewed life. Given the importance of functional fit, buildings must be appreciated in terms of the functions they perform, and, as in nature appreciation, functional descriptions become more significant. In the English language words for the parts of the human environment do not always

emphasize this significance. Those for the internal parts of one small ecosystem—the house—certainly do; we refer to the living room, the dining room, the bathroom. However, words such as "building," "house," and "church" are not as suggestive. Perhaps phrases such as "dwelling place" or "place of worship" would be better. Consider the aesthetic appreciation of churches under a description such as "place of worship." Unlike the word "church," "place of worship" forces function to the forefront of our minds, and questions such as, "Is this place conducive to worship?" "Does it make one humble, or does it inspire awe or even fear?" become a part of our appreciation of the structure. Functionalist appreciation under functional descriptions can also be extended to larger complexes. As noted, many human environments have developed naturally over time so as to achieve a functional fit, and others have been expressly designed to fit together in a functional manner. These explicitly functional complexes are appropriately appreciated as such.

Functionalism, of course, is an important theme in twentieth-century architecture; architects like Louis Sullivan, Frank Lloyd Wright, Walter Gropius, Louis Kahn, and others have stressed it. However, the emphasis has often been on the functions of individual structures and the problems of designing them to suit these functions. An ecological approach emphasizes not only the functions of particular buildings, but the functional fit of the particular into the whole of its environment. Moreover, this functionalist tradition by and large eschews the utilization of ornamentation in architectural design. However, as is realized by many postmodern architects, ornamentation is an important means of achieving another kind of fit of the particular into the whole. This fit is not in essence functional, but only apparently so. The fit yields the look and feel, the ambiance, of a functional fit without necessarily achieving it. Indeed, the fact that we perceive this kind of fit as a fit at all underscores the importance of the functional fit, for the fitness is typically only a matter of suggesting a functional fit by means of ornamentation. In the most obvious cases, it amounts to no more than making a building blend with its immediate spatial surroundings—a new building in an older section may be given some of the frills of buildings typical of that area. However, in more subtle cases it can involve an apparent functional fit not simply with the spatial environment, but rather with what might be called the temporal environment. Ornamentation can give an ambiance of fit with the cultural history of a place and its peoples and even perhaps with their vision of the future. And even though the fit achieved is not a real functional fit, it is yet an important way in which designed architecture can reflect, represent, and express people and their cultures and is thus a significant element in our aesthetic appreciation of human environments.

In this discussion I emphasize the notion of fit because I think it is the key to the aesthetic appreciation of architecture in the broadest sense. An ecological approach to architectural aesthetics brings this out by the analogy to natural ecosystems in which functional fit is always a reality. In our human environments, however, functional fit is in some cases a reality, but in others only the appearance of such a fit. Nonetheless, aesthetic appreciation deals with appearance as well as with reality. Thus with respect to such appreciation a key lesson given by an ecological approach is that nothing in our human environments, as in natural environments, can be fully appreciated in isolation. Each building, cityscape, or landscape must rather be appreciated in virtue of the fit that exists within it and with its larger environment. To fail to do so is often to miss much that is of aesthetic interest and merit. Keeping with an ecological approach, we may emphasize this point by remembering that natural environments work on the principle of the survival of the fittest and that ecologically interpreted this principle can be taken to mean the survival of that which best fits with its environment. For the aesthetic appreciation of our natural human environments, and of architecture in particular, perhaps a comparable principle suggests that we may find the greatest aesthetic interest and merit in the fittest.

Notes

1. See Allen Carlson, "Appreciation and the Natural Environment," *Journal of Aesthetics and Art Criticism* 37, no. 3 (1979): 267–75; Allen Carlson, "Nature, Aesthetic Judgment, and Objectivity," *Journal of Aesthetics and Art Criticism* 40, no. 1 (1981): 15–27.

2. Carlson develops this point more fully in "On Appreciating Agricultural Landscapes," *Journal of Aesthetics and Art Criticism* 43, no. 3 (1985): 301–12.

Further Reading

Davies, Stephen. 1995. Is architecture art? In *Philosophy and architecture*, edited by Michael Mitias, 31–47. Amsterdam: Editions Rodopi. Argues that architecture is not an art form.

Goodman, Nelson. 1985. How buildings mean. *Critical Inquiry* 11: 642–53. Details three ways in which buildings can communicate in a cognitively enlightening manner.

Harries, Karsten. 1998. *The ethical function of architecture*. Cambridge, MA: MIT Press. An extended analysis of the symbolic dimensions of buildings that is

limited by lack of engagement with the work of contemporary philosophers on architecture.

Parsons, Glenn, and Allen Carlson. 2009. "Architecture and the Built Environment." In *Functional beauty*, 137–66. New York: Oxford University Press. Includes extended discussion of the difficulties that architecture poses for a function-oriented aesthetic.

Ross, Stephanie. 1998. *What gardens mean*. Chicago: University of Chicago Press. Addresses whether landscape gardening is a species of the art of architecture.

Scruton, Roger. 1979. *The aesthetics of architecture*. Princeton, NJ: Princeton University Press. One of the few extensive philosophical works on this topic.

About the Authors

Robert Stecker is professor of philosophy at Central Michigan University. He has also taught at the National University of Singapore, Auckland University (New Zealand), and Lingnan University (Hong Kong). He is the author of *Artworks: Definition, Meaning, Value* (1997), and *Interpretation and Construction: Art, Speech and the Law* (2003). He has coedited *A Companion to Aesthetics*, 2nd ed. (2009), with Stephen Davies, Kathleen Higgins, Robert Hopkins, and David Cooper, and *Aesthetics Today* (2010) with Ted Gracyk.

Theodore Gracyk (PhD University of California, Davis) is professor of philosophy at Minnesota State University Moorhead. He is the author of three philosophical books on music (*Rhythm and Noise: An Aesthetics of Rock Music*, 1996; *I Wanna Be Me: Rock Music and the Politics of Identity*, 2001; *Listening to Popular Music*, 2007) and many articles on aesthetics and its history. He is currently coediting (with Andrew Kania) *The Routledge Companion to Philosophy and Music*.